EVERYMAN,
I WILL GO WITH THEE,
AND BE THY GUIDE,
IN THY MOST NEED
TO GO BY THY SIDE

JOHN JAMES AUDUBON

THE AUDUBON READER

EDITED BY RICHARD RHODES

WITH 16 COLOR PLATES FROM THE
ORIGINAL WATERCOLORS

EVERYMAN'S LIBRARY
Alfred A. Knopf New York London Toronto
284

THIS IS A BORZOI BOOK
PUBLISHED BY ALFRED A. KNOPF

First included in Everyman's Library, 2006
Copyright © 2006 by Richard Rhodes
Typography by Peter B. Willberg

US website: www.randomhouse/everymans

ISBN: 1-4000-4369-7 (US)
1-85715-284-0 (UK)

A CIP catalogue reference for this book is available from the
British Library

Book design by Barbara de Wilde and Carol Devine Carson

Typeset in the UK by AccComputing, North Barrow, Somerset
Printed and bound in Germany by GGP Media GmbH, Pössneck

For Bill Steiner

Contents

Part I: Going West

Part II: The American Woodsman

Part III: Mr. Audubon Arrives

Part IV: Underway for Old England

Part V: Florida

Part VI: Labrador

Part VII: Hope for Great Things

Illustrations

Introduction: America's Rare Bird

The handsome, excitable eighteen-year-old Frenchman who would become John James Audubon had already lived his way through two names when he landed in New York from Nantes in August 1803. His father Jean, a canny ship's captain with Pennsylvania property, had sent his only son off to America with a false passport to escape Napoleonic conscription, the young man's second or third escape. The tenant who farmed the plantation Jean Audubon owned, Mill Grove, which straddled Perkiomen Creek close above Valley Forge, had reported a vein of lead ore. John James or Jean Jacques or Fougère was supposed to evaluate the tenant's report, learn what he could of plantation management and eventually—since the French and Haitian revolutions had all but erased the Audubon fortune—make a life for himself.

He did that and much, much more. He married an extraordinary woman, opened a string of general stores on the Kentucky frontier, built a great steam mill on the Ohio River, explored the American wilderness from Galveston Bay to Newfoundland, hunted with Shawnees and Osages, rafted the Ohio and the Mississippi, identified, studied and drew almost five hundred species of American birds, saw English noblemen kneel before him to examine his dazzling drawings, raised the equivalent of several million dollars to publish a great work of art, wrote five volumes of "bird biographies" larded with narratives of pioneer life, won fame enough to dine with presidents and became a national icon, "The American Woodsman," his ultimate appellation, a name he gave himself.

John James had first been Jean Rabin, his father's bastard child, born in 1785 on Jean Audubon's sugar plantation on Saint Domingue (soon to be renamed Haiti) to a twenty-seven-year-old French chambermaid, Jeanne Rabin, who died of infection within months of his birth. The first stirrings of slave rebellion in 1791 prompted Jean Audubon to sell what he could of his holdings and ship his son home to France, where his wife Anne, a generous older widow whom Jean had married long before, welcomed the handsome boy and raised him as her own.

When the Terror approached Nantes in 1793 the Audubons had formally adopted the bastard Jean Rabin, christening him Jean Jacques or Fougère Audubon, Fougère—"Fern"—an offering to placate the Revolutionary authorities, who scorned the names of saints. Jean-Baptiste Carrier, sent out from Paris to quell the Vendéan peasant counterrevolution, ordered the slaughter of thousands in Nantes—a guillotine and firing squads in the town square, victims chained to barges sunk in the Loire, tainting the river for months—and even though Jean Audubon was an officer in the Revolutionary French navy, he and his family were jailed and barely spared. Two escapes and two names, and now a third escape and John James; but this escape opened up a world.

The young country to which John James Audubon emigrated in the summer of 1803 was barely settled beyond its eastern shores; Lewis and Clark were just then preparing to depart for the West. France in that era counted a population of more than 27 million, Britain about 15 million, but only 6 million people yet thinly populated the United States, two-thirds of them living within fifty miles of Atlantic tidewater. In European eyes America was still an experiment. It would need a second American revolution—the War of 1812—to compel England and Europe to honor American sovereignty.

But the first generation of Americans which the young French émigré was joining was different from its parents. Like Audubon, it had left home to migrate westward. Like Audubon also, it would break with tradition and take great risks in pursuit of new opportunities which its elders had not enjoyed. "National spirit is the natural result of national existence," Gouverneur Morris had predicted back in 1784; "and although some of the present generation may feel colonial oppositions of opinion, that generation will die away, and give place to a race of Americans." Audubon's was the era, as the historian Joyce Appleby has discerned, when "the autonomous individual emerged as an ideal." American individualism was not a natural phenomenon, Appleby writes; it "[took] shape historically [and] came to personify the nation and the free society it embodied." And no life was at once more unique and more representative of that expansive era when a national character emerged than Audubon's. Celebrate him for his wonderful birds;

but recognize him as well as a characteristic American of the first generation—a man who literally made a name for himself.

Lucy Bakewell, the tall, slim, gray-eyed girl next door whom he married, came from a distinguished English family. Erasmus Darwin had dandled her on his knee in their native Derbyshire. Her father had moved his family to America to follow Joseph Priestley, the chemist and religious reformer, but opportunity had also drawn the Bakewells. Their plantation, Fatland Ford, was more ample than the Audubons', and William Bakewell sponsored one of the first experiments in steam-powered threshing there while his young French neighbor lay ill with a fever in his house under his talented daughter's care. Lucy was a gifted pianist, an enthusiastic reader, a skillful rider—sidesaddle—who kept an elegant house. She and John James, once they married and moved out to Kentucky in 1808, regularly swam across and back the half-mile-wide Ohio for morning exercise.

Lucy's handsome young Frenchman had learned to be a naturalist from his father and his father's medical friends, exploring the forested marshes along the Loire. Her younger brother Will left a memorable catalog of his future brother-in-law's interests and virtues; even as a young man, Audubon was someone men and women alike wanted to be around:

On entering his room, I was astonished and delighted to find that it was turned into a museum. The walls were festooned with all kinds of birds' eggs, carefully blown out and strung on a thread. The chimney-piece was covered with stuffed squirrels, raccoons, and opossums; and the shelves around were likewise crowded with specimens, among which were fishes, frogs, snakes, lizards, and other reptiles. Besides these stuffed varieties, many paintings were arrayed on the walls, chiefly of birds. He had great skill in stuffing and preserving animals of all sorts. He had also a trick in training dogs with great perfection, of which art his famous dog Zephyr was a wonderful example. He was an admirable marksman, an expert swimmer, a clever rider, possessed of great activity [and] prodigious strength, and was notable for the elegance of his figure and the beauty of his features, and he aided nature by a careful attendance to his dress.

Besides other accomplishments he was a musician, a good fencer, danced well, and had some acquaintance with legerdemain tricks, worked in hair, and could plait willow baskets.

Audubon had begun teaching himself to draw birds in France. In Louisville and then downriver in frontier Henderson, Kentucky, he was responsible for keeping the pot filled with fish and game and the shelves with supplies while his business partner Ferdinand Rozier ran the store and Lucy kept house, worked the garden and bore him two sons; as he hunted and traveled he improved his art on American birds and kept careful field notes as well. His narrative of an encounter with a flood of passenger pigeons is legendary (they were "passengers" rather than migratory because they moved from forest to forest feeding on fruit and mast, and they numbered in the billions). His descriptions match his best drawings in vivacity: of American swifts lining a hollow seventy-foot sycamore stump near Louisville like bats in a cave, of brown pelicans fishing the shallows of the Ohio, of sandhill cranes tearing away water-lily roots in a backwater slough, of the bald eagles that nested by the hundreds along the Mississippi stooping like falling stars to strike swans to ground, of robins down from Labrador occupying apple trees, of crowds of black vultures, protected by law, patrolling the streets of Natchez and Charleston to clean up carrion and roosting at night on the roofs of houses and barns, of bright scarlet, yellow and emerald-green Carolina parakeets completely obscuring a shock of grain like "a brilliantly colored carpet" in the center of a field, of a least bittern standing perfectly still for two hours on a table in his studio while he drew it.

Drawing birds had been something of an obsession, but only a hobby, until Audubon's businesses failed in the Panic of 1819, a failure his critics and too many of his biographers have ascribed to a lack of ability or the irresponsible distraction of his art. But almost every business in the trans-Appalachian West failed that year, because the Western state banks and the businesses they serviced were built on paper. When the Bank of the United States, needing specie (gold and silver) to finish paying off the Louisiana Purchase, demanded the redemption in specie of state bank balances and notes, the banks in response began calling in their

loans, shrinking the money supply. "One thing seems to be universally conceded," an adviser told the governor of Ohio, "that the greater part of our mercantile citizens are in a state of bankruptcy— that those of them who have the largest possessions of real and personal estate . . . find it almost impossible to raise sufficient funds to supply themselves with the necessaries of life." The Audubons lost everything except John James's portfolio and his drawing and painting supplies. Before he took bankruptcy Audubon was even briefly thrown in jail for debt.

Through these disasters, Lucy never failed him, although they lost an infant daughter to fever that year as well. "[Lucy] felt the pangs of our misfortunes perhaps more heavily than I," Audubon remembered gratefully of his stalwart love, "but never for an hour lost her courage; her brave and cheerful spirit accepted all, and no reproaches from her beloved lips ever wounded my heart. With her was I not always rich?"

Resourcefully, Audubon took up portrait drawing at five dollars a head. His friends found him work painting exhibit backgrounds and doing taxidermy for a new museum in Cincinnati modeled on Charles Wilson Peale's famous museum in Philadelphia, which Audubon knew from his Mill Grove days. Peale's Philadelphia Museum displayed mounted birds as if alive against natural backgrounds, and preparing such displays in Cincinnati probably pointed Audubon to his technical and esthetic breakthrough of portraying American birds in realistic, lifelike poses and settings rather than stiffly perched on branches as ornithological tradition required. Members of the Long Expedition passing through Cincinnati in the spring of 1820, including the young artist Titian Ramsey Peale, son of the Philadelphia museum keeper, alerted Audubon to the possibility of exploring beyond the line of the frontier. Daniel Drake, the prominent Cincinnati physician who had founded the new museum, praised Audubon's work in a public lecture and encouraged him to think of extending the range of American natural history by adding the birds of the Mississippi flyway to his collection.

By spring 1820, falling casualty to the Panic, Drake's museum owed Audubon twelve hundred dollars, most of which it never paid. The artist scraped together such funds as he could raise from

drawing and teaching to support Lucy and their two boys while he was gone—she would move to Shippingport, below Louisville, to live with her prosperous brother-in-law and younger sister, not entirely happily—recruited his best student, eighteen-year-old Joseph Mason, to draw backgrounds, bartered pot hunting for boat passage on a commercial flatboat headed for New Orleans and in October floated off down the Ohio and the Mississippi to claim his future.

For the next five years Audubon labored to assemble a definitive collection of drawings of American birds while struggling to support himself and his family, to move Lucy and the boys to Louisiana and to accumulate the funds he would need to travel to England and hire an engraver. He had decided to produce a great work of art and ornithology (a decision that Lucy's relatives condemned as derelict): *The Birds of America* would comprise four hundred two-by-three-foot engraved, hand-colored plates of American birds "at the size of life" to be sold in sets of five and collected into four huge leather-bound volumes of one hundred plates each, with five leather-bound accompanying volumes of "bird biographies" worked up from his field notes.

He had found a paradise of birds in the deciduous forests and bluegrass prairies of Kentucky; he found another paradise of birds in the pine forests and cypress swamps of Louisiana around St. Francisville in West Feliciana Parish, north of Baton Rouge along the Mississippi River inland from the river port of Bayou Sarah, where prosperous cotton planters hired him to teach their sons to fence and their daughters to draw and dance the cotillion. Elegant Lucy, when finally she was able to move south, opened a popular school of piano and deportment on a cotton plantation operated by a hardy Scots widow.

On his first inspection of the St. Francisville environs Audubon identified no fewer than sixty-five species of birds. He probably collected his best-known image there, the prized first plate of *The Birds of America*—a magnificent specimen of wild turkey cock which he had called from a Mississippi canebrake. (In Audubon's time the river margins of the Midlands and the South were one vast canebrake; cane, the giant perennial grass *Arundinaria gigantea*, one of only two native American bamboos, grew in dense profusion

ten to twenty feet high wherever the soil was rich and wet, with woody stems like corn and fern-like compound leaves that it shed in the spring when new leaves emerged. Birds nested in the cane; it sheltered deer, bears and other wild game; settlers turned their cattle and hogs into it to graze as bison had grazed it in Daniel Boone's day all the way east to the Potomac.)

Finally, in May 1826, he was ready. With the equivalent of about ten thousand dollars in gold in his purse and a collection of letters of introduction from New Orleans merchants and Louisiana and Kentucky politicians including Henry Clay, he sailed from New Orleans on a merchant ship bound for Liverpool with a load of cotton. He knew not a soul in Liverpool other than Lucy's younger sister Ann and her English husband Alexander Gordon, a cotton factor, who would take one look at his rough frontier pantaloons and unfashionable shoulder-length chestnut hair (about which he was comically vain) and avoid him like the plague. But James Fenimore Cooper's *The Last of the Mohicans* had been published in London in April and was blooming to a nationwide fad, and some who met Audubon in Liverpool judged him a real-life Natty Bumppo. His letters introduced him to the first family of Liverpool shipping, the Rathbones, Quaker abolitionists who recognized his originality and sponsored him socially. Within a month he was the Georgian equivalent of a rock star, his presence sought at every wealthy table; the Gordons soon came round.

More than Audubon's novelty won him attention in Liverpool and then in Manchester, Edinburgh and London. Britain was the most technologically advanced nation in the world in 1826, with gaslights illuminating its cities, steam mills weaving cotton, steam-boats plying its ports and railroad lines just being laid to replace its mature network of canals, but the only permanent images then available in the world were images drawn by hand. Traveling from city to city, Audubon would hire a hall and hang it with his lifesized watercolors of birds luminescent against their backgrounds of wilderness, several hundred images at a time, and charge admission to the visitors who flocked to see them. So many scenes of birds going about their complicated lives—birds hunting, feeding, courting, soaring and fighting, nesting and nurturing young—in such natural settings of wild shoreline and forest and canebrake,

would have flooded viewers' senses as an Imax Theater presentation floods viewers today, and all the more so because the world these creatures inhabited was America, still largely wilderness and a romantic mystery to the British, as Audubon discovered to his surprise. He answered questions about "Red Indians" and rattle-snakes, imitated war whoops and owl hoots until he could hardly bear to accept another invitation, but accept he did, because the prosperous merchants and the country gentry would become his subscribers once he found an engraver in London worthy of the great project, which he calculated would occupy him for sixteen years.

Audubon produced his five-plate "Numbers" of *The Birds of America* pay as you go, and managed to complete the work in only ten years even though he had to increase the total number of plates to 435 as he identified new species in collecting expeditions to the Carolinas and East Florida, the Republic of Texas, northeastern Pennsylvania, Labrador and the Jersey Shore. In the end, he esti-mated that producing *The Birds of America* cost him $115,640—about $2 million today. Unsupported by gifts, grants or legacies, he raised almost every penny of that immense sum himself from painting, exhibiting and selling subscriptions and skins. He paced the flow of funds to his engraver so that, as he said proudly, "the continuity of execution" was not "broken for a single day." He paced the flow of drawings as well, and before that the flow of expeditions and collections. He personally solicited most of his subscribers and personally serviced most of his accounts. Lucy supported herself and their children while he was establishing him-self; thereafter he supported them all and the work as well. If he made a profit it was small, but in every other way the project was an unqualified success. After he returned to America he and his sons produced a less costly octavo edition with reduced images printed by lithography that made him rich.

These facts should lay to rest once and for all the enduring canard that John James Audubon was "not a good businessman." His retail business failed in Henderson in 1819, like nearly every other business in the trans-Appalachian West, in the wake of an economic disaster that was beyond his control. When he set out to create a monumental work of art with his own heart and mind

and hands, he succeeded—a staggering achievement, as if one man had singlehandedly financed and built an Egyptian pyramid.

He did not leave Lucy languishing in West Feliciana all those years, but before he could return to America for the first time to collect her, their miscommunications, exacerbated by the uncertainties and delays of mail delivery in an era of sailing ships, nearly wrecked their marriage. Lonely for her, he wanted her to close her school and come to London; she was willing once she had earned enough to sustain their adolescent sons at school. But a round of letters took six months, one ship in six (and the letters it carried) never made port, and by 1828 Audubon had convinced himself that Lucy expected him to amass a fortune before she would leave Louisiana, while she feared her husband had been dazzled by success in glamorous London and didn't love her any more. (London was fouled with coal smoke; Audubon hated it.) Finally she insisted that he come in person to claim her, and after finding a trustworthy friend to handle a year's production of plates for the *Birds*, he did, in 1829, with results that can be read in Part III of this book. The marriage survived and went on to thrive; when Audubon died in 1851 he and his Lucy had been husband and wife for forty-three years.

If Audubon's life sounds like a nineteenth-century novel with its missed connections, Byronic ambitions, dramatic reversals and passionate highs and lows, nineteenth-century novels were evidently more realistic than moderns have understood. Besides his art, which is as electrifying on first encounter today as it was two centuries ago—no one has ever drawn birds better—Audubon left behind a large collection of letters, many of them unpublished; the five volumes of the *Ornithological Biography*; the *Viviparous Quadrupeds of North America*; two complete surviving journals, fragments of two more and a name which has become synonymous with wilderness and wildlife preservation.

I have selected from most of these sources. I tried to minimize overlap with the selections in the Library of America *Audubon* so that more of Audubon's work might be returned to print. Whenever possible I have drawn on the original printed or handwritten text. The episodes and bird biographies are taken from a facsimile edition of the *Ornithological Biography* published in 1985

to accompany the Abbeville Press/National Audubon Society facsimile edition of *The Birds of America*. The *Labrador Journal* comes from an 1897 two-volume anthology, *Audubon and His Journals*, edited by Audubon's granddaughter Maria R. Audubon. Originals of Audubon's letters and those of family and friends are held in the manuscript collections at Harvard's Houghton Library, Princeton's Firestone Library, Yale's Beinecke Library, the library of the American Philosophical Society in Philadelphia, Pennsylvania, the Stark Museum in Orange, Texas, the library of the Musée Nationale d'Histoire Naturelle in Paris, the Liverpool Public Library, the Filson Historical Society in Louisville, Kentucky, and the John James Audubon Museum of the John James Audubon State Park in Henderson, Kentucky. I searched all these sources for selections and thank them for allowing me access. Some letters are taken from two volumes edited by Howard Corning and published by the Club of Odd Volumes of Boston in 1930, a source for which I have been unable to locate a copyright holder. John Bachman's correspondence is reproduced in part from Catherine Bachman, *John Bachman*, published in Charleston by Walker, Evans and Cogswell Co. in 1888. Head notes and this introduction are based on my 2004 biography *John James Audubon: The Making of an American*, published by Alfred A. Knopf, to which I refer readers interested in a full recounting and assessment of Audubon's life. Since this collection is intended for general readers, I have modernized Audubon's somewhat eccentric spelling, capitalization and punctuation and deleted material of only specialized interest, such as the formal anatomical descriptions that conclude each bird biography, which were prepared for Audubon by his Scottish associate William MacGillivray.

"All but the remembrance of his goodness is gone forever," Lucy Audubon wrote sadly of her husband's death from complications of dementia in January 1851. For Lucy all was gone—she lived on until 1874—but for the rest of us, wherever there are birds there is Audubon: *rara avis*.

Richard Rhodes

Select Bibliography

Works

No complete edition of Audubon's works that includes his surviving journals and letters has yet been published. Selections may be found in this volume and in:

John James Audubon, *Ornithological Biography*, 5 vols, Edinburgh: Adam and Charles Black, 1831–1839 (facsimile edition, Abbeville Press/National Audubon Society, 1985).

Maria R. Audubon (ed.), *Audubon and His Journals*, 2 vols, New York: Charles Scribner's Sons, 1897.

Howard Corning (ed.), *Letters of John James Audubon, 1826–1840*, 2 vols, New York: Kraus Reprint Co., 1969.

Alice Ford (ed.), *The 1826 Journal of John James Audubon*, Norman, OK: University of Oklahoma Press, 1967.

Christoph Irmscher (ed.), *John James Audubon: Writings and Drawings*, New York: The Library of America, 1999.

John Francis McDermott (ed.), *Audubon in the West*, Norman, OK: University of Oklahoma Press, 1965.

National Audubon Society, *The Complete Audubon: A Precise Replica of the Complete Works of John James Audubon, Comprising* The Birds of America *(1840–44) and* The Quadrupeds of North America *(1851–54) in Their Entirety*, New York: Volair Books, 1979.

Biography and Reference

Richard Rhodes, *John James Audubon: The Making of an American*, New York: Alfred A. Knopf, 2004 (with a full bibliography).

Stanley Clisby Arthur, *Audubon: An Intimate Life of the American Woodsman*, Gretna, LA: Pelican Publishing Company, 2000.

John Chalmers, *Audubon in Edinburgh and His Scottish Associates*, Edinburgh: NMS Publishing, 2003.

Carolyn Delatte, *Lucy Audubon: A Biography*, Baton Rouge, LA: Louisiana State University Press, 1982.

Francis Hobart Herrick, *Audubon the Naturalist: A History of His Life and Time*, 2nd edn, New York: D. Appleton-Century Company, 1938.

Jay Shuler, *Had I the Wings: The Friendship of Bachman & Audubon*, Athens, GA: University of Georgia Press, 1995.

Annette Blaugrund and Theodore E. Stebbins, Jr. (eds), *John James Audubon: The Watercolors for* The Birds of America, New York: Villard Books, 1993.

Susanne M. Low, *A Guide to Audubon's* Birds of America, New Haven, CT: William Reese Company & Donald A. Heald, 2002.

Bill Steiner, *Audubon Art Prints: A Collector's Guide to Every Edition*, Columbia, SC: University of South Carolina Press, 2003.

Chronology

DATE	AUTHOR'S LIFE	CULTURAL CONTEXT	HISTORICAL EVENTS
1731–43		Mark Catesby: *The Natural History of Carolina, Florida, and the Bahama Islands.*	
1769	Jean Audubon serves in French Navy.		James Watt patents steam engine.
1775			Aquatint introduced into England by Paul Sandby.
1785	26 April: Audubon born Jean Rabin, illegitimately, to ship's captain and sugar planter Jean Audubon and French chambermaid Jeanne Rabin at Les Cays, Saint-Domingue (Haiti).	James Boswell: *Journal of a Tour to the Hebrides with Samuel Johnson.*	Edmund Cartwright invents power loom.
1786	Jeanne Rabin dies of infection.	Robert Burns: *Poems.*	
1787	18 January: Lucy Green Bakewell born at Burton-on-Trent, England, first child and firstborn daughter of wealthy country squire William Bakewell and Lucy Green Bakewell. Audubon's half-sister Rosa born to Catherine Bouffard, "créole de Saint-Domingue."	James Madison, Alexander Hamilton: *Federalist Papers.*	First state (Delaware) ratifies U.S. Constitution. Pennsylvania and New Jersey follow.
1789	Slaves near rebellion in Saint-Domingue. Jean Audubon sells plantation, buys substantial farm in Pennsylvania—Mill Grove, near Valley Forge—and returns to Nantes.	William Blake: *Songs of Innocence.* Erasmus Darwin: *Botanic Garden.*	French Revolution begins with the storming of the Bastille on 14 July.
1791	Jean Audubon's two illegitimate children arrive in France. His wife, Anne Moynet, welcomes them.	William Bartram: *Travels.* Thomas Paine: *Rights of Man.*	France adopts the guillotine as the official method of execution. Slave rebellion engulfs Saint-Domingue.
1793	Jean Audubon and his wife formally adopt his children; Jean Rabin renamed Jean-Jacques Fougère ("Fern") Audubon.		Louis XVI guillotined. Vendéan counterrevolution. The Terror bloodies Nantes; Audubons jailed but released.

DATE	AUTHOR'S LIFE	CULTURAL CONTEXT	HISTORICAL EVENTS
1801	Jean Audubon and family retire to Couëron. William Bakewell family emigrates to America.	Chateaubriand: *Atala*.	First Washington, D.C., Presidential inaugural: Thomas Jefferson.
1803	August: John James Audubon, 18, arrives in America, settles at Mill Grove. Bakewell family occupies Fatland Ford.		Louisiana Purchase. Meriwether Lewis and William Clark depart for Illinois to train corps of discovery.
1804	Audubon and Lucy Bakewell meet at Fatland Ford and begin long courtship.	Maria Edgeworth: *Popular Tales*. William Blake: *Milton*.	Lewis and Clark Expedition departs for the West. Napoleon Bonaparte crowned Emperor of France by Pope Pius VII.
1805	Audubon sails to France to seek permission to marry Lucy Bakewell. Carries some 120 drawings of French and American birds which he gives to his mentor Charles d'Orbigny.	William Wordsworth: *Prelude*.	First Conestoga wagons roll on Kentucky bluegrass.
1806	Audubon returns to America with business partner Ferdinand Rozier, applies for U.S. citizenship, begins business training in New York under Benjamin Bakewell.	Erasmus Darwin: *Zoonomia* (U.S. edition).	Lewis and Clark Expedition returns from the West.
1808	5 April: Lucy Bakewell and John James Audubon married at Fatland Ford. With Ferdinand Rozier, they emigrate to Louisville, Kentucky, to operate a general store.	Alexander Wilson: *American Ornithology* (9 vols, 1808–14). Goethe: *Faust, Part I*.	Beethoven composes Sixth Symphony.
1809	12 June: Victor Gifford Audubon born in Louisville.		James Madison inaugurated President of the U.S.A.
1810	Wilson and Audubon meet in Louisville. Audubons and Rozier move to Henderson, Kentucky. Audubon and Rozier travel by keelboat to Ste. Genevieve, Missouri Territory ("Journey Up the Mississippi").		1810 U.S. census: 7,239,903 U.S. inhabitants.

DATE	AUTHOR'S LIFE	CULTURAL CONTEXT	HISTORICAL EVENTS
1811	Audubon and Rozier dissolve their partnership. Audubons return to Pennsylvania planning to move to New Orleans.		Great Comet of 1811. *New Orleans*, first steamboat on Western waters, begins passage to New Orleans from Pittsburgh. First great shock of New Madrid earthquake sequence; continue through winter and spring of 1812.
1812	Audubon draws Whip-poor-will and Nighthawk in flight: first successful flight drawings. 3 July: Audubon becomes American citizen; Audubons return to Henderson, floating down the Ohio on William Clark's barge. 30 November: John Woodhouse Audubon born in Henderson.		U.S.A. declares war on England.
1813	Audubon and brother-in-law Thomas Bakewell form partnership to build steam-powered mill at Henderson.	Jane Austen: *Pride and Prejudice*.	Alexander Wilson dies in Philadelphia at 47.
1814	December: girl, Lucy, born to the Audubons; hydrocephalic, she will live less than two years.		Treaty of Ghent ends War of 1812.
1815			Battle of New Orleans makes General Andrew Jackson a national hero. Battle of Waterloo; Napoleon exiled to St. Helena for life.
1816	Eliza Bakewell, Lucy's younger sister, marries Nicholas Berthoud.	Coleridge: *Kubla Khan*.	James Monroe elected President.
1818	Jean Audubon dies at Nantes.	Mary Shelley: *Frankenstein*. Walter Scott: *Rob Roy*.	First Seminole War (1817–18) ends.
1819	Audubon's business fails; family possessions sold at auction; jailed for debt, takes bankruptcy. Begins new career as professional artist drawing portraits; continues drawing birds. Daughter Rose born in Shippingport; dies of fever at seven months.	Washington Irving: *The Sketch Book of Geoffrey Crayon, Gent.* Byron: *Don Juan* (1819–24).	Panic of 1819 induced by federal bank's demand for specie to pay off Louisiana Purchase; most banks and businesses fail in trans-Appalachian West.

DATE	AUTHOR'S LIFE	CULTURAL CONTEXT	HISTORICAL EVENTS
1820	Audubon joins Western Museum, Cincinnati, as artist and taxidermist. Long Expedition stops over in Cincinnati, views Audubon's work. October: Audubon departs Cincinnati by flatboat with assistant Joseph Mason, bound for New Orleans, to collect birds for *The Birds of America*; begins *Mississippi River Journal*.	Scott: *Ivanhoe*.	Missouri Compromise. Daniel Boone, 90, dies in St. Charles County, Missouri Territory.
1821	Audubon arrives in New Orleans. Paints Fair Incognito. In June, takes up residence at Oakley Plantation as artist and teacher. Fired in October; returns to New Orleans. 18 October: Anne Moynet dies in Couëron. Lucy and sons arrive from Shippingport in time for Christmas. At least 31 drawings completed this year for the *Birds*.		Napoleon dies on St. Helena. Santa Fe Trail opened.
1822	Audubon breaks through to new richness of drawing; decides to redraw all his earlier work. Moves to Natchez, where his family joins him in September.	Irving: *Bracebridge Hall*.	
1823	Lucy Audubon opens school at Beechwood Plantation, near Bayou Sarah. Audubon begins preparing to go to Europe to see his drawings engraved.	John Dunn Hunter: *Memoirs of a Captivity Among the Indians of North America*.	James Monroe promulgates Monroe Doctrine.
1824	Audubon travels to Pennsylvania to find work as a teacher and study oil painting with Thomas Sully; meets Charles-Lucien Bonaparte. In autumn, explores Great Lakes. Returns in November to Bayou Sarah.		Lafayette tours the U.S.A. Portland cement patented.

DATE	AUTHOR'S LIFE	CULTURAL CONTEXT	HISTORICAL EVENTS
1825	Audubon at Beechwood Plantation teaching fencing, drawing and cotillion dancing to raise money for England.		U.S. population reaches 11,252,000. Erie Canal opens. John Quincy Adams inaugurated President.
1826	17 May: Audubon, 41, sails for Liverpool; arrives 21 July. Taken up by Rathbone family. In Edinburgh, William Home Lizars agrees to undertake engraving of *Birds*.	James Fenimore Cooper: *Last of the Mohicans*.	Charles Babbage designs analytical calculator ("difference engine").
1827	Lucy moves to Beech Grove Plantation. Audubon issues *Prospectus*, moves to London, transfers engraving of *Birds* to establishment of Robert Havell, Sr., and sons Robert, Jr. and George. By year's end, has more than 100 subscribers, 20 finished plates and £777 due after expenses.	Scott: *Life of Napoleon*. Cooper: *The Prairie*.	
1828		Victor Hugo: *Les Orientales*.	Andrew Jackson elected President. "Tom Thumb," first steam locomotive in the U.S.A.
1829	Audubon returns to U.S.A., works through summer at Great Egg Harbor and Great Pine Swamp. In November, reunites with Lucy at Beech Grove.		
1830	Audubons sail for England. Audubon elected Fellow of Royal Society of London. In October, begins writing *Ornithological Biography*. First volume of *Birds* completed in December.	Charles Lyell: *Principles of Geology*. Hector Berlioz, *Le Symphonie Fantastique*.	French revolution of 1830; Louis Philippe crowned king. Liverpool & Manchester Railroad begins service. Death of George IV.
1831	Audubons return to U.S.A.; Audubon explores South Carolina and East Florida.	Stendhal: *Le Rouge et le Noir*. Hugo: *Notre Dame de Paris*.	H.M.S. *Beagle* sails for South America with Charles Darwin. Slave revolt in Jamaica.
1832	Audubon collects in the Florida Keys, winters in Boston. Robert Havell, Sr., dies.	Edward Lear: *Parrots*. Goethe: *Faust, Part II*. Frances Trollope: *Domestic Manners of the Americans*.	Andrew Jackson reelected for second term. Samuel F. B. Morse invents telegraph. Oregon Trail opens.

DATE	AUTHOR'S LIFE	CULTURAL CONTEXT	HISTORICAL EVENTS
1833	Audubon charters schooner, spends summer exploring Gulf of St. Lawrence and Labrador coast, writes *Labrador Journal*.	Thomas Carlyle: *Sartor Resartus*. Robert Browning: *Pauline*. Black Hawk: *Autobiography*.	British Emancipation Act prohibits slavery in British colonies.
1834	Audubons return to England in May. Second volume of *Birds* finished, third underway.		Mount Vesuvius erupts. First U.S. railroad tunnel.
1835	Audubon finishes drawings for fourth volume of *Birds*. Third volume published; third volume of *Ornithological Biography* published. Fire in New York destroys pre-1821 journals.	Alexis de Tocqueville: *Democracy in America*, vol. 1.	Second Seminole War begins in Florida (1835–42). Halley's Comet returns.
1836	Audubon and John Woodhouse return to U.S.A., work from Nuttall-Townsend Expedition skins in Charleston, dine at White House with Andrew Jackson.	Charles Dickens: *Pickwick Papers* (–1837). Ralph Waldo Emerson: *Nature*.	Texas fights free of Mexico; Lone Star Republic established (–1845).
1837	Father and son explore Gulf westward to Galveston Bay. Meet Sam Houston. John Woodhouse marries Maria Bachman. Audubons return to England.	Dickens: *Oliver Twist*. Carlyle: *French Revolution*. Nathaniel Hawthorne: *Twice-Told Tales*.	Martin Van Buren inaugurated as President. Panic of 1837. Victoria accedes to throne upon death of William IV.
1838	16 June: *The Birds of America* finished: 435 plates, 1,065 figures.	William Wordsworth: *Sonnets*.	First Atlantic crossing by steamship (New York–Southampton).
1839	Last volume of *Ornithological Biography* finished; Audubons return to America. Begin work on lithograph Octavo edition, plan *Quadrupeds*. Victor Audubon and Eliza Bachman married.	Edgar Allan Poe: *Tales of the Grotesque and Arabesque*.	Robert Havell, Jr., moves to America. Daguerreotype invented.
1840	Maria Bachman Audubon dies of consumption at 23.	Charles Darwin: *Voyage of the H.M.S. Beagle*. Tocqueville: *Democracy in America*, vol. 2.	U.S. population: 17,069,453. Victoria marries Albert.
1841	Eliza Bachman Audubon dies of consumption at 22.	Cooper: *Deerslayer*. Carlyle: *On Heroes and Hero-Worship*.	President William Henry Harrison dies one month after inauguration; John Tyler inaugurated.

DATE	AUTHOR'S LIFE	CULTURAL CONTEXT	HISTORICAL EVENTS
1842	Audubons acquire Minnie's Land on Hudson River at 155 St., Manhattan. Audubon visits Quebec.	Dickens: *American Notes*.	P. T. Barnum opens American Museum in New York.
1843	Audubon explores Upper Missouri River on American Fur Company steamboat; *Missouri River Journals*.	Dickens: *A Christmas Carol*. John Stuart Mill: *A System of Logic*.	
1846	*Viviparous Quadrupeds of North America* begins publication (1846–54).	Herman Melville: *Typee*.	U.S.–Mexican War begins (–1848). Anesthesia first used in dentistry by Massachusetts dentist William Morton.
1847	Audubon disabled by dementia.	Marx and Engels: *The Communist Manifesto*. Emily Brontë: *Wuthering Heights*.	
1851	27 January: Audubon, 65, dies at Minnie's Land. Buried in Trinity Cemetery.	Melville: *Moby-Dick*.	U.S. population 23,191,876.
1874	Lucy Audubon, 86, dies at Shelbyville, Kentucky, and is buried beside her husband in New York.		

PART I: GOING WEST

The Pewee Flycatcher

The plantation or farm to which Audubon refers in the first para-graph of this delightful essay, Mill Grove, had been purchased in 1789 by his father, Jean Audubon, with the proceeds of the partial sale of his sugar plantation on Saint Domingue, soon to be convulsed by revolution and renamed Haiti. It was located on Perkiomen Creek above Valley Forge in Pennsylvania. Arriving there from France as a young man of eighteen, Audubon devoted his spare time to observ-ing birds, these Eastern Phoebes among his first subjects. The "light threads" he describes attaching to the Pewees' legs to determine if they returned to the same nest after their winter migration (they did) constitute the first known instance of bird banding in America. It was common in Europe, however, where it was called "ringing"; Audubon presumably learned it there.

Connected with the biography of this bird are so many incidents relative to my own, that could I with propriety deviate from my proposed method, the present volume would contain less of the habits of birds than of those of the youthful days of an American woodsman. While young I had a plantation that lay on the sloping declivities of a creek, the name of which I have already given, but as it will ever be dear to my recollection you will, I hope, allow me to repeat it—the Perkiomen. I was extremely fond of rambling along its rocky banks, for it would have been difficult to do so either without meeting with a sweet flower spreading open its beauties to the sun or observing the watchful Kingfisher perched on some projecting stone over the clear water of the stream. Nay, now and then the Fish Hawk itself, followed by a White-headed Eagle, would make his appearance and by his graceful aerial motions raise my thoughts far above them into the heavens, silently leading me to the admiration of the sublime Creator of all. These impressive and always delightful reveries often accompanied my steps to the entrance of a small cave scooped out of the solid rock by the hand of nature. It was, I then thought, quite large enough for my study. My paper and pencils, with now and then a volume of [Maria] Edgeworth's natural and fascinating *Tales* or LaFontaine's *Fables*, afforded me ample pleasures. It was in that place, kind

reader, that I first saw with advantage the force of parental affection in birds. There it was that I studied the habits of the Pewee; and there I was taught most forcibly that to destroy the nest of a bird or to deprive it of its eggs or young is an act of great cruelty.

I had observed the nest of this plain-colored Flycatcher fastened as it were to the rock immediately over the arched entrance of this calm retreat. I had peeped into it: although empty it was yet clean, as if the absent owner intended to revisit it with the return of spring. The buds were already much swelled and some of the trees were ornamented with blossoms, yet the ground was still partially covered with snow and the air retained the piercing chill of winter. I chanced one morning early to go to my retreat. The sun's glowing rays gave a rich coloring to every object around. As I entered the cave, a rustling sound over my head attracted my attention, and on turning I saw two birds fly off and alight on a tree close by—the Pewees had arrived! I felt delighted, and fearing that my sudden appearance might disturb the gentle pair I walked off, not however without frequently looking at them. I concluded that they must have just come, for they seemed fatigued: their plaintive note was not heard, their crests were not erected and the vibration of the tail so very conspicuous in this species appeared to be wanting in power. Insects were yet few and the return of the birds looked to me as prompted more by their affection to the place than by any other motive. No sooner had I gone a few steps than the Pewees with one accord glided down from their perches and entered the cave. I did not return to it any more that day, and as I saw none about it or in the neighborhood, I supposed that they must have spent the day within it.

I concluded also that these birds must have reached this haven either during the night or at the very dawn of that morn. Hundreds of observations have since proved to me that this species always migrates by night.

Filled with the thoughts of the little pilgrims I went early next morning to their retreat, yet not early enough to surprise them in it. Long before I reached the spot my ears were agreeably saluted by their well-known note, and I saw them darting about through the air giving chase to some insects close over the water. They were full of gaiety, frequently flew into and out of the cave and while

alighted on a favorite tree near it, seemed engaged in the most interesting converse. The light fluttering or tremulous motions of their wings, the jetting of their tail, the erection of their crest and the neatness of their attitudes all indicated that they were no longer fatigued but on the contrary refreshed and happy. On my going into the cave the male flew violently towards the entrance, snapped his bill sharply and repeatedly, accompanying this action with a tremulous rolling note the import of which I soon guessed. Presently he flew into the cave and out of it again with a swiftness scarcely credible: it was like the passing of a shadow.

Several days in succession I went to the spot and saw with pleasure that as my visits increased in frequency the birds became more familiarized to me and, before a week had elapsed, the Pewees and myself were quite on terms of intimacy. It was now the 10th of April; the spring was forward that season, no more snow was to be seen, Redwings and Grackles were to be found here and there. The Pewees, I observed, began working at their old nest. Desirous of judging for myself, and anxious to enjoy the company of this friendly pair, I determined to spend the greater part of each day in the cave. My presence no longer alarmed either of them. They brought a few fresh materials, lined the nest anew and rendered it warm by adding a few large soft feathers of the common goose which they found strewn along the edge of the water in the creek. There was a remarkable and curious twittering in their note while both sat on the edge of the nest at those meetings and which is never heard on any other occasion. It was the soft, tender expression, I thought, of the pleasure they both appeared to anticipate of the future. Their mutual caresses, simple as they might have seemed to another, and the delicate manner used by the male to please his mate, riveted my eyes on these birds and excited sensations which I can never forget.

The female one day spent the greater part of the time in her nest; she frequently changed her position; her mate exhibited much uneasiness; he would alight by her sometimes, sit by her side for a moment and, suddenly flying out, would return with an insect which she took from his bill with apparent gratification. About three o'clock in the afternoon I saw the uneasiness of the female increase; the male showed an unusual appearance of despondence,

when of a sudden the female rose on her feet, looked sidewise under her and flying out, followed by her attentive consort, left the cave, rose high in the air, performing evolutions more curious to me than any I had seen before. They flew about over the water, the female leading her mate as it were through her own meanderings. Leaving the Pewees to their avocations I peeped into their nest and saw there their first egg, so white and so transparent—for I believe, reader, that eggs soon lose this peculiar transparency after being laid—that to me the sight was more pleasant than if I had met with a diamond of the same size. The knowledge that in an enclosure so frail, life already existed, and that ere many weeks would elapse, a weak, delicate and helpless creature, but perfect in all its parts, would burst the shell and immediately call for the most tender care and attention of its anxious parents, filled my mind with as much wonder as when looking towards the heavens I searched, alas! in vain, for the true import of all that I saw.

In six days, six eggs were deposited; but I observed that as they increased in number the bird remained a shorter time in the nest. The last she deposited in a few minutes after alighting. Perhaps, thought I, this is a law of nature intended for keeping the eggs fresh to the last. Kind reader, what are your thoughts on the subject? About an hour after laying the last egg the female Pewee returned, settled in her nest and, after arranging the eggs as I thought several times under her body, expanded her wings a little and fairly commenced the arduous task of incubation.

Day after day passed by. I gave strict orders that no one should go near the cave, much less enter it, or indeed destroy any bird's nest on the plantation. Whenever I visited the Pewees one or other of them was on the nest, while its mate was either searching for food or perched in the vicinity filling the air with its loudest notes. I not unfrequently reached out my hand near the sitting bird; and so gentle had they both become, or rather so well acquainted were we, that neither moved on such occasions even when my hand was quite close to it. Now and then the female would shrink back into the nest, but the male frequently snapped at my fingers and once left the nest as if in great anger, flew round the cave a few times, emitting his querulous whining notes and alighted again to resume his labors.

At this very time a Pewee's nest was attached to one of the rafters of my mill, and there was another under a shed in the cattle yard. Each pair, anyone would have felt assured, had laid out the limits of its own domain, and it was seldom that one trespassed on the grounds of its neighbor. The Pewee of the cave generally fed or spent its time so far above the mill on the creek that he of the mill never came in contact with it. The Pewee of the cattle yard confined himself to the orchard and never disturbed the rest. Yet I sometimes could hear distinctly the notes of the three at the same moment. I had at that period an idea that the whole of these birds were descended from the same stock. If not correct in this supposition, I had ample proof afterwards that the brood of young Pewees raised in the cave returned the following spring and established themselves farther up on the creek and among the outhouses in the neighborhood.

On some other occasion I will give you such instances of the return of birds, accompanied by their progeny, to the place of their nativity that perhaps you will become convinced as I am at this moment that to this propensity every country owes the augmentation of new species, whether of birds or of quadrupeds, attracted by the many benefits met with as countries become more open and better cultivated: but now I will, with your leave, return to the Pewees of the cave.

On the thirteenth day, the little ones were hatched. One egg was unproductive and the female on the second day after the birth of her brood very deliberately pushed it out of the nest. On examining this egg I found it containing the embryo of a bird partly dried up, with its vertebrae quite fast to the shell, which had probably occasioned its death. Never have I since so closely witnessed the attention of birds to their young. Their entrance with insects was so frequently repeated that I thought I saw the little ones grow as I gazed upon them. The old birds no longer looked upon me as an enemy and would often come in close by me, as if I had been a post. I now took upon me to handle the young frequently; nay, several times I took the whole family out and blew off the exuviae of the feathers from the nest. I attached light threads to their legs: these they invariably removed either with their bills or with the assistance of their parents. I renewed them, however, until I found

the little fellows habituated to them; and at last, when they were about to leave the nest, I fixed a light silver thread to the leg of each, loose enough not to hurt the part but so fastened that no exertions of theirs could remove it.

Sixteen days had passed when the brood took to wing; and the old birds, dividing the time with caution, began to arrange the nest anew. A second set of eggs were laid and in the beginning of August a new brood made its appearance.

The young birds took much to the woods as if feeling themselves more secure there than in the open fields; but before they departed they all appeared strong and minded not making long sorties into the open air over the whole creek and the fields around it. On the 8th of October not a Pewee could I find on the plantation: my little companions had all set off on their travels. For weeks afterwards, however, I saw Pewees arriving from the north and lingering a short time as if to rest, when they also moved southward.

At the season when the Pewee returns to Pennsylvania I had the satisfaction to observe those of the cave in and about it. There again in the very same nest two broods were raised. I found several Pewees' nests at some distance up the creek, particularly under a bridge and several others in the adjoining meadows attached to the inner part of sheds erected for the protection of hay and grain. Having caught several of these birds on the nest I had the pleasure of finding that two of them had the little ring on the leg.

I was now obliged to go to France, where I remained two years. On my return, which happened early in August, I had the satisfaction of finding three young Pewees in the nest of the cave; but it was not the nest which I had left in it. The old one had been torn off from the roof and the one which I found there was placed above where it stood. I observed at once that one of the parent birds was as shy as possible, while the other allowed me to approach within a few yards. This was the male bird and I felt confident that the old female had paid the debt of nature. Having inquired of the miller's son I found that he had killed the old Pewee and four young ones to make bait for the purpose of catching fish. Then the male Pewee had brought another female to the cave! As long as the plantation of Mill Grove belonged to me there continued to be a Pewee's nest in my favorite retreat; but after I

had sold it the cave was destroyed, as were nearly all the beautiful rocks along the shores of the creek, to build a new dam across the Perkiomen.

This species is so peculiarly fond of attaching its nest to rocky caves that were it called the Rock Flycatcher it would be appropriately named. Indeed I seldom have passed near such a place, particularly during the breeding season, without seeing the Pewee or hearing its notes. I recollect that while traveling in Virginia with a friend, he desired that I would go somewhat out of our intended route, to visit the renowned Rock Bridge of that state. My companion, who had passed over this natural bridge before, proposed a wager that he could lead me across it before I should be aware of its existence. It was early in April; and from the descriptions of this place which I had read I felt confident that the Pewee Flycatcher must be about it. I accepted the proposal of my friend and trotted on, intent on proving to myself that by constantly attending to one subject a person must sooner or later become acquainted with it. I listened to the notes of the different birds which at intervals came to my ear and at last had the satisfaction to distinguish those of the Pewee. I stopped my horse to judge of the distance at which the bird might be and a moment after told my friend that the bridge was short of a hundred yards from us, although it was impossible for us to see the spot itself. The surprise of my companion was great. "How do you know this?" he asked, "for," continued he, "you are correct."

"Simply," answered I, "because I hear the notes of the Pewee and know that a cave or a deep rocky creek is at hand." We moved on; the Pewees rose from under the bridge in numbers; I pointed to the spot and won the wager.

This rule of observation I have almost always found to work, as arithmeticians say, both ways. Thus the nature of the woods or place in which the observer may be, whether high or low, moist or dry, sloping north or south, with whatever kind of vegetation, tall trees of particular species or low shrubs, will generally disclose the nature of their inhabitants.

The flight of the Pewee Flycatcher is performed by a fluttering light motion, frequently interrupted by sailings. It is slow when the bird is proceeding to some distance, rather rapid when in

pursuit of prey. It often mounts perpendicularly from its perch after an insect, and returns to some dry twig, from which it can see around to a considerable distance. It then swallows the insect whole unless it happen to be large. It will at times pursue an insect to a considerable distance and seldom without success. It alights with great firmness, immediately erects itself in the manner of hawks, glances all around, shakes its wings with a tremulous motion and vibrates its tail upwards as if by a spring. Its tufty crest is generally erected and its whole appearance is neat if not elegant. The Pewee has its particular stands from which it seldom rambles far. The top of a fence stake near the road is often selected by it, from which it sweeps off in all directions, returning at intervals and thus remaining the greater part of the morning and evening. The corner of the roof of the barn suits it equally well, and if the weather requires it, it may be seen perched on the highest dead twig of a tall tree. During the heat of the day it reposes in the shade of the woods. In the autumn it will choose the stalk of the mullein for its stand and sometimes the projecting angle of a rock jutting over a stream. It now and then alights on the ground for an instant, but this happens principally during winter or while engaged during spring in collecting the materials of which its nest is composed, in our southern states, where many spend their time at this season.

I have found this species abundant in the Floridas in winter, in full song and as lively as ever, also in Louisiana and the Carolinas, particularly in the cotton fields. None, however, to my knowledge, breed south of Charlestown in South Carolina and very few in the lower parts of that state. They leave Louisiana in February and return to it in October. Occasionally during winter they feed on berries of different kinds and are quite expert at discovering the insects impaled on thorns by the Loggerhead Shrike, and which they devour with avidity. I met with a few of these birds on the Magdeleine Islands, on the coast of Labrador and in Newfoundland.

The nest of this species bears some resemblance to that of the Barn Swallow, the outside consisting of mud with which are firmly impacted grasses or mosses of various kinds deposited in regular strata. It is lined with delicate fibrous roots or shreds of vine bark, wool, horsehair and sometimes a few feathers. The greatest diameter across the open mouth is from five to six inches and

the depth from four to five. Both birds work alternately, bringing pellets of mud or damp earth mixed with moss, the latter of which is mostly disposed on the outer parts, and in some instances the whole exterior looks as if entirely formed of it. The fabric is firmly attached to a rock or a wall, the rafter of a house, &c. In the barrens of Kentucky I have found the nests fixed to the side of those curious places called *sinkholes* and as much as twenty feet below the surface of the ground. I have observed that when the Pewees return in spring, they strengthen their tenement by adding to the external parts attached to the rock as if to prevent it from falling, which after all it sometimes does when several years old. Instances of their taking possession of the nest of the Republican Swallow (*Hirundo fulva*) have been observed in the state of Maine. The eggs are from four to six, rather elongated, pure white, generally with a few reddish spots near the larger end.

In Virginia and probably as far as New York they not unfrequently raise two broods, sometimes three, in a season. My learned friend, Professor [Thomas] Nuttall of [Harvard University] Massachusetts, thinks that the Pewee seldom raises more than one brood in the year in that state.

This species ejects the hard particles of the wings, legs, abdomen and other parts of insects in small pellets in the manner of owls, goatsuckers and swallows.

[The Pewee Flycatcher (Eastern Phoebe), *Sayornis phoebe*, appears in Plate 120 of *The Birds of America*.]

William Bakewell to Euphemia Gifford
"Lucy was married..."

William Bakewell was Lucy Bakewell Audubon's father, Euphemia Gifford a wealthy English cousin to whom many members of the extended Bakewell family regularly wrote.

Fatland Ford, Pennsylvania
17 April 1808

My dear Cousin,

I should have written to you sooner but the difficulty of sending letters to England is much increased by the embargo on all American vessels & no ship has sailed from Philadelphia for Europe since that measure was enforced.

You have no doubt heard of the embarrassment which it has occasioned amongst the Merchants & you would be much concerned to hear of my brother [Benjamin] being under the necessity of stopping payment. He has the mortification to find his past labors fruitless & that he must begin the world anew.

I went over to New York to see what was best to be done & it was concluded to assign his effects over to Mr. Page & Mr. Kinder, two of his friends who will dispose of his property so as if possible to avoid the loss which at this time would ensue from a preemptory sale. He has suffered much uneasiness of mind & I was afraid of his health for some time but he is now recovered & appears tolerably reconciled to his situation. He seems to dislike engaging in a commercial life & proposes to become a cotton planter in the Southern or Western states, should he be able to manage the purchase of a plantation. If to *deserve* success was to *command* it he would not have failed, but you know him & I need not say more on this point.

My daughter Lucy was married the 5th of this month [to John James Audubon] & on the 8th she left us for Louisville in Kentucky. I informed you that Mr. Audubon went last autumn to look out a situation for trade & he has fixed on that place as the best adapted for it. It is situated on the Ohio River at what are called

the rapids (i.e., some rocks which obstruct the navigation & the vessels are often detained there till the river rises).

She went in the stage coach to Pittsburgh 300 miles; from there they sail down the Ohio in boats 700 miles to their place of destination. It is a formidable undertaking & I wish it had suited her to be nearer us, but smaller circumstances must give way to greater.

Mr. Audubon is entered into partnership with a Mr. Rozier, a native of the same town (Nantes), a young man of good character & property & I hope they will succeed. They have purchased a considerable quantity of merchandise which together with Lucy's furniture (i.e., such kinds as are not too bulky for carriage) are conveyed by wagons to Pittsburgh & from there down the river to Louisville. Mr. Rozier is a single man & proposes to board with Mr. A. for the present.

[My son] Thomas is in New Orleans. He sailed from New York a little before this unfortunate affair [i.e., the Embargo] in a ship of my brother's with a cargo of merchandise chiefly French such as claret, olive oil & some manufactories. He has met with good sale for them, & Mr. Kinder (the gentleman before mentioned) has sent him from New York a second cargo. Thomas was by agreement with my brother to have half the profits of the adventure & Mr. K. has sent his on the same terms.

It is not a very common case that a youth not yet twenty years of age should have sufficient judgment & stability to be entrusted with such a charge but my brother & Mr. K. have full confidence in him & I hope he will augment himself to their satisfaction.

As New Orleans is liable to the yellow fever in autumn Thomas proposes to return by land & will come by the way of Louisville & see how Lucy goes on. The rest of my young people are now at home . . .

Lucy Audubon to Euphemia Gifford
"The partner of my destiny"

Louisville, Kentucky
27 May 1808

My dear Cousin,

My papa has, I imagine, before this time informed you of my change of situation. My marriage took place in the beginning of April. I soon afterwards left home and entered on my new duties. As yet they have been light and be they what they may I hope I shall ever cheerfully perform them. I wish you were acquainted with the partner of my destiny. It is useless to say more of him to you at so great a distance, than that he has most excellent dispositions which add very much to the happiness of married life. I wish, my dear cousin, you could have enjoyed the variety [of] beautiful prospects we did on our journey without partaking of the fatigues. However, considering the length of it I must not complain. We traveled something more than three hundred miles by land and seven hundred by water. You will form some idea of the roads when I tell you that the first day we traveled seventy miles, set out at four in the morning and arrived at the inn about seven in the evening, and every day afterwards, traveling the same number of hours, we could only go between thirty and forty. Unfortunately, we had rain most of the way, as I intended to walk a great deal, for whilst the stage is going either up or down the mountains they move as slowly forwards as possible, but the great stones beneath the wheels make the stage coach rock about most dreadfully.

After the two first days we commenced climbing the mountains. We crossed the low mountains, the Allegheny, the Laurel, the Sidling and many others which are very stony and disagreeable to pass through. They are not mentioned in the maps. The Cove Mount is the highest, I think, that we passed and also the most stony, though there is a great deal more said of the Allegheny mountain. We stayed at Pittsburgh two weeks. It is situated at the extremity of Pennsylvania just at the junction of three rivers, the Allegheny, [Monongahela] and Ohio. High mountains on all sides

environ Pittsburgh, and a thick fog is almost constant over the town, which is rendered still more disagreeable by the dust from a dirty sort of coal that is universally burnt. Coal is found at the surface of the earth in the neighborhood of this place, which is really the blackest looking place I ever saw. There are many nail manufactories carried on here, which supply the inland states of this country, also iron castings, tin ware, and glass manufactured. There is great trade carried on between Pittsburgh and New Orleans by means of the rivers Ohio and Mississippi as well as many other places situated on the banks of those rivers. The seven hundred miles by water was performed without much fatigue though not without some disagreeables. Our conveyance was a large square or rather oblong boat; but perfectly flat on all sides; and just high enough to admit a person walking upright. There are no sails made use of owing to the many turns on the river which brings the wind from every quarter in the course of an hour or two. The boat is carried along by the current, and in general without the least motion, but one day we had as high a wind as to make some of us feel a little seasick. Bread, beer and hams we bought at Pittsburgh, but poultry, eggs and milk can always be had from the farmhouses on the banks.

There are not many extensive prospects on the river as the shores are in general bounded by high rocks covered with woods. However I was gratified by the sight of a great variety of foliage and flowers. There are many small towns on the way, some of which we stopped at. Mr. Audubon regretted he had not his drawing implements with him as he would have taken some views for you. However, there are some well worth taking in this neighborhood when he has got a little more settled and arranged his business. We traveled generally all right, and reached the place of our future residence which is a very pleasantly situated place. The country round is rather flat, but the land is very fertile. I cannot quite tell how I shall like Louisville as I have only been here three weeks and have not yet got a house, but I have received every attention from the inhabitants... Where we board we have very accommodating people... We are as private as we please... Most of the houses here have gardens adjoining, and some of them are very prettily laid out indeed. Vegetation is a month or six weeks forwarded here

than in Pennsylvania or New York State. I am very sorry there is
no library here or book store of any kind for I have very few of my
own and as Mr. Audubon is constantly at the store, I should often
enjoy a book very much whilst I am alone...

Episode: Kentucky Barbecue on the Fourth of July

Along with the four volumes of large, hand-colored copperplate engravings that made up The Birds of America, *Audubon also wrote and published separately a five-volume text he called* Ornithological Biography. *Most of its several thousand pages are devoted to detailed narratives of his encounters with each of the almost 500 species in* The Birds. *But to alleviate what might become tedium for some readers, Audubon interspersed among the bird biographies what he called "episodes," which more lightheartedly (sometimes even stretching the truth) described life on the American frontier as Audubon had encountered it living in Kentucky, Ohio and the American South.*

Beargrass Creek, which is one of the many beautiful streams of the highly cultivated and happy state of Kentucky, meanders through a deeply shaded growth of majestic beech woods in which are interspersed various species of walnut, oak, elm, ash and other trees extending on either side of its course. The spot on which I witnessed the celebration of an anniversary of the glorious proclamation of our independence is situated on its banks, near the city of Louisville. The woods spread their dense tufts towards the shores of the fair Ohio on the west and over the gently rising grounds to the south and east. Every open spot forming a plantation was smiling in the luxuriance of a summer harvest. The farmer seemed to stand in admiration of the spectacle: the trees of his orchards bowed their branches as if anxious to restore to their mother earth the fruit with which they were laden; the flocks leisurely ruminated as they lay on their grassy beds; and the genial warmth of the season seemed inclined to favor their repose.

The free, single hearted Kentuckian, bold, erect and proud of his Virginian descent, had as usual made arrangements for celebrating the day of his country's independence. The whole neighborhood joined with one consent. No personal invitation was required where everyone was welcomed by his neighbor, and from the governor to the guider of the plough all met with light hearts and merry faces.

It was indeed a beautiful day; the bright sun rode in the clear blue

heavens; the gentle breezes wafted around the odors of the gorgeous flowers; the little birds sang their sweetest songs in the woods and the fluttering insects danced in the sunbeams. Columbia's sons and daughters seemed to have grown younger that morning. For a whole week or more, many servants and some masters had been busily engaged in clearing an area. The undergrowth had been carefully cut down, the low boughs lopped off and the grass alone, verdant and gay, remained to carpet the sylvan pavilion. Now the wagons were seen slowly moving along under their load of provisions, which had been prepared for the common benefit. Each denizen had freely given his ox, his ham, his venison, his turkeys and other fowls. Here were to be seen flagons of every beverage used in the country; "la belle rivière" had opened her finny stores; the melons of all sorts, peaches, plums and pears, would have sufficed to stock a market. In a word, Kentucky, the land of abundance, had supplied a feast for her children.

A purling stream gave its waters freely, while the grateful breezes cooled the air. Columns of smoke from the newly-kindled fires rose above the trees; fifty cooks or more moved to and fro as they plied their trade; waiters of all qualities were disposing the dishes, the glasses and the punch-bowls amid vases filled with rich wines. "Old Monongahela" filled many a [whiskey] barrel for the crowd. And now the roasting viands perfume the air and all appearances conspire to predict the speedy commencement of a banquet such as may suit the vigorous appetite of American woodsmen. Every steward is at his post, ready to receive the joyous groups that at this moment begin to emerge from the dark recesses of the woods.

Each comely fair one, clad in pure white, is seen advancing under the protection of her sturdy lover, the neighing of their prancing steeds proclaiming how proud they are of their burden. The youthful riders leap from their seats and the horses are speedily secured by twisting their bridles round a branch. As the youth of Kentucky lightly and gaily advanced towards the barbecue they resembled a procession of nymphs and disguised divinities. Fathers and mothers smiled upon them as they followed the brilliant cortege. In a short time the grove was alive with merriment. A great wooden cannon, bound with iron hoops, was now crammed with homemade powder; fire was conveyed to it by means of a

[powder] train, and as the explosion burst forth, thousands of hearty huzzas mingled with its echoes. From the most learned a good oration fell in proud and gladdening words on every ear, and although it probably did not equal the eloquence of a Clay, an Everett, a Webster or a Preston, it served to remind every Kentuckian present of the glorious name, the patriotism, the courage and the virtue of our immortal Washington. Fifes and drums sounded the march which had ever led him to glory; and as they changed to our celebrated "Yankee Doodle" the air again rang with acclamations.

Now the stewards invited the assembled throng to the feast. The fair led the van and were first placed around the tables, which groaned under the profusion of the best productions of the country that had been heaped upon them. On each lovely nymph attended her gay beau, who in her chance or sidelong glances ever watched an opportunity of reading his happiness. How the viands diminished under the action of so many agents of destruction I need not say, nor is it necessary that you should listen to the long recital. Many a national toast was offered and accepted, many speeches were delivered and many essayed in amicable reply. The ladies then retired to booths that had been erected at a little distance, to which they were conducted by their partners, who returned to the table and having thus cleared for action, recommenced a series of hearty rounds. However, as Kentuckians are neither slow nor long at their meals, all were in a few minutes replenished, and after a few more draughts from the bowl, they rejoined the ladies, and prepared for the dance.

Double lines of a hundred fair ones extended along the ground in the most shady part of the woods, while here and there smaller groups awaited the merry trills of reels and cotillions. A burst of music from violins, clarinets and bugles gave the welcome notice, and presently the whole assemblage seemed to be gracefully moving through the air. The "hunting shirts" now joined in the dance, their fringed skirts keeping time with the gowns of the ladies, and the married people of either sex stepped in and mixed with their children. Every countenance beamed with joy, every heart leaped with gladness; no pride, no pomp, no affectation, were there; their spirits brightened as they continued their exhilarating exercise and

care and sorrow were flung to the winds. During each interval of rest refreshments of all sorts were handed round, and while the fair one cooled her lips with the grateful juice of the melon, the hunter of Kentucky quenched his thirst with ample draughts of well-tempered punch.

I know, reader, that had you been with me on that day you would have richly enjoyed the sight of this national *fête champetre* [country festival]. You would have listened with pleasure to the ingenuous tale of the lover, the wise talk of the elder on the affairs of the state, the accounts of improvement in stock and utensils and the hopes of continued prosperity to the country at large and to Kentucky in particular. You would have been pleased to see those who did not join the dance shooting at distant marks with their heavy rifles or watched how they shewed off the superior speed of their high bred "old Virginia" horses while others recounted their hunting exploits and at intervals made the woods ring with their bursts of laughter. With me the time sped like an arrow in its flight, and although more than twenty years have elapsed since I joined a Kentucky barbecue, my spirit is refreshed every 4th of July by the recollection of that day's merriment.

But now the sun has declined and the shades of evening creep over the scene. Large fires are lighted in the woods, casting the long shadows of the live columns far along the trodden ground and flaring on the happy groups, loath to separate. In the still clear sky began to sparkle the distant lamps of heaven. One might have thought that Nature herself smiled on the joy of her children. Supper now appeared on the tables and after all had again refreshed themselves preparations were made for departure. The lover hurried for the steed of his fair one, the hunter seized the arm of his friend, families gathered into loving groups and all returned in peace to their happy homes.

Episode: Journey Up the Mississippi

From Louisville the Audubons and their partner Ferdinand Rozier moved in 1810 to Henderson, Kentucky, on the Ohio River about 175 miles upriver from its junction with the Mississippi—the western edge of frontier settlement. That winter Audubon and Rozier filled a keelboat with barrels of Kentucky whiskey to sell in the markets of Missouri Territory and floated off down the Ohio on Christmas Day.

About the end of December, some eighteen years ago, I left my family at a village near Henderson, in the lower part of Kentucky, being bound on an expedition to the upper parts of the Mississippi. I started with my friend Ferdinand Rozier in a vessel there termed a keelboat: an open boat with a covered stern which forms the cabin, over which projects the slender trunk of some tree (about sixty feet long) as a steering oar; the boat being impelled by four oars worked in the bow, at the rate of about five miles an hour, going with the current. The banks of the Ohio were already very dreary; indeed nothing green remained except the hanging canes that here and there bordered its shores, and the few dingy grape leaves, which hardly invited the eye to glance towards them.

We started in a heavy snowstorm, and our first night was indeed dismal; but as day began to appear, the storm ceased, and we found ourselves opposite the mouth of the Cumberland River, which flows from the state of Tennessee, passing Nashville, and is a tolerably navigable stream for many hundred miles. Here the Ohio spreads to a considerable width and forms in summer a truly magnificent river, and is even at this season broad and beautifully transparent, though so shallow that it is often fordable from the Illinois shore to Cumberland Island. Vast trees overhang both banks, and their immense masses of foliage are reflected in the clear mirror.

Ere long we passed the mouth of the Tennessee River and Fort Massacre [i.e., Fort Massiac] and could easily perceive that the severe and sudden frost which had just set in had closed all the small lakes and lagoons in the neighborhood, as thousands of wild waterfowl were flying and settling themselves on the borders of the Ohio. Suffering our boat to drift with the stream whenever large flocks approached us, we shot a great number of them.

About the third day of our journey we entered the mouth of
Cache Creek, a very small stream, but at all times a sufficient deep
and good harbor. Here I met a French count, a celebrated traveler,
bound like ourselves to St. Genevieve, Upper Louisiana (now the
State of Missouri). We soon learned that the Mississippi was
covered by thick ice, and that it was therefore impossible to ascend
it. Cache Creek is about six miles above the confluence of the Ohio
and Mississippi. The stream flows from some hills to the northward
of its mouth, which are covered with red and black oak, sumac and
locust trees; and were formerly said to contain valuable minerals,
of which they have since proved to be totally destitute. The point
of land between the creek and the junction of the two rivers is all
alluvial and extremely rich soil covered with heavy black walnut,
ash and pecan trees and closely tangled canes and nettles that are
in summer at least six feet high. It is overflowed by both rivers
during their freshes.

The creek, now filled by the overplus of the Ohio, abounded
with fish of various sorts and innumerable ducks driven by winter
to the south from the Polar Regions. Though the trees were entirely
stripped of their verdure, I could not help raising my eyes towards
their tops and admiring their grandeur. The large sycamores with
white bark formed a lively contrast with the canes beneath them;
and the thousands of paroquets that came to roost in their hollow
trunks at night were to me objects of interest and curiosity. About
fifty families of Shawnee Indians had moreover chosen this spot
for an encampment, to reap the benefit of a good harvest of pecan
nuts; and to hunt the innumerable deer, bears and raccoons which
the same cause had congregated there. These were not the first
natives (for I cannot, like many Europeans, call them savages) that
I had seen; I understand their habits and a few words of their
language, and as many of them spoke French passably, I easily
joined both their "talks" and their avocations.

An apparent sympathy connects those fond of the same pursuit,
with a discernment almost intuitive, whatever be their nation. All
those hunters who loved fishing and pursuits of enterprise ere long
crowded round me; and as soon as they learned my anxiety for
curiosities of natural history, they discovered the most gratifying
anxiety to procure them for me. Even the squaws set small traps

for the smaller animals, and when, in return, I presented them with a knife, a pair of scissors, &c., they expressed their gratitude as gracefully as the most educated female would have done. My friend Ferdinand Rozier, neither hunter nor naturalist, sat in the boat all day, brooding in gloomy silence over the loss of time &c. entailed by our detention. The Count kept a valuable journal, since published, hunted a great deal, and was as careless of the weather as myself; but his companion and father-in-law, like my partner, sat in his boat, pining with chagrin and ennui. Their case, however, was hopeless; here we were, and were forced to remain, until liberated by a thaw.

On the second morning after our arrival I heard a movement in the Indian camp, and having hastily risen and dressed myself, I discovered that a canoe containing half a dozen squaws and as many hunters was about to leave the Illinois for the Tennessee side of the river. I learned also that their object was to proceed to a large lake opposite, to which immense flocks of swans resorted every morning. These flocks were so numerous and strong that it is, however incredible it may at first seem, a well-known fact that they keep the lakes which they frequent open merely by swimming upon them night and day.

Having obtained permission to join the party, I seated myself in the canoe, well supplied with ammunition and whiskey. In a few moments the paddles were at work and we swiftly crossed to the opposite shore. I was not much astonished during our passage to see all the labor of paddling performed by the squaws, for this feature of Indian manners was not new to me; but I was surprised to see that upon entering the canoe the hunters laid down and positively slept during the whole passage. On landing, the squaws, after securing the boat, proceeded to search for nuts, while the *gentlemen* hunters made the best of their way through the "thick and thin" to the lake.

Those who have never seen anything of what I call "thick and thin" may perhaps think I allude to something like the furze which covers some of the moors of Scotland. But they must imagine the shores of the Ohio, at its junction with the great muddy river called the Mississippi, to be fairly overgrown with a kind of thick-set cotton tree [i.e., willows] that rise as closely from the muddy soil

of the bank as can well be conceived. They are not to be beaten down; you must slide yourself between them, and in summer you have a pretty task to keep off the mosquitoes that abound amongst them. After these thickets there are small nasty lagoons, which you must either swim across, jump over or leap into and be drowned, according to your taste or capability.

But when the task of reaching the lake *is* accomplished—what a feast for a sportsman! There they lie, by hundreds, of a white or rich cream color—either dipping their black bills in the water, or leaning backwards and gently resting with one leg expanded, floating along and basking in the sunshine. The moment that these beautiful birds saw our *vedettes* [i.e., scouts], they started up in immediate apprehension. But the plan of our Indians drove the poor swans the nearer to their fate, the farther they retreated from either shore. Men were placed behind the trees who knew how to take a dead aim, and every shot told. Being divided, three on one side and four on the other, the former hid themselves, and when the birds flew from the latter, they alighted within a good distance of those who had first alarmed them.

What would those English sportsmen—who, after walking a whole day and exploding a pound of powder, march home in great glee holding a partridge by the legs, with a smile on their lips and a very empty stomach—say to this day's devastation amongst the swans? I saw these beautiful birds floating on the water, their backs downwards, their heads under the surface and their legs in the air, struggling in the last agonies of life to the number of at least fifty, their beautiful skins all intended for the ladies of Europe.

The sport was now over, the sun was nearly even with the tops of the trees, a conch was sounded, and after awhile the squaws appeared, dragging the canoe and moving about in quest of the dead game. It was at last all transported to the river's edge and we were landed upon the Illinois bank again before dark. The fires were lighted. Each man ate his mess of pecan nuts and bear's fat and then stretched himself out with feet close to the small heap of coal intended for the night. The females then began their work— it was their duty to skin the birds. I observed them for some time and then retired to rest, very well satisfied with the sports of this day, the 25th of December.

On the following morning I found that a squaw had given birth to beautiful twins during the night. She was at work tanning deer-skins. She had cut two vines at the roots of opposite trees, which, having their upper branches twined in the tops of the trees, made a kind of swing; and framed a cradle of bark in which the infants were swung to and fro by a gentle push of her hand. From time to time she gave them the breast and to all appearance seemed as unconcerned as if nothing had taken place. What a difference between this Indian mother and a lady of fashion!

An Indian camp upon a hunting expedition is not, I assure you, a place of idleness, and although the men do little more than hunt, they pursue this task with a degree of eagerness bordering upon enthusiasm. One of their party, a tall and robust man, assured us one morning that he would have some good sport that day, as he had found the *gite* [i.e., the den] of a bear of some size and wished to combat him singly. We all started with him to see him fulfill his bold promise. When we had gone about half a mile from the camp, he said he discerned the bear's track, although I could posi-tively perceive nothing, and he went on rambling through the thick canebrake until we reached a large decaying log of timber of an immense size. In this he said that the bear was concealed.

I have rarely seen a finer object than this Indian at the moment when he prepared to encounter his prey. His eyes sparkled with joy, the rusty blanket was thrown in an instant from his shoulders, his brawny arms seemed swelling with the blood that rushed through their prominent veins, and he drew his scalping knife with a fantastic gesture that plainly declared *la guerre à l'outrance* [i.e., war to the death]. He ordered me to mount a delicate sapling, which would, he said, be secure from the bear, who could easily ascend a larger tree with the activity of a squirrel, whilst the other two Indians stood at the entrance of the hollow log, which the hero entered with the most resolute determination.

All was still for some minutes. He then emerged and said the bear was slain and that I could safely descend. His companions entered the log, and having tied the animal to a long vine which they had cut, our united strength drew him out. This exploit was in fact less dangerous than it appeared, for the bear, when attacked in a confined spot like the trunk of a hollow tree, makes no

resistance, but retires further and further back until he is killed. As we returned to camp, one of our Indians broke the twigs in our way from time to time, and on our reaching the camp, two squaws were sent on the track of the broken twigs, who returned at night with the flesh and skin of the animal.

The nuts were soon nearly all gathered, and I began to perceive that the game must be getting scarce, as the hunters remained in the camp during the greater part of the day. At last, one morning, they packed up their movables, destroyed their abodes and put off in their canoes down the Mississippi for the Little Prairie, bent on moving towards the Arkansas [River]. Their example made us desirous of moving, and I set off with two of the crew to cross the bend of the river and ascertain if the ice still remained too solid to allow us to proceed. The weather was milder, and on reaching the Mississippi, I found the ice so much sunk as to be scarcely discernible above the water, and I toiled along the muddy shore, my fellows keeping about fifty yards behind me, until I reached [the shore opposite] Cape Girardeau. After calling for some time loudly for a boat, we saw a canoe put off from the opposite shore. When it reached us, a stout dark-colored man leaped on shore who said his name was Lorimier, the son of the Spanish governor of Louisiana. Being a good pilot, he undertook with six stout men of his own in addition to our four hands to bring our boat up, and the bargain was soon arranged. His canoe was hauled into the woods, some blaze was made on the surrounding trees [to mark its location] and he then took us by a direct route through the woods back to Cache Creek in about one third of the time I had occupied in coming and ten times more comfortably. The night was spent in preparations— in making towing ropes of bullocks' hides and cutting good oars —and at daylight we left Cache Creek to embark on wider waters.

Going down the stream to the mouth of the Ohio was fine sport, and my friend Rozier thought himself near the end of the journey, but alas! when we turned the point and began to ascend the Mississippi we had to stem a current of three miles an hour and to encounter ice which, although sunk, much impeded our progress. The patron, as the director of the boat's crew is termed, got onshore, and it became the duty of every man to *haul the cordelle*—viz., to tow the boat by a rope fastened to a pole in the

bow, leaving only one man in her to steer. This was slow and heavy work, and we only advanced seven miles during the whole day up the famous Mississippi. On the approach of night, our crew camped on the bank, and having made a tremendous fire, we all ate and drank like men that had worked hard, and went to sleep in a few moments. We started the next morning two hours before daybreak, and made about a mile an hour against the current, our sail lying useless, as the wind was contrary. That night we camped out as before, and another, and another after that. A following day finding us at the same work, with very little progress, and the frost becoming quite severe again, our patron put us into winter quarters in the great bend of Tawapatee Bottom.

What a place for winter quarters! Not a white man's cabin within twenty miles on the other side of the river, and on our own, none within at least fifty! A regular camp was raised—trees cut down and a cabin erected in less time than a native of Europe would think possible. In search for objects of natural history, I rambled through the deep forests and soon knew all the Indian passes and lakes in the neighborhood. The natives, by some intuitive faculty, discover an encampment of this kind almost as quickly as a flight of vultures find a dead deer; and I soon met some strolling in the woods on the lookout. Their numbers gradually increased, and in about a week, several of these unfortunate rambling beings were around us. Some were Osages, but the greater part were Shawnees. The former were athletic, robust, well-formed, of a nobler aspect than the others, from whom they kept apart. They hunted nothing but larger game—the few elks that remain in the country and one or two buffaloes were all that they paid attention to. The latter were more reduced, or rather harder pressed upon by the whites; they condescended to kill opossums and even wild turkeys for their subsistence. Though I was often amongst the Osages and very anxious to observe their manners, as they were a race new to me, yet as they spoke no French and very little English, I could hardly get acquainted with them, being ignorant of their language. They were delighted to see me draw, and when I made a tolerable portrait of one of them in red chalk, the others, to my astonishment, laughed to an excess. They bore the cold better than the Shawnees and were more expert in the use of their bows and arrows.

Our time passed away; after hunting all day with a young Kentuckian of our party [John Pope], he would join me at night to chase the wolves that were prowling on the ice, crossing the river to and fro, howling and sneaking about the very camp for the bones which we threw away. Meanwhile I studied the habits of the wild turkeys, bears, cougars, raccoons and many other animals and drew more or less every day by the side of our great fire.

I will try to give you some idea of a great fire at a camp of this sort in the woods of America. Just before evening the axemen tumble down four or five trees—probably ash, about three feet in diameter and sixty feet to the first branches, or as we call them, the limbs. These are again cut into logs of about ten feet in length and, with the assistance of some strong sticks, are rolled together into a heap several feet high. A fire is made at the top with brushwood and dry leaves kindled by a flint and steel, and in the course of an hour, there is a flame that would roast you at the distance of five paces. Under the smoke of this, the party go to sleep. It happened, on the only night that my friend Rozier slept on shore [rather than in the keelboat], that being very chill, he drew himself so close to the fire, that the side of his face which lay uppermost was fairly singed and he lost one [side] of his whiskers. We all laughed at this, but it was not a joke to him, and he shaved off the remaining whiskers very ruefully the next morning.

We remained here six weeks. We had plenty of company from our Indian friends, with whiskey and food in abundance, but our stock of bread began to give way and we got tired of using the breasts of wild turkeys for bread and bear oil instead of meat. The raccoons and opossums, however tender, were at last disliked, and it was decided one morning that I and my Kentuckian friend should cross the bend to procure some Indian cornmeal and have it dragged down by men on skates or otherwise. I was no novice in the woods and my companion bound on his moccasins with great glee and told me to come onwards, and I followed his steps until, meeting a herd of deer, we pursued them, tracking them with great ease through the snow. I shot one, and as we did not know what to do with it, we hung it on a tree, and after marking the place, resumed our course. We walked on till nearly dark, but no river was seen. My friend urged me forward and I still followed

him, knowing very well that the business would end at last in supping on an opossum, when we suddenly struck upon two tracks which I took for those of Indians. He said that they would guide us to the river, and we followed them until at an opening I saw the wished-for Mississippi. But many shoe tracks were visible and I began to get alarmed. My friend still kept up his spirits until at length we arrived at—our own encampment! The boatmen laughed, and the Indians joined in the chorus. We ate a raccoon supper and were soon after refreshed by sleep. This was a raw expedition, yet nothing was more natural than that it should happen to those not perfectly acquainted with the woods. They start, form a circle, and return to the point where they left at first. I cannot account for this, but the same thing has often occurred to me in my early hunting excursions . . .

My friend and I were not to be . . . defeated; we moved off as soon as day broke without mentioning our intentions, taking our guns and my dog, in search of the opposite side of the bend. This time, luckily, we pushed straight across; neither the innumerable flocks of turkeys nor the herds of deer stopped us until we saw Cape Girardeau, about an hour before sunset. On reaching the river we called in vain for a boat; the ice was running swiftly down the stream, and none dared put out. A small abandoned hut stood close to us, and we made it our home for the night; and our evening meal was principally composed of a pumpkin that had withstood the frost. With a gun and a little powder we soon kindled a fire and lighted some broken branches. We fed the flames with the boards of the abandoned house, and went to sleep very comfortably. What a different life from the one I lead now! And yet that very evening I wrote the day's occurrences in my journal before going to sleep, just as I do now; and I well remember that I gained more information that evening about the roosting of the prairie hen than I had ever done before.

Daylight returned, fair and frosty. The trees, covered with snow and icicles, became so brilliant when the sun rose that the wild turkeys, quite dazzled, preferred walking under them to flying amongst their glittering branches. After hailing the opposite shore for some time, we perceived a canoe picking its way towards us through the floating ice. It arrived and we soon told the boatmen

our wishes to procure some bread or flour. They returned, after having been absent nearly the whole day, bringing us a barrel of flour, several large loaves and a bag of Indian cornmeal. The flour was rolled high on the bank; we thrust our gun barrels through the loaves; and having hung the bag of Indian cornmeal on a tree to preserve it from the wild hogs, we marched for our camp, which we reached about midnight. Four of our men were sent with axes who formed a small sledge, on which they placed the precious cargo and hauled it safely to the camp over the snow.

The river having risen slowly and regularly, as the Mississippi always does, now began to subside; the ice, falling with the water, prepared fresh trouble for us; and in order to keep the boat afloat, it was thought prudent to unload the cargo. It took us two days, with the assistance of the Indian women, to pile our goods safely on the shore and to protect them from the weather. For the security of the boat, we cut down some strong trees with which we framed a kind of jetty a little higher up the stream to ward off the ice, which was rapidly accumulating.

Being now fairly settled in our winter quarters, we spent our time very merrily, and so many deer, bears and wild turkeys suffered in our hunting parties that the trees around our camp looked like butchers' stalls, being hung round with fat venison &c. Moreover we soon found that the lakes contained abundance of excellent fish, and many of us would walk over the ice with axes, and whenever a trout, pike or catfish rose immediately beneath it, a severe blow on the ice killed the fish, which the hunter secured by opening a large hole in the ice, several feet in diameter. The fish, in search of air, resorted to it from different quarters and were shot as they appeared on the surface of the water. The squaws tanned the deerskins, stretched those of the raccoons and otters and made baskets of canes. [John Pope] played tolerably on the violin; I had a flute, and our music found pleased hearers, whilst our men danced to the tunes and squaws laughed heartily at our merriment. The Indian hunters formed the outer ring of our auditory, smoking their tomahawk pipes with a degree of composure which no white man ever displayed at such merry-makings.

While our time went pleasantly enough, a sudden and startling catastrophe threatened us without warning. The ice began to break,

and our boat was in instant danger of being cut to pieces by the ice floes or swamped by their pressure. Roused from our sleep, we rushed down pell-mell to the bank as if attacked by savages and discovered the ice was breaking up rapidly. It split with reports like those of heavy artillery; and as the water had suddenly risen from an overflow of the Ohio, the two streams seemed to rush against each other with violence, in consequence of which the congealed mass was broken into large fragments, some of which rose nearly erect here and there and again fell with thundering crash, as the wounded whale, when in the agonies of death, springs up with furious force and again plunges into the foaming waters. To our surprise, the weather, which in the evening had been calm and frosty, had become wet and blowy. The water gushed from the fissures formed in the ice, and the prospect was extremely dismal. When day dawned, a spectacle strange and fearful presented itself: the whole mass of water was violently agitated; its covering was broken into small fragments, and although not a foot of space was without ice, not a step could the most daring have ventured to make upon it. Our boat was in imminent danger, for the trees which had been placed to guard it from the ice were cut or broken into pieces and were thrust against her. It was impossible to move her; but our pilot ordered every man to bring down great bunches of cane, which were lashed along her sides, and before these were destroyed by the ice, she was afloat and riding above it. While we were gazing on the scene, a tremendous crash was heard, which seemed to have taken place about a mile below, when suddenly the great dam of ice gave way. The current of the Mississippi had forced its way against that of the Ohio, and in less than four hours we witnessed the complete breaking up of the ice.

At last our patron said that this was the time to depart for Cape Girardeau. All was bustle—the cargo was once more put on board—our camp was abandoned and the Indians and we parted like brethren . . .

The little village of Cape Girardeau contained nothing remarkable or interesting except Mr. Lorimier, the father of our patron, who was indeed an original and the representative of a class of men now fast disappearing from the face of the earth. His portrait is so striking and well worth preserving that I shall attempt to draw it.

Imagine a man not exceeding four feet six inches in height, and thin in proportion, looking as if he had just been shot out of a popgun. He had a spare, meager countenance in which his nose formed decidedly the most prominent feature. It was a true *nez à la Grand Frederic*—a tremendous promontory full three inches in length—hooked like a hawk's beak and garnished with a pair of eyes resembling those of an eagle. His hair was plastered close to his head with a quantity of pomatum; and behind he wore a long queue rolled up in a dirty ribbon which hung down below his waist. The upper part of his dress was European, and had evidently once been made of the richest materials; and though now woefully patched and dilapidated, you might still observe here and there shreds of gold and silver lace adhering to the worn apparel. His waistcoat, of a fashion as antique as that of his nose, had immense flaps or pockets that covered more than one-half of his lower garments. These latter were of a description totally at variance with the upper part of his costume. They were of dressed buckskin, fitting tight to his attenuated limbs and ornamented with large iron buckles at the knees which served to attach and support a pair of Indian hunting gaiters that had, like the rest of his dress, seen long and hard service. To complete his costume, he wore on his feet a pair of moccasins, or Indian shoes, that were really of most beautiful workmanship. These articles of dress, together with his small stature and singular features, rendered his appearance at a little distance the most ludicrous caricature that can be imagined; but upon approaching nearer and conversing with him, his manners were found to be courteous and polished. He had been, as I before mentioned, the governor of Louisiana while it was in the possession of the Spaniards; when this country was purchased by the Government of the United States, he retired to this little village where he was looked upon as a great general and held in the highest esteem and consideration by all the inhabitants.

But the village was small, and no market for us, and we determined to push up to St. Genevieve and once more were in motion between the ice. We arrived in a few days at the Grand Tower, an immense rock detached from the shore around which the current rushes with great violence. Our *cordelles* were used to force a passage at this dangerous spot; and our men, clinging to the rock as well

as they could, looked as if each movement would plunge them into the abyss—but we passed on without accident. All this night we heard the continual howling of the wolves amidst the heavy woods that covered the large hills on the Illinois shore, opposite to this rock. From what I know of their habits, I am convinced that they were hunting deer in the following manner. They hunt in packs, like dogs, but with far more sagacity and contrivance. They divide themselves into separate bodies, some to rouse the game and others to waylay them. The pack that is on the hunt starts one or more deer, following them with a note like that of hounds in full cry, and drives the game before it towards the wolves posed in ambush. These wolves, when the deer pass, start up fresh and following their prey, soon overtake it. And it is well known that a cry is uttered as a signal for assembling at the death of the game somewhat like the death note of the hunter's bugle.

The weather continued favorable, and we arrived safely at St. Genevieve and found a favorable market. Our whiskey was especially welcome, and what we had paid twenty-five cents a gallon for, brought us two dollars. St. Genevieve was then an old French town, small and dirty, and I far preferred the time I spent in Tawapatee Bottom to my sojourn here. Here I met with the Frenchman who accompanied Lewis and Clark to the Rocky Mountains. They had just returned [*sic*] and I was delighted to learn from them many particulars of their interesting journey.

Having arranged my affairs, I waited only for a thaw to return home. The ice broke at last, and bidding my companions goodbye, I whistled to my dog, crossed the Mississippi and in a few hours was on my road, on foot and alone, bent on reaching Shawnee Town as soon as possible. I had little foreseen the nature of the task before me. As soon as I had left the bottomlands, on reaching the prairies, I found them covered with water, like large seas; however, nothing could induce me to return, and my ardent desire to rejoin my wife and family made me careless of inconvenience or fatigue. Unfortunately, I had no shoes, and my moccasins constantly slipped, which made the wading very irksome. Nevertheless, on the first day I made forty-five miles and swam the Muddy River. I saw only two cabins during the whole day, but I had great pleasure in observing the herds of deer that were crossing the prairies as

well as myself, ankle-deep in water. Their graceful motions and their tails spread to the breeze were discernible for many miles.

With the exception of these beautiful animals and the thousands of buffalo skulls that lay scattered about, just appearing above the water, which was about a foot deep, there was nothing remarkable at this season. But in spring, about the month of May, the prairies are indeed a garden. The grass, rich and succulent, shoots from the soil with incredible rapidity, and amongst its green carpeting, millions of variegated flowers raise their odoriferous heads. Butterflies of the richest colors hover about in the sunshine and the hummingbird darts swiftly along, gathering honey, amongst clouds of bees. The deer are quietly reposing upon the luxuriant herbage in picturesque groups and the flocks of the squatters are seen scattered about in all directions. The weather is mild, the sky cloudless; and nothing can be conceived more delightful than traveling over these fertile regions at this season.

Yet they are infested by one scourge—the buffalo gnats. These insects fly in dense bodies, compacted together like swarms of bees, as swift as the wind. They attack a deer or buffalo, alight upon it and torture the animal to death in a few minutes. This may appear incredible till we recollect that the swarms are so dense that above a hundred will often alight upon a square inch. I had myself an opportunity of witnessing their fatal power when I crossed the same prairies in the May following the very Christmas of which I am writing.

I was mounted upon a fine horse, and in consequence of the advice of experienced persons, I had his head and body wholly clothed with light linen to protect him from these gnats, leaving only the nostrils uncovered. Being unaware of the full extent of the danger, I was not, as it proved, sufficiently careful in joining the different cloths which covered my horse. I had ridden a considerable distance when, on a sudden, he actually began to dance; he snorted, leaped and almost flew from under me. This took place near the Big Muddy River, for which I instantly made, and plunged the horse into the stream to quiet him. But upon reaching the shore, his motions were languid, his head drooped, and it was with difficulty that I reached a squatter's hut, where the poor animal died in a few hours. He had been bitten between the joinings of

his body-clothes by a swarm of these remorseless insects, whose bite is invariably fatal whenever they can settle upon the body of an animal in any number. They do not attack the human species, and it is only during the heat of the day that they appear, at which time the cattle in the prairies resort to the woods for security. The deer rush to the water to avoid them, and stand during the midday heats with only their noses appearing above the surface.

A light smoke arising from the trees which covered a beautiful mound promised me a good dinner and gave me an appetite, and I made straight for it. The woman of the house which stood there received me kindly, and whilst the boys were busied in examining my handsome double-barreled gun, as I sat drying my clothes by the fire, the daughter ground coffee, fried venison and prepared eggs, which, washed down by a good glass of brandy, formed a sumptuous repast. To those who, used to the ceremonies of cities, have no idea how soon an acquaintance is cemented in these wilds by the broad ties of hospitality, it would have been a matter of surprise to see how, though we were previously strangers, we became in an hour as familiar as if we had been friends of years.

I slept at this hospitable dwelling, and the kind hostess was stirring at daybreak to get me a good breakfast before I started. Of course for all this she would receive no recompense, so I gave each of the boys a horn of powder—a rare and valuable article to a squatter in those days.

My way lay through woods, and many crossroads that intersected them embarrassed me much; but I marched on, and according to my computation, I had left about forty-five miles behind me at nightfall. I found a party of Indians encamped by the edge of a canebrake, and having asked in French permission to pass the night with them, my request was granted. My bed was soon prepared, in which, after eating some supper, I was ere long fast asleep. On awakening the next morning I found to my surprise that all the Indians were gone, with their guns, leaving only two dogs to guard the camp from the wolves. I was now not above forty miles from Shawnee Town, and my dog, who knew very well that he was near home, seemed as happy as myself. I did not meet a single person the whole day and not a cabin was then to be found on that road. At four the same evening I passed the first salt well [outside

Shawnee Town], and half an hour brought me to the village. At the inn I was met by several of my friends who had come to purchase salt, and here I slept, forty-seven miles from home. The next day, to my great joy, brought me to my family: and thus ended this pleasant excursion. Now confess, my dear friend, were not these rare Christmas doings?

Episode: The Earthquake

A little after two o'clock in the morning on December 16, 1811, the first of three massive sequences of earthquakes centered near the village of New Madrid (pronounced MAD-rid) in the Missouri Territory bootheel on the Mississippi River shook the North American continent. The earthquakes were felt from northern Canada to the Gulf and from the East Coast to the Rockies; in modern terms, all three major quakes would have registered well above 8.0 on the Richter scale and two out of three closer to 9.0. Fifteen of the total of about 1,800 quakes up to March 15, 1812 were felt in Washington, D.C. Audubon mistakes the date of his experience in this narrative; probably he is recalling one of the major aftershocks on January 23, when he was returning to Henderson from Pennsylvania.

Traveling through the Barrens of Kentucky…in the month of November, I was jogging on one afternoon when I remarked a sudden and strange darkness rising from the western horizon. Accustomed to our heavy storms of thunder and rain, I took no more notice of it, as I thought the speed of my horse might enable me to get under shelter of the roof of an acquaintance who lived not far distant before it should come up. I had proceeded about a mile when I heard what I imagined to be the distant rumbling of a violent tornado, on which I spurred my steed with a wish to gallop as fast as possible to the place of shelter; but it would not do, the animal knew better than I what was forthcoming, and instead of going faster, so nearly stopped that I remarked he placed one foot after another on the ground with as much precaution as if walking on a smooth sheet of ice. I thought he had suddenly foundered, and speaking to him, was on the point of dismounting and leading him when he all of a sudden fell a-groaning piteously, hung his head, spread out his four legs as if to save himself from falling and stood stock still, continuing to groan.

I thought my horse was about to die and would have sprung from his back had a minute more elapsed, but at that instant all the shrubs and trees began to move from their very roots, the ground rose and fell in successive furrows like the ruffled waters of a lake and I became bewildered in my ideas as I too plainly

discovered that all this awful commotion in nature was the result of an earthquake.

I had never witnessed anything of the kind before, although like every other person I knew of earthquakes by description. But what is description compared with the reality? Who can tell of the sensations which I experienced when I found myself rocking as it were on my horse and with him moved to and fro like a child in a cradle, with the most imminent danger around and expecting the ground every moment to open and present to my eye such an abyss as might engulf myself and all around me? The fearful convulsion, however, lasted only a few minutes and the heavens again brightened as quickly as they had become obscured; my horse brought his feet to the natural position, raised his head and galloped off as if loose and frolicking without a rider.

I was not, however, without great apprehension respecting my family, from which I was yet many miles distant, fearful that where they were the shock might have caused greater havoc than I had witnessed. I gave the bridle to my steed and was glad to see him appear as anxious to get home as myself. The pace at which he galloped accomplished this sooner than I had expected, and I found with much pleasure that hardly any greater harm had taken place than the apprehension excited for my own safety.

Shock succeeded shock almost every day or night for several weeks, diminishing, however, so gradually as to dwindle away into mere vibrations of the earth. Strange to say, I for one became so accustomed to the feeling as rather to enjoy the fears manifested by others. I never can forget the effects of one of the slighter shocks which took place when I was at a friend's house where I had gone to enjoy the merriment that in our western country attends a wedding. The ceremony being performed, supper over and the fiddles tuned, dancing became the order of the moment. This was merrily followed up to a late hour when the party retired to rest. We were in what is called with great propriety a *log house*, one of large dimensions and solidly constructed. The owner was a physician, and in one corner were not only his lancets, tourniquets, amputating knives and other sanguinary apparatus, but all the drugs which he employed for the relief of his patients arranged in jars and vials of different sizes. These had some days before made a narrow escape

from destruction but had been fortunately preserved by closing the doors of the cases in which they were contained.

As I have said, we had all retired to rest, some to dream of sighs and smiles and others to sink into oblivion. Morning was fast approaching when the rumbling noise that precedes the earthquake began so loudly as to waken and alarm the whole party and drive them out of bed in the greatest consternation. The scene which ensued it is impossible for me to describe and it would require the humorous pencil of [*Punch* cartoonist George] Cruickshank to do justice to it. Fear knows no restraints. Every person, old and young, filled with alarm at the creaking of the log house and apprehending instant destruction, rushed wildly out to the grass enclosure fronting the building. The full moon was slowly descending from her throne, covered at times by clouds that rolled heavily along as if to conceal from her view the scenes of terror which prevailed on the earth below. On the grass-plat we all met in such condition as rendered it next to impossible to discriminate any of the party, all huddled together in a state of almost perfect nudity. The earth waved like a field of corn before the breeze: the birds left their perches and flew about not knowing whither; and the Doctor, recollecting the danger of his gallipots, ran to his shop room to prevent their dancing off the shelves to the floor. Never for a moment did he think of closing the doors, but spreading his arms, jumped about the front of the cases, pushing back here and there the falling jars; with so little success, however, that before the shock was over he had lost nearly all he possessed.

The shock at length ceased and the frightened females, now sensible of their dishabille, fled to their several apartments. The earthquakes produced more serious consequences in other places. Near New Madrid [Missouri], and for some distance on the Mississippi, the earth was rent asunder in several places, one or two islands sunk for ever and the inhabitants fled in dismay towards the eastern shores.

The Pinnated Grouse

The "Barrens" Audubon refers to here were prairie-like sandstone and limestone grasslands in midwestern Kentucky where he found the Greater Prairie-Chicken he called the Pinnated Grouse. Like the term "Great American Desert," applied to the tall- and shortgrass prairies of the Middle West, the pejorative reflects the inexperience with grassland farming of settlers accustomed to carving their farms out of forest.

It has been my good fortune to study the habits of this species of Grouse at a period when, in the district in which I resided, few other birds of any kind were more abundant. I allude to the lower parts of the states of Kentucky, Indiana, Illinois and Missouri. Twenty-five years and more have elapsed since many of the notes to which I now recur were written, and at that period I little imagined that the observations which I recorded should ever be read by any other individuals than those composing my own family, all of whom participated in my admiration of the works of Nature.

The Barrens of Kentucky are by no means so sterile as they have sometimes been represented. Their local appellation, however, had so much deceived me before I traveled over them that I expected to find nothing but an undulated extent of rocky ground, destitute of vegetation and perforated by numberless caverns. My ideas were soon corrected. I saw the Barrens for the first time in the early days of June, and as I entered them from the skirts of an immense forest, I was surprised at the beauty of the prospect before me. Flowers without number and vying with each other in their beautiful tints sprung up amidst the luxuriant grass; the fields, the orchards and the gardens of the settlers presented an appearance of plenty, scarcely anywhere exceeded; the wild fruit trees, having their branches interlaced with grapevines, promised a rich harvest; and at every step I trod on ripe and fragrant strawberries. When I looked around, an oak knob rose here and there before me, a charming grove embellished a valley, gently sloping hills stretched out into the distance; while at hand the dark entrance of some cavern attracted my notice, or a bubbling spring gushing forth at my feet seemed to invite me to rest and refresh myself with its

cooling waters. The timid deer snuffed the air as it gracefully bounded off, the Wild Turkey led her young ones in silence among the tall herbage, and the bees bounded from flower to blossom. If I struck the stiff foliage of a blackjack oak, or rustled among the sumacs and brambles, perchance there fluttered before me in dismay the frightened Grouse and her cowering brood. The weather was extremely beautiful, and I thought that the Barrens must have been the parts from which Kentucky derived her name of the "Garden of the West!"

There it was that, year after year and each successive season, I studied the habits of the Pinnated Grouse. It was there that, before sunrise or at the close of day, I heard its curious boomings, witnessed its obstinate battles, watched it during the progress of its courtships, noted its nest and eggs and followed its young until, fully grown, they betook themselves to their winter quarters.

When I first removed to Kentucky, the Pinnated Grouse were so abundant that they were held in no higher estimation as food than the most common flesh, and no "hunter of Kentucky" deigned to shoot them. They were, in fact, looked upon with more abhorrence than the Crows are at present in Massachusetts and Maine, on account of the mischief they committed among the fruit trees of the orchards during winter when they fed on their buds, or while in the spring months they picked up the grain in the fields. The farmer's children or those of his Negroes were employed to drive them away with rattles from morning to night, and also caught them in pens and traps of various kinds. In those days during the winter the Grouse would enter the farmyard and feed with the poultry, alight on the houses or walk in the very streets of the villages. I recollect having caught several in a stable at Henderson where they had followed some Wild Turkeys. In the course of the same winter, a friend of mine who was fond of practicing rifle-shooting, killed upwards of forty in one morning, but picked none of them up, so satiated with Grouse was he as well as every member of his family. My own servants preferred the fattest flitch of bacon to their flesh, and not unfrequently laid them aside as unfit for cooking.

Such an account may appear strange to you, reader; but what will you think when I tell you that in that same country where,

twenty-five years ago, they could not have been sold at more than one cent apiece, scarcely one is now to be found? The Grouse have abandoned the State of Kentucky and removed (like the Indians) every season farther to the westward, to escape from the murderous white man. In the Eastern states, where some of these birds still exist, game laws have been made for their protection during a certain part of the year when, after all, few escape to breed the next season. To the westward you must go as far at least as the State of Illinois before you meet with this species of Grouse, and there too, as formerly in Kentucky, they are decreasing at a rapid rate. The sportsman of the Eastern states now makes much ado to procure them, and will travel with friends and dogs and all the paraphernalia of hunting, an hundred miles or more, to shoot at most a dozen braces in a fortnight; and when he returns successful to the city, the important results are communicated by letter to all concerned. So rare have they become in the markets of Philadelphia, New York and Boston, that they sell at from five to ten dollars the pair. An excellent friend of mine, resident in the city of New York, told me that he refused 100 dollars for ten brace which he had shot on the Pocono Mountains of Pennsylvania.

On the eastern declivities of our Atlantic coast, the districts in which the Pinnated Grouse are still to be met with, are some portions of the State of New Jersey, the "brushy" plains of Long Island, Martha's Vineyard, the Elizabeth Islands, Mount Desert Island in the State of Maine, and a certain tract of barren country in the latter state, lying not far from the famed Mar's Hill where, however, they have been confounded with the Willow Grouse. In the three first places mentioned, notwithstanding the preventive laws now in force, they are killed without mercy by persons such as in England are called poachers, even while the female bird is in the act of sitting on her eggs. Excepting in the above named places, not a bird of the species is at present to be found until you reach the lower parts of Kentucky where, as I have told you before, a few still exist. In the State of Illinois, all the vast plains of the Missouri, those bordering the Arkansas River and on the prairies of Opelousas, the Pinnated Grouse is still very abundant and very easily procured.

As soon as the snows have melted away and the first blades of

grass issue from the earth announcing the approach of spring, the Grouse, which had congregated during the winter in great flocks, separate into parties of from twenty to fifty or more. Their love season commences, and a spot is pitched upon to which they daily resort until incubation is established. Inspired by love, the male birds, before the first glimpse of day lightens the horizon, fly swiftly and singly from their grassy beds, to meet, to challenge and to fight the various rivals led by the same impulse to the arena. The male is at this season attired in his full dress, and enacts his part in a manner not surpassed in pomposity by any other bird. Imagine them assembled to the number of twenty by daybreak, see them all strutting in the presence of each other, mark their consequential gestures, their looks of disdain and their angry pride as they pass each other. Their tails are spread out and inclined forward to meet the expanded feathers of their neck, which now, like stiffened frills, lie supported by the globular orange-colored receptacles of air from which their singular booming sounds proceed. Their wings, like those of the Turkey Cock, are stiffened and declined so as to rub and rustle on the ground as the bird passes rapidly along. Their bodies are depressed towards the ground, the fire of their eyes evinces the pugnacious workings of the mind, their notes fill the air around and at the very first answer from some coy female, the heated blood of the feathered warriors swells every vein and presently the battle rages. Like Game Cocks they strike and rise in the air to meet their assailants with greater advantage. Now many close in the encounter; feathers are seen whirling in the agitated air or falling around them tinged with blood. The weaker begin to give way and one after another seeks refuge in the neighboring bushes. The remaining few, greatly exhausted, maintain their ground and withdraw slowly and proudly, as if each claimed the honors of victory. The vanquished and the victors then search for the females who, believing each to have returned from the field in triumph, receive them with joy.

It not unfrequently happens that a male already mated is suddenly attacked by some disappointed rival, who unexpectedly pounces upon him after a flight of considerable length, having been attracted by the cacklings of the happy couple. The female invariably squats next to and almost under the breast of her lord

while he, always ready for action, throws himself on his daring antagonist, and chases him away never to return. Such is the moment which I have attempted to represent in the plate which you will find in the second volume of my "Illustrations" [i.e., *The Birds of America*].

In such places in the western country as I have described, the Prairie Hen is heard "booming" or "tooting" not only before break of day, but frequently at all hours from morning until sunset; but in districts where these birds have become wild in consequence of the continual interference of man they are seldom heard after sunrise, sometimes their meetings are noiseless, their battles are much less protracted or of less frequent occurrence and their beats or scratching grounds are more concealed. Many of the young males have battles even in autumn, when the females generally join not to fight but to conciliate them, in the manner of the Wild Turkeys.

The Pinnated Grouse forms its nest according to the latitude of the place between the beginning of April and the 25th of May. In Kentucky I have found it finished and containing a few eggs at the period first mentioned, but I think, taking the differences of seasons into consideration, the average period may be about the first of May. The nest, although carelessly formed of dry leaves and grasses interwoven in a tolerably neat manner, is always carefully placed amidst the tall grass of some large tuft in the open ground of the Prairies, or at the foot of a small bush in the barren lands. The eggs are from eight to twelve, seldom more, and are larger than those of the *Tetrao umbellus* [*Bonasa umbellus* today, Ruffed Grouse], although nearly of the same color. The female sits upon them eighteen or nineteen days, and the moment the young have fairly disengaged themselves, leads them away from the nest, when the male ceases to be seen with her. As soon as autumn is fairly in, the different families associate together, and at the approach of winter I have seen packs composed of many hundred individuals.

When surprised, the young squat in the grass or weeds, so that it is almost impossible to find any of them. Once while crossing a part of the barrens on my way homewards, my horse almost placed his foot on a covey that was in the path. I observed them and instantly leaped to the ground; but notwithstanding all my endeavors, the cunning mother saved them by a single cluck. The little fellows

rose on the wing for only a few yards, spread themselves all round, and kept so close and quiet that, although I spent much time in search for them, I could not discover one. I was much amused, however, by the arts the mother employed to induce me to leave the spot where they lay concealed, when perhaps I was actually treading on some of them.

This species never raises more than one brood in the season, unless the eggs have been destroyed, in which case the female immediately calls for her mate and produces a second set of eggs, generally much smaller in number than the first. About the 1st of August the young are as large as our little American Partridge [i.e., Northern Bobwhite], and are then most excellent eating. They do not acquire much strength of wing until the middle of October, and after that period they become daily more difficult to be approached. Their enemies are at this season very numerous, but the principal are the polecat, the raccoon, the weasel, the wildcat and various Hawks.

The Pinnated Grouse is easily tamed and easily kept. It also breeds in confinement, and I have often felt surprised that it has not been fairly domesticated. While at Henderson I purchased sixty alive that were expressly caught for me within twelve miles of that village and brought in a bag laid across the back of a horse. I cut the tips of their wings and turned them loose in a garden and orchard about four acres in extent. Within a week they became tame enough to allow me to approach them without their being frightened. I supplied them with abundance of corn and they fed besides on vegetables of various kinds. This was in the month of September, and almost all of them were young birds. In the course of the winter they became so gentle as to feed from the hand of my wife, and walked about the garden like so many tame fowls, mingling occasionally with the domestic poultry. I observed that at night each individual made choice of one of the heaps in which a cabbage had grown, and that they invariably placed their breast to the wind, whatever way it happened to blow. When spring returned, they strutted, "tooted," and fought as if in the wilds where they had received their birth. Many laid eggs, and a good number of young ones made their appearance, but the Grouse at last proved so destructive to the young vegetables, tearing them up

by the roots, that I ordered them to be killed. So brave were some of the male birds that they never flinched in the presence of a large Turkey Cock, and now and then they would stand against a Dunghill Cock [i.e., a Rooster] for a pass or two before they would run from him.

During very severe weather I have known this species to roost at a considerable height on trees, but they generally prefer resting on the ground. I observed that for several nights in succession, many of these Grouse slept in a meadow not far distant from my house. This piece of ground was thickly covered with tall grass, and one dark night I thought of amusing myself by trying to catch them. I had a large seine, and took with me several Negroes supplied with lanterns and long poles, with the latter of which they bore the net completely off the ground. We entered the meadow in the early part of the night, although it was so dark that without a light one could hardly have seen an object a yard distant, and spreading out the leaded end of the net, carried the other end forward by means of the poles at the height of a few feet. I had marked before dark a place in which a great number of the birds had alighted, and now ordered my men to proceed towards it. As the net passed over the first Grouse in the way, the alarmed bird flew directly towards the confining part of the angle, and almost at the same moment a great number of others arose, and, with much noise, followed the same direction. At a signal, the poles were laid flat on the ground, and we secured the prisoners, bagging some dozens. Repeating our experiment three times in succession, we met with equal success, but now we gave up the sport on account of the loud bursts of laughter from the Negroes, who could no longer refrain. Leaving the net on the ground, we returned to the house laden with spoil, but next evening not a Grouse was to be found in the meadow, although I am confident that several hundred had escaped.

On the ground the Pinnated Grouse exhibits none of the elegance of manner observed in the Ruffed Grouse, but walks more like the Common Hen, although in a more erect attitude. If surprised it rises at once with a moderate whirring sound of the wings; but if it happens to see you at a distance and the place is clear, it instantly runs off with considerable speed and stops at the

first tuft of high grass or bunch of briar, when it squats and remains until put up. In newly ploughed grounds I have seen them run with all their might, their wings partially expanded, until suddenly meeting with a large clod, they would stop, squat and disappear in a moment. During the noontide hours several may often be seen dusting themselves near each other, either on the ploughed fields or the dry sandy roads, and rearranging their feathers in a moment in the same manner as the Wild Turkey. Like the Common Fowls, they watch each other's motions, and if one has discovered a grasshopper and is about to chase it, all the rest within sight of it either fly or run up to the place. When the mother of a brood is found with her young ones she instantly ruffles up her feathers and often looks as if she would fly at you; but this she never ventures to do, although she tries every art to decoy you from the place. On large branches of trees these birds walk with great ease, but on small ones they require the aid of their wings to enable them to walk steadily. They usually, if not always, roost singly within a few feet of each other and on such little eminences as the ground affords. I have found them invariably fronting the wind, or the quarter from which it was to blow. It is only during the early age of the young birds that they sit on the ground in a circle.

The flight of the Prairie Hen is strong, regular, tolerably swift, and at times protracted to the distance of several miles. The whirring of its wings is less conspicuous than that of the Ruffed Grouse or "Pheasant" (*Tetrao umbellus*), and its flight is less rapid. It moves through the air with frequent beats, after which it sails with the wings bent downwards, balancing itself for a hundred yards or more as if to watch the movements of its pursuer, for at this time they can easily be observed to look behind them as they proceed. They never rise when disturbed without uttering four or five distinct clucks, although at other times they fly off in silence. They are easily shot down by a calm sportsman but are very apt to deceive a young hand. In the western country they rarely stand before the pointer, and I think the setter is a more profitable dog there. In the Eastern states, however, pointers, as I am informed, are principally employed. These birds rarely wait the approach of the sportsman, but often rise when he is at such a distance as to render it necessary for him to be very prompt in firing. Unlike

other species, they seldom pass over you even when you surprise them, and if the country is wooded, they frequently alight on the highest branches of the tallest trees, where they are usually more accessible. If shot almost dead, they fall and turn round on the ground with great violence until life is extinct; but when less injured, they run with great celerity to some secluded place, where they remain so quiet and silent as to render it difficult to find them without a good dog. Their flesh is dark, and resembles that of the Red Grouse of Scotland or the Spotted Grouse of North America.

The curious notes emitted in the love season are peculiar to the male. When the receptacles of air, which in form, color and size resemble a small orange, are perfectly inflated, the bird lowers its head to the ground, opens its bill and sends forth, as it were, the air contained in these bladders in distinctly separated notes, rolling one after another from loud to low and producing a sound like that of a large muffled drum. This done, the bird immediately erects itself, refills its receptacles by inhalation and again proceeds with its tootings. I frequently observed in those Prairie Hens which I had tamed at Henderson that after producing the noise the bags lost their rotundity, and assumed the appearance of a burst bladder, but that in a few seconds they were again inflated. Having caught one of the birds, I passed the point of a pin through each of its air cells, the consequence of which was that it was unable to toot anymore. With another bird I performed the same operation on one only of the cells, and next morning it tooted with the sound one, although not so loudly as before, but could not inflate the one which had been punctured. The sound, in my opinion, cannot be heard at a much greater distance than a mile. All my endeavors to decoy this species, by imitating its curious sounds, were unsuccessful, although the Ruffed Grouse is easily deceived in this manner. As soon as the strutting and fighting are over, the collapsed bladders are concealed by the feathers of the ruff, and during autumn and winter are much reduced in size. These birds, indeed, seldom if ever meet in groups on the scratching grounds after incubation has taken place; at all events, I have never seen them fight after that period for, like the Wild Turkeys, after spending a few weeks apart to recover their strength, they gradually unite, and as soon as the young are grown up, individuals of both sexes mix with the

latter and continue in company till spring. The young males exhibit the bladders and elongated feathers of the neck before the first winter, and by the next spring have attained maturity, although, as in many other species, they increase in size and beauty for several years.

As I have never shot these birds in the Eastern states, and therefore cannot speak from experience of the sport which they afford, I here introduce a very interesting letter from a well-known sportsman, my friend David Eckleiy, Esq., residing at Boston, who is in the habit of shooting them annually.

"Dear Sir, I have the pleasure of sending you a brace of Grouse from Martha's Vineyard, one of the Elizabeth Islands, which for many years past I have been accustomed to visit annually for the purpose of enjoying the sport of shooting these fine birds. Nashawenna [i.e., Nashawena] is the only other island of the group on which they are found. This, however, is a sort of preserve, as the island being small and the birds few, strangers are not permitted to shoot without the consent of the owners of the soil. It would be difficult to assign a reason why they are found upon the islands above named and not upon others, particularly Nashann [i.e., Naushon], which, being large, well wooded and abounding in feed, seems quite as favorable to the peculiar habits of the birds.

"Fifteen or twenty years ago, I know from my own experience, it was a common thing to see as many birds in a day as we now see in a week; but whilst they have grown scarcer, our knowledge of the ground has become more extended, so that the result of a few weeks' residence of a party of three, with which I usually take the field, is ten brace of birds. Packs of twenty to fifty are now no longer seen, and the numbers have so diminished in consequence of a more general knowledge of their value, the price in Boston market being five dollars per brace, that we rarely see of late more than ten or twelve collected together. It is often observed, however, that there is very little encouragement to be derived from the circumstance of falling in with a large number, and that the greater the pack, the more likely they are to elude the vigilance of the sportsman; though it must be acknowledged that it is a most exhilarating yet tantalizing sight to start a large pack out of gunshot. To watch them as their wings glisten in the sun, alternately sailing,

fluttering and scooming [i.e., skimming] over the undulating ground, apparently just about alighting, but exerting their strength and fluttering on once more, some old stager of the pack leading them beyond an intervening swell, out of harm's way, beyond which all is conjecture as to the extent or the direction of their flight. In such a case it is best to follow on as quick and as straight as possible keeping the eye fixed upon the tree or bush which served to mark them, and after having proceeded a reasonable distance in the direction which they have flown, if a 'clear' or 'cutting place' should lie in the course, the birds may be confidently expected to have alighted there. They never in fact settle down where the woods are thick or the bushes close and tangled, but invariably in some open space and often in the roads; neither do they start from thick foliage or briary places, but seek at once to disengage themselves from all embarrassment to their flight by attaining the nearest open space, thus offering to the sportsman the fairest mark of all game birds. It frequently happens that not one is killed on the first flight of a pack, as they are often very unexpectedly started, but on approaching them a second time with greater caution, success is more likely to follow, particularly if they have become scattered.

"Towards the middle of November they have attained their average weight of nearly two pounds each, and nothing can be fuller, richer or more game-like than their plumage. At this time of year, however, in sportsman's phrase, they will seldom 'lie to the dog,' but are easily started by every sound they hear. Even loud talking alarms them; for which reason a high wind, which drowns the approach of danger, is the most desirable weather. A calm, drizzly day is also favorable; for the birds being less likely to be disturbed by the glare of objects, venture into the old rye fields, the low edges of the wood, and the bushy pastures to feed.

"It is seldom that we start a bird a second time in the exact spot where he has been seen to hover down, for no sooner do they alight than they run, and frequently into thick cover, from which they often attempt in vain to disentangle themselves. A dog is then necessary to scent the bird, which alternately runs and squats until, being hard pressed, it rises, and frequently with a sound which resembles the syllables *coo, coo, coo,* uttered with rapidity. One good dog is better than two, and though sufficient, is absolutely

necessary, for besides the enjoyment of observing his action generally, his challenging cheers and his pointing prepare you. But more than all, a dog is required in recovering those which are winged or not fatally wounded which, but for his tracking them, would be entirely lost.

"The barberry, which abounds in many parts of Martha's Vineyard, is the principal food of the Grouse, particularly such as grow on low bushes near the ground and easily reached by the birds. They also feed on the boxberry or partridgeberry, the highland and lowland cranberry, rosebuds, pine and alder buds, acorns, &c. In summer, when young, they feed on the more succulent berries.

"We frequently meet with the remains of such as have been destroyed in various ways, but more particularly by the domestic cat, which prowls the woods in a wild state, and which often receives a very unwelcome salute for the mischief it does. Owls, hawks and skunks also do their part towards the destruction of these valuable but defenseless birds. In these ways they are thinned off much more effectually than by the sportsman's gun. They frequent no particular soil, and like all other hunting, wherever the feed is, there is the likeliest place for the game. In addition to this rule as a guide, we look for their fresh tracks among the sandy barberry hillocks and along the numerous paths which intersect that remarkable part of the Vineyard called Tisbury Plain. Into this, should the birds fly from the edges as they sometimes do, it is almost impossible to start them a second time, as there are no trees or large objects to mark their flight. Being mostly covered with scrub oaks of a uniform height, with occasional mossy hollows, it affords them a place of refuge, into which they fly for protection, but from which they soon emerge, when the danger is past, to their more favorite haunts.

"I have only seen them in the month of November, but I am told that in the spring of the year previous to the season of incubation they congregate in large companies in particular places, where they hold a grand tournament, fighting with great desperation and doing one another all the mischief possible. In these chosen spots it is said the cunning natives were accustomed to strew ashes and rush upon them with sticks when blinded by the dust which they had raised. In later times the custom of baiting them has proved

more destructive to the species. In this way, very great but very unsportsmanlike shots have often been made. Another practice has been that of stealing upon them unawares, guided by that peculiar sound for which they are remarkable in the spring of the year, called 'tooting.' By these and other means to which I have adverted, the birds were diminishing in numbers from year to year; but it is to be hoped that they will revive again, as they are now protected by an act of the State of Massachusetts passed in 1831 which limits the time of shooting them to the months of November and December, and imposes a penalty of ten dollars each bird for all that are killed, except in those two months. Boston, Massachusetts, December 6, 1832."

In the western country, at the approach of winter, these birds frequent the tops of the sumac bushes to feed on their seeds, often in such numbers that I have seen them bent by their weight; and I have counted more than fifty on a single apple tree, the buds of which they entirely destroyed in a few hours. They also alight on high forest trees on the margins of large rivers such as the Mississippi, to eat grapes and the berries and leaves of the parasitical mistletoe. During several weeks which I spent on the banks of the Mississippi above the mouth of the Ohio I often observed flocks of them flying to and fro across the broad stream, alighting at once on the highest trees with as much ease as any other bird. They were then so abundant that the Indians, with whom I was in company, killed them with arrows whenever they chanced to alight on the ground or low bushes.

During the sowing season, their visits to the wheat and corn fields are productive of considerable damage. They are fond of grasshoppers and pursue these insects as chickens are wont to do, sometimes to a distance of thirty or forty yards. They drink water like the common fowl when at liberty and, like all other species of this family, are fond of dusting themselves in the paths or among the earth of the fields.

I have often observed them carry their tail in the manner of the Common Hen. During the first years of my residence at Henderson, in severe winters, the number of Grouse of this species was greatly augmented by large flocks of them that evidently came from Indiana, Illinois and even from the western side of the Mississippi.

They retired at the approach of spring, no doubt to escape from the persecution of man.

It would not perhaps be proper that I should speak of the value put on the flesh of these birds by epicures. All that I shall say is that I never thought much of it, and would at any time prefer a piece of buffalo or bear flesh; so that I have no reason to regret my inability to purchase Prairie Hens for eating at five dollars the pair.

[The Pinnated Grouse (Greater Prairie Chicken), *Tympanuchus cupido*, appears in Plate 186 of *The Birds of America*.]

Episode: A Wild Horse

While residing at Henderson in Kentucky I became acquainted with a gentleman who had just returned from the country in the neighborhood of the headwaters of the Arkansas River, where he had purchased a newly caught wild horse, a descendant of some of the horses originally brought from Spain and set at liberty in the vast prairies of the Mexican lands. The animal was by no means handsome: he had a large head with a considerable prominence in its frontal region, his thick and unkempt mane hung along his neck to the breast and his tail, too scanty to be called flowing, almost reached the ground. But his chest was broad, his legs clean and sinewy and his eyes and nostrils indicated spirit, vigor and endurance. He had never been shod, and although he had been ridden hard and had performed a long journey, his black hoofs had suffered no damage. His color inclined to bay, the legs of a deeper tint and gradually darkening below until they became nearly black. I inquired what might be the value of such an animal among the Osage Indians, and was answered that the horse being only four years old, he had given for him with the tree and the buffalo tug fastened to his head, articles equivalent to about thirty-five dollars. The gentleman added that he had never mounted a better horse and had very little doubt that if well fed, he could carry a man of ordinary weight from thirty-five to forty miles a day for a month, as he had traveled at that rate upon him without giving him any other food than the grass of the prairies or the canes of the bottom lands until he had crossed the Mississippi at Natchez, when he fed him with corn. Having no farther use for him now that he had ended his journey, he said he was anxious to sell him and thought he might prove a good hunting horse for me, as his gaits were easy and he stood fire as well as any charger he had seen. Having some need of a horse possessed of qualities similar to those represented as belonging to the one in question, I asked if I might be allowed to try him. "Try him, Sir, and welcome; nay, if you will agree to feed him and take care of him, you may keep him for a month, if you choose." So I had the horse taken to the stable and fed.

About two hours afterwards I took my gun, mounted the prairie nag and went to the woods. I was not long in finding him very

sensible to the spur, and as I observed that he moved with great ease both to himself and his rider, I thought of leaping over a log several feet in diameter to judge how far he might prove serviceable in deer driving or bear hunting. So I gave him the reins and pressed my legs to his belly without using the spur, on which, as if aware that I wished to try his mettle, he bounded off and cleared the log as lightly as an elk. I turned him and made him leap the same log several times, which he did with equal ease, so that I was satisfied of his ability to clear any impediment in the woods. I next determined to try his strength, for which purpose I took him to a swamp which I knew was muddy and tough. He entered it with his nose close to the water as if to judge of its depth, at which I was well pleased, as he thus evinced due caution. I then rode through the swamp in different directions and found him prompt, decided and unflinching. Can he swim well? thought I—for there are horses which, although excellent, cannot swim at all but will now and then lie on their side as if contented to float with the current, when the rider must either swim and drag them to the shore or abandon them. To the Ohio then I went and rode into the water. He made off obliquely against the current, his head well raised above the surface, his nostrils expanded, his breathing free and without any of the grunting noise emitted by many horses on such occasions. I turned him down the stream, then directly against it, and finding him quite to my mind, I returned to the shore, on reaching which he stopped of his own accord, spread his legs and almost shook me off my seat. After this I put him to a gallop, and returning home through the woods, shot from the saddle a turkey cock, which he afterwards approached as if he had been trained to the sport, and enabled me to take it up without dismounting.

As soon as I reached the house of Dr. Rankin, where I then resided, I sent word to the owner of the horse that I should be glad to see him. When he came I asked him what price he would take; he said fifty dollars in silver was the lowest. So I paid the money, took a bill of sale and became master of the horse. The Doctor, who was an excellent judge, said smiling to me, "Mr. Audubon, when you are tired of him, I will refund you the fifty dollars, for depend upon it he is a capital horse." The mane was trimmed but the tail left untouched; the Doctor had him shod "all

round," and for several weeks he was ridden by my wife, who was highly pleased with him.

Business requiring that I should go to Philadelphia, Barro (he was so named after his former owner) was put up for ten days and well attended to. The time of my departure having arrived, I mounted him; and set off at the rate of four miles an hour—but here I must give you the line of my journey that you may, if you please, follow my course on some such map as that of Tanner's. From Henderson through Russellville, Nashville and Knoxville, Abington in Virginia, the Natural Bridge, Harrisonburg, Winchester and Harper's Ferry, Frederick and Lancaster to Philadelphia.

There I remained four days, after which I returned by way of Pittsburgh, Wheeling, Zanesville, Chillicothe, Lexington and Louisville to Henderson. But the nature of my business was such as to make me deviate considerably from the main roads and I computed the whole distance at nearly two thousand miles, the post roads being rather more than sixteen hundred. I traveled not less than forty miles a day and it was allowed by the Doctor that my horse was in as good condition on my return as when I set out. Such a journey on a single horse may seem somewhat marvelous in the eyes of a European; but in those days almost every merchant had to perform the like, some from all parts of the western country, even from St Louis on the Missouri, although the travelers not unfrequently on their return sold their horses at Baltimore, Philadelphia or Pittsburgh, at which latter place they took boat.

My wife rode on a single horse from Henderson to Philadelphia, traveling at the same rate. The country was then comparatively new; few coaches traveled and in fact the roads were scarcely fit for carriages. About twenty days were considered necessary for performing a journey on horseback from Louisville to Philadelphia, whereas now the same distance may be traveled in six or seven days or even sometimes less, this depending on the height of the water in the Ohio.

It may be not uninteresting to you to know the treatment which the horse received on those journeys. I rose every morning before day, cleaned my horse, pressed his back with my hand to see if it had been galled, and placed on it a small blanket folded double in such a manner that when the latter was put on, half of the cloth

was turned over it. The surcingle, beneath which the saddlebags were placed, confined the blanket to the seat, and to the pad behind was fastened the great coat or cloak tightly rolled up. The bridle had a snaffle bit; a breastplate was buckled in front to each skirt, to render the seat secure during an ascent; but my horse required no crupper [behind, to prevent the saddle from slipping forward], his shoulders being high and well-formed. On starting he trotted off at the rate of four miles an hour, which he continued. I usually traveled from fifteen to twenty miles before breakfast and after the first hour allowed my horse to drink as much as he would. When I halted for breakfast I generally stopped two hours, cleaned the horse and gave him as much corn blades as he could eat. I then rode on until within half an hour of sunset, when I watered him well, poured a bucket of cold water over his back, had his skin well rubbed, his feet examined and cleaned. The rack was filled with blades, the trough with corn; a good-sized pumpkin or some hens' eggs, whenever they could be procured, were thrown in and if oats were to be had, half a bushel of them was given in preference to corn, which is apt to heat some horses. In the morning, the nearly empty trough and rack afforded sufficient evidence of the state of his health.

I had not ridden him many days before he became so attached to me that on coming to some limpid stream in which I had a mind to bathe, I could leave him at liberty to graze and he would not drink if told not to do so. He was ever surefooted, and in such continual good spirits that now and then when a turkey happened to rise from a dusting place before me, the mere inclination of my body forward was enough to bring him to a smart canter, which he would continue until the bird left the road for the woods, when he never failed to resume his usual trot.

On my way homewards I met at the crossings of the Juniata River a gentleman from New Orleans whose name is Vincent Nolte. He was mounted on a superb horse for which he had paid three hundred dollars, and a servant on horseback led another as a change. I was then an utter stranger to him and as I approached and praised his horse, he not very courteously observed that he wished I had as good a one. Finding that he was going to Bedford to spend the night, I asked him at what hour he would get there.

"Just soon enough to have some trouts ready for our supper, provided you will join when you get there." I almost imagined that Barro understood our conversation; he pricked up his ears and lengthened his pace, on which Mr. Nolte caracoled his horse and then put him to a quick trot, but all in vain, for I reached the hotel nearly a quarter of an hour before him, ordered the trouts, saw to the putting away of my good horse and stood at the door ready to welcome my companion. From that day Vincent Nolte has been a friend to me. It was from him I received letters of introduction to the Rathbones of Liverpool, for which I shall ever be grateful to him. We rode together as far as Shippingport, where my worthy friend Nicholas Berthoud, Esq., resided, and on parting with me he repeated what he had many times said before, that he never had seen so serviceable a creature as Barro.

If I recollect rightly, I gave a short verbal account of this journey and of the good qualities of my horse to my learned friend J. Skinner, Esq., of Baltimore, who I believe has noticed them in his excellent *Sporting Magazine*. We agreed that the importation of horses of this kind from the Western Prairies might improve our breeds generally; and judging from those which I have seen, I am inclined to think that some of them may prove fit for the course. A few days after reaching Henderson, I parted with Barro, not without regret, for a hundred and twenty dollars.

Episode: The White Perch and Its Favorite Bait

No sooner have the overflowing waters of early spring subsided within their banks and the temperature become pleasant than the trees of our woods are seen to unfold their buds and blossoms and the white perch, which during the winter has lived in the ocean, rushes up our streams to seek the well-known haunts in which it last year deposited its spawn. With unabating vigor it ascends the turbulent current of the Mississippi, of which, however, the waters are too muddy to suit its habits; and glad no doubt is it to enter one of the numberless tributaries whose limpid waters are poured into the mighty river. Of these subsidiary waters the Ohio is one in whose pure stream the white perch seems to delight; and towards its head springs the fish advances in numerous shoals following the banks with easy progress. Over many a pebbly or gravelly bar does it seek its food. Here the crawling mussel it crunches and devours; there with the speed of an arrow it darts upon the minnow; again, at the edge of a shelving rock or by the side of a stone, it secures a crayfish. No impure food will "the growler" touch; therefore, reader, never make use of such to allure it; otherwise not only will your time be lost, but you will not enjoy the gratification of tasting this delicious fish. Should you have no experience in fishing for perch I would recommend to you to watch the men you see on that shore, for they are excellent anglers.

Smooth are the waters, clear is the sky and gently does the stream move—perhaps its velocity does not exceed a mile in the hour. Silence reigns around you. See, each fisher has a basket or calabash containing many a live cray; and each line, as thick as a crow quill, measures scarce a furlong. At one end two perch hooks are so fastened that they cannot interfere with each other. A few inches below the reaching point of the farthest hook, the sinker, perhaps a quarter of a pound in weight, having a hole bored through its length, is passed upon the line and there secured by a stout knot at its lower extremity. The other end of the line is fastened ashore. The tackle, you observe, is carefully coiled on the sand at the fisher's feet. Now on each hook he fixes a crayfish, piercing the shell beneath the tail and forcing the keen weapon to reach the very head of the suffering creature while all its legs are

left at liberty to move. Now each man, holding his line a yard or so from the hooks, whirls it several times overhead and sends it off to its full length directly across the stream. No sooner has it reached the gravelly bed than, gently urged by the current, it rolls over and over until it is nearly in the line of the water. Before this, however, I see that several of the men have had a bite and that by a short jerk they have hooked the fish. Hand over hand they haul in their lines. Poor perch, it is useless labor for thee to flounce and splash in that manner, for no pity will be shewn thee, and thou shalt be dashed on the sand and left there to quiver in the agonies of death. The lines are within a few yards of being in. I see the fish gasping on its side. Ah! there are two on this line, both good; on most of the others there is one; but I see some of the lines have been robbed by some cunning inhabitant of the water. What beautiful fishes these perches are! so silvery beneath, so deeply colored above! What a fine eye too! But friend, I cannot endure their gaspings. Pray put them on this short line and place them in the water beside you until you prepare to go home. In a few hours each fisher has obtained as many as he wishes. He rolls up his line, fastens five or six perches on each side of his saddle, mounts his horse and merrily wends his way.

In this manner the white perch is caught along the sandy banks of the Ohio from its mouth to its source. In many parts above Louisville some fishers prefer using the trotline, which, however, ought to be placed upon or very little above the bottom of the stream. When this kind of line is employed, its hooks are more frequently baited with mussels than with crayfish, the latter being perhaps not so easily procured there as farther down the stream. Great numbers of perches are also caught in seines, especially during a transient rise of the water. Few persons fish for them with the pole, as they generally prefer following the edges of the sand-bars next to deep water. Like all others of its tribe, the white perch is fond of depositing its spawn on gravelly or sandy beds, but rarely at a depth of less than four or five feet. These beds are round and have an elevated margin formed of the sand removed from their center, which is scooped out for two or three inches. The fish, although it generally remains for some days over its treasure, is by no means so careful of it as the little sunny, but starts off at the

least appearance of danger. I have more than once taken considerable pleasure in floating over their beds when the water was sufficiently clear to admit of my seeing both the fish and its place of deposit; but I observed that if the sun was shining, the very sight of the boat's shadow drove the perches away. I am of opinion that most of them return to the sea about the beginning of November; but of this I am not certain.

The usual length of this fish, which on the Ohio is called the white perch and in the State of New York the growler, is from fifteen to twenty inches. I have, however, seen some considerably larger. The weight varies from a pound and a half to four and even six pounds. For the first six weeks of their arrival in freshwater streams they are in season; the flesh is then white and firm and affords excellent eating; but during the heats of summer they become poor and are seldom very good. Now and then, in the latter days of September, I have eaten some that tasted as well as in spring. One of the most remarkable habits of this fish is that from which it has received the name of growler. When poised in the water close to the bottom of a boat it emits a rough croaking noise somewhat resembling a groan. Whenever this sound is heard under a boat, if the least disturbance is made by knocking on the gunwale or bottom it at once ceases; but is renewed when everything is quiet. It is seldom heard, however, unless in fine calm weather.

The white perch bites at the hook with considerable care and very frequently takes off the bait without being caught. Indeed, it requires a good deal of dexterity to hook it, for if this is not done the first time it touches the bait you rarely succeed afterwards; and I have seen young hands at the game who, in the course of a morning, seldom caught more than one or two, although they lost perhaps twenty crays. But now that I have afforded you some information respecting the habits of the white perch, allow me to say a few words on the subject of its favorite bait.

The cray is certainly not a fish, although usually so styled; but as everyone is acquainted with its form and nature, I shall not inflict on you any disquisition regarding it. It is a handsome crustaceous animal certainly, and its whole tribe I consider as dainties of the first order. To me *Ecrevisses*, whether of fresh or of salt water,

stripped of their coats and blended into a soup or a "gumbo," have always been most welcome. Boiled or roasted too, they are excellent in my estimation and mayhap in yours. The crayfish of which I here more particularly speak—for I shall not deprive them of their caudal appendage, lest like a basha without his tail, they might seem of less consequence—are found most abundantly swimming, crawling at the bottom or on shore or working at their muddy burrows in all the southern parts of the Union. If I mistake not, we have two species at least, one more an inhabitant of rocky streamlets than the other and that one by far the best, though the other is good too. Both species swim by means of rapid strokes of the tail, which propel them backwards to a considerable distance at each repetition. All that I regret concerning these animals is that they are absolutely little aquatic vultures—or, if you please, crustacea with vulturine habits—for they feed on everything impure that comes in their way when they cannot obtain fresh aliment. However this may be, the crays somehow fall in with this sort of food, and any person may catch as many as he may wish by fastening a piece of flesh to a line, allowing it to remain under water for a while and drawing it up with care, when with the aid of a hand net he may bring it ashore with *a few!* But although this is a good method of procuring crayfish, it answers only for those that live in running waters. The form of these is delicate, their color a light olive and their motions in the water are very lively. The others are larger, of a dark greenish-brown, less active in the water than on land, although they are most truly amphibious. The first conceal themselves beneath shelving rocks, stones or water plants; the others form a deep burrow in the damp earth, depositing the materials drawn up, as a man would do in digging a well. The manner in which they dispose of the mud you may see by glancing at the plate of the White Ibis in my third volume of illustrations, where also you will find a tolerable portrait of one of these creatures.

According to the nature of the ground, the burrows of this crayfish are more or less deep. Indeed, this also depends partly on the increasing dryness of the soil when influenced by the heat of summer as well as on the texture of the substratum. Thus in some places where the cray can reach the water after working a few inches, it rests contented during the day but crawls out for food at

night. Should it, however, be left dry, it renews its labor; and thus while one burrow may be only five or six inches deep, another may be two or three feet and a third even more. They are easily procured when thus lodged in shallow holes; but when the burrow is deep a thread is used with a small piece of flesh fastened to it. The cray eagerly seizes the bait and is gently drawn up and thrown to a distance, when he becomes an easy prey. You have read of the method used by the White Ibis in procuring crays; and I leave you to judge whether the bird or the man is the best fisher. This species is most abundant round the borders of the stagnant lakes, bayous or ponds of the Southern Districts; and I have seen them caught even in the streets of the suburbs of New Orleans after a heavy shower. They become a great pest by perforating embankments of all sorts, and many are the maledictions that are uttered against them both by millers and planters, nay even by the overseers of the levees along the banks of the Mississippi. But they are curious creatures, formed no doubt for useful purposes, and as such they are worthy of your notice.

The Passenger Pigeon

Audubon's description of the Passenger Pigeon may be his best-known essay. The birds were "passengers" because they did not migrate but flocked from region to region seeking food. By modern estimates, of some nine billion birds in North America at the time of the continent's European discovery, three billion were Passenger Pigeons. Audubon's predecessor Alexander Wilson wrote that the flocks made "a space on the face of the heavens resembling the windings of a vast and majestic river." Overharvesting continued throughout the nineteenth century until the species finally became extinct; the last known wild pigeon, a hen named Martha, died at the Cincinnati Zoo in 1914.

The Passenger Pigeon, or as it is usually named in America, the Wild Pigeon, moves with extreme rapidity, propelling itself by quickly repeated flaps of the wings, which it brings more or less near to the body according to the degree of velocity which is required. Like the Domestic Pigeon it often flies during the love season in a circling manner, supporting itself with both wings angularly elevated, in which position it keeps them until it is about to alight. Now and then during these circular flights the tips of the primary quills of each wing are made to strike against each other, producing a smart rap which may be heard at a distance of thirty or forty yards. Before alighting the Wild Pigeon, like the Carolina Parrot and a few other species of birds, breaks the force of its flight by repeated flappings, as if apprehensive of receiving injury from coming too suddenly into contact with the branch or the spot of ground on which it intends to settle.

I have commenced my description of this species with the above account of its flight because the most important facts connected with its habits relate to its migrations. These are entirely owing to the necessity of procuring food and are not performed with the view of escaping the severity of a northern latitude or of seeking a southern one for the purpose of breeding. They consequently do not take place at any fixed period or season of the year. Indeed, it sometimes happens that a continuance of a sufficient supply of food in one district will keep these birds absent from another for

years. I know at least, to a certainty, that in Kentucky they remained for several years constantly and were nowhere else to be found. They all suddenly disappeared one season when the mast was exhausted and did not return for a long period. Similar facts have been observed in other states.

Their great power of flight enables them to survey and pass over an astonishing extent of country in a very short time. This is proved by facts well known in America. Thus, Pigeons have been killed in the neighborhood of New York with their crops full of rice which they must have collected in the fields of Georgia and Carolina, these districts being the nearest in which they could possibly have procured a supply of that kind of food. As their power of digestion is so great that they will decompose food entirely in twelve hours, they must in this case have traveled between three hundred and four hundred miles in six hours, which shews their speed to be at an average about one mile in a minute. A velocity such as this would enable one of these birds, were it so inclined, to visit the European continent in less than three days.

This great power of flight is seconded by as great a power of vision, which enables them as they travel at that swift rate to inspect the country below, discover their food with facility and thus attain the object for which their journey has been undertaken. This I have also proved to be the case by having observed them, when passing over a sterile part of the country or one scantily furnished with food suited to them, keep high in the air, flying with an extended front so as to enable them to survey hundreds of acres at once. On the contrary, when the land is richly covered with food or the trees abundantly hung with mast they fly low in order to discover the part most plentifully supplied.

Their body is of an elongated oval form, steered by a long, well-plumed tail and propelled by well-set wings, the muscles of which are very large and powerful for the size of the bird. When an individual is seen gliding through the woods and close to the observer it passes like a thought, and on trying to see it again the eye searches in vain; the bird is gone.

The multitudes of Wild Pigeons in our woods are astonishing. Indeed, after having viewed them so often and under so many circumstances, I even now feel inclined to pause and assure myself

that what I am going to relate is fact. Yet I have seen it all, and that too in the company of persons who, like myself, were struck with amazement.

In the autumn of 1813 I left my house at Henderson, on the banks of the Ohio, on my way to Louisville. In passing over the Barrens a few miles beyond Hardensburgh I observed the Pigeons flying from northeast to southwest in greater numbers than I thought I had ever seen them before, and feeling an inclination to count the flocks that might pass within the reach of my eye in one hour, I dismounted, seated myself on an eminence and began to mark with my pencil, making a dot for every flock that passed. In a short time, finding the task which I had undertaken impracticable, as the birds poured in in countless multitudes, I rose and, counting the dots then put down, found that 163 had been made in twenty-one minutes. I traveled on and still met more the farther I proceeded. The air was literally filled with Pigeons; the light of noonday was obscured as by an eclipse; the dung fell in spots not unlike melting flakes of snow; and the continued buzz of wings had a tendency to lull my senses to repose.

Whilst waiting for dinner at Young's Inn, at the confluence of Salt River with the Ohio, I saw at my leisure immense legions still going by, with a front reaching far beyond the Ohio on the west and the beechwood forests directly on the east of me. Not a single bird alighted; for not a nut or acorn was that year to be seen in the neighborhood. They consequently flew so high that different trials to reach them with a capital rifle proved ineffectual; nor did the reports disturb them in the least. I cannot describe to you the extreme beauty of their aerial evolutions when a Hawk chanced to press upon the rear of a flock. At once, like a torrent, and with a noise like thunder, they rushed into a compact mass, pressing upon each other towards the center. In these almost solid masses they darted forward in undulating and angular lines, descended and swept close over the earth with inconceivable velocity, mounted perpendicularly so as to resemble a vast column and, when high, were seen wheeling and twisting within their continued lines, which then resembled the coils of a gigantic serpent.

Before sunset I reached Louisville, distant from Hardensburgh fifty-five miles. The Pigeons were still passing in undiminished

numbers and continued to do so for three days in succession. The people were all in arms. The banks of the Ohio were crowded with men and boys incessantly shooting at the pilgrims, which there flew lower as they passed the river. Multitudes were thus destroyed. For a week or more, the population fed on no other flesh than that of Pigeons, and talked of nothing but Pigeons. The atmosphere during this time was strongly impregnated with the peculiar odor which emanates from the species.

It is extremely interesting to see flock after flock performing exactly the same evolutions which had been traced as it were in the air by a preceding flock. Thus, should a Hawk have charged on a group at a certain spot, the angles, curves and undulations that have been described by the birds in their efforts to escape from the dreaded talons of the plunderer are undeviatingly followed by the next group that comes up. Should the bystander happen to witness one of these affrays, and struck with the rapidity and elegance of the motions exhibited, feel desirous of seeing them repeated, his wishes will be gratified if he only remain in the place until the next group comes up.

It may not perhaps be out of place to attempt an estimate of the number of Pigeons contained in one of those mighty flocks and of the quantity of food daily consumed by its members. The inquiry will tend to shew the astonishing bounty of the great Author of Nature in providing for the wants of his creatures. Let us take a column of one mile in breadth, which is far below the average size, and suppose it passing over us without interruption for three hours at the rate mentioned above of one mile in the minute. This will give us a parallelogram of 180 miles by 1 covering 180 square miles. Allowing two pigeons to the square yard, we have one billion, one hundred and fifteen millions, one hundred and thirty-six thousand pigeons in one flock. As every pigeon daily consumes fully half a pint of food, the quantity necessary for supplying this vast multitude must be eight millions seven hundred and twelve thousand bushels per day.

As soon as the Pigeons discover a sufficiency of food to entice them to alight, they fly round in circles reviewing the country below. During their evolutions on such occasions the dense mass which they form exhibits a beautiful appearance as it changes its

direction, now displaying a glistening sheet of azure when the backs of the birds come simultaneously into view and anon suddenly presenting a mass of rich deep purple. They then pass lower over the woods and for a moment are lost among the foliage, but again emerge and are seen gliding aloft. They now alight, but the next moment as if suddenly alarmed they take to wing, producing by the flappings of their wings a noise like the roar of distant thunder, and sweep through the forests to see if danger is near. Hunger, however, soon brings them to the ground. When alighted they are seen industriously throwing up the withered leaves in quest of the fallen mast. The rear ranks are continually rising, passing over the main body and alighting in front in such rapid succession that the whole flock seems still on wing. The quantity of ground thus swept is astonishing, and so completely has it been cleared that the gleaner who might follow in their rear would find his labor completely lost. Whilst feeding, their avidity is at times so great that in attempting to swallow a large acorn or nut they are seen gasping for a long while as if in the agonies of suffocation.

On such occasions, when the woods are filled with these Pigeons, they are killed in immense numbers, although no apparent diminution ensues. About the middle of the day, after their repast is finished, they settle on the trees to enjoy rest and digest their food. On the ground they walk with ease, as well as on the branches, frequently jerking their beautiful tail and moving the neck backwards and forwards in the most graceful manner. As the sun begins to sink beneath the horizon they depart *en masse* for the roosting place, which not unfrequently is hundreds of miles distant, as has been ascertained by persons who have kept an account of their arrivals and departures.

Let us now, kind reader, inspect their place of nightly rendezvous. One of these curious roosting places, on the banks of the Green River in Kentucky, I repeatedly visited. It was, as is always the case, in a portion of the forest where the trees were of great magnitude and where there was little underwood. I rode through it upwards of forty miles, and crossing it in different parts found its average breadth to be rather more than three miles. My first view of it was about a fortnight subsequent to the period when they had made choice of it and I arrived there nearly two hours

before sunset. Few Pigeons were then to be seen, but a great number of persons with horses and wagons, guns and ammunition, had already established encampments on the borders. Two farmers from the vicinity of Russelsville, distant more than a hundred miles, had driven upwards of three hundred hogs to be fattened on the pigeons which were to be slaughtered. Here and there the people employed in plucking and salting what had already been procured were seen sitting in the midst of large piles of these birds. The dung lay several inches deep, covering the whole extent of the roosting place like a bed of snow. Many trees two feet in diameter, I observed, were broken off at no great distance from the ground; and the branches of many of the largest and tallest had given way as if the forest had been swept by a tornado. Everything proved to me that the number of birds resorting to this part of the forest must be immense beyond conception.

As the period of their arrival approached, their foes anxiously prepared to receive them. Some were furnished with iron pots containing sulfur, others with torches of pine-knots, many with poles and the rest with guns. The sun was lost to our view, yet not a Pigeon had arrived. Everything was ready and all eyes were gazing on the clear sky which appeared in glimpses amidst the tall trees. Suddenly there burst forth a general cry of "Here they come!" The noise which they made, though yet distant, reminded me of a hard gale at sea passing through the rigging of a close-reefed vessel.

As the birds arrived and passed over me I felt a current of air that surprised me. Thousands were soon knocked down by the pole-men. The birds continued to pour in. The fires were lighted and a magnificent, as well as wonderful and almost terrifying sight presented itself. The Pigeons, arriving by thousands, alighted every-where one above another until solid masses as large as hogsheads were formed on the branches all round. Here and there the perches gave way under the weight with a crash and, falling to the ground, destroyed hundreds of the birds beneath, forcing down the dense groups with which every stick was loaded. It was a scene of uproar and confusion. I found it quite useless to speak or even to shout to those persons who were nearest to me. Even the reports of the guns were seldom heard and I was made aware of the firing only by seeing the shooters reloading.

No one dared venture within the line of devastation. The hogs had been penned up in due time, the picking up of the dead and wounded being left for the next morning's employment. The Pigeons were constantly coming, and it was past midnight before I perceived a decrease in the number of those that arrived. The uproar continued the whole night; and as I was anxious to know to what distance the sound reached, I sent off a man accustomed to perambulate the forest who, returning two hours afterwards, informed me he had heard it distinctly when three miles distant from the spot. Towards the approach of day the noise in some measure subsided; long before objects were distinguishable the Pigeons began to move off in a direction quite different from that in which they had arrived the evening before, and at sunrise all that were able to fly had disappeared. The howlings of the wolves now reached our ears, and the foxes, lynxes, cougars, bears, raccoons, opossums and polecats were seen sneaking off, whilst eagles and hawks of different species accompanied by a crowd of vultures came to supplant them and enjoy their share of the spoil.

It was then that the authors of all this devastation began their entry amongst the dead, the dying and the mangled. The Pigeons were picked up and piled in heaps until each had as many as he could possibly dispose of, when the hogs were let loose to feed on the remainder. Persons unacquainted with these birds might naturally conclude that such dreadful havoc would soon put an end to the species. But I have satisfied myself by long observation that nothing but the gradual diminution of our forests can accomplish their decrease, as they not unfrequently quadruple their numbers yearly and always at least double it. In 1805 I saw schooners loaded in bulk with Pigeons caught up the Hudson River coming in to the wharf at New York, when the birds sold for a cent a piece. I knew a man in Pennsylvania who caught and killed upwards of 500 dozens in a clap net in one day, sweeping sometimes twenty dozens or more at a single haul. In the month of March 1830 they were so abundant in the markets of New York that piles of them met the eye in every direction. I have seen the Negroes at the United States' Salines or Saltworks of Shawnee Town [Ohio] wearied with killing Pigeons as they alighted to drink the water issuing from the leading pipes for weeks at a time; and yet in 1826 in

Louisiana I saw congregated flocks of these birds as numerous as ever I had seen them before during a residence of nearly thirty years in the United States.

The breeding of the Wild Pigeons and the places chosen for that purpose are points of great interest. The time is not much influenced by season and the place selected is where food is most plentiful and most attainable, and always at a convenient distance from water. Forest trees of great height are those in which the Pigeons form their nests. Thither the countless myriads resort and prepare to fulfill one of the great laws of nature. At this period the note of the Pigeon is a soft *coo-coo-coo-coo*, much shorter than that of the domestic species. The common notes resemble the monosyllables *kee-kee-kee-kee*, the first being the loudest, the others gradually diminishing in power. The male assumes a pompous demeanor and follows the female whether on the ground or on the branches, with spread tail and drooping wings which it rubs against the part over which it is moving. The body is elevated, the throat swells, the eyes sparkle. He continues his notes and now and then rises on the wing and flies a few yards to approach the fugitive and timorous female. Like the domestic Pigeon and other species, they caress each other by billing, in which action the bill of the one is introduced transversely into that of the other and both parties alternately disgorge the contents of their crop by repeated efforts. These preliminary affairs are soon settled and the Pigeons commence their nests in general peace and harmony. They are composed of a few dry twigs, crossing each other, and are supported by forks of the branches. On the same tree from fifty to a hundred nests may frequently be seen— I might say a much greater number were I not anxious, kind reader, that however wonderful my account of the Wild Pigeon is, you may not feel disposed to refer it to the marvelous. The eggs are two in number, of a broadly elliptical form and pure white. During incubation the male supplies the female with food. Indeed, the tenderness and affection displayed by these birds towards their mates are in the highest degree striking. It is a remarkable fact that each brood generally consists of a male and a female.

Here again the tyrant of the creation, man, interferes, disturbing the harmony of this peaceful scene. As the young birds grow up, their enemies, armed with axes, reach the spot to seize and destroy

all they can. The trees are felled and made to fall in such a way that the cutting of one causes the overthrow of another or shakes the neighboring trees so much that the young Pigeons, or *squabs*, as they are named, are violently hurried to the ground. In this manner also, immense quantities are destroyed.

The young are fed by the parents in the manner described above; in other words, the old bird introduces its bill into the mouth of the young one in a transverse manner or with the back of each mandible opposite the separations of the mandibles of the young bird, and disgorges the contents of its crop. As soon as the young birds are able to shift for themselves, they leave their parents and continue separate until they attain maturity. By the end of six months they are capable of reproducing their species.

The flesh of the Wild Pigeon is of a dark color but affords tolerable eating. That of young birds from the nest is much esteemed. The skin is covered with small white filmy scales. The feathers fall off at the least touch, as has been remarked to be the case in the Carolina Turtle[dove]. I have only to add that this species, like others of the same genus, immerses its head up to the eyes while drinking.

In March 1830, I bought about 350 of these birds in the market of New York at four cents a piece. Most of these I carried alive to England and distributed amongst several noblemen, presenting some at the same time to the Zoological Society.

[The Passenger Pigeon, *Ectopistes migratorius*, appears in Plate 62 of *The Birds of America*.]

Jean Audubon to John James Audubon
"Jean Rabin, Creole from Santo Domingo..."

This translation of a rare surviving letter from Audubon's father confirms that Audubon knew the fact of his illegitimacy, who his mother was and where he was born. ("Creole" here means a citizen of France born abroad, not that Audubon was of mixed race; Jeanne Rabin, his mother, was French, born in a village near Nantes in 1758.) Audubon appears to have been exploring business connection with his father or brother-in-law in the wake of Will Bakewell's withdrawal from partnership, inviting his French relations to emigrate to America or possibly returning to France himself.

Couëron, France
24 September 1817

My good friend,

We have in front of us your two letters, of last June 8th and July 27th. We have categorically answered the first and we will [now] do so with the second.

First you tell us that you are sending us a proxy under the name of Jean Rabin and you sign it Jean [i.e., John James] Audubon. This change of name invalidates the proxy; the name you sign must be Jean Rabin, Creole from Santo Domingo, with no question of Jean Audubon except as it concerns the name of your spouse. Since the fall of the usurper [i.e., Napoleon] our laws have changed and are those of a legitimate king; the new code requires that the name of the mother be the only one you employ in your proxy, which, when you have read and judged it, you can sign by the name Jean Rabin. Then get the authorities of the country you live in to legalize it and have it certified by the French consul; and don't forget to have each authority stamp it.

You ask us if a naturalized citizen of the United States can come to France without risking trouble or difficulty if he didn't like it—if he could return to the United States to enjoy the same rights he had before he left for France. Yes, he can, and without any problem for anybody. Here is proof: First, the government here considers

that men are free to travel, to go wherever they please for their business, by asking for a passport at the City Hall of the place where they live; for people living overseas, a passport is available without difficulty from the French embassy. Mr. Wenir came with a fortune made on your continent without settling here and he has been warmly accepted. Mr. Formont has had a similar experience, and there are many others, none of whom were bothered in the least. They could, if it pleased them, go back to the United States or elsewhere. We even have several American [import-export] houses, which trade only with the United States and obtain, like all French citizens, government protection.

You complain that we don't write as often as you do. In fact, during a lapse of thirty months without hearing from you, we have written on all the following occasions: September 24th by Mr. Bakewell; November 9th, 1815, through South Carolina; October 8th, 1815, through Louisiana; January 5th, 1816, through Charleston; February 13th, 1816, through Charleston; April 6th, 1816, through New Orleans, and lastly, in answer to your June 8th letter through Louisiana, on the ship of Mr. James Dupuis, the letter included in that of Mr. Rozier and finally this one in answer to your last letter. We give you all these details to show you the pleasure we have in writing to you and that we take all the chances we get [i.e., to send a letter by ship]. It is possible a large number of letters get lost— from you as well as from us.

In your first [letter] you gave us the details of your situation: the dissolution of your partnership with your brother-in-law, founded upon his marriage; this seems very agreeable and advantageous for you. You speak of at least 50,000 dollars. It's the fortune of a rich man, since it would convert here to a capital of 275,000 francs. I'm not considered poor and live honorably, and my fortune, all included, doesn't exceed 80,000 francs and when you say that in your country a rich man must own 100,000 dollars, it all depends on the place and the running of business which can turn more or less precarious. If I had the opportunity to put 3,000 dollars in the smallholding farm at Doly, I'd be considered a rich man. Events and vicissitudes that go along with great fortunes overseas make them much more exposed to ruin [than in Europe]. I'm a striking example, and if I could have restrained my ambitions I would be

today a very rich individual. The man in Nantes who earns a yearly pension of 10,000 francs from 200,000 francs, and who made 50–60,000 francs in business, not trying to overdo it, could have half a dozen children and would be well suited to give them all a brilliant education and honorable future positions. Witness Mr. Formont, a Creole from Santo Domingo, who has just been named a justice by our good king, Louis XVIII. He made his fortune on the continent. Ever since our good constitutional charter, merit today now equals the most distinguished birth.

You push us to sell everything, to join our monies and to settle by your side. We'd just be small people there, whereas here we enjoy full consideration for our custom and our honesty, and although not really rich, our complete independence. From this, my friend, judge if it would not be reckless to move at our age.

In case you find these facts encouraging and wish to give us the immediate pleasure of your presence and that of your family in our old age, we would not advise you to come, putting your fortune in jeopardy. Instead, since you will need more time to fulfill your ambitions, you could pay alternatively 10 to 15,000 francs in merchandise to the address of your authorized representative, who is incapable of stealing but rather adds value to your funds until your arrival. When you consider your fortune in France to be sufficient, you could settle your affairs and come. We have here a great confidence in the fire pump, newly invented; it can change the face of things. There was just in England a great fire and a lot of people died. In case you would wish to turn a profit, the cotton industry offers an advantageous exchange.

Your reasoning is extremely wise; one does not dishonor himself by working. Youth, as you say so well, is quick in passing. It is useful to take advantage of it to ensure oneself of an honest existence in old age and that's why I firmly believe that Europe provides more safety than the newly established countries where revolutions are more frequent. Ambition and great fortunes are usually their causes.

You speak sometimes of the misfortunes of France. They are over with, the government is legitimate and stable and free from all upheaval.

The country you live in is the best, the richest and beyond

compare to any other; you do good business there. Your enthusiasm is quite forgivable. You left France too early and in a state of shock to know what you can enjoy here. Your wife, having left Europe at a young age, could only have known the unhappiness that her father experienced in England and chose the United States instead, basing her choice, no doubt, on the great freedom you could find there—which is now only equal to ours.

Your good mother, Mrs. Audubon, would have a longer and fuller life if she could enjoy your presence. You know how much she loves you. Tell all your family how much we love them. We kiss your dear children, which are also ours, and would enlighten my old age as do those of [Audubon's half-sister Rose and her husband Gabriel-Loyen] du Puigaudeau. Let us know if Mr. [Benjamin] Bakewell, who came to France, has arrived back to the United States in good form.

Your father and true friend,
Audubon

The American Crow

In several of his bird biographies Audubon pleads with his readers to spare the lives of species of birds such as Crows and Carolina Parrots that were treated as vermin because they fed on farmers' crops. As he grew older his concern for wildlife conservation increased, less because his perspective changed, as some biographers have speculated, than because he saw the exploitation of the primordial American wilderness accelerating with the accelerating increase of population in the trans-Appalachian West.

The Crow is an extremely shy bird, having found familiarity with man no way to his advantage. He is also cunning—at least he is so called, because he takes care of himself and his brood. The state of anxiety, I may say of terror, in which he is constantly kept, would be enough to spoil the temper of any creature. Almost every person has an antipathy to him, and scarcely one of his race would be left in the land did he not employ all his ingenuity and take advantage of all his experience in counteracting the evil machinations of his enemies. I think I see him perched on the highest branch of a tree, watching every object around. He observes a man on horseback traveling towards him; he marks his movements in silence. No gun does the rider carry, no, that is clear; but perhaps he has pistols in the holsters of his saddle! Of that the Crow is not quite sure, as he cannot either see them or "smell powder." He beats the points of his wings, jerks his tail once or twice, bows his head and merrily sounds the joy which he feels at the moment. Another man he spies walking across the field towards his stand, but he has only a stick. Yonder comes a boy shouldering a musket loaded with large shot for the express purpose of killing crows! The bird immediately sounds an alarm; he repeats his cries, increasing their vehemence the nearer his enemy advances. All the crows within half a mile round are seen flying off, each repeating the well-known notes of the trusty watchman who, just as the young gunner is about to take aim, betakes himself to flight. But alas, he chances unwittingly to pass over a sportsman whose dexterity is greater; the mischievous prowler aims his piece, fires—down towards the earth, broken-winged, falls the luckless bird in an instant. "It is nothing but a

crow," quoth the sportsman, who proceeds in search of game and leaves the poor creature to die in the most excruciating agonies.

Wherever within the Union the laws encourage the destruction of this species, it is shot in great numbers for the sake of the premium offered for each crow's head. You will perhaps be surprised, reader, when I tell you that in one single state, in the course of a season, 40,000 were shot, besides the multitudes of young birds killed in their nests. Must I add to this slaughter other thousands destroyed by the base artifice of laying poisoned grain along the fields to tempt these poor birds? Yes, I will tell you of all this too. The natural feelings of everyone who admires the bounty of Nature in providing abundantly for the subsistence of all her creatures prompt me to do so. Like yourself, I admire all her wonderful works and respect her wise intentions even when her laws are far beyond our limited comprehension.

The Crow devours myriads of grubs every day of the year that might lay waste the farmer's fields; it destroys quadrupeds innumerable, every one of which is an enemy to his poultry and his flocks. Why then should the farmer be so ungrateful when he sees such services rendered to him by a providential friend as to persecute that friend even to the death? Unless he plead ignorance, surely he ought to be found guilty at the bar of common sense. Were the soil of the United States, like that of some other countries, nearly exhausted by long continued cultivation, human selfishness in such a matter might be excused and our people might look on our Crows as other people look on theirs; but every individual in the land is aware of the superabundance of food that exists among us, and of which a portion may well be spared for the feathered beings that tend to enhance our pleasures by the sweetness of their song, the innocence of their lives or their curious habits. Did not every American open his door and his heart to the wearied traveler, and afford him food, comfort and rest, I would at once give up the argument; but when I know by experience the generosity of the people, I cannot but wish that they would reflect a little and become more indulgent toward our poor, humble, harmless and even most serviceable bird, the Crow.

The American Crow is common in all parts of the United States. It becomes gregarious immediately after the breeding season when

it forms flocks sometimes containing hundreds or even thousands. Towards autumn, the individuals bred in the Eastern Districts almost all remove to the Southern States, where they spend the winter in vast numbers.

The voice of our Crow is very different from that of the European species which comes nearest to it in appearance, so much so indeed that this circumstance, together with others relating to its organization, has induced me to distinguish it, as you see, by a peculiar name, that of *Corvus Americanus*. I hope you will think me excusable in this, should my ideas prove to be erroneous, when I tell you that the Magpie of Europe is assuredly the very same bird as that met with in the western wilds of the United States, although some ornithologists have maintained the contrary, and that I am not disposed to make differences in name where none exist in nature. I consider our Crow as rather less than the European one, and the form of its tongue does not resemble that of the latter bird; besides the Carrion Crow of that country seldom associates in numbers, but remains in pairs excepting immediately after it has brought its young abroad, when the family remains undispersed for some weeks.

Wherever our Crow is abundant, the Raven is rarely found, and *vice versa*. From Kentucky to New Orleans, Ravens are extremely rare, whereas in that course you find one or more Crows at every half mile. On the contrary, far up the Missouri as well as on the coast of Labrador, few Crows are to be seen, while Ravens are common. I found the former birds equally scarce in Newfoundland.

Omnivorous like the Raven, our Crow feeds on fruits, seeds and vegetables of almost every kind; it is equally fond of snakes, frogs, lizards and other small reptiles; it looks upon various species of worms, grubs and insects as dainties; and if hard pressed by hunger it will alight upon and devour even putrid carrion. It is as fond of the eggs of other birds as is the Cuckoo, and like the Titmouse, it will, during a paroxysm of anger, break in the skull of a weak or wounded bird. It delights in annoying its twilight enemies the Owls, the opossum, and the raccoon and will even follow by day a fox, a wolf, a panther or in fact any other carnivorous beast as if anxious that man should destroy them for their mutual benefit. It plunders the fields of their superabundance and is blamed for so

doing, but it is seldom praised when it chases the thieving Hawk from the poultry yard.

The American Crow selects with uncommon care its breeding place. You may find its nest in the interior of our most dismal swamps or on the sides of elevated and precipitous rocks, but almost always as much concealed from the eye of man as possible. They breed in almost every portion of the Union, from the Southern Cape of the Floridas to the extremities of Maine and probably as far westward as the Pacific Ocean. The period of nestling varies from February to the beginning of June according to the latitude of the place. Its scarcity on the coast of Labrador furnishes one of the reasons that have induced me to believe it different from the Carrion Crow of Europe; for there I met with several species of birds common to both countries, which seldom enter the United States farther than the vicinity of our most eastern boundaries.

The nest, however, greatly resembles that of the European Crow, as much in fact as that of the American Magpie resembles the nest of the European. It is formed externally of dry sticks interwoven with grasses, and is within thickly plastered with mud or clay and lined with fibrous roots and feathers. The eggs are from four to six, of a pale greenish color, spotted and clouded with purplish-grey and brownish-green. In the Southern States they raise two broods in the season, but to the eastward seldom more than one. Both sexes incubate, and their parental care and mutual attachment are not surpassed by those of any other bird. Although the nests of this species often may be found near each other, their proximity is never such as occurs in the case of the Fish Crow, of which many nests may be seen on the same tree.

When the nest of this species happens to be discovered, the faithful pair raise such a hue and cry that every Crow in the neighborhood immediately comes to their assistance, passing in circles high over the intruder until he has retired or following him, if he has robbed it, as far as their regard for the safety of their own will permit them. As soon as the young leave the nest, the family associates with others, and in this manner they remain in flocks till spring. Many crows' nests may be found within a few acres of the same wood, and in this particular their habits accord more with those of the Rooks of Europe which as you very well know breed

and spend their time in communities. The young of our Crow, like that of the latter species, are tolerable food when taken a few days before the period of their leaving the nest.

The flight of the American Crow is swift, protracted and at times performed at a great elevation. They are now and then seen to sail among the Turkey Buzzards or Carrion Crows in company with their relatives the Fish Crows, none of the other birds, however, shewing the least antipathy towards them, although the Vultures manifest dislike whenever a White-headed Eagle comes among them.

In the latter part of autumn and in winter in the Southern States this Crow is particularly fond of frequenting burnt grounds. Even while the fire is raging in one part of the fields, the woods or the prairies, where tall grass abounds the Crows are seen in great numbers in the other, picking up and devouring the remains of mice and other small quadrupeds as well as lizards, snakes and insects which have been partly destroyed by the flames. At the same season they retire in immense numbers to roost by the margins of ponds, lakes and rivers covered with a luxuriant growth of rank weeds or cattails. They may be seen proceeding to such places more than an hour before sunset in long straggling line and in silence, and are joined by the Grackles, Starlings and Reed Birds, while the Fish Crows retire from the very same parts to the interior of the woods many miles distant from any shores.

No sooner has the horizon brightened at the approach of day than the Crows sound a reveille, and then with mellowed notes, as it were, engage in a general thanksgiving for the peaceful repose they have enjoyed. After this they emit their usual barking notes as if consulting each other respecting the course they ought to follow. Then parties in succession fly off to pursue their avocations and relieve the reeds from the weight that bent them down.

The Crow is extremely courageous in encountering any of its winged enemies. Several individuals may frequently be seen pursuing a Hawk or an Eagle with remarkable vigor, although I never saw or heard of one pouncing on any bird for the purpose of preying on it. They now and then tease the Vultures when those foul birds are alighted on trees with their wings spread out, but they soon desist, for the Vultures pay no attention to them.

The most remarkable feat of the Crow is the nicety with which it, like the Jay, pierces an egg with its bill in order to carry it off and eat it with security. In this manner I have seen it steal, one after another, all the eggs of a Wild Turkey's nest. You will perceive, reader, that I endeavor to speak of the Crow with all due impartiality, not wishing by any means to conceal its faults nor withholding my testimony to its merits, which are such as I can well assure the farmer that were it not for its race, thousands of cornstalks would every year fall prostrate, in consequence of being cut over close to the ground by the destructive grubs which are called "cutworms."

I never saw a pet Crow in the United States and therefore cannot say with how much accuracy they may imitate the human voice or indeed if they possess the power of imitating it at all, which I very much doubt, as in their natural state they never evince any talents for mimicry. I cannot say if it possess the thieving propensities attributed by authors to the European Crow.

Its gait while on the ground is elevated and graceful, its ordinary mode of progression being a sedate walk, although it occasionally hops when under excitement. It not unfrequently alights on the backs of cattle to pick out the worms lurking in their skin, in the same manner as the Magpie, Fish Crow and Cowbird. Its note or cry may be imitated by the syllables *caw, caw, caw*, being different from the cry of the European Carrion Crow and resembling the distant bark of a small dog.

At Pittsburgh in Pennsylvania I saw a pair of Crows perfectly white, in the possession of Mr. Lambdin, the owner of the museum there, who assured me that five which were found in the nest were of the same color.

[On Plate 156 of *The Birds of America*] I have placed the pensive oppressed Crow of our country on a beautiful branch of the Black Walnut tree loaded with nuts, on the lower twig of which I have represented the delicate nest of our Common Hummingbird...

In conclusion, I would again address our farmers and tell them that if they persist in killing Crows, the best season for doing so is when their corn begins to ripen.

The Black Walnut

The Black Walnut of the United States is generally a tree of beautiful form and often, especially in the Western and Southern States, attains a great size. Wherever it is found you may calculate on the land being of good quality; the wood is very firm, of a dark brown tint, veined and extremely useful for domestic purposes, many articles of furniture being made of it. It is also employed in shipbuilding. When used for posts or fence rails it resists the action of the weather for many years. The nuts are gathered late in autumn and although rather too oily, are eaten and considered good by many persons. The husking of them is however a disagreeable task, as their covering almost indelibly stains every object with which it comes in contact.

[The American Crow, *Corvus brachyrhynchos*, appears in Plate 156 of *The Birds of America*, perched on a branch of a Black Walnut tree.]

A Reader's Response: The Adventures of Buck Crow

Audubon's skepticism about the imitative intelligence of the American Crow prompted this witty narrative from an American reader of the late Octavo edition of The Birds of America.

Greensboro, Alabama
28 September 1842

Dear Sir,

In examining your history of the "American Crow"—recently published—I noticed that you express yourself as never having seen "a pet crow in the United States and therefore (you add) cannot say with how much accuracy they may imitate the human voice or indeed if they possess the power of imitating it at all, *which I very much doubt*, as in their natural state they never evince any talents for mimicry. I cannot say (you continue) if it possess the *thieving propensities* attributed by authors to the European Crow."

Not doubting that any interesting facts in relation to natural history in general & particularly that branch of it embracing the "feathered tribe" would meet with your kind attention even though those facts might not exactly accord with the opinions you may have formed—I have concluded to submit to your notice some particulars concerning a bird of the species alluded to. Being a stranger to you, your credence will of course be based upon the credibility of the statements themselves—& though they may wear very much the appearance of a "fish story"—I could give you, independent of my own declaration, the testimony of a score of individuals who, for veracity, stand "above suspicion."

The bird I have reference to was caught some twenty years ago in Orange County, North Carolina, by one of my brothers, & presented to a sister for a pet. It was barely fledged when taken. Getting a leg broken shortly after its capture & having one of its wings cropped to prevent its escape—the field of its exercises was restricted to the yard—& indeed in a great measure to the kitchen where it soon became intimate with its sable occupants—perhaps from similarity of color.

In the midst of its garrulous companions it was merely a *listener* for some months. It at length manifested a disposition to imitate some of the common household names—at first monosyllables. "Buck," for instance, the son of Fan the old cook, who was on his mother's tongue almost constantly—he [i.e., the crow] tried his "prentice hand" upon—& succeeding to the astonishment of all in this effort, & apparently greatly to his own gratification— he ventured upon disyllables—"Martin"—next the connection of words—as "Mas' Carter"—& finally upon connected & intelligible sentences. The superstitious fears of the old cook being greatly excited by the loquacious faculties of the crow thus wonderfully developed themselves—declared that if ever he called her name she would take his life.

A little while after, Fan, bearing in dinner & loaded with dishes, heard just at her heels—"Fan, where's Buck? Tell Buck to come here!" Cook, dishes & dinner dropped as if felled by lightning! On recovery, however, she decided it most prudent not to execute her threats of destruction.

These are a few of the expressions daily used by Buck (for thus we designated our friend Corvus). He would immediately distinguish a stranger, whether man or dog, that might visit the house—& would never say anything in the presence of the former if he conceived himself observed by him. He spoke with great rapidity, distinctiveness & earnestness—& would spend hours talking to himself in a hurried intelligible jargon—occasionally making a considerable approximation to laughter—and seeming all the while deeply interested.

His great characteristics were, a disposition to *thieve* & to *tease*! His wings sometimes growing out so that he could fly—he was ever seizing keys—broaches—& other domestic articles—& watchfully secreting them, if possible beyond the reach of the family. He was generally with us at the marble ring—waiting an opportunity to break in upon our sport by snatching a marble & flying off with it—& the only chance of recovery in such cases was to throw something else at him while on the wing—when he would immediately drop the stolen article & catch at the one flying through the air. He has been known to dip down on the wing & detach an old woman's cap from her head—& deposit it in a

tree. He greatly amused himself in slightly biting the toes of the barefooted urchins he met with—& a child with *red shoes* on could get no rest for him.

Finding a dog asleep he would softly approach him—smartly pinch his ear—& then look in a different direction as unconcernedly as if he was unconscious of what had been done. The dog shaking his head & once more composing himself to sleep would soon be again aroused by his innocent-looking tormentor—& again, & yet again—until the *flies* becoming insupportably troublesome—the poor deluded animal would seek for a bed, where he might be less annoyed by them. If two dogs got to fighting over a bone Buck was certain to terminate the contention by making off with the cause of it. Or if necessary—by exercising the most presumptuous daring, throwing himself upon a piece of disputed bread—he would by his dreaded mandibles keep off dogs & poultry of every description. He suffered nothing to approach the poultry trough upon a fresh acquisition of water until he had first laved his own glossy self.

Buck was the unrivaled lord of the walk. All other sources of sport failing, he would secrete himself & call out in huntsman's phrase—"Hear! Hear! Hear!"—and have the dogs running & yelping all over the lot. Nothing seemed to suit the crow's palette so well as young rats & birds—and like the *Frenchman*, he conceived them to be greatly improved by *mellowing*! To effect which he would carefully unearth them—keeping a "sharp lookout" during the process to avoid discovery. Nor was the massacre of these little animals the least interesting part of the ceremony of preparation—he delighted in the infliction of pain.

He manifested no disposition to return to a wild state—seeming to prefer his domestic comforts & the society of man to the precarious results of a wandering life & the company of his own "kith & kin." Should a straggling brother pass in sight—he would merely salute him with his nasal *Caw*—& let him pass on.

Poor Buck's career was short as it was wonderful, for after many remarkable adventures & hairbreadth escapes, he terminated his existence singularly in a *tub of water*! (whether *suicidally* or not did not appear!) at about 3 years of age. All lamented his death—& as the last testimony of respect for our sable friend—all the young

folks of the family, black & white, marched in procession, accompanied by the rustic music of the *tin pan* & *whistle*. We deposited his remains at the foot of a pear tree in the garden at Poplar Grove—discharging the arrows from our bows in his tiny tomb—& left the spot where "Buck Crow" lies, deeply impressed with the conviction that "we never should see his like again!"

Pardon me for thus so foolishly taxing your time & patience.

Respectedly,

Joseph J. Moore

The Republican or Cliff Swallow

It had long been believed that swallows burrowed into the mud in wintertime and hibernated. Audubon's careful field observations of swallow migration laid that myth to rest. He first reported them in a paper he read before the New York Lyceum in 1824, "Facts and Observations Connected with the Permanent Residence of Swallows in the United States," printed in the Lyceum Annual *later that year—his first published work. This essay from his* Ornithological Biography *draws on that earlier report.*

In the spring of 1815 I for the first time saw a few individuals of this species at Henderson, on the banks of the Ohio a hundred and twenty miles below the Falls of that river [at Louisville]. It was an excessively cold morning and nearly all were killed by the severity of the weather. I drew up a description at the time, naming the species *Hirundo republicana*, the *Republican Swallow*, in allusion to the mode in which the individuals belonging to it associate for the purpose of forming their nests and rearing their young. Unfortunately, through the carelessness of my assistant the specimens were lost, and I despaired for years of meeting with others.

In the year 1819 my hopes were revived by Mr. Robert Best, curator of the Western Cincinnati Museum, who informed me that a strange species of bird had made its appearance in the neighborhood, building nests in clusters affixed to the walls. In consequence of this information, I immediately crossed the Ohio to Newport, in Kentucky, where he had seen many nests the preceding season; and no sooner were we landed than the chirruping of my long-lost little strangers saluted my ear. Numbers of them were busily engaged in repairing the damage done to their nests by the storms of the preceding winter.

Major Oldham of the United States Army, then commandant of the garrison, politely offered us the means of examining the settlement of these birds attached to the walls of the building under his charge. He informed us that in 1815 he first saw a few of them working against the wall of the house, immediately under the eaves and cornice; that their work was carried on rapidly and peaceably and that as soon as the young were able to travel, they all departed.

Since that period they had returned every spring and then amounted to several hundreds. They usually appeared about the 10th of April and immediately began their work, which was at that moment, it being then the 20th of that month, going on in a regular manner against the walls of the arsenal. They had about fifty nests quite finished and others in progress.

About daybreak they flew down to the shore of the river one hundred yards distant for the muddy sand of which the nests were constructed and worked with great assiduity until near the middle of the day, as if aware that the heat of the sun was necessary to dry and harden their moist tenements. They then ceased from labor for a few hours, amused themselves by performing aerial evolutions, courted and caressed their mates with much affection and snapped at flies and other insects on the wing. They often examined their nests to see if they were sufficiently dry, and as soon as these appeared to have acquired the requisite firmness they renewed their labors. Until the females began to sit, they all roosted in the hollow limbs of the sycamores growing on the banks of the Licking River, but when incubation commenced the males alone resorted to the trees. A second party arrived and were so hard pressed for time that they betook themselves to the holes in the wall where bricks had been left out for the scaffolding. These they fitted with projecting necks similar to those of the complete nests of the others. Their eggs were deposited on a few bits of straw, and great caution was necessary in attempting to procure them, as the slightest touch crumbled their frail tenement into dust. By means of a tablespoon I was enabled to procure many of them. Each nest contained four eggs which were white with dusky spots. Only one brood is raised in a season. The energy with which they defended their nests was truly astonishing. Although I had taken the precaution to visit them at sunset when I supposed they would all have been on the sycamores, yet a single female happened to be sitting and gave the alarm, which immediately called out the whole tribe. They snapped at my hat, body and legs [and] passed between me and the nests within an inch of my face twittering their rage and sorrow. They continued their attacks as I descended and accompanied me for some distance. Their note may be perfectly imitated by rubbing a cork damped with spirit against the neck of a bottle.

A third party arrived a few days after and immediately commenced building. In one week they had completed their operations and at the end of that time thirty nests hung clustered like so many gourds, each having a neck two inches long. On the 27th July the young were able to follow their parents. They all exhibited the white frontlet and were scarcely distinguishable in any part of their plumage from the old birds. On the 1st of August they all assembled near their nests, mounted about three hundred feet in the air and at ten in the morning took their departure, flying in a loose body in a direction due north. They returned the same evening about dusk and continued these excursions, no doubt to exercise their powers, until the third when, uttering a farewell cry, they shaped the same course at the same hour and finally disappeared. Shortly after their departure, I was informed that several hundreds of their nests were attached to the courthouse at the mouth of the Kentucky River. They had commenced building them in 1815. A person likewise informed me that along the cliffs of the Kentucky he had seen many *bunches*, as he termed them, of these nests attached to the naked shelving rocks overhanging that river.

Being extremely desirous of settling the long-agitated question respecting the migration or supposed torpidity of Swallows, I embraced every opportunity of examining their habits, carefully noted their arrival and disappearance and recorded every fact connected with their history. After some years of constant observation and reflection I remarked that among all the species of migratory birds, those that remove farthest from us depart sooner than those which retire only to the confines of the United States; and by a parity of reasoning, those that remain later return earlier in the spring. These remarks were confirmed as I advanced towards the southwest on the approach of winter, for I there found numbers of Warblers, Thrushes &c. in full feather and song. It was also remarked that the *Hirundo viridis* [White-bellied Swallow] of [Alexander] Wilson (called by the French of Lower Louisiana, *Le Petit Martinet à ventre blanc*) remained about the city of New Orleans later than any other Swallow. As immense numbers of them were seen during the month of November I kept a diary of the temperature from the third of that month until the arrival of *Hirundo purpurea* [Purple Martin]. The following notes are taken

from my journal, and as I had excellent opportunities during a residence of many years in that country of visiting the lakes to which these Swallows were said to resort during the transient frosts, I present them with confidence.

November 11.—Weather very sharp, with a heavy white frost. Swallows in abundance during the whole day. On inquiring of the inhabitants if this was a usual occurrence I was answered in the affirmative by all the French and Spaniards. From this date to the 22nd the thermometer averaged 65°, the weather generally a drizzly fog. Swallows playing over the city in thousands.

November 25.—Thermometer this morning at 30°. Ice in New Orleans a quarter of an inch thick. The Swallows resorted to the lee of the cypress swamp in the rear of the city. Thousands were flying in different flocks. Fourteen were killed at a single shot, all in perfect plumage and very fat. The markets were abundantly supplied with these tender, juicy, and delicious birds. Saw Swallows every day but remarked them more plentiful the stronger the breeze blew from the sea.

December 20.—The weather continues much the same. Foggy and drizzly mist. Thermometer averaging 63°.

January 14.—Thermometer 42°. Weather continues the same. My little favorites constantly in view.

January 28.—Thermometer at 40°. Having seen the *Hirundo viridis* continually, and the *H. purpurea* or Purple Martin appear, I discontinued my observations.

During the whole winter many of them retired to the holes about the houses, but the greater number resorted to the lakes and spent the night among the branches of *Myrica cerifera*, the *Cirier*, as it is termed by the French settlers [Southern waxmyrtle].

About sunset they began to flock together, calling to each other for that purpose, and in a short time presented the appearance of clouds moving towards the lakes or the mouth of the Mississippi as the weather and wind suited. Their aerial evolutions before they alight are truly beautiful. They appear at first as if reconnoitering the place when, suddenly throwing themselves into a vortex of apparent confusion, they descend spirally with astonishing quickness and very much resemble a *trombe* or waterspout. When within a few feet of the *ciriers* they disperse in all directions and settle in

a few moments. Their twittering and the motions of their wings are, however, heard during the whole night. As soon as the day begins to dawn they rise, flying low over the lakes, almost touching the water for some time and then rising, gradually move off in search of food, separating in different directions. The hunters who resort to these places destroy great numbers of them by knocking them down with light paddles used in propelling their canoes.

[The Republican or Cliff Swallow, *Petrochelidon pyrrhonota*, appears in Plate 68 of *The Birds of America*.]

Henderson House Inventory

When the United States purchased the Louisiana Territory from France in 1803 it did so with specie—gold and silver—borrowed in Europe. The final payment, more than $4 million, came due early in 1819. To meet it, the Bank of the United States in Philadelphia called in its loans to the undercapitalized state banks of the trans-Appalachian West. Those banks in turn called in their loans to the new young businesses of the frontier. A wave of bank and other business failures followed; the Audubons, who had speculated in town lots in Henderson, Kentucky, and invested heavily in a steam grist mill and sawmill, were not spared. Their brother-in-law and business partner Nicholas Berthoud bought their real and personal property at auction; Audubon himself compiled the inventory appended to the sale Indenture that listed the property. As newlyweds the Audubons had emigrated west from Pennsylvania in 1808 with little more than Lucy's piano and a few items of furniture; in their first year at Louisville, Lucy had complained of having no books to read.

July 13, 1819

1 pianoforte, 3 cherry tables, 3 walnut tables, 3 poplar & ash tables, 3 bureaus walnut & cherry, 1 large walnut desk, 1 portable writing desk, 20 Windsor chairs, 6 flag-bottom chairs, 2 children's chairs, 4 carpets, 1 hearth rug, 6 tea boards, 1 pair brass hand irons, 2 pair brass shovel & tongs, 3 pair cast-iron dogs, 4 looking glasses different sizes, 2 footstools, 4 silver candlesticks, 1 pair plated snuffers and stand, 3 dozen plates assorted, ½ dozen dishes assorted, 1 dozen cups & saucers, 1 silver tea pot, 1 Britannia, 1 silver cream jug, 3 dozen assorted silver spoons, 2 silver salt sellers, 1 set plated castors, 4 decanters, 1 dozen tumblers, 1–2 dozen stone jars assorted sizes, 2 dozen B. M. & White bottles, 6 demijohns, 150 volumes of assorted books, 1 map of the world, 2 gilt picture frames, a parcel of music assorted, all my drawings, crayons, paints, pencils, drawing paper, silver compasses, rules, microscopes, presses, square, 4 ovens assorted sizes, 6 kettles assorted, 4 skillets assorted, 1 griddle, 1 gridiron, 3 pair pot hooks, 4 cranes, 5 smoothing irons,

1 Italian iron, 1 copper teakettle, 1 brass kettle, 1 frying pan, 3 bread trays, 3 bread baskets assorted, 1 dozen knives & forks, 1 coffee and pepper mill, 1 plough & 1 arrow, 2 spades, 3 hoes, 2 rakes, 2 pair of tins, scales, 4 iron weights, $^1/_2$ dozen canisters different sorts and sizes, 1 single fowling piece & box, 1 duck gun, 3 shot bags, 1 double gun, 4 flasks and 2 horns, 1 smooth rifle, 3 bags shot, $^1/_2$ keg powder, tin pan colanders, ladles 16, 3 wash bowls and jugs, $^1/_2$ dozen chambers, $^1/_2$ dozen assorted pitchers, 1 dozen assorted baskets & French, English, etc., 4 feather beds, 1 crib bed, 5 bolsters & 8 pillows, 5 bedsteads painted plain, 1 crib of cherry, 15 blankets of all sorts and sizes, $^1/_2$ dozen quilts and comforter, plain, 1 dozen pair of sheets, 1 dozen bolsters and pillow cases, 1 dozen damask table cloths, 2 dozen French towels, 1 dozen common towels, 1 warming pan, 1 fiddle, 1 flute, 1 guitar, 1 flageolet, 2 brooms, 2 rolls hanging paper, 2 sets red curtains, 6 mosquito bars, 2 cows & 2 calves, 30 head of hogs more or less, my stock of them big & small, 1 ear cut & 1 [?] fork, 1 sorrel mare, 1 sidesaddle & 3 bridles, some platted, 2 pole axes, 7 wild geese and 10 tame geese, 8 bee hives, 1 doz. jugs, different sizes & sorts.

PART II:
THE AMERICAN WOODSMAN

The Least Bittern

Audubon's reference here to the Cincinnati Museum alludes to the six months he worked there as a painter of display backgrounds and taxidermist after his bankruptcy in Kentucky in 1819. Inspired in part by a visit from members of the government-funded Long Expedition, in part by a lecture by the museum's founder, Dr. Daniel Drake, Audubon decided he should undertake to complete his informal collection of bird drawings to make a book of the birds of America more comprehensive than the previous standard work by Alexander Wilson. His study of the Least Bittern illustrates the experimental side of his ornithology; he not only observed birds but also examined them and probed their behavior.

One morning while I was at the Cincinnati Museum in the State of Ohio a woman came in holding in her apron one of this delicate species alive, which she said had fallen down the chimney of her house under night and which, when she awoke at daybreak, was the first object she saw, it having perched on one of the bedposts. It was a young bird. I placed it on the table before me and drew from it the figure on the left of my plate. It stood perfectly still for two hours, but on my touching it with a pencil after my drawing was done, it flew off and alighted on the cornice of a window. Replacing it on the table I took two books and laid them so as to leave before it a passage of an inch and a half, through which it walked with ease. Bringing the books nearer each other, so as to reduce the passage to one inch, I tried the Bittern again and again it made its way between them without moving either. When dead its body measured two inches and a quarter across, from which it is apparent that this species, as well as the Gallinules and Rails, is enabled to contract its breadth in an extraordinary degree.

While I was in Philadelphia in September 1832 a gentleman presented me with a pair of adult birds of this species, alive and in perfect plumage. They had been caught in a meadow a few miles below the city and I kept them alive several days, feeding them on small fish and thin stripes of pork. They were expert at seizing flies and swallowed caterpillars and other insects. My wife admired them much on account of their gentle deportment, for although

on being tormented they would spread their wings, ruffle their feathers and draw back their head as if to strike, yet they suffered themselves to be touched by anyone without pecking at his hand. It was amusing to see them continually attempting to escape through the windows, climbing with ease from the floor to the top of the curtain by means of their feet and claws. This feat they would repeat whenever they were taken down. The experiment of the books was tried with them and succeeded as at Cincinnati. At the approach of night they became much more lively, walked about the room in a graceful manner with much agility and generally kept close together. I had ample opportunities of studying their natural positions and drew both of them in the attitudes exhibited in the plate. I would gladly have kept them longer; but as I was bound for the south, I had them killed for the purpose of preserving their skins.

This bird ranges over most parts of the United States but is nowhere to be found in tolerable abundance excepting about the mouths of the Mississippi and the Southern portions of the Floridas, especially the Everglades. I have met with them to the eastward as far as New Brunswick, on our large lakes and in the intermediate portions of the country, although I have seldom found more than one or two at a time. In the Floridas and Carolinas they have been known to breed in small communities of four or five pairs. One instance of this was observed by my friend Dr. Horlbeck of Charleston and Dr. Leitner, another friend of mine, found them quite abundant in certain portions of the Florida marshes.

Although the Least Bittern is not unfrequently started in salt marshes, it gives a decided preference to the borders of ponds, lakes or bayous of fresh water, and it is in secluded situations of this kind that it usually forms its nest. This is sometimes placed on the ground amid the rankest grasses, but more frequently it is attached to the stems several inches above it. It is flat, composed of dried or rotten weeds and in shape resembles that of the Louisiana Heron, although this latter employs nothing but sticks. The eggs are three or four, seldom more, of a dull yellowish green, without spots, an inch and a quarter in length, almost equal at both ends.

When the young are yet quite small their heads are covered with large tufts of reddish down, their bill is very short and they sit on

their rump with their legs extended on each side before their body in the manner of young Herons. If disturbed when about two weeks old they leave the nest and scramble through the grass with celerity, clinging to the blades with their sharp claws whenever this is necessary. At a later period they seem to await the coming of their parents with impatience; and if no noise is made you may hear them calling continually in a low croaking voice for half an hour at a time. As soon as they are able to fly they not unfrequently alight on the branches of trees to escape from their various enemies, such as minxes and water snakes, the latter of which destroy a good number of them.

In two instances I found the nests of the Least Bittern about three feet above the ground in a thick cluster of smilax and other briary plants. In the first, two nests were placed in the same bush within a few yards of each other. In the other instance there was only one nest of this bird but several of the Boat-tailed Grackle and one of the Green Heron, the occupants of all of which seemed to be on friendly terms. When startled from the nest the old birds emit a few notes resembling the syllable *qua*, alight a few yards off and watch all your movements. If you go towards them you may sometimes take the female with the hand but rarely the male, who generally flies off or makes his way through the woods. Its ordinary cry, however, is a rough croak resembling that of the Great Blue Heron but much weaker.

The flight of this bird is apparently weak by day, for then it seldom removes to a greater distance than a hundred yards at a time and this, too, only when frightened in a moderate degree, for if much alarmed it falls again among the grass in the manner of the Rail; but in the dusk of the evening and morning I have seen it passing steadily along at the height of fifty yards or more with the neck retracted and the legs stretched out behind in the manner of the larger Herons. On such occasions it uttered at short intervals its peculiar cry and continued its flight until out of sight. Several individuals were together and I imagined them to be proceeding in search of breeding grounds or on a migratory expedition. When disturbed by day they fly with extended neck and dangling legs and are easily shot, as their course is generally direct and their flight slow. When walking it shoots its head forward at every step

as if about to thrust its bill into some substance; and if you attempt to lay hold of it when disabled it is apt to inflict a painful wound.

The food of this bird consists of snails, slugs, tadpoles or young frogs and water lizards. In several instances, however, I have found small shrews and field mice in their stomach. Although more nocturnal than diurnal, it moves a good deal about by day in search of food. About noon, being doubtless much fatigued, they are not unfrequently observed standing erect on one foot and so soundly asleep as to be easily knocked down or even caught by the hand if cautiously approached. This very remarkable habit of both our species of Bittern has brought upon them the charge of extreme *stupidity*, whence the name of *Butor* [i.e., lout] given to them by the Creoles of Louisiana. Whether or not this term be appropriate to the case I leave for you to determine; but my opinion is that the animal truly deserving to be called stupid yet remains to be discovered, and that the quality designated by that epithet occurs nowhere else than among the individuals of that species which so thoughtlessly applies the opprobrium.

[The Least Bittern, *Ixobrychus exilis*, appears in Plate 210 of *The Birds of America*.]

The Carolina Parrot

Like the Passenger Pigeon, the Carolina Parrot is extinct today, making Audubon's eyewitness description of the habitat and behavior of the only parrot native to America north of Mexico a valuable record as well as a eulogy. He identifies the fatal intersection of the birds' appetite for fruit and grain and the determination of farmers to protect the crops that fed their families which probably accounts for the Carolina Parrot's extinction. The last independently confirmed sightings date from the late 1930s.

Doubtless, kind reader, you will say while looking at the seven figures of Parakeets represented in the plate that I spared not my labor. I never do, so anxious am I to promote your pleasure.

These birds are represented feeding on the plant commonly named the *cocklebur*. It is found much too plentifully in every state west of the Alleghenies and in still greater profusion as you advance towards the Southern districts. It grows in every field where the soil is good. The low alluvial lands along the Ohio and Mississippi are all supplied with it. Its growth is so measured that it ripens after the crops of grain are usually secured, and in some rich old fields it grows so exceedingly close that to make one's way through the patches of it at this late period is no pleasant task. The burs stick so thickly to the clothes as to prevent a person from walking with any kind of ease. The wool of sheep is also much injured by them; the tails and manes of horses are converted into such tangled masses that the hair has to be cut close off, by which the natural beauty of these valuable animals is impaired. To this day no useful property has been discovered in the cocklebur, although in time it may prove as valuable either in medicine or chemistry as many other plants that had long been considered of no importance.

Well, reader, you have before you one of these plants, on the seeds of which the parrot feeds. It alights upon it, plucks the bur from the stem with its bill, takes it from the latter with one foot in which it turns it over until the joint is properly placed to meet the attacks of the bill, when it bursts it open, takes out the fruit and allows the shell to drop. In this manner a flock of these birds, having discovered a field ever so well filled with these plants, will

eat or pluck off all their seeds, returning to the place day after day until hardly any are left. The plant might thus be extirpated, but it so happens that it is reproduced from the ground, being perennial, and our farmers have too much to do in securing their crops to attend to the pulling up the cockleburs by the roots, the only effectual way of getting rid of them.

The Parrot does not satisfy himself with cockleburs but eats or destroys almost every kind of fruit indiscriminately, and on this account is always an unwelcome visitor to the planter, the farmer or the gardener. The stacks of grain put up in the field are resorted to by flocks of these birds, which frequently cover them so entirely that they present to the eye the same effect as if a brilliantly colored carpet had been thrown over them. They cling around the whole stack, pull out the straws and destroy twice as much of the grain as would suffice to satisfy their hunger. They assail the pear and apple trees when the fruit is yet very small and far from being ripe, and this merely for the sake of the seeds. As on the stalks of corn, they alight on the apple trees of our orchards or the pear trees in the gardens in great numbers; and as if through mere mischief, pluck off the fruits, open them up to the core and, disappointed at the sight of the seeds, which are yet soft and of a milky consistence, drop the apple or pear and pluck another, passing from branch to branch until the trees which were before so promising are left completely stripped like the ship waterlogged and abandoned by its crew, floating on the yet agitated waves after the tempest has ceased. They visit the mulberries, pecan-nuts, grapes and even the seeds of the dogwood before they are ripe and on all commit similar depredations. The maize alone never attracts their notice.

Do not imagine, reader, that all these outrages are borne without severe retaliation on the part of the planters. So far from this, the Parakeets are destroyed in great numbers, for whilst busily engaged in plucking off the fruits or tearing the grain from the stacks, the husbandman approaches them with perfect ease and commits great slaughter among them. All the survivors rise, shriek, fly round about for a few minutes and again alight on the very place of most imminent danger. The gun is kept at work; eight or ten or even twenty are killed at every discharge. The living birds, as if conscious of the death of their companions, sweep over their bodies screaming as

loud as ever but still return to the stack to be shot at, until so few remain alive that the farmer does not consider it worth his while to spend more of his ammunition. I have seen several hundreds destroyed in this manner in the course of a few hours and have procured a basketful of these birds at a few shots in order to make choice of good specimens for drawing the figures by which this species is represented in the plate now under your consideration.

The flight of the Parakeet is rapid, straight and continued through the forests or over fields and rivers, and is accompanied by inclinations of the body which enable the observer to see alternately their upper and under parts. They deviate from a direct course only when impediments occur such as the trunks of trees or houses, in which case they glance aside in a very graceful manner, merely as much as may be necessary. A general cry is kept up by the party, and it is seldom that one of these birds is on wing for ever so short a space without uttering its cry. On reaching a spot which affords a supply of food, instead of alighting at once as many other birds do, the Parakeets take a good survey of the neighborhood, passing over it in circles of great extent first above the trees and then gradually lowering until they almost touch the ground, when suddenly reascending they all settle on the tree that bears the fruit of which they are in quest or on one close to the field in which they expect to regale themselves.

They are quite at ease on trees or any kind of plant, moving sidewise, climbing or hanging in every imaginable posture, assisting themselves very dexterously in all their motions with their bills. They usually alight extremely close together. I have seen branches of trees as completely covered by them as they could possibly be. If approached before they begin their plundering they appear shy and distrustful, and often at a single cry from one of them the whole take wing and probably may not return to the same place that day. Should a person shoot at them as they go and wound an individual, its cries are sufficient to bring back the whole flock, when the sportsman may kill as many as he pleases. If the bird falls dead they make a short round and then fly off.

On the ground these birds walk slowly and awkwardly as if their tail incommoded them. They do not even attempt to run off when approached by the sportsman, should he come upon them

unawares; but when he is seen at a distance they lose no time in trying to hide or in scrambling up the trunk of the nearest tree, in doing which they are greatly aided by their bill.

Their roosting place is in hollow trees and the holes excavated by the larger species of Woodpeckers as far as these can be filled by them. At dusk a flock of Parakeets may be seen alighting against the trunk of a large sycamore or any other tree when a considerable excavation exists within it. Immediately below the entrance the birds all cling to the bark and crawl into the hole to pass the night. When such a hole does not prove sufficient to hold the whole flock, those around the entrance hook themselves on by their claws and the tip of the upper mandible and look as if hanging by the bill. I have frequently seen them in such positions by means of a [spy]glass and am satisfied that the bill is not the only support used in such cases.

When wounded and laid hold of the Parakeet opens its bill, turns its head to seize and bite and, if it succeed, is capable of inflicting a severe wound. It is easily tamed by being frequently immersed in water and eats as soon as it is placed in confinement. Nature seems to have implanted in these birds a propensity to destroy, in consequence of which they cut to atoms pieces of wood, books and, in short, everything that comes in their way. They are incapable of articulating words, however much care and attention may be bestowed upon their education; and their screams are so disagreeable as to render them at best very indifferent companions. The woods are the habitation best fitted for them, and there the richness of their plumage, their beautiful mode of flight and even their screams, afford welcome intimation that our darkest forests and most sequestered swamps are not destitute of charms.

They are fond of sand in a surprising degree and on that account are frequently seen to alight in flocks along the gravelly banks about the creeks and rivers or in the ravines of old fields in the plantations, when they scratch with bill and claws, flutter and roll themselves in the sand and pick up and swallow a certain quantity of it. For the same purpose they also enter the holes dug by our Kingfisher. They are fond of saline earth for which they visit the different licks interspersed in our woods.

Our Parakeets are very rapidly diminishing in number; and in

some districts where twenty-five years ago they were plentiful scarcely any are now to be seen. At that period they could be procured as far up the tributary waters of the Ohio as the Great Kenhawa, the Scioto, the heads of the Miami, the mouth of the Manimee at its junction with Lake Erie, on the Illinois River and sometimes as far northeast as Lake Ontario and along the eastern districts as far as the boundary line between Virginia and Maryland. At the present day very few are to be found higher than Cincinnati, nor is it until you reach the mouth of the Ohio that Parakeets are met with in considerable numbers. I should think that along the Mississippi there is not now half the number that existed fifteen years ago.

Their flesh is tolerable food when they are young, on which account many of them are shot. The skin of their body is usually much covered with the mealy substances detached from the roots of the feathers. The head especially is infested by numerous minute insects, all of which shift from the skin to the surface of the plumage immediately after the bird's death. Their nest, or the place in which they deposit their eggs, is simply the bottom of such cavities in trees as those to which they usually retire at night. Many females deposit their eggs together. I am of opinion that the number of eggs which each individual lays is two, although I have not been able absolutely to assure myself of this. They are nearly round and of a light greenish white. The young are at first covered with soft down such as is seen on young Owls. During the first season the whole plumage is green; but towards autumn a frontlet of carmine appears. Two years, however, are passed before the male or female are in full plumage. The only material differences which the sexes present externally are that the male is rather larger with more brilliant plumage. I have represented a female with two supernumerary feathers in the tail. This, however, is merely an accidental variety.

[The Carolina Parrot, *Conuropsis carolinensis*, appears in Plate 26 of *The Birds of America*.]

The Ivory-billed Woodpecker

The magnificent Ivory-billed Woodpecker, happily rediscovered in Arkansas in 2005 after years when it was believed to be extinct, is the largest of the Woodpeckers, 21 inches long as Audubon measured it, with a 30-inch wingspan. He found both pioneers and American Indians fond of ornamenting themselves with the male's ivory beak and crest of bold red feathers, wearing the heads on their belts like rabbits' feet. The bird was big and colorful and all too easy to track by its repeated, clarinet-like cries of pait, pait, pait.

I have always imagined that in the plumage of the beautiful Ivory-billed Woodpecker there is something very closely allied to the style of coloring of the great Vandyke. The broad extent of its dark glossy body and tail, the large and well-defined white markings of its wings, neck, and bill, relieved by the rich carmine of the pendent crest of the male and the brilliant yellow of its eye have never failed to remind me of some of the boldest and noblest productions of that inimitable artist's pencil. So strongly indeed have these thoughts become engrafted in my mind as I gradually obtained a more intimate acquaintance with the Ivory-billed Woodpecker that whenever I have observed one of these birds flying from one tree to another I have mentally exclaimed, "There goes a Vandyke!" This notion may seem strange, perhaps ludicrous to you, good reader, but I relate it as a fact, and whether or not it may be found in accordance with your own ideas, after you have inspected the plate in which is represented this great chieftain of the Woodpecker tribe, is perhaps of little consequence.

The Ivory-billed Woodpecker confines its rambles to a comparatively very small portion of the United States, it never having been observed in the middle states within the memory of any person now living there. In fact, in no portion of these districts does the nature of the woods appear suitable to its remarkable habits.

Descending the Ohio we meet with this splendid bird for the first time near the confluence of that beautiful river and the Mississippi; after which, following the windings of the latter either downwards towards the sea or upwards in the direction of the Missouri, we frequently observe it. On the Atlantic coast, North

Carolina may be taken as the limit of its distribution, although now and then an individual of the species may be accidentally seen in Maryland. To the westward of the Mississippi it is found in all the dense forests bordering the streams which empty their waters into that majestic river, from the very declivities of the Rocky Mountains. The lower parts of the Carolinas, Georgia, Alabama, Louisiana and Mississippi, are, however, the most favorite resorts of this bird, and in those states it constantly resides, breeds, and passes a life of peaceful enjoyment, finding a profusion of food in all the deep, dark, and gloomy swamps dispersed throughout them.

I wish, kind reader, it were in my power to present to your mind's eye the favorite resort of the Ivory-billed Woodpecker. Would that I could describe the extent of those deep morasses, overshadowed by millions of gigantic dark cypresses spreading their sturdy moss-covered branches as if to admonish intruding man to pause and reflect on the many difficulties which he must encounter should he persist in venturing farther into their almost inaccessible recesses extending for miles before him, where he should be interrupted by huge projecting branches, here and there the massy trunk of a fallen and decaying tree and thousands of creeping and twining plants of numberless species! Would that I could represent to you the dangerous nature of the ground, its oozing, spongy and miry disposition, although covered with a beautiful but treacherous carpeting composed of the richest mosses, flags and water lilies, no sooner receiving the pressure of the foot than it yields and endangers the very life of the adventurer whilst here and there, as he approaches an opening that proves merely a lake of black muddy water, his ear is assailed by the dismal croaking of innumerable frogs, the hissing of serpents or the bellowing of alligators! Would that I could give you an idea of the sultry pestiferous atmosphere that nearly suffocates the intruder during the meridian heat of our dog days in those gloomy and horrible swamps! But the attempt to picture these scenes would be vain. Nothing short of ocular demonstration can impress any adequate idea of them.

How often, kind reader, have I thought of the difference of the tasks imposed on different minds when, traveling in countries far distant from those where birds of this species and others as difficult to be procured are now and then offered for sale in the form of

dried skins, I have heard the amateur or closet naturalist express his astonishment that half a crown was asked by the person who had perhaps followed the bird when alive over miles of such swamps, and after procuring it had prepared its skin in the best manner and carried it to a market thousands of miles distant from the spot where he had obtained it. I must say that it has at least grieved me as much as when I have heard some idle fop complain of the poverty of the gallery of the Louvre where he had paid nothing, or when I have listened to the same infatuated idler lamenting the loss of his shilling as he sauntered through the Exhibition Rooms of the Royal Academy of London or any equally valuable repository of art. But let us return to the biography of the famed Ivory-billed Woodpecker.

The flight of this bird is graceful in the extreme although seldom prolonged to more than a few hundred yards at a time, unless when it has to cross a large river, which it does in deep undulations, opening its wings at first to their full extent and nearly closing them to renew the propelling impulse. The transit from one tree to another, even should the distance be as much as a hundred yards, is performed by a single sweep, and the bird appears as if merely swinging itself from the top of the one tree to that of the other, forming an elegantly curved line. At this moment all the beauty of the plumage is exhibited and strikes the beholder with pleasure. It never utters any sound whilst on wing unless during the love season; but at all other times, no sooner has this bird alighted than its remarkable voice is heard at almost every leap which it makes, whilst ascending against the upper parts of the trunk of a tree or its highest branches. Its notes are clear, loud and yet rather plaintive. They are heard at a considerable distance, perhaps half a mile, and resemble the false high note of a clarinet. They are usually repeated three times in succession and may be represented by the mono-syllable *pait, pait, pait*. These are heard so frequently as to induce me to say that the bird spends few minutes of the day without uttering them, and this circumstance leads to its destruction, which is aimed at not because (as is supposed by some) this species is a destroyer of trees but more because it is a beautiful bird, and its rich scalp attached to the upper mandible forms an ornament for the war dress of most of our Indians or for the shot-pouch of our

squatters and hunters, by all of whom the bird is shot merely for that purpose.

Travelers of all nations are also fond of possessing the upper part of the head and the bill of the male, and I have frequently remarked, that on a steamboat's reaching what we call a *wooding place*, the *strangers* were very apt to pay a quarter of a dollar for two or three heads of this Woodpecker. I have seen entire belts of Indian chiefs closely ornamented with the tufts and bills of this species, and have observed that a great value is frequently put upon them.

The Ivory-billed Woodpecker nestles earlier in spring than any other species of its tribe. I have observed it boring a hole for that purpose in the beginning of March. The hole is, I believe, always made in the trunk of a live tree, generally an ash or a hackberry, and is at a great height. The birds pay great regard to the particular situation of the tree and the inclination of its trunk; first, because they prefer retirement, and again, because they are anxious to secure the aperture against the access of water during beating rains. To prevent such a calamity the hole is generally dug immediately under the junction of a large branch with the trunk. It is first bored horizontally for a few inches, then directly downwards, and not in a spiral manner as some people have imagined. According to circumstances this cavity is more or less deep, being sometimes not more than ten inches, whilst at other times it reaches nearly three feet downwards into the core of the tree. I have been led to think that these differences result from the more or less immediate necessity under which the female may be of depositing her eggs, and again have thought that the older the Woodpecker is, the deeper does it make its hole. The average diameter of the different nests which I have examined was about seven inches within, although the entrance, which is perfectly round, is only just large enough to admit the bird.

Both birds work most assiduously at this excavation, one waiting outside to encourage the other whilst it is engaged in digging, and when the latter is fatigued, taking its place. I have approached trees whilst these Woodpeckers were thus busily employed in forming their nest, and by resting my head against the bark, could easily distinguish every blow given by the bird. I observed that in two instances, when the Woodpeckers saw me thus at the foot of the

tree in which they were digging their nest, they abandoned it forever. For the first brood there are generally six eggs. They are deposited on a few chips at the bottom of the hole and are of a pure white color. The young are seen creeping out of the hole about a fortnight before they venture to fly to any other tree. The second brood makes its appearance about the 15th of August.

In Kentucky and Indiana the Ivory-bills seldom raise more than one brood in the season. The young are at first of the color of the female only that they want the crest, which, however, grows rapidly, and towards autumn, particularly in birds of the first breed, is nearly equal to that of the mother. The males have then a slight line of red on the head and do not attain their richness of plumage until spring or their full size until the second year. Indeed, even then a difference is easily observed between them and individuals which are much older.

The food of this species consists principally of beetles, larvae and large grubs. No sooner, however, are the grapes of our forests ripe than they are eaten by the Ivory-billed Woodpecker with great avidity. I have seen this bird hang by its claws to the vines in the position so often assumed by a Titmouse and, reaching downwards, help itself to a bunch of grapes with much apparent pleasure. Persimmons are also sought for by them as soon as the fruit becomes quite mellow, as are hackberries.

The Ivory-bill is never seen attacking the corn or the fruit of the orchards, although it is sometimes observed working upon and chipping off the bark from the belted trees of the newly cleared plantations. It seldom comes near the ground but prefers at all times the tops of the tallest trees. Should it, however, discover the half-standing broken shaft of a large dead and rotten tree, it attacks it in such a manner as nearly to demolish it in the course of a few days. I have seen the remains of some of these ancient monarchs of our forests so excavated and that so singularly that the tottering fragments of the trunk appeared to be merely supported by the great pile of chips by which its base was surrounded. The strength of this Woodpecker is such that I have seen it detach pieces of bark seven or eight inches in length at a single blow of its powerful bill, and by beginning at the top branch of a dead tree, tear off the bark to an extent of twenty or thirty feet in the course of a few

hours, leaping downwards with its body in an upward position, tossing its head to the right and left or leaning it against the bark to ascertain the precise spot where the grubs were concealed and immediately after renewing its blows with fresh vigor, all the while sounding its loud notes as if highly delighted.

This species generally moves in pairs after the young have left their parents. The female is always the most clamorous and the least shy. Their mutual attachment is, I believe, continued through life. Excepting when digging a hole for the reception of their eggs, these birds seldom if ever attack living trees for any other purpose than that of procuring food, in doing which they destroy the insects that would otherwise prove injurious to the trees.

I have frequently observed the male and female retire to rest for the night, into the same hole in which they had long before reared their young. This generally happens a short time after sunset.

When wounded and brought to the ground, the Ivory-bill immediately makes for the nearest tree and ascends it with great rapidity and perseverance until it reaches the top branches, when it squats and hides, generally with great effect. Whilst ascending it moves spirally round the tree, utters its loud *pait, pait, pait* at almost every hop but becomes silent the moment it reaches a place where it conceives itself secure. They sometimes cling to the bark with their claws so firmly as to remain cramped to the spot for several hours after death. When taken by the hand, which is rather a hazardous undertaking, they strike with great violence and inflict very severe wounds with their bill as well as claws, which are extremely sharp and strong. On such occasions, this bird utters a mournful and very piteous cry.

[The Ivory-billed Woodpecker, *Campephilus principalis*, appears in Plate 66 of *The Birds of America*.]

Lucy Audubon to Euphemia Gifford
"A large work on ornithology"

Louisville, Kentucky
1 April 1821

Dear Cousin,

It is now a long, long time since I heard from you though I have
written several times without a reply, a circumstance which is a
source of grief to me, for with my years increases my attachment
to old friends and the early scenes of my youth and now I see the
walks and favorite spots I used to frequent in my happier times as
plainly before me as if no time had elapsed since I last had them.
A week or two ago we heard of the death of my dear afflicted
Father; his departure from this scene of trouble can hardly be
regretted when his misfortunes are considered, particularly as he
has not left his room or been sensible of any external object scarcely
for the last twelvemonth, not even the knowledge of sister Ann,
who has been with him all the time. Still we feel as his children
and lament the loss of one so exemplary, and every way prepared to
join his Maker. The various losses and misfortunes of my husband's
affairs you have probably heard of and for the last year he has
supported us by his talent in drawing and painting which he learnt
from [Jacques-Louis] David as a recreation in better times. This
last year we have spent in Cincinnati, where Mr. Audubon com-
bined a drawing school with a situation in the Museum, and taking
portraits of various sizes and kinds; at the same time he is prosecut-
ing a large work on ornithology which when complete he means
to take to Europe to be published. The birds are all drawn from
nature [in] the natural size and embellished with plants, trees or
views as best suits the purpose. It is his intention to go first to
England, and I hope it will be in my power to accompany him and
visit once more those scenes of happy childhood. Mr. A. is now
out on a tour of search for the birds he has not; at present he is in
New Orleans and it will be a year before he returns. I am now
with my two boys, Gifford and Woodhouse, at my Sister Eliza's,
but I expect soon either to go to housekeeping here or return for

economy's sake to Cincinnati, which is a cheaper place. My two children occupy nearly the whole of my time, for I educate them myself. My two dear daughters [deceased in infancy] are I hope with their grandmother in happier regions . . .

John James Audubon to Lucy Audubon
"We cannot be epicures…"

Audubon responded to a flurry of questions and opinions from Lucy, not all of them welcome, in a meandering letter he wrote in New Orleans between 24 May and 1 June 1821 that paints a colorful picture of his life there; the letter also contained the narrative of the Fair Incognito (p. 120), drawn from his journal.

New Orleans, Louisiana
24 May–1 June 1821

…We now and then of moon-shining evenings ramble to what is called the Museum coffeehouse; there (where it cost nothing) we hear a few indifferent musicians and amuse our taste for critics on the poor collection of paintings &c. that fill the gallery—and often walk up to the roulette table to infuse a strong sketch of intentness on our minds; it is there that one may well judge of tempers.

Mosquitoes are at this season so troublesome that we seldom can sit in our room. After dark we fix ourselves about the middle of the street until bedtime, piping the flageolet or blowing the flute. We sometimes have a painter for company and then we talk of the arts.

I have so far gone on towards giving an idea of our daily expenditure of time that I will, I believe, enter on our actual way of living—

We cannot be epicures. Our purse is that that suits best strong appetites. We generally have a ham on the nail, and convenience makes us cook it by slices when hungry.

During cooler weather we had cheese but the heat that disperses and sends off one part of the inhabitants of this place brings on myriads of others called maggots with which we are not Englishmen enough to desire very close acquaintance. Salt mackerels are good, for they are very cheap; we suffer the want of pure cool water—this cannot well be purchased by us—the vegetable market is as good as in any part of America, and very early in the season. Fresh meat we never taste. We see it hanging in the market house and that satisfies us completely. Our rent, washing [and] cook's wages amount [to] about one dollar and 50 cents per day.

Now, my Lucy, I will proceed by thy letter.

Thou speaketh of a school here. When I arrived I knew not how long I might remain, and had no [art] models, and from week to week expected to go elsewhere. Certainly I have lost a great deal not to have one.

Thou art not it seems daring as I am about leaving one place to go to another without the means. I am sorry for that. I never now will fear want as long as I am well, and God will grant me that, as I have received from Nature my little talents. I would dare go to England without one cent, one single letter of introduction to anyone, and on landing would make shillings or pence if I could not make more but no doubt I would make enough.

Prejudices and habits carry many I think too far—but I am thinking that I can raise the means; I intend to try.

If I do not go to England in the course of twelvemonth we will send *Victor* (do call him) to Lexington College. Hope, my dearest friend, that our sweet [son, John] Woodhouse will lose the habits that make thee at present fear he has not the natural gifts about him. I think his eyes are extremely intelligent, he is quick of movements [and] these are indications of natural sense—but he is yet a boy and has not had the opportunities of Victor to improve. The latter was thy only attention for some years before John required any. I will agree with thee that the education of children is perplexing, but how sweet the recompense to the parent when brought up by themselves only; it is rendered twofold.

Thy liability to tooth-aching is very dreadful and it is as painful for me to know thou has had it as the drawing of those unsound [teeth] can be to thee. I hope thee and our children, our real friends, my Lucy, are now quite well; if my Lucy would try to amuse herself and have good spirits, she would soon recover and have her flesh again. Dear girl, how much I wish to press thee to my bosom.

I am glad that the neatness of thy house renders it comfortable. The knowledge of thy excellent care insures its cleanliness to last— a well so nigh [to the house] is a real comfort—and when the shutters are to, I hope thy dreads are left. I would like to hear that Victor did thy marketing. Thy stock of cash is small I daresay but I hope to keep it sufficiently good. I daresay the gentlemen of the

[Western] Museum [in Cincinnati, where Audubon had worked] found it hard to send thee anything. Mr. Best, who tells no lies, says he has not received $10 since I left; this however I doubt. I shall speak more of his letter [but am] not willing at present to lose thine from my mind.

I have received a good pair of suspenders, but thou does not say that they are from thy hands. I hope they are; I am so much of a lover yet that every time I will touch them I think & bless the maker. Thank thee, sweet girl, for them ...

Here the letter segues to the Fair Incognito episode and then returns to Lucy's queries.

Now, sweet girl, to the next question of thy letter, "What will I do with [Audubon's twenty-year-old pupil and assistant] Joseph Mason?" As long at least as I travel I shall keep him with me. I have a great pleasure in affording that good young man the means of becoming able to do well. His talent for painting if I am a judge is fine, his expenses very moderate and his company quite indispensable. We have heard [of] his father's death and on that account I am more attached to him. He now draws flowers better than any man probably in America. Thou knows I do not flatter young artists much; I never said this to him but I think so—and to show his performance will bring me as many pupils as I can attend to, anywhere.

Kenilworth [the Walter Scott novel] is in town but not for sale; perhaps some of my fair acquaintances will procure it for thee—but can thou enjoy novels without thy liked friend to read them to thee?

It is quite impossible for me to say where my next winter will be spent. Migratory birds or beasts follow the mast. Certainly if it is in this place I shall be, I hope, blessed with thy company.

Music is next. There, my Lucy, I think thou art wrong to abandon it. I should not say so if thou would draw—yet please thyself.

I am glad thou did not accept thy brother Tom's (as thou calls him) house. We are poor but not beggars, I assure thee.

Here is a part I do not understand well. Mr. [Nicholas] Berthoud, according to thy way of thinking, has *done wonders*

for us, and according to my way of thinking he has acted *indeed* wonderfully. But here I must hush—I am a painter and know no more than my business. His silence on the second aid I have been fool enough to ask of him since I have fooled what I had, gags me.

Thank thee, dearest Lucy, for thy good wishes; they are all I want [and] to deserve them, all I am intent on.

Now I have answered every line of thine. This is the third time I have set to write this. There certainly is a copious dose for thee. Good night. I shall continue tomorrow. God bless thee.

May 24th, Saturday—

I have now thine of the 12th instant by the [steamboat] *Car of Commerce*. I have not yet had the pleasure of seeing Mr. Forrestal and I would have wished that the *Columbus* had reached [here]; it would have given me great satisfaction to know thou had received the money I sent thee by it. I am glad thou art satisfied with what I sent thee by the *Car*.

I have not forgotten either thy list or [the] tenor of thy letter and thou shalt receive in time the whole.

I will try to forward thee an orange myrtle and a cape jessamine, two very different plants, I assure thee. And I hope thou never will be deceived or disappointed more by those to whom thou may have to give things in charge. But my Lucy, thou must not be quite so hard on the world—there are a few yet that are good and do something for others beside themselves...

I must thank thee again & again for this last letter. It is kind and written as if to a beloved friend and may this be or not, I wish to be deceived in that way forever.

Again I have answered all thou asked. I give lessons to a young lady here, of drawing. She is the daughter of a rich widow lady, her name Eliza Pirrie, and resides near Bayou Sarah during the summer heat. Yesterday I begged to hear her sing and play on the piano; I played with her on a flute and made the mother stare. She was much surprised to hear me sing the notes. This lady asked me if I would go with them and teach her daughter (about 16, an interesting age) until next winter. I am to think of the terms and give an answer. This I have already formed in my mind: she must pay me $100 per month, in advance, furnish us with one room, our board & washing and I will devote one half of each day for her

daughter. It is very high, but I will not go unless I get it. If she accedes I will have a very excellent opportunity of forwarding my collections, being able to draw every day...

Thy brother William's letter pleases me much and I will answer it shortly; my remembrances to him until then.

I have no doubt now that Mr. Berthoud is determined not to favor me even with a letter. My thanks to him; it will make me use my own powers the more...

Wilt thou not be very fatigued of all the reading necessary to give thee an idea of what I have put down? I think in conscience I may here close.

My future plans are, and will forever be, to do all in my power to enable thee to live with comfort and satisfaction. Wherever I may chance to be carried by circumstances, believe it, my Lucy, and I shall be ever happy and comfortable. Farewell.

Thy true devoted friend,

J. J. Audubon

May 31st 1821

I have thine by the *Columbus* acknowledging the receipt of mine per Manhattan.

Wert thou not to give me hints about money I should be sorry as I know it is as necessary for the support of thy life as thy affection is to the comfort of mine. I admire the family Berthoud's maxim extremely. I am not afraid of the climate, but I already feel very powerfully the effect of the intense heat on my faculties—I can scarce draw for the perspiration.

I am very sorry that thou art so intent on my *not* returning to thee; if that country we live in cannot feed us why not fly from it? I am sorry thy beloved friend has been so ill...If Mr. Berthoud has wrote me it is more than *I* know of yet. Why, Lucy, do you not cling to your better friend, your husband? Not to boast of my intentions anymore towards thy happiness I will merely say that I am afraid *for thee*. We would be better, much better—happier.

If you have not wrote to your uncle, *do not*. I want no one's help but those who are not *quite* so engaged about their business. Your great desire that I should stay away is, I must acknowledge, very unexpected. If you can bear to have me go on a voyage of at

least three years without wishing to see me before—I cannot help thinking that Lucy probably would be better pleased should I never return—and so it may be.

Kiss my dear young friends for me, pray.

For life, your really devoted

Audubon

I can scarce hope now to go to the Pacific. My plans, my wishes will forever be abortive. However, I now enclose [for] you what I have for the President [i.e., a letter seeking an appointment to a Pacific expedition]. You may send it or not as you may think best fit. But I assure you that I shall ever remember Clark's expedition—*and feel my love for you.* Farewell—

June 1st 1821

My dearest girl, I am so sorry of the last part I wrote yesterday, but I then felt miserable. I hope thou wilt look on it as a momentary incident. I love thee so dearly, I feel it so powerfully that I cannot bear anything from thee that has the appearance of coolness. Write me always care of Mr. Roman Pamar. I will leave in a few days, [I] know not wherefore. God bless thee—I hope the hats will suit our dear boys. Thomas W. Bakewell has wrote me quite a positive and very *brotherly* letter, that I shall never answer.

God bless thee. *Thine forever.*

The Fair Incognito

This uncensored account of Audubon fulfilling a commission to paint a nude portrait in the days when he was down and out in New Orleans—enclosed in a letter to his wife Lucy, whom he had not seen for months—is a rare glimpse into the private world of women in the early nineteenth century. "Mrs. André," who lived on the rue d'Amour in the Faubourg Marigny, was probably one of the mistresses of the wealthy French nobleman Bernard de Marigny, a friend of Audubon's who was building the suburb as an investment and who housed his mistresses there. Some biographers, and some readers, have convinced themselves that the encounter never happened and that Audubon's narrative is fictional. Were it so, would such a proud man have depicted himself as naive, awkward and, worst of all, a less skillful artist than his subject?

I was accosted on the day of —— 1821, at the corner of Royale Street & —— Street—the former I take almost daily, not to be seen so much on Levee Street lugging my portfolio, the astonishment of many—by a female of a fine form but whose face [was so] thickly covered by a veil that I could not then distinguish it and who addressed me quickly in about the following words in French: "Pray sir, are you the one sent by the French Academy to draw the birds of America?"

I answered that I drew them for my pleasure.

"You are he that draws likenesses in black chalk so remarkably strong?"

I answered again that I took likenesses in that style.

"Then call in thirty minutes at number × in —— Street and walk upstairs; I will wait for you."

I bowed.

"Do not follow me now."

I bowed again and as I went from her [by] the course I had at first, took my pencil and put down the street and number; I soon reached a bookstore where I waited some time, having a feeling of astonishment undescribable. Recollecting however how far I had to walk, I started and suppose the stranger employed a carriage.

I arrived, and as I walked upstairs I saw her apparently waiting.

"I am glad you have come, walk in quickly." My feeling became so agitated that I trembled like a leaf. This she perceived, shut the door with a double lock and, throwing her veil back, shewed me one of the most beautiful faces I ever saw. "Have you been or are you married?"

Yes, madam.

"Long?"

Twelve years.

"Is your wife in this city?"

No, madam.

"Your name Audubon?"

Yes, madam.

"Set down and be easy," and with the smile of an angel, "I will not hurt you."

I felt such a blush and such deathness through me I could not answer. She raised and handed me a glass of cordial; so strange was all this to me that I drank it—for I needed it—but awkwardly gave her the glass to take back.

She sat again immediately opposite me, and looking [at] me steadfastly asked me if I thought I could draw her face. Indeed I fear not, answered I.

"I am sure you can if you will, but before I say more, what is your price?"

Generally twenty-five dollars.

She smiled again most sweetly. "Will you keep my name if you discover it and my residence a secret?"

If you require it.

"I do. You must promise that to me. Keep it forever sacred, although I care not about anything else."

I promised to keep her name and her place of residence to myself.

"Have you ever drawn a full figure?"

Yes.

"Naked?"

Had I been shot with a forty-eight pounder through the heart my articulating powers could not have been more suddenly stopped.

"Well, why do you not answer?"

I answered yes.

She raised, walked the room a few times and sitting again said, "I want you to draw my likeness and the whole of my form naked, but as I think you cannot work now, leave your portfolio and return in one hour. Be silent."

She had judged of my feelings precisely. I took my hat, she opened the door and I felt like a bird that makes his escape from a strong cage filled with sweetmeats. Had I met a stranger on the stairs, no doubt I would have been suspected for a thief. I walked away fast, looking behind me.

My thoughts rolled on her conduct. She looked as if perfect mistress of herself and yet looked, I then thought, too young, not supposing her more than sixteen (a mistake however) and apparently not at all afraid to disclose to my eyes her sacred beauties. I tried to prepare myself for the occasion, the time passed and I arrived again at the foot of the stairs.

She again was waiting for me and beckoned to me to move quick. She shut the door as the first time, then, coming to me: "Well, how do you feel now? Still trembling a little, what a man you are. Come, come, I am anxious to see the outline you will make, take time and be sure do not embellish any parts with your brilliant imagination, have your paper sufficiently large, I have some beautiful and good chalks, the drawing will be completed in this room and you will please do it on this"—raising, she gave me a large sheet of Elephant paper out of an *armoire.*

The die was cast, I felt at once easy, ready and pleased. I told her I was waiting for her convenience. She repeated the urgency of secrecy which I again promised.

The couch in the room was superbly decorated. She drew the curtains and I heard her undress. "I must be nearly in the position you will see me unless your taste should think proper to alter it by speaking."

Very well, was my answer, although I felt yet very strange and never will forget the moment.

"Please to draw the curtains and arrange the light to suit yourself."

When drawing hirelings in company with twenty more I never cared but for a good outline, but shut up with a beautiful young

woman as much a stranger to me as I was to her, I could not well reconcile all the feelings that were necessary to draw well without mingling with them some of a very different nature. Yet I drew the curtain and saw this beauty.

"Will I do so?" I eyed her but dropped my black lead pencil. "I am glad you are so timid, but tell me will I do so?"

Perceiving at once that the position, the light and all had been carefully studied before, I told her I feared she looked only too well for my talent. She smiled and I begun.

I drew fifty-five minutes by my watch, when she desired I should close the curtains. She dressed in an instant and came immediately to look at what was done.

"Is it like me? Will it be like me? I hope it will be a likeness. I am a little chill, can you work any more without me today?"

I told her I could correct my sketch.

"Well, be contented and work as much as you can, I wish it was done, it is a folly but all our sex is more or less so."

She remarked very appropriately an error and made me correct it. She pulled a bell, a woman came in with a waiter covered with cakes & wine, left it and passed through a door I had not perceived before. She insisted on my resting awhile, made me drink, asked me a thousand questions about my family, residence, birds, way of traveling or living &c., &c. and certainly is a well-informed female, using the best expressions and in all her actions possessing the manners necessary to insure respect & wonder.

I worked nearly two hours more and cast all the outlines of the drawing. It pleased her apparently very much; I soon found she had received good lessons. I begged to know her name.

"Not today and if you are not careful and silent you never will see me again."

I assured her I would.

"I have thought well of you from hearsay and hope not to be mistaken."

I felt now very different thoughts from those I had while she was undressing in her curtains and asked when I must return again.

"Every day at the same hour until done, but never again with your portfolio. I will manage this once through your drawings of birds."

For ten days, at the exception of one Sunday that she went out of the city, I had the pleasure of this beautiful woman's company about one hour naked and two talking on different subjects. She admired my work more every day—at least was pleased to say so—and on the fifth sitting she worked herself in a style much superior to mine.

The second day she desired to know what I would ask her for my work. I told her I would be satisfied with whatever she would [be] pleased [to] give me.

"I take you at your word; it will be *un souvenir.* One who hunts so much needs a good gun or two. This afternoon see if there is one in the city & give this on account if you wish to please me to the last." She handed me five dollars. "I must see it and if I do not like it you are not to have it."

I thanked her and told her it probably would be a high-price piece.

"Well, that probably is necessary to insure the good quality, do what I bid."

I took the note, when gone felt very undetermined, yet I hunted through the stores, found a good one & gave the note on account with my name, telling the shopman that I did not well know when I would call for it.

She was much gratified I had found one. When I told her I was asked one hundred and twenty dollars [she said], "No more? Well, we will say nothing about it until I see how I am pleased with your part."

I worked from day to day, drawing besides a twenty-five-dollar likeness every day, to be sure a little at the expense of my eyes at night, but how could I complain? How many artists would have been delighted of such lessons?

I finished my drawing, or rather she did, for when I returned every day I always found the work much advanced. She touched it, she said, not because she was fatigued of my company daily but because she felt happy in mingling her talents with mine in a piece she had had in contemplation to have done even before she left the country she came from—I suppose from Italy or France, but never could ascertain.

She often took my pencil to compose a device to have engraved

on the gun barrels and asked me to have one of my own, but this I declined and left to her taste and will. She at last decided on one which she said I must absolutely have done for her sake and ordered me to have it finished in a few days.

She had a beautiful frame the last morning I went, on which she asked my opinion, this of course I gave as I thought her desires inclined. She put her name at the foot of the drawing as if *her own* and mine in a dark, shaded part of drapery. When I had closed it and put it in a true light she gazed at it for some moments and assured me her wish was at last gratified, and taking me by one hand gave me a delightful kiss. "Had you acted otherwise than you have, you would have received a very different recompense, go, take this ($125), be happy, think of me sometimes as you rest on your gun, keep forever my name a secret." I begged to kiss her hand. She held it out freely. We parted, probably forever.

It is well that I should say that she had heard of me in a circle [of acquaintances] a few days after I had taken the British consul's likeness and of my collection of birds; that she then understood I was from France, purposely sent by the Academy of Paris, but soon was assured of the contrary by my way of living; and that she asked me to try my veracity—that she employed a servant to watch my ways and that for several nights this servant had remained very late to see if I absented from the boat [where Audubon was then living] and that in fact she knew every step I had taken since the day she had resolved on employing me. She asked me if I had not seen a mulatto man standing near the gates of Madame André two days successively; this I recollected but never supposed that anyone watched my steps. She praised the few drawings of birds I shewed her the first day and assured me that she had no doubt I would be well recompensed for such a collection.

She never asked me to go see her when we parted. I have tried several times in vain, the servants always saying Madame is absent. I have felt a great desire to see the drawing since, to judge of it as I always can do best after some time.

Here my journal takes to another subject and I leave to thee to conclude what thou may of this extraordinary female. Since, I have wished often I could have shewn that drawing to [the painter] Mr. Vanderlyn.

The lady was kind, the gun is good and here are the inscriptions on it: *Ne refuse pas ce don d'une amie qui t'est reconnaissante puisse t'il t'égaler en bonté.* [Do not refuse this gift from a friend who is in your debt; may its goodness equal yours.]

And under the ramming rod: *Property of LaForest Audubon, February 22nd 1821.*

Her name I engraved on it where I do not believe it will ever be found.

The Swallow-tailed Hawk

The flight of this elegant species of Hawk is singularly beautiful and protracted. It moves through the air with such ease and grace that it is impossible for any individual who takes the least pleasure in observing the manners of birds not to be delighted by the sight of it whilst on wing. Gliding along in easy flappings it rises in wide circles to an immense height, inclining in various ways its deeply forked tail to assist the direction of its course, dives with the rapidity of lightning and suddenly checking itself reascends, soars away and is soon out of sight. At other times a flock of these birds amounting to fifteen or twenty individuals is seen hovering around the trees. They dive in rapid succession amongst the branches, glancing along the trunks and seizing in their course the insects and small lizards of which they are in quest. Their motions are astonishingly rapid and the deep curves which they describe, their sudden doublings and crossings and the extreme ease with which they seem to cleave the air, excite the admiration of him who views them while thus employed in searching for food.

A solitary individual of this species has once or twice been seen in Pennsylvania. Farther to the eastward the Swallow-tailed Hawk has never, I believe, been observed. Traveling southward along the Atlantic coast we find it in Virginia, although in very small numbers. Beyond that state it becomes more abundant. Near the Falls of the Ohio a pair had a nest and reared four young ones in 1820. In the lower parts of Kentucky it begins to become numerous; but in the states farther to the south and particularly in parts near the sea it is abundant. In the large prairies of the Attacapas and Opelousas it is extremely common.

In the states of Louisiana and Mississippi, where these birds are abundant, they arrive in large companies in the beginning of April and are heard uttering a sharp plaintive note. At this period I generally remarked that they came from the westward and have counted upwards of a hundred in the space of an hour passing over me in a direct easterly course. At that season and in the beginning of September, when they all retire from the United States, they are easily approached when they have alighted, being then apparently fatigued and busily engaged in preparing themselves for continuing

their journey by dressing and oiling their feathers. At all other times, however, it is extremely difficult to get near them, as they are generally on wing through the day and at night rest on the highest pines and cypresses bordering the river bluffs, the lakes or the swamps of that district of country.

They always feed on the wing. In calm and warm weather they soar to an immense height, pursuing the large insects called *Mosquito Hawks* [dragonflies] and performing the most singular evolutions that can be conceived, using their tail with an elegance of motion peculiar to themselves. Their principal food, however, is large grasshoppers, grass caterpillars, small snakes, lizards and frogs. They sweep close over the fields, sometimes seeming to alight for a moment to secure a snake, and holding it fast by the neck, carry it off and devour it in the air. When searching for grasshoppers and caterpillars it is not difficult to approach them under cover of a fence or tree. When one is then killed and falls to the ground the whole flock comes over the dead bird as if intent upon carrying it off. An excellent opportunity is thus afforded of shooting as many as may be wanted, and I have killed several of these Hawks in this manner, firing as fast as I could load my gun.

The Forked-tailed Hawks are also very fond of frequenting the creeks, which in that country are much encumbered with drifted logs and accumulations of sand, in order to pick up some of the numerous water snakes which lie basking in the sun. At other times they dash along the trunks of trees and snap off the pupae of the locust or that insect itself. Although when on wing they move with a grace and ease which it is impossible to describe, yet on the ground they are scarcely able to walk.

I kept for several days one which had been slightly wounded in the wing. It refused to eat, kept the feathers of the head and rump constantly erect and vomited several times part of the contents of its stomach. It never threw itself on its back nor attempted to strike with its talons unless when taken up by the tip of the wing. It died from inanition, as it constantly refused the food placed before it in profusion and instantly vomited what had been thrust down its throat.

The Swallow-tailed Hawk pairs immediately after its arrival in the southern states, and as its courtships take place on the wing its

motions are then more beautiful than ever. The nest is usually placed on the top branches of the tallest oak or pine tree, situated on the margin of a stream or pond. It resembles that of the Common Crow externally, being formed of dry sticks intermixed with Spanish moss, and is lined with coarse grasses and a few feathers. The eggs are from four to six, of a greenish-white color with a few irregular blotches of dark brown at the larger end. The male and the female sit alternately, the one feeding the other. The young are at first covered with buff-colored down. Their next covering exhibits the pure white and black of the old birds but without any of the glossy purplish tints of the latter. The tail, which at first is but slightly forked, becomes more so in a few weeks, and at the approach of autumn exhibits little difference from that of the adult birds. The plumage is completed the first spring. Only one brood is raised in the season. The species leaves the United States in the beginning of September, moving off in flocks which are formed immediately after the breeding-season is over.

Hardly any difference as to external appearance exists between the sexes. They never attack birds or quadrupeds of any species with the view of preying upon them. I never saw one alight on the ground. They secure their prey as they pass closely over it and in so doing sometimes seem to alight, particularly when securing a snake...

[The Swallow-tailed Hawk (Swallow-tailed Kite), *Elanoides forficatus*, appears in Plate 72 of *The Birds of America*.]

The White-throated Sparrow

This pretty little bird is a visitor of Louisiana and all the southern districts, where it remains only a very short time. Its arrival in Louisiana may be stated to take place in the beginning of November and its departure in the first days of March. In all the middle states it remains longer. How it comes and how it departs are to me quite unknown. I can only say that, all of a sudden, the hedges of the fields bordering on creeks or swampy places and overgrown with different species of vines, sumac bushes, briars and the taller kinds of grasses appear covered with these birds. They form groups sometimes containing from thirty to fifty individuals and live together in harmony. They are constantly moving up and down among these recesses with frequent jerkings of the tail and uttering a note common to the tribe. From the hedges and thickets they issue one by one in quick succession and ramble to the distance of eight or ten yards, hopping and scratching, in quest of small seeds, and preserving the utmost silence. When the least noise is heard or alarm given and frequently, as I thought, without any alarm at all, they all fly back to their covert, pushing directly into the very thickest part of it. A moment elapses when they become reassured, and ascending to the highest branches and twigs, open a little concert which, although of short duration, is extremely sweet. There is much plaintive softness in their note which I wish, kind reader, I could describe to you; but this is impossible although it is yet ringing in my ear, as if I were in those very fields where I have so often listened to it with delight. No sooner is their music over than they return to the field and thus continue alternately sallying forth and retreating during the greater part of the day. At the approach of night they utter a sharper and shriller note consisting of a single *twit* repeated in smart succession by the whole group and continuing until the first hooting of some owl frightens them into silence. Yet often during fine nights I have heard the little creatures emit here and there a twit, as if to assure each other that "all's well."

During the warmer days they remove partially to the woods but never out of reach of their favorite briar thickets, ascend the tops of hollies or such other trees as are covered with tangled vines and

pick either a berry or a winter grape. Their principal enemies in the daytime are the little Sparrow Hawk, the Slate-colored or Sharp-shinned Hawk and above all the Hen-harrier or Marsh Hawk. The latter passes over their little coteries with such light wings and so unlooked for that he seldom fails in securing one of them.

No sooner does spring return, when our woods are covered with white blossoms in gay mimicry of the now melted snows and the delighted eye is attracted by the beautiful flowers of the dogwood tree, than the White-throated Sparrow bids farewell to these parts, not to return till winter. Where it spends the summer I know not, but I should think not within the States.

It is a plump bird, fattening almost to excess whilst in Louisiana, and affords delicious eating, for which purpose many are killed with *blow-guns*. These instruments—should you not have seen them—are prepared by the Indians, who cut the straightest canes, perforating them by forcing a hickory rod through the internal partitions which intersect this species of bamboo, and render them quite smooth within by passing the rod repeatedly through. The cane is then kept perfectly straight and is well dried, after which it is ready for use. Splints of wood, or more frequently of cane, are then worked into tiny arrows, quite sharp at one end, and at the other, instead of being feathered, covered with squirrel hair or other soft substances in the manner of a bottle brush, so as to fill the tube and receive the impulse imparted by a smart puff of breath, which is sufficient to propel such an arrow with force enough to kill a small bird at the distance of eight or ten paces. With these blow-guns or pipes several species of birds are killed in large quantities; and the Indians sometimes procure even squirrels by means of them.

The dogwood, of which I have represented a twig in early spring [in the plate], is a small tree found nearly throughout the Union but generally preferring such lands as with us are called of second quality, although it occasionally makes its appearance in the richest alluvial deposits. Its height seldom exceeds twenty feet or its diameter ten inches. It is scarcely ever straight to any extent, but the wood, being extremely hard and compact, is useful for turning when well dried and free of wind shakes, to which it is rather

liable. Its berries are eaten by various species of birds and especially by our different kinds of squirrels, all of which shew great partiality to them. Its flowers, although so interesting in early spring, are destitute of odor and of short duration. The bark is used by the inhabitants in decoction as a remedy for intermittent fevers and the berries are employed by the housewife for dyeing black.

[The White-throated Sparrow, *Zonotrichia albicollis*, appears in Plate 8 of *The Birds of America*.]

The Purple Martin

The Purple Martin makes its appearance in the city of New Orleans from the 1st to the 9th of February, occasionally a few days earlier than the first of these dates, and is then to be seen gamboling through the air over the city and the river feeding on many sorts of insects which are there found in abundance at that period.

It frequently rears three broods whilst with us. I have had several opportunities at the period of their arrival of seeing prodigious flocks moving over that city or its vicinity at a considerable height, each bird performing circular sweeps as it proceeded for the purpose of procuring food. These flocks were loose and moved either eastward or towards the northwest at a rate not exceeding four miles in the hour, as I walked under one of them with ease for upwards of two miles at that rate on the 4th of February 1821 on the bank of the river below the city, constantly looking up at the birds, to the great astonishment of many passengers who were bent on far different pursuits. My Fahrenheit's thermometer stood at 68°, the weather being calm and drizzly. This flock extended about a mile and a half in length by a quarter of a mile in breadth. On the 9th of the same month not far above the *Battleground* [of the Battle of New Orleans] I enjoyed another sight of the same kind, although I did not think the flock so numerous.

At the Falls of the Ohio I have seen Martins as early as the 15th of March arriving in small detached parties of only five or six individuals when the thermometer was as low as 28°, the next day at 45° and again in the same week so low as to cause the death of all the Martins or to render them so incapable of flying as to suffer children to catch them. By the 25th of the same month they are generally plentiful about that neighborhood.

At St. Genevieve in the State of Missouri they seldom arrive before the 10th or 15th of April and sometimes suffer from unexpected returns of frost. At Philadelphia they are first seen about the 10th of April. They reach Boston about the 25th and continue their migration much farther north as the spring continues to open.

On their return to the Southern states they do not require to wait for warmer days, as in spring, to enable them to proceed and they all leave the above-mentioned districts and places about the

20th of August. They assemble in parties of from fifty to a hundred and fifty about the spires of churches in the cities or on the branches of some large dead tree about the farms for several days before their final departure. From these places they are seen making occasional sorties, uttering a general cry and inclining their course towards the west, flying swiftly for several hundred yards, when suddenly checking themselves in their career they return in easy sailings to the same tree or steeple. They seem to act thus for the purpose of exercising themselves as well as to ascertain the course they are to take and to form the necessary arrangements for enabling the party to encounter the fatigues of their long journey. Whilst alighted during these days of preparation they spend the greater part of the time in dressing and oiling their feathers, cleaning their skins and clearing, as it were, every part of their dress and body from the numerous insects which infest them. They remain on their roosts exposed to the night air, a few only resorting to the boxes where they have been reared, and do not leave them until the sun has traveled an hour or two from the horizon, but continue during the fore part of the morning to plume themselves with great assiduity. At length on the dawn of a calm morning they start with one accord and are seen moving due west or southwest, joining other parties as they proceed until there is formed a flock similar to that which I have described above. Their progress is now much more rapid than in spring and they keep closer together.

It is during these migrations, reader, that the power of flight possessed by these birds can be best ascertained, and more especially when they encounter a violent storm of wind. They meet the gust and appear to slide along the edges of it as if determined not to lose one inch of what they have gained. The foremost front the storm with pertinacity, ascending or plunging along the skirts of the opposing currents and entering their undulating recesses as if determined to force their way through, while the rest follow close behind, all huddled together into such compact masses as to appear like a black spot. Not a twitter is then to be heard from them by the spectator below; but the instant the farther edge of the current is doubled, they relax their efforts, to refresh themselves, and twitter in united accord as if congratulating each other on the successful issue of the contest.

The usual flight of this bird more resembles that of the *Hirundo urbica* of Linneus or that of the *Hirundo fulva* of Vieillot than the flight of any other species of Swallow; and although graceful and easy, cannot be compared in swiftness with that of the Barn Swallow. Yet the Martin is fully able to distance any bird not of its own genus. They are very expert at bathing and drinking while on the wing when over a large lake or river, giving a sudden motion to the hind part of the body as it comes into contact with the water, thus dipping themselves in it and then rising and shaking their body like a water spaniel to throw off the water. When intending to drink they sail close over the water with both wings greatly raised and forming a very acute angle with each other. In this position they lower the head, dipping their bill several times in quick succession and swallowing at each time a little water.

They alight with comparative ease on different trees, particularly willows, making frequent movements of the wings and tail as they shift their place in looking for leaves to convey to their nests. They also frequently alight on the ground where notwithstanding the shortness of their legs they move with some ease, pick up a goldsmith or other insect and walk to the edges of puddles to drink, opening their wings, which they also do when on trees, feeling as if not perfectly comfortable.

These birds are extremely courageous, persevering and tenacious of what they consider their right. They exhibit strong antipathies against cats, dogs and such other quadrupeds as are likely to prove dangerous to them. They attack and chase indiscriminately every species of Hawk, Crow or Vulture and on this account are much patronized by the husbandman. They frequently follow and tease an Eaglet until he is out of sight of the Martin's box; and to give you an idea of their tenacity when they have made choice of a place in which to rear their young I shall relate to you the following occurrences.

I had a large and commodious house built and fixed on a pole for the reception of Martins in an enclosure near my house, where for some years several pairs had reared their young. One winter I also put up several small boxes with a view to invite Bluebirds to build nests in them. The Martins arrived in the spring and imagining these smaller apartments more agreeable than their own

mansion took possession of them after forcing the lovely Bluebirds from their abode. I witnessed the different conflicts and observed that one of the Bluebirds was possessed of as much courage as his antagonist, for it was only in consequence of the more powerful blows of the Martin that he gave up his house in which a nest was nearly finished, and he continued on all occasions to annoy the usurper as much as lay in his power. The Martin shewed his head at the entrance and merely retorted with accents of exultation and insult. I thought fit to interfere, mounted the tree on the trunk of which the Bluebird's box was fastened, caught the Martin and clipped his tail with scissors in the hope that such mortifying punishment might prove effectual in inducing him to remove to his own tenement. No such thing; for no sooner had I launched him into the air than he at once rushed back to the box. I again caught him and clipped the tip of each wing in such a manner that he still could fly sufficiently well to procure food and once more set him at liberty. The desired effect, however, was not produced and as I saw the pertinacious Martin keep the box in spite of all my wishes that he should give it up, I seized him in anger and disposed of him in such a way that he never returned to the neighborhood.

At the house of a friend of mine in Louisiana some Martins took possession of sundry holes in the cornices and there reared their young for several years, until the insects which they introduced to the house induced the owner to think of a reform. Carpenters were employed to clean the place and close up the apertures by which the birds entered the cornice. This was soon done. The Martins seemed in despair; they brought twigs and other materials and began to form nests wherever a hole could be found in any part of the building; but were so chased off that after repeated attempts, the season being in the meantime advanced, they were forced away and betook themselves to some Woodpeckers' holes on the dead trees about the plantation. The next spring a house was built for them. The erection of such houses is a general practice, the Purple Martin being considered as a privileged pilgrim and the harbinger of spring.

The note of the Martin is not melodious but is nevertheless very pleasing. The twitterings of the male while courting the female are

more interesting. Its notes are among the first that are heard in the morning and are welcome to the sense of everybody. The industrious farmer rises from his bed as he hears them. They are soon after mingled with those of many other birds and the husbandman, certain of a fine day, renews his peaceful labors with an elated heart. The still more independent Indian is also fond of the Martin's company. He frequently hangs up a calabash on some twig near his camp, and in this cradle the bird keeps watch and sallies forth to drive off the vulture that might otherwise commit depredations on the deerskins or pieces of venison exposed to the air to be dried. The humbled slave of the Southern states takes more pains to accommodate this favorite bird. The calabash is neatly scooped out and attached to the flexible top of a cane brought from the swamp, where that plant usually grows, and placed close to his hut. It is, alas! to him a mere memento of the freedom which he once enjoyed; and at the sound of the horn which calls him to his labor, as he bids farewell to the Martin, he cannot help thinking how happy he should be were he permitted to gambol and enjoy himself day after day with as much liberty as that bird. Almost every country tavern has a Martin box on the upper part of its signboard; and I have observed that the handsomer the box, the better does the inn generally prove to be.

All our cities are furnished with houses for the reception of these birds; and it is seldom that even lads bent upon mischief disturb the favored Martin. He sweeps along the streets, here and there seizing a fly, hangs to the eaves of the houses or peeps into them as he poises himself in the air in front of the windows or mounts high above the city soaring into the clear sky, plays with the string of the child's kite, snapping at it as he swiftly passes with unerring precision or suddenly sweeps along the roofs, chasing off grimalkin, who is probably prowling in quest of his young.

In the Middle states the nest of the Martin is built or that of the preceding year repaired and augmented eight or ten days after its arrival on about the 20th of April. It is composed of dry sticks, willow twigs, grasses, leaves, green and dry, feathers and whatever rags he meets with. The eggs, which are pure white, are from four to six. Many pairs resort to the same box to breed and the little fraternity appear to live in perfect harmony. They rear two broods

in a season. The first comes forth in the end of May, the second about the middle of July. In Louisiana they sometimes have three broods. The male takes part of the labor of incubation and is extremely attentive to his mate. He is seen twittering on the box and frequently flying past the hole. His notes are at this time emphatical and prolonged, low and less musical than even his common *pews*. Their food consists entirely of insects, among which are large beetles. They seldom seize the honeybee.

The circumstance of their leaving the United States so early in autumn, has inclined me to think that they must go farther from them than any of our migratory land birds . . .

[The Purple Martin, *Progne subis*, appears in Plate 22 of *The Birds of America*.]

The Barred Owl

Should you, kind reader, find it convenient or agreeable to visit the noble forests existing in the lower parts of the State of Louisiana about the middle of October, when nature, on the eve of preparing for approaching night, permits useful dews to fall and rest on every plant with the view of reviving its leaves, its fruits or its lingering blossoms ere the return of morn; when every night insect rises on buzzing wings from the ground and the firefly, amidst thousands of other species, appears as if purposely to guide their motions through the somber atmosphere; at the moment when numerous reptiles and quadrupeds commence their nocturnal prowlings and the fair moon, empress of the night, rises peacefully on the distant horizon, shooting her silvery rays over the heavens and the earth and, like a watchful guardian, moving slowly and majestically along; when the husbandman, just returned to his home after the labors of the day, is receiving the cheering gratulations of his family and the wholesome repast is about to be spread out for master and servants alike—it is at this moment, kind reader, that were you as I have said to visit that happy country, your ear would suddenly be struck by the discordant screams of the Barred Owl. Its *whah*, *whah*, *whah*, *whah-aa* is uttered loudly and in so strange and ludicrous a manner that I should not be surprised were you, kind reader, when you and I meet, to compare these sounds to the affected bursts of laughter which you may have heard from some of the fashionable members of our own species.

How often, when snugly settled under the boughs of my temporary encampment and preparing to roast a venison steak or the body of a squirrel on a wooden spit, have I been saluted with the exulting bursts of this nightly disturber of the peace that, had it not been for him, would have prevailed around me as well as in my lonely retreat! How often have I seen this nocturnal marauder alight within a few yards of me, exposing his whole body to the glare of my fire, and eye me in such a curious manner that had it been reasonable to do so, I would gladly have invited him to walk in and join me in my repast that I might have enjoyed the pleasure of forming a better acquaintance with him. The liveliness of his motions joined to their oddness have often made me think that

his society would be at least as agreeable as that of many of the buffoons we meet with in the world. But as such opportunities of forming acquaintance have not existed, be content, kind reader, with the imperfect information which I can give you of the habits of this Sancho Panza of our woods.

Such persons as conclude when looking upon owls in the glare of day that they are as they then appear, extremely dull, are greatly mistaken. Were they to state, like Buffon, that Woodpeckers are miserable beings, they would be talking as incorrectly; and to one who might have lived long in the woods they would seem to have lived only in their libraries.

The Barred Owl is found in all those parts of the United States which I have visited and is a constant resident. In Louisiana it seems to be more abundant than in any other state. It is almost impossible to travel eight or ten miles in any of the retired woods there without seeing several of them even in broad day; and at the approach of night their cries are heard proceeding from every part of the forest around the plantations. Should the weather be lowering and indicative of the approach of rain, their cries are so multiplied during the day and especially in the evening, and they respond to each other in tones so strange, that one might imagine some extraordinary fate about to take place among them. On approaching one of them, its gesticulations are seen to be of a very extraordinary nature. The position of the bird, which is generally erect, is immediately changed. It lowers its head and inclines its body to watch the motions of the person beneath, throws forward the lateral feathers of its head, which thus has the appearance of being surrounded by a broad ruff, looks towards him as if half blind and moves its head to and fro in so extraordinary a manner as almost to induce a person to fancy that part dislocated from the body. It follows all the motions of the intruder with its eyes; and should it suspect any treacherous intentions flies off to a short distance, alighting with its back to the person and immediately turning about with a single jump to recommence its scrutiny. In this manner the Barred Owl may be followed to a considerable distance if not shot at, for to halloo after it does not seem to frighten it much. But if shot at and missed, it removes to a consid-erable distance, after which its *whah–whah–whah* is uttered with

considerable pomposity. This owl will answer the imitation of its own sounds and is frequently decoyed by this means.

The flight of the Barred Owl is smooth, light, noiseless and capable of being greatly protracted. I have seen them take their departure from a detached grove in a prairie and pursue a direct course towards the skirts of the main forest, distant more than two miles, in broad daylight. I have thus followed them with the eye until they were lost in the distance and have reason to suppose that they continued their flight until they reached the woods. Once, whilst descending the Ohio not far from the well-known *Cave-in-Rock*, about two hours before sunset in the month of November, I saw a Barred Owl teased by several crows and chased from the tree in which it was. On leaving the tree it gradually rose in the air in the manner of a Hawk and at length attained so great a height that our party lost sight of it. It acted, I thought, as if it had lost itself, now and then describing small circles and flapping its wings quickly, then flying in zigzag lines. This being so uncommon an occurrence, I noted it down at the time. I felt anxious to see the bird return towards the earth, but it did not make its appearance again. So very lightly do they fly that I have frequently discovered one passing over me and only a few yards distant by first seeing its shadow on the ground during clear moonlit nights when not the faintest rustling of its wings could be heard.

Their power of sight during the day seems to be rather of an equivocal character, as I once saw one alight on the back of a cow, which it left so suddenly afterwards when the cow moved as to prove to me that it had mistaken the object on which it had perched for something else. At other times I have observed that the approach of the grey squirrel intimidated them if one of these animals accidentally jumped on a branch close to them, although the Owl destroys a number of them during the twilight. It is for this reason, kind reader, that I have represented the Barred Owl gazing in amazement at one of the squirrels placed only a few inches from him.

The Barred Owl is a great destroyer of poultry, particularly of chickens when half-grown. It also secures mice, young hares, rabbits and many species of small birds, but is especially fond of a kind of frog of a brown color, very common in the woods of Louisiana. I have heard it asserted that this bird catches fish, but

never having seen it do so, and never having found any portion of fish in its stomach, I cannot vouch for the truth of the report.

About the middle of March these Owls begin to lay their eggs. This they usually do in the hollows of trees on the dust of the decomposed wood. At other times they take possession of the old nest of a Crow or a Red-tailed Hawk. In all these situations I have found their eggs and young. The eggs are of a globular form, pure white, with a smooth shell and are from four to six in number. So far as I have been able to ascertain they rear only one brood in a season. The young, like those of all other Owls, are at first covered with a downy substance, some of which is seen intermixed with and protruding from the feathers some weeks after the bird is nearly fledged. They are fed by the parents for a long time, standing perched and emitting a hissing noise in lieu of a call. This noise may be heard in a calm night for fifty or probably a hundred yards and is by no means musical. To a person lost in a swamp it is indeed extremely dismal.

The plumage of the Barred Owl differs very considerably in respect to color in different individuals, more so among the males. The males are also smaller than the females, but less so than in some other species.

During the severe winters of our middle districts those that remain there suffer very much; but the greater number, as in some other species, remove to the Southern states. When kept in captivity, they prove excellent mousers.

The antipathy shewn to Owls by every species of day bird is extreme. They are followed and pursued on all occasions; and although few of the day birds ever prove dangerous enemies, their conduct towards the Owls is evidently productive of great annoyance to them. When the Barred Owl is shot at and wounded it snaps its bill sharply and frequently, raises all its feathers, looks towards the person in the most uncouth manner but, on the least chance of escape, moves off in great leaps with considerable rapidity.

The Barred Owl is very often exposed for sale in the New Orleans market. The Creoles make *gumbo* of it, and pronounce the flesh palatable.

[The Barred Owl, *Strix varia*, appears in Plate 46 of *The Birds of America*.]

Chuck-will's-widow

The Chuck-will's-widow and the Whippoorwill, both named for their calls, fly at dusk or at night scooping insects into their prodigious fringed mouths. Both are categorized as goatsuckers because they were once imagined to nurse from the goats whose presence and activity stirred up the insects. In his plate Audubon depicted two Chuck-will's-widows harassing what he calls a harlequin snake. There are harmless snakes with similar patterns, but the fact that Audubon's specimen has red bands touching yellow ones identifies it as a coral snake, an American relative of the cobra with a deadly bite; if he or his assistant Joseph Mason handled it, they did so at great risk.

Our goatsuckers, although possessed of great power of wing, are particularly attached to certain districts and localities. The species now under consideration is seldom observed beyond the limits of the Choctaw Nation in the state of Mississippi or the Carolinas on the shores of the Atlantic, and may with propriety be looked upon as the southern species of the United States. Louisiana, Florida, the lower portions of Alabama and Georgia are the parts in which it most abounds; and there it makes its appearance early in spring, coming over from Mexico and probably still warmer climates.

About the middle of March the forests of Louisiana are heard to echo with the well-known notes of this interesting bird. No sooner has the sun disappeared and the nocturnal insects emerge from their burrows than the sounds *"chuck-will's-widow,"* repeated with great clearness and power six or seven times in as many seconds, strike the ear of every individual, bringing to the mind a pleasure mingled with a certain degree of melancholy which I have often found very soothing. The sounds of the Goatsucker at all events forebode a peaceful and calm night, and I have more than once thought are conducive to lull the listener to repose.

The deep ravines, shady swamps and extensive pine ridges are all equally resorted to by these birds; for in all such places they find ample means of providing for their safety during the day and of procuring food under night. Their notes are seldom heard in cloudy weather and never when it rains. Their roosting places

are principally the hollows of decayed trees whether standing or prostrate, from which latter they are seldom raised during the day excepting while incubation is in progress. In these hollows I have found them lodged in the company of several species of bats, the birds asleep on the moldering particles of the wood, the bats clinging to the sides of the cavities. When surprised in such situations, instead of trying to effect their escape by flying out they retire backwards to the farthest corners, ruffle all the feathers of their body, open their mouth to its full extent and utter a hissing kind of murmur not unlike that of some snakes. When seized and brought to the light of day they open and close their eyes in rapid succession as if it were painful for them to encounter so bright a light. They snap their little bill in the manner of Flycatchers and shuffle along as if extremely desirous of making their escape. On giving them liberty to fly I have found them able to proceed until out of my sight. They passed between the trees with apparently as much ease and dexterity as if it had been twilight. I once cut two of the quill feathers of a wing of one of these birds and allowed it to escape. A few days afterwards I found it in the same log, which induces me to believe that they like many other birds resort to the same spot to roost or spend the day.

The flight of the Chuck-will's-widow is as light as that of its relative the well-known *Whippoorwill*, if not more so, and is more graceful as well as more elevated. It somewhat resembles the flight of the Hen-harrier, being performed by easy flappings of the wings interspersed with sailings and curving sweeps extremely pleasing to the bystander. At the approach of night this bird begins to sing clearly and loudly and continues its notes for about a quarter of an hour. At this time it is perched on a fence stake or on the decayed branch of a tree in the interior of the woods, seldom on the ground. The sounds or notes which it emits seem to cause it some trouble as it raises and lowers its head in quick succession at each of them. This over, the bird launches into the air and is seen sweeping over the cotton fields or the sugar plantations, cutting all sorts of figures, mounting, descending or sailing with so much ease and grace that one might be induced to call it the *fairy of the night*. If it passes close to one, a murmuring noise is heard, at times resembling that spoken of when the bird is caught by day. It suddenly checks its

course, inclines to the right or left, secures a beetle or a moth, continues its flight over the field, passes and repasses hundreds of times over the same ground and now and then alights on a fence stake or the tallest plant in the place, from which it emits its notes for a few moments with increased vivacity. Now it is seen following a road or a path on the wing and alighting here and there to pick up the beetle emerging from its retreat in the ground; again it rises high in air and gives chase to the insects that are flying there, perhaps on their passage from one wood to another. At other times I have seen it poise itself on its wings opposite the trunk of a tree and seize with its bill the insects crawling on the bark, in this manner inspecting the whole tree with motions as light as those by which the Hummingbird flutters from one flower to another. In this manner Chuck-will's-widow spends the greater part of the night.

The greatest harmony appears to subsist between the birds of this species, for dozens may be observed flying together over a field and chasing insects in all directions without manifesting any enmity or envy. A few days after the arrival of the male birds the females make their appearance and the love season at once commences. The male pays his addresses to the female with a degree of pomposity only equaled by the Tame Pigeon. The female, perched lengthwise on a branch, appears coy and silent, whilst the male flies around her, alights in front of her and with drooping wings and expanded tail advances quickly, singing with great impetuosity. They are soon seen to leave the branch together and gambol through the air. A few days after this, the female, having made choice of a place in one of the most retired parts of some thicket, deposits two eggs, which I think, although I cannot be certain, are all that she lays for the season.

This bird forms no nest. A little space is carelessly scratched amongst the dead leaves and in it the eggs, which are elliptical, dull olive and speckled with brown, are dropped. These are not found without great difficulty, unless when by accident a person passes within a few feet of the bird whilst sitting, and it chances to fly off. Should you touch or handle these dear fruits of happy love and, returning to the place, search for them again, you would search in vain; for the bird perceives at once that they have been

meddled with and both parents remove them to some other part of the woods where chance only could enable you to find them again. In the same manner they also remove the young when very small.

This singular occurrence has as much occupied my thoughts as the equally singular manner in which the *Cow Bunting* deposits her eggs, which she does like the *Common Cuckoo* of Europe one by one in the nests of other birds of different species from her own. I have spent much time in trying to ascertain in what manner the Chuck-will's-widow removes her eggs or young, particularly as I found, by the assistance of an excellent dog, that neither the eggs nor the young were to be met with within at least a hundred yards from the spot where they at first lay. The Negroes, some of whom pay a good deal of attention to the habits of birds and quadrupeds, assured me that these birds push the eggs or young with their bill along the ground. Some farmers, without troubling themselves much about the matter, imagined the transportation to be performed under the wings of the old bird. The account of the Negroes appearing to me more likely to be true than that of the farmers, I made up my mind to institute a strict investigation of the matter. The following is the result.

When the Chuck-will's-widow, either male or female (for each sits alternately) has discovered that the eggs have been touched, it ruffles its feathers and appears extremely dejected for a minute or two, after which it emits a low murmuring cry, scarcely audible to me, as I lay concealed at a distance of not more than eighteen or twenty yards. At this time I have seen the other parent reach the spot, flying so low over the ground that I thought its little feet must have touched it as it skimmed along, and after a few low notes and some gesticulations, all indicative of great distress, take an egg in its large mouth, the other bird doing the same, when they would fly off together skimming closely over the ground until they disappeared among the branches and trees. But to what distance they remove their eggs I have never been able to ascertain; nor have I ever had an opportunity of witnessing the removal of the young. Should a person coming upon the nest when the bird is sitting refrain from touching the eggs, the bird returns to them and sits as before. This fact I have also ascertained by observation.

I wish I could have discovered the peculiar use of the *pectinated claw* which this bird has on each foot; but, reader, this remains one of the many desiderata in ornithology, and I fear, with me at least, will continue so.

The Chuck-will's-widow manifests a strong antipathy towards all snakes, however harmless they may be. Although these birds cannot in any way injure the snakes, they alight near them on all occasions and try to frighten them away by opening their prodigious mouth and emitting a strong hissing murmur. It was after witnessing one of these occurrences, which took place at early twilight, that the idea of representing these birds in such an occupation struck me. The beautiful little snake gliding along the dead branch between two Chuck-will's-widows, a male and a female, is commonly called the *Harlequin Snake*, and is, I believe, quite harmless.

The food of the bird now under consideration consists entirely of all sorts of insects, among which the larger species of moths and beetles are very conspicuous. The long bristly feathers at the base of the mandibles of these birds no doubt contribute greatly to prevent the insects from escaping after any portion of them has entered the mouth of the bird.

These birds become silent as soon as the young are hatched, but are heard again before their departure towards the end of summer. At this season, however, their cry is much less frequently heard than in spring. They leave the United States all of a sudden, about the middle of the month of August.

[The Chuck-will's-widow, *Caprimulgus carolinensis*, appears in Plate 52 of *The Birds of America*.]

The Little Screech Owl

This Owl, although found in the Southern states, is there very rare. During a long residence in Louisiana I have not met with more than two individuals. On advancing towards the confluence of the Ohio and Mississippi we find them becoming rather more numerous; above the Falls of the former they increase in number; and as the traveler advances towards the sources of that noble river their mournful notes are heard in every quarter during mild and serene nights. In Virginia, Maryland and all the eastern districts the bird is plentiful, particularly during the autumnal and winter months, and is there well known under the name of the *Screech Owl*.

You are presented [in the plate], kind reader, with three figures of this species, the better to shew you the differences which exist between the young and the full-grown bird. The contrast of coloring in these different stages I have thought it necessary to exhibit, as the *Red Owl* of [Alexander] Wilson and other naturalists is merely the young of the bird called by the same authors the *Mottled Owl* and which in fact is the adult of the species under consideration. The error committed by the author of the *American Ornithology* [i.e., Wilson] for many years misled all subsequent students of nature; and the specific identity of the two birds which he had described as distinct under the above names was first publicly maintained by my friend Charles-Lucien Bonaparte, although the fact was long before known to many individuals with whom I am acquainted, as well as to myself.

The flight of the Mottled Owl is smooth, rapid, protracted and noiseless. It rises at times above the top branches of the highest of our forest trees whilst in pursuit of large beetles, and at other times sails low and swiftly over the fields or through the woods in search of small birds, field-mice, moles or wood rats, from which it chiefly derives its subsistence. On alighting, which it does plumply, the Mottled Owl immediately bends its body, turns its head to look behind it, performs a curious nod, utters its notes, then shakes and plumes itself and resumes its flight in search of prey. It now and then while on wing produces a *clicking* sound with its mandibles, but more frequently when perched near its mate or young. This I have thought is done by the bird to manifest its courage and let

the hearer know that it is not to be meddled with, although few birds of prey are more gentle when seized, as it will suffer a person to touch its feathers and caress it without attempting to bite or strike with its talons, unless at rare intervals. I carried one of the young birds represented in the plate in my coat pocket from Philadelphia to New York, traveling alternately by water and by land. It remained generally quiet, fed from the hand and never attempted to escape. It was given me by my good friend Dr. Richard Harlan of Philadelphia and was lost at sea in the course of my last voyage to England.

The notes of this Owl are uttered in a tremulous, doleful manner and somewhat resemble the chattering of the teeth of a person under the influence of extreme cold, although much louder. They are heard at a distance of several hundred yards and by some people are thought to be of ominous import.

The little fellow is generally found about farmhouses, orchards and gardens. It alights on the roof, the fence or the garden gate and utters its mournful ditty at intervals for hours at a time as if it were in a state of great suffering, although this is far from being the case, the song of all birds being an indication of content and happiness. In a state of confinement it continues to utter its notes with as much satisfaction as if at liberty. They are chiefly heard during the latter part of winter, that being the season of love, when the male bird is particularly attentive to the fair one which excites his tender emotions and around which he flies and struts much in the manner of the Common Pigeon, adding numerous nods and bows, the sight of which is very amusing.

The nest is placed in the bottom of the hollow trunk of a tree, often not at a greater height than six or seven feet from the ground, at other times so high as from thirty to forty feet. It is composed of a few grasses and feathers. The eggs are four or five, of a nearly globular form and pure white color. If not disturbed, this species lays only one set of eggs in the season. The young remain in the nest until they are able to fly. At first they are covered with a downy substance of a dull yellowish white. By the middle of August they are fully feathered and are then generally of the color exhibited in the plate, although considerable differences exist between individuals, as I have seen some of a deep chocolate color and others

nearly black. The feathers change their colors as the pairing season advances, and in the first spring the bird is in its perfect dress.

After nearly thirty years of observation, I may say, hardly interrupted, I may be allowed to draw your attention to the following fact as highly curious. I have observed that every species of Owl which breeds in the Northern and Middle states is considerably more deficient in its powers of vision during the day or on moonlight nights when the ground is covered with snow than the species that breed in, and consequently may be considered as residents of, more northern countries, such as the Snow Owl, the Forked-tailed Owl, and the Hawk Owl, all of which shew no material difference in their power of vision, be the sun or moon shining ever so brightly on the snow. I have frequently approached the Great Horned Owl, as well as every other species that breeds in the United States, during what I call *glaring* snows, whilst on the same day my attempts to approach the Snow Owl or the Hawk Owl were ineffectual. Yet on examining the structure of the eyes of all these species I have found little or no difference in them. I wish some competent anatomist would investigate this singular fact, and communicate the result of his inquiries for the benefit of the scientific world, and that of the author of the biography of the birds of the United States.

The Mottled Owl rests or spends the day either in a hole of some decayed tree or in the thickest part of the evergreens which are found so abundantly in the country, to which it usually resorts during the breeding season as well as in the depth of winter.

The branch on which you see three individuals of this species, an adult bird and two young ones, is that of the Jersey Pine (*Pinus inops*), a tree of moderate height and diameter and of a scrubby appearance. The stem is generally crooked and the wood is not considered of great utility. It grows in large groves in the state from which it has derived its name and is now mostly used for fuel on board our steam vessels. The Mottled Owl is often observed perched on its branches.

[The Little Screech Owl (Eastern Screech Owl), *Otus asia*, appears in Plate 97 of *The Birds of America*.]

Episode: A Tough Walk for a Youth

Audubon collected and drew in Louisiana in the 1820s while working part-time instructing the children of plantation owners in cotillion dancing, drawing, fencing and French. Lucy Audubon ran a successful plantation school as well and taught piano. Bayou Sarah was then a village port on the Mississippi River where cotton was loaded, one mile riverward from St. Francisville in West Feliciana Parish. Like his father, Victor Gifford Audubon was still recovering from yellow fever when this long journey began.

About twelve years ago I was conveyed along with my son Victor from Bayou Sarah to the mouth of the Ohio on board the steamer *Magnet*, commanded by Mr. McKnight, to whom I here again offer my best thanks for his attentions. The very sight of the waters of that beautiful river filled me with joy as we approached the little village of Trinity, where we were landed along with several other passengers, the water being too low to enable the vessel to proceed to Louisville. No horses could be procured, and as I was anxious to continue my journey without delay, I consigned my effects to the care of the tavern keeper, who engaged to have them forwarded by the first opportunity. My son, who was not fourteen, with all the ardour of youth, considered himself able to accomplish on foot the long journey which we contemplated. Two of the passengers evinced a desire to accompany us, "provided," said the tallest and stoutest of them, "the lad can keep up. My business," he continued, "is urgent, and I shall push for Frankfort pretty fast." Dinner, to which we had contributed some fish from the river, being over, my boy and I took a ramble along the shores of Cache Creek, on which some years before I had been detained several weeks by ice. We slept at the tavern and next morning prepared for our journey, and were joined by our companions, although it was past twelve before we crossed the creek.

One of our fellow travelers, named Rose, who was a delicate and gentlemanly person, acknowledged that he was not a good walker and said he was glad that my son was with us, as he might be able to keep up with the lively youth. The other, a burly personage, at once pushed forward. We walked in Indian file along the

narrow track cut through the canes, passed a wood yard and entered the burnt forest, in which we met with so many logs and briars that we judged it better to make for the river, the course of which we followed over a bed of pebbles, my son sometimes ahead and again falling back, until we reached America, a village having a fine situation but with a shallow approach to the shore. Here we halted at the best house, as every traveler ought to do, whether pedestrian or equestrian, for he is there sure of being well treated and will not have more to pay than in an inferior place.

Now we constituted Mr. Rose our purser. We had walked twelve miles over rugged paths and pebbly shores and soon proceeded along the edge of the river. Seven tough miles ended, we found a house near the bank and in it we determined to pass the night. The first person we met with was a woman picking cotton in a small field. On asking her if we might stay in her cabin for the night, she answered we might and hoped we could make a shift with the fare on which she and her husband lived. While she went to the house to prepare supper, I took my son and Mr. Rose to the water, knowing how much we should be refreshed by a bath. Our fellow traveler refused and stretched himself on a bench by the door. The sun was setting; thousands of robins were flying southward in the calm and clear air; the Ohio was spread before us smooth as a mirror, and into its waters we leaped with pleasure. In a short time the good man of the hut called us to supper and in a trice we were at his heels. He was a tall rawboned fellow with an honest bronzed face. After our frugal meal we all four lay down in a large bed spread on the floor while the good people went up to a loft.

The woodsman, having agreeably to our instructions roused us at daybreak, told us that about seven miles farther we should meet with a breakfast much better than the last supper we had. He refused any pecuniary compensation but accepted from me a knife. So we again started. My dear boy appeared very weak at first, but soon recovered, and our stout companion, whom I shall call S., evidently shewed symptoms of lassitude. On arriving at the cabin of a lazy man blessed with an industrious wife and six healthy children, all of whom labored for his support, we were welcomed by the woman, whose motions and language indicated her right to

belong to a much higher class. Better breakfast I never ate: the bread was made of new corn ground on a tin grater by the beautiful hands of our blue-eyed hostess; the chickens had been prepared by one of her lovely daughters; some good coffee was added and my son had fresh milk. The good woman, who now held a babe to her bosom, seemed pleased to see how heartily we all ate; the children went to work and the lazy husband went to the door to smoke a corncob pipe. A dollar was put into the ruddy hand of the chubby urchin and we bade its mother farewell. Again we trudged along the beach but after a while betook ourselves to the woods. My son became faint. Dear boy! never can I forget how he lay exhausted on a log, large tears rolling down his cheeks. I bathed his temples, spoke soothingly to him, and chancing to see a fine turkey cock run close by, directed his attention to it, when as if suddenly refreshed, he got up and ran a few yards towards the bird. From that moment he seemed to acquire new vigor, and at length we reached Wilcox's, where we stopped for the night. We were reluctantly received at the house, and had little attention paid to us, but we had a meal and went to bed.

The sun rose in all its splendor and the Ohio reflected its ruddy beams. A finer view of that river can scarcely be obtained than that from the house which we were leaving. Two miles through intricate woods brought us to Belgrade, and having passed Fort Massacre, we halted and took breakfast. S. gave us to understand that the want of roads made traveling very unpleasant; he was not, he added, in the habit of "skulking through the bushes or tramping over stony bars in the full sunshine," but how else he had traveled was not explained. Mr. Rose kept up about as well as Victor and I now led the way. Towards sunset we reached the shores of the river opposite the mouth of the Cumberland. On a hill, the property of a Major B., we found a house and a solitary woman, wretchedly poor but very kind. She assured us that if we could not cross the river, she would give us food and shelter for the night, but said that as the moon was up, she could get us put over when her skiff came back. Hungry and fatigued we laid us down on the brown grass, waiting either a scanty meal or the skiff that was to convey us across the river. I had already grated the corn for our supper, run down the chickens and made a fire, when a cry of "Boat

coming" roused us all. We crossed half of the Ohio, walked over Cumberland Isle and after a short ferry found ourselves in Kentucky, the native land of my beloved sons. I was now within a few miles of the spot where, some years before, I had a horse killed under me by lightning.

It is unnecessary to detain you with a long narrative, and state every occurrence until we reached the banks of Green River. We had left Trinity at twelve o'clock of the 15th October, and on the morning of the 18th four travelers descending a hill were admiring the reflection of the sun's rays on the forest-margined horizon. The frost which lay thick on the ground and the fences glittered in the sheen and dissolved away; all nature seemed beautiful in its calm repose; but the pleasure which I felt on gazing on the scene was damped by the fatigue of my son, who now limped like a lamed turkey, although, as the rest of the party were not much better off, he smiled, straightened himself and strove to keep up with us. Poor S. was panting many yards behind and was talking of purchasing a horse. We had now, however, a tolerably good road, and in the evening got to a house where I inquired if we could have a supper and beds. When I came out Victor was asleep on the grass, Mr. Rose looking at his sore toes and S. just finishing a jug of Monongahela. Here we resolved that instead of going by Henderson we should take a cut across to the right and make direct for Smith's Ferry by way of Highland Lick Creek.

Next day we trudged along, but nothing very remarkable occurred excepting that we saw a fine black wolf quite tame and gentle, the owner of which had refused a hundred dollars for it. Mr. Rose, who was an engineer and a man of taste, amused us with his flageolet and frequently spoke of his wife, his children and his fireside, which increased my good opinion of him. At an orchard we filled our pockets with October peaches, and when we came to Trade Water River we found it quite low. The acorns were already drifted on its shallows and the Wood Ducks were running about picking them up. Passing a flat bottom, we saw a large Buffalo Lick. Where now are the bulls which erst scraped its earth away, bellowing forth their love or their anger?

Good Mr. Rose's feet became sorer and sorer each succeeding day; Mr. S. at length nearly gave up; my son had grown brisker.

The 20th was cloudy and we dreaded rain, as we knew the country to be flat and clayey. In Union County we came to a large opening and found the house of a Justice, who led us kindly to the main road and accompanied us for a mile, giving us excellent descriptions of brooks, woods and barrens, notwithstanding which we should have been much puzzled, had not a neighbor on horseback engaged to shew us the way. The rain now fell in torrents and rendered us very uncomfortable, but at length we reached Highland Lick, where we stumbled on a cabin, the door of which we thrust open, overturning a chair that had been placed behind it. On a dirty bed lay a man, a table with a journal or perhaps a ledger before him, a small cask in a corner near him, a brass pistol on a nail over his head and a long Spanish dagger by his side. He rose and asked what was wanted. "The way to a better place, the road to Sugg's." "Follow the road and you'll get to his house in about five miles!" My party were waiting for me, warming themselves by the fires of the salt-kettles. The being I had seen was an overseer. By-and-by we crossed a creek; the country was hilly, clayey and slippery; Mr. S. was cursing, Rose limped like a lame duck, but Victor kept up like a veteran.

Another day, kind reader, and I shall for a while shut my journal. The morning of the 21st was beautiful; we had slept comfortably at Sugg's, and we soon found ourselves on pleasant barrens with an agreeable road. Rose and S. were so nearly knocked up that they proposed to us to go on without them. We halted and talked a few minutes on the subject, when our companions stated their resolution to proceed at a slower pace. So we bade them adieu. I asked my son how he felt; he laughed and quickened his steps; and in a short time our former associates were left out of sight. In about two hours we were seated in the Green River ferry boat with our legs hanging in the water. At Smith's Ferry this stream looks like a deep lake; and the thick cane on its banks, the large over-hanging willows and its dark green waters never fail to form a fine picture, more especially in the calm of an autumnal evening. Mr. Smith gave us a good supper, sparkling cider and a comfortable bed. It was arranged that he should drive us to Louisville in his Dearborn [wagon]; and so here ended our walk of two hundred and fifty miles...

The Baltimore Oriole

No traveler who is at all gifted with the faculty of observation can ascend that extraordinary river, the Mississippi, in the first days of autumn without feeling enchanted by the varied vegetation which adorns its alluvial shores: the tall cottonwood tree descending to the very margin of the stream, the arrow-shaped ash mixing its branches with those of the pecan and black walnut, immense oaks and numerous species of hickory covering with their foliage the densely tangled canes from amongst which at every step vines of various kinds shoot up, winding round the stems and interlacing their twigs and tendrils, stretching from one branch to another until they have reached and overspread the whole like a verdant canopy, forming one solid mass of richest vegetation in the foreground of the picture; whilst wherever the hills are in view the great magnolias, the hollies, and the noble pines are seen gently waving their lofty heads to the breeze.

The current becomes rapid and ere long several of the windings of the great stream have been met and passed, and with these new scenes present themselves to the view. The forest at this place, as if in doleful mourning at the sight of the havoc made on its margin by the impetuous and regardless waters, has thrown over her a ragged veil produced by the long dangling masses that spread from branch to branch over the cypress trees. The dejected Indian's camp lies in your sight. He casts a melancholy glance over the scene and remembers that he is no longer the peaceful and sole possessor of the land. Islands one after another come in sight and at every winding of the stream you see boats propelled by steam ascending the river, and others without such aid silently gliding with the current.

Much might the traveler find to occupy his mind and lead him into speculations regarding the past, the present and the future were he not attracted by the clear mellow notes that issue from the woods, and gratified by the sight of the brilliant Oriole now before you. In solitudes like these the traveler might feel pleased with any sound, even the howl of the wolf or the still more dismal bellow of the alligator. Then how delightful must it be to hear the melody resulting from thousands of musical voices that come from some

neighboring tree and which insensibly leads the mind, with whatever it may previously have been occupied, first to the contemplation of the wonders of nature, and then to that of the Great Creator himself.

Now we have ascended the mighty river, have left it and entered the still more enchanting Ohio, and yet never for a day have we been without the company of the Oriole. Here amongst the pendulous branches of the lofty tulip trees it moves gracefully up and down, seeking in the expanding leaves and opening blossoms the caterpillar and the green beetle which generally contribute to its food. Well, reader, it was one of these pendulous twigs which I took when I made the drawing before you. But instead of having cut it on the banks of the Ohio I found it in the State of Louisiana, to which we shall return.

The Baltimore Oriole arrives from the south, perhaps from Mexico or perhaps from a more distant region, and enters Louisiana as soon as spring commences there. It approaches the planter's house and searches amongst the surrounding trees for a suitable place in which to settle for the season. It prefers, I believe, the trees that grow on the sides of a gentle declivity. The choice of a twig being made, the male Oriole becomes extremely conspicuous. He flies to the ground, searches for the longest and driest filaments of the moss which in that state is known by the name of Spanish beard, and whenever he finds one fit for his purpose ascends to the favorite spot where the nest is to be, uttering all the while a continued chirrup which seems to imply that he knows no fear but on the contrary fancies himself the acknowledged king of the woods. This sort of chirruping becomes louder and is emitted in an angry tone whenever an enemy approaches or the bird is accidentally surprised, the sight of a cat or a dog being always likely to produce it. No sooner does he reach the branches than with bill and claws, aided by an astonishing sagacity, he fastens one end of the moss to a twig with as much art as a sailor might do and takes up the other end, which he secures also, but to another twig a few inches off, leaving the thread floating in the air like a swing, the curve of which is perhaps seven or eight inches from the twigs. The female comes to his assistance with another filament of moss or perhaps some cotton thread or other fibrous substance,

inspects the work which her mate has done and immediately commences her operations, placing each thread in a contrary direction to those arranged by her lordly mate and making the whole cross and re-cross so as to form an irregular network. Their love increases daily as they see the graceful fabric approaching perfection, until their conjugal affection and faith become as complete as in any species of birds with which I am acquainted.

The nest has now been woven from the bottom to the top and so secured that no tempest can carry it off without breaking the branch to which it is suspended. Remark what follows. This nest contains no warming substance such as wool, cotton, or cloth, but is almost entirely composed of the Spanish moss interwoven in such a manner that the air can easily pass through it. The parents no doubt are aware of the intense heat which will exist ere long in this part of the world, and moreover take especial care to place their nest on the northeast side of the trees. On the contrary, had they gone as far as Pennsylvania or New York they would have formed it of the warmest and softest materials and have placed it in a position which would have left it exposed to the sun's rays, the changes in the weather during the early period of incubation being sometimes so great there that the bird looks on these precautions as necessary to ensure the life of its brood against intense cold should it come, while it knows that the heat in these northern latitudes will not be so great as to incommode them. I have observed these sensible differences in the formation and position of the nests of the Baltimore Oriole a great many times, as no doubt have other persons. The female lays from four to six eggs and in Louisiana frequently rears two broods in a season. The period of incubation is fourteen days. The eggs are about an inch in length, rather broadly ovate, pale brown, dotted, spotted and tortuously lined with dark brown.

The movements of these birds as they run among the branches of trees differ materially from those of almost all others. They cling frequently by the feet in order to reach an insect at such a distance from them as to require the full extension of their neck, body and legs without letting go their hold. They sometimes glide as it were along a small twig and at other times move sidewise for a few steps. Their motions are elegant and stately. Their song consists of

three or four or at most eight or ten loud, full and mellow notes, extremely agreeable to the ear.

A day or two before the young are quite able to leave the nest they often cling to the outside and creep in and out of it like young Woodpeckers. After leaving the nest, they follow the parents for nearly a fortnight and are fed by them. As soon as the mulberries and figs become ripe they resort to these fruits, and are equally fond of sweet cherries, strawberries and others. During spring their principal food is insects, which they seldom pursue on the wing but which they search for with great activity among the leaves and branches. I have seen the young of the first brood out early in May and of the second in July. As soon as they are fully able to take care of themselves they generally part from each other and leave the country as their parents had come, that is, singly.

During migration the flight of the Baltimore Oriole is performed high above all the trees and mostly during day, as I have usually observed them alighting, always singly, about the setting of the sun, uttering a note or two and darting into the lower branches to feed and afterwards to rest. To assure myself of this mode of traveling by day I marked the place where a beautiful male had perched one evening and on going to the spot next morning long before dawn I had the pleasure of hearing his first notes as light appeared and saw him search a while for food and afterwards mount in the air, making his way to warmer climes. Their flight is straight and continuous.

This beautiful bird is easily kept in cages and may be fed on dried figs, raisins, hard-boiled eggs, and insects. When shot they will often clench the twig so firmly as to remain hanging fast to it until dislodged by another shot or a blow against the twig.

The plumage of the male bird is not mature until the third spring and I have therefore in my drawing represented the males of the first, second and third years. The female will form the subject of another plate. The male of the first year was taken for a female by my engraver during my absence and marked as such, although some of the plates were corrected the moment I saw the mistake.

The Baltimore Oriole, although found throughout the Union, is so partial to particular sections or districts that of two places not twenty miles distant from each other, while none are to be seen in

the one, a dozen pairs or more may be in the neighborhood of the other. They are fondest of hilly ground, refreshed by streams.

[The Baltimore Oriole, *Icterus galbula*, appears in Plates 12 and 433 of *The Birds of America*.]

Episode: Niagara

After wandering on some of our great lakes for many months, I bent my course towards the celebrated Falls of Niagara, being desirous of taking a sketch of them. This was not my first visit to them and I hoped it should not be the last.

Artists (I know not if I can be called one) too often imagine that what they produce must be excellent, and with that foolish idea go on spoiling much paper and canvas when their time might have been better employed in a different manner. But digressions aside—I directed my steps towards the Falls of Niagara with the view of representing them on paper for the amusement of my family. Returning as I then was from a tedious journey and possessing little more than some drawings of rare birds and plants, I reached the tavern at Niagara Falls in such plight as might have deterred many an individual from obtruding himself upon a circle of well-clad and perhaps well-bred society. Months had passed since the last of my linen had been taken from my body and used to clean that useful companion, my gun. I was in fact covered just like one of the poorer class of Indians and was rendered even more disagreeable to the eye of civilized man by not having, like them, plucked my beard or trimmed my hair in any way. Had Hogarth been living, and there when I arrived, he could not have found a fitter subject for a Robinson Crusoe. My beard covered my neck in front, my hair fell much lower at my back, the leather dress which I wore had for months stood in need of repair, a large knife hung at my side, a rusty tin box containing my drawings and colors and wrapped up in a worn-out blanket that had served me for a bed was buckled to my shoulders. To everyone I must have seemed immersed in the depths of poverty, perhaps of despair. Nevertheless, as I cared little about my appearance during those happy rambles, I pushed into the sitting-room, unstrapped my little burden and asked how soon breakfast would be ready. In America no person is ever refused entrance to the inns, at least far from cities. We know too well how many poor creatures are forced to make their way from other countries in search of employment or to seek uncultivated land and we are ever ready to let them have what they may call for. No one knew who I was, and the landlord looking at

me with an eye of close scrutiny, answered that breakfast would be on the table as soon as the company should come down from their rooms. I approached this important personage, told him of my avocations and convinced him that he might feel safe as to remuneration. From this moment I was, with him at least, on equal footing with every other person in his house. He talked a good deal of the many artists who had visited the Falls that season from different parts, and offered to assist me by giving such accommodations as I might require to finish the drawings I had in contemplation. He left me and as I looked about the room, I saw several views of the Falls by which I was so disgusted that I suddenly came to my better senses. "What!" thought I, "have I come here to mimic nature in her grandest enterprise and add my caricature of one of the wonders of the world to those which I here see? No—I give up the vain attempt. I shall look on these mighty cataracts and imprint them where alone they can be represented— on my mind!"

Had I taken a view, I might as well have given you what might be termed a regular account of the form, the height, the tremendous roar of these Falls; might have spoken of people periling their lives by going between the rock and the sheet of water, calculated the density of the atmosphere in that strange position, related wondrous tales of Indians and their canoes having been precipitated the whole depth—might have told of the narrow, rapid and rock-bound river that leads the waters of the Erie into those of Ontario, remarking *en passant* the Devil's Hole and sundry other places or objects—but supposing you had been there, my description would prove useless and quite as puny as my intended view would have been for my family; and should you not have seen them and are fond of contemplating the more magnificent of the Creator's works, go to Niagara, reader, for all the pictures you may see, all the descriptions you may read of these mighty Falls, can only produce in your mind the faint glimmer of a glowworm compared with the overpowering glory of the meridian sun.

I breakfasted amid a crowd of strangers who gazed and laughed at me, paid my bill, rambled about and admired the Falls for a while, saw several young gentlemen sketching on cards the mighty mass of foaming waters and walked to Buffalo, where I purchased

new apparel and sheared my beard. I then enjoyed civilized life as much as, a month before, I had enjoyed the wildest solitudes and the darkest recesses of mountain and forest.

John James Audubon to Charles-Lucien Bonaparte
"Nature is all alive in our woods…"

Audubon first met Prince Charles-Lucien Bonaparte, son of Lucien Bonaparte and nephew of Napoleon, on a visit to Philadelphia in 1824. The young Frenchman was making a study of American birds, preparing an American Ornithology *to update Alexander Wilson's work. He and Audubon briefly considered joining forces, but the hostile response of Bonaparte's engraver, Alexander Lawson, discouraged the partnership. The two men continued to correspond, in English, for the next several decades.*

Beech Woods, West Feliciana Parish, Louisiana
14 April 1825

My dear sir,

Your very polite answer of the 15th ultimo reached me last evening; please to accept my thanks for your civilities. The complaints of Mr. [Charles-Alexandre] Lesueur to me were only such as I deserved, for had I watched your movements whilst in New York, I now think I certainly could have had an opportunity of speaking to you and remitting also to you the papers I had—but I hope these little [illegible] and disappointments will rarely happen again and that time will prove to you that I am sincere and that probably my fault most predominately is too much frankness towards all those who have anything to do with me.

[I am] anxious always to see all articles connected with natural history correct in all their parts. I will here assure you that all the drawings of birds I have made for upwards of twenty years have all been so exactly measured with the compass in all their parts & even feathers . . . I shall be sorry as long as I live [if] any alterations should have been made to my drawings by such a person as Mr. Lawson whom you will know is by no means my friend. I have often repeated to you that I painted birds and studied their habits for pleasure's sake. Indeed, before I went to Philadelphia, the idea never entered my head to have anything to do with Publications &c.

I shall feel really highly honored to receive from your hands the

first volume of your work. I am already well aware that as far as science is connected with it nothing will be wanting. I shall look on it as a gift of value and could I return such a compliment in the same manner I believe *now* that I would count myself happy *then*.

I heard through my good & estimable friend Richard Harlan that Mr. Titian Peale had gone to the Floridas for you; the choice you have made I think could not have been bettered; young, of excellent morals, and attached to natural scientific pursuits as he is, you may and no doubt will expect many new & interesting findings as well as important facts.

The season has been opened here with an unusual degree of brilliancy; Nature is really all alive in our woods. The 20th of last month the Wood Thrush [returned?], the Martins had eggs, the *Hirundo rustica* [Barn Swallow] vividly was leaving and the *Falco peregrinus* [Peregrine Falcon] swimming easily through the air. The first of this month young Black-headed Titmouses were following their parents abroad from the nest and thousands of Humming-birds sucked the Florida jasmines. I have drawn much since I saw you for posterity.

Could I convince myself entitled to the honor of presenting one of my efforts at copying birds to your Lady I would beg of you such a favor.

I have, a few minutes since, forwarded to Bayou Sarah Landing two boxes of plants for yourself & Mr. R. Haines and a barrel for Richard Harlan containing [an] alligator and sundry lizards in spirits . . .

Thermometer of twelve o'clock at 86.

General Lafayette [then touring the United States in advance of the fiftieth anniversary of the Declaration of Independence] passes Bayou Sarah this day on his way to Natchez—

John James Audubon to Charles-Lucien Bonaparte
"My work proceeds as fast as it can..."

Bayou Sarah, Louisiana
1 October 1825

My dear sir,

I was as much surprised as pleased at receiving last evening only, your kind letter dated Saratoga July 28th. The routes it followed must have indeed been circuitous; it appears that your letter came by sea to New Orleans, as no other postmarks are affixed to the direction, and as it came from thence to this place. It would be difficult for me to express my thanks to you, as I feel them, for your friendly presentation of the first volume of your work; believe me, my dear sir, I very seldom in my life felt a greater pleasure. I sincerely hope that ere long I shall have it from Dr. DeKay, to whom you say you gave it. If my account of the Wild Turkey has been useful to *you*, I am the more pleased with it: I assure you I never expected you to publish any portion of it, from reports made me of the little influence my work had either with you or the scientific academicians of Philadelphia.

I have indeed many important curious facts yet in store respecting that fine bird and should ever my work be published they will fully appear. It would be strange indeed if a man who spends fully three-fourths of his life in the forests in pursuit of their featherly inhabitants was not apt to see much of their manners, and that so repeatedly as to retain the principal outline of these habits when written on the spot. I have often laughed off the conclusions brought forward by those who knew me still less than they knew themselves when of the expiration of a few weeks' sight of me tried to dispel the favorable opinion created in the mind of others by saying that Mergansers could never have been fed on corn!! &c. &c. *Mon cher monsieur, la vérité se découvre toujours* [my dear sir, the truth will out], except indeed when the influenced ignorant never leaves the walks of cities where Nature is much more altered and contaminated than the flesh of the Merganser fed on corn.

I am sorry you should have felt so much anxiety about reproducing the *Gracula* either from my drawing or that of any other person

whatever, yet I can vouch the size of birds drawn by me as correct, and that I call *Gracula barita* [Audubon's Great Crow Blackbird]. Please to recollect what I told you of a larger bird common in the Floridas & plenty in the West Indies known by the name of *Bous de Petun*—whatever you have done or wrote employing my name is received thankfully by me. As soon as I receive your volume I shall write you so.

I have no doubt that your Journey to the Falls of Niagara has been very agreeable, and if you have rambled as I did in the Florida swamps, your ornithological collection has no doubt been much augmented. I need not say to you that were you to come to this part of Louisiana I should be happy in trying to promulgate your arrival among the French hunters and to procure for you the specimens you might want if in season.

I have . . . now concluded to leave the U. States sometime in spring for Europe, I shall first land in England and exhibit my drawings there; if not successful in London I shall go to the Continent, pass through Brussels & proceed to that capital where I fervently wish the great Napoleon was still existing, Paris.

You have frequently made me offers of letters of recommendation or introduction; should you on the receipt of this think one still worthy such attentions, please to forward me some. My Work proceeds as fast as it can under the efforts of an humble citizen destitute to a degree of many advantages derived by others better situated, but my courage is not the least abated and every new bird enlarges my collection with the progressive pleasure that cannot fail following a man impelled by natural disposition to study and to try to imitate those beauties of Nature.

I will send you by the first safe conveyance a Drawing for your Lady; her acceptance of it is the highest praise ever bestowed on them. It is probable it shall be accompanied by a few skins of birds for you—in my last excursions to the great lakes I killed seven Snake Birds [Anhinga] but the weather was so hot that I could not bear the odor of their flesh and gave up skinning them—those birds, although passengers here, breed abundantly within ten miles of this. I would have wrote to you sometime since, but having no acknowledgement from you of my letters I became fearful of being importunate . . .

The weather is now beautiful and cool—

The beautiful Wood Ducks are assembled in juvenile congregations and the gunners are busily engaged in killing them for the flavorful flesh of the young. [Alexander] Wilson says the birds never go in flocks. I wish that great man was alive and had been with us last week to see hundreds in a flight & again, though Mr. [William] Bartram...says that Wood Ducks go singly, I have seen, and any man can in our lakes at this season, flocks of thousands clearing a lake of its fish by wading along the margins, and so innocent are they that a man might load a horse with them in a few hours...

PART III:
MR. AUDUBON ARRIVES

Ann Bakewell Gordon to Euphemia Gifford
"Mr. Audubon arrived with all his drawings…"

Liverpool, England
5 August 1826

My dear Madam,

Since I wrote last I have had a letter from John Bakewell dated New Orleans 13th May…He seems to be in good health and spirits.

His letter was brought by Mr. Audubon who arrived with all his drawings about ten days ago. He (Mr. A.) brought a great many letters to persons of the first respectability in this place, and he has already received a great deal of attention on account of the beauty of his collection of birds. I wish you could see them. He leaves here in a few days for London and Paris, but whether he will go to Duffield [where E.G. lived] or not I do not know.

I have heard from Mrs. [Eliza Bakewell] Berthoud [in Shipping-port, Kentucky], several times lately. She has had a good deal of trouble within the last few months. Mr. Berthoud in [New] Orleans, she in the family way, the water 4 feet in the house for several days owing to the sudden rise of the Ohio, the departure of her little daughter to school to Pittsburgh which is 400 miles from her, and lastly her youngest son, a sweet child between three and four years old, was seized with an inflammatory fever which deprived him of the use of his limbs so much that he could not walk, but she tells me as he seems to improve daily, she is in hope he will recover the use of it in time. My sister Sarah is at Hopkins-ville and my brother Thomas in Cincinnati. My youngest brother, William, is the only member of the family who is near her now…

Since writing the above I have seen Mr. Audubon, who says he wishes to visit you, and I daresay he will be with you soon after the receipt of this. You will find him pleasant in his manners and I hope much improved in character. He is anxious to take some views of the scenery around Matlock for my sister and perhaps he may remain several days in your neighborhood…

John James Audubon to Victor Gifford Audubon
"It seems I am considered unrivaled..."

Liverpool, England
1 September 1826

My dear Victor,

I have been in England now upward of a month and am quite well. I have been received most kindly and I think that I have much in my favor now towards enabling me to do well with my collection. The letters that I brought from [Henry] Clay, Dewitt Clinton, [Andrew] Jackson, General William Clark, &c., &c., &c., have been all received with a due regard, I assure thee, and I am in miniature in Liverpool what Lafayette was with us [i.e., celebrated on his recent triumphal tour of America]...My drawings are exhibited at the Liverpool Royal Institution and will continue so this week. The proceeds are far beyond my expectations, and it seems that I am considered unrivaled in the art of drawing even by the most learned of this country. The newspapers have given so many flattering accounts of my productions and of my being a superior ornithologist that I dare no longer look into any of them.

I shall continue to exhibit my works through the three Kingdoms and then proceed to the Continent. I have no doubt that this method will pay well and that it will not prevent me from my publication.

I have not heard from our dear friend, your Mamma, since I left. Pray write to her often and tell her to write to me and do thou also. Direct to the care of Messrs. Rathbone Bros. & Co., Liverpool.

My dear son let me now request you to pay great attention to music, drawing in my style and to read as much as possible—talents are regarded more than wealth and if both are together how happy is the possessor.

You would be surprised to see the marked attentions paid me wherever I go by the first people of Liverpool. My exhibition attracts the *beau monde* altogether and the lords of England look at them with wonder—more so I assure thee than at my flowing

curling locks, that again loosely are about my shoulders. The ladies of England are ladies indeed—beauty, suavity of manners and the most improved education render them desirable objects of admiration.

I will leave this [place] on Monday for Manchester. The president of the Royal Institution here gives me a letter to the one there and so on throughout the country. This procures me the Exhibition Room gratis. I have letters to introduce me to the famous critics [and] reviewers of Edinburgh—to Sir Walter Scott, Thomas Lawrence, Maria Edgeworth, Anna Moore, Baron de Humboldt, [Conrad Jacob] Temminck and 500 besides I believe. I shall go more game shooting at the seat of the famous Thomas Coke and at the one of Selby's in Northumberland.

Remember me to your uncle [Nicholas Berthoud, under whom Victor was clerking] and ask him to write to me. I have written to him since here. Ask my beloved sister, your Aunt Eliza, to put a few words for me either in yours or your Uncle's letters to me. Remember me to all besides who are not ashamed of my being a relation or an acquaintance . . .

John James Audubon to Lucy Audubon
"My situation borders on the miraculous..."

Edinburgh, Scotland
21 December 1826

My beloved wife,

After postponing day after day for the last two weeks writing to thee full of hopes that each new day would bring some tidings of thee or of someone connected with me in America I am forced to sit and write filled with fear and sorrow. Many of the vessels I have wrote by have returned from America with full cargoes but nothing from thee—it is the more surprising because, a fortnight since, Dewitt Clinton answered a letter of mine dated Manchester and enclosed one of recommendation to General Lafayette.

My situation in Edinburgh borders almost on the miraculous; without education and scarce one of those qualities necessary to render a man able to pass through the throng of the learned here, I am positively looked on by all the professors & many of the principal persons here as a very extraordinary man. I brought from Liverpool 13 letters of most valuable introduction. After I had delivered them and my drawings had been seen by a few of those persons, I requested them to engage all their acquaintances to call on me and see them also. For that purpose I remained each day for a week at my lodgings from 10 till 2 and my room was filled constantly by persons of the first rank in society. After that, the Committee of the Royal Institution having met, an order was passed to offer me the Exhibition Rooms gratis for some weeks. My drawings were put up in the splendid room; all the newspapers took notice of them in a very handsome manner, and having continued to do so constantly, the rooms have been well-attended when the weather has in the least permitted it. Last Saturday I took in £15. It will continue open to the last of Christmas week when I will remove them to Glasgow, 50 miles from here where I expect to do well with them. I have had the pleasure of being introduced to several noblemen here and have found them extremely kind indeed. About a fortnight since, Sir William Jardine came to spend a few days here purposely to see

me—he was most constantly with me—he and Mr. [Prideaux John] Selby are engaged in a general ornithological work and as I find I am a useful man that way, it is most likely that I shall be connected with them, with a good share of credit and a good deal of cash. They both will be in in a few days when this matter will be discussed over at length and probably arranged.

It is now a month since my work has been begun by Mr. W. H. Lizars of this city. It is to come out in Numbers of 5 prints [each], all the size of life and in the same size paper of my largest drawings, that is called double elephant. They will be brought up & finished in such superb style as to eclipse all of the kind in existence. The price of each Number is two guineas, and all individuals have the privilege of subscribing for the whole or any portion of it. Two of the plates were finished last week; some of the engravings, colored, are now put up in my exhibition rooms and are truly beautiful. I think that the middle of January, the first number will be completed and underway to each subscriber. I shall send thee the very first, and I think it will please thee. It consists of the Turkey Male, the Cuckoos in the papaws and three small drawings that I doubt thou dost not remember, but when thou seest them I am quite sure thou wilt. The little drawings in the center of those beautiful large sheets have a fine effect and an air of richness and wealth that cannot help insure success in this country. I cannot yet say that I will ultimately succeed but at present all bears a better prospect than I ever expected to see, I think, this under the eyes of the most discerning people in the world—I mean Edinburgh— if it takes here it cannot fail anywhere.

It is not the naturalist that I wish to please altogether, I assure thee; it is the wealthy part of the community: the first can only speak well or ill of me, but the latter will fill my pockets.

The University of Edinburgh having subscribed, I look to the rest of them—11 in number—to follow. I have here strong friends who interest themselves considerably in the success of my work [and] who will bear me a good hand, but I cannot do wonders at once. I must wait patiently until the first number is finished & exhibit that for although my drawings are much admired, if the work itself was inferior nothing could be done, and until I have it I cannot expect many subscribers.

As soon as it is finished I will travel with it over all England, Ireland and Scotland and then over the European Continent, taking my collection with me to exhibit it in all principal cities to raise the means of supporting myself well, and would like most dearly to add thyself & my sons also but can I or can I not expect it? Alas it is not in my power to say; it does not depend on me, or it would soon be accomplished. The first professor of the place, Mr. [Robert] Jameson, the conductor of the [*Edinburgh*] *Philosophical Journal*... gives a beautiful announcement of my work in his present number along with an account of mine of the Turkey Buzzard. Dr. [David] Brewster also announces it with an introductory letter to my work and professor of natural philosophy John Wilson also in *Blackwood's Magazine.* These 3 journals print upwards of 30,000 copies so that my name will spread quickly enough. I am to deliver lectures on natural history at the Wernerian Society at each of its meetings whilst here and I will do the same at all the cities where I will be received [as] an honorary member. Prof. Jameson, who also is professor of natural history, told me that I would soon be a member of all the societies here and that it would give my work a great standing throughout Europe. In the event of ultimate success I must have either my son or some other person to travel for me to see about the collection of payments for the work and to procure new subscribers constantly. As I conceive my Victor a well-fit man for such business, and as it would at once afford him the means of receiving a most complete education and a knowledge of Europe surpassing that of probably any other man—in case I say of success I will write for him immediately, when I hope no more constraint or opposition will be made to my will. I am now better aware of the advantages of a family in unison than ever and I am quite satisfied that by acting conjointly and by my advice we can realize a handsome fortune for each of us. It needs but industry & perseverance. Going to America is mere song and I now find that most valuable voyages could be made by procuring such articles as are wanted here and most plentiful there.

It is now about time to know from thee what thy future intentions are. I wish thee to act according to thy dictates but wish to know what those dictates are. Think that we are far divided and that either sickness or need may throw one into a most shocking

situation without either friend or help, for as thou sayest thyself, "the world is not indulgent." Cannot we move together and feel and enjoy the natural need of each other? Lucy, my friend, think of all this very seriously. Not a portion of the earth exists but will support us amply, and we may feel happiness anywhere if careful. When you receive this sit and consider well. Consult N. Berthoud, thy son Victor or such a person as Judge Matthews. Then consult thyself and in a long, plain, explanatory letter give me thy own heart entire. In this country John can receive an education that America does not yet afford, and his propensities are such that, attached to me, he would be left at my death possessor of a talent that would be the means of his support for life. I earnestly begged of thee in all my letters since I discovered that I was advancing in the world to urge him by all means to set to and begin a collection of drawings of all he can, and not to destroy one drawing, no matter how indifferent, but to take all from nature. I find here that although I have drawn much I have not drawn half enough. Tell him to employ my method of putting up birds &c.; to draw fishes, reptiles, eggs, trees, landscapes, all—all he can draw—it will be most valuable to him if he be industrious and work well and closely. By the time he comes of age he would be quite able to have a collection that would be a little fortune for him to begin upon.

I was much surprised at hearing of Charles Bonaparte in Liverpool last week. He arrived on the very vessel that took thy watch to New York—the *Canada*.

The difference of manners here from those of America are astonishing. The great round of company I am thrown in has become fatiguing to me in the extreme and does not agree with my early habits. I go to dine out at 6, 7 or 8 o'clock in the evening and it is one or two in the morning when the party breaks up; then painting all day with my correspondence that increases daily. My head is like a hornet's nest and my body wearied beyond calculation, yet it has to be done. I cannot refuse a single invitation.

Edinburgh must be the handsomest city in the world. Thou wouldst like it of all things I think for a place of residence. When I send thee the first number of the *Birds of America* I will also send a book given me containing 51 views of this place. In the event of you all removing from America, keep those things, I beg...

I regret exceedingly not having brought barrels of reptiles of all sorts with me. I could get fine prices, I assure thee, and also for rare bird skins [and] seeds of plants—but I thought I had enough to attend to.

I very frequently spoke to thee respecting the very great kindness I have experienced from the family Rathbone of Liverpool. This kindness they continue to me so constantly and in such a manner that I feel quite anxious to repay them through our humble means. William Rathbone is one of the principal members of the Royal Society of London and one of the wealthiest merchants there. I wrote thee from his mother's house, dated Green Bank, to forward him some seeds, flowers, leaves &c. and some segments of the largest trees. I hope that thou wilt attend to these things, for in the event of thy coming to England thou would land and come to their care and they would be as kind to thee as they have been to me. The seal with which I now close all my principal letters was given me by Mrs. Rathbone, the mother of that excellent family, and accompanied by a letter that would honor any man living. Keep always directing thy letters to them and write to Mrs. R. herself; she will be a most valuable friend to thee.

Since here, I have painted 2 pictures in oil now in the exhibition. One contains 11 Turkeys with a landscape; the other is my *Otter in a Trap*. My success in oil painting is truly wonderful—I am called an astonishing artist &c. What different times I see here, courted as I am, from those I spent at the Beech Woods where certain people scarcely thought fit to look upon me . . .

I must now close this and bid thee adieu for a while. I have to copy it as I do all I write. The task is an arduous one, but the consolation of seeing what I say to thee from time to time compensates amply. I very frequently forward thee the newspapers; each of these contain my name. I dined at the Antiquarian Society and was toasted by Lord Elgin. Thou wilt see it in the papers I sent thee. I would have forwarded thee books and other objects but [am] uncertain if thou wouldst not come to [England] as soon as my plans are solidly fixed. I thought not to do so, but I assure thee I cannot at present conceive failure on my part, and may God grant that it may be true. If I can procure in the whole of 2 years, 300 subscribers we will be rich indeed. God forever bless thee—

remember me kindly to all about thee—kiss my son and believe me forever

Thine husband and friend,
John J. Audubon

[Added the next day]

Thou hast here a copy of my last because it contains much of all sorts. But my sweet friend the very morning that I forwarded thee the original, I had the pleasure of receiving two kind letters from thee forwarded me here from London by Mrs. Middlemist. I need not say how gratified I was and how happy I felt at knowing thee quite well and our dear sons also. I sincerely hope that thou wilt continue thy rides on horseback every fair day and walk a great deal besides in the rich magnolia woods about thee. I never felt so much in my life the want of a glance at our forests as I now do. Could I see thee but a moment there, hear the mellow mock bird or the wood thrush to me always so pleasing, and be able to give thee a kiss of affection—ah, my wife, how happy I would again be.

Since I received thy letters (they are dated 9th and 27th August) I have felt delighted at the idea of thy probably coming to Europe sometime next summer. But my Lucy, we must not hurry too much. I wish to sound all well and be perfectly assured of the general ultimate success of my work. The engravings are proceeding apace and are thought beautiful. My exhibition closes here on Saturday next and I will remove it either to Glasgow or to Newcastle-on-Tyne, but this place will continue my residence until my first number is quite finished.

I received a kind letter from [Thomas] Sully a few days ago, dated only 29 days [previously], enclosing one to Sir Thomas Lawrence. I continue to be well with everybody for an astonishing round of company. I will have copied here for thee some of the invitations I received; it will give thee an idea of the circles I move in—I was elected a member of the Society of Arts & Sciences a few days ago by acclamation, and when I was presented to the Wernerian Society (this is the natural [history] society) for an honorary member[ship] I had the same acclamation, and no doubt I will be elected next meeting, for the President told the committee that on such occasions the usual time wanted for consideration

must be laid aside. I have the honor of being at the Royal Academy meeting; the halls are beautiful indeed. The great British ornithologist Sir William Jardine and Mr. [Prideaux John] Selby have spent two days with me drawing in my style. I am very much pleased with both and would have gone to Jardine Hall to spend a week but I am really too much engaged at present... I wish I could see John to tell him to draw all he can, for his and my sake.

I expect to hear from thee now very shortly through Messrs. Rathbone, to whom always direct [correspondence] at Liverpool. I want to know how thou art pleased with thy watch &c. and thy Matlock spars. I hope thou wilt like the book I now send thee; it will give thee an idea of the beauty of Edinburgh. Do not forget to collect acorns of all sorts and all other kinds of seeds and forward them to Mrs. Rathbone at Liverpool. Send a great quantity, as all the noblemen are pleased to have some, and I will have them sent here. I send thee very frequently parcels of newspapers. They all contain my name somewhere and it will be a pleasure for thee to read them. I wish thou wouldst write every week and enter in any little details thou likest. Tell Friend [Augustin] Bourgeat that I will send him a pair of the best English hounds when I go to Liverpool again in about 6 weeks. I think John might use my gun if he would be careful of it and keep it particularly clean. Does he play on the piano now? Send me some of his drawings; I wish to see what Charles Middlemist has made of him. I feared myself that he might not be quite as good a teacher as I wished and for his own sake hoped he might be. I will now again bid thee farewell—do take especial care of thy sweet self for my sake.

Thy health is uniformly drank wherever I go and at Mr. Lizars, it is expressed thus: "*Mr. Audubon, let us drink Mrs. Audubon and the bairns!*" I have not dined at my lodgings for upwards of a fortnight one single day. My Journal would amuse thee. I herein send thee the results of Mr. [George] Combe, the phrenologist, about my skull. It proves to resemble that of Raphael very much, and I have been astounded at the merit of the science through some particular observations that the gentleman and others have made about my propensities and faculties.

Mr. Selby will take me to the Duke of Northumberland when I call on him at his house on my way to Newcastle; he will, Mr.

Selby says, subscribe to my work. The number allotted to Scotland is now filled and I bid fair to have more, but I will take nothing for granted until within my grasp. I will exert myself much—depend on it—to ensure success, and may God grant that I will reach it. I want thee to send me by first opportunity as much of thy hair as will make me a cord for my watch. The silver one that I wear now measures three feet and is about the size of that: ⋙⋙⋙⋙⋙⋙ but a mere thread in thickness will content me much as I wear a guard besides. I have come to fine dressing again—silk stockings and pumps, shave every morning and sometimes dress twice a day. My hairs are now as beautifully long and curly as ever and, I assure thee, do as much for me as my talent for painting. I began this morning a painting in oil of 14 Pheasants on the wing attacked by a fox that I wish to finish for the exhibition of the Royal Academy at London by March, when I will be there myself. Read this to Johnny for my sake more than once.

Copies of invitations: "Lady Hunter requests the honor of Mr. Audubon's company at dinner upon Saturday, 16th December, at six o'clock, 16 Hope Street, Friday, 8th December."

"30 Abercrombie Place—Mr. Russell requests the honor of Mr. Audubon's company to supper on Monday, the 18th of December, at ½ past nine o'clock after the meeting of the Royal Society."

"Lord & Lady Morton request the pleasure of Mr. J. Audubon's company at Dalmahoy on Wednesday, the 27th of December, to dine and remain all night. Lord Morton's carriage will call for Mr. Audubon at one o'clock that day if convenient to Mr. Audubon. Lord Morton begs Mr. Audubon will bring a Portfolio of his drawings of birds with him and he requests to see particularly the *Hawks Killing Game* [and] the *Death of General Montgomery*. A note sent by post to answer this, directed to the Earl of Morton, Dalmahoy, will arrive safe. Dalmahoy, Dec. 20th."

God for ever bless my Lucy.

John James Audubon to Lucy Audubon
"I unbuckled the great Book of Nature..."

Dalmahoy, the seat of the Earl of Morton, 8 miles from Edinburgh
27 December 1826

There is a date for you, my sweet wife. Thy husband has leaped from America to Liverpool & from there to Manchester, Bakewell, Matlock, Buxton, twenty other places besides; then to Edinburgh, and now is seated at a sweet little table in the yellow bedchamber at the Earl of Morton's! But in this fine room I am quite alone, I believe, and will write for thy sake and that of our dear sons a regular account of this day. After my Breakfast, not anxious to begin [painting] another Pheasant, I called on Mr. Lizars who was much engaged. I saw the ladies and bid them farewell for one day. The morning being longer than usual, I called on Messrs. [John and Patrick] Syme, the painter [i.e., John] the one who was unwell. The other being absent, my visit extended only to my walk to their door & I returned to my lodgings to make ready to pay a visit to an earl and some countesses. All this did not go on without thinking of thee a good deal; indeed, I thought of other people besides thee— my good friend Mrs. Rathbone was about me and so [also] her dear [daughter] Hannah. The Quarry Bank family and the Dockrays all visited me whilst my razor was smoothing my chin, but I thought of thee the most. I had to pack a box for thee...I did all this assisted by D. Lizars and brother and I wished it a good voyage to thee.

Now we three had a luncheon—some fried oysters, some drink and some cake—and were still all at work thus when [Audubon's landlady] Mrs. Dickie opened my room door and said, "Lord Morton's carriage, Sir." Well, I was ready. We shook hands all round, my portfolio was taken off and I, after having washed my hands & walked downstairs, touched lightly the arm of the waiter, who opened the carriage door & jumped on a large soft seat lined with purple Morocco. The carriage moved—yes, my Lucy, the carriage moved but upon my word I now moved as never such before. The ship that under easy sail glides slowly on an even sea has more fatiguing motion and had I not been fully persuaded

(being awake) that it was a carriage I was in, I would have thought myself gently wafted thru the air in a swinging hammock. It passed the Castle, through Charlotte Square, through Coats Crescent and along the Glasgow road for eight miles so swiftly that my watch had just changed the hour to another when the porter pushed open the gates of Dalmahoy.

I now began thinking of my meeting a man who has been great chamberlain to the late Queen Charlotte, for I was not so terrified at meeting the countess—her eyes, the day I had seen her at the Royal Institution, spoke softness & amiability of disposition—but the chamberlain I could not help dreading to encounter. "And why, my dear, I would not?" No thou wouldest not because thou are a well-bred woman but I do because I am a fool. All this did not stop the carriage from proceeding smoothly round a great circle; neither did it stop my eyes from seeing a large square half-gothic building with two turrets in front surmounted with great lions and all the signs of heraldry belonging to the great Lord Morton. The carriage has stopped, it is opened, a bell is rung; a man in livery unfolds a large door and I walk in, giving my hat & gloves and my American stick that by the bye never leaves me when I do not leave it myself. Now I am led through this hall & upstairs. My name is given and I enter the drawing room of the Earl of Morton. The Countess runs to me, then returns to her lord & presents him to me, my Lucy—yes, him to me! I look—I stare— I am astonished; I have before me another Richard Coeur de Lion, for positively I had expected nothing less. I had formed an idea that a chamberlain & an earl must be a man able to cleave worlds in two. Oh my imagination, where dost thou lead me to! Why, my dear wife, I saw a small slender man, tottering on his feet, weaker than a new-hatched partridge, welcoming me to his hall with tears almost trickling from his eyes. He held one of my hands and attempted speaking, but this was difficult; his good lady was rubbing his other hand. I saw at a glance his situation & begged he would be seated; this was done and I was relieved. The Countess of Balcarres [was] introduced also, and I at last seated my body on a sofa that I thought would swallow me up as this downy bed swelled around me.

Now I am looking fearfully around—what a room—full 60 feet

by 30, all hung with immense paintings on a solid purple ground. All was purple about me. The tables were covered with various books & instruments: telescopes, drawing apparatus with thousands of ornaments. The Queen of England fronting Marie of Scots; a chamberlain was here, a duke there, and in another place I could see a beautiful head of Rembrandt. Claude Lorrain had some landscapes here also. Vandyke had not been forgotten & Titian gave a luster to the whole. I rose and took a closer view. The Countess explained all to me, but conceive my surprise when on looking through the middle window I saw at the horizon an object that was no less attractive than any about me: the castle and city of Edinburgh a complete miniature 8 miles off, making its way to the north through avenues and over pieces of water and fields innumerable.

Now, my Lucy, I am told that luncheon is ready. What, said I to myself, luncheon again? I am sure, if my friends complain of my not eating much, they must at all events allow that I eat sufficiently often. Well, to luncheon we go, the Countess of Balcarres rolls Lord Morton in his castored chair and I give my arm to Lady Morton. We cross a large antechamber and enter a dining room also quite rich in paintings and at present with a sumptuous repast. I eat again and drink again and in the middle of all this, three gentlemen make their appearance. They were visitors at the hall also, Messrs. Hays, Ramsay, and a young clergyman. This luncheon over, we had to see my drawings. The lord was rolled into a good situation for light and I again unbuckled the great Book of Nature. I am not going to repeat praises my Lucy for I am quite sickened at the sound. The drawings seen, we adjourn to the drawing room again. The Countess desires to receive a lesson of drawing from thy husband tomorrow and I acquiesce with great satisfaction. Conversation becomes now more general; I gradually feel at ease and all goes on smoothly. The Countess is about thy age; thus I save you both from being called old, as you are both quite young enough to delight a husband. She is not what men call handsome nor beautiful, but she is good-looking, has a good form, fine, clear, fresh skin and eyes, Lucy, that I dared not meet they were so dark. Her conversation is frequently interrupted by a natural impediment but it gives more spirit to all she says and

she is certainly a very superior woman. As ladies are sometimes concerned about another's dress, the Countess, I will tell thee, was then enrobed in a rich crimson gown. Her mother was dressed in black satin.

Now Lucy, it had become 6 in the afternoon. I had taken a short walk about the grounds with the gentleman and returned to this hall when I was asked by the Countess if I wished to see my room. I knew that this meant that to dress for dinner was now necessary and I followed a gentleman waiter to this room, who on hearing his mistress say the "Yellow Room," pointed the way to me. When I came in, a good fire of wood was lighted. My [illegible] was warming in front of it; my shoes had been unpacked, as well as my night apparel. I begged to be left alone and I looked around me. All was truly yellow in the Yellow Chamber; it might have been called a parlor in some other countries. The bed for me this night was ornamented with a crown and was large enough to receive 4 of my size. A sofa was at the foot of it, large armed chairs on each side the fire, a table containing a working desk with all ready and all that I never use anywhere. My toilet is soon over, thou knowest—for in my opinion it is a vile lot of time that spent in arranging a cravat with as much care as a hangman does his knot—and I was down again in a moment.

"Ring the bell, Mr. Hays," said the Countess, who now is dressed superbly in white satin. A waiter came and dinner is ordered. It is now seven, and I again lead the Countess under my arm and the Earl is again rolled in his chair. I set by the mother's side. Mr. Hays officiates as a master and I dine again for the third time this day. The waiters, Lucy, are all powdered & draped in rich, red clothes all liveried over excepting one who has black clothes on and who gives plates by handling them with a neat napkin without touching them. Positively, after one hour, the ladies & the lord retire and we the gentleman visitors set to talk & drink wine. We talk entirely of antiquities. Mr. Hays is a deeply learned man, an original besides & quite interesting in his manners. At 10 we joined the Countess again, but the Earl has retired for the night, and now that we have been looking at the signatures of the kings of old— of Mary, Henry, James &c.—and examined a cabinet of ancient coins & 12 o'clock is come, the ladies bid us goodnight by shaking

all our hands. We were then left alone and to settle the coffee that we have drank we drank now Madeira wine. What a life, oh my Lucy. I could not stand this; I prefer my primitive woods after all, but as I hope this life will enable me to enjoy them at a future period I bear it patiently. I leave the gentlemen at their wine and cakes & have come to my Yellow Chamber. Now Lucy, I have prayed on my knees, my God to grant thee well, and I will go to bed, sweet friend—good night.

Daylight comes, my Lucy, and I get up from a bed where awake & without a wife [I feel] very stupid. I opened all the yellow curtains & visited my room by day. Three doors besides that of my entrance were in sight. The spirit of seeking new adventures prompted me to open one. Singular: a neat little closet lighted by a high narrow slip of a gothic window was before me & in a moment I discovered its purpose; it was a bathing room. Large porcelain tubs, jars of water, drying linen & all else wanted laid about, but the color of the whole was quite changed; the carpet was variegated with crimson & all appeared alike warm [and] beautifully contrived. I saw, but touched nothing; I was clean enough. The door opposite led me into another closet, differently intended, and I merely saw its use. I was going to unlatch the third, yet unknown, when, thinking a moment, I made up my mind not to intrude, for I recollected that it led back towards the interior of the hall. The chimney piece was decorated with choice shells; I saw myself in the large mirror on it & above it a painting representing a lovely young female, a true resemblance of Queen Mary. I concluded to venture down. I say "venture" for naught but the breeze had yet been heard, but I proceeded & arrived at the drawing room where two young women were engaged busily cleaning. The youngest saw me first & I heard her tell her companion, "the American gentleman is down," and they instantly both vanished. I examined quite at leisure all about me; the paintings were truly beautiful. The morning was clear & the light on them very good.

The young clergyman came in and a walk was instantly undertaken. The hares all started before our dogs from wood to wood. We arrived at the stables, where I saw 4 truly well-formed Abyssinian horses with tails down to the earth & legs of one sinew

no longer than that of an elk. The riding room was still lighted and the training of those animals had been performed that morning. The gamekeeper was unkenneling his dogs; he shewed a large tame fox, and through farther woods we proceeded to the manor, now the habitat of the great falconer. I saw John Anderson and his hawks. He had already received orders to come to the hall at 11 to shew me these birds in their full dress. We visited next hanging gardens, where to my surprise roses were blooming most sweetly. I plucked one for my buttonhole, & returning to the hall by following the sinuosities of a brook, reached [it] by 10 o'clock.

The ladies were in the drawing room; a sweet babe was here also. It was a little nephew of the Countess, rosy with health & gay with the innocence of his age. Mr. Hays & Ramsay had left for Edinburgh. The Earl came in and we went to breakfast. Neither at this meal nor at luncheon are seen waiters. Now all was bustle about the drawing lesson. I might positively have said that I was about receiving one, Lucy, for Lady Morton draws much better than I do, believe me. The chalks, crayons and all wanting was before us in a few minutes & I sat to give a lesson to one of the first & most ancient peeresses of Scotland as well as of England. Singular fact. Yet sometimes, when in the woods, I have rested and anticipated being introduced to the great nobles of Europe & I am now gradually proceeding to that effect. Well, I gave a lesson, taught how to rub with the cork & prepare with water colors. The Earl saw the proceeding and was delighted at my invention; I shewed him many of my drawings. The falconer came and I saw his falcons ready for the chase. He held them perched on his gloved hand with bells & hoods flowing, but the morning was not fit for a flight & I lost the sight of that pleasure. During one of the resting moments, the Countess asked for my subscription board & wrote very legibly with a steel pen, "The Countess of Morton." She wished to pay for the first number then, but this I declined. She promised me letters for England & I assure thee I was pleased. I evinced a wish to have some fresh pheasants and she immediately ordered some to be killed for me. Luncheon again, after which I walked out to see a flock of full one hundred brown deer that, like sheep, were feeding a few hundred paces of the hall. The carriage had been ordered for me, for I was engaged to dinner in Edinburgh at Capt.

Basil Hall's. I saw it come to the hall & returned to pay my respects & did so, but it was agreed by all parties that it should be sent for me next week to give another lesson & spend another night. I pumped their hands & took my leave.

My ride home was soon over; the carriage moved as before. Here I found a packet from the American minister, letter from Charles Bonaparte, some books also from him & a bill from my tailor. I ran to Mr. Lizars's to give an account of my journey and reached No. 8 St. Colm at 6 o'clock.

Capt. Hall soon spoke of America. Strange to say, he was a midshipman on board the *Leander* when Pierce was killed off New York, & when on my way from France [in 1806], our captain, seeing the British vessel, went round Long Island & reached New York by Hellgate. My portfolio was there. After dinner the crowd accumulated, I opened for a moment my book but soon closed it, for I felt wearied. Lady Hunter came in & Sir William Hamilton. I saw a beautiful sister of Captain Hall, the handsome Mr. Harvey & many more, but Lucy, I made my escape without bidding adieu except to the Captain, and I have reached George Street almost broke down…

The Great-footed Hawk

Audubon reveals his ambivalence about predators in this "biography" of the Peregrine Falcon as well as in the plate, where he depicts two falcons feasting bloody-beaked on a pair of ducks. In childhood in France he lived through the worst days of the Terror, public mass executions in Nantes with thousands of victims drowned in the Loire and fed on by avian scavengers. Like many others, he and his family were arrested and jailed and barely escaped with their lives. He admired the hawks and falcons, understood that their violence was part of the natural order—he sometimes dreamed of being a hawk—but despised it nonetheless. He was of course a predator himself, however worthy his purpose.

The French and Spaniards of Louisiana have designated all the species of the genus Falco by the name of *Mangeurs de Poulets*; and the farmers in other portions of the Union have bestowed upon them according to their size the appellations of Hen Hawk, Chicken Hawk, Pigeon Hawk, &c. This mode of naming these rapacious birds is doubtless natural enough, but it displays little knowledge of the characteristic manners of the species. No bird can better illustrate the frequent inaccuracy of the names bestowed by ignorant persons than the present, of which on referring to the plate, you will see a pair enjoying themselves over a brace of ducks of different species. Very likely, were tame ducks as plentiful on the plantations in our states as wild ducks are on our rivers, lakes and estuaries, these hawks might have been named by some of our settlers *Mangeurs de Canards*.

Look at these two pirates eating their *dejeuné à la fourchette*, as it were, congratulating each other on the savoriness of the food in their grasp. One might think them real epicures, but they are in fact true gluttons. The male has obtained possession of a Green-winged Teal, while his mate has procured a Gadwall Duck. Their appetites are equal to their reckless daring and they well deserve the name of pirates which I have above bestowed upon them.

The Great-footed Hawk or Peregrine Falcon is now frequently to be met with in the United States, but within my remembrance it was a very scarce species in America. I can well recollect the

time when, if I shot one or two individuals of the species in the course of a whole winter, I thought myself a fortunate mortal; whereas of late years I have shot two in one day and perhaps a dozen in the course of a winter. It is quite impossible for me to account for this increase in their number, the more so that our plantations have equally increased and we have now three gunners for every one that existed twenty years ago, and all of them ready to destroy a hawk of any kind whenever an occasion presents itself.

The flight of this bird is of astonishing rapidity. It is scarcely ever seen sailing unless after being disappointed in its attempt to secure the prey which it has been pursuing, and even at such times it merely rises with a broad spiral circuit to attain a sufficient elevation to enable it to reconnoiter a certain space below. It then emits a cry much resembling that of the Sparrow Hawk but greatly louder, like that of the European Kestrel, and flies off swiftly in quest of plunder. The search is often performed with a flight resembling that of the tame pigeon until, perceiving an object, it redoubles its flappings and pursues the fugitive with a rapidity scarcely to be conceived. Its turnings, windings and cuttings through the air are now surprising. It follows and nears the timorous quarry at every turn and back-cutting which the latter attempts. Arrived within a few feet of the prey, the Falcon is seen protruding his powerful legs and talons to their full stretch. His wings are for a moment almost closed; the next instant he grapples the prize which, if too weighty to be carried off directly, he forces obliquely towards the ground, sometimes a hundred yards from where it was seized, to kill it and devour it on the spot. Should this happen over a large extent of water, the Falcon drops his prey and sets off in quest of another. On the contrary, should it not prove too heavy, the exulting bird carries it off to a sequestered and secure place. He pursues the smaller Ducks, Water-hens and other swimming birds and if they are not quick in diving seizes them and rises with them from the water. I have seen this Hawk come at the report of a gun and carry off a Teal not thirty steps distant from the sportsman who had killed it, with a daring assurance as surprising as unexpected. This conduct has been observed by many individuals and is a characteristic trait of the species. The largest duck that I have seen this bird attack and grapple with on the wing is the Mallard.

The Great-footed Hawk does not however content himself with waterfowl. He is generally seen following the flocks of Pigeons and even Blackbirds, causing great terror in their ranks and forcing them to perform various aerial evolutions to escape the grasp of his dreaded talons. For several days I watched one of them that had taken a particular fancy to some tame pigeons, to secure which it went so far as to enter their house at one of the holes, seize a bird and issue by another hole in an instant, causing such terror among the rest as to render me fearful that they would abandon the place. However, I fortunately shot the depredator.

They occasionally feed on dead fish that have floated to the shores or sand bars. I saw several of them thus occupied while descending the Mississippi on a journey undertaken expressly for the purpose of observing and procuring different specimens of birds and which lasted four months as I followed the windings of that great river, floating down it only a few miles daily. During that period I and my companion counted upwards of fifty of these Hawks and killed several, among which was the female represented in the plate now before you, and which was found to contain in its stomach bones of birds, a few downy feathers, the gizzard of a Teal and the eyes and many scales of a fish. It was shot on the 26th December 1820. The ovary contained numerous eggs, two of which were as large as peas.

Whilst in quest of food, the Great-footed Hawk will frequently alight on the highest dead branch of a tree in the immediate neighborhood of such wet or marshy grounds as the Common Snipe resorts to by preference. His head is seen moving in short starts, as if he were counting every little space below; and while so engaged, the moment he spies a Snipe, down he darts like an arrow, making a rustling noise with his wings that may be heard several hundred yards off, seizes the Snipe and flies away to some near wood to devour it.

It is a cleanly bird in respect to feeding. No sooner is the prey dead than the Falcon turns its belly upward and begins to pluck it with his bill, which he does very expertly, holding it meantime quite fast in his talons; and as soon as a portion is cleared of feathers, tears the flesh in large pieces and swallows it with great avidity. If it is a large bird he leaves the refuse parts, but if small,

swallows the whole in pieces. Should he be approached by an enemy, he rises with it and flies off into the interior of the woods, or if he happens to be in a meadow, to some considerable distance, he being more wary at such times than when he has alighted on a tree.

The Great-footed Hawk is a heavy, compact and firmly built bird for its size and when arrived at maturity, extremely muscular with very tough flesh. The plumage differs greatly according to age. I have seen it vary in different individuals from the deepest chocolate-brown to light grey. Their grasp is so firm that should one be hit while perched and not shot quite dead, it will cling to the branch until life has departed.

Like most other Hawks this is a solitary bird excepting during the breeding season, at the beginning of which it is seen in pairs. Their season of breeding is so very early that it might be said to be in winter. I have seen the male caressing the female as early as the first days of December.

This species visits Louisiana during the winter months only; for although I have observed it mating then, it generally disappears a few days after and in a fortnight later none can be seen. It is scarce in the Middle states where, as well as in the Southern districts, it lives along watercourses and in the neighborhood of the shores of the sea and inland lakes. I should think that they breed in the United States, having shot a pair in the month of August near the Falls of Niagara. It is extremely tenacious of life and if not wounded in the wings, though mortally so in the body, it flies to the last gasp and does not fall until life is extinct. I never saw one of them attack a quadruped although I have frequently seen them perched within sight of squirrels, which I thought they might easily have secured had they been so inclined.

Once when nearing the coast of England, being then about a hundred and fifty miles distant from it in the month of July, I obtained a pair of these birds which had come on board our vessel and had been shot there. I examined them with care and found no difference between them and those which I had shot in America. They are at present scarce in England, where I have seen only a few. In London some individuals of the species resort to the cupola of St. Paul's Cathedral and the towers of Westminster Abbey to

roost and probably to breed. I have seen them depart from these places at day dawn and return in the evening.

The achievements of this species are well known in Europe, where it is even at the present day trained for the chase. Whilst on a visit at Dalmahoy, the seat of the Earl of Morton near Edinburgh, I had the pleasure of seeing a pair of these birds hooded and with small brass bells on their legs in excellent training. They were the property of that nobleman.

These birds sometimes roost in the hollows of trees. I saw one resorting for weeks every night to a hole in a dead sycamore near Louisville in Kentucky. It generally came to the place a little before sunset, alighted on the dead branches and in a short time after flew into the hollow where it spent the night and from whence I saw it issuing at dawn. I have known them also retire for the same purpose to the crevices of high cliffs on the banks of Green River in the same state. One winter when I had occasion to cross the Homochitta River in the State of Mississippi I observed these Hawks in greater numbers than I had ever before seen.

Many persons believe that this Hawk and some others never drink any other fluid than the blood of their victims; but this is an error. I have seen them alight on sand bars, walk to the edge of them, immerse their bills nearly up to the eyes in the water and drink in a continued manner, as Pigeons are known to do.

[The Great-footed Hawk (Peregrine Falcon), *Falco peregrinus*, appears in Plate 16 of *The Birds of America*.]

The Alligator

One of Audubon's first published works, rarely reprinted, "Observations on the Natural History of the Alligator" appeared in the Edinburgh New Philosophical Journal *after the artist and naturalist read it before Edinburgh's Wernerian Natural History Society in January 1827.*

One of the most remarkable objects connected with the natural history of the United States that attracts the traveler's eye as he ascends through the mouths of the mighty sea-like River Mississippi, is the alligator. There, along the muddy shores and on the large floating logs, these animals are seen either lying basking and asleep, stretched to their full length, or crossing to and fro the stream in search of food, with only the head out of water. It is here neither wild nor shy, neither is it the very dangerous animal represented by travelers. But to give you details that probably may not be uninteresting to you, I shall take you to their more private haunts, and relate what I have experienced and seen respecting them and their habits.

In Louisiana, all our lagoons, bayous, creeks, ponds, lakes and rivers are well stocked with them—they are found wherever there is a sufficient quantity of water to hide them or to furnish them with food, and they continue thus in great numbers as high as the mouth of the Arkansas River, extending east to North Carolina and as far west as I have penetrated. On the Red River, before it was navigated by steam vessels, they were so extremely abundant that to see hundreds at a sight along the shores or on the immense rafts of floating or stranded timber was quite a common occurrence, the smaller on the backs of the larger, groaning and uttering their bellowing noise like thousands of irritated bulls about to meet in fight, but all so careless of man that unless shot at or positively disturbed they remained motionless, suffering boats or canoes to pass within a few yards of them without noticing them in the least. The shores are yet trampled by them in such a manner that their large tracks are seen as plentiful as those of sheep in a fold. It was on that river particularly that thousands of the largest size were killed when the mania of having either shoes, boots or saddle-seats

made of their hides lasted. It had become an article of trade, and many of the squatters and strolling Indians followed for a time no other business. The discovery that the skins are not sufficiently firm and close-grained to prevent water or dampness long, put a stop to their general destruction, which had already become very apparent. The leather prepared from these skins was handsome and very pliant, exhibiting all the regular lozenges of the scales and able to receive the highest degree of polish and finishing.

The usual motion of the alligator when on land is slow and sluggish; it is a kind of labored crawling, performed by moving alternately each leg in the manner of a quadruped when walking, scarce able to keep up their weighty bodies from dragging on the earth and leaving the track of their long tail on the mud as if that of the keel of a small vessel.

Thus they emerge from the water and go about the shores and the woods, or the fields, in search of food, or of a different place of abode, or one of safety to deposit their eggs. If, at such times, when at all distant from the water, an enemy is perceived by them, they droop and lie flat with their nose on the ground, watching the intruder's movements with their eyes, which are able to move considerably round without affecting the position of the head. Should a man then approach them, they do not attempt either to make away or attack but merely raise their body from the ground for an instant, swelling themselves and issuing a dull blowing sound not unlike that of a blacksmith's bellows. Not the least danger need be apprehended; then you either kill them with ease or leave them. But to give you a better idea of the slowness of their movements and progress of travels on land, when arrived at a large size, say 12 to 15 feet, believe me when I tell you that, having found one in the morning 50 yards from a lake going to another in sight, I have left him unmolested, hunted through the surrounding swamp all day and met the same alligator within 500 yards of the spot when returning to my camp at dusk. On this account they usually travel during the night, they being then less likely to be disturbed and having a better chance to surprise a litter of pigs or of land tortoises for prey.

The power of the alligator is in his great strength; and the chief means of his attack or defense is his large tail, so well contrived by

nature to supply his wants or guard him from danger that it reaches, when curved into half a circle, his enormous mouth. Woe be to him who goes within the reach of this tremendous thrashing instrument, for no matter how strong or muscular, if human, he must suffer greatly if he escapes with his life. The monster, as he strikes with this, forces all objects within the circle towards his jaws which, as the tail makes a motion, are open to their full stretch, thrown a little sidewise to receive the object and, like battering rams, to bruise it shockingly in a moment.

The alligator, when after prey in the water or at its edge, swims so slowly towards it as not to ruffle the water. It approaches the object sidewise, body and head all concealed, till sure of his stroke; then, with a tremendous blow, as quick as thought, the object is secured as I described before.

When alligators are fishing, the flapping of their tails about the water may be heard at half a mile; but to describe this in a more graphic way, suffer me to take you along with me in one of my hunting excursions, accompanied by friends and Negroes. In the immediate neighborhood of Bayou Sarah, on the Mississippi, are extensive shallow lakes and morasses that are yearly overflowed by the dreadful floods of that river and supplied with myriads of fishes of many kinds, amongst which trouts are most abundant, white perch, catfish and alligator gars or devilfish. Thither in the early part of autumn, when the heat of a southern sun has exhaled much of the water, the squatter, the planter, the hunter all go in search of sport. The lakes are then about 2 feet deep, having a fine sandy bottom; frequently much grass grows in them bearing crops of seeds for which multitudes of waterfowls resort to those places. The edges of these lakes are deep swamps, muddy for some distance, overgrown with heavy large timber, principally cypress, hung with Spanish beard and tangled with different vines, creeping plants and cane, so as to render them almost dark during the day and very difficult to the hunter's progress. Here and there in the lakes are small islands with clusters of the same trees on which flocks of snakebirds, wood ducks and different species of herons build their nests. Fishing lines, guns and rifles, some salt and some water, are all the hunters take. Two Negroes precede them—the woods are crossed—the scampering deer is seen—the raccoon and the

opossum cross before you—the black, the grey and the fox squirrel
are heard barking—here on a tree close at hand is seen an old male
[squirrel] pursuing intensely a younger one; he seizes it, they fight
desperately, but the older attains his end, *vincit, castratque juniorem*
[Victory, the younger one is castrated]. (Now, my dear sirs, if this
is not mental power illustrated, what shall we call it?) As you
proceed farther on, the *hunk hunk* of the lesser ibis is heard from
different parts as they rise from the puddles that supply them with
crayfishes. At last the opening of the lake is seen; it has now
become necessary to drag oneself along through the deep mud,
making the best of the way, with the head bent, through the small
brushy growth, caring about naught but the lock of your gun. The
long, narrow Indian canoe kept to hunt those lakes, and taken into
them during the fresh [i.e., the flood], is soon launched, and the
party seated in the bottom is paddled or poled in search of water
game. There, at a sight, hundreds of alligators are seen dispersed
over all the lake, their head and all the upper part of the body
floating like a log, and in many instances so resembling one that
it requires to be accustomed to see them to know the distinction.
Millions of the large wood ibis are seen wading through the water,
mudding it up and striking deadly blows with their bills on the
fish within. Here are a hoard of blue herons—the sandhill crane
rises with his hoarse note—the snakebirds are perched here and
there on the dead timber of the trees—the cormorants are fishing—
buzzards and carrion crows exhibit a mourning train, patiently
waiting for the water to dry and leave food for them—and far in
the horizon the eagle overtakes a devoted wood duck singled from
the clouded flocks that have been bred there. It is then that you
see and hear the alligator at his work. Each lake has a spot deeper
than the rest, rendered so by those animals who work at it and
always situate at the lower end of the lake near the connecting
bayous that, as drainers, pass through all those lakes, and discharge
sometimes many miles below where the water has made its entrance
above, thereby ensuring to themselves water as long as any will
remain. This is called by the hunters the Alligator's Hole. You see
them there lying close together. The fish that are already dying by
thousands through the insufferable heat and stench of the water
and the wounds of the different winged enemies constantly in

pursuit of them, resort to the Alligator's Hole to receive refreshment, with a hope of finding security also, and follow down the little currents flowing through the connecting sluices; but no! for, as the water recedes in the lake, they are here confined. The alligators thrash them and devour them whenever they feel hungry, while the ibis destroys all that make towards the shore. By looking for a little on this spot, you plainly see the tails of the alligators moving to and fro, splashing, and now and then, when missing a fish, throwing it up in the air. The hunter, anxious to prove the value of his rifle, marks one of the eyes of the largest alligator, and as the hair-trigger is touched, the alligator dies. Should the ball strike one inch astray from the eye, the animal flounces, rolls over and over beating furiously with his tail all about him, frightening all his companions, who sink immediately, whilst the fishes, like blades of burnished metal, leap in all directions out of the water, so terrified are they at this uproar. (This so alarms the remaining alligators that regularly, in the course of the following night, every one large and small removes to another hole, going to it by water, and probably for a week not one will be seen there.) Another and another receives the shot in the eyes, and expires; yet those that do not feel the fatal bullet pay no attention to the death of their companions till the hunter approaches very close, when they hide themselves for a few moments, by sinking backward.

So truly gentle are the alligators at this season that I have waded through such lakes in company of my friend Augustin Bourgeat, Esq., to whom I owe much information, merely holding a stick in one hand to drive them off, had they attempted to attack me. When first I saw this way of traveling through the lakes, waist-deep, sometimes with hundreds of these animals about me, I acknowledge to you that I felt great uneasiness, and thought it foolhardiness to do so; but my friend, who is a most experienced hunter in that country, removed my fears by leading the way, and after a few days I thought nothing of it. If you go towards the head of the alligator there is no danger, and you may safely strike it with a club, four feet long, until you drive it away, merely watching the operations of the point of the tail that at each blow you give, thrashes to the right and left most furiously.

The drivers of cattle from the Opelousas, and those of mules

from Mexico, on reaching a lagoon or creek, send several of their party into the water armed merely each with a club, for the purpose of driving away the alligators from the cattle; and you may then see men, mules and those monsters all swimming together, the men striking the alligators that would otherwise attack the cattle, of which they are very fond, and those latter hurrying towards the opposite shores to escape those powerful enemies. They will swim swiftly after a dog, or a deer, or a horse before attempting the destruction of a man, of which I have always remarked they were afraid, if the man feared not them.

Although I have told you how easily an alligator may be killed with a single rifle ball, if well aimed, that is to say, if it strike either in the eye or very immediately above it, yet they are quite as difficult if not shot properly; and to give you an idea of this, I shall mention two striking facts.

My good friend Richard Harlan, M.D., of Philadelphia, having intimated a wish to have the heart of one of those animals to study its comparative anatomy, I one afternoon went out about half a mile from the plantation, and seeing an alligator that I thought I could put whole into a hogshead of spirits, I shot it immediately on the skull bone. It tumbled over from the log on which it had been basking into the water, and with the assistance of two Negroes, I had it out in a few minutes, apparently dead. A strong rope was fastened round its neck, and in this condition I had it dragged home across logs, thrown over fences and handled without the least fear. Some young ladies there, anxious to see the inside of its mouth, requested that the mouth should be propped open with a stick put in vertically; this was attempted, but at this instant the first stunning effect of the wound was over and the animal thrashed and snapped its jaws furiously, although it did not advance a foot. The rope being still around the neck, I had it thrown over a strong branch of a tree in the yard, and hauled the poor creature up, swinging free from all about it, and left it twisting itself and scratching with its forefeet to disengage the rope. It remained in this condition until the next morning when, finding it still alive, though very weak, the hogshead of spirits was put under it and the alligator fairly lowered into it with a surge. It twisted about a little, but the cooper secured the cask and it was shipped to Philadelphia, where it arrived in course.

Again, being in company with Augustin Bourgeat, Esq., we met an extraordinary large alligator in the woods whilst hunting; and for the sake of destruction I may say, we alighted from our horses and approached it with full intention to kill it. The alligator was put between us, each of us provided with a long stick to irritate it, and, by making it turn its head partly on one side, afford us the means of shooting it immediately behind the foreleg and through the heart. We both discharged five heavy loads of duck shot into its body, and almost all into the same hole, without any other effect than that of exciting regular strokes of the tail, and snapping of the jaws, at each discharge, and the flow of a great quantity of blood out of the wound and mouth and nostrils of the animal; but it was still full of life and vigor, and to have touched it with the hand would have been madness; but as we were anxious to measure it and to knock off some of its larger teeth, to make powder chargers [i.e., funnels for measuring powder into a muzzle-loading gun], it was shot with a single ball just over the eye, when it bounded a few inches off the ground and was dead when it reached it again. Its length was seventeen feet; it was apparently centuries old; many of its teeth measured three inches. The shots taken were without a few feet only of the circle that we knew the tail could form, and our shots went *en masse*.

As the lakes become dry, and even the deeper connecting bayous empty themselves into the rivers, the alligators congregate into the deepest hole in vast numbers; and to this day in such places are shot for the sake of their oil, now used for greasing the machinery of steam engines and cotton mills, though formerly, when indigo was made in Louisiana, the oil was used to assuage the overflowing of the boiling juice by throwing a ladleful into the kettle whenever this was about to take place. The alligators are caught frequently in nets by fishermen; then they come without struggling to the shore and are killed by blows on the head given with axes.

When autumn has heightened the coloring of the foliage of our woods, and the air feels more rarefied during the nights and earlier part of the day, the alligators leave the lakes and seek for winter quarters by burrowing under the roots of trees or covering them-selves simply with earth along their edges. They become then very languid and inactive, and at this period to sit or ride on one would

not be more difficult than for a child to mount his wooden rocking-horse. The Negroes who now kill them put all danger aside by separating, at one blow with an axe, the tail from the body. They are afterwards cut up in large pieces and boiled whole in a good quantity of water, from the surface of which the fat is collected with large ladles. One single man kills oftentimes a dozen or more of large alligators in the evening, prepares his fire in the woods, where he has erected a camp for the purpose, and by morning has the oil rendered.

I have frequently been very much amused, when fishing in a bayou where alligators were numerous, by throwing a blown bladder on the water towards the nearest to me. The alligator makes for it at once, flaps it towards its mouth or attempts seizing it at once, but all in vain. The light bladder slides off; in a few minutes many alligators are trying to seize this, and their evolutions are quite interesting. They then put one in mind of a crowd of boys running after a football. A black bottle is sometimes thrown also, tightly corked; but the alligator seizes this easily, and you hear the glass give way under its teeth as if ground in a coarse mill. They are easily caught by Negroes, who most expertly throw a rope over their heads when swimming close to shore and haul them out instantly.

But my dear sirs, you must not conclude that alligators are always thus easily conquered: there is a season when they are dreadfully dangerous; it is during spring, during the love season. The waters have again submerged the low countries; fish are difficult of access; the greater portion of the game has left for the northern latitudes; the quadrupeds have retired to the highlands; and the heat of passion, joined to the difficulty of procuring food, render these animals now ferocious and very considerably more active. The males have dreadful fights together, both in the water and on the land. Their strength and weight adding much to their present courage, exhibit them like colossuses wrestling. At this time no man swims or wades among them; they are usually left alone at this season.

About the first days of June the female prepares a nest. A place is chosen forty or fifty yards from the water, in thick bramble or cane, and she gathers leaves, sticks and rubbish of all kinds to form a bed to deposit her eggs; she carries the materials in her mouth

as a hog does straw. As soon as a proper nest is finished, she lays about ten eggs, then covers them with more rubbish and mud and goes on depositing in different layers until fifty or sixty or more eggs are laid. The whole is then covered up, matted and tangled with long grasses in such a manner that it is very difficult to break it up. These eggs are the size of that of a goose, more elongated, and instead of being contained in a shell are in a bladder of thin, transparent, parchment-like substance, yielding to the pressure of the fingers yet resuming its shape at once, like the eggs of snakes and tortoises. They are not eaten even by hogs. The female now keeps watch near the spot and is very wary and ferocious, going to the water from time to time only for food. Her nest is easily discovered, as she always goes and returns the same way, and forms quite a path by the dragging of her heavy body. The heat of the nest, from its forming a mass of putrescent manure, causes the hatching of the eggs, not that of the sun, as is usually believed.

Some European writers say that at this juncture the vultures feed on the eggs and thereby put a stop to the increase of those animals. In the United States, I assure you, it is not so, nor can it be so, were the vultures ever so anxiously inclined; for as I have told you before, the nest is so hard and matted, all plastered together, that a man needs his superior strength, with a strong sharp stick, to demolish it.

The little alligators, as soon as hatched (and they all break shell within a few hours from the first to last), force themselves through and issue forth all beautiful, lively and as brisk as lizards. The female leads them to the lake, but more frequently into small detached bayous for security's sake; for now the males, if they can get at them, devour them by hundreds, and the wood ibis and the sandhill cranes also feast on them.

I believe that the growth of alligators takes place very slowly, and that an alligator of twelve feet long, for instance, will most probably be fifty or more years old. My reason for believing this to be fact is founded on many experiments, but I shall relate to you one made by my friend Bourgeat. That gentleman, anxious to send some young alligators as a present to an acquaintance in New York, had a bag of young ones, quite small, brought to his house. They were put out on the floor to shew the ladies how beautiful

they were when young. One accidentally made its way out into a servant's room and lodged itself snug from notice into an old shoe. The alligator was not missed, but upwards of twelve months after this, it was discovered about the house, full of life, and apparently scarcely grown bigger; one of his brothers that had been kept in a tub and fed plentifully had grown only a few inches during the same period.

Few animals emit a stronger odor than the alligator; and when it has arrived at great size, you may easily discover one in the woods in passing fifty or sixty yards from it. This smell is highly musky, and so strong that when near, it becomes insufferable; but this I never experienced when the animal is in the water, although I have whilst fishing been so very close to them as to throw the cork of my fishing line on their heads to tease them. In those that I have killed, and I assure you I have killed a great many, if opened to see the contents of the stomach or take fresh fish out of them, I regularly have found round masses of a hard substance resembling petrified wood. These masses appeared to be useful to the animal in the process of digestion, like those found in the craws of some species of birds. I have broken some of them with a hammer and found them brittle and as hard as stones, which they resemble outwardly also very much. And, as neither our lakes nor rivers in the portion of the country I have hunted them in afford even a pebble as large as a common egg, I have not been able to conceive how they are procured by the animals, if positively stones, or by what power wood can become stone in their stomachs.

Victor Gifford Audubon to John James Audubon
"I long to see all of you…"

Victor Gifford Audubon, sixteen years old, wrote this letter to his father from Shippingport, Kentucky, below the mile of shoals called the Falls of the Ohio, at a time when a canal was being dug to allow shipping to bypass this only impediment to boat traffic along the Ohio River's entire length. Victor was learning business as a clerk in his Uncle Nicholas Berthoud's counting room.

Shippingport, Kentucky
17 April 1827

Dear Pappa,

I received a letter from Mamma a few days ago containing a copy of one of your letters to her. She says you no longer speak of our going to Europe—or of your return to us. She was well and pleased with her situation. Brother John is well also, and I suppose has grown quite a man. I long to see all of you, and hope you will soon let me know what your prospects and intentions are.

We have received your newspapers, and I am delighted with their contents. Mamma sent me a New Orleans paper containing an extract from an English paper speaking of your drawings as they deserve. I hope and think you will have no difficulty in filling your subscription list. The only objection I have to your publishing a work is that it will, I am afraid, be·long before you can realize a reward for your labors, which will enable you and Mamma to enjoy the blessings of Independence and a comfortable home…

We had, last spring (1826), a very high freshet which came to 4 ft. deep in the counting room. The rise was 57 ft. 3 in. perpendicular. The canal is progressing fast and nothing interrupts the work but an occasional shower or rise in the river. Uncle Berthoud has been appointed postmaster at this place and I am his assistant…

John James Audubon to Lucy Audubon
"I am tormented day & night..."

London, England
20 June 1827

My dearest Lucy—

I have but little news to tell thee, and was in hopes to have heard from thee within these 2 or 3 last days, as thy letters have been of late very regular; but having the opportunity of Charles Bonaparte who leaves Liverpool in a few days for New York, I take it with great pleasure if it be only to let thee know that I am quite well and still in London. It is truly an immense place, but as poor Mr. Hall used to say to us at the Beech Woods, the most disagreeable place in the world probably unless indeed to dukes and great lords who can throw their multiplied thousands of pounds to procure comforts necessary to persons of their station.

I wrote to thee 3 long letters from Liverpool a few weeks ago. One of them I fear will not please thee, but I did not mean to offend thee in the least; only I do wish for thy dear self, that I am tormented day & night for the comforts thou art so well able to grant me. If I could write now, with safety, for thee to come [to England]; but I cannot, and must wait awhile, until the ways and means are quite and safely secured. My subscription list [to *The Birds of America*] goes on increasing well and I have great hopes without any sanguinity about me.

I wrote yesterday a long letter to our Victor in answer to one I received from him, the only one; going by the same opportunity, I hope it will reach him and to thee the copy of it.

The British Museum is quite too poor to afford me the amount I ask to work for them. Charles Bonaparte has written to the Baron of Temminck who, he thinks, can give me good pay; I am to hear from him in a short time. I long to be settled for thy sake, and may God grant me the pleasure of doing so to thy liking! Charles B. said before me and many members of the Royal Society that I was the best naturalist *in fact* existing now in his opinion, and is

extremely kind to me. He writes the Zoological Society to employ me also.

At last I am glad to inform thee that thy watch [an expensive gold pocket watch Audubon had bought for his wife soon after his arrival in Liverpool] is not lost—it has been remaining in New York in the hands of Messrs. Walker & Sons, Merchant, there because I had told Messrs. Rathbone to beg of them to forward [it] to thee by a safe private opportunity by land and not again to trust it to sea. Now however Messrs. Walker & Sons have desired to have it left to them to send, and Mr. Rathbone has wrote to them to [illegible] them on [a] way; I hope that by the time this reaches thee thou will have had it some time. I long to have from thee in answer to this when, I hope, all I have sent thee will have been received by thee.

It is expected that Parliament will break up in about a fortnight; if so I will leave London for Oxford & Cambridge &c...

I paint a great deal in oil colors at my leisure hours in the smooth style that thou admires so much and was I by accident obliged to return to America I could still from there receive the benefit that this country affords to good artists. I had the pleasure the other day of breakfasting with [English portraitist] Sir Thomas Lawrence and he praised my work very much. I have many opportunities of seeing great lords & ladies I assure thee, but cannot say that I like many of them. The Countess of Morton is perhaps the only one perfectly unassuming and truly kind to me. Lady Spencer the next, and the widow of Sir Stamford Raffles. Amongst the other sex, Sir John Swinburn, the Earl of Stanley and Lord Meadowbank. The rest receive me merely because they admire my talents, but are overbearing, and proud to an excess. It is a rule, or rather call it a law, never to receive anybody without a previous invitation, and the waiters universally answer "*Not at home, sir.*"

Our Minister Albert Gallatin has been extremely kind to me, he called upon me the 2nd day after I arrived [and] will present me to the King if it pleases his Majesty to have a Levee before I depart. Of course it will be necessary for me to visit London from time to time as my work goes on. I am glad that subscribers that I have already procured is sufficient to afford a full continuance of the publication. In the course of twelvemonth more it is now more

than probable that this business connected with the publication of my work will need a secondary assistance and if by then I feel perfectly assured that all will be safe I will have Victor at the head of it. You are, my dear Lucy, quite mistaken about the habits of this country and a young man attending to such a business is neither a rambler or considered as such by anyone, but on the contrary, I am looked on and received with more kindness under the appellation of author of *The Birds of America* than nine-tenths of the rich merchants who travel as I do to collect and settle their affairs. Thou has an idea that, for instance, to go about to collect subscribers is a great loss of time to a young man, but I am fully persuaded that, on the contrary, it is the means of procuring such a knowledge of men and of their habits without which little can be done in our circle.

But my wish is not that Victor should collect subscribers but superintend the whole management of the work and give me the means of settling myself awhile. I assure thee that if I can procure as many as 500 subscribers it will be an immense revenue, quite sufficient to make us all comfortable for the rest of our days, and I do not see why I should not, when in the course of 3 months that I have been employed at it, I have already 94. It is a work that to be sure not every individual can reach, but I think an advantage is attached to this, as none but persons of real and immense fortunes can or do subscribe and therefore insure my being able to go on with it.

I will have many difficulties to surmount for the next twelve months, I have not a doubt, as I am obliged to pay for everything as I go, and to be supported by exertions in collecting from the subscribers or the agents I must have; and by my painting which I assure thee keep up an appearance and a style of dress and expenses that, although I shun society as much as I dare do, is extremely cumbersome to my purse; but I think that after this first 12 months the business will be in such a train as to afford me more rest a great deal. I do not infer from this that I think it necessary that 12 months should elapse before I write to thee to come, I hope to be able to do so much sooner; but from many thoughts and recollecting, yet alas too pointedly present to my mind, I have no wish to have thee unless thou art convinced at being *comfortable in thy own way.*

It is probable that many blame me much in America for this *appearance* of carelessness and absence from my family, and the same doubtless think and say that I am pleasuring whilst thou art slaving thy life away, but can they know my hopes, my intentions, my wishes or my exertions to do well and for the best? I am sure they cannot, for they do not know me a jot: yet I have to bear the blame and hear of those things by various channels much to the loss of my peace. I now have reached that age when I think it unnecessary to take the advice of anyone but thyself, and will consequently follow no other. It is impossible to foresee if I may be induced to remain in England the rest of my life, or accidents may send me to America once more; but whatever takes place, and whatever my situation may be hereafter, I have, and will always have the consolation to think that I have done all I can, or could since my misfortunes in Kentucky, to restore thee to comfort.

The difference of habits between us are very different; so much so indeed, that what I conceive real comfort is misery to thee. Those are misfortunes indeed, but it is too late to take such things in consideration and I am still anxiously inclined to meet thy wishes and procure all I can for thy sake. I sometimes feel a great inclination to leave this work, so full of sorrow is my heart, when quite alone, dull and oppressed by thousands of recollections all more disagreeable to me than even the present moment; when I am checked by the thoughts, that some change for the better may take place, and that my peace and joy at seeing thee happy will be restored.

Comparatively speaking, thy present situation with mine is full of comforts. The constant sight of our John must grant to thee enjoyments that I never feel at this distance; it is merely by looking at his portrait and thine and by shedding tears that a glimpse of mixed pleasure is obtained, and that only whilst those dear images are before me. I feel as if I had no one who cares for me; those about me are all engaged in different ways from mine, I am indeed alone in the world. Could I be assured that my journals would reach thee safely I would send them, but I have fears of the contrary and were they to fall into the hands of strangers, it would be a source of everlasting sorrow to me, as they contain all my thoughts, my movements, in fact all my life as it passes on from day to day,

written as if the salvation of my soul depended on the accuracy and minuteness of those details that I am sure to anyone else but me or my sons after my death must be insipid quite.

Probably when I write again I will have 100 subscribers to my list and will have their names printed on my Prospectuses. I will then send thee some, as it may be agreeable for thee to see their names, or those institutions that have been pleased to confer me honors. Since here I have received 3 new diplomas. I have an immense number of notes from all kinds of individuals and on them very interesting seals. I would send them all to thee now but I must wait until I hear that what I have already forwarded thee has arrived. I am rather surprised that thou hast not said a word of the seal generally on my letters to thee, the figure of the Wild Turkey with "America my Country" round it. It is thought beautiful by everyone here. It was a present from that good, generous & benevolent friend of mine, Lady Rathbone. Charles Bonaparte is a subscriber to my work; he told me that he would have it without pay. The Pope created him Prince of Musignano since he arrived in Europe this voyage. He does not keep any servants about him, indeed he goes almost incog., but is highly thought of by everybody, both for his titles and for his great talents.

I have of course procured an immense number of acquaintances in the literary range of society, but they are acquaintances only. It is probable that I will go to Paris this next autumn and so far as Frankfort in Germany, but only for a few weeks, and as it is yet so far distant thou willst hear of it in time.

I have filled up my paper a great deal now with many different subjects—if thou art pleased to have it copied and sent to Victor I would like it. I think Mr. Berthoud does not wish to write to me. Robert Bakewell, the great wool man, resides 5 miles from this at a village called Hampstead. He has wrote several very kind letters to me, but he is confined to his house by the gout and no more attends any of the scientific meetings—I will see him soon.

Now my Dearest, my only friend, once more I must bid thee farewell and remind thee to take care of thy health and comforts [and] to make John remember me. Dear fellow what would I give in my power to have him or Victor with me! Do write, my Lucy, as frequently as possible, and say much in all thy letters! I am sure

I set a good example to thee when I send, as now, 8 sheets full. Before I close I will tell thee that I have been quite disappointed at the theatres of London; they are neither so fine nor so well managed as those of America, although the multitudes that attend them is surprising. God for ever preserve and Bless thee.

John James Audubon to Lucy Audubon
"I have a clear profit of nearly £500..."

Manchester, England
20 September 1827

My dearest friend,

I received thy letter of the 16th July about a week ago in London and have ever since been very anxious to answer it fully.

The pleasure that I feel at seeing thy disposition to come to England is great, I assure thee, and I will always consider our meeting on this land as a consolidation of our affections.

I left London 4 days ago to take a grand tour to collect about five hundred and fifty pounds now due me by my subscribers and to augment their number; I am glad to say that so far I am fortunate in both objects. I wrote to thee by my good friend Vincent Nolte and ask of him to call & see thee, to acquaint thee more particularly than I can do by letter with what I am doing, and told him that I was in great hopes to see my way so clear by the 1st of January next that I would thus write to thee to come over to me. Thou must not think me, dearest friend, too tardy; I am, I assure thee, bent on thy future happiness; but I wish to make every thing quite certain before I write for thee. I will then forward thee the means of moving comfortably and will send thee not only letters for New York, but make such arrangements with my excellent friends, the Rathbones, as will ensure thee that comfort. But I beg of thee not to move or make any other arrangements in thy affairs than those at present existing until then. Thou may think this language cooler than usual but it is not so in reality. I am determined not to disappoint thee or my sons when you all come over. Should Mr. Nolte not go to thee, I think it would be well for thee to write to him at New Orleans and should thou go there on business to call on him thyself. I saw him at my rooms in London frequently. I esteem him much and he knows a good deal of my business.

I wrote thee long ago that I had removed my whole work to London. The advantages of that place are wonderful over those of Edinburgh or Paris, and my business is carried on as I wish it.

Since Mr. Nolte left, I had the great honor of receiving the particular *patronage, approbation and protection* of the King, who has become a subscriber also, and the next day through the same channel (Sir Mathew Waller, Bart, K.C. &c.) sent word that her Royal Highness the Duchess of Clarence wished also her name on my list. They are no better in my eye than any other two, but as the world goes, it must do me much good. Thou wilt see here my Prospectus and [the] names of all I have so far procured. With good care and management I have a clear profit of nearly five hundred pounds per annum on 100 subscribers and every new name adds in a ratio of about 1/3 more profit. I write to thee now by 3 different opportunities the same letter, so that one at least will arrive and give thee a good idea of what I am doing. I will be in Liverpool as soon as I have completed my business here; then I will go northward through Leeds, York, Newcastle and lastly to Edinburgh to settle finally with Mr. Lizars. I wish to be back in London by the 15th of November, but will write to thee many times in the interim.

I sent an excellent 5 Keyed Flageolet to Victor & some music by Nolte ... I have left [the Middlemist] house and removed in the same street to some rooms more appropriate to my present situation and where I hope to see thee next spring ... The third Number of my work is now out and is so greatly superior to the first two that I am told by all those who see it that I will do well altogether. I have a great comfort, that all those persons who know me, all receive me, with the same kind manners every time we meet. Mr. Bentley is now absent from Manchester and I am at a good friend's house of the name of Sergeant—one of my subscribers, but really a friend.

I have had 2 Subscribers today ... I wish Johnny would attempt to draw for me a male & female Sparrow Hawk, or if he cannot, have him kill some & send them to me, I mean the skins. I wrote a long letter to Mr. Berthoud but never have received a word from him and only one letter from Victor ... Try my sweet Lucy to make thyself happy. We will, I hope, soon meet again ...

John James Audubon to Lucy Audubon
"I have wished for thee every moment..."

Liverpool, England
5 December 1827

My dearest Lucy,

Mr. Rathbone sent me this morning thy letter of the 23rd Sept. and I set at once to answer it, but previously will tell thee of duplicate and enormously long letters containing all I thought of, and could say, respecting my situation at present, my expectations and my hopes. One of those letters went off by the packet ship *Pacific* of New York; the other went by the brig *Elvira*, Capt. Greece, in a small box directed to the care of Mr. Charles Briggs, New Orleans, the box contained newspapers &c. and two cases which thy sister Anne bought for thee and for which I paid. I at the same time wrote a few lines to Mr. Brigg and hope that parcel or rather box will reach thee safely and the case may be to thy taste. Since those letters, no change of note has taken place in my situation.

I am here for a week or more to try to augment my subscribers...I assure thee, England is such a land of plenty that nothing is done or obtained without much trouble and expense.

Now, dearest girl, for my answer. The letter I wrote to Victor and which he sent to thee was written when indeed although in London I had the blues with a vengeance. But it would take 20 sheets to explain the reasons why I had the blues and I am sorry, quite sorry, dear wife, that then I should feel uncomfortable. I would wish thee for *once* and *forever* to believe that I *never* mean to cause thee pain whatever I may say or do. But often, when quite down and feeling as if forsaken, my heart as well as my spirits give way and I commit these errors which it seems must have filled my letter to Victor. However, generally I try to look at the bright side of everything, and I assure thee my hopes are still good, but I have much to [illegible]. Only think in what situation I came to England, without friends and but little money, and compare with that the success I have met with and the numerous friends...I must

have met. Think again of the expense I have been at continually and the traveling I have had to perform and the care I have been at constantly to promote my views and then thou wilt conceive if or not I have been without or with materials to think about, to raise & lower my spirits a thousand times.

I have wished for thee every day, every moment; and yet at my present age I have postponed daily because of what *thou* callest prudence to write for thee positively to come. I feel quite convinced that it is thy wish to join me; did I think differently for a moment, my travels would cease and my happiness would be only a vapor. No, my dear wife, I assure thee I never have doubted thy goodwill towards me, but have more than once sighed and deeply too at thy fears of suffering *as much as me* by being together... Were thou here I only would have to work a very little harder than I do now and the comforts I would really feel, I am afraid my Lucy *will never feel*. How often have I told thee how dearly I love thee? Well, my Lucy, I am convinced that I feel more attached and truly devoted to thee than ever. Honors—hopes of wealth—even the education of our children—is all in my soul for thy own sake and for thy own sake only.

Come or stay, I must live thy friend, thy lover, thy faithful husband. I write a close journal every day of all my deeds & thoughts, merely with the hope that it may make thee spend a few moments in the belief that what I say here is true when thou wilt see that every night since we parted I wished thee well, blessed, happy. Now, my love, read this hurried letter and answer if or not. I wish & long for thee—in thirty days I will write either in full confidence for thee to come or leave it for thee to consider...

Prospectus to *The Birds of America*

Audubon used this Prospectus *to sell subscriptions to his great work, accompanied by a list of subscribers headed by "His Most Gracious Majesty," the King of England. At this point—May 1828—his list encompassed 124 names of persons and institutions.*

To those who have not seen any portion of the author's splendid collection of original drawings, it may be proper to explain that their superiority consists in every specimen being of the full size of life, portrayed with a degree of accuracy as to proportion and outline, the result of peculiar means discovered and employed by the author, and lately exhibited to a meeting of the Wernerian Society. Besides, in every instance where a difference of plumage exists between the sexes, both the male and the female birds have been represented. The author has not contented himself with single profile views of the originals, but in very many instances he has grouped them, as it were, at their natural avocations, in all sorts of attitudes, either on branches of trees, or amidst plants or flowers: some are seen pursuing with avidity their prey through the air, or searching diligently their food amongst the fragrant foliage; whilst others of an aquatic nature swim, wade or glide over their allotted element. The insects, reptiles or fishes that form the food of the birds have been introduced into the drawings; and the nests of the birds have been frequently represented. The plants are all copied from Nature, and the botanist, it is hoped, will look upon them with delight. The eggs of most of the species will appear in the course of publication.

The great interest which has been excited by the exhibition of these drawings, and the flattering praise which has been bestowed upon them in Edinburgh, Liverpool and Manchester, have induced the author to publish engravings of them upon a scale of elegance never before attempted in this or any other country. He has been encouraged to commence such an arduous undertaking at the suggestions of some of the most eminent naturalists both in America and Great Britain; and he is proud to acknowledge that their patronage has been extended to him towards the encouragement of the work; and he trusts to their support, and that of the public,

enabling him to complete one of the most splendid publications which has ever appeared.

The particulars of the plan of the work will be found detailed below:

1. The engravings in every instance to be the exact dimensions of the drawings, which without any exception represent the birds of their natural size.

2. The plates will be colored, in the most careful manner, from the original drawings.

3. The size of the work will be Double Elephant, and printed on the finest drawing paper.

4. Five plates will constitute a Number; one plate from one of the largest drawings, one from one of the second size and three from the smaller drawings.

5. There are 300 drawings; and it is proposed that they shall comprise three volumes, each containing about 100 plates, to which an Index will be given at the end of each, to be bound up with the volume.

6. Five Numbers will come out annually.

7. The price of each Number will be two guineas; payable on delivery.

Six Numbers being now completed, will give an exact idea of the nature and style of the work. All the other Numbers will at least equal these in interest and execution. It would be advisable for the subscribers to procure a portfolio, to keep the Numbers till a volume is completed. Persons desirous of becoming subscribers are requested to apply to Mr. Audubon, 90 Great Russell Street, Bedford Square, or Mr. R. Havell, Jun., Engraver, 79 Newman Street, Oxford Street, London; Messrs. Robinsons, Booksellers, Liverpool; Mr. T. Sowler, Bookseller, Manchester; Mr. M. A. Barclay, Bookseller, York; Messrs. Hernaman and Robinson, Leeds; Mr. E. Charnley, Bookseller, Newcastle-upon-Tyne; and S. Highley, Bookseller, 174 Fleet Street, London.—*May* 1828.

Lucy Audubon to Victor Gifford Audubon
"What he really means, I cannot tell..."

St. Francisville, Louisiana
15 June 1828

My dear child,

Yours of May 10th received yesterday; where it has been all this time I cannot conceive, but welcome at last. You say you hope I have received all your letters. That I cannot possibly tell, but I was, for about six weeks, expecting [at] every mail to hear from you, and more anxiously because you said in a previous letter you were going to tell me some particulars relative to yourself which I did not get, unless you mean the $25 for separate bookkeeping, which I do not exactly understand, but I'm satisfied provided you take care of yourself, which I have yet to learn...I have been terribly imposed upon this last six months, and for the next year I must make a more fair, as well as an advantageous arrangement; these people are selfish beyond my calculations...

John will have reached you in safety, I trust, long before this. I determined in a moment almost upon sending him up, for I delayed on account of not having funds in my hands at the moment, but [her brother] William's letter made me feel assured that for his sister he would *advance* which is all I ask. Your music box ought to have reached you by this time and I hope its sweet strains will keep your mother and her advice before your mind. If I could see you both supporting yourselves and put $2,000 at interest here, I need not work so hard and could afford to live near you all. This is a prospect to which I turn my thoughts and hopes.

From your Papa I am quite at a loss to grasp anything. He complains of your silence, says it will be long before he has finished the *Birds*, that in the meantime as soon as he is *able* he will ask me to go over if I like with John, that England is not what it was, that I might not like it, that "if I do not choose to go, he will, when he does come to America, bring me a piano worth having." What he really means I cannot tell—those are his words, and we must interpret them as we can. The piano you bought is so much better

than the other [Audubon sent her] that I shall keep it exclusively for myself and the other for the girls. The music is not worth a cent, but I cannot tell this to your Papa. Any letter from you, my dear boy, is a treasure that says you are well and well doing. All my anxiety and hope turns to you two; if any good comes from any other quarter, so much the better, but I have ceased to expect it...

John James Audubon to John Woodhouse Audubon
"I wish you would send me skins…"

London, England
10 August 1828

My dear John,

I wrote a very long letter to your dear Mamma a few days ago, nay 2 days ago, and I merely write to you now to shew you how anxious I am that you should as well as her write to me oftener. I have been nearly 4 months without a word from her and I at last received 3 letters from her about 10 days ago, up to the 24th of May. I am quite well and I think doing well. The 8th Number of my work is out and the 9th nearly finished engraving.

I am most particularly desirous that you should spend 2 hours every day, or more if you can, in skinning birds of all sorts for me. I wish you would send me skins of Wild Turkeys, Ivory-billed Woodpeckers and the large Black Woodpecker, all kinds of Hawks, Owls, Buzzards, Carrion Crows &c., &c., all kinds of small birds also, and all kinds of mussels, shells &c., &c. Send all to Mr. Briggs in a box; he will send them on to me. As it is very probable that I will write for Mamma and you on the 1st of January next, try to procure as many birds alive as you can. I was asked 15 dollars the other day for a male redbird. Skins of birds would be worth to you from 50 cents to 5 dollars, and it will all be for you. I should send a violin but I do not know if it is worthwhile now, as I have such great hopes to be able to write for Mamma to come in January.

I would give you 500 dollars per annum were you able to make for me such drawings as I will want. I wish you would draw one bird only, on a twig, and send it to look at as soon as you can after receiving this letter.

I saw Captain [Basil] Hall on Monday last. He saw Victor [on the] last day of May at Shippingport, but Victor did not write by him, which I am very sorry for. How do you manage without my gun? I should like to have a large box filled with branches of trees, covered with mosses &c., such as Mamma knows I want. Now recollect, *all sorts* of birds, males or females, ugly or handsome.

I will write again in a few days. I hope Mamma likes the piano and the dresses I sent to her. Do my dear boy exert yourself for me, as I do here every day of my life for your own sake. Kiss Mamma dearly for me and believe me forever your affectionate father...

John James Audubon to William Swainson
"I have had sad news..."

London, England
13 August 1828

My dear Mr. Swainson,

I reached my lodging in great comfort by the side of your amiable
Dr. Davie, two hours and a half after we shook hands. I wish I
might say as much of my journey through life. I have had sad news
from my dear wife this morning. She has positively abandoned her
coming to England for some indefinite time; indeed, she says that
she looks anxiously for the day when, tired myself of this country,
I will return to mine and live, although a humbler (public) life, a
much happier one.

Her letter has not raised my already despondent spirits in some
things and at the very instant I am writing to you it may perhaps
be well that no instrument is at hand with which a woeful sin
might be committed. I have laid aside brushes, thoughts of painting
and all except the ties of friendship. I am miserable just now and
you must excuse so unpleasant a letter. Would you go to Paris with
me? I could go with you any day that you would be pleased to
mention. I will remain there as long and no longer than may suit
your callings. I will go with you to Rome or anywhere, where
something may be done for either of our advantage and to drive
off my very great uncomfortableness of thoughts. My two sons are
also very much against coming to England, a land they say where
neither freedom or simplicity of habits exist and altogether uncon-
genial to their mode of life. What am I to do? As a man of the
world and a man possessed of strong, unprejudiced understanding,
I wish that you would advise me...

Should you not feel inclined to go to France at present, which,
by the bye, is the very best season on account of seeing the vintage,
&c., &c.—please write to me so or come to town which would be
still more agreeable & talk the matter over as I think I would
persuade you to absent yourself for a month or so...

John James Audubon to Lucy Audubon
"I have no fortune to give thee yet..."

London, England
17 November 1828

Since last Sunday...I have received two letters from thee, one dated August 29th and the other (which came first) Sept. 15th. From their general tenor, I think that it is thy wish to come over to me, and I am truly happy at the thought! Although I have not accumulated that *wanted fortune* which on thy account I so much desire to possess, I think that we might live together tolerably comfortable. I am particular in my expressions because I do not in any point of view wish thee to expect too much, and to see thee unhappy and discontented now would infringe on my faculties. Should thou determine on coming, *thou wilt be welcome* and thy husband will do his very best to render thy days and thy nights comfortable—to have thee *willingly* with me will give spur to my industry and I should think all may go on well.

I am now glad of the idea of having John situated as Victor is, and I received thy letter of the last date with great satisfaction on this account. I think it will be better for awhile that thou should come alone and by way of [New] Orleans through the medium of Charles Briggs as will be directed by Mr. Gordon, to whom hearing to that effect will see that thou are well arranged with a good captain and a good man.

Our absence from our dear sons will I hope be only partial, and to know that they are doing well and are healthy must suffice us for a while. Thy being with me must be of inexpressible value to me and to my ultimate success. It is at the distance impossible to say to thee of what service thou wouldst be to me. I am sorry about the piano &c., &c., but never mind it anymore—thou wilt have a good one here...

Continue to write through my friend Rathbone always. Should thou make up in thy mind to come over to me *write me immediately* by three several letters to that effect and manage to come to Liverpool where I will be sure to be awaiting thy arrival. I have

here, a parlor, a painting room, a bedroom, a kitchen and a servant room, which will do until thou hast seen a little of London, and should thou not like this, we can go anywhere else...

I returned 2½ weeks ago from Paris where I did pretty well. I procured 14 subscribers among which are the king, the duke & duchess of Orleans, &c., &c., and the government has ordered 6 copies. I do not think of sending thee anything more until I hear from this in answer, as I fondly hope to have thee here in the spring or summer. To come by way of N. Orleans will save thee an enormity of trouble and expense; indeed, I think (and thou must not think hard of me for so thinking) that to see thy relations and thy sons [in Kentucky, requiring passage from New York] would only cause thee more sorrow.

The 11th Number of my work is began and the 10th, the last for this year, is now distributing. I can assure thee that I do not owe a pound in any way and I have much due to me that comes in gradually. Bring with thee thy clothes and valuable effects only, and *every scrap* of my journals and drawings that thou canst get or have by then—and our sons' portraits—whatever in Natural History objects, thy best books and so on...

Now, after all I say, should thou feel the least repugnance about coming, say so openly, as I tell thee that I have no fortune to give thee yet. I speak most candidly to thee because I do not wish to mislead thee. I promise that I will try my very best to render thee comfortable. I write constantly, until I hear from thee, every Sunday, either from London where I am or anyplace I may go to. Is John to go to [work with] Mr. Berthoud or thy Brother William? Write often, dearest wife, and believe me, thy happiness is my principal object in view.

May God bless thee forever—

Thy husband & friend for life—

John James Audubon to Lucy Audubon
"I am dreadfully fatigued of our separation…"

London, England
23 December 1828

My dearest friend—

Thine of the 11th October reached me two days ago, and this is in answer to it. Meantime I must speak of the letters I have lately received from Victor, one of which reached [me] in only 40 days from Louisville. He has been writing respecting your coming over and I have answered them nearly in the following words: I wish much to have thee here, thinking that I can afford thee *moderate* comforts. I have 3 rooms and a servant in a portion of Mr. Havell's house, my engraver, in a good situation, and as I am now what may be considered a house keeper, my little establishment is kept up when I am absent and is as costly almost as when at home. I pay 100 pounds rent. My work goes on as usual and I do not think that your being here would make much alteration in my expenses but a great deal to my comfort.

[I also told Victor] that you should come alone (I mean without either Victor or John) under the care of a good captain recommended by Mr. Charles Briggs or any other person you may know at New Orleans. I wish to go on smoothly and with great care so as to enable me, in one year after thy arrival, to be quite able to write for John should *he* feel inclined to prefer Europe to America—and again afterwards to Victor. But as Victor says that your brother William is anxious to have both of them (Victor & John) in his counting house and that they also wish to go to him who is now married—I have not the least objection. I love my sons dearly, but I love them for their own sake and not the mere idea that because they are my sons, I must dictate to them, when they are sufficiently able to act for themselves & their comforts.

I wish thee to weigh these ideas of mine and do as thou may like best. I have now 144 subscribers which bring me an income of about 100 pounds and I make something by painting in oil. I will have to go to America in about 3 years, but only for 3 or 6 months

at most, and will not go further than the Falls of the Ohio to see our sons...

I am glad to read of thy being happy and comfortable, but I am dreadfully fatigued of our separation; whenever I lay my head on the pillow to rest, I feel a fear that we never will meet again, and many of my nights are sleepless. I am not enamored of England, much less of this [illegible] of London, and certainly would greatly prefer being in America did I not see it my interest to remain here until the completion of my extraordinary work. I hope to have it in my power to dispose of the plates, copyright &c. when I have finished the publication and to have as much money as will render us quite comfortable near our dear children.

Victor's letters to me are highly interesting, full of [illegible], sentiment & second judgment and I am very proud of him. I hope that the goodness of heart natural to John will also form & finish him equal to his brother. I have not, at present, a single full set or copy of my work, or I would send thee one by this opportunity. I this day send 100 of my Prospectus & reviews by Cuvier & Swainson to New York, Philadelphia, Boston &c., &c., for I am truly astonished that my work is not known in America...

I have just finished 2 very large pictures in oil which will be exhibited, one in about a month in the British Gallery and the other in May next at the [illegible] House... Next Saturday I will dine with the envoy of the Grand Duke of Tuscany and may procure his name to my list. My last printed prospectus contains the review of Baron Cuvier, and I will put one in this, as I think it will give thee pleasure to translate it—

Write often dearest Friend and let me know thy conclusions...

Lucy Audubon to Victor Gifford Audubon
"Papa's last letter is a very severe and painful one..."

St. Francisville, Louisiana
19 January 1829

My dear Victor,

I begin to think it long since I heard from you. Business, I hope, is the only reason of your silence. We have had a most disagreeable winter; indeed, I have only left the house twice since December came on. One of my trips was to Mrs. Sims, above Hamilton [Mississippi], with the expectation of changing her note into cash according to her promise, but they gave me no hopes of ever paying it, supposing perhaps that as I had waited so long I might wait a few years longer. I rode 26 miles through wet and cold, ten of them after sunset with only a Negro boy with me. I am now determined to dispose of her [note] somehow even at a loss. I have one chance in a week from a gentleman who has money and does not in the least regard her feelings, but he is not quite determined and I do not like going to law myself, though you may rely upon it, I shall endeavor to close the business with her Ladyship. Nor have I yet made a single collection anywhere.

I mean to wait no longer, but as all my own time is taken up, send out my accounts all round, for I am anxious of sending the money for John to [New] Orleans [on] Sunday, the 25th, by Mr. Johnson, who is going down then, and it is not right that he does not produce the money as I told [him I] wanted it, and would save me any more trouble. I shall get his note this year and then I can more easily obtain the proceeds if necessary. I am pretty sure of sending the money by him to Gordon & Forstall, and I will tell them to write immediately and let your Uncle William know it is in their hands, then or in a very short time after that. I shall send five hundred, because I know the expense of John must be considerable, though I hope not quite all that; he will want pocket money, but must use it sparingly.

Now I must revert to the subject of your Papa's last letter, received tonight, which is a very severe and painful one, and poor

consolation for all my labor. You are now of an age to be my friend, my comforter and confidant. The date of the letter is early in November, when he had just come from Paris. He obtained 14 subscribers and says he was much pleased with his trip, not a word of his relations [i.e., Audubon's family in Couëron], has now 144 subscribers, much less than I expected from former advice, that he has got a letter from you in which he finds that neither of his boys will join him, and doubts whether I will, that we have no consideration for him, that I require from him a "princely domain," but I must say whether I mean to go over soon or not, because if not we had better have a formal separation, as he cannot answer for the continuance of his affections much longer, that as the piano was broken and the gowns saltwater-damaged, he shall take good care to send no more articles of any sort.

Surely your father is blind to the real state of affairs, for these eight years I have relieved him of all expense but himself, paid him $500 with him and three hundred since he went away in demands here, and he says I write "I am extremely happy here," which I'm sure I never did—I only have said I had the comforts of life and did not wish to move till he could ensure me the continuance of them, which I had not at Cincinnati, Natchez or [New] Orleans [i.e., after Audubon's bankruptcy]. I have, however, concluded to give up my school after *this* year and take John with me, to whom a few years more of instruction in Europe either in a school or counting room would be beneficial, and trust to Providence for my happiness and yours. In a few years it is possible we may be able to afford you to take the voyage and bring your brother back to his country if I cannot come then.

This is what I now think of, but will not speak of it to anyone but you, and circumstances may change. God knows my duty alone must guide me, for a mother's feelings will be torn to agony at leaving you, my dear, dear, child. Though I do not see you now, no danger comparatively is risked in getting to you, [compared] to what the Atlantic affords. I think the best plan will be for me to keep John up with you and where he is till next spring,* when he can come for me as soon as the month of March and [I] can journey on to you and spend a month and then proceed. My earnings, all but my passage money, I shall leave with you, my beloved son.

This is looking far ahead. I shall only write to your father that I will wind up my business and cross over as soon as I can; now it is impossible, for half the year would be gone before I could send him word, and I cannot get my money, and I hope this year if nothing happens to me to save a thousand; but keep this to yourself. Have you received the ten pair of socks I knit and sent? Have you got anything for the trunk? I shall send some more socks by Mr. Johnson to [New] Orleans to be shipped up.

Write, my child, my comfort, to me, I hope you are well. The piano is yours that you choose, and I hope you will think of me as you play, and remember your mother's happiness hangs upon your good conduct and welfare. I have been quite sick for a week past but feel better tonight. I am now going to write to John—Adieu, may God preserve you...

*I mean the spring 1830. John can spend his vacation with you, for he will surely be sick if he comes here to run about in the summer after an absence so long...A second thought is that John need not come down at all, for I can go up alone and save expenses. Do send me a shirt for a pattern, as I want to make up some linen for you both and bring with me in 1830. Do not write to your Papa anything about it, my dear son; leave it to me to settle with him.

John James Audubon to Lucy Audubon
"I will sail for America..."

London, England
20 January 1829

My dearest friend,

Thine of the 8th November reached me about a fortnight ago, and ever since I have been debating what was or would be the best thing to do, as I plainly read in it the same that has filled every other that has come from thee since I left America, i.e., the *uncertainty* of thy *ever* joining me in Europe. I have therefore come to the following conclusion, which thou mayest take for granted if I have life within me: I will sail for America (New York) on or about the 1st day of April next and will (God willing) be on American soil once more in all May next. I had no wish to go there so soon, although as I have often repeated to thee, I always intended to go on account of my work; but I have decided in doing so now with a hope that I can persuade thee to come over here with me and under my care and charge.

I will try between this time and the time of my departure to make all such preparations & arrangements as I can best adopt for the safety of the progression of my publication, the collection of my dues, the insurance of my drawings, copper plates & oil paintings &c., and leave the main part of all my cares in this land to my excellent friend William Rathbone. I have wrote duplicate letters to Victor on this subject, with strongest injunctions to keep it a perfect secret, and I wish thee to do the same. Only 3 or 4 friends in England will know positively when I have gone; my subscribers and the world will think me on the European Continent after more patronage. This is absolutely necessary for the safekeeping of my present subscribers, most all of which would become alarmed and would expect the work to fall through. I will advise thee of my arrival at New York, and previously give thee the name of the packet in which I will sail &c., &c.

It is not my wish to go as far as Louisiana but as far as Louisville, Kentucky, where after my landing we will make arrangements to

meet, never to part again! I have been induced to come to this firm and decided conclusion because writing is of no avail. Thou couldst not understand my situation in England or my views of the future was I to write 100 pages on it, but will understand me well in one hour's talk!

By the time of our coming over, John will be settled, I hope, to thy heart's content, and I hope to make thee happy & comfortable here the remainder of thy days. I wish to be absent just 12 months, and on my return I will have material enough to finish my stupendous work...

Lucy Audubon to Victor Gifford Audubon
"I sometimes consider why I wish any longer to live..."

Bayou Sarah, Louisiana
30 January 1829

My much loved son,

Yours of the 7th received late last night and as a tremendous rain prevents the Miss Carpenters from coming to their school I will at least begin my letter. I have been at the piano since five. It is now half past seven [in the] morning but so dark that I have not long put out my candles. With respect to your living with your Uncle William [Bakewell], my dear son, I am not any judge, but you seem aware of the gratitude you owe your Uncle [Nicholas] Berthoud, as to your time I do not know it, and indeed I misunderstood the affair altogether, that does not signify, use your own reflection and as a disinterested party your Uncle [Benjamin] Bakewell of Cincinnati would advise you, for I am too far off to know the particulars, and must leave you to act for yourself only begging you to preserve your probity, candor, and industry wherever you be. I sent [on] the 25th eight hundred dollars, all I could then collect, to Mr. Briggs to pay for a piano, my stationers bill, and the balance $400 or over to be sent to you for your brother's use. I was in hopes to have sent more but cannot get it. I have paid all my expenses here, have Mr. Johnson's note for six hundred, and Mrs. Sims for $499 and about five hundred out—and Mrs. Sims' note I shall never get without suing, and till I leave the place I do not like to do that. I have tried to pass it away for a great discount but no one will have it.

This last year till November I had no school scarcely from the expectation of leaving, now I have really a profitable and agreeable school, and though it is my serious intention to give it up the last of December next, I do not mean to say so until the moment comes. I have many reasons for my conclusion, but whether it be to remove to another school, or join you all must depend upon wants not now known.

I have the linen for your shirts but would rather have a pattern

for each of you. I wrote you a week ago and sent you a pair of socks, I do not think John can wash so many pair. With respect to the gig [i.e., a one-horse two-wheeled carriage], I must do without it for one loss and expense and another have taken more funds than I expected. I wrote to you for a horse, a strong pacer, before mine is nearly gone. The amount for that I hope to have in a few weeks. I would not have had the pupils without going to them once in the week and as to my strength, it will last its time. I sometimes consider why I wish any longer to live, all my best days are over and yourself and John will soon be able, I trust, to provide for yourselves; still I look forward and hope for the termination of your good character [i.e., his business training] and study before I die. It is my opinion that in so large an establishment as Bardstown [Academy] little is learned, and had I been able to command John I am sure he would have learned quite as much with me. At the vacation you can judge of him, but I do not think he ought to come down in the summer, if he is benefited by his studies let him go again till the end of the year, when I shall be going up and can join him at Louisville.

Should I go to Europe, a finishing to John's education may be given there, and as he is yet young he will have time to go and return to you when he is able to go into business. I must only look to my duty, not my chores. The apples came and were very, very nice . . . Now as to chitchat it is very scarce for I do not go out to obtain any . . . Miss Christiania Perry is still at Natchez—quite a belle—also Juliana Randolph. The Miss Davises beg to be remembered to you, they have lately been thrown into trouble by their cousin Flood's husband stabbing his wife's mother, Mrs. Flood the sister of Mrs. Hathaway, and a nephew of Mr. Flood's is to be hung in March for a similar affair. How thankful I ought to be I am not the wife, the mother or the aunt even of those two wretched young men who will both be hung.

I have written very very bad, but my pen knife is not here and I shall have no other time before the boy goes down to the Bayou. Can you send us any pretty easy tunes from your new aunt? I have fifteen music scholars. Write to me soon, my dear son and tell me all your arrangements, and precisely what John's college expenses are. Mr. Briggs has been very kind to me in paying duties, expenses,

&c. and I do not know how much but have written to him about it ... Since I began my letter I have another scholar added to the number. I went to town the other day and as it was very like rain on my return I came home without my bonnet for fear of spoiling it. I have not any idea of getting a gig in [New] Orleans because I'm not certain *when*, about the cash these people are so uncertain though.

All summer the heat is so great here that it is not fit for a horse to one shut up all week. I cannot think of John coming home in the sickly season; you must tell him how hazardous; how much I love him and I hope he will not forget me ...

Lucy Audubon to John James Audubon
"I am coming to the resolution of joining you..."

St. Francisville, Louisiana
8 February 1829

My dear husband,

I have this day received yours of August; where it has been I cannot imagine, but I am, at any rate, glad of it, as you speak of things I did not know before. To begin with the first thing, it is our John whom I often hear from, and who from all accounts is improving; I have often told him to write to you. Next you speak of the piano, which answers all the purpose I could wish now. I have had it repaired [it had been damaged at sea], which cost me fifty dollars, and I assure you I feel very much gratified by your sending it. I am sorry you do not send me any more of your engravings. The French dresses and bracelets you speak of sending from Paris will be very acceptable, I assure you; the two gowns Ann sent me fit me beautifully, but they are not *here* called dress gowns. However, for two years I have not wanted an article of that sort.

Next you speak of Mr. Swainson, whose review we all so much admired, so much that the gentlemen got the two I had and I could not get them again. Then your portrait, which I think cannot be better than the one hanging opposite to me at this moment.

You say you must not speak as a "man in love." I do not see why, if you do love, which there seemed some doubt of from your last; I must attribute it to a fit of blues, for I cannot believe you so lost to reason and sense as to blame me for the part I am performing. I am, however, come to the resolution of giving up my occupation and joining you, as soon as I hear from you finally that you desire it, and can place John for a year or so at a first-rate school; then in a counting room, and by that time we may be able to return with him to America.

I beg of you, my husband, to be plain and clear in your reply; if any circumstance has occurred to change your affection for me, as you rather insinuate, be explicit and let me remain where I am. If, on the contrary, you still think I can add to your happiness and

John can finish his education, you will find me prompt in preparing to quit Louisiana as soon as I can collect my funds to travel with and ascend the Ohio to see my dear Victor on my way. His plan of operation will be guided by us, after we meet; letters are a poor way of knowing. Thank you for thinking about me and the lace.

And now that I have replied to yours fully, and repeated part of what probably I have said over and over, I must proceed to something else—and finish. I make little more than myself and the boys spend, but they have not wanted for anything. I should not like to sail from [New] Orleans, nor could I leave without seeing Victor again. It will cost me & John about six hundred dollars to reach you, and all the rest I may then make will be for Victor, as I am sure you do not want me to take it to you, or you would not want me to leave when I am doing.

I have now said all I can on business and will finish with a little chat. Tonight as Mrs. Butler was taking home her little girl for me, from school, the horses ran off, the carriage was upset and Mrs. B. very much hurt indeed, the carriage broken and horses run away. I mean to go tomorrow evening to see her after my lessons are over in music, it being Saturday. I wrote you Dr. Hereford was married to one of the Misses Shirley, and Mr. Lobdell to the other. On Wednesday last Miss Holl was married to Mr. Nübling, the nephew of Mr. Hall. I was not at the wedding, nor do I often see them, but Mrs. Percy saved me a piece of cake. I have no day to myself but Sunday, and that day I generally spend in writing. I wish you would send me gowns made up, if you can, for I am obliged to pay for mine made out, not having a moment to sew. There are no material changes here, Mrs. Hamilton that was has not paid me yet, but I have a few days ago put the affair into a lawyer's hands for collection. I hope this will reach you and find you well and comfortable. Write soon and send me your full opinion of my proposal and plan and tell me what you wish me to do as I shall be sure to do it as nearly as I can...

Lucy Audubon to John James Audubon
"My thoughts will be often of this side of the globe..."

St. Francisville, Louisiana
20 February 1829

My dear LaForest,

You told me, in the last I have had from you, to write thee several letters informing you of my intentions respecting my voyage to England, and in consequence of that request I have already written two letters informing you that if my answer from you is telling me to set out I shall do so. I could not have left now had I got your last letter sooner, for several reasons. First, John is at school, but at the end of this year he will be able in America to enter a counting room, but if you say bring him to England, I should certainly, and I think you also would like him more improved; at any rate, his expenses must be paid and he yet wants a parent, and as you cannot be with him, I think it my duty to be near and be both father and mother, and see that he is paid for and provided with all things necessary.

You know I am very independent and will not, while I am able to work, be helped by anybody but you. Victor and William have for two years urged me to give up and live with them, but I never will. It would be a shame to take anything from Victor's earnings [when he is] just beginning [in] the world, but another reason is that I cannot collect funds enough for the expense. I shall be endeavoring to have all ready by the close of this year, and nothing but your letters will change my plans. However, as both the boys will remain behind for some time, I can leave my business to be settled by them, and come over to you and try what we can do for them. I hope that it will not be long before you can return to them and America, for my thoughts will be often, very often of this side of the globe.

I yesterday had the pleasure of seeing Mr. Reynolds, the president of the college where John is, and also a letter from our dear boy, who begs me for a watch, and if you were not in England and would not be most happy to send him one, I should write to [New]

236

Orleans for one of the kind he wants, a plain silver patent leather with a gold key and slide and seal, also a seal for Victor, who has none; a chain I have for him that would do. I have promised John a watch next Christmas, but did not say from whence; but I am quite sure the gratification would be doubled if it came from you, and if you can spare the money you will have an opportunity of sending it free from duty by Mr. Boggs to me this summer, ready for John... You cannot have a better opportunity of sending me anything, and I am sure your son and myself shall be most grateful to you.

If you can not do it, tell me and I will get him the best I can here, before I leave America. He is so good a boy we had ought to encourage him, indeed both our sons deserve our blessings, and I cannot help hoping you may some day realize enough to enable me to live near them or with them. And my leaving them and going to you is a proof of affection and duty towards you of the highest kind I could give.

I have nothing new to add, for my three letters followed in quick succession, but I anxiously wait your answer. John will come down for me next January and help me to get in my money, and travel with me to see my Victor and my sisters and then I shall proceed in May to you, and I hope to promote your happiness much by the great step. So do not mislead me; if you think it most prudent for me to earn my stipend a little longer, you have only to say so, for I shall take it kind to know precisely what you wish me to do.

I am now sitting by a good fire but still feel the cold, which has been intense this winter here, ice thick and freezing in the daytime all day. My poor plants have had a hard time of it but I keep them in the house and they look pretty well. I shall write you the name of the packet I cross in, in due time...

Lucy Audubon to John James Audubon
"I give you myself and my heart..."

St. Francisville, Louisiana
22 March 1829

My dear husband,

This is the fourth letter in succession, a week apart, that I have written you for the same purpose, namely to announce my determination (if you are in the mind and circumstances to receive me) of departing this country [at] the close of the year, but it takes so many months to obtain an answer that I begin to fear I shall not hear from you before the end of this. However, I shall endeavor to be ready and to settle all my affairs, which consists in collecting my scanty income, for scanty after all expenses and losses it is. When I see you, I can fully detail all; it is enough now for me to say, if I come I give you myself, my endeavors to increase your happiness, and my heart. Nothing more have I, and if it is your opinion or wish I should continue my avocation longer, say so, if not, in a few months now, we shall meet, and I hope and trust for the advantage and comfort of us both. But do write plainly, and quickly; I cannot alter anything here till I get your positive answer and request to move.

With respect to our children, Victor is settled with his uncle William, from whom we have received all the aid we have stood in need of, and I believe from Victor's representations that had we required more, we should have had it. William repeatedly begged me to tell of whatever I wanted, and the moment my occupation was unpleasant or insufficient to let him take me home till you could, but thank God I owe no one money. Kindness I have had from many, and hope I never shall be guilty of ingratitude for it.

I now feel that my assistance is not indispensable to Victor, and as to John, if you can or will let him pursue his education a year or so longer, I will bring him with me; if not, he shall remain with his brother and uncle the three years which you say will be about the time when you will visit America again.

I am now forty, I have no indication of age but gray hair and

loss of teeth, I may live many years yet, and must have a good constitution to endure the unceasing fatigue I do, and have not had a fever since I left Mrs. Percy—the headache and want of breath being all I ever suffer from, and change of life would I am pretty sure remove them. However, this is uncertain, and I live, and regulate all concerns relative to me, as if I was to be called to the other world any moment; all should do...

I shall sail from New York about this time next year unless you countermand my intention. Adieu. Try to send me a watch for John as most likely he will remain here with his brother.

John James Audubon to Lucy Audubon
"I have come for thee, dearest Lucy!"

New York, New York
6 May 1829

My dearest friend,

I simply wish to inform thee of my safe arrival here yesterday after a passage of 35 days from Portsmouth in the packet ship *Columbia*. I am so busy with custom-house affairs, &c., that I cannot say anything more to thee now, but in a couple of days will let thee know all my views & plans. I have come for thee, dearest Lucy! I am in perfect health and so fat that I must take great care of the climate. I have brought a superb watch for our Victor. Write to me care of Messrs. Thos. Walker & Sons here until further notice.

God forever bless thee—be assured that I left my business going on well in London, &c., but more when I write next—again farewell...

Thine for ever—

John James Audubon to Lucy Audubon
"To my Lucy I now offer myself..."

New York
10 May 1829

My dearest friend,

I have been landed here from on board the packet ship the *Columbia*, four days after an agreeable passage of 35 from Portsmouth. I have written thee, since then, 2 short letters to announce thee my safe arrival and my good health and now set to write at length a letter which I sincerely hope and wish thee to read with due attention, and believe to be in its whole contents the true sentiment of thy affectionate friend and husband.

1. I have come to America to remain as long as consistent with the safety of my publication in London without my personal presence, and according to future circumstances either to return to England on the 1st of October next or, if possible, not till the 1st of April 1830. In this I must be guided entirely by the advice of my friends in England, William Rathbone, J. G. Children of the British Museum, and Mr. Robert Havell, Jr., my engraver.

2. I wish to employ and devote every moment of my sojourn in America at drawing such birds and plants as I think necessary to enable me to give my publication throughout the degree of perfection that I am told exists in that portion already published and now before the public. This intention is known to no one individual and I wish it to be kept perfectly a secret between our two selves. To accomplish the whole of this, or as much as I can of it, between now and my return to Europe I intend to remain as stationary as possible in such parts of the country as will afford me most of the subjects, and these parts I know well.

3. I have left my business going on quite well and with hopes that my return there will not be forced upon me by disappointments. My engraver has in his hands all the drawings wanted to complete this present year and those necessary to form the 1st Number of the next year, and my cash arrangements to meet my

engagements with him I think have been, and are, prudently man-
aged and sure.

4. The exact situation of my stock on hand left in Europe I give
thee here *bona fide*, copied from the receipt I have on hand and
with me here:

Amount of debts due me	1st Jan'y 1829	466.16. 4	
Value of my engraved coppers	" " "	504. 0. 0	
Stock of the work ready for sale	" " "	262. 8. 0	
Cash in Wm. Rathbone's hands	" " "	132. 5. 0	
Sundry paintings, frames, books, &c., &c.		200. 0. 0	

Sterling £1565. 9. 4

about 6,960 dollars.

I have with me 150 £, 2 copies of my work, $200, plenty of clothes,
my watch [@] 100 £, Gun [@] 20 £, &c. The above, my dear Lucy,
is the present stock of thy husband, raised in the 2 first years of my
publication, the two most difficult years to be encountered, with a
stock of fame not likely, I hope, to decrease but to support me and
enable me to live decently but not in affluence but respectably.
Should I be absent until the 1st of January next without drawing
for money on England, and my work is published with regularity,
there will be 500 pounds to be added of money either due to me
or received for my account—and an additional stock of coppers
[i.e., engraving plates] of 252 £. The more my subscribers augment
in numbers, the greater my profits, and on that score I have great
hopes!!—*and good reasons for thus hoping!*

To my Lucy I now offer myself with my stock, wares and chattels
and all the devotedness of heart attached to such an enthusiastic
being as I am—to which I proffer to add my industry and humble
talents as long as able, through health and our God's will, to render
her days as comfortable as such means may best afford, with caution
and prudence. In return for these present offers, I wish to receive
as *true* and as *frank* an answer *as I know my Lucy will give me*,
saying whether or no the facts and the prospects will entice her to
join her husband and go to Europe with him; to enliven his spirits
and assist him with her kind advice. The "no" or the "yes" will

stamp my future years. If a "no" comes *I never will put the question again* and *we probably never will meet again*. If a "yes," a kindly "yes" comes bounding from thy heart, my heart will bound also, and it seems to me that it will give me nerve for further exertions!

We have been married a good time; circumstances have caused our voyage to be very mottled with incidents of very different nature; but our *happy days* are the only days *I now remember*. The tears that now almost blind me are the vouchers for my heart's emotions at the recollection of those happy days! I have no wish to *entice thee to come by persuasions*; I wish thee to consult thy own self and that only, and to write to me accordingly thy determination, the amount of thy own pecuniary means and how soon I might expect thee in Philadelphia from after the time this reaches thee. I cannot go to Louisiana without running risks incalculable of not receiving regular news from London. Either go to Louisville and even to Wheeling on the Ohio and I will meet thee at the latter place at the time appointed by thyself.

5. I do not wish to take John with us unless it be to follow my profession and I have no wish whatever to enforce this upon him. Settle him at Louisville with whomever thou may like best; some future years may bring us *all* together!

Victor being settled I feel happy on his account, and that is all a father must desire.

6. Thy determination must be prompt, either "yes" or "no." If coming, thou must settle as quick as prudence will permit, sell all that is at all cumbersome and ship whatever is not absolutely necessary for thy journey through Mr. Charles Briggs to the care of Messrs. Rathbone Brothers & Co., Liverpool. Ascend the Ohio or sail direct for here or Philadelphia as may suit thy wishes best. Sell for cash at reduced prices rather than leave debts behind thee. If thou determine on coming, I wish thee to be with me before the 1st day of October, because, should I be recalled to England on account of accidents, we must sail on that day in the same vessel that has brought me here. I have pitched on Philadelphia for remaining until I have thy answer to this because the market is good for my purpose and the woods very diversified in their trees. When with me, we can go somewhere else if time will permit. Do not forget to bring my old journals and whatever drawings of mine

(of birds) that thou may have. I have brought an excellent and beautiful gold watch for Victor; perhaps Mr. Berthoud [Victor's employer] would permit him to take care of thee to Wheeling or to Philadelphia. I will now pass to other subjects.

I have been received here with great kindness by the scientific men of New York, Col. Trumbull, Major Long, Mr. Cooper, &c., &c., have paid me many compliments. The collector of the Custom House gave me a permit to enter my books, gun &c., free of duty, and all the public institutions and exhibitions are open to me. I found my good old friend Dr. Pascallis quite well, his amiable daughter married and the mother of three sweet children. Dr. Mitchell [the former U.S. senator] is now lost to himself and to the world. I have seen him once, half dead with drunkenness. My immense book has been laid on the table of the Lyceum and looked at [and] praised and I may have one or two subscribers here, a few more at Boston, Phila., &c. Should I procure 20 in the whole United States I will be proud of myself. I have seen Messrs. Walker and Sons and given them a letter from friend Wm. Rathbone; they will attend to the forwarding of my letters from England &c., direct to their care until I write to the contrary.

It was my intention to proceed to Phila. tomorrow—Monday, the 11th May—but the president of the Lyceum desired me to remain here a few days more and I will do so with hopes to have a subscriber or so. I have written to Mr. [Thomas] Sully to procure me a boarding house in a private family &c., and I expect his answer tomorrow. I will write to thee frequently, perhaps twice per week, until I hear from thee. I should like exceedingly to spend a week or two at Mr. Johnson's with thee, but it cannot be, and probably forever my eyes will not rest on magnolia woods or see the mocking thrush gaily gamboling full of melody amongst the big trees of the South. A vessel arrived yesterday in 12 days from New Orleans, the news of which shook my frame as if electrified; to know that in so short a time I might again see my Lucy and press her to my heart is a blessing beyond anything I have felt since three years.

Thy sister Ann [Gordon] was quite well when I left. I had a letter from Mr. Gordon a few days before my sailing, and a week or 2 before, he called on me in London to view my paintings.

I have here a beautiful dog of [the] King Charles breed; I will try to send it to my old friend [Augustus] Bourgeat if I can prevail on any captain or passenger to take charge of it. Remember me most kindly to them all...

John James Audubon to Victor Gifford Audubon
"Was I to lose my summer I would miss the birds..."

Philadelphia
18 July 1829

Not a word from you yet, my dear Victor. Where are you? What are you doing? Are you, as your Mother seems to be, quite unwilling to believe that I am doing all I can for the best for all of us; and in such a case have you abandoned the idea of ever answering my letters?

I have been in America now for two months and 13 days. I wrote to you on my landing, gave you my address, have written since several times, all in vain. It is neither kind as a man or dutiful as a son to keep such an extraordinary silence. Have you thought, as your Mother, that although I wrote that I could not go westerly or southerly that I would undoubtedly do so? If you have, undeceive yourself and believe me I cannot go either to Kentucky or to Louisiana and for the third time I will advert to my reasons for a different conduct.

I came to America with two views in thought. One, to engage your dear Mother to go to England with me if agreeable to herself; and secondly, to make a series of drawings such as I think necessary to enable me to continue my publication on the same plan and regulations that have existed since its beginning. I wrote to this effect to your Mamma, explained my plans as well as my poor style of writing will permit me to do, &c. Three long years have elapsed since I saw your Mamma, and about 5 since you and I walked together. My voyage to Europe has been as good a one as I could possibly have expected in the most enthusiastic of my moments. I landed there with 240 pounds of cash and two letters of recommendations from Vincent Nolte, besides 2 from Henry Clay. I have frequently wrote to you that I had been kindly received [and] highly honored, and formed a connection of valued and valuable friends (I might add, better friends than any excepting my Father and Mother) who advised me well and put me ultimately in a way of doing for you, your brother and mother what I always have longed to do.

I began my publication in the most difficult of times for an individual without money, and certainly have had a great share of trouble; but I have established my publication and it is looked upon as unrivaled. Two full years of my work are now before the public and the present year is going on well. My subscribers have slowly but regularly increased, and when I left England I left behind me in stock of plates, copies of my work and monies due me and in Wm. Rathbone's hands rather more than 1,200 pounds—I brought with me 150 pounds, a good double gun, excellent watch, wearing apparels, &c., with 2 copies bound of my "Birds of America" and a heart full of joy at being able to tread again the "Land of Liberty." I felt as if the world smiled to me once more, and wrote to your Mother to join me as I would write to my only friend in the World. I wrote to you to say all this and more, and now I am with 2 letters of your Mother only.

Those two are full of doubt & fear, nay quite the contrary of what I expected. She is not able to come to me for the want of funds; neither can she collect any until fall or winter, and *I cannot go to her* because was I to lose my summer by so doing I would miss the birds that I want and that are not at all to be found west of the mountains. She does not seem to understand this; she complains of my want of affection; of the coolness of my style of writing, &c., and thinks that my not going to Louisiana for her is quite sufficient proof for all these her doubts and fears. Ever since I left her I never have had from her a letter containing the *facts of her situation*, never have known how much or how little she made or received; but on the contrary from her independent manner of expressing herself have always hoped that she was doing well and happy.

Now as a man of business I wish you to write to her, taking in consideration what I have said here and again what follows. I wish her to settle her business as soon as conveniently possible, to collect as much money as she can and arrange the remaining debts in such a way as may insure *you* the receiving of the greater portion after her departure. I wish her as soon as she can (again conveniently), to make her way up to Louisville in a steamboat and in the charge of a good, well-known commander, and from there to continue on to Pittsburgh by herself under some such same care, or under your

own if your time or your avocations or your engagements with
Mr. Berthoud will permit—to Pittsburgh or to Wheeling (either).
I will go and meet her (and I hope you also) and bring her to
Philadelphia.

When I left London I had it in contemplation to have returned
to England by the 1st of October from New York. Now that I
know of your Mother that at all events she cannot join me before
December or thereabouts, I have written to my engraver and my
friendly agent, Mr. Children of the British Museum, to say to
them that it was very probable that my sailing from New York
would not take place before April or May next. Your Mamma is
afraid, it appears, of traveling by herself. I remember having seen
Mrs. Gordon leaving your "White House" [i.e., the Nicholas
Berthoud house in Shippingport] for New Orleans with a willing
heart and apparently without further thoughts than those of soon
being with her husband—why cannot your Mamma do the same?
I have written to her that if absolutely necessary she might draw
at sight on Messrs. Thomas E. Walker & Co., Merchants, in
Philadelphia for 200 dollars; and during all the time I have been
here have been closely engaged at work and have now 20 drawings
finished which in England for my publication are positively worth
400 pounds! Every day is to me of the greatest importance, and if
I can renew the 100 drawings which I wish to renew, I will feel
happy on my account and for your sake and that of John, for whom
both only I ultimately work so much at present.

You, my dear son, must not conceive that the want of affection
keeps me east of the mountains and that should I not ever see you
or your brother it is because I have not the wish. No, my dear boy,
I am more pained at such a visit to America than anyone may
conceive: and I foresee the numberless critics of my conduct tearing
me into piecemeals about it. Nevertheless, neither these critics nor
no one in the world but you and I knows the reasons and the force
of those reasons and therefore little will I care about the criticism.
I probably might have had other inducements to go to Kentucky
had I had a friend there besides my son, but at present I know no
one in that country by that precious name, and I may safely say
that I paddle my canoe in the face of the storm, and against strong
contrary currents, but no matter.

I wrote to you that I had brought an excellent gold timekeeper for you. I have it still and will keep it until I know from you how I am to send it safely. I have also a copy of my work for you and one for your Uncle William Bakewell. The dog I have, your Mamma seems anxious should be given to a friend of hers near Bayou Sarah, and it is therefore at her disposal.

I have received several letters from England: the last date is 12th May, when all my business was going on well. Some ferment had taken place in Manchester and some damages had been the fruits of this discontent, but none of my subscribers there (and I have 30) had suffered or discontinued. In France I am afraid that matters do not go on so well. Mr. Children had no letters from my agent in Paris, M. Pitois, and therefore no remittance. I have about 1,000 dollars due me there.

When I know that 15 or 20 days could take my body to near yours, and that in such time we might converse together and exchange a long train of thoughts, my heart palpitates, and I feel the blood rushing to my head so quickly that it seems as if my life was at an end. I now know next to nothing about any of your Mother's relations except Mrs. Gordon, whom I saw a few times, and her husband, who called upon me a few days before my departure from London. What is my former partner Mr. Thomas W. Bakewell doing? or Mr. Berthoud and their increased families? Upon my word it is wonderful to live a long life and see the movements, thoughts and different actions of our poor degenerated species—good only through interest; forgetful, envious or hateful through the same medium. Well, my dear boy, so goes the world, and with it we must move the best way we can.

Adieu. Give this to your dear brother John to read. Write to me on some such paper as I use, and give me some such lengthy account as I have done here. Now is the season to procure some shells for me for my friend John Adamson of Newcastle-upon-Tyne. Try to have some for me and send them to my friend Wm. Rathbone of Liverpool through Mr. Charles Briggs of New Orleans. Remember me kindly to your uncles and aunts and such of their children to whom the name of J. J. A. is still in memory...

Episode: The Great Pine Swamp

Audubon collected in the Great Pine Swamp (or Forest) of north-eastern Pennsylvania in the summer of 1829.

I left Philadelphia at four of the morning by the coach, with no other accoutrements than I knew to be absolutely necessary for the jaunt which I intended to make. These consisted of a wooden box containing a small stock of linen, drawing paper, my journal, colors and pencils, together with 25 pounds of shot, some flints, the due quantum of cash, my gun *Tearjacket* and a heart as true to nature as ever.

Our coaches are none of the best, nor do they move with the velocity of those of some other countries. It was eight, and a dark night, when I reached Mauch Chunk ["Bear Mountain"], now so celebrated in the Union for its rich coal mines and 88 miles distant from Philadelphia. I had passed through a very diversified country, part of which was highly cultivated, while the rest was yet in a state of nature and consequently much more agreeable to me. On alighting, I was shewn to the travelers' room, and on asking for the landlord, saw coming towards me a fine-looking young man to whom I made known my wishes. He spoke kindly and offered to lodge and board me at a much lower rate than travelers who go there for the very simple pleasure of being dragged on the railway. In a word, I was fixed in four minutes, and that most comfortably.

No sooner had the approach of day been announced by the cocks of the little village than I marched out with my gun and notebook, to judge for myself of the wealth of the country. After traversing much ground and crossing many steep hills I returned, if not wearied, at least much disappointed at the extraordinary scarcity of birds. So I bargained to be carried in a cart to the central parts of the Great Pine Swamp, and although a heavy storm was rising, ordered my conductor to proceed.

We winded round many a mountain and at last crossed the highest. The weather had become tremendous and we were thoroughly drenched, but my resolution being fixed, the boy was obliged to continue his driving. Having already traveled about fifteen miles or so, we left the turnpike and struck up a narrow and

bad road that seemed merely cut out to enable the people of the Swamp to receive the necessary supplies from the village which I had left. Some mistakes were made and it was almost dark when a post directed us to the habitation of a Mr. Jediah Irish, to whom I had been recommended. We now rattled down a steep declivity, edged on one side by almost perpendicular rocks and on the other by a noisy stream which seemed grumbling at the approach of strangers. The ground was so overgrown by laurels and tall pines of different kinds that the whole presented only a mass of darkness.

At length we got to the house, the door of which was already opened, the sight of strangers being nothing uncommon in our woods, even in the most remote parts. On entering I was presented with a chair while my conductor was shewn the way to the stable, and on expressing a wish that I should be permitted to remain in the house for some weeks, I was gratified by receiving the sanction of the good woman to my proposal, although her husband was then from home. As I immediately fell a-talking about the nature of the country and inquired if birds were numerous in the neighborhood, Mrs. Irish, more *au fait* to household affairs than ornithology, sent for a nephew of her husband's who soon made his appearance and in whose favor I became at once prepossessed. He conversed like an educated person, saw that I was comfortably disposed of and finally bade me goodnight in such a tone as made me quite happy.

The storm had rolled away before the first beams of the morning sun shone brightly on the wet foliage, displaying all its richness and beauty. My ears were greeted by the notes, always sweet and mellow, of the Wood Thrush and other songsters. Before I had gone many steps, the woods echoed to the report of my gun and I picked from among the leaves a lovely *Sylvia*, long sought for but until then sought for in vain. I needed no more, and standing still for awhile, I was soon convinced that the Great Pine Swamp harbored many other objects as valuable to me.

The young man joined me, bearing his rifle, and offered to accompany me through the woods, all of which he well knew. But I was anxious to transfer to paper the form and beauty of the little bird I had in my hand; and requesting him to break a twig of blooming laurel, we returned to the house, speaking of nothing else than the picturesque beauty of the country around.

A few days passed during which I became acquainted with my hostess and her sweet children and made occasional rambles, but spent the greater portion of my time in drawing. One morning as I stood near the window of my room, I remarked a tall and powerful man alight from his horse, loose the girth of the saddle, raise the latter with one hand, pass the bridle over the head of the animal with the other and move towards the house, while the horse betook himself to the little brook to drink. I heard some movements in the room below and again the same tall person walked towards the mills and stores a few hundred yards from the house. In America, business is the first object in view at all times, and right it is that it should be so. Soon after, my hostess entered my room accompanied by the fine-looking woodsman, to whom, as Mr. Jediah Irish, I was introduced. Reader, to describe to you the qualities of that excellent man were vain; you should know him as I do to estimate the value of such men in our sequestered forests. He not only made me welcome, but promised all his assistance in forwarding my views.

The long walks and long talks we have had together I never can forget, or the many beautiful birds which we pursued, shot and admired. The juicy venison, excellent bear flesh and delightful trout that daily formed my food, methinks I can still enjoy. And then, what pleasure I had in listening to him as he read his favorite poems of [Robert] Burns while my pencil was occupied in smoothing and softening the drawing of the bird before me! Was not this enough to recall to my mind the early impressions that had been made upon it by the description of the golden age, which I here found realized?

The Lehigh [River] about this place forms numerous short turns between the mountains and affords frequent falls, as well as below the falls deep pools, which render this stream a most valuable one for mills of any kind. Not many years before this date my host was chosen by the agent of the Lehigh Coal Company as their mill-wright and manager for cutting down the fine trees which covered the mountains around. He was young, robust, active, industrious and persevering. He marched to the spot where his abode now is with some workmen, and by dint of hard labor first cleared the road mentioned above and reached the river at the center of a

bend, where he fixed on erecting various mills. The pass here is so narrow that it looks as if formed by the bursting asunder of the mountain, both sides ascending abruptly so that the place where the settlement was made is in many parts difficult of access and the road then newly cut was only sufficient to permit men and horses to come to the spot where Jediah and his men were at work. So great in fact were the difficulties of access that, as he told me, pointing to a spot about 150 feet above us, they for many months slipped from it their barreled provisions assisted by ropes to their camp below. But no sooner was the first sawmill erected than the axemen began their devastations. Trees one after another were and are yet constantly heard falling during the days; and in calm nights, the greedy mills told the sad tale that in a century the noble forests around should exist no more. Many mills were erected, many dams raised in defiance of the impetuous Lehigh. One full third of the trees have already been culled, turned into boards and floated as far as Philadelphia.

In such an undertaking the cutting of the trees is not all. They have afterwards to be hauled to the edge of the mountains bordering the river, launched into the stream and led to the mills over many shallows and difficult places. Whilst I was in the Great Pine Swamp I frequently visited one of the principal places for the launching of logs. To see them tumbling from such a height, touching here and there the rough angle of a projecting rock, bouncing from it with the elasticity of a football and at last falling with awful crash into the river forms a sight interesting in the highest degree, but impossible for me to describe. Shall I tell you that I have seen masses of these logs heaped above each other to the number of five thousand? I may so tell you, for such I have seen. My friend Irish assured me that at some seasons these piles consisted of a much greater number, the river becoming in those places completely choked up.

When *freshets* (or floods) take place, then is the time chosen for forwarding the logs to the different mills. This is called a *frolic*. Jediah Irish, who is generally the leader, proceeds to the upper leap with his men, each provided with a strong wooden handspike and a short-handled axe. They all take to the water be it summer or winter like so many Newfoundland spaniels. The logs are gradually

detached, and after a time are seen floating down the dancing stream, here striking against a rock and whirling many times round, there suddenly checked in dozens by a shallow over which they have to be forced with the handspikes. Now they arrive at the edge of a dam and are again pushed over. Certain numbers are left in each dam, and when the party has arrived at the last, which lies just where my friend Irish's camp was first formed, the drenched leader and his men, about sixty in number, make their way home, find there a healthful repast and spend the evening and a portion of the night in dancing and frolicking in their own simple manner in the most perfect amity, seldom troubling themselves with the idea of the labor prepared for them on the morrow.

That morrow now come, one sounds a horn from the door of the storehouse, at the call of which each returns to his work. The sawyers, the millers, the rafters and raftsmen are all immediately busy. The mills are all going and the logs, which a few months before were the supporters of broad and leafy tops, are now in the act of being split asunder. The boards are then launched into the stream, and rafts are formed of them for market.

During the summer and autumnal months the Lehigh, a small river of itself, soon becomes extremely shallow, and to float the rafts would prove impossible had not art managed to provide a supply of water for this express purpose. At the breast of the lower dam is a curiously constructed lock which is opened at the approach of the rafts. They pass through this lock with the rapidity of lightning, propelled by the water that had been accumulated in the dam, and which is of itself generally sufficient to float them to Mauch Chunk, after which, entering regular canals, they find no other impediments but are conveyed to their ultimate destination.

Before population had greatly advanced in this part of Pennsylvania, game of all descriptions found within that range was extremely abundant. The elk itself did not disdain to browse on the shoulders of the mountains near the Lehigh. Bears and the common deer must have been plentiful, as at the moment when I write, many of both kinds are seen and killed by the resident hunters. The Wild Turkey, the Pheasant and the Grouse are also tolerably abundant; and as to trout in the streams—ah, reader, if you are an angler, do go there and try for yourself. For my part, I

can only say that I have been made weary with pulling up from the rivulets the sparkling fish allured by the struggles of the common grasshopper.

A comical affair happened with the bears which I shall relate to you, good reader. A party of my friend Irish's raftsmen, returning from Mauch Chunk one afternoon through sundry short cuts over the mountains at the season when the huckleberries are ripe and plentiful, were suddenly apprised of the proximity of some of these animals by their snuffing the air. No sooner was this perceived than to the astonishment of the party not fewer than eight bears, I was told, made their appearance. Each man, being provided with his short-handled axe, faced about and willingly came to the scratch; but the assailed soon proved the assailants and with claw and tooth drove off the men in a twinkling. Down they all rushed from the mountain; the noise spread quickly; rifles were soon procured and shouldered; but when the spot was reached no bears were to be found; night forced the hunters back to their homes and a laugh concluded the affair.

I spent six weeks in the Great Pine Forest—swamp it cannot be called—where I made many a drawing. Wishing to leave Pennsylvania and to follow the migratory flocks of our birds to the south, I bade adieu to the excellent wife and rosy children of my friend and to his kind nephew. Jediah Irish, shouldering his heavy rifle, accompanied me, and trudging directly across the mountains, we arrived at Mauch Chunk in good time for dinner. Shall I ever have the pleasure of seeing that good, that generous man again?

At Mauch Chunk, where we both spent the night, Mr. White, the civil engineer, visited me and looked at the drawings which I had made in the Great Pine Forest. The news he gave me of my sons, then in Kentucky, made me still more anxious to move in their direction, and long before daybreak I shook hands with the good man of the forest and found myself moving towards the capital of Pennsylvania, having as my sole companion a sharp frosty breeze. Left to my thoughts I felt amazed that such a place as the Great Pine Forest should be so little known to the Philadelphians, scarcely any of whom could direct me towards it. How much is it to be regretted, thought I, that the many young gentlemen who are there so much at a loss how to employ their leisure days should

not visit these wild retreats, valuable as they are to the student of nature. How differently would they feel if, instead of spending weeks in smoothing a useless bow and walking out in full dress intent on displaying the make of their legs to some rendezvous where they may enjoy their wines, they were to occupy themselves in contemplating the rich profusion which nature has poured around them, or even in procuring some desiderated specimen for their *Peale's Museum*, once so valuable and so finely arranged? But alas! no: they are none of them aware of the richness of the Great Pine Swamp, nor are they likely to share the hospitality to be found there.

Night came on as I was thinking of such things and I was turned out of the coach in the streets of the fair city just as the clock struck ten. I cannot say that my bones were much rested, but not a moment was to be lost. So I desired a porter to take up my little luggage, and leading him towards the nearest wharf I found myself soon after gliding across the Delaware towards my former lodgings in the Jerseys. The lights were shining from the parallel streets as I crossed them, all was tranquil and serene, until there came the increasing sound of the Baltimore steamer which, for some reason unknown to me, was that evening later than usual in its arrival. My luggage was landed and carried home by means of a bribe. The people had all retired to rest, but my voice was instantly recognized and an entrance was afforded to me.

John James Audubon to Lucy Audubon
"Do not be troubled with curious ideas…"

Great Pine Swamp, Pennsylvania
28 August 1829

My dearest friend & wife,

I wrote to thee twice on the 25th instant but I do so again; I feel so very uneasy and uncomfortable that I have not a line from thee yet saying, "*I will leave such month; and will be at Louisville in Kentucky about such time or thereabouts.*" I have been in America now 4 months full, and although I expressed my extreme wish to have thee to join me as soon as thou couldst settle affairs and arrange thy business to the best advantage and at thy convenience, not a word have I yet at all satisfactory. Let me beseech thee, my dearest Lucy, not to pine away and make out conjectures and all sorts of ideal fears; let me beseech thee also to be assured that my not going to Louisiana is *much more to our mutual advantage* than if I had done so, as my poor heart thoroughly dictated. I do write thee to come, and that as soon as thou canst; have no fears whatever, I am thy friend and thy husband, as fond of thee as ever, and as ever anxious—oh, devotedly anxious—to render thee comfortable. Come, confide in me, throw thy heart in my care and I will be bound all will go on pretty well! I cannot say more until we meet, and I hope God will will it to be soon.

I am doing what is right, and thou wilt agree with me as soon as I have talked to thee, I am sure. Only let me know thy convenience and time and I will be at Louisville waiting for thee. I have written so to Victor and will do so again this day.

The last lines I have from thee are dated June 28th. Victor enclosed them to me. I have letters from London up to the 12th of June [when] all was going on well there. My French agent, however, had not remitted about 150 pounds, which disappoints my expectations. For God's sake, my Lucy, do not be troubled with curious ideas such as my liking the birds better than thee, &c., &c., &c. Come and be mine. Write to me often to say so; let me know the *probabilities* of thy being at Louisville and I will go there in time, depend on it…

The Wild Turkey

The great size and beauty of the Wild Turkey, its value as a delicate and highly prized article of food, and the circumstance of its being the origin of the domestic race now generally dispersed over both continents, render it one of the most interesting of the birds indigenous to the United States of America.

The unsettled parts of the States of Ohio, Kentucky, Illinois, and Indiana, an immense extent of country to the northwest of these districts, upon the Mississippi and Missouri, and the vast regions drained by these rivers from their confluence to Louisiana, including the wooded parts of Arkansas, Tennessee, and Alabama, are the most abundantly supplied with this magnificent bird. It is less plentiful in Georgia and the Carolinas, becomes still scarcer in Virginia and Pennsylvania, and is now very rarely seen to the eastward of the last mentioned states. In the course of my rambles through Long Island, the State of New York, and the country around the Lakes, I did not meet with a single individual, although I was informed that some exist in those parts. Turkeys are still to be found along the whole line of the Alleghany Mountains, where they have become so wary as to be approached only with extreme difficulty. While in the Great Pine Forest, in 1829, I found a single feather that had been dropped from the tail of a female, but saw no bird of the kind. Farther eastward, I do not think they are now to be found. I shall describe the manners of this bird as observed in the countries where it is most abundant, and having resided for many years in Kentucky and Louisiana, may be understood as referring chiefly to them. The Turkey is irregularly migratory, as well as irregularly gregarious. With reference to the first of these circumstances, I have to state, that whenever the *mast* of one portion of the country happens greatly to exceed that of another, the Turkeys are insensibly led towards that spot, by gradually meeting in their haunts with more fruit the nearer they advance towards the place where it is most plentiful. In this manner flock follows after flock, until one district is entirely deserted, while another is, as it were, overflowed by them. But as these migrations are irregular, and extend over a vast expanse of country, it is necessary that I should describe the manner in which they take place.

About the beginning of October, when scarcely any of the seeds and fruits have yet fallen from the trees, these birds assemble in flocks, and gradually move towards the rich bottom lands of the Ohio and Mississippi. The males, or, as they are more commonly called, the *gobblers*, associate in parties of from ten to a hundred, and search for food apart from the females; while the latter are seen either advancing singly, each with its brood of young, then about two-thirds grown, or in connection with other families, forming parties often amounting to seventy or eighty individuals, all intent on shunning the old cocks, which, even when the young birds have attained this size, will fight with, and often destroy them by repeated blows on the head. Old and young, however, all move in the same course, and on foot, unless their progress be interrupted by a river, or the hunter's dog force them to take wing. When they come upon a river, they betake themselves to the highest eminences, and there often remain a whole day, or sometimes two, as if for the purpose of consultation. During this time, the males are heard *gobbling*, calling, and making much ado, and are seen strutting about, as if to raise their courage to a pitch befitting the emergency. Even the females and young assume something of the same pompous demeanor, spread out their tails, and run round each other, *purring* loudly, and performing extravagant leaps. At length, when the weather appears settled, and all around is quiet, the whole party mounts to the tops of the highest trees, whence, at a signal, consisting of a single *cluck*, given by a leader, the flock takes flight for the opposite shore. The old and fat birds easily get over, even should the river be a mile in breadth; but the younger and less robust frequently fall into the water, not to be drowned, however, as might be imagined. They bring their wings close to their body, spread out their tail as a support, stretch forward their neck, and, striking out their legs with great vigor, proceed rapidly towards the shore; on approaching which, should they find it too steep for landing, they cease their exertions for a few moments, float down the stream until they come to an accessible part, and by a violent effort generally extricate themselves from the water. It is remarkable, that immediately after thus crossing a large stream, they ramble about for some time, as if bewildered. In this state, they fall an easy prey to the hunter.

When the Turkeys arrive in parts where the mast is abundant, they separate into smaller flocks, composed of birds of all ages and both sexes, promiscuously mingled, and devour all before them. This happens about the middle of November. So gentle do they sometimes become after these long journeys, that they have been seen to approach the farmhouses, associate with the domestic fowls, and enter the stables and corn cribs in quest of food. In this way, roaming about the forests, and feeding chiefly on mast, they pass the autumn and part of the winter.

As early as the middle of February, they begin to experience the impulse of propagation. The females separate, and fly from the males. The latter strenuously pursue, and begin to gobble or to utter the notes of exultation. The sexes roost apart, but at no great distance from each other. When a female utters a call-note, all the gobblers within hearing return the sound, rolling note after note with as much rapidity as if they intended to emit the last and the first together, not with spread tail, as when fluttering round the females on the ground, or practicing on the branches of the trees on which they have roosted for the night, but much in the manner of the domestic turkey, when an unusual or unexpected noise elicits its singular hubbub. If the call of the female comes from the ground, all the males immediately fly towards the spot, and the moment they reach it, whether the hen be in sight or not, spread out and erect their tail, draw the head back on the shoulders, depress their wings with a quivering motion, and strut pompously about, emitting at the same time a succession of puffs from the lungs, and stopping now and then to listen and look. But whether they spy the female or not, they continue to puff and strut, moving with as much celerity as their ideas of ceremony seem to admit. While thus occupied, the males often encounter each other, in which case desperate battles take place, ending in bloodshed, and often in the loss of many lives, the weaker falling under the repeated blows inflicted upon their head by the stronger.

I have often been much diverted, while watching two males in fierce conflict, by seeing them move alternately backwards and forwards, as either had obtained a better hold, their wings drooping, their tails partly raised, their body-feathers ruffled, and their heads covered with blood. If, as they thus struggle, and gasp for

breath, one of them should lose his hold, his chance is over, for the other, still holding fast, hits him violently with spurs and wings, and in a few minutes brings him to the ground. The moment he is dead, the conqueror treads him under foot, but, what is strange, not with hatred, but with all the motions which he employs in caressing the female.

When the male has discovered and made up to the female (whether such a combat has previously taken place or not), if she be more than one year old, she also struts and gobbles, turns round him as he continues strutting, suddenly opens her wings, throws herself towards him, as if to put a stop to his idle delay, lays herself down, and receives his dilatory caresses. If the cock meet a young hen, he alters his mode of procedure. He struts in a different manner, less pompously and more energetically, moves with rapidity, sometimes rises from the ground, taking a short flight around the hen, as is the manner of some Pigeons, the Red-breasted Thrush, and many other birds, and on alighting, runs with all his might, at the same time rubbing his tail and wings along the ground, for the space of perhaps ten yards. He then draws near the timorous female, allays her fears by purring, and when she at length assents, caresses her.

When a male and a female have thus come together, I believe the connection continues for that season, although the former by no means confines his attentions to one female, as I have seen a cock caress several hens, when he happened to fall in with them in the same place, for the first time. After this the hens follow their favorite cock, roosting in his immediate neighborhood, if not on the same tree, until they begin to lay, when they separate themselves, in order to save their eggs from the male, who would break them all, for the purpose of protracting his sexual enjoyments. The females then carefully avoid him, excepting during a short period each day. After this the males become clumsy and slovenly, if one may say so, cease to fight with each other, give up gobbling or calling so frequently, and assume so careless a habit, that the hens are obliged to make all the advances themselves. They *yelp* loudly and almost continually for the cocks, run up to them, caress them, and employ various means to rekindle their expiring ardor.

Turkey-cocks when at roost sometimes strut and gobble, but I have more generally seen them spread out and raise their tail, and emit the pulmonic puff, lowering their tail and other feathers immediately after. During clear nights, or when there is moonshine, they perform this action at intervals of a few minutes, for hours together, without moving from the same spot, and indeed sometimes without rising on their legs, especially towards the end of the love-season. The males now become greatly emaciated, and cease to gobble, their *breast-sponge* becoming flat. They then separate from the hens, and one might suppose that they had entirely deserted their neighborhood. At such seasons I have found them lying by the side of a log, in some retired part of the dense woods and cane thickets, and often permitting one to approach within a few feet. They are then unable to fly, but run swiftly, and to a great distance. A slow turkey-hound has led me miles before I could flush the same bird. Chases of this kind I did not undertake for the purpose of killing the bird, it being then unfit for eating, and covered with ticks, but with the view of rendering myself acquainted with its habits. They thus retire to recover flesh and strength, by purging with particular species of grass, and using less exercise. As soon as their condition is improved, the cocks come together again, and recommence their rambles. Let us now return to the females.

About the middle of April, when the season is dry, the hens begin to look out for a place in which to deposit their eggs. This place requires to be as much as possible concealed from the eye of the Crow, as that bird often watches the Turkey when going to her nest, and, waiting in the neighborhood until she has left it, removes and eats the eggs. The nest, which consists of a few withered leaves, is placed on the ground, in a hollow scooped out, by the side of a log, or in the fallen top of a dry leafy tree, under a thicket of sumac or briars, or a few feet within the edge of a canebrake, but always in a dry place. The eggs, which are of a dull cream color, sprinkled with red dots, sometimes amount to twenty, although the more usual number is from ten to fifteen. When depositing her eggs, the female always approaches the nest with extreme caution, scarcely ever taking the same course twice; and when about to leave them, covers them carefully with leaves, so that it is very difficult

EASTERN BLUEBIRD *(Sialia sialis)*
1863.17.113
Collection of the New-York Historical Society

BARRED OWL *(Strix varia)*
1863.17.46
Collection of the New-York Historical Society

CHUCK-WILL'S-WIDOW *(Caprimulgus carolinensis)*
1863.17.52
Collection of the New-York Historical Society

PASSENGER PIGEON *(Ectopistes migratorius)*
1863.17.62
Collection of the New-York Historical Society

EASTERN PHOEBE *(Sayornis phoebe)*
1863.17.120
Collection of the New-York Historical Society

BALTIMORE ORIOLE *(Icterus galbula)*
1863.17.12
Collection of the New-York Historical Society

PURPLE MARTIN *(Progne subis)*
1863.17.22
Collection of the New-York Historical Society

CLIFF SWALLOW *(Petrochelidon pyrrhonota)*
1863.17.68
Collection of the New-York Historical Society

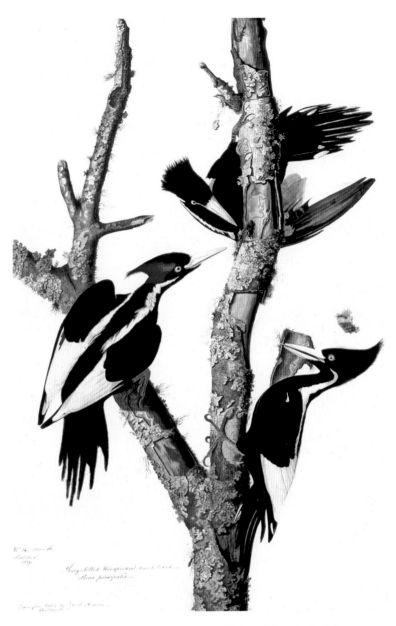

IVORY-BILLED WOODPECKER *(Campephilus principalis)*
1863.17.66
Collection of the New-York Historical Society

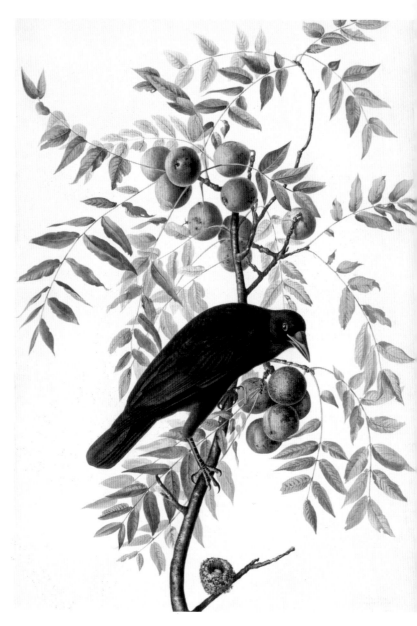

AMERICAN CROW *(Corvus brachyrhynchos)*
1863.17.156
Collection of the New-York Historical Society

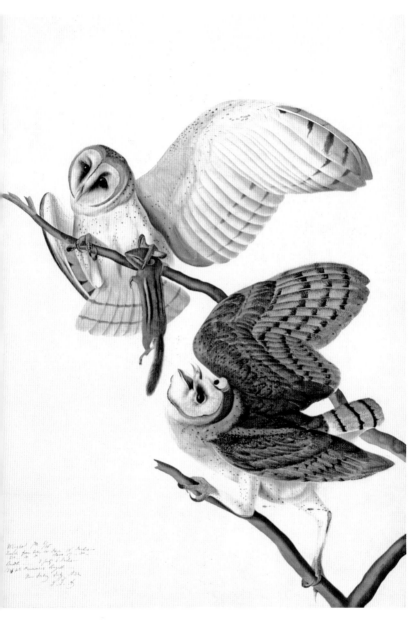

COMMON BARN OWL *(Tyto alba)*
1863.17.171
Collection of the New-York Historical Society

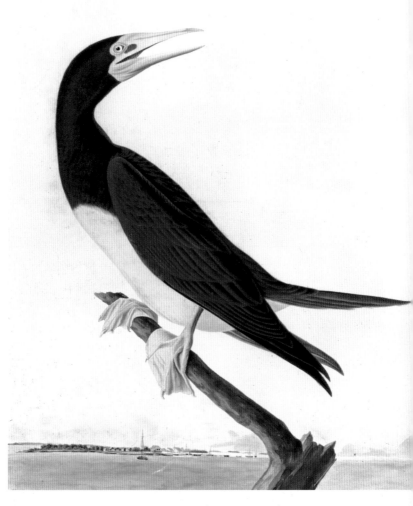

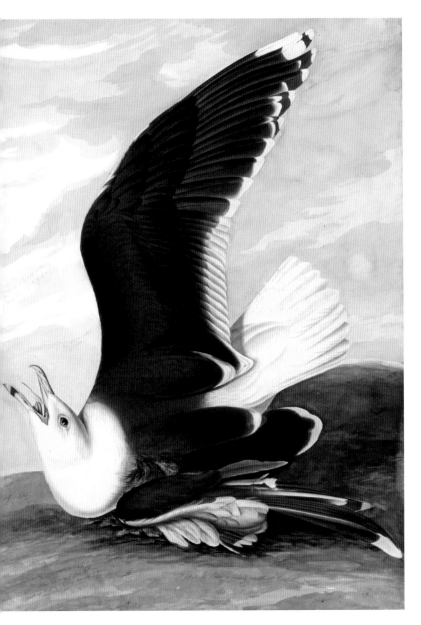

GREAT BLACK-BACKED GULL *(Larus marinus)*
1863.17.241
Collection of the New-York Historical Society

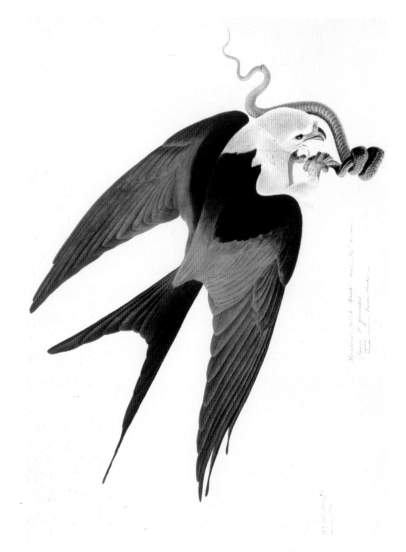

SWALLOW-TAILED
KITE
(*Elanoides forficatus*)
1863.17.72
Collection of the
New-York
Historical Society

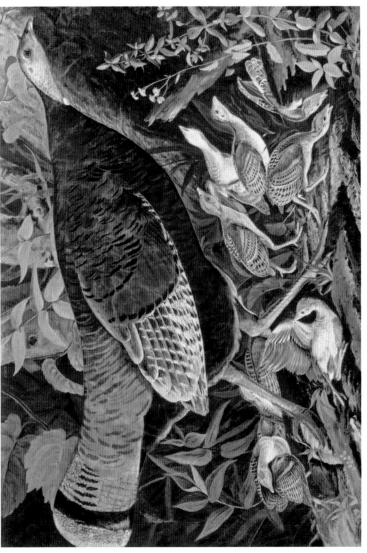

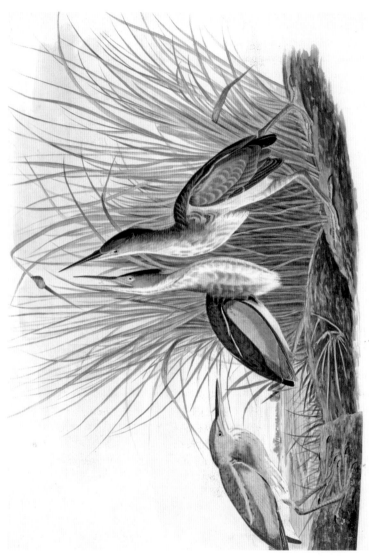

LEAST BITTERN
(Ixobrychus exilis)
1863.17.207
Collection of the
New-York
Historical Society

for a person who may have seen the bird to discover the nest. Indeed, few Turkeys' nests are found, unless the female has been suddenly started from them, or a cunning Lynx, Fox, or Crow has sucked the eggs and left their shells scattered about.

Turkey hens not unfrequently prefer islands for depositing their eggs and rearing their young, probably because such places are less frequented by hunters, and because the great masses of drifted timber which usually accumulate at their heads, may protect and save them in cases of great emergency. When I have found these birds in such situations, and with young, I have always observed that a single discharge of a gun made them run immediately to the pile of drifted wood, and conceal themselves in it. I have often walked over these masses, which are frequently from ten to twenty feet in height, in search of the game which I knew to be concealed in them.

When an enemy passes within sight of a female, while laying or sitting, she never moves, unless she knows that she has been discovered, but crouches lower until he has passed. I have frequently approached within five or six paces of a nest, of which I was previously aware, on assuming an air of carelessness, and whistling or talking to myself, the female remaining undisturbed; whereas if I went cautiously towards it, she would never suffer me to approach within twenty paces, but would run off, with her tail spread on one side, to a distance of twenty or thirty yards, when assuming a stately gait, she would walk about deliberately, uttering every now and then a cluck. They seldom abandon their nest, when it has been discovered by men; but, I believe, never go near it again, when a snake or other animal has sucked any of the eggs. If the eggs have been destroyed or carried off, the female soon yelps again for a male; but, in general, she rears only a single brood each season. Several hens sometimes associate together, I believe for their mutual safety, deposit their eggs in the same nest, and rear their broods together. I once found three sitting on forty-two eggs. In such cases, the common nest is always watched by one of the females, so that no Crow, Raven, or perhaps even Pole-cat, dares approach it.

The mother will not leave her eggs, when near hatching, under any circumstances, while life remains. She will even allow an

enclosure to be made around her, and thus suffer imprisonment, rather than abandon them. I once witnessed the hatching of a brood of Turkeys, which I watched for the purpose of securing them together with the parent. I concealed myself on the ground within a very few feet, and saw her raise herself half the length of her legs, look anxiously upon the eggs, cluck with a sound peculiar to the mother on such occasions, carefully remove each half-empty shell, and with her bill caress and dry the young birds, that already stood tottering and attempting to make their way out of the nest. Yes, I have seen this, and have left mother and young to better care than mine could have proved, to the care of their Creator and mine. I have seen them all emerge from the shell, and, in a few moments after, tumble, roll, and push each other forward, with astonishing and inscrutable instinct.

Before leaving the nest with her young brood, the mother shakes herself in a violent manner, picks and adjusts the feathers about her belly, and assumes quite a different aspect. She alternately inclines her eyes obliquely upwards and sideways, stretching out her neck, to discover hawks or other enemies, spreads her wings a little as she walks, and softly clucks to keep her innocent offspring close to her. They move slowly along, and as the hatching generally takes place in the afternoon, they frequently return to the nest to spend the first night there. After this, they remove to some distance, keeping on the highest undulated grounds, the mother dreading rainy weather, which is extremely dangerous to the young, in this tender state, when they are only covered by a kind of soft hairy down, of surprising delicacy. In very rainy seasons, Turkeys are scarce, for if once completely wetted, the young seldom recover. To prevent the disastrous effects of rainy weather, the mother, like a skillful physician, plucks the buds of the spice-wood bush, and gives them to her young.

In about a fortnight, the young birds, which had previously rested on the ground, leave it and fly, at night, to some very large low branch, where they place themselves under the deeply curved wings of their kind and careful parent, dividing themselves for that purpose into two nearly equal parties. After this, they leave the woods during the day, and approach the natural glades or prairies, in search of strawberries, and subsequently of dewberries,

blackberries and grasshoppers, thus obtaining abundant food, and enjoying the beneficial influence of the sun's rays. They roll themselves in deserted ants' nests, to clear their growing feathers of the loose scales, and prevent ticks and other vermin from attacking them, these insects being unable to bear the odor of the earth in which ants have been.

The young Turkeys now advance rapidly in growth, and in the month of August are able to secure themselves from unexpected attacks of Wolves, Foxes, Lynxes, and even Cougars, by rising quickly from the ground, by the help of their powerful legs, and reaching with ease the highest branches of the tallest trees. The young cocks shew the tuft on the breast about this time, and begin to gobble and strut, while the young hens purr and leap, in the manner which I have already described.

The old cocks have also assembled by this time, and it is probable that all the Turkeys now leave the extreme northwestern districts, to remove to the Wabash, Illinois, Black River, and the neighborhood of Lake Erie.

Of the numerous enemies of the Wild Turkey, the most formidable, excepting man, are the Lynx, the Snowy Owl, and the Virginian Owl. The Lynx sucks their eggs, and is extremely expert at seizing both young and old, which he effects in the following manner. When he has discovered a flock of Turkeys, he follows them at a distance for some time, until he ascertains the direction in which they are proceeding. He then makes a rapid circular movement, gets in advance of the flock, and lays himself down in ambush, until the birds come up, when he springs upon one of them by a single bound, and secures it. While once sitting in the woods, on the banks of the Wabash, I observed two large Turkeycocks on a log, by the river, pluming and picking themselves. I watched their movements for awhile, when of a sudden one of them flew across the river, while I perceived the other struggling under the grasp of a Lynx. When attacked by the two large species of Owl above mentioned, they often effect their escape in a way which is somewhat remarkable. As Turkeys usually roost in flocks, on naked branches of trees, they are easily discovered by their enemies, the Owls, which, on silent wing, approach and hover around them, for the purpose of reconnoitering. This, however, is

rarely done without being discovered, and a single *cluck* from one of the Turkeys announces to the whole party the approach of the murderer. They instantly start upon their legs, and watch the motions of the Owl, which, selecting one as its victim, comes down upon it like an arrow, and would inevitably secure the Turkey, did not the latter at that moment lower its head, stoop, and spread its tail in an inverted manner over its back, by which action the aggressor is met by a smooth inclined plane, along which it glances without hurting the Turkey; immediately after which the latter drops to the ground, and thus escapes, merely with the loss of a few feathers.

The Wild Turkeys cannot be said to confine themselves to any particular kind of food, although they seem to prefer the pecan nut and winter grape to any other, and, where these fruits abound, are found in the greatest numbers. They eat grass and herbs of various kinds, corn, berries, and fruit of all descriptions. I have even found beetles, tadpoles, and small lizards in their crops.

Turkeys are now generally extremely shy, and the moment they observe a man, whether of the red or white race, instinctively move from him. Their usual mode of progression is what is termed walking, during which they frequently open each wing partially and successively, replacing them again by folding them over each other, as if their weight were too great. Then, as if to amuse themselves, they will run a few steps, open both wings and fan their sides, in the manner of the common fowl, and often take two or three leaps in the air and shake themselves. Whilst searching for food among the leaves or loose soil, they keep their head up, and are unremittingly on the lookout; but as the legs and feet finish the operation, they are immediately seen to pick up the food, the presence of which, I suspect, is frequently indicated to them through the sense of touch in their feet, during the act of scratching. This habit of scratching and removing the dried leaves in the woods, is pernicious to their safety, as the spots which they thus clear, being about two feet in diameter, are seen at a distance, and, if fresh, shew that the birds are in the vicinity. During the summer months they resort to the paths or roads, as well as the ploughed fields, for the purpose of rolling themselves in the dust, by which means they clear their bodies of the ticks which at that season

infest them, as well as free themselves of the mosquitoes, which greatly annoy them, by biting their heads.

When, after a heavy fall of snow, the weather becomes frosty, so as to form a hard crust on the surface, the Turkeys remain on their roosts for three or four days, sometimes much longer, which proves their capability of continued abstinence. When near farms, however, they leave the roosts, and go into the very stables and about the stacks of corn, to procure food. During melting snowfalls, they will travel to an extraordinary distance, and are then followed in vain, it being impossible for hunters of any description to keep up with them. They have then a dangling and straggling way of running, which, awkward as it may seem, enables them to outstrip any other animal. I have often, when on a good horse, been obliged to abandon the attempt to put them up, after following them for several hours. This habit of continued running, in rainy or very damp weather of any kind, is not peculiar to the Wild Turkey, but is common to all gallinaceous birds. In America, the different species of Grouse exhibit the same tendency.

In spring, when the males are much emaciated, in consequence of their attentions to the females, it sometimes happens that, on plain and open ground, they may be overtaken by a swift dog, in which case they squat, and allow themselves to be seized, either by the dog, or the hunter who has followed on a good horse. I have heard of such occurrences, but never had the pleasure of seeing an instance of them.

Good dogs scent the Turkeys, when in large flocks, at extra-ordinary distances—I think I may venture to say half a mile. Should the dog be well trained to this sport, he sets off at full speed, and in silence, until he sees the birds, when he instantly barks, and pushing as much as possible into the center of the flock, forces the whole to take wing in different directions. This is of great advantage to the hunter, for should the Turkeys all go one way, they would soon leave their perches and run again. But when they separate in this manner, and the weather happens to be calm and lowering, a person accustomed to this kind of sport finds the birds with ease, and shoots them at pleasure.

When Turkeys alight on a tree, it is sometimes very difficult to see them, which is owing to their standing perfectly motionless.

Should you discover one, when it is down on its legs upon the branch, you may approach it with less care. But if it is standing erect, the greatest precaution is necessary, for should it discover you, it instantly flies off, frequently to such a distance that it would be vain to follow.

When a Turkey is merely winged by a shot, it falls quickly to the ground in a slanting direction. Then, instead of losing time by tumbling and rolling over, as other birds often do when wounded, it runs off at such a rate, that unless the hunter be provided with a swift dog, he may bid farewell to it. I recollect coming on one shot in this manner, more than a mile from the tree where it had been perched, my dog having traced it to this distance, through one of those thick canebrakes that cover many portions of our rich alluvial lands near the banks of our western rivers. Turkeys are easily killed if shot in the head, the neck, or the upper part of the breast; but if hit in the hind parts only, they often fly so far as to be lost to the hunter. During winter many of our *real* hunters shoot them by moonlight, on the roosts, where these birds will frequently stand a repetition of the reports of a rifle, although they would fly from the attack of an owl, or even perhaps from his presence. Thus sometimes nearly a whole flock is secured by men capable of using these guns in such circumstances. They are often destroyed in great numbers when most worthless, that is, early in the fall or autumn, when many are killed in their attempt to cross the rivers, or immediately after they reach the shore.

Whilst speaking of the shooting of Turkeys, I feel no hesitation in relating the following occurrence, which happened to myself. While in search of game, one afternoon late in autumn, when the males go together, and the females are by themselves also, I heard the clucking of one of the latter, and immediately finding her perched on a fence, made towards her. Advancing slowly and cautiously, I heard the yelping notes of some gobblers, when I stopped and listened in order to ascertain the direction in which they came. I then ran to meet the birds, hid myself by the side of a large fallen tree, cocked my gun, and waited with impatience for a good opportunity. The gobblers continued yelping in answer to the female, which all this while remained on the fence. I looked over the log and saw about thirty fine cocks advancing rather cautiously

towards the very spot where I lay concealed. They came so near that the light in their eyes could easily be perceived, when I fired one barrel, and killed three. The rest, instead of flying off, fell a strutting around their dead companions, and had I not looked on shooting again as murder without necessity, I might have secured at least another. So I shewed myself, and marching to the place where the dead birds were, drove away the survivors. I may also mention, that a friend of mine shot a fine hen, from his horse, with a pistol, as the poor thing was probably returning to her nest to lay.

Should you, good-natured reader, be a sportsman, and now and then have been fortunate in the exercise of your craft, the following incident, which I shall relate to you as I had it from the mouth of an honest farmer, may prove interesting. Turkeys were very abundant in his neighborhood, and, resorting to his corn fields, at the period when the maize had just shot up from the ground, destroyed great quantities of it. This induced him to swear vengeance against the species. He cut a long trench in a favorable situation, put a great quantity of corn in it, and having heavily loaded a famous duck gun of his, placed it so as that he could pull the trigger by means of a string, when quite concealed from the birds. The Turkeys soon discovered the corn in the trench, and quickly disposed of it, at the same time continuing their ravages in the fields. He filled the trench again, and one day seeing it quite black with the Turkeys, whistled loudly, on which all the birds raised their heads, when he pulled the trigger by the long string fastened to it. The explosion followed of course, and the Turkeys were seen scampering off in all directions, in utter discomfiture and dismay. On running to the trench, he found nine of them extended in it. The rest did not consider it expedient to visit his corn again for that season.

During spring, Turkeys are *called*, as it is termed, by drawing the air in a particular way through one of the second joint bones of a wing of that bird, which produces a sound resembling the voice of the female, on hearing which the male comes up, and is shot. In managing this, however, no fault must be committed, for Turkeys are quick in distinguishing counterfeit sounds, and when *half civilized* are very wary and cunning. I have known many to

answer to this kind of call, without moving a step, and thus entirely defeat the scheme of the hunter, who dared not move from his hiding-place, lest a single glance of the gobbler's eye should frustrate all further attempts to decoy him. Many are shot when at roost, in this season, by answering with a rolling gobble to a sound in imitation of the cry of the Barred Owl.

But the most common method of procuring Wild Turkeys, is by means of *pens*. These are placed in parts of the woods where Turkeys have been frequently observed to roost, and are constructed in the following manner. Young trees of four or five inches diameter are cut down, and divided into pieces of the length of twelve or fourteen feet. Two of these are laid on the ground parallel to each other, at a distance of ten or twelve feet. Two other pieces are laid across the ends of these, at right angles to them; and in this manner successive layers are added, until the fabric is raised to the height of about four feet. It is then covered with similar pieces of wood, placed three or four inches apart, and loaded with one or two heavy logs to render the whole firm. This done, a trench about eighteen inches in depth and width is cut under one side of the cage, into which it opens slantingly and rather abruptly. It is continued on its outside to some distance, so as gradually to attain the level of the surrounding ground. Over the part of this trench within the pen, and close to the wall, some sticks are placed so as to form a kind of bridge about a foot in breadth. The trap being now finished, the owner places a quantity of Indian corn in its center, as well as in the trench, and as he walks off drops here and there a few grains in the woods, sometimes to the distance of a mile. This is repeated at every visit to the trap, after the Turkeys have found it. Sometimes two trenches are cut, in which case the trenches enter on opposite sides of the trap, and are both strewn with corn. No sooner has a Turkey discovered the train of corn, than it communicates the circumstance to the flock by a cluck, when all of them come up, and searching for the grains scattered about, at length come upon the trench, which they follow, squeezing themselves one after another through the passage under the bridge. In this manner the whole flock sometimes enters, but more commonly six or seven only, as they are alarmed by the least noise, even the cracking of a tree in frosty weather. Those within, having gorged themselves,

raise their heads, and try to force their way through the top or sides of the pen, passing and repassing on the bridge, but never for a moment looking down, or attempting to escape through the passage by which they entered. Thus they remain until the owner of the trap arriving, closes the trench, and secures his captives. I have heard of eighteen Turkeys having been caught in this manner at a single visit to the trap. I have had many of these pens myself, but never found more than seven in them at a time. One winter I kept an account of the produce of a pen which I visited daily, and found that seventy-six had been caught in it, in about two months. When these birds are abundant, the owners of the pens sometimes become satiated with their flesh, and neglect to visit the pens for several days, in some cases for weeks. The poor captives thus perish for want of food; for, strange as it may seem, they scarcely ever regain their liberty, by descending into the trench, and retracing their steps. I have, more than once, found four or five, and even ten, dead in a pen, through inattention. Where Wolves or Lynxes are numerous, they are apt to secure the prize before the owner of the trap arrives. One morning, I had the pleasure of securing in one of my pens, a fine Black Wolf, which, on seeing me, squatted, supposing me to be passing in another direction.

Wild Turkeys often approach and associate with tame ones, or fight with them, and drive them off from their food. The cocks sometimes pay their addresses to the domesticated females, and are generally received by them with great pleasure, as well as by their owners, who are well aware of the advantages resulting from such intrusions, the half-breed being much more hardy than the tame, and, consequently, more easily reared.

While at Henderson, on the Ohio, I had, among many other wild birds, a fine male Turkey, which had been reared from its earliest youth under my care, it having been caught by me when probably not more than two or three days old. It became so tame that it would follow any person who called it, and was the favorite of the little village. Yet it would never roost with the tame Turkeys, but regularly betook itself at night to the roof of the house, where it remained until dawn. When two years old, it began to fly to the woods, where it remained for a considerable part of the day, to return to the enclosure as night approached. It continued this

practice until the following spring, when I saw it several times fly from its roosting place to the top of a high cotton tree, on the bank of the Ohio, from which, after resting a little, it would sail to the opposite shore, the river being there nearly half a mile wide, and return towards night. One morning I saw it fly off, at a very early hour, to the woods, in another direction, and took no particular notice of the circumstance. Several days elapsed, but the bird did not return. I was going towards some lakes near Green River to shoot, when, having walked about five miles, I saw a fine large gobbler cross the path before me, moving leisurely along. Turkeys being then in prime condition for the table, I ordered my dog to chase it, and put it up. The animal went off with great rapidity, and as it approached the Turkey, I saw, with great surprise, that the latter paid little attention. Juno was on the point of seizing it, when she suddenly stopped, and turned her head towards me. I hastened to them, but you may easily conceive my surprise when I saw my own favorite bird, and discovered that it had recognized the dog, and would not fly from it; although the sight of a strange dog would have caused it to run off at once. A friend of mine happening to be in search of a wounded deer, took the bird on his saddle before him, and carried it home for me. The following spring it was accidentally shot, having been taken for a wild bird, and brought to me on being recognized by the red ribbon which it had around its neck. Pray, reader, by what word will you designate the recognition made by my favorite Turkey of a dog which had been long associated with it in the yard and grounds? Was it the result of instinct, or of reason, an unconsciously revived impression, or the act of an intelligent mind?

At the time when I removed to Kentucky, rather more than a fourth of a century ago, Turkeys were so abundant, that the price of one in the market was not equal to that of a common barn-fowl now. I have seen them offered for the sum of three pence each, the birds weighing from ten to twelve pounds. A first-rate Turkey, weighing from twenty-five to thirty pounds avoirdupois, was considered well sold when it brought a quarter of a dollar.

The weight of Turkey hens generally averages about nine pounds avoirdupois. I have, however, shot barren hens in strawberry season, that weighed thirteen pounds, and have seen a few so fat as to

burst open on falling from a tree when shot. Male Turkeys differ more in their bulk and weight. From fifteen to eighteen pounds may be a fair estimate of their ordinary weight. I saw one offered for sale in the Louisville market, that weighed thirty-six pounds. Its pectoral appendage measured upwards of a foot.

Some closet naturalists suppose the hen Turkey to be destitute of the appendage on the breast, but this is not the case in the full-grown bird. The young males, as I have said, at the approach of the first winter, have merely a kind of protuberance in the flesh at this part, while the young females of the same age have no such appearance. The second year, the males are to be distinguished by the hairy tuft, which is about four inches long, whereas in the females that are not barren, it is yet hardly apparent. The third year, the male Turkey may be said to be adult, although it certainly increases in weight and size for several years more. The females at the age of four are in full beauty, and have the pectoral appendage four or five inches long, but thinner than in the male. The barren hens do not acquire it until they are very old. The experienced hunter knows them at once in the flock, and shoots them by preference. The great number of young hens destitute of the appendage in question, has doubtless given rise to the idea that it is wanting in the female Turkey.

The long downy *double* feathers about the thighs and on the lower parts of the sides of the Wild Turkey, are often used for making tippets [i.e., capes], by the wives of our squatters and farmers. These tippets, when properly made, are extremely beautiful as well as comfortable . . .

[The Wild Turkey, *Meleagris gallopavo*, appears in Plate 1 and Plate 6 of *The Birds of America*.]

Lucy Audubon to John James Audubon
"In January I can ascend the Ohio..."

St. Francisville, Louisiana
29 August 1829

Your last, my dear husband, of July 24th, I have this moment received, and you remark August is nearly here, but it is gone before I can reply to you and thus month after month rolls on. I can now say I have only four months to serve, and by the time this reaches you at the usual rate, one more month may be put off the list. I wrote to you on the 17th of this month that I was preparing to join you as fast as I could, and all other particulars; therefore I will not repeat them any more, for I am tired of the subject. Ever since last January I determined to be with you as soon as I could with my ideas of right, and you should say yes; and now I need only refer to the few things in yours which seemed to ask for reply.

And first I leave most implicitly to your own management the work you are about, trusting you know best about it. Next, with regard to my funds, call it what you will, I must divide them into three. If you require it, you shall be sure to have it, but then I must remain and fill my purse again. You will not find me come to you embarrassed, but this is my last effort for those [for] whom it was intended and who have stimulated me on. You say you have enough to support yourself to me; then why take any more out of the country when a good interest can be got...? Be candid: if you are in want of money, say so, but then do not deprive me of the means of supply for either of us in future. You may depend upon my bringing as much as will prevent the necessity of your drawing on London, if all you state in your letter is understood by me—that you have enough for yourself till you embark on your return. If not, for heaven's sake tell me and as soon as it is in my power I will aid you, but then I must remain till you are better able to support an idle wife, for you must be sensible [that] I do not look to anything like labor after I give up these toils. Do not think me harsh, dear LaForest, but it is absolutely necessary for our happiness to be *sincere* in our views and wishes.

And now let me drop this painful and resolved subject forever, we meet as friends, I view you as such and conceal nothing from you. I am much afraid the greater part of my money will be left behind for the children to collect. This is a horrible money country, and just now the yellow fever has made its appearance in all the little neighboring towns as well as [New] Orleans. I wish Victor had his watch, that John might have his. I have not heard very lately from them, but when I did, the plan was for John to be with his brother at their Uncle William's for the future. I think we shall have a mild winter, and in January I can ascend the Ohio and wait for you or take John with me to see a little of the world till I meet you...

I cannot say anything more but that my heart is yours; only I cannot overlook justice and comfort to our sons...

Lucy Audubon to John James Audubon
"I have had much pleasure in my independence ..."

St. Francisville, Louisiana
29 September 1829

My dear LaForest,

Yours without date, and the one of Aug. 25th have this moment come to me, and as it is a month ago, you may have changed your abode and even this which I shall send to Philadelphia not reach you; but I have not written this month and will therefore do so now. You, I find, did not write for a month between the date of your last letters. I calculate that on the 17th of this month, you would get two from me of the same date, sent different ways, which would, I hope, give you some pleasure more than what you had before, not that I felt any difference, but I had become reconciled almost to your manner of acting, which does indeed surprise me; and had you landed in [New] Orleans and come up, after seeing me and understanding one another it would have saved much pain; that I hope is all over & if I have said anything harsh, allow for my peculiar situation, for my disappointment, and forget it. I have written so often *when I could have*, and the preparations I was making for so doing, and I'm tired of repeating them; and after all you have misunderstood me as to time by a month, which I said was the *last* of December, not the *first*. Even if my word was nothing, many of my employers are now on to the eastward, and I could not possibly collect more than a hundred dollars [at this time], if that. I have done *all* I could preparative, even to agreeing for the sale of one of my pianos; spoken to all my employers, &c., but with all this it will be sometime in January before I can finish it all conclusively. You want to remember what trouble you had to collect money, and every year the country has been getting worse, though ultimately good.

And now that I have told you what I have done in the cause for my departure, I would just tell you the school, or income that has been offered to me for next year. If, on deliberation, you thought it best for me to take it—but *mind, my dear husband*, I do not tell

you it is my choice, I only state the fact...and *you must choose* what I shall do on a prudential score, in the meantime I am getting all in readiness till I hear from you again, and can only say it is a pleasure to think that after seven years' trial I rise in the estimation of those who know me. I have had much pleasure in my independence but I willingly give it up for you, now that our children do not require it, nor you.

The proposition is twelve scholars all learning music, which at $12.50 each per month is a very pretty sum, I believe $1,800 without any doubt. Either you, Victor or John must come down for me. I will only say that when it is positively known I am no longer of any service to the world, the world will take no interest in me! I have not lived so long not to *know that.* I shall, I hope, bring with me between $700 and $800 but I cannot tell till all my accounts are paid. I am not famous for economy. If you prefer meeting me at Louisville do so; but be so good as to reply to this and let me know as soon as possible, *whether* I may *expect* you and *when.*

We have the yellow fever at Bayou Sarah now; but I do not go there...Mr. and Mrs. Brand and family are come from [New] Orleans out of the way of the fever. You say fame is not felt while living, most true, but I am persuaded nevertheless you will never be happy but in toiling for it; should you also realize a pecuniary reward, your recompense will be tenfold. I hope you will find all well on your return to England; to me it will be quite a new country. And if you have plenty to support both, which I cannot now doubt, as you say so, we shall enjoy many things till our return, which I must always look forward to, even till I come to America again. You will, I hope, believe me speaking to you with the utmost sincerity and seriousness, and meaning just what I say...

The weather is so warm we can scarcely bear anything on— cotton crops very short indeed generally.

John James Audubon to Lucy Audubon
"My 42nd drawing is finished…"

Philadelphia, Pennsylvania
11 October 1829

My dearest love,

My day to write thee has come again! But I am sorry to have to say that I am not going to do so in answer to anything from thy hand. It is now 11 days since I had a letter from thee, and I think it is too long when in America.

I am at work and I think I have done much. My 42nd drawing is finished. I wrote to thee in my last that I was so much pleased with thy last letters that I had taken "a help" to assist me in finishing the plants; that it was a young Swiss of the name of Lehman whom I have known now about 6 years, having found him at Pittsburgh when on my way back from the Northern Lakes. He has now been with me 10½ days—he is to work 30 and as soon as he has finished I will make ready to go to Kentucky and leave this from the 5th to the 10th of November. I will go by Baltimore and Washington City as I wish to see Major Long and the President of our U.S.

I asked thee in my last to address my future letters (after the receipt of that and this) to Louisville where I will be, I hope, by the 1st of December; therefore do so. I have no late news from England which makes me hope all goes on well there. I do most sincerely hope and wish that thou mayest settle thy business *very early* in January and reach Louisville about the end of that month. We ought to stay with Victor & John the month of February and be underway eastwardly by the very first day of March so as to sail from New York or Boston as best may please thee on the 1st of April next. Only think, the rascals of captains refuse to take my dog unless I pay an enormous price for his passage, i.e., 25 dollars. Some refused altogether. I therefore have concluded to take him with me to Louisville and send it from there.

My letter will be through necessity of interest either in facts or of their nature a short and dull one, but I like to write to thee

regularly. When Sunday comes I have measuring its distance since the one just gone to speak to thee. I have no other pleasures. I live alone and see scarcely anyone besides those belonging to the house I am at. I raise before day, take a walk, return and set to my work until nightfall—take another walk, equally short—hot water time comes on—I drink my grog, read some, think of thee and of tomorrow and lay my head to rest with the hopes of rendering thee happy forever hereafter!

I am delighted with what I have accumulated in drawings this season. Indeed, I am surprised when sometimes I spread them on the carpet and look to see their effect: 24 drawings in 4 months, 11 large, 11 middle size and 20 small, comprising 95 birds, from Eagles downwards, with plants, nests, flowers and 60 different kinds of eggs.

I have collected some thousands of insects for our good friend Mr. Children and I will forward them all to him by the first packet going to London direct.

I have felt anxious to have my portrait painted by Thomas Sully for the frontispiece of the "Birds of America," but I doubt now if I or he will have time, for although we are both willing, neither of us can well spare the time.

Well, my love, I believe I have said all. I wish I had a letter of thine and I hope that tomorrow may bring me one...

Lucy Audubon to John James Audubon
"I expect to see a polished and fashionable gentleman..."

St. Francisville, Louisiana
30 October 1829

My dear husband,

Your last of October 20th I have today received and sit down to reply, though having written every week to Kentucky for some time it is hardly necessary, except that you seem quite unaware that I am a woman alone and moving and packing require aid more powerful than mine. However, I have not even thought of packing yet, and if I had there is nothing I can spare but the papers you mention, and I shall have no *time* to put them all up till Christmas week, nor does it seem necessary to me to do so. As to who comes down, you can decide between yourself and Victor, but I certainly would rather you came, and John's coming must be altogether a jaunt of pleasure as he could not do much yet in assisting me were any difficulty to present itself. I long to see you all, but I cannot get them to believe here I should leave them at all. To be sure, I have not pressed the belief further than to beg them to be ready to pay me, for many reasons which I can tell you, but particularly till I heard from you a *negative* to the proposal made me. To say the truth, I did not hope you would agree to it, but if you had I should have worked on a year longer for our children if it could have done them any good and $1,800 is no trifle per annum.

As I hear the water is high [on the Ohio River], I shall look for you the beginning of December... and in the middle of January we may be off, but if you had rather not come, write to Mr. Johnson a flattering letter thanking him for his kindness, &c., &c., and hoping he will aid all he can towards having my affairs arranged, not that I want his help really except his *own* account [paid], which I much fear will be the most tardy of all. Paper calculations always fall short of real cash and my lawsuit will take $106—from that sum the interest for these two years [is lost] but it cannot be helped; nothing *material* can be done before Christmas because I have no claims till then, nor can I pay my debts, which you know somehow

or other are always large enough. I cannot get anything of a cloak here but wish you may get a good one in the north . . . I want your attention to this and those of our sons as I want handsome ones for them also. You are not, I hope, mistaken in your means of support, for I give up a very good and sure salary to join you, and two-thirds of what I may have made is our sons'; the other part ours. You see, I speak plain, and in return I shall I hope to contribute to your comfort, though we may be mistaken—I know we both are singular in some things. The dog I suppose we shall soon see. I assure you the kindness of the Harbor family has been great to me and the Carpenters and Mrs. Percy. Write constantly and tell me of when and how you [paper damaged] . . . Seven weeks and three days, till the 24 of December, I count upon as slaving and then I am fine; if I must toil or suffer I hope it will always be in this way and with as good a recompense. Farewell, I must now attend my pupils. And may all our plans be for our good and end in happiness; and believe me my wish is to make you comfortable and be your affectionate wife and friend,

 Lucy Audubon

 I expect as well as all the rest of us to see a most polished and fashionable gentleman amongst us, who have been rusticating and vegetating in the woods . . .

Sunday night, November 1.

 My dear husband,

As I was disappointed in sending my letter after all my hurry, I must add a few lines to say the weather has become cold; still, our young men are dying of the fever but as we had a white frost last night I hope it will now end. Many, many are gone, and Mary Gurley lost her husband of it a few days after their marriage. I hope you will write or come in this month; I am getting tired of expecting and waiting. Do as you please about John. I want him to have my horse for Sundays. Let me know; it will be long before I can do anything for him again unless you decide on my remaining here longer. Love to all, do bring us some pippins with you if you can. Farewell for a few weeks.

"Once More We Were Together..."

Finally in November 1829 Audubon was able to set aside his work, travel to Louisville to see his sons and then take passage on a steamboat to Bayou Sarah to reunite with his wife after a difficult three-year separation. He wrote of the reunion in his journal (the passage reprinted here was edited by his granddaughter Maria, the only form in which it survives) and again more casually the next day in a letter to his Philadelphia physician friend Richard Harlan.

It was dark, sultry, and I was quite alone. I was aware yellow fever was still raging at St. Francisville, but walked thither to procure a horse. Being only a mile distant, I soon reached it, and entered the open door of a house I knew to be an inn; all was dark and silent. I called and knocked in vain, it was the abode of Death alone! The air was putrid; I went to another house, another, and another; everywhere the same state of things existed; doors and windows were all open, but the living had fled. Finally I reached the home of Mr. Nübling, whom I knew. He welcomed me, and lent me his horse, and I went off at a gallop. It was so dark that I soon lost my way, but I cared not, I was about to rejoin my wife, I was in the woods, the woods of Louisiana, my heart was bursting with joy! The first glimpse of dawn set me on my road, at six o'clock I was at Mr. Johnson's house; a servant took the horse, I went at once to my wife's apartment; her door was ajar, already she was dressed and sitting by her piano, on which a young lady was playing. I pronounced her name gently, she saw me, and the next moment I held her in my arms. Her emotion was so great I feared I had acted rashly, but tears relieved our hearts, once more we were together.

John James Audubon to Richard Harlan, M.D.
St. Francisville, Louisiana
18 November 1829

My dear friend,

You will see by the date of this the rapidity with which I have crossed two-thirds of the United States. I had the happiness of

pressing my beloved wife to my breast yesterday morning; saw my two sons at Louisville and all is well. From Philadelphia to Pittsburgh I found the roads, the coaches, horses, drivers and inns all much improved and yet needing a great deal to make the traveler quite comfortable. The slowness of the stages is yet a great bore to a man in a hurry. I remained part of a day at Pittsburgh where of course I paid my respects to the museum! I was glad to see the germ of one. It is conducted by a very young man named Lambdin... At Cincinnati I also visited the museum [where Audubon had worked in 1819–20]. It scarcely improves since my last view of it, except indeed by wax figures and such other shows as are best suitable to make money and the least so to improve the mind. I could not see [Daniel] Drake as my time was very limited.

The Ohio was in good order for navigation and I reached Louisville, distant from you about 1,000 miles, in one week. As you spoke of traveling westwardly, I give you here an a/c of the fare. To Pittsburgh, all included, 21$. To Louisville, 12$. And 25$ more to Bayou Sarah where I landed. 30$ is the price from Louisville to N[ew] Orleans. Our steamboats are commodious and go well. But my dear friend, the most extraordinary change has taken place in appearance as I have proceeded. The foliage had nearly left the trees in Pennsylvania; the swallows had long since disappeared; severe frost indeed had rendered Nature gloomy and uninteresting. Judge of the contrast: I am now surrounded by *green trees* and swallows gambol around the house as in Pennsylvania during June & July. The mock bird is heard to sing and during a walk with my wife yesterday I collected some 20 or 30 insects. That is not all; a friend of mine here says that he has discovered 2 or 3 *new birds!!!* New birds are new birds our days, and I shall endeavor to shew you the facsimile when again I shall have the pleasure of shaking your hand.

Although so lately arrived, I have established the fact that Mrs. A. and myself will be on our way towards "Old England" by the 15th of Jan'y. We will ascend the Mississippi, and after resting ourselves at Louisville with our sons and other relatives about one month and then proceed with the rapidity of the Wild Pigeon should God grant our wishes!

...I will begin drawing next week having much scratching with

the pen to perform this one, and I am also desirous to make [illegible] large shipment of aborigines both animal and vegetal as soon as possible: Turkeys, alligators, opossums, Paroquets and plants [such] as begonias, &c., &c., &c., will be removed to the Zoological Gardens of London from the natural ones of this magnificent Louisiana!

Meantimes I will not forget *my friends in Phila*. No, I would rather forgive all, to all my enemies there. Assure Dr. Hammersley that Ivory-billed and Pileated Woodpeckers will be skinned, and who knows but I may find something more for him. I will give free leave to Dr. Pickering to choose amongst the insects and who knows but I may find something new for him. Remember me most kindly to both, nay, not in the common manner of saying "Mr. Audubon begs to be remembered," no, not [at] all. This way Mr. A remembers *you* and *you* and *I* will remember *you* and *you* and *I* always!!

May I also beg to be remembered in humble words to a fine pair of eyes divided, not by the Allegany Mountains; but by a nose evidently imported from far *East*, to a placid forehead, to a mouth speaking happiness to——

Should you see Friend Sully remember me to him also— and should you see George Ord, Esq. *Fellow* of all the Societies *imaginable,* present him my most humble ——

Should you see that good woman where I boarded at Camden, tell her that I am well and thankful to her for her attentions to me.

I cannot hope the pleasure of an answer from you here, but you may do so, and I say pray do so, directed to the care of N. Berthoud Esq., Louisville, Kentucky. By the bye, my sons are taller than me, the eldest one so much altered that I did not know him at first sight, and yet I have *eyes*...

[Written across the first page:]

I reopened my letter to say that I have just now killed a large new falcon—yes, positively a new species of hawk, almost black, about 25 inches long and 4 feet broad, tail square, eye yellowish-white, legs and feet bare, short and strong. I will skin it!!!!

Remember me to [George] Lehman ——

What I have said about the hawk to you must be [made] *lawful to academicians* and you will please announce *Falco Harlanii* [*Buteo borealis harlanii*] by John J. Audubon.

PART IV:
UNDERWAY FOR OLD ENGLAND

John James Audubon to Robert Havell, Jr.

"We are now underway for Old England..."

Louisville, Kentucky
29 January 1830

My dear Mr. Havell,

The last of your letters are dated 2nd and 20th of November, both of which I received at this place a few days since. Thank you for them and their contents. We left New Orleans on the 7th instant and after an agreeable passage up the Mississippi and the Ohio Rivers reached this place in 14 days in a fine steamer called the *Philadelphia*. The same that brought up Captain Basil Hall, and we occupied the same staterooms that he had. We have found here our dear sons quite well. So you see we are now regularly underway for Old England again. Mrs. Audubon's health is good, although her frame is delicate, and we will rest here until the last of next month, when we will again take a steamer and ascend the Ohio up to Wheeling. Then we will cross the mountains and go to Washington City, as I am desirous to pay my respects to the President of these United States. Thence to Baltimore, Philadelphia and New York from which place we intend sailing either on the 1st or the 8th of April for Liverpool, unless we may think it more agreeable to sail from Boston. Within 2 months past I have traveled about 4,000 miles, have made several drawings, skinned a great number of birds, shipped 1,150 forest trees to England and whilst at New Orleans shipped also 14 live opossums and a beautiful male Turkey for the Gardens.

I think that the drawings I take with us will please you much and will in fact be a great acquisition to my works. I will be in time (God willing) for the 16th Number and will be on the spot to give you materials for the 17th...

John James Audubon to Charles-Lucien Bonaparte
"The President was kind and polite to us..."

London, England
5 May 1830

My dear sir,

It is with pleasure that with the announcement of my return to England, I sit to write you to renew a correspondence at all times so valuable to me and of which I have ever been proud. I hope you are well and happy!!

I received a letter from you on my reaching New York last spring which enabled me to receive from Mr. Lea your fine work, volumes 2 & 3; but previously to my going to Philadelphia I presented to the members of the Lyceum at New York 11 Numbers of my work, bound up. It was kindly received and myself kindly treated, particularly so by your amiable friend Mr. [William] Cooper. A committee was appointed to review my work, it was done and the report highly flattering. I then left for the seashore of New Jersey, where I made ample collections of skins, eggs and memorandums accompanied by valuable drawings. From there I threw myself into the center of the Great Pine Forest on the headwaters of the Lehigh and found work enough to do. I returned to Philadelphia with a valuable cargo and well satisfied and pleased with the two months of my life spent in that grand forest. As the weather grew colder I marched towards my favorite river the Ohio, navigated it, and reached my house where winter seldom intrudes. There and [in the] neighborhood I ransacked closely the woods, the lakes and prairies.

January the 1st saw my wife and self reascending the [illegible] stream. Some time was spent with our relations and our sons at the Falls of the Ohio, and as spring chased the black clouds northward again, we made our way to Washington City. The President was kind and polite to us [and] the Congress subscribed to my work...At Baltimore I secured 4 more names, and doubt not would have had more at those cities had not my desire to return quickly to Europe urged us onwards.

Philadelphia, oh Philadelphia! I stayed through 2 days. At New York I remained only 2 days and have crossed the Atlantic in the *Pacific* and am again in great London taking the reins of my work in my hands. Thanks to my excellent and worthy friend [George] Children and the industry of my engraver, all has gone on well, and I think the execution improved. I may perhaps think so because I am desirous it should be so; therefore, judge yourself and let me have your opinion. The 16th Number is finished, the 17th began and the drawings that I have brought will I trust be of material advantage to the whole. Permit me to say that I regret that the name of the Earl of Shrewsbury is not yet on my augmented list. May I call on him? I will write again very soon and give you longer details. I see much said respecting the Horticultural & Zoological Society in the papers but know little of the cause. The King's health is very low—the weather very fine ...

On March 19th I was honored with the title F.R.S.L. [Fellow of the Royal Society of London]; now the query is, do I deserve all that honor!

Lucy Audubon to Victor Gifford and
John Woodhouse Audubon
"Preserve your morals, my dear sons..."

Liverpool, England
15 May 1830

My beloved children,

This is the second time I have written to you since my arrival in this beautiful country. I wrote to Brother William and to Sister Eliza each week in succession and though I have nothing very new to say, I will write by the *Pacific* and then wait till I am in London. I have heard once from your Papa since he has been there ... I have had some visitors and been at some dinners, and I am invited to an evening party which I wish I could avoid; there is so much ceremony, so many little forms of etiquette and many little things to be attended to.

As I have nothing better to say, I will give you a sketch of dinner. In the first place, there are 3 wine glasses at each plate; no tumblers, for nobody drinks any water, and beer ... is handed from the sideboard. Then comes the soup, as rich as gravy. Then fish. The plates are hot and changed as well as knives & forks, every article you eat. During this time the company keep drinking wine, the ladies choose what kind and the gentleman who drinks will take the same. Then comes the butcher's meat and poultry, and the third course is pastry and jellies, changing plates, &c., all the time. Then the cloth is removed and the dessert of nuts and fruit, then more wine glasses to everyone and in half or 3/4 of an hour the ladies retire, in an hour or more coffee is in the drawing room and a little delicate cake. The gentlemen are informed of coffee but they do not always come. This is generally about 9—at 11 they go home, and the same form is observed everywhere.

The ladies at table are placed alternately between guests, but if there are but two or one they are placed next the master of the house, and always gentleman next the mistress of the house. To live in England known requires an immense sum—to live unknown [and] quite secluded, a very moderate sum. The dressing

for company is expensive, but handsome things such as are worn in America for dress can be had quite moderate.

I shall begin your shirts as soon as I get settled. I wish I could send you both something now, but you must wait a little. The weather has for two days been uncommonly rainy and gloomy. I can see to work and sew till half past eight in the evening without candle—and at five in the morning I am up...I hope you are both well and very attentive to your business; look forward to our being all together and spending some happy hours at last. But really so far I have nothing to regret but [not seeing] you, my children, and my brothers and sisters...

Preserve your morals, my dear sons; let me never have to blush for you or shed a tear of reproach; be guarded but prudent, and have resolution to turn from temptation not only on account of punishment here, and mortification, but eternal sorrow hereafter...

Lucy Audubon to John James Audubon
"Sister Ann has had another violent attack..."

Liverpool, England
18 June 1830

Yours my dear LaForest of the 16th came last night to me. I am afraid you are rather dull from the air of the letter, but keep up your spirits and always hope for the best. You do not wish for me more than I do to be with you, and I still hope to join you on the last of this month somewhere. As to sister Ann, it is impossible to say when she will be well, if ever (but this you must keep to yourself). She has had another violent attack of fever and pain and has had to go through all the leeches, &c., &c., again, and is now not able to leave her bed though free from pain almost, but in a few days she may be as bad as ever. Her spirits are very bad of such repeated returns, but they do not know of any danger. Mr. Gordon is very attentive to her and sat up the other night with her to give the medicines.

What will become of the poor boy [i.e., the Gordons' son Will] I know not, but we must hope the best even here, and if she is at all tolerable I will join you when you write me to do so at Birmingham, though I dread traveling without you...

Mr. Richard Rathbone bought me some flowers again. The "Lady Rathbone" is expected home next week, they heard from her yesterday. I have not seen anybody else. Mr. Gordon's respects; he says that yesterday he saw the Athenaeum people and he thinks it likely they will subscribe; but he will see more into it and we will send your things to you direct, but the [live passenger] pigeons I will keep till I go or [find] someone who will take care of them, as they are very well here...

Ann told me say her love to you when I wrote and thank you kindly for leaving me with her, but when you say so, she says she must try and do without me as well as she can. Little Will is well; the other day his Mamma said "perhaps he would soon have no Mamma; what would he do?" to which he gaily replied "but I have Aunt Audubon." I hope sincerely she may recover and that soon.

Now I have filled my paper and must say farewell with a return kiss in exchange for you, and I hope I shall hear of your having subscribers at Birmingham. In the meantime, be informed of the unalterable affection of your wife . . .

John James Audubon to Lucy Audubon
"Lord Stanley kneeled down to my drawing…"

Birmingham, England
21 June 1830

My dearest friend,

I left London last evening at 4 and reached this place this morning at $^1/_2$ past six, quite well. On Friday last I had a long visit from Lord Stanley, who kneeled down (not to me my Lucy) but to my drawing with as much anxiety as I myself did in our young days to beg thy favors! I subsequently received two letters from him and he seems rather anxious to have my collection of original drawings and besides asks how much I would charge for drawings of birds unconnected with my present work. The matter stands thus, for he did not call upon me yesterday when I fully expected him. I met Capt. Basil Hall and his brother, the confessor, at the Royal Society's last meeting for this year on Thursday last. He gave me his card and I gave him mine (I could have wrote better by saying that we exchanged cards, but never mind). They both called yesterday at 3 and on my opening the conversation about America, the Capt. exhibited symptoms of madness that surprised me indeed— he took his hat, flew towards the door and said that if a word respecting the U.S. was uttered he must go [Hall had recently published his *Travels in North America*, which took a dim view of American democracy]. His brother sat mute & quiet but I also flew to the door, held him fast and having promised not to say America he became [calmer]. We shook hands several times and at this very moment I cannot return to that scene without thinking it highly ludicrous and theatrical. He offered me a full copy of his work and doubtless it will be in waiting for me when I return. But Lucy, I watched the muscles of his countenance and I will say no more. He asked after thee, spoke much of Mr. Gordon & Mr. Berthoud.

I have nearly delivered all my letters [of introduction] here and so far I am tolerably pleased with the place. Probably tomorrow I will open my small exhibition in the Society of Arts rooms,

gratis!...I will remain here a good fortnight, for I am determined to beat the bushes to the purpose. I have brought with me a copy of my 17th Number, 120 drawings and plenty of good spirits...

Lucy Audubon to John James Audubon
"The King is dead..."

Liverpool, England
27 June 1830

Your last, my dear husband, of Wednesday & Thursday I received
on Friday night, but as I wished the good news of Sister Ann's
amendment to be a little certain I did not write sooner. Ann begs
me thank you kindly for your concern for her and for my stay; she
says I must tell you that she is certainly better, but that my good
[offices] would be very desirable to complete a cure, that [she] has
had so many relapses she cannot but feel they may return, or the
want of a friend at her elbow to advise and assist may bring back
those spasms so painful. Now, my LaForest, you cannot perhaps
tell how desirous I am of being with you, because Ann's forlorn
state made me forget myself, but she is able to sit up an hour or
two, and I told her I wished to join you.

She, of course, is very sad about it, but I will, at her request, just
say that if you cannot make it more convenient to go your rounds
without me, that if there is no change I hope to be able to leave
when your Birmingham business is done, and I had rather you
should come for me if you possibly can, whenever you can, and by
letting me know a day before, I could be ready for you as to having
my clothes from the wash. I need say no more on the subject; my
wish is to be with you, but the same sisterly feeling as you express
has kept me here when necessary. Now you can either travel further
without me or not, as you may deem the most prudent or agreeable.
I am willing to do anything for a while longer. I am sorry you have
had [bad] news from France: perhaps you would like to go there
immediately; if so, I am ready.

You could not expect in less than a few weeks that such a place
as Birmingham should know of you. I hope you are now better
pleased...We have had two or three fine days but it is raining
now. I do not know of anything new to tell you, for you know I
am here as a nurse. Little Willy often talks about you. Ann and
Mr. Gordon speak often of you...We have just had a report that

the King is dead. I can assure you if I had been going out much I should have felt the want of my gown, for my black is nearly gone indeed. I will not close my letter till evening that I may see to the latest if there is any change in Ann, but conclude begging you to keep up your spirits, think before you act and be assured you have a sincere and affectionate friend and wife, Lucy Audubon.

Dear husband,
6 o'clock. Mr. Gordon is just come to dinner and confirmed the reports about the King's death. Ann says if your business is stopped by it, come here and then we can plan together, but I really must soon have a black gown—and my stays are dreadful, waiting for my going to London. Adieu...

John James Audubon to Lucy Audubon
"I never give up the ship..."

Birmingham, England
28 June 1830

I was fidgety indeed until I received thy last and that was after the shutting my doors yesterday evening. I am particularly glad to hear such good tidings of our Sister Ann, and I will write to thee on Thursday evening when we are to meet. My time here has been of the dullest cast, I have only one subscriber in Birmingham, the good people will hardly give themselves the trouble of coming to see the "Birds of America" much less to subscribe to the publication. However, I never give up the ship, and if Birmingham does not meet my expectations I must go elsewhere.

The death of George the 4th may or may not alter my plans for a few weeks (for even the demise of a King will not attract attention more than a fortnight). I have written to Havell this day for information and I will have his answer on Thursday next. I must say that I will find it rather inconvenient to go to Liverpool for thee, but if I cannot get thee without, I must do so...

Episode: The Opossum

North America's only marsupial was an object of curiosity to Audubon's British and European readers. In the third volume of his Ornithological Biography *he obliged them with a brief episode devoted to the unusual animal, anticipating the large work on quadrupeds he was already planning,* Viviparous Quadrupeds of North America, *that his sons John Woodhouse and Victor Gifford Audubon would complete on his behalf between 1846 and 1854 with his co-author John Bachman.*

This singular animal is found more or less abundant in most parts of the Southern, Western, and Middle States of the Union. It is the *Didelphis virginiana* of Pennant, Harlan and other authors who have given some account of its habits; but as none of them so far as I know have illustrated its propensity to dissimulate, and as I have had opportunities of observing its manners, I trust that a few particulars of its biography will prove amusing.

The opossum is fond of secluding itself during the day, although it by no means confines its predatory rangings to the night. Like many other quadrupeds which feed principally on flesh it is also both frugivorous and herbivorous, and when very hard pressed by hunger it seizes various kinds of insects and reptiles. Its gait while traveling and at a time when it supposes itself unobserved is altogether ambling: in other words it, like a young foal, moves the two legs of one side forward at once. The Newfoundland dog manifests a similar propensity. Having a constitution as hardy as that of the most northern animals, it stands the coldest weather and does not hibernate, although its covering of fur and hair may be said to be comparatively scanty even during winter. The defect, however, seems to be compensated by a skin of considerable thickness and a general subcutaneous layer of fat. Its movements are usually rather slow, and as it walks or ambles along its curious prehensile tail is carried just above the ground, its rounded ears are directed forward and at almost every step its pointed nose is applied to the objects beneath it in order to discover what sort of creatures may have crossed its path.

Methinks I see one at this moment slowly and cautiously

trudging over the melting snows by the side of an unfrequented pond, nosing as it goes for the fare its ravenous appetite prefers. Now it has come upon the fresh track of a grouse or hare and it raises its snout and snuffs the keen air. At length it has decided on its course and it speeds onward at the rate of a man's ordinary walk. It stops and seems at a loss in what direction to go, for the object of its pursuit has either taken a considerable leap or has cut backwards before the opossum entered its track. It raises itself up, stands for a while on its hind feet, looks around, snuffs the air again and then proceeds; but now at the foot of a noble tree it comes to a full stand. It walks round the base of the huge trunk, over the snow-covered roots, and among them finds an aperture which it at once enters. Several minutes elapse, when it reappears dragging along a squirrel already deprived of life, with which in its mouth it begins to ascend the tree. Slowly it climbs. The first fork does not seem to suit it, for perhaps it thinks it might there be too openly exposed to the view of some wily foe, and so it proceeds until it gains a cluster of branches intertwined with grapevines, and there composing itself, it twists its tail round one of the twigs and with its sharp teeth demolishes the unlucky squirrel, which it holds all the while with its fore paws.

The pleasant days of spring have arrived and the trees vigorously shoot forth their buds; but the opossum is almost bare and seems nearly exhausted by hunger. It visits the margins of creeks and is pleased to see the young frogs, which afford it a tolerable repast. Gradually the pokeberry and the nettle shoot up and on their tender and juicy stems it gladly feeds. The matin calls of the Wild Turkey Cock delight the ear of the cunning creature, for it well knows that it will soon hear the female and trace her to her nest, when it will suck the eggs with delight. Traveling through the woods, perhaps on the ground, perhaps aloft from tree to tree, it hears a cock crow and its heart swells as it remembers the savory food on which it regaled itself last summer in the neighboring farmyard. With great care, however, it advances and at last conceals itself in the very henhouse.

Honest farmer! why did you kill so many crows last winter? aye, and ravens too? Well, you have had your own way of it; but now hie to the village and procure a store of ammunition, clean your

rusty gun, set your traps and teach your lazy curs to watch the opossum. There it comes! The sun is scarcely down, but the appetite of the prowler is keen; hear the screams of one of your best chickens that has been seized by him! The cunning beast is off with it and nothing now can be done unless you stand there to watch the fox or the owl, now exulting in the thought that you have killed their enemy and your own friend, the poor crow. That precious hen under which you last week placed a dozen eggs or so is now deprived of them. The opossum, notwithstanding her angry outcries and rufflings of feathers, has removed them one by one; and now look at the poor bird as she moves across your yard; if not mad she is at least stupid, for she scratches here and there, calling to her chickens all the while. All this comes from your shooting crows. Had you been more merciful or more prudent the opossum might have been kept within the woods, where it would have been satisfied with a squirrel, a young hare, the eggs of a Turkey or the grapes that so profusely adorn the boughs of our forest trees. But I talk to you in vain.

There cannot be a better exemplification of maternal tenderness than the female opossum. Just peep into that curious sack in which the young are concealed, each attached to a teat. The kind mother not only nourishes them with care but preserves them from their enemies; she moves with them as the shark does with its progeny and now, aloft on the tulip tree, she hides among the thick foliage. By the end of two months they begin to shift for themselves; each has been taught its particular lesson and must now practice it.

But suppose the farmer has surprised an opossum in the act of killing one of his best fowls. His angry feelings urge him to kick the poor beast which, conscious of its inability to resist, rolls off like a ball. The more the farmer rages, the more reluctant is the animal to manifest resentment; at last there it lies, not dead but exhausted, its jaws open, its tongue extended, its eye dimmed; and there it would lie until the bottle fly should come to deposit its eggs, did not its tormentor at length walk off. "Surely," says he to himself, "the beast must be dead." But no, reader, it is only "possuming," and no sooner has its enemy withdrawn than it gradually gets on its legs and once more makes for the woods.

Once while descending the Mississippi in a sluggish flat-bottomed boat expressly for the purpose of studying those objects of nature more nearly connected with my favorite pursuits, I chanced to meet with two well-grown opossums and brought them alive to the "ark." The poor things were placed on the roof or deck and were immediately assailed by the crew when, following their natural instinct, they lay as if quite dead. An experiment was suggested and both were thrown overboard. On striking the water and for a few moments after, neither evinced the least disposition to move; but finding their situation desperate they began to swim towards our uncouth rudder, which was formed of a long, slender tree extending from the middle of the boat thirty feet beyond its stern. They both got upon it, were taken up and afterwards let loose in their native woods.

In the year 1829 I was in a portion of lower Louisiana where the opossum abounds at all seasons, and having been asked by the president and the secretary of the Zoological Society of London to forward live animals of this species to them, I offered a price a little above the common and soon found myself plentifully supplied, twenty-five having been brought to me. I found them excessively voracious and not less cowardly. They were put into a large box with a great quantity of food and conveyed to a steamer bound for New Orleans. Two days afterwards I went to the city to see about sending them off to Europe; but to my surprise I found that the old males had destroyed the younger ones and eaten off their heads and that only sixteen remained alive. A separate box was purchased for each and some time after they reached my friends the Rathbones of Liverpool, who with their usual attention sent them off to London where, on my return, I saw a good number of them in the Zoological Gardens.

This animal is fond of grapes, of which a species now bears its name. Persimmons are greedily eaten by it, and in severe weather I have observed it eating lichens. Fowls of every kind and quadrupeds less powerful than itself, are also its habitual prey.

The flesh of the opossum resembles that of a young pig and would perhaps be as highly prized were it not for the prejudice generally entertained against it. Some "very particular" persons, to my knowledge, have pronounced it excellent eating. After cleaning

its body, suspend it for a whole week in the frosty air, for it is not eaten in summer; then place it on a heap of hot wood embers; sprinkle it when cooked with gunpowder; and now tell me, good reader, does it not equal the famed Canvas-back Duck? Should you visit any of our markets you may see it there in company with the best game.

Episode: Improvements in the Navigation of the Mississippi

Under this unprepossessing heading Audubon looked back from the vantage of 1830 at the remarkable developments he had lived through in American communications. Rivers had been the continent's first roads, penetrating the wilderness beyond the Appalachians and delivering a flood of settlers. Beginning in 1810 the steamboat accelerated settlement by making it possible to transport people and goods upriver almost as easily as down. Audubon had arrived barely in time to experience primordial America.

I have so frequently spoken of the Mississippi that an account of the progress of navigation on that extraordinary stream may be interesting even to the student of nature. I shall commence with the year 1808, at which time a great portion of the western country, and the banks of the Mississippi River from above the city of Natchez particularly, were little more than a waste, or to use words better suited to my feelings, remained in their natural state. To ascend the great stream against a powerful current, rendered still stronger wherever islands occurred, together with the thousands of sand-banks as liable to changes and shiftings as the alluvial shores themselves, which at every deep curve or bend were seen giving way as if crushed down by the weight of the great forests that everywhere reached to the very edge of the water, and falling and sinking in the muddy stream by acres at a time, was an adventure of no small difficulty and risk, and which was rendered more so by the innumerable logs called sawyers and planters that everywhere raised their heads above the water as if bidding defiance to all intruders. Few white inhabitants had yet marched towards its shores and these few were of a class little able to assist the navigator. Here and there a solitary encampment of native Indians might be seen, but its inmates were as likely to prove foes as friends, having from their birth been made keenly sensible of the encroachments of the white men upon their lands.

Such was then the nature of the Mississippi and its shores. That river was navigated principally in the direction of the current in small canoes, pirogues, keelboats, some flatboats and a few barges.

The canoes and pirogues being generally laden with furs from the different heads of streams that feed the great river, were of little worth after reaching the market of New Orleans and seldom reascended, the owners making their way home through the woods amidst innumerable difficulties. The flatboats were demolished and used as firewood. The keelboats and barges were employed in conveying produce of different kinds besides furs, such as lead, flour, pork and other articles. These returned laden with sugar, coffee and dry goods suited for the markets of St. Genevieve and St. Louis on the upper Mississippi or branched off and ascended the Ohio to the foot of the Falls near Louisville in Kentucky. But reader, follow their movements and judge for yourself of the fatigues, troubles and risks of the men employed in that navigation.

A keelboat was generally manned by ten hands, principally Canadian French, and a patroon or master. These boats seldom carried more than from twenty to thirty tons. The barges frequently had forty or fifty men with a patroon and carried fifty or sixty tons. Both these kinds of vessels were provided with a mast, a square-sail and coils of cordage, known by the name of *cordelles*. Each boat or barge carried its own provisions. We shall suppose one of these boats underway and, having passed Natchez, entering upon what were called the difficulties of their ascent. Wherever a point projected so as to render the course or bend below it of some magnitude, there was an eddy, the returning current of which was sometimes as strong as that of the middle of the great stream. The bargemen therefore rowed up pretty close under the bank and had merely to keep watch in the bow lest the boat should run against a planter or sawyer. But the boat has reached the point, and there the current is to all appearance of double strength and right against it. The men, who have all rested a few minutes, are ordered to take their stations and lay hold of their oars, for the river must be crossed, it being seldom possible to double such a point and proceed along the same shore. The boat is crossing, its head slanting to the current, which is however too strong for the rowers, and when the other side of the river has been reached it has drifted perhaps a quarter of a mile. The men are by this time exhausted and, as we shall suppose it to be twelve o'clock, fasten the boat to the shore or to a tree. A small glass of whiskey is given to each,

when they cook and eat their dinner, and after repairing their fatigue by an hour's repose recommence their labors. The boat is again seen slowly advancing against the stream. It has reached the lower end of a large sandbar along the edge of which it is propelled by means of long poles if the bottom be hard. Two men called bowsmen remain at the prow to assist in concert with the steersman in managing the boat and keeping its head right against the current. The rest place themselves on the land side of the footway of the vessel, put one end of their poles on the ground, the other against their shoulders, and push with all their might. As each of the men reaches the stern he crosses to the other side, runs along it and comes again to the landward side of the bow, when he recommences operations. The barge in the meantime is ascending at a rate not exceeding one mile in the hour.

The bar is at length passed, and as the shore in sight is straight on both sides of the river and the current uniformly strong, the poles are laid aside, and the men being equally divided, those on the river side take to their oars whilst those on the land side lay hold of the branches of willows or other trees and thus slowly propel the boat. Here and there, however, the trunk of a fallen tree, partly lying on the bank and partly projecting beyond it, impedes their progress, and requires to be doubled. This is performed by striking it with the iron points of the poles and gaff hooks. The sun is now quite low and the barge is again secured in the best harbor within reach. The navigators cook their supper and betake themselves to their blankets or bearskins to rest, or perhaps light a large fire on the shore, under the smoke of which they repose in order to avoid the persecutions of the myriads of mosquitoes which occur during the whole summer along the river. Perhaps, from dawn to sunset, the boat may have advanced fifteen miles. If so it has done well. The next day the wind proves favorable, the sail is set, the boat takes all advantages and meeting with no accident, has ascended thirty miles, perhaps double that distance. The next day comes with a very different aspect. The wind is right ahead, the shores are without trees of any kind and the canes on the banks are so thick and stout that not even the cordelles can be used. This occasions a halt. The time is not altogether lost as most of the men, being provided with rifles, betake

themselves to the woods and search for the deer, the bears or the turkeys, that are generally abundant there. Three days may pass before the wind changes and the advantages gained on the previous fine day are forgotten. Again the boat proceeds, but in passing over a shallow place runs on a log, swings with the current but hangs fast, with her lee side almost under water. Now for the poles! All hands are on deck, bustling and pushing. At length towards sunset the boat is once more afloat and is again taken to the shore where the wearied crew pass another night.

I shall not continue this account of difficulties, it having already become painful in the extreme. I could tell you of the crew abandoning the boat and cargo and of numberless accidents and perils; but be it enough to say that, advancing in this tardy manner, the boat that left New Orleans on the first of March often did not reach the Falls of the Ohio until the month of July, nay, sometimes not until October; and after all this immense trouble it brought only a few bags of coffee and at most 100 hogsheads of sugar. Such was the state of things in 1808. The number of barges at that period did not amount to more than 25 or 30, and the largest probably did not exceed 100 tons burden. To make the best of this fatiguing navigation I may conclude by saying that a barge which came up in three months had done wonders, for I believe few voyages were performed in that time.

If I am not mistaken, the first steamboat that went down out of the Ohio to New Orleans was named the [New] *Orleans*, and if I remember right was commanded by Captain Ogden. This voyage, I believe, was performed in the spring of 1810. It was, as you may suppose, looked upon as the *ne plus ultra* of enterprise. Soon after, another vessel came from Pittsburgh, and before many years elapsed, to see a vessel so propelled became a common occurrence. In 1826, after a lapse of time that proved sufficient to double the population of the United States of America, the navigation of the Mississippi had so improved both in respect to facility and quickness that I know no better way of giving you an idea of it than by presenting you with an extract of a letter from my eldest son, which was taken from the books of N. Berthoud, Esq. with whom he at that time resided.

"You ask me in your last letter for a list of the arrivals and

departures here. I give you an abstract from our list of 1826 shewing the number of boats which plied each year, their tonnage, the trips which they performed and the quantity of goods landed here from New Orleans and intermediate places.

1823, from Jan. 1 to Dec. 31, 42 boats measuring 7,860 tons. 98 trips. 19,453 tons.

1824, from Jan. 1 to Nov. 25, 36 boats measuring 6,393 tons. 118 trips. 20,291 tons.

1825, from Jan. 1 to Aug. 15, 42 boats measuring 7,484 tons. 140 trips. 24,102 tons.

1826, from Jan. 1 to Dec. 31, 51 boats measuring 9,388 tons. 182 trips. 28,914 tons.

"The amount for the present year will be much greater than any of the above. The number of flatboats and keels is beyond calculation. The number of steamboats above the Falls I cannot say much about except that one or two arrive at and leave Louisville every day. Their passage from Cincinnati is commonly 14 or 16 hours. The *Tecumseh*, a boat which runs between this place and New Orleans, and which measures 210 tons, arrived here on the 10th instant in 9 days, 7 hours from port to port; and the *Philadelphia*, of 300 tons, made the passage in 9 days 9¹/₂ hours, the computed distance being 1,650 miles. These are the quickest trips made. There are now in operation on the waters west of the Alleghany Mountains 140 or 145 boats. We had last spring (1826) a very high freshet, which came 4¹/₂ feet deep in the counting room. The rise [of the Ohio River] was 57 feet, 3 inches perpendicular."

The whole of the steamboats of which you have an account did not perform voyages to New Orleans only but to all points on the Mississippi and other rivers which fall into it. I am certain that since the above date the number has increased, but to what extent I cannot at present say.

When steamboats first plied between Shippingport and New Orleans the cabin passage was a hundred dollars, and a hundred and fifty dollars on the upward voyage. In 1829 I went down to Natchez from Shippingport for twenty-five dollars and ascended from New Orleans on board the *Philadelphia* in the beginning of

January 1830 for sixty dollars, having taken two staterooms for my wife and myself. On that voyage we met with a trifling accident which protracted it to fourteen days; the computed distance being, as mentioned above, 1,650 miles, although the real distance is probably less. I do not remember to have spent a day without meeting with a steamboat, and some days we met several. I might here be tempted to give you a description of one of these steamers of the western waters, but the picture having been often drawn by abler hands, I shall desist.

Lucy Audubon to Victor Gifford and
John Woodhouse Audubon
"Your father's goodness to me has made a change for the better..."

Manchester, England
30 August 1830

My beloved sons,

I wrote to you a month ago to inform you that we did not go to France owing to the disturbances there [i.e., the Revolution of 1830], which have so happily terminated (it is hoped at least). My trip to the Continent has therefore yet to come. Your father wrote to you the other day, but I do not remember what he said; therefore I will write while I am in the neighborhood of Liverpool, as I may not do so again for some time. I have seen most of the manufactories of this place while your father has been engaged in trying to increase his subscribers here, which he has done, and he is today in the country for that purpose. Tomorrow we set out for Leeds in Yorkshire, but will not remain many days. However, I will give you an account of the places we go to when I next write. We often wish for our dear sons to partake with us the sights we see.

Machinery is on the most extensive and improved plan here, but it is not in my power to give you any idea of many things. I went to look at the method of obtaining gas [from coal]... and saw the decomposing of the tar and dross, also the immense reservoirs or machines for containing the gas till wanted [i.e., gasometers]. They are of sheet iron, square, about 20 feet [across] and stand in twenty-seven feet of water when empty, but as the gas is conducted into them by tubes they rise, perceptibly to the eye, till nearly the whole body is on the surface.

The cotton mill we went into is 7 stories high and occupies about 900 persons. Many rooms on each floor, and through the middle is a square platform [i.e., an elevator] from which we were propelled upwards at a good speed, just stopping as we ascended at the door of each room to look in. We descended rather faster but not in the least disagreeably.

We went to see the method of making cotton and wool cards

and I was really surprised at the plan. A machine conveys the wire from a reel a little distance through the machinery, which first makes two holes, then a bit of wire is broken off, all the same length, bent to the right shape and pushed into pieces of sole leather, at a moment one after the other, and this leather is nailed or glued upon boards as we see them in the form of cards. I was glad to see the operation of the circular saw, which divides board into thin pieces like sash board in an instant and no waste or irregularity.

I went to see the calendering of calicos, the weaving of tapes, cords, worsted bindings and ribband. Today I am going to see the printing of calico.

On Saturday we had the pleasure of seeing the locomotive engines on the railway arrive and set out. They contained about 600 passengers, the bugle was playing and an immense concourse of people assembled to see them. Your father stationed me where I had an excellent view, but so rapid is the flight that there is not time to particularize any thing or any person. The part of the vehicle assigned to the ladies was covered and much like one of our stages; the sight was truly novel and quite amusing. This carriage came from Liverpool, 36 miles, in two hours and four minutes; it returned to Liverpool in one hour and forty minutes exactly.

We went afterwards to see a large lunar microscope [i.e., a telescope] which is very fine recreation for a time but fatigues the eye soon. I wish you could both join us tonight in hearing a concert to which we are invited and which from the great love of music the Manchester people have, will I daresay be very good. We spent yesterday at the house of Mr. Dyer, an American of great fortune, a subscriber of your Father's. The whole establishment is beautiful. I had the pleasure of eating a peach! and found it more flavorful than ours usually, but not so juicy or so sweet. There was abundance of fine grapes and plums and pears. In the garden I saw some rather yellow-looking Indian corn which had been sown on the first of June and was about a foot high yesterday. Mr. & Mrs. Dyer are very agreeable and very kind; we have been quite fortunate in Manchester in kind people whom we have seen.

Your father the other day made me a present of some very

valuable books which I hope someday we shall shew you; amongst them are the British classics and Shakespeare's works. I need not say how much I esteem what your father gives me, and when we are no more, you will take care of them for both our sakes, for you could not have parents more desirous of promoting your welfare or your happiness. I only regret sometimes that now I have only good wishes for you, but as the old adage says, take the will for the deed—when you see me again I hope you will find that England & your father's goodness to me has made a change for the better in me, though a few years more will be added to my age. The paints, canvases, violin, and model of the Tunnel [under the Thames] we could not get ready [to send] now but two months later will not signify. Remember, my dear children, your duty to your Maker, to yourselves and your fellow creatures. Avoid all temptation to err, for few of us would be unblemished if much tried, I fear ...

[John James Audubon Postscript]

My dear sons, I wish to add my good wishes to those of your dear Mamma; I have been much engaged since at Manchester, but as I have added four names to my list I am quite repaid. I wish very much I had you here with us, and when we are in America must talk the matter over.

The Duke of Bordeaux has hanged himself.

John James Audubon to Charles-Lucien Bonaparte
"I am trudging on . . ."

Edinburgh, Scotland
2 January 1831

My dear friend,

. . . My first volume is at last finished and I have the whole 100 plates, which constitute it, delivered to my English patrons at least. I sincerely hope that as soon as you receive the title page and page of contents you will honor this, my first volume, with a solid binding cover.

My good wife & I have been residing in fair Edinburgh for these three months, where I have been most industriously engaged in preparing for the press the first volume of my biographical remarks on the birds of my beloved country. I have now rather more than one half ready for the printer—say, about 300 pages of royal octavo—and this work will commence the printing of it in that format.

I think I see a smile on your face at the idea of my presumption, but I could not well help writing something, and as I am truly concerned that the book will be composed of nothing but plain truth, I hope that your smile will continue to the last word, with which I think you will have a fair opportunity to do in April next.

Yes, my dear sir, I have dared to write a book on the manners of the birds of America . . . It was my first intention to have been assisted by our learned friend William Swainson, and I wrote to him on this head in full confidence. However, Friend Swainson so startled me by the demand of a salary too much above my pecuniary means, and at the same time required the appearance of his name on the title page in such an unequivocal wise, that it at once appeared to me as if I must have paid him a most exorbitant price to enable him to reap the benefit of all my observations, things which I could not well afford and in consequence of which, I am trudging on, assisted only by a person who puts into better English than I can myself write, my ideas. I have no wish to plume myself with others' feathers, but neither am I willing to plume away

the obvious benefit of my observations. Therefore, instead of W. Swainson at the rate of 200 pounds sterling per volume, I am employing Mr. MacGillivray for a little more than 50.

The latter is a good scholar and fond of our study and as all I write is quite simple & true, the book may perhaps be of some benefit to the science of ornithology. I am bent on interlarding the whole with past events of my life & American manners, to render it welcome, if possible, to the common reader, meantime not forgetting the necessary components agreeable or looked for by naturalists of the high classes. But when you have read this first attempt of mine you will be able to judge of its matter fully, & therefore I will not say anymore on the subject.

Yet I must add that I am following your nomenclature throughout & will stick to it! . . . I would give much at this present time to be by your side & be able to be benefited with your good advice, but this is improbable, & I must do the best I can alone.

What will you think when you have read here that it is my intention to write a synopsis of the birds of the United States? You will laugh, I have no doubt, yet such will be the case, and I have made already the necessary preparations to become able to accomplish this, by preserving in the flesh or spirituous liquors every individual [specimen] found in the extensive U.S.

That synopsis will have plates most correctly engraved of the bills, legs & feet, markings, tails, eggs &c., with descriptions of the birds in different states of plumage & age, in a word all I can collect respecting them. I have not told you all. I am going to America again and I assure you that if life is granted me I will leave no place in the whole of the U.S. unsearched. The fact is that I have devoted so much of my life to this study in my humble practical manner that I am now determined to pursue it with as much ardor as if I were still a young man.

I should be greatly obliged to you if you would send me as soon as convenient a letter of recommendation to your illustrious relation now residing in the Floridas; it is my full intention to traverse the peninsula in 5 or 6 different parts & to spend at least one year along its extensive southern coast. I have also asked of Mr. [and U.S. Representative] Edward Everett, an old friend of mine, as well as from our President letters to the same effect. I may indeed

proceed to a great distance in the interior of the Northwestern Territory afterward, having made such arrangements in London as will infuse the publication of my illustrations during the whole of my absence, which probably may exceed two years. I shall go accompanied by men fully able to assist me & I look forward to my return in Europe as very gratifying to my enthusiastical ways of working.

Such a jaunt will meanwhile enable me to augment considerably the number of my drawings of quadrupeds, a work which if I do not live to see finished will I hope at least be completed by one of my sons...

I have named the Petit Caporal [Merlin] in honor of your great-uncle Napoleon to whom I have reason to be greatly indebted...

Lucy Audubon to Victor Gifford Audubon
"Britain and even Europe is now natural-history mad..."

Edinburgh, Scotland
26 February 1831

My dear Victor,

Only six days ago your Father wrote you on the business of the edition of his letterpress entitled *Ornithological Biography* which, for the sake of security, he has requested to have the copyright of entered in your name as proprietor, which is the case when book-sellers purchase the manuscript from the author. Should Dr. Harlan of Philadelphia (your Papa's agent there) not find this practicable, then the copyright will be secured in his own name, and for the expenses of this publication, which is obliged to be printed in U.S. to affect this, your Papa remitted one hundred pounds sterling along with the first 12 sheets of proofs and letters to Dr. Harlan, Dr. McMurtrie, yourself and William, apprising you of what he was doing, and for the best. The expense necessary for this publica-tion is $700, therefore a balance besides the hundred pounds will be wanting, and we feel assured that that balance will be furnished by you or your uncle... and this package of proof sheets will sail in the *Manchester* on the first of March. Duplicates and fresh sheets will follow in each succeeding packet till the whole is gone; there will be 500 copies in the American edition, a copy of which must appear at Washington City three months after the title of the book is registered there to ensure the copyright, a matter important to us and to you.

If any accident befall us, you will always remember your brother is to share equally any profits from your parents, but I trust we shall meet in autumn, all well, and talk over these and many other affairs. The expense of publishing what is necessary is double the amount that it is with you. To subscribers, the book will be sold at a guinea each [i.e., 21 shillings]; to non-subscribers to the plates or *Birds of America* the price will be 30 shillings each; and it is considered low for a scientific book, which that is. It will be bound in boards neatly.

The booksellers' profit is always two hundred per cent, but we might be content with one hundred clear; however, it is quite a new business to you, and the two doctors, Harlan and McMurtrie, will determine and let you know. You will, soon after this reaches you if not before, get the colors, canvas, and violin unless they are detained in [New] Orleans. Tell John I hope he will be steady and try to improve as much as possible; without he helps himself by his good conduct he need not expect either credit or friends, and consequently no comfort either. You will calculate how late you can write to us that we may get your letters through Messrs. Rathbone & Co. of Liverpool; we cannot tell yet when precisely we shall sail, nor from what port, for business must lead all things, and the expense of portage here from one place to another is very great.

We mentioned you would get your flageolet either by Mr. Cuthbertson or us, and perhaps some other things, but this *Ornithological Biography* takes a great deal of money away before it begins to throw back any.

Your father begs me to urge you both to preserve all the eggs and nests of birds you can possibly get, blow the eggs and endeavor to mark them, all the skins, all the feet and bills, in short everything appertaining to birds is required by your father to make his work, as the learned say here, the standard of ornithology. But every object in nature has a great value attached to it in Britain, and even Europe in general is now natural-history mad. The age of literature is on the decline, I have read nothing lately but the papers which you will have sent by the packet for the eighth of March...

May you be well and successful in all your undertakings, my dear sons. Your Father joins his blessing to mine, he has many letters to write. The weather is cold but fine today; yesterday we had a fall of snow for some hours, but the sea air so modifies the atmosphere here that it is now all gone, and a day or two ago I had a nosegay of flowers from the garden sent me, amongst which were some snowdrops and crocuses...

You must tell John that the birds [he sent] were very well described, and very rare, in that part where you are, but [although] your Papa knows them and has them, yours are not the less valuable. The moths had got into them a little, be careful about them...

John James Audubon to Robert Havell, Jr.
"I will proceed for the Floridas..."

Philadelphia, Pennsylvania
20 September 1831

My dear Mr. Havell,

...At our arrival at New York on the 3rd Instant we met with our sister & brother-in-law, Mr. [Nicholas] Berthoud, and went to their house where we spent a week in great comfort...

We received at New York letters from our sons mentioning my eldest one coming to take charge of his mother, over the mountains to Kentucky, and we are awaiting his arrival at this place hourly. As soon as he arrives, we push off for Baltimore, where we will part and I will proceed for the Floridas as fast as steamboats or coaches will allow. Since here (Philadelphia) I have obtained three subscribers—to wit, the [American] Philosophical Society of Philadelphia, John C. Wetherill, Esq., and Dr. Richard Harlan of Philadelphia. I have some hopes of a few more. My enemies are going downhill very fast and fine reviews of the work coming forth. The Government will pass an act this winter for the free entry of my works in America. I have already received upwards of 200 letters of recommendation for all parts of the United States and when I reach Washington will have one from Government that will render my visits on the frontiers quite easy...

PART V: FLORIDA

Lucy Audubon to John James Audubon
"The world has its eyes on you, my dear LaForest..."

Wheeling, Virginia
12 October 1831

My dear husband,

We arrived here at half past two in the morning of Monday after bearing the journey much better than I did before. Our travelers were just middling and plenty of them; one named Hunt from Wabash County seems to know you and your book. We found [Lucy's sister] Sarah within three weeks of her confinement and but for our dear boys I should stay with her; however, I hope she will do well, and most sincerely do I hope you are well and doing well. We hoped to have heard from you here but find no letters. We have in [port] a steamer this afternoon and hope for a safe journey. I must not say much, notwithstanding Victor's kind affection I miss you, but on this journey, I know, much of your future fame and success depends, for the world has its eyes upon you, my dear LaForest.

But in the midst of fame, remember thy friend of 25 years' standing [i.e., herself] and the prosperity of our beloved children. I shall write from Louisville to Savannah and hope we shall soon hear from you. Walsh has quoted in the literary gazette half at least of *Blackwood's* review for you.

Victor is gone down to the boat, but when he comes in he will add a few lines to you. I have not heard from anyone yet. I have nothing more to say my dear husband now, but every good wish that can attend him, to beg he will take care of himself, do nothing that affects his health or intellect, to remember the *three* individuals behind you who are not many minutes without thinking of you and whose happiness is linked to yours forever...

The Barn Owl

Not a single individual of the numerous persons who have described the birds of the United States seems to have had opportunities of studying the habits of this beautiful Owl, and all that I find related respecting it is completely at variance with my observations. In describing the manners of this bird I shall therefore use all due caution, although at the same time I shall not be too anxious to obtain credit in this more than in some other matters for which I have patiently borne the contradictions of the ignorant. The following extracts from my journals I hope will prove interesting.

St. Augustine, East Florida, 8th November 1831. Mr. Simmons, the Keeper of the Fort, whom I had known at Henderson in Kentucky, having informed me that some boys had taken five young Barn Owls from a hole in one of the chimneys, I went with a ladder to see if I could procure some more. After much search I found only a single egg which had been recently laid. It was placed on the bare stone of the wall surrounded by fragments of small quadrupeds of various kinds. During our search I found a great number of the disgorged pellets of the Owl, among which some were almost fresh. They contained portions of skulls and bones of small quadrupeds unknown to me. I also found the entire skeleton of one of these Owls in excellent condition, and observing a curious bony crest-like expansion on the skull from the base of the cere [i.e., the nostril membrane of the beak] above to that of the lower mandible elevated nearly a quarter of an inch from the solid part of the skull and forming a curve like a horseshoe, I made an outline of it. On speaking to the officers of the garrison respecting this species of Owl, Lieutenant Constantine Smith, a most amiable and intelligent officer of our army, informed me that in the months of July and August of that year these birds bred more abundantly than at the date above stated. Other persons also assured me that like the House Pigeon, the Barn Owl breeds at all seasons of the year in that part of the country. The statement was farther corroborated by Mr. Lee Williams, a gentleman formerly attached to the topographical department and who, I believe, has written an excellent account of the eastern portion of the peninsula of the Floridas.

Having arrived at Charleston, South Carolina, in October 1833, as soon as my family and myself were settled in the house of my friend the Reverend John Bachman I received information that a pair of Owls (of the present species) had a nest in the upper story of an abandoned sugar house in the city, when I immediately proceeded to the place accompanied by Dr. Samuel Wilson and William Kunhardt, Esq. We ascended cautiously to the place, I having pulled off my boots to prevent noise. When we reached it I found a sort of large garret filled with sugar molds and lighted by several windows, one of which had two panes broken. I at once discovered the spot where the Owls were by the hissing sounds of the young ones and approached slowly and cautiously towards them until within a few feet, when the parent bird, seeing me, flew quickly towards the window, touched the frame of the broken panes and glided silently through the aperture. I could not even afterwards observe the course of its flight. The young were three in number and covered with down of a rich cream color. They raised themselves on their legs, appeared to swell and emitted a constant hissing sound somewhat resembling that of a large snake when angry. They continued thus without altering their position during the whole of our stay, which lasted about twenty minutes. They were on a scattered parcel of bits of straw and surrounded by a bank made of their ejected pellets. Very few marks of their excrements were on the floor and they were beautifully clean. A cotton rat, newly caught and still entire, lay beside them and must have been brought from a distance of several miles, that animal abounding in the rice fields, none of which, I believe, are nearer than three or four miles. After making some arrangements with the Negro man who kept the house we returned home. The eggs from which these young Owls had been hatched must have been laid six weeks before this date, or about the 15th of September.

On the 25th of November they had grown much in size, but none of the feathers had yet made their appearance excepting the primaries, which were now about an inch long, thick, full of blood and so tender that the least pressure of the fingers might have burst them. As the young grow more and more, the parents feed and attend to them less frequently than when very small, coming to them in the night only with food. This proves the caution of these

birds in avoiding danger, and the faculty which the young possess of supporting abstinence in this middle state of their growth.

On the 7th of December I visited the Owls in company with my friend John Bachman. We found them much grown; indeed, their primaries were well out; but their back and breast and all their lower parts were still thickly covered with down.

On the 6th of January I again saw them, but one of the young was dead although in good condition. I was surprised that their food still continued to be composed entirely of small quadrupeds, and principally of the rat mentioned above.

My last visit to them was on the 18th of January. The two younger ones were now to all appearance fully grown but were yet unable to fly. A few tufts of down still remained attached to the feathers on scattered parts of the body. I took them home. One was killed and the skin preserved.

Now these facts are the more interesting [in] that none of the numerous European authors with whom I am acquainted have said a single word respecting the time of breeding of this species, but appear to be more intent on producing long lists of synonyms than on presenting the useful materials from which the student of nature can draw inferences. I shall therefore leave to them to say whether our species is or is not the same as the one found in the churches and ruins of Europe. Should it prove to be the same species and if the European bird breeds, as I suspect it does, at so different a period of the year, the habits of the American Owl will form a kind of mystery in the operations of nature, as they differ not only from those of the bird in question but of all other Owls with which I am acquainted.

My opinion is, that the Barn Owl of the United States is far more abundant in the Southern Districts than in the other parts. I never found it to the east of Pennsylvania and only twice in that state, nor did I ever see or even hear of one in the Western Country; but as soon as I have reached the maritime districts of the Carolinas, Georgia, the Floridas and all along to Louisiana, the case has always been different. In Cuba they are quite abundant according to the reports which I have received from that island. I am indeed almost tempted to believe that the few which have been found in Pennsylvania were bewildered birds surprised by the

coldness of the winter and perhaps unable to return to the Southern Districts. During my visit to Labrador I neither saw any of these birds nor found a single person who had ever seen them, although the people to whom I spoke were well acquainted with the Snowy Owl, the Grey Owl, and the Hawk Owl.

Thomas Butler King, Esq., of St. Simon's Island, Georgia, sent me two very beautiful specimens of this Owl which had been caught alive. One died shortly after their arrival at Charleston; the other was in fine order when I received it. The person to whose care they were consigned kept them for many weeks at Charleston before I reached that city and told me that in the night their cries never failed to attract others of the same species, which he observed hovering about the place of their confinement.

This species is altogether nocturnal or crepuscular, and when disturbed during the day flies in an irregular bewildered manner as if at a loss how to look for a place of refuge. After long observation I am satisfied that our bird feeds entirely on the smaller species of quadrupeds, for I have never found any portions of birds about their nests nor even the remains of a single feather in the pellets which they regurgitate and which are always formed of the bones and hair of quadrupeds.

Owls which approach to the diurnal species in their habits or which hunt for food in the morning and evening twilight are more apt to seize on objects which are themselves more diurnal than otherwise or than the animals which I have found to form the constant food of our Barn Owl. Thus the Short-eared, the Hawk, the Fork-tailed, the Burrowing and other Owls which hunt either during broad day, or mostly towards evening or at the return of day, will be found to feed more on mixed food than the present species. I have no doubt that the anatomist will detect corresponding differences in the eye, as they have already been found in the ear. The stomach is elongated, almost smooth, and of a deep gamboge-yellow; the intestines small, rather tough and measuring one foot nine inches in length.

Its flight is light, regular and much protracted. It passes through the air at an elevation of thirty or forty feet in perfect silence and pounces on its prey like a Hawk, often waiting for a fair opportunity from the branch of a tree on which it alights for the purpose.

During day they are never seen unless accidentally disturbed, when they immediately try to hide themselves. I am not aware of their having any propensity to fish, as the Snowy Owl has, nor have I ever seen one pursuing a bird. Ever careful of themselves, they retreat to the hollows of trees and such holes as they find about old buildings. When kept in confinement they feed freely on any kind of flesh and will stand for hours in the same position, frequently resting on one leg while the other is drawn close to the body. In this position I watched one on my drawing table for six hours.

This species is never found in the depth of the forests but confines itself to the borders of the woods around large savannas or old abandoned fields overgrown with briars and rank grass where its food, which consists principally of field mice, moles, rats and other small quadrupeds, is found in abundance and where large beetles and bats fly in the morning and evening twilight. It seldom occurs at a great distance from the sea. I am not aware that it ever emits any cry or note as other owls are wont to do; but it produces a hollow hissing sound continued for minutes at a time which has always reminded me of that given out by an opossum when about to die by strangulation.

When on the ground this Owl moves by sidelong leaps with the body much inclined downwards. If wounded in the wing, it yet frequently escapes through the celerity of its motions. Its hearing is extremely acute and as it marks your approach, instead of throwing itself into an attitude of defense, as Hawks are wont to do, it instantly swells out its plumage, extends its wings and tail, hisses and clacks its mandibles with force and rapidity. If seized in the hand it bites and scratches, inflicting deep wounds with its bill and claws.

It is by no means correct to say that this Owl, or indeed any other, always swallows its prey entire: some which I have kept in confinement have been seen tearing a young hare in pieces with their bills in the manner of hawks; and mice, small rats or bats are the largest objects that I have seen them gobble up entire, and not always without difficulty. From having often observed their feet and legs covered with fresh earth I am inclined to think that they may use them to scratch mice or moles out of their shallow burrows,

a circumstance which connects them with the Burrowing Owls of our western plains, which like them have very long legs. In a room their flight is so noiseless that one is surprised to find them removed from one place to another without having heard the least sound. They disgorge their pellets with difficulty, although generally at a single effort, but I did not observe that this action was performed at any regular period. I have mentioned these circumstances to induce you to examine more particularly the habits of the Barn Owls of Europe and the Southern states of America, that the question of their identity may be decided.

The pair which I have represented were given to me by my friend Richard Harlan, M.D., of Philadelphia. They had been brought from the south and were fine adult birds in excellent plumage. I have placed a ground squirrel under the feet of one of them as being an animal on which the species is likely to feed.

[The Barn Owl, *Tyto alba*, appears in Plate 171 of *The Birds of America*.]

Lucy Audubon to Robert Havell, Jr.
"Mr. A. is in Florida, scouring the woods..."

Louisville, Kentucky
15 December 1831

Dear Mr. Havell,

...Mr. A. is I imagine in Florida, scouring the woods. His last letter is a month date since, but it takes a month to come from where he is to me. He wrote you from Charleston and doubtless informed you of his two subscribers there and how to forward to them. He has nine *new* drawings, much information and 250 [bird] skins and a number of insects. As soon as there is free navigation again of our river, you will have shipped to you the hundred [live wild] turkeys. You must send two males and two females to the honorable Thomas Liddell, or rather let him know immediately and pick out the best for him. I hope to bring him some mockingbirds as I have gained much relative to the mode of keeping them that I did not know before. His other commissions Mr. A. will, I am sure, attend to. The River Ohio has been frozen over for nearly three weeks and the cold is so intense that I scarcely can do anything; my water jug is standing by a large fire and a tumbler of water on the chimneypiece is all ice...

Lucy Audubon to John James Audubon
"Trust no one but your wife and children..."

Louisville, Kentucky
22 January 1832

...I assure you, my dear, you cannot be too careful; trust no one but your wife and children, surely you can confide in them for *everything*. I wrote you how your affairs with Nicholas Berthoud stood and that he has 7,000 [dollars] against you in his books, and [name illegible] 4,000, now these people will take every advantage, depend upon it, the moment they think we are above want, and I cannot bear to think your labor should forever be wrested from you, which it may be, because as I told you before, N.B. did not act according *to law* in your affairs, and never advertised or made known to the world and your creditors that you had *given up all* [i.e., that Audubon had sold everything and taken bankruptcy in 1819 after his business failed], which he ought to have done. I only tell you this my love that you may be upon your guard, and once more I urge you to believe no one but us three can be trusted with money. Since we left Phila., Dr. Harlan has been posted as the vilest of vile, of this we know nothing at present, nor have we any need to notice it anyway; I hope he will turn out true to you. But I cannot help much anxiety to see this journey ended and ourselves once more living in ourselves, I hope and pray we may find it practicable to have our sons with us, or at least not left in the uncertain way they were before. They are too deserving to be left to the mercy of this hard world...Write fully whatever you wish us to do and it shall be done...

Episode: Spring Garden

The largest springs in North America rise in northern Florida; Spring Garden (Ponce de Leon Spring today), flowing 12 million gallons of water per day, falls midrange in a complex region where more than thirty first-magnitude springs each release at least 64 million gallons per day. Spring water is rainwater from a wide watershed filtered as it flows through geologic strata underground; the sulfurous smell Audubon noticed when he visited Spring Garden in 1832 must have been a temporary contamination. A constricted natural pipe accelerates the rising water to form the "boil" Audubon describes.

Having heard many wonderful accounts of a certain spring near the sources of the St. John's River in East Florida, I resolved to visit it in order to judge for myself. On the 6th of January 1832 I left the plantation of my friend John Bulow accompanied by an amiable and accomplished Scotch gentleman, an engineer employed by the planters of those districts in erecting their sugar-house establishments. We were mounted on horses of the Indian breed, remarkable for their activity and strength, and were provided with guns and some provisions. The weather was pleasant but not so our way, for no sooner had we left the "King's Road" which had been cut by the Spanish government for a goodly distance than we entered a thicket of scrubby oaks succeeded by a still denser mass of low palmettos which extended about three miles and among the roots of which our nags had great difficulty in making good their footing. After this we entered the pine barrens so extensively distributed in this portion of the Floridas. The sand seemed to be all sand and nothing but sand and the palmettos at times so covered the narrow Indian trail which we followed that it required all the instinct or sagacity of ourselves and our horses to keep it.

It seemed to us as if we were approaching the end of the world. The country was perfectly flat, and so far as we could survey it, presented the same wild and scraggy aspect. My companion, who had traveled there before, assured me that at particular seasons of the year he had crossed the barrens when they were covered with water fully knee-deep when according to his expression they "looked most awful"; and I readily believed him, as we now and

then passed through muddy pools which reached the saddle girths of our horses. Here and there large tracts covered with tall grasses and resembling the prairies of the western wilds, opened to our view. Wherever the country happened to be sunk a little beneath the general level it was covered with cypress trees, whose spreading arms were hung with a profusion of Spanish moss. The soil in such cases consisted of black mud and was densely covered with bushes, chiefly of the Magnolia family.

We crossed in succession the heads of three branches of Haw Creek, of which the waters spread from a quarter to half a mile in breadth and through which we made our way with extreme difficulty. While in the middle of one, my companion told me that once when in the very spot where we then stood his horse chanced to place his forefeet on the back of a large alligator which, not well pleased at being disturbed in his repose, suddenly raised his head, opened his monstrous jaws and snapped off a part of the lips of his affrighted pony. You may imagine the terror of the poor beast which, however, after a few plunges, resumed its course and succeeded in carrying its rider through in safety. As a reward for this achievement it was ever after honored with the appellation of "Alligator."

We had now traveled about twenty miles, and the sun having reached the zenith, we dismounted to partake of some refreshment. From a muddy pool we contrived to obtain enough of tolerably clear water to mix with the contents of a bottle, the like of which I would strongly recommend to every traveler in these swampy regions; our horses, too, found something to grind among the herbage that surrounded the little pool; but as little time was to be lost we quickly remounted and resumed our disagreeable journey during which we had at no time proceeded at a rate exceeding two miles and a half in the hour.

All at once, however, a wonderful change took place: the country became more elevated and undulating; the timber was of a different nature and consisted of red and live oaks, magnolias and several kinds of pine. Thousands of "mole-hills" or the habitations of an animal here called "the salamander," and "gopher's burrows" presented themselves to the eye and greatly annoyed our horses, which every now and then sank to the depth of a foot and stumbled at the risk of breaking their legs and what we considered fully as

valuable, our necks. We now saw beautiful lakes of the purest water and passed along a green space having a series of them on each side of us. These sheets of water became larger and more numerous the farther we advanced, some of them extending to a length of several miles and having a depth of from two to twenty feet of clear water; but their shores being destitute of vegetation, we observed no birds near them. Many tortoises, however, were seen basking in the sun and all as we approached plunged into the water. Not a trace of man did we observe during our journey, scarcely a bird and not a single quadruped, not even a rat; nor can one imagine a poorer and more desolate country than that which lies between the Halifax River, which we had left in the morning, and the undulated grounds at which we had now arrived.

But at length we perceived the tracks of living beings and soon after saw the huts of Colonel Rees's Negroes. Scarcely could ever African traveler have approached the city of Timbuktu with more excited curiosity than we felt in approaching this plantation. Our Indian horses seemed to participate in our joy and trotted at a smart rate towards the principal building, at the door of which we leaped from our saddles just as the sun was withdrawing his ruddy light. Colonel Rees was at home and received us with great kindness. Refreshments were immediately placed before us, and we spent the evening in agreeable conversation.

The next day I walked over the plantation and examining the country around, found the soil of good quality, it having been reclaimed from swampy ground of a black color, rich and very productive. The greater part of the cultivated land was on the borders of a lake which communicates with others leading to the St. John's River, distant about seven miles, and navigable so far by vessels not exceeding fifty or sixty tons. After breakfast our amiable host shewed us the way to the celebrated spring, the sight of which afforded me pleasure sufficient to counterbalance the tediousness of my journey.

This spring presents a circular basin having a diameter of about sixty feet, from the center of which the water is thrown up with great force, although it does not rise to a height of more than a few inches above the general level. A kind of whirlpool is formed, on the edges of which are deposited vast quantities of shells, with

pieces of wood, gravel and other substances which have coalesced into solid masses having a very curious appearance. The water is quite transparent, although of a dark color, but so impregnated with sulfur that it emits an odor which to me was highly nauseous. Its surface lies fifteen or twenty feet below the level of the woodland lakes in the neighborhood and its depth in the autumnal months is about seventeen feet when the water is lowest. In all the lakes, the same species of shells as those thrown up by the spring occur in abundance, and it seems more than probable that it is formed of the water collected from them by infiltration, or forms the subterranean outlet of some of them. The lakes themselves are merely reservoirs containing the residue of the waters which fall during the rainy seasons and contributing to supply the waters of the St. John River, with which they all seem to communicate by similar means. This spring pours its waters into "Rees's Lake" through a deep and broad channel called Spring Garden Creek. This channel is said to be in some places fully sixty feet deep, but it becomes more shallow as you advance towards the entrance of the lake, at which you are surprised to find yourself on a mud flat covered only by about fifteen inches of water under which the depositions from the spring lie to a depth of four or five feet in the form of the softest mud, while under this again is a bed of fine white sand. When this mud is stirred up by the oars of your boat or otherwise it appears of a dark green color and smells strongly of sulfur. At all times it sends up numerous bubbles of air, which probably consist of sulfurated hydrogen gas.

The mouth of this curious spring is calculated to be two and a half feet square; and the velocity of its water during the rainy season is three feet per second. This would render the discharge per hour about 499,500 gallons. Colonel Rees showed us the remains of another spring of the same kind which had dried up from some natural cause.

My companion the engineer having occupation for another day, I requested Colonel Rees to accompany me in his boat towards the River St. John, which I was desirous of seeing, as well as the curious country in its neighborhood. He readily agreed and after an early breakfast next morning we set out accompanied by two servants to manage the boat. As we crossed Rees's Lake I observed

that its northeastern shores were bounded by a deep swamp covered by a rich growth of tall cypresses, while the opposite side presented large marshes and islands ornamented by pines, live oaks and orange trees. With the exception of a very narrow channel, the creek was covered with nymphaea [water lilies], and in its waters swam numerous alligators, while Ibises, Gallinules, Anhingas, Coots and Cormorants were seen pursuing their avocations on its surface or along its margins. Over our heads the Fish Hawks were sailing, and on the broken trees around we saw many of their nests.

We followed Spring Garden Creek for about two miles and a half and passed a mud bar before we entered "Dexter's Lake." The bar was stuck full of unios in such profusion that each time the Negroes thrust their hands into the mud they took up several. According to their report these shellfish are quite unfit for food. In this lake the water had changed its hue and assumed a dark chestnut color, although it was still transparent. The depth was very uniformly five feet and the extent of the lake was about eight miles by three. Having crossed it, we followed the creek and soon saw the entrance of Woodruff's Lake, which empties its still darker waters into the St. John's River.

I here shot a pair of curious Ibises . . . and landed on a small island covered with wild orange trees, the luxuriance and freshness of which were not less pleasing to the sight than the perfume of their flowers was to the smell. The group seemed to me like a rich bouquet formed by nature to afford consolation to the weary traveler cast down by the dismal scenery of swamps and pools and rank grass around him. Under the shade of these beautiful evergreens and amidst the golden fruits that covered the ground while the hummingbirds fluttered over our heads, we spread our cloth on the grass, and with a happy and thankful heart I refreshed myself with the bountiful gifts of an ever-careful Providence. Colonel Rees informed me that this charming retreat was one of the numerous *terrae incognitae* of this region of lakes and that it should henceforth bear the name of "Audubon's Isle."

In conclusion, let me inform you that the spring has been turned to good account by my generous host Colonel Rees who, aided by my amiable companion the engineer, has directed its current so as to turn a mill which suffices to grind the whole of his sugar cane.

John James Audubon to Edward Everett
"There is a country quite unknown called the Everglades..."

St. Augustine, East Florida
1 February 1832

My dear sir,

I have been in this infirmary of the Floridas and around it for nearly two months.

I would have written to you long ere this but I tell you the truth I have been extremely engaged both in traveling and drawing besides an immensity of writing connected with the excursions of myself and party.

The letters which you so kindly presented me with have been of essential service to us all ever since we reached the Southern states—Charleston and its neighbors have afforded me all that could possibly be expected...

I have received from the Honorable Lewis McLam a letter which has enabled me and my small party to be received on board the U.S. schooner the *Spark*, Lieut. Commander Piercy (Wm. P.), who has received us with great kindness and is anxious to do all in his power to accommodate my views and wishes. Lieut. Piercy is a man of great enterprise and...talents, and in some confidential talks which we have had, it has been concluded that should the Secretary of the Navy, in concert with the Secretary of the Treasury, grant to him...the privilege of going around this coast and exploring where best suited for the advantage of science connected with the wishes of our Government for a few months, that much might be done and accomplished...

There is in this peninsula a portion of country quite unknown. It is called the *Everglades*. Give me a chance of investigating that Terra Incognita and I will do it or die in the attempt! The schooner has but little to do, our country is the richest in the world and I am at her service with zeal, heart and utmost willingness.

I write in a hurry, as I expect to leave in a few hours for the St. John's River in the *Spark*, but I feel confident that you will understand me and I therefore hope that you will do all in your power

to enable the commander of the *Spark* and myself to traverse and coast the whole of the Floridas.

I have discovered a *few new species*, have collected a great number of specimens of birds, fishes, shells, &c., &c., and kept up the writing of a journal which I hope, when presented to the world, will give a knowledge of land & water and vegetations yet as unknown as they are valuable.

I hope you will make out to read this and hope also that you will do all in your power to assist the calling of science where a most excellent opportunity presents itself to ransack this extraordinary territory... The *Spark* will need a good Boat, a few additional hands and a new set of sails—

Pray, my dear good friend, do all in your power to enable this undertaking to go on...

Episode: St. John's River in Florida

Soon after landing at St. Augustine in East Florida I formed acquaintance with Dr. Simmons, Dr. Pocher, Judge Smith, the Misses Johnson and other individuals, my intercourse with whom was as agreeable as beneficial to me. Lieutenant Constantine Smith of the United States Army I found of a congenial spirit, as was the case with my amiable but since deceased friend, Dr. Bell of Dublin. Among the planters who extended their hospitality to me I must particularly mention General Hernandez and my esteemed friend John Bulow, Esq. To all these estimable individuals I offer my sincere thanks.

While in this part of the peninsula I followed my usual avocations, although with little success, it being then winter. I had letters from the Secretaries of the Navy and Treasury of the United States to the commanding officers of vessels of war of the revenue service directing them to afford me any assistance in their power; and the schooner *Spark* having come to St. Augustine on her way to the St. John's River, I presented my credentials to her commander Lieutenant Piercy, who readily and with politeness received me and my assistants on board. We soon after set sail with a fair breeze. The strict attention to duty on board even this small vessel of war afforded matter of surprise to me. Everything went on with the regularity of a chronometer: orders were given, answered to and accomplished before they ceased to vibrate on the ear. The neatness of the crew equaled the cleanliness of the white planks of the deck; the sails were in perfect condition; and, built as the *Spark* was, for swift sailing, on she went gamboling from wave to wave.

I thought that while thus sailing no feeling but that of pleasure could exist in our breasts; but alas! how fleeting are our enjoyments. When we were almost at the entrance of the river the wind changed, the sky became clouded and before many minutes had elapsed the little bark was lying to "like a duck," as her commander expressed himself. It blew a hurricane—let it blow, reader. At the break of day we were again at anchor within the bar of St. Augustine.

Our next attempt was successful. Not many hours after we had crossed the bar we perceived the star-like glimmer of the light in

the great lantern at the entrance of the St. John's River. This was before daylight; and as the crossing of the sand banks or bars which occur at the mouths of all the streams of this peninsula is difficult and can be accomplished only when the tide is up, one of the guns was fired as a signal for the government pilot. The good man, it seemed, was unwilling to leave his couch, but a second gun brought him in his canoe alongside. The depth of the channel was barely sufficient. My eyes, however, were not directed towards the waters but on high, where flew some thousands of snowy Pelicans which had fled affrighted from their resting grounds. How beautifully they performed their broad gyrations, and how matchless after awhile was the marshaling of their files as they flew past us!

On the tide we proceeded apace. Myriads of Cormorants covered the face of the waters, and over it Fish Crows innumerable were already arriving from their distant roosts. We landed at one place to search for the birds whose charming melodies had engaged our attention, and here and there some young Eagles we shot to add to our store of fresh provisions! The river did not seem to me equal in beauty to the fair Ohio; the shores were in many places low and swampy, to the great delight of the numberless Herons that moved along in gracefulness and the grim alligators that swam in sluggish sullenness. In going up a bayou we caught a great number of the young of the latter for the purpose of making experiments upon them.

After sailing a considerable way, during which our commander and officers took the soundings as well as the angles and bearings of every nook and crook of the sinuous stream, we anchored one evening at a distance of fully one hundred miles from the mouth of the river. The weather, although it was the 12th of February, was quite warm, the thermometer on board standing at 75° and on shore at 90°. The fog was so thick that neither of the shores could be seen, and yet the river was not a mile in breadth. The "blind mosquitoes" covered every object even in the cabin, and so wonderfully abundant were these tormentors that they more than once fairly extinguished the candles whilst I was writing my journal, which I closed in despair, crushing between the leaves more than a hundred of the little wretches. Bad as they are, however, these blind mosquitoes do not bite. As if purposely to render

our situation doubly uncomfortable, there was an establishment for jerking beef on the nearer shores to the windward of our vessel from which the breeze came laden with no sweet odors.

In the morning when I arose the country was still covered with thick fogs, so that although I could plainly hear the notes of the birds on shore, not an object could I see beyond the bowsprit and the air was as close and sultry as on the previous evening. Guided by the scent of the jerkers' works we went on shore, where we found the vegetation already far advanced. The blossoms of the jessamine, ever pleasing, lay steeped in dew; the humming bee was collecting her winter's store from the snowy flowers of the native orange; and the little warblers frisked along the twigs of the smilax. Now amid the tall pines of the forest the sun's rays began to force their way, and as the dense mists dissolved in the atmosphere, the bright luminary at length shone forth. We explored the woods around, guided by some friendly live-oakers who had pitched their camp in the vicinity. After a while the *Spark* again displayed her sails, and as she silently glided along we spied a Seminole Indian approaching us in his canoe. The poor dejected son of the woods, endowed with talents of the highest order, although rarely acknowledged by the proud usurpers of his native soil, has spent the night in fishing and the morning in procuring the superb-feathered game of the swampy thickets; and with both he comes to offer them for our acceptance. Alas! thou fallen one, descendant of an ancient line of freeborn hunters, would that I could restore to thee thy birthright, thy natural independence, the generous feelings that were once fostered in thy brave bosom. But the irrevocable deed is done, and I can merely admire the perfect symmetry of his frame as he dexterously throws on our deck the trouts and turkeys which he has captured. He receives a recompense and without smile or bow or acknowledgement of any kind, off he starts with the speed of an arrow from his own bow.

Alligators were extremely abundant, and the heads of the fishes which they had snapped off lay floating around on the dark waters. A rifle bullet was now and then sent through the eye of one of the largest, which with a tremendous splash of its tail expired. One morning we saw a monstrous fellow lying on the shore. I was desirous of obtaining him to make an accurate drawing of his head

and, accompanied by my assistant and two of the sailors, proceeded cautiously towards him. When within a few yards, one of us fired and sent through his side an ounce ball which tore open a hole large enough to receive a man's hand. He slowly raised his head, bent himself upwards, opened his huge jaws, swung his tail to and fro, rose on his legs, blew in a frightful manner and fell to the earth. My assistant leaped on shore and contrary to my injunctions caught hold of the animal's tail when the alligator, awakening from its trance, with a last effort crawled slowly towards the water and plunged heavily into it. Had he thought of once flourishing his tremendous weapon there might have been an end of his assailant's life, but he fortunately went in peace to his grave, where we left him, as the water was too deep. The same morning, another of equal size was observed swimming directly for the *bows* of our vessel, attracted by the gentle rippling of the water there. One of the officers, who had watched him, fired and scattered his brain through the air, when he tumbled and rolled at a fearful rate, blowing all the while most furiously. The river was bloody for yards around, but although the monster passed close by the vessel we could not secure him, and after awhile he sunk to the bottom.

Early one morning I hired a boat and two men with the view of returning to St. Augustine by a short cut. Our baggage being placed on board, I bade adieu to the officers and off we started. About four in the afternoon we arrived at the short cut, forty miles distant from our point of departure and where we had expected to procure a wagon, but were disappointed. So we laid our things on the bank and, leaving one of my assistants to look after them, I set out accompanied by the other and my Newfoundland dog. We had eighteen miles to go; and as the sun was only two hours high we struck off at a good rate.

Presently we entered a pine barren. The country was as level as a floor; our path although narrow was well-beaten, having been used by the Seminole Indians for ages, and the weather was calm and beautiful. Now and then a rivulet occurred from which we quenched our thirst, while the magnolias and other flowering plants on its banks relieved the dull uniformity of the woods. When the path separated into two branches both seemingly leading the same way, I would follow one while my companion took the other,

and unless we met again in a short time, one of us would go across the intervening forest.

The sun went down behind a cloud and the southeast breeze that sprung up at this moment sounded dolefully among the tall pines. Along the eastern horizon lay a bed of black vapor which gradually rose and soon covered the heavens. The air felt hot and oppressive and we knew that a tempest was approaching. Plato was now our guide, the white spots on his coat being the only objects that we could discern amid the darkness, and as if aware of his utility in this respect he kept a short way before us on the trail. Had we imagined ourselves more than a few miles from the town, we would have made a camp and remained under its shelter for the night; but conceiving that the distance could not be great, we resolved to trudge along.

Large drops began to fall from the murky mass overhead; thick, impenetrable darkness surrounded us, and to my dismay the dog refused to proceed. Groping with my hands on the ground I discovered that several trails branched out at the spot where he lay down; and when I had selected one he went on. Vivid flashes of lightning streamed across the heavens, the wind increased to a gale and the rain poured down upon us like a torrent. The water soon rose on the level ground so as almost to cover our feet and we slowly advanced, fronting the tempest. Here and there a tall pine on fire presented a magnificent spectacle, illumining the trees around it and surrounded with a halo of dim light abruptly bordered with the deep black of the night. At one time we passed through a tangled thicket of low trees, at another crossed a stream flushed by the heavy rain and again proceeded over the open barrens.

How long we thus half-lost groped our way is more than I can tell you; but at length the tempest passed over and suddenly the clear sky became spangled with stars. Soon after we smelt the salt marshes and walking directly towards them like pointers advancing on a covey of partridges we at last to our great joy descried the light of the beacon near St. Augustine. My dog began to run briskly around, having met with ground on which he had hunted before, and taking a direct course led us to the great causeway that crosses the marshes at the back of the town. We refreshed ourselves with the produce of the first orange tree that we met with and in

half an hour more arrived at our hotel. Drenched with rain, steaming with perspiration and covered to the knees with mud, you may imagine what figures we cut in the eyes of the good people whom we found snugly enjoying themselves in the sitting room. Next morning, Major Gates, who had received me with much kindness, sent a wagon with mules and two trusty soldiers for my companion and luggage.

John James Audubon to Richard Harlan, M.D.
"Our expedition has proved a complete failure..."

St. Augustine, East Florida
1 March 1832

My dear Harlan,

I am no longer on board the U.S. schooner *Spark*—nay, never again will I be on board.

Our expedition up the St. John's River has proved a complete failure—after three weeks of existing we could not reach the Lake George—*no birds, no fishes, no turtles*—nay, scarcely any land fit for cultivation—never was a man more completely disappointed than I am and have been.

I sail, as soon as the wind will become favorable, for Charleston, with a view to sail from that place directly to Key West. Continue to forward all letters to the care of the Rev. John Bachman, Charleston. How does it happen that I have not had a line from you for a whole month? Has any accident befallen you...?

Lucy Audubon to John James Audubon
"Oh do come away come away!"

Louisville, Kentucky
19 March 1832

My dear husband

Your last from St. John's River, February 17, has this morning been handed to me and first let me acknowledge your kindness in availing yourself of the opportunity of writing from your dismal residence, but let me ask why you are in that desolate region? Where there are no *new birds* why remain? Do not let enthusiasm make you quite forget what is due to yourself [and] to your family, and depend upon it my love the *world* will never repay either your toil, your privation or your purse.

I am now going to tell you a few unpleasant truths, and think it my duty so to do, for had we known precisely what was passing *here* when we were in London, what a different arrangement we should have made. Now in addition to all that then existed, the health of our sons is materially affected. John has had three or four slight attacks of illness, which plainly shew his mode of life does not agree with [him], yet he perseveres manfully in what he dislikes extremely, in the hope you will be able to make a change. His salary just feeds and clothes him, no more and barely that. As to Victor, he toils like a horse for $550 [a year], which is just enough to feed and clothe him, and I do not think W.B. [i.e., William Bakewell] has it in his power to do anything for him, not even to raise his salary, which I think ought to be [raised] when we consider the unbounded confidence and management he does and which it would be vain to seek elsewhere for.

My next trouble is that you still speak of staying so late in the South. Do come away, of what avail to see a little more or less of Florida if you lose your health or life? Your work calls for the *Birds of the United States* but you are multiplying it into a universal history. We are here counting, with pain and suspense, the days and weeks till we see you, Victor is patiently waiting your final determination towards him, losing time to opportunity, I cannot

think of being a burden much longer, and I cannot go to [New] Orleans. Mr. Brand has not ever acknowledged the Eagle or my letter, they are coming to this part of the country in April or first of May, and supposing we could finally settle our affairs without our sons being present I have no place to meet you at.

As to the trip across the Rocky Mountains [that Audubon was hoping to make], I have made every possible inquiry about [it] from many persons who have traveled with the Indian traders and some of these persons are to be fully relied upon. They all concur in the danger at this period to be encountered from the disturbed Indians. The company leave Franklin in Missouri the last of April and expect to be absent a year, that you cannot join, and if you did, they keep the beaten track stopping only at night, not for the benefit of natural history. And my dear it has been more than once suggested that your absence from London so long will be injurious to your work.

I hope and trust this may reach you and that you will see the utility of what I say. Your funds are not accumulating, see what a loss through the agent in Philadelphia and I pray you may find *that* 900 the whole of it. Do come home and put us all at ease, I assure you I regret more every day that I did not go straight down and resume my labor in the South; but now I wait most anxiously your replies, or your presence. How you can think of remaining in the South so late I cannot conceive, when you reflect that you have been in Europe so long and the South never agreed with you. I may write warmly but I feel so for you—for us all four. I have not heard from [Robert] Havell since January; the letters are continually coming from England from other people and I keep waiting. But oh do come away come away!

Victor is gone to Shawnee Town on business, John is at his counting room, on Friday last he was in bed with fever. Think of us, of yourself, and do come home. I heard from [Senator Edward] Everett a day or two ago and he hopes the bill for the admission of your work free of duty will become law. Mr. Berthoud has lost his youngest child of the croup, and some pecuniary losses also will not add to their personal comfort. Take care of everybody, I say, you are too good for the generality of mankind. Think of our dear sons, who are every way worthy of your kindness. If you *cannot*

come up, or if you can write your plans, your wishes, *decidedly,* do so and promptly they will be obeyed, depend upon it, by your most affectionate sons and your true friend, adviser and affectionate wife,

 Lucy Audubon

Episode: The Turtlers

Fort Jefferson had not yet been built when Audubon visited the Tortugas in 1832 aboard a U.S. government revenue cutter, the Marion, *which the U.S. Secretary of the Treasury and Secretary of the Navy had made available to him—a testament to his achievement of a national reputation as a naturalist and artist. Audubon concludes this episode with one of the earliest reports on record of the turtles' long-distance migrations.*

The Tortugas are a group of islands lying about eighty miles from Key West and the last of those that seem to defend the peninsula of the Floridas. They consist of five or six extremely low uninhabitable banks formed of shelly sand, and are resorted to principally by that class of men called wreckers and turtlers. Between these islands are deep channels which, although extremely intricate, are well known to those adventurers as well as to the commanders of the revenue cutters whose duties call them to that dangerous coast. The great coral reef or wall lies about eight miles from these inhospitable isles in the direction of the Gulf, and on it many an ignorant or careless navigator has suffered shipwreck. The whole ground around them is densely covered with corals, sea-fans and other productions of the deep, amid which crawl innumerable crustaceous animals, while shoals of curious and beautiful fishes fill the limpid waters above them. Turtles of different species resort to these banks to deposit their eggs in the burning sand and clouds of sea fowl arrive every spring for the same purpose. These are followed by persons called "Eggers" who, when their cargoes are completed, sail to distant markets to exchange their ill-gotten ware for a portion of that gold on the acquisition of which all men seem bent.

The *Marion* having occasion to visit the Tortugas, I gladly embraced the opportunity of seeing those celebrated islets. A few hours before sunset the joyful cry of "land" announced our approach to them, but as the breeze was fresh and the pilot was well acquainted with all the windings of the channels we held on and dropped anchor before twilight. If you have never seen the sun setting in those latitudes, I would recommend to you to make a

voyage for the purpose, for I much doubt if in any other portion of the world the departure of the orb of day is accompanied with such gorgeous appearances. Look at the great red disk increased to triple its ordinary dimensions! Now it has partially sunk beneath the distant line of waters, and with its still remaining half irradiates the whole heavens with a flood of golden light, purpling the far-off clouds that hover over the western horizon. A blaze of refulgent glory streams through the portals of the west and the masses of vapor assume the semblance of mountains of molten gold. But the sun has now disappeared and from the east slowly advances the grey curtain which night draws over the world.

The Nighthawk is flapping its noiseless wings in the gentle sea breeze; the Terns, safely landed, have settled on their nests; the Frigate Pelicans are seen wending their way to distant mangroves; and the Brown Gannet, in search of a resting-place, has perched on the yard of the vessel. Slowly advancing landward, their heads alone above the water, are observed the heavily-laden turtles, anxious to deposit their eggs in the well-known sands. On the surface of the gently rippling stream I dimly see their broad forms as they toil along, while at intervals may be heard their hurried breathings, indicative of suspicion and fear. The moon with her silvery light now illumines the scene, and the turtle having landed, slowly and laboriously drags her heavy body over the sand, her "flappers" being better adapted for motion in the water than on shore. Up the slope, however, she works her way, and see how industriously she removes the sand beneath her, casting it out on either side. Layer after layer she deposits her eggs, arranging them in the most careful manner and with her hind-paddles brings the sand over them. The business is accomplished, the spot is covered over and with a joyful heart the turtle swiftly retires towards the shore and launches into the deep.

But the Tortugas are not the only breeding places of the turtles; these animals on the contrary frequent many other Keys as well as various parts of the coast of the mainland. There are four different species which are known by the names of the *green* turtle, the *hawk-billed* turtle, the *loggerhead* turtle and the *trunk* turtle. The first is considered the best as an article of food, in which capacity it is well known to most epicures. It approaches the shores and enters the

bays, inlets and rivers early in the month of April after having spent
the winter in the deep waters. It deposits its eggs in convenient
places at two different times in May and once again in June. The
first deposit is the largest and the last the least, the total quantity
being at an average about two hundred and forty. The hawk-billed
turtle, whose shell is so valuable as an article of commerce, being
used for various purposes in the arts, is the next with respect to the
quality of its flesh. It resorts to the outer Keys only, where it deposits
its eggs in two sets, first in July and again in August, although it
"crawls" the beaches of these Keys much earlier in the season as if
to look for a safe place. The average number of its eggs is about
three hundred. The loggerhead visits the Tortugas in April and
lays from that period until late in June three sets of eggs, each
set averaging a hundred and seventy. The trunk turtle, which is
sometimes of an enormous size and which has a pouch like a
pelican, reaches the shores latest. The shell and flesh are so soft
that one may push his finger into them almost as into a lump of
butter. This species is therefore considered as the least valuable and
indeed is seldom eaten unless by the Indians who, ever alert when
the turtle season commences, first carry off the eggs and afterwards
catch the turtles themselves. The average number of eggs which it
lays in the season, in two sets, may be three hundred and fifty.

The loggerhead and the trunk turtles are the least cautious in
choosing the places in which to deposit their eggs, whereas the
two other species select the wildest and most secluded spots. The
green turtle resorts either to the shores of the Main between Cape
Sable and Cape Florida or enters Indian, Halifax and other large
rivers or inlets from which it makes its retreat as speedily as possible
and betakes itself to the open sea. Great numbers, however, are
killed by the turtlers and Indians as well as by various species of
carnivorous animals, as cougars, lynxes, bears and wolves. The
hawk-bill, which is still more wary and is always the most difficult
to surprise, keeps to the sea islands. All the species employ nearly
the same method in depositing their eggs in the sand, and as I
have several times observed them in the act, I am enabled to
present you with a circumstantial account of it.

On first nearing the shores, and mostly on fine calm moon-
light nights, the turtle raises her head above the water, being still

distant thirty or forty yards from the beach, looks around her and attentively examines the objects on the shore. Should she observe nothing likely to disturb her intended operations she emits a loud hissing sound, by which such of her many enemies as are unaccustomed to it are startled and so are apt to remove to another place, although unseen by her. Should she hear any noise or perceive indications of danger, she instantly sinks and goes off to a considerable distance; but should everything be quiet she advances slowly towards the beach, crawls over it, her head raised to the full stretch of her neck, and when she has reached a place fitted for her purpose she gazes all round in silence. Finding "all well," she proceeds to form a hole in the sand which she effects by removing it from *under* her body with her *hind* flappers, scooping it out with so much dexterity that the sides seldom if ever fall in. The sand is raised alternately with each flapper, as with a large ladle, until it has accumulated behind her, when supporting herself with her head and fore part on the ground fronting her body, she with a spring from each flapper sends the sand around her, scattering it to the distance of several feet. In this manner the hole is dug to the depth of eighteen inches or sometimes more than two feet. This labor I have seen performed in the short period of nine minutes. The eggs are then dropped one by one and disposed in regular layers to the number of a hundred and fifty or sometimes nearly two hundred. The whole time spent in this part of the operation may be about twenty minutes. She now scrapes the loose sand back over the eggs and so levels and smoothes the surface that few persons on seeing the spot could imagine anything had been done to it. This accomplished to her mind she retreats to the water with all possible dispatch, leaving the hatching of the eggs to the heat of the sand. When a turtle, a loggerhead for example, is in the act of dropping her eggs, she will not move although one should go up to her or even seat himself on her back, for it seems that at this moment she finds it necessary to proceed at all events and is unable to intermit her labor. The moment it is finished, however, off she starts; nor would it then be possible for one, unless he were as strong as a Hercules, to turn her over and secure her.

To upset a turtle on the shore, one is obliged to fall on his knees and, placing his shoulder behind her forearm, gradually raise her

up by pushing with great force and then with a jerk throw her over. Sometimes it requires the united strength of several men to accomplish this; and if the turtle should be of very great size, as often happens on that coast, even hand spikes are employed. Some turtlers are so daring as to swim up to them while lying asleep on the surface of the water and turn them over in their own element when, however, a boat must be at hand to enable them to secure their prize. Few turtles can bite beyond the reach of their forelegs and few, when once turned over, can without assistance regain their natural position; but notwithstanding this, their flappers are generally secured by ropes so as to render their escape impossible.

Persons who search for turtles' eggs are provided with a light stiff cane or a gun rod with which they go along the shores probing the sand near the tracks of the animals which, however, cannot always be seen on account of the winds and heavy rains, that often obliterate them. The nests are discovered not only by men but also by beasts of prey and the eggs are collected or destroyed on the spot in great numbers, as on certain parts of the shores hundreds of turtles are known to deposit their eggs within the space of a mile. They form a new hole each time they lay and the second is generally dug near the first, as if the animal were quite unconscious of what had befallen it. It will readily be understood that the numerous eggs seen in a turtle on cutting it up could not be all laid the same season. The whole number deposited by an individual in one summer may amount to four hundred, whereas if the animal is caught on or near her nest, as I have witnessed, the remaining eggs, all small, without shells, and as it were threaded like so many large beads, exceed three thousand. In an instance where I found that number the turtle weighed nearly four hundred pounds. The young, soon after being hatched and when yet scarcely larger than a dollar, scratch their way through their sandy covering and immediately betake themselves to the water.

The food of the green turtle consists chiefly of marine plants, more especially the grasswrack, which they cut near the roots to procure the most tender and succulent parts. Their feeding grounds . . . are easily discovered by floating masses of these plants on the flats or along the shores to which they resort. The hawk-billed species feeds on seaweeds, crabs, various kinds of shellfish

and fishes; the loggerhead mostly on the meat of conch shells of large size, which they are enabled by means of their powerful beak to crush to pieces with apparently as much ease as a man cracks a walnut. One which was brought on board the *Marion* and placed near the fluke of one of her anchors made a deep indentation in that hammered piece of iron that quite surprised me. The trunk turtle feeds on mollusks, fish, crustaceans, sea urchins and various marine plants.

All the species move through the water with surprising speed; but the green and hawk-billed in particular remind you by their celerity and the ease of their motions of the progress of a bird in the air. It is therefore no easy matter to strike one with a spear, and yet this is often done by an accomplished turtler.

While at Key West and other islands on the coast, where I made the observations here presented to you, I chanced to have need to purchase some turtles to feed my friends on board the *Lady of the Green Mantle*—not my friends her gallant officers or the brave tars who formed her crew, for all of them had already been satiated with turtle soup, but my friends the Herons, of which I had a goodly number alive in coops, intending to carry them to John Bachman of Charleston and other persons for whom I ever feel a sincere regard. So I went to a "crawl" accompanied by Dr. Benjamin Strobel to inquire about prices when, to my surprise, I found that the smaller the turtles above ten pounds weight the dearer they were, and that I could have purchased one of the loggerhead kind that weighed more than seven hundred pounds for little more money than another of only thirty pounds. While I gazed on the large one I thought of the soups the contents of its shell would have furnished for a "Lord Mayor's dinner," of the numerous eggs which its swollen body contained and of the curious carriage which might be made of its shell—a car in which Venus herself might sail over the Caribbean sea provided her tender doves lent their aid in drawing the divinity and provided no shark or hurricane came to upset it. The turtler assured me that although the "great monster" was in fact better meat than any other of a less size there was no disposing of it unless indeed it had been in his power to have sent it to some very distant market. I would willingly have purchased it but I knew that if killed, its flesh could not keep much

longer than a day, and on that account I bought eight or ten small ones, which "my friends" really relished exceedingly and which served to support them for a long time.

Turtles such as I have spoken of are caught in various ways on the coasts of the Floridas or in estuaries and rivers. Some turtlers are in the habit of setting great nets across the entrance of streams so as to answer the purpose either at the flow or at the ebb of the waters. These nets are formed of very large meshes into which the turtles partially enter when, the more they attempt to extricate themselves, the more they get entangled. Others harpoon them in the usual manner; but in my estimation no method is equal to that employed by Mr. Egan, the pilot of Indian Isle.

That extraordinary turtler had an iron instrument which he called a *peg* and which at each end had a point not unlike what nail-makers call a brad, it being four-cornered but flattish and of a shape somewhat resembling the beak of an Ivory-billed Woodpecker together with a neck and shoulder. Between the two shoulders of this instrument a fine tough line fifty or more fathoms in length was fastened by one end being passed through a hole in the center of the peg, and the line itself was carefully coiled up and placed in a convenient part of the canoe. One extremity of this peg enters a sheath of iron that loosely attaches it to a long wooden spear until a turtle has been pierced through the shell by the other extremity. He of the canoe paddles away as silently as possible whenever he spies a turtle basking on the water until he gets within a distance of ten or twelve yards, when he throws the spear so as to hit the animal about the place which an entomologist would choose, were it a large insect, for pinning it to a piece of cork. As soon as the turtle is struck the wooden handle separates from the peg in consequence of the looseness of its attachment. The smart of the wound urges on the animal as if distracted, and it appears that the longer the peg remains in its shell, the more firmly fastened it is, so great a pressure is exercised upon it by the shell of the turtle, which being suffered to run like a whale soon becomes fatigued and is secured by hauling in the line with great care. In this manner, as the pilot informed me, eight hundred green turtles were caught by one man in twelve months.

Each turtler has his *crawl*, which is a square wooden building

or pen formed of logs which are so far separated as to allow the tide to pass freely through and stand erect in the mud. The turtles are placed in this enclosure, fed and kept there until sold. If the animals thus confined have not laid their eggs previous to their seizure they drop them in the water, so that they are lost. The price of green turtles when I was at Key West was from four to six cents per pound.

The loves of the turtles are conducted in a most extraordinary manner; but as the recital of them must prove out of place here I shall pass them over. There is, however, a circumstance relating to their habits which I cannot omit although I have it not from my own ocular evidence but from report. When I was in the Floridas several of the turtlers assured me that any turtle taken from the depositing ground and carried on the deck of a vessel several hundred miles would, if then let loose, certainly be met with at the same spot either immediately after or in the following breeding season. Should this prove true, and it certainly may, how much will be enhanced the belief of the student in the uniformity and solidity of Nature's arrangements when he finds that the turtle, like a migratory bird, returns to the same locality with perhaps a delight similar to that experienced by the traveler who, after visiting distant countries, once more returns to the bosom of his cherished family.

The Booby Gannet

As the *Marion* was nearing the curious islets of the Tortugas, one of the birds that more particularly attracted my notice was of this species. The nearer we approached the land, the more numerous did they become, and I felt delighted with the hope that before many days should elapse, I should have an opportunity of studying their habits. As night drew her somber curtain over the face of Nature, some of these birds alighted on the top yard of our bark, and I observed ever afterwards that they manifested a propensity to roost at as great a height as possible above the surrounding objects, making choice of the tops of bushes or even upright poles and disputing with each other the privilege. The first that was shot at was approached with considerable difficulty: it had alighted on the prong of a tree which had floated and been fastened to the bottom of a rocky shallow at some distance from shore; the water was about four feet deep and quite rough; sharks, we well knew, were abundant around us, but the desire to procure the bird was too strong to be overcome by such obstacles. In an instant the pilot and myself were over the sides of the boat, and onward we proceeded with our guns cocked and ready. The yawl was well manned and its crew awaiting the result. After we had struggled through the turbulent waters about a hundred yards, my companion raised his gun and fired; but away flew the bird with a broken leg, and we saw no more of it that day. Next day, however, at the same hour, the Booby was seen perched on the same prong where, after resting about three hours, it made off to the open sea, doubtless in search of food.

About eight miles to the northeast of the Tortugas lighthouse lies a small sand bar a few acres in extent called Booby Island, on account of the number of birds of this species that resort to it during the breeding season, and to it we accordingly went. We found it not more than a few feet above the surface of the water, but covered with Boobies, which lay basking in the sunshine and pluming themselves. Our attempt to land on the island before the birds should fly off proved futile, for before we were within fifty yards of it they had all betaken themselves to flight and were dispersing in various directions. We landed however, distributed

ourselves in different parts and sent the boat to some distance, the pilot assuring us that the birds would return. And so it happened. As they approached, we laid ourselves as flat as possible in the sand, and although none of them alighted, we attained our object, for in a couple of hours we procured thirty individuals of both sexes and of different ages, finding little difficulty in bringing them down as they flew over us at a moderate height. The wounded birds that fell on the ground made immediately for the water, moving with more ease than I had expected from the accounts usually given of the awkward motions of these birds on the land. Those which reached the water swam off with great buoyancy, and with such rapidity, that it took much rowing to secure some of them, while most of those that fell directly into the sea with only a wing broken, escaped.

The island was covered with their dung, the odor of which extended to a considerable distance leeward. In the evening of the same day we landed on another island named after the Noddy and thickly covered with bushes and low trees, to which thousands of that species of Tern resort for the purpose of breeding. There also we found a great number of Boobies. They were perched on the top branches of the trees, on which they had nests, and here again we obtained as many as we desired. They flew close over our heads, eyeing us with dismay but in silence; indeed, not one of these birds ever emitted a cry, except at the moment when they rose from their perches or from the sand. Their note is harsh and guttural, somewhat like that of a strangled pig, and resembling the syllables *hork, hork*.

The nest of the Booby is placed on the top of a bush at a height of from four to ten feet. It is large and flat, formed of a few dry sticks, covered and matted with seaweeds in great quantity. I have no doubt that they return to the same nest many years in succession, and repair it as occasion requires. In all the nests which I examined only one egg was found, and as most of the birds were sitting, and some of the eggs had the chick nearly ready for exclusion, it is probable that these birds raise only a single young one, like the Common Gannet or Solan Goose. The egg is of a dull white color, without spots and about the size of that of a common hen, but more elongated, being $2^{3}/_{8}$ inches in length, with a diameter of $1^{3}/_{4}$.

In some nests they were covered with filth from the parent bird in the manner of the Florida Cormorant. The young, which had an uncouth appearance, were covered with down; the bill and feet of a deep livid blue or indigo color. On being touched they emitted no cry, but turned away their heads at every trial. A great quantity of fish lay beneath the trees in a state of putrefaction, proving how abundantly the young birds were supplied by their parents. Indeed, while we were on Noddy Island, there was a constant succession of birds coming in from the sea with food for their young, consisting chiefly of flying fish and small mullets, which they disgorged in a half macerated state into the open throats of their offspring. Unfortunately, the time afforded me on that coast was not sufficient to enable me to trace the progress of their growth. I observed, however, that none of the birds which were still brown had nests, and that they roosted apart, particularly on Booby Island, where also many barren ones usually resorted, to lie on the sand and bask in the sun.

The flight of the Booby is graceful and extremely protracted. They pass swiftly at a height of from twenty yards to a foot or two from the surface, often following the troughs of the waves to a considerable distance, their wings extended at right angles to the body; then, without any apparent effort, raising themselves and allowing the rolling waters to break beneath them, when they tack about and sweep along in a contrary direction in search of food, much in the manner of the true Petrels. Now, if you follow an individual, you see that it suddenly stops short, plunges headlong into the water, pierces with its powerful beak and secures a fish, emerges again with inconceivable ease, after a short interval rises on wing, performs a few wide circlings and makes off towards some shore. At this time its flight is different, being performed by flappings for twenty or thirty paces, with alternate sailings of more than double that space. When overloaded with food, they alight on the water where, if undisturbed, they appear to remain for hours at a time, probably until digestion has afforded them relief.

The range to which this species confines itself along our coast seldom extends beyond Cape Hatteras to the eastward, but they become more and more numerous the farther south we proceed. They breed abundantly on all such islands or keys as are adapted

for the purpose, on the southern and western coasts of the Floridas and in the Gulf of Mexico, where I was told they breed on the sand bars. Their power of wing seems sufficient to enable them to brave the tempest, while during a continuance of fair weather they venture to a great distance seaward, and I have seen them fully 200 miles from land.

The expansibility of the gullet of this species enables it to swallow fishes of considerable size, and on such occasions their mouth seems to spread to an unusual width. In the throats of several individuals that were shot as they were returning to their nests, I found mullets measuring seven or eight inches that must have weighed fully half a pound. Their body beneath the skin is covered with numerous air-cells which probably assist them in raising or lowering themselves while on wing, and perhaps still more so when on the point of performing the rapid plunge by which they secure their prey.

Their principal enemies during the breeding season are the American Crow and the Fish Crow, both of which destroy their eggs, and the Turkey Buzzard, which devours their young while yet unfledged. They breed during the month of May, but I have not been able to ascertain if they raise more than one brood in the season. The adult birds chase away those which are yet immature during the period of incubation. It would seem that they take several years in attaining their perfect state.

When procured alive, they feed freely and may be kept any length of time, provided they are supplied with fish. No other food, however, could I tempt them to swallow, excepting slices of turtle, which after all they did not seem to relish. In no instance did I observe one drinking. Some authors have stated that the Frigate Pelican and the *Lestris* [i.e., the Jager] force the Booby to disgorge its food that they may obtain it; but this I have never witnessed. Like the Common Gannet, they may be secured by fastening a fish to a soft plank and sinking it a few feet beneath the surface of the water, for if they perceive the bait, which they are likely to do if they pass over it, they plunge headlong upon it, and drive their bill into the wood.

When a Booby has alighted on the spar of a vessel it is no easy matter to catch it unless it is much fatigued; but if exhausted and

asleep, an expert seaman may occasionally secure one. I was informed that after the breeding season, these birds roost on trees in company with the Brown Pelican and a species of Tern, *Sterna stolida*, and spend their hours of daily rest on the sand banks. Our pilot who, as I have mentioned in my second volume, was a man of great observation, assured me that while at Vera Cruz, he saw the fishermen there go to sea, and return from considerable distances, simply by following the course of the Boobies.

The bills and legs of those which I procured in the brown plumage, and which were from one to two years of age, were dusky blue. These were undergoing molt on the 14th of May. At a more advanced age the parts mentioned become paler, and when the bird has arrived at maturity are as represented in my plate. I observed no external difference between the sexes in the adult birds. The stomach is a long dilatable pouch, thin and of a yellow color. The body is muscular, and the flesh, which is of a dark color, tough, and having a disagreeable smell, is scarcely fit for food.

I am unable to find a good reason for those who have chosen to call these birds *boobies*. Authors, it is true, generally represent them as extremely *stupid*; but to me the word is utterly inapplicable to any bird with which I am acquainted. The Woodcock, too, is said to be stupid, as are many other birds; but my opinion, founded on pretty extensive observation, is that it is only when birds of any species are unacquainted with man, that they manifest that kind of *ignorance* or *innocence* which he calls *stupidity*, and by which they suffer themselves to be imposed upon. A little acquaintance with him soon enables them to perceive enough of his character to induce them to keep aloof. This I observed in the Booby Gannet, as well as in the Noddy Tern, and in certain species of land birds of which I have already spoken. After my first visit to Booby Island in the Tortugas, the Gannets had already become very shy and wary, and before the *Marion* sailed away from those peaceful retreats of the wandering seabirds, the *Boobies* had become so knowing, that the most expert of our party could not get within shot of them.

[The Booby Gannet (Brown Booby), *Sula leucogaster*, appears in Plate 207 of *The Birds of America*.]

The White Ibis

Sandy Island...is remarkable as a breeding place for various species of water and land birds. It is about a mile in length, not more than a hundred yards broad and in form resembles a horse-shoe, the inner curve of which looks towards Cape Sable in Florida, from which it is six miles distant. At low water it is surrounded to a great distance by mud flats abounding in food for wading and swimming birds, while the plants, the fruits and the insects of the island itself supply many species that are peculiar to the land. Besides the White Ibis, we found breeding there the Brown Pelican, the Purple, the Louisiana, the White and the Green Herons, two species of Gallinule, the Cardinal Grosbeak, Crows and Pigeons. The vegetation consists of a few tall mangroves, thousands of wild plum trees, several species of cactus, some of them nearly as thick as a man's body and more than twenty feet high, different sorts of smilax, grapevines, cane, palmettos, Spanish bayonets and the rankest nettles I ever saw, all so tangled together that I leave you to guess how difficult it was for my companions and myself to force a passage through them in search of birds' nests, which, however, we effected, although the heat was excessive and the stench produced by the dead birds, putrid eggs and the natural effluvia of the Ibises was scarcely sufferable. But then, the White Ibis was there, and in thousands; and although I already knew the bird, I wished to study its manners once more, that I might be enabled to present you with an account of them, which I now proceed to do—endeavoring all the while to forget the pain of the numerous scratches and lacerations of my legs caused by the cactuses of Sandy Island.

As we entered that well-known place we saw nests on every bush, cactus or tree. Whether the number was one thousand or ten I cannot say, but this I well know: I counted forty-seven on a single plum tree. These nests of the White Ibis measure about fifteen inches in their greatest diameter and are formed of dry twigs intermixed with fibrous roots and green branches of the trees growing on the island, which this bird easily breaks with its bill; the interior, which is flat, being finished with leaves of the cane and some other plants. The bird breeds only once in the year and

the full number of its eggs is three. They measure two inches and a quarter in length with a diameter of one inch and five eighths, are rough to the touch, although not granulated, of a dull white color, blotched with pale yellow and irregularly spotted with deep reddish brown. They afford excellent eating, although when boiled they do not look inviting, the white resembling a livid-colored jelly, and the yolk being of a reddish orange, the former wonderfully transparent instead of being opaque like that of most other birds. The eggs are deposited from the 10th of April to the 1st of May and incubation is general by the 10th of the latter month. The young birds, which are at first covered with thick down of a dark grey color, are fed by regurgitation. They take about five weeks to be able to fly, although they leave the nest at the end of three weeks and stand on the branches or on the ground, waiting the arrival of their parents with food, which consists principally of small fiddler crabs and crayfish. On some occasions I have found them at this age miles away from the breeding places, and in this state they are easily caught. As soon as the young are able to provide for themselves, the old birds leave them and the different individuals are then seen searching for food apart. While nesting or in the act of incubating these Ibises are extremely gentle and unwary unless they may have been much disturbed, for they almost allow you to touch them on the nest. The females are silent all the while, but the males evince their displeasure by uttering sounds which greatly resemble those of the White-headed Pigeon and which may be imitated by the syllables *crooh*, *croo*, *croo*. The report of a gun scarcely alarms them at first, although at all other periods these birds are shy and vigilant in the highest degree.

The change in the coloring of the bill, legs and feet of this bird that takes place in the breeding-season is worthy of remark, the bill being then of a deep orange red, and the legs and feet of a red nearly amounting to carmine. The males at this season have the gular pouch of a rich orange color and somewhat resembling in shape that of the Frigate Pelican although proportionally less. During winter these parts are of a dull flesh color. The irides also lose much of their clear blue and resume in some degree the umber color of the young birds. I am thus particular in these matters because it is doubtful if anyone else has ever paid attention to them.

While breeding, the White Ibises go to a great distance in search of food for their young, flying in flocks of several hundreds. Their excursions take place at particular periods determined by the decline of the tides, when all the birds that are not sitting go off perhaps twenty or thirty miles to the great mud flats where they collect abundance of food with which they return the moment the tide begins to flow. As the birds of this genus feed by night as well as by day, the White Ibis attends the tides at whatever hour they may be. Some of those which bred on Sandy Key would go to the keys next the Atlantic, more than forty miles distant, while others made for the Everglades; but they never went off singly. They rose with common accord from the breeding ground, forming themselves into long lines, often a mile in extent, and soon disappeared from view. Soon after the turn of the tide we saw them approaching in the same order. Not a note could you have heard on those occasions; yet if you disturb them when far from their nests they utter loud hoarse cries resembling the syllables *hunk, hunk, hunk,* either while on the ground or as they fly off.

The flight of the White Ibis is rapid and protracted. Like all other species of the genus these birds pass through the air with alternate flappings and sailings; and I have thought that the use of either mode depended upon the leader of the flock, for with the most perfect regularity each individual follows the motion of that preceding it so that a constant appearance of regular undulations is produced through the whole line. If one is shot at this time the whole line is immediately broken up, and for a few minutes all is disorder; but as they continue their course they soon resume their former arrangement. The wounded bird never attempts to bite or to defend itself in any manner, although if only winged it runs off with more speed than is pleasant to its pursuer.

At other times the White Ibis, like the Red and the Wood Ibises, rises to an immense height in the air, where it performs beautiful evolutions. After they have thus, as it were, amused themselves for some time they glide down with astonishing speed and alight either on trees or on the ground. Should the sun be shining they appear in their full beauty and the glossy black tips of their wings form a fine contrast with the yellowish-white of the rest of their plumage.

This species is as fond of resorting to the ponds, bayous or lakes that are met with in the woods as the Wood Ibis itself. I have found it breeding there at a distance of more than three hundred miles from the sea and remaining in the midst of the thickest forests until driven off to warmer latitudes by the approach of winter. This is the case in the State of Mississippi not far from Natchez and in all the swampy forests around Bayou Sarah and Pointe Coupee as well as the interior of the Floridas. When disturbed in such places these Ibises fly at once to the tops of the tallest trees, emitting their hoarse *hunk*, and watch your motions with so much care that it is extremely difficult to get within shot of them.

The manner in which this bird searches for its food is very curious. The Woodcock and the Snipe, it is true, are probers as well as it, but their task requires less ingenuity than is exercised by the White or the Red Ibis. It is also true that the White Ibis frequently seizes on small crabs, slugs and snails and even at times on flying insects; but its usual mode of procuring food is a strong proof that cunning enters as a principal ingredient in its instinct. The crayfish often burrows to the depth of three or four feet in dry weather, for before it can be comfortable it must reach the water. This is generally the case during the prolonged heats of summer, at which time the White Ibis is most pushed for food. The bird to procure the crayfish walks with remarkable care towards the mounds of mud which the latter throws up while forming its hole and breaks up the upper part of the fabric, dropping the fragments into the deep cavity that has been made by the animal. Then the Ibis retires a single step and patiently waits the result. The crayfish, incommoded by the load of earth, instantly sets to work anew and at last reaches the entrance of its burrow; but the moment it comes in sight, the Ibis seizes it with his bill.

Whilst at Indian Key I observed an immense quantity of beautiful tree snails of a pyramidal or shortly conical form, some pure white, others curiously marked with spiral lines of bright red, yellow and black. They were crawling vigorously on every branch of each bush where there was not a nest of the White Ibis; but wherever that bird had fixed its habitation not a live snail was to be seen although hundreds lay dead beneath. Was this caused by the corrosive quality of the bird's ordure?

There is a curious though not altogether general difference between the sexes of this species as to the plumage: the male has five of its primaries tipped with glossy black for several inches, while the female, which is very little smaller than the male, has only four marked in this manner. On examining more than a hundred individuals of each sex I found only four exceptions which occurred in females that were very old birds and which, as happens in some other species, might perhaps have been undergoing the curious change exhibited by ducks, pheasants and some other birds, the females of which when old sometimes assume the livery of the males.

Much, as you are aware, good reader, has been said respecting the "oil bags" of birds. I dislike controversy, simply because I never saw the least indications of it in the ways of the Almighty Creator. Should I err, forgive me, but my opinion is that these organs were not made without an object. Why should they consist of matter so conveniently placed and so disposed as to issue under the least pressure through apertures in the form of well-defined tubes? The White Ibis, as well as the Wood Ibis and all the other species of this genus when in full health, has these oil bags of great size, and if my eyes have not deceived me, makes great use of their contents. Should you feel anxious to satisfy yourself on this subject, I request of you to keep some Ibises alive for several weeks as I have done and you will have an opportunity of judging. And again, tell me if the fat contained in these bags is not the very best *lip salve* that can be procured.

When any species of Ibis with which I am acquainted falls into the water on being wounded, it swims tolerably well; but I have never observed any taking to the water and swimming either by choice or to escape pursuit. While in the company of Mr. Joseph Mason, a young man who was for some time employed by me and who has drawn plants to some of my birds, although not so successfully as my amiable friend Miss Martin, or George Lehman, who finish those they draw as beautifully as my learned and valued friend William Macgillivray of Edinburgh does his faithful drawings of birds, I chanced one morning to be on the lookout for White Ibises in a delightful swamp not many miles from Bayou Sarah. It was in the end of summer and all around was pure and

calm as the clear sky, the bright azure of which was reflected by the lake before us. The trees had already exchanged the verdure of their foliage for more mellow tints of diversified hue; the mast dropped from the boughs; some of the Warblers had begun to think of removing farther south; the Night Hawk in company with the Chimney Swallow was passing swiftly towards the land of their winter residence and the Ibises had all departed for the Florida coasts excepting a few of the white species, one of which we at length espied. It was perched about fifty yards from us towards the center of the pool, and as the report of one of our guns echoed among the tall cypresses, down to the water, broken-winged, it fell. The exertions which it made to reach the shore seemed to awaken the half-torpid alligators that lay in the deep mud at the bottom of the pool. One shewed his head above the water, then a second and a third. All gave chase to the poor wounded bird, which on seeing its dreaded and deadly foes made double speed towards the very spot where we stood. I was surprised to see how much faster the bird swam than the reptiles who, with jaws widely opened, urged their heavy bodies through the water. The Ibis was now within a few yards of us. It was the alligator's last chance. Springing forward as it were, he raised his body almost out of the water; his jaws nearly touched the terrified bird when, pulling three triggers at once, we lodged the contents of our guns in the throat of the monster. Thrashing furiously with his tail and rolling his body in agony the alligator at last sunk to the mud; and the Ibis as if in gratitude walked to our very feet, and there lying down, surrendered itself to us. I kept this bird until the succeeding spring, and by care and good nursing had the pleasure of seeing its broken wing perfectly mended when, after its long captivity, I restored it to liberty in the midst of its loved swamps and woods.

The young bird of this species, which I kept alive for some time, fed freely after a few days' captivity on soaked Indian cornmeal but evinced great pleasure when crayfishes were offered to it. On seizing one it beat it sideways on the ground until the claws and legs were broken off, after which it swallowed the body whole. It was fond of lying on its side in the sun for an hour or so at a time, pluming its body and nursing the sore wing. It walked lightly and very gracefully, though not so much so as the Herons. It did not

molest its companions and became very gentle and tame, following those who fed it like a common fowl.

The Creoles of Louisiana call this species "*Bec croche*" and also "*Petit Flaman,*" although it is also generally known by the name of "Spanish Curlew." The flesh which, as well as the skin, is of a dull orange color is extremely fishy, although the birds are often sold in our southernmost markets and are frequently eaten by the Indians.

The White Ibis has been shot eastward as far as New Jersey. Of this I have been made aware by my generous friend Edward Harris, Esq. I never saw one farther up the Mississippi than Memphis.

[The White Ibis, *Eudocimus albus*, appears in Plate 222 of *The Birds of America*.]

PART VI: LABRADOR

John James Audubon to Edward Harris
"We have been received with much urbanity..."

Boston, Massachusetts
14 August 1832

My dear Sir,

It would be impossible for me to express the regret which we all felt at being obliged to leave Camden without bidding you adieu, and of thanking you for your generous continued acts of kindness. We left Camden pressed by the season and the desire I have to fulfill towards my subscribers, the world and indeed myself the task allotted me by Nature, the completion of my work. We arrived at New York but remained there only a portion of a day [and] therefore were denied the gratification of paying our regards to Mr. Lang. We proceeded by water and land carriage to this beautiful place, and I am happy to say have been received with as much urbanity as yourself are wont to do whenever we meet. We have indeed been quite successful, for we have now added to the list of our patrons 9 names and expect some more. Allow me to say that with my work, as in the days of '76, the Bostonians have proved themselves the best supporters of a good cause in our country! Independent of the number of subscribers mentioned, we expect the support of the Cambridge University [i.e., Harvard], that of the Natural History Society and again that of the state (pray remember how anxious we are to have all of the states). I made drawings of 3 rare species. One is the Marsh Wren, which we searched in vain when near Salem. The second is a Fly Catcher described by Mr. Nuttall and the last a Thrush. We leave this tomorrow for Portland in Maine, through which we will merely pass, and ere one week expires expect to be at the Bay of Fundy...

Lucy Audubon to Euphemia Gifford
"I left Kentucky to join Mr. Audubon..."

Boston, Massachusetts
7 October 1832

My dear Mrs. Gifford,

Our son leaves us in a few days for England, and I avail myself of the opportunity to address you again for the third time since my arrival in America, and I am very sorry to say I have not received a line from you since I left England. I trust no affliction is the cause of your silence. Our son will see you as soon as possible on his arrival and deliver to you a very few seeds which I have collected from different parts of this continent, a number of leaves I gathered and pressed I cannot send you now owing to their being left with other packages to come by sea, and I am afraid they will not reach us before the departure of Gifford for England.

I left Kentucky about the end of June to join Mr. Audubon in Philadelphia on his return from Florida; with some difficulties from the low stage of water in the Ohio, we at length landed at Pittsburgh, where we found all my uncle's family quite well. Mrs. Campbell was just recovering from her confinement. From Pittsburgh we crossed the mountains and proceeded to New York, where we spent one day with my sister Eliza and had the pleasure of also seeing sisters Ann and Sarah, who were on a visit at that time. We proceeded up the Sound and on to Boston, which is a more interesting place than any I have seen in the United States, and where we met with a most cordial welcome and obtained eight subscribers to our work. After two weeks we proceeded east to Portland in Maine by sea, and from thence on the seacoast in quest of new objects for publication, until we came to the extreme boundary of the U.S., a place called Eastport, where there is an American garrison kept, and across the bay is the Island of Campobello and the province of New Brunswick, belonging to the British. After visiting all round this spot in a circuit we proceeded still further up the Bay of Fundy and remained one day at St. John's at the mouth of the river of the same name, which we ascended to

Fredericton, the seat of government, a very pretty village on the bank of the river. Here we stayed four days and Mr. A. completed a drawing or two, when we continued our progress up the river to Woodstock, the last settlement on the boundary line of Maine, where there is another American garrison commanded by Major Clarke and in a village founded by and called after a Colonel Houlton. There are not more than a dozen dwellings in the place, and from the wildness of the adjacent country it seemed to me like being in exile for the inhabitants. We dined in sight of Mars Hill, as it is called, a mountain of interest from its natural shape and as being the spot where the compromises for the two nations [i.e., the U.S. and Britain] disagreed about the boundary line, the settlement of which may yet occasion some difficulties. From Houlton we proceeded west again a great part of the way near the Penobscot River, on the banks of which we generally took our meal in the middle of the day and drank of the stream. Many times we came in view of very pretty islands or small streams tumbling over rocks into the river, but the greater part of the distance was through dense forests with very few settlements until we reached Bangor, a very thriving place.

We passed many Indian villages, but the occupants were generally absent, either hunting or fishing for their winter supplies, that season being both long and severe in this latitude, so much so that the means of communication is thereupon the ice of the numerous streams that flow through this country. Our son will present you with a map of our states which I hope will afford you some pleasure as a medium of tracing the spots and places where we have traveled and where the birds and plants have been found. You will also derive some pleasure, I hope, from the new drawings which Gifford will shew you. We shall cross the ocean sometime in the present year, and then I hope to have the long-looked-for gratification of seeing you and those scenes which ever will be dear to me . . .

John James Audubon to Richard Harlan, M.D.
"I received a splendid specimen of the Golden Eagle..."

Boston, Massachusetts
20 March 1833

My dear friend,

The hand which now drives my pen was paralyzed on Saturday last for about one hour. The attack seized on my mouth & particularly my lips, so much so that I neither could articulate or hold anything. My good dear wife was terribly frightened, and yet acted so promptly with prudence & knowledge that I was relieved, as I already said, in about one hour. Dr. Warren came in, with our ever worthy friend Parkman, and administered me a dose which kept me "a-going" for 24 hours. Now much debility is all that ails me; moderate exercise and a cessation of work will reverse this and I hope soon to be myself again.

Friendship, my dear Harlan, is a jewel which I hold not only sacred, but one which being hereditary (for I received the principles thereof from my father), I never can part with. Through friendship and the love of nature's works, all my happiness on this earth has been derived. I never redraw it when I have once found it accepted by anyone worthy of such deposit. Ergo, you are my friend and I am yours to the end of my days.

Money, the curse of mankind, never contributes to ameliorate our dispositions unless when it is dealt through benevolence's hand. I shall be proud to have been poor as much as I am proud to receive money through generous benevolence. Money is wanted, money must be had and money shall be had as long as my fingers will not be palsied. Sometimes (and that is pretty frequently too) I feel myself as if about to be cast on a lee shore, it is true, but I shake myself on all such occasion, make a drawing and away with it to the nearest market. It brings something, always, and sometimes more than its intrinsic value. I have an extraordinary degree of confidence in providence, and thank God that power has never failed towards me!

Dr. Chalmer himself could scarce have delivered a better lecture

on the subject of money & friendship than I have accomplished and thus ends the subject.

Your welcome bill [i.e., banknote] for one hundred & fifty dollars is now going in the care of my better half. I wish you were as well in health as that bit of paper is in safety. I regret, however, that you should have been pushed for it. Your wife would not have been your friend had she nursed you any other way than kindly. What do you think of the balm which ever and anon circulates through a man's veins on such occasions? The blessing of a happy marriage is the finest emblem of God's power in behalf of the beings which he has created to "go forth and multiply!" God bless her and protect you both!!

My old friend … will write to you as well as to her as soon as we reach New York, where we expected to have been more than a week since. But to shew you that all is for the best, we, by having been unexpectedly detained here, have augmented our list of subscribers with five valuable names, and moreover, we have received 7 volumes handsomely colored to supply those and receive "the ready" [cash]. See now how strangely our bark is tossed: poor as Job yesterday, rich as Croesus tomorrow! And who could not wish to live to enjoy this life of pleasurable anxiety? Not I, believe me.

Two days after you left us I received a splendid specimen of the Golden Eagle. Six hours of confinement under a blanket in a tight closet with a pot of coal (lighted) so as to be carbonic gas [i.e., carbon monoxide] had no effect. $1/4$ of a pound of the best powdered sulfur was added; we were all drove off but Mr. Eagle paid no attention to our doings. A fine tale this to relate to Monsieur G[eorge] Ord of Philadelphia! It took me 13 days to draw it, and depend upon it, I have the drawing! The bird did not cost 100$ — it was a female, caught in a fox trap and bought in per order. I had a great desire to try electricity [to euthanize it] but could not obtain a battery sufficiently powerful to be trusted for a single stroke. Tell all this to your society and assure them in my name that the experiments were made with care by an F.R.S. [i.e., a fellow of the Royal Society of London] of some merit!

The Numbers up to 31 of *The Birds of America* are now in New York. That work enters the U.S. free of duty. The Numbers for your fair city will be there as soon as possible after I reach New York …

Labrador Journal

"The difficulties which are to be encountered in studying the habits of our Water Birds are great," Audubon writes in the introduction to volume 3 of the Ornithological Biography. *"He who follows the feathered inhabitants of the forests and plains, however rough or tangled the paths may be, seldom fails to obtain the objects of his pursuit, provided he be possessed of due enthusiasm and perseverance. The Land Bird flits from bush to bush, runs before you, and seldom extends its flight beyond the range of your vision. It is very different with the Water Bird, which sweeps afar over the wide ocean, hovers above the surges, or betakes itself for refuge to the inaccessible rocks on the shore...If you endeavor to approach these birds in their haunts, they betake themselves to flight, and speed to places where they are secure from your intrusion."* Since the water birds would not come to him, he decided to go to them—to their nesting grounds in Labrador, where he could observe them in summer plumage rearing their young. In Eastport, Maine, in the spring of 1833 he chartered a nearly-new 100-ton schooner, the Ripley, and had the hold floored to make a workroom, great room and dormitory. Besides his son John Woodhouse, who was 21 that year, he invited along four vigorous young men he and John had befriended in their New England expeditions: George Shattuck of Boston, a young physician; Thomas Lincoln, a stoic downeaster whose father was a judge; William Ingalls, a Boston medical student; and Joseph Coolidge, the son of an Eastport revenue cutter captain. The journal Audubon kept exists today only in a version edited by his granddaughter Maria R. Audubon, who softened, formalized and expurgated her grandfather's more colorful prose. It is still lively, however, has long been out of print and is reproduced here in full.

Eastport, Maine, June 4. Our vessel is being prepared for our reception and departure, and we have concluded to hire two extra sailors and a lad; the latter to be a kind of major-domo, to clean our guns, etc., search for nests, and assist in skinning birds. Whilst rambling in the woods this morning, I found a Crow's nest, with five young, yet small. As I ascended the tree, the parents came to their offspring crying loudly, and with such perseverance that in less than fifteen

minutes upwards of fifty pairs of these birds had joined in their vociferations; yet when first the parents began to cry I would have supposed them the only pair in the neighborhood.

Wednesday, June 5. This afternoon, when I had concluded that everything relating to the charter of the *Ripley* was arranged, some difficulty arose between myself and Mr. Buck, which nearly put a stop to our having his vessel. Pressed, however, as I was, by the lateness of the season, I gave way and suffered myself to be imposed upon as usual, with a full knowledge that I was so. The charter was signed, and we hoped to have sailed, but tomorrow is now the day appointed. Our promised Hampton boat is not come.

Thursday, June 6. We left the wharf of Eastport about one o'clock p.m. Everyone of the male population came to see the show, just as if no schooner the size of the *Ripley* had ever gone from this mighty port to Labrador. Our numerous friends came with the throng, and we all shook hands as if never to meet again. The batteries of the garrison and the cannon of the revenue cutter saluted us, each firing four loud, oft-echoing reports. Captain Coolidge accompanied us, and indeed was our pilot, until we had passed Lubec. The wind was light and ahead, and yet with the assistance of the tide we drifted twenty-five miles down to Little River during the night, and on rising on the morning of June 7 we were at anchor near some ugly rocks, the sight of which was not pleasing to our good captain.

June 7. The whole morning was spent trying to enter Little River, but in vain; the men were unable to tow us in. We landed for a few minutes and shot a Hermit Thrush, but the appearance of a breeze brought us back and we attempted to put to sea. Our position now became rather dangerous, as we were drawn by the current nearly upon the rocks; but the wind rose at last and we cleared for sea. At three o'clock it became suddenly so foggy that we could not see the bowsprit. The night was spent in direful apprehensions of ill luck; at midnight a smart squall decided in our favor, and when day broke on the morning of June 8 the wind was from the northeast, blowing fresh, and we were dancing on the waters, all shockingly seasick, crossing that worst of all dreadful bays, the Bay of Fundy. We passed between the Seal Islands and the Mud Islands; in the latter the Stormy Petrel breeds abundantly;

their nests are dug out of the sand in an oblique direction to the depth of two or two and a half feet. At the bottom of these holes, and on the sand, the birds deposit their pure white eggs. The holes are perforated, not in the banks like the Bank Swallow, but are like rat holes over the whole of the islands. On Seal Islands the Herring Gull breeds as abundantly as on Grand Menan, but altogether *on trees*. As we passed Cape Sable, so called on account of its being truly a sand-point of some caved-in elevation, we saw a wrecked ship with many small crafts about it. I saw there the Foolish Guillemot and some Gannets. The sea was dreadful and scarcely one of us was able to eat or drink this day. We came up with the schooner *Caledonia*, from Boston for Labrador; her captain wished to keep in our company, and we were pretty much together all night and also on Sunday.

June 9. We now had a splendid breeze, but a horrid sea, and were scarce able to keep our feet or sleep. The *Caledonia* was very near to us for some time, but when the breeze increased to a gale and both vessels had to reef, we showed ourselves superior in point of sailing. So good was our run that on the next morning, June 10, we found ourselves not more than thirty miles from Cape Canseau, ordinarily called Cape Cancer. The wind was so fair for proceeding directly to Labrador that our captain spoke of doing so, provided it suited my views; but anxious as I am not to suffer any opportunity to escape of doing all I can to fulfill my engagements, I desired that we should pass through what is called the *Gut of Canseau*, and we came into the harbor of that name at three of the afternoon. Here we found twenty vessels, all bound to Labrador, and of course all fishermen. We had been in view of the southeastern coast of Nova Scotia all day, a dreary, poor, and inhospitable-looking country. As we dropped our anchor we had a snowfall, and the sky had an appearance such as I never before recollect having seen. Going on shore we found not a tree in blossom, though the low plants near the ground were all in bloom; I saw azaleas, white and blue violets, etc., and in some situations the grass really looked well. The Robins were in full song; one nest of that bird was found; the White-throated Sparrow and Savannah Finch were also in full song. The Snow Bunting was seen, and we were told that the Canada Grouse was very abundant, but saw none. About a dozen

houses form this settlement; there was no Custom House officer, and not an individual who could give an answer of any value to our many questions. We returned on board and supped on a fine codfish. The remainder of our day was spent in catching lobsters, of which we procured forty. They were secured simply by striking them in shallow water with a gaff-hook. It snowed and rained at intervals, and to my surprise we did not observe a single seabird.

June 11. The Great Black-backed Gull is so superior both in strength and courage to Fulmars, *Lestris*, or even Gannets, to say nothing of Gulls of all sorts, that at its approach they all give way, and until it has quite satiated itself none venture to approach the precious morsel on which it is feeding. In this respect, it is as the Eagle to the Vultures or Carrion Crows. I omitted saying that last night, before we retired to rest, after much cold, snow, rain, and hail, the frogs were piping in all the pools on the shore, and we all could hear them clearly, from the deck of the *Ripley*. The weather today is beautiful, the wind fair, and when I reached the deck at four a.m. we were underway in the wake of the whole of the fleet which last evening graced the harbor of Canseau, but which now gave life to the grand bay across which all were gliding under easy pressure of sail. The land locked us in, the water was smooth, the sky pure, and the thermometer was only 46°, quite cold; indeed, it was more grateful to see the sunshine whilst on deck this morning, and to feel its warmth, than I can recollect before at this season. After sailing for twenty-one miles, and passing one after another every vessel of the fleet, we entered the Gut of Canseau, so named by the Spanish on account of the innumerable Wild Geese which in years long past and forgotten resorted to this famed passage. The land rises on each side in the form of an amphitheater, and on the Nova Scotia side to a considerable height. Many *appearances* of dwellings exist, but the country is too poor for comfort; the timber is small, and the land very stony. Here and there a small patch of ploughed land, planted, or to be planted, with potatoes, was all we could see evincing cultivation. Near one house we saw a few apple trees yet without leaves. The general appearance of this passage reminded me of some parts of the Hudson River, and accompanied as we were by thirty smaller vessels, the time passed agreeably. Vegetation about as forward as at Eastport; saw a

Chimney Swallow, heard some Blue Jays, saw some Indians in a
bark canoe, passed Cape Porcupine, a high, rounding hill, and
Cape George, after which we entered the Gulf of St. Lawrence.

From this place, on the 20th of May last year, the sea was a
complete sheet of ice as far as a spy-glass could inform. As we
advanced, running parallel with the western coast of Cape Breton
Island, the country looked well at the distance we were from it;
the large, undulating hills were scattered with many hamlets, and
here and there a bit of cultivated land was seen. It being calm when
we reached Jestico Island, distant from Cape Breton about three
miles, we left the vessel and made for it. On landing we found
it covered with well-grown grass sprinkled everywhere with the
blossoms of the wild strawberry; the sun shone bright, and the
weather was quite pleasant. Robins, Savannah Finches, Song
Sparrows, Tawny Thrushes, and the American Redstart were
found. The Spotted Sandpiper was breeding in the grass and flew
slowly with the common tremor of their wings, uttering their
wheet-wheet-wheet note to invite me to follow them. A Raven had
a nest and three young in it, one standing near it, the old birds not
seen. Foolish Guillemot and Black Guillemot were breeding in the
rocks, and John [Woodhouse Audubon] saw several Great Blue
Heron flying in pairs, also a pair of Red-breasted Mergansers that
had glutted themselves with fish so that they were obliged to
disgorge before they could fly off. Amongst the plants the wild
gooseberry, nearly the size of a green pea, was plentiful, and the
black currant, I think of a different species from the one found in
Maine. The wind rose and we returned on board. John and the
sailors almost killed a seal with their oars.

June 12. At four this morning we were in sight of the Magdalene
Islands, or as they are called on the chart, Amherst Islands; they
appeared to be distant about twenty miles. The weather was dull
and quite calm, and I thought the prospect of reaching these isles
this day very doubtful and returned to my berth sadly disappointed.
After breakfast a thick fog covered the horizon on our bow, the
islands disappeared from sight, and the wind rose sluggishly and
dead ahead. Several brigs and ships loaded with lumber out from
Miramichi came near us, beating their way towards the Atlantic.
We are still in a great degree landlocked by Cape Breton Island,

the highlands of which look dreary and forbidding; it is now nine a.m. and we are at anchor in four fathoms of water and within a quarter of a mile of an island, one of the general group; for our pilot, who has been here for ten successive years, informs us that all these islands are connected by dry sandbars, without any other ship channel between them than the one which we have taken, and which is called Entree Bay, formed by Entree Island and a long, sandy, projecting reef connected with the main island. This latter measures forty-eight miles in length, by an average of about three in breadth; Entree Island contains about fifteen hundred acres of land, such as it is, of a red, rough, sandy formation, the northwest side constantly falling into the sea, and exhibiting a very interesting sight. Guillemots were seen seated upright along the projecting shelvings in regular order, resembling so many sentinels on the lookout. Many Gannets also were seen about the extreme point of this island. On Amherst Island we saw many houses, a small church, and on the highest land a large cross, indicating the Catholic tendency of the inhabitants. Several small schooners lay in the little harbor called Pleasant Bay, and we intend to pay them an early visit tomorrow. The wind is so cold that it feels to us all like the middle of December at Boston.

Magdalene Islands, June 13. This day week we were at Eastport and I am sure not one of our party thought of being here this day. At four this morning we were seated at breakfast around our great drawing table; the thermometer was at 44°; we blew our fingers and drank our coffee, feeling as if in the very heart of winter, and when we landed I felt so chilled that it would have been quite out of the question to use my hands for any delicate work. We landed between two great bluffs that looked down upon us with apparent anger, the resort of many a Black Guillemot and noble Raven, and following a tortuous path, suddenly came plump upon one of God's best finished jewels, a woman. She saw us first, for women are always keenest in sight and sympathy, in perseverance and patience, in fortitude, and love, and sorrow, and faith, and for aught I know, much more. At the instant that my eyes espied her, she was in full run towards her cottage, holding to her bosom a fine babe, simply covered with a very short shirt, the very appearance of which set me shivering. The woman was dressed in coarse French homespun,

a close white cotton cap which entirely surrounded her face tied under her chin, and I thought her the wildest-looking woman, both in form and face, I had seen for many a day. At a venture, I addressed her in French, and it answered well, for she responded in a wonderful jargon, about one third of which I understood, and abandoned the rest to a better linguist, should one ever come to the island. She was a plain, good woman, I doubt not, and the wife of an industrious fisherman. We walked through the woods and followed the road to the church. Who would have thought that on these wild islands, among these impoverished people, we should have found a church; that we should have been suddenly confronted with a handsome, youthful, vigorous, black-haired, black-bearded fellow in a soutane as black as the Raven's wedding-dress, and with a heart as light as a bird on the wing? Yet we met with both church and priest, and our ears were saluted by the sound of a bell which measures one foot by nine and a half inches in diameter, and weighs thirty pounds; and this bell may be heard a full quarter of a mile. It is a festival day, *La Petite Fête de Dieu.* The chapel was illuminated at six o'clock and the inhabitants, even from a distance, passed in; among them were many old women who, staff in hand, had trudged along the country road. Their backs were bent by age and toil, their eyes dimmed by time; they crossed their hands upon their breasts, and knelt before the sacred images in the church with so much simplicity and apparent truth of heart that I could not help exclaiming, "This is indeed religion!" The priest, Père Brunet, is originally from Quebec. These islands belong or are attached to Lower Canada; he, however, is under the orders of the Bishop of Halifax. He is a shrewd-looking fellow, and if I mistake not, has a dash of the devil in him. He told me there were no reptiles on the island, but this was an error; for while rambling about, Tom Lincoln, Ingalls, and John saw a snake and I heard frogs a-piping. He also told me that black and red foxes and the changeable hare, with rats lately imported, were the only quadrupeds to be found except cows, horses, and mules, of which some had been brought over many years ago and which had multi-plied, but to no great extent. The land, he assured us, was poor in every respect—soil, woods, game; that the seal fisheries had been less productive these last years than formerly. On these islands,

about a dozen in number, live one hundred and sixty families, all of whom make their livelihood by the cod, herring and mackerel fisheries. One or two vessels from Quebec come yearly to collect this produce of the ocean. Not a bird to be found larger than a Robin, but certainly thousands of those. Père Brunet said he lived the life of a recluse and invited us to accompany him to the house where he boarded and take a glass of good French wine.

During our ramble on the island we found the temperature quite agreeable; indeed, in some situations the sun was pleasant and warm. Strawberry blossoms were under our feet at every step and here and there the grass looked well. I was surprised to find the woods (by woods I mean land covered with any sort of trees, from the noblest magnolia down to dwarf cedars) rich in Warblers, Thrushes, Finches, Buntings, etc. The Fox-tailed Sparrow breeds here, the Siskin also. The Hermit and Tawny Thrushes crossed our path every few yards, the Black-capped Warbler flashed over the pools, the Winter Wren abounded everywhere. Among the water birds we found the Great Tern very abundant and shot four of them on the sand ridges. The Piping Plover breeds here—shot two males and one female; so plaintive is the note of this interesting species that I feel great aversion to killing them. These birds certainly are the swiftest of foot of any water birds which I know, of their size. We found many land snails and collected some fine specimens of gypsum.

This afternoon, being informed that across the bay where we are anchored we might, perhaps, purchase some black fox skins, we went there, and found Messieurs Muncey keen fellows; they asked $5 for black fox and $1.50 for red. No purchase on our part.

Being told that Geese, Brents, Mergansers, etc., breed eighteen miles from here, at the eastern extremity of these islands, we go off there tomorrow in boats. Saw Bank Swallows and House Swallows. The woods altogether small evergreens, extremely scrubby, almost impenetrable, and swampy beneath. At seven this evening the thermometer is at 52°. This morning it was 44°.

After our return to the *Ripley*, our captain, John, Tom Lincoln and Coolidge went off to the cliffs opposite our anchorage in search of Black Guillemots' eggs. This was found to be quite an undertaking; these birds, instead of having to *jump* or *hop* from

one place to another on the rocks, to find a spot suitable to deposit their spotted egg, as has been stated, are on the contrary excellent walkers, at least upon the rocks, and they can fly from the water to the very entrance of the holes in the fissures where the egg is laid. Sometimes this egg is deposited not more than eight or ten feet above high-water mark, at other times the fissure in the rock which has been chosen stands at an elevation of a hundred feet or more. The egg is laid on the bare rock without any preparation, but when the formation is sandy, a certain scoop is indicated on the surface. In one instance, I found two feathers with the egg; this egg is about the size of a hen's, and looks extravagantly large, splashed with black or deep umber, apparently at random, the markings larger and more frequent towards the great end. At the barking of a dog from any place where these birds breed, they immediately fly towards the animal, and will pass within a few feet of the observer, as if in defiance. At other times they leave the nest and fall in the water, diving to an extraordinary distance before they rise again. John shot a Gannet on the wing; the flesh was black and unpleasant. The Piping Plover, when missed by the shot, rises almost perpendicularly, and passes sometimes out of sight; this is, I am convinced by the many opportunities I have had to witness the occurrence, a habit of the species.

These islands are well watered by large springs, and rivulets intersect the country in many directions. We saw large flocks of Velvet Ducks feeding close to the shores; these did not appear to be in pairs. The Gannet dives quite under the water after its prey, and when empty of food rises easily off the water.

June 14, off the Gannett Rocks. We rose at two o'clock with a view to proceed to the eastern extremity of these islands in search of certain ponds wherein, so we were told, Wild Geese and Ducks of different kinds are in the habit of resorting annually to breed. Our informer added that formerly Brents bred there in abundance, but that since the erection of several buildings owned by Nova Scotians, and in the immediate vicinity of these ponds or lakes, the birds have become gradually very shy, and most of them now proceed farther north. Some of these lakes are several miles in circumference, with shallow, sandy bottoms; most of them are fresh water, the shores thickly overgrown with rank sedges and grasses, and on

the surface are many water lilies. It is among these that the wild fowl, when hid from the sight of man, deposit their eggs. Our way to these ponds would have been through a long and narrow bay, formed by what seamen call seawalls. In this place these walls are entirely of light-colored sand, and form connecting points from one island to another, thus uniting nearly the whole archipelago. Our journey was abandoned just as we were about to start, in consequence of the wind changing and being fair for our passage to Labrador, the ultimatum of our desires. Our anchor was raised, and we bid adieu to the Magdalenes. Our pilot, a Mr. Godwin from Nova Scotia, put the vessel towards what he called the "Bird Rocks," where he told us that Gannets bred in great numbers. For several days past we have met with an increased number of Gannets, and as we sailed this morning we observed long and numerous files, all flying in the direction of the rocks. Their flight now was low above the water, forming easy undulations, flapping thirty or forty times and sailing about the same distance; these were all returning from fishing, and were gorged with food for their mates or young. About ten a speck rose on the horizon, which I was told was the Rock; we sailed well, the breeze increased fast, and we neared this object apace. At eleven I could distinguish its top plainly from the deck, and thought it covered with snow to the depth of several feet; this appearance existed on every portion of the flat, projecting shelves. Godwin said, with the coolness of a man who had visited this Rock for ten successive seasons, that what we saw was not snow—but Gannets! I rubbed my eyes, took my spyglass, and in an instant the strangest picture stood before me. They were birds we saw, a mass of birds of such a size as I never before cast my eyes on. The whole of my party stood astounded and amazed, and all came to the conclusion that such a sight was of itself sufficient to invite anyone to come across the Gulf to view it at this season. The nearer we approached, the greater our surprise at the enormous number of these birds, all calmly seated on their eggs or newly hatched brood, their heads all turned to windward and towards us. The air above for a hundred yards, and for some distance around the whole rock, was filled with Gannets on the wing, which from our position made it appear as if a heavy fall of snow was directly above us. Our pilot told us the wind was too

high to permit us to land, and I felt sadly grieved at this unwelcome news. Anxious as we all were, we decided to make the attempt; our whaleboat was overboard, the pilot, two sailors, Tom Lincoln and John pushed off with guns and clubs. Our vessel was brought to, but at that instant the wind increased, and heavy rain began to fall. Our boat neared the rock and went to the lee of it and was absent nearly an hour but could not land. The air was filled with Gannets, but no difference could we perceive on the surface of the rock. The birds, which we now could distinctly see, sat almost touching each other and in regular lines, seated on their nests quite unconcerned. The discharge of the guns had no effect on those that were not touched by the shot, for the noise of the Gulls, Guillemots, etc., deadened the sound of the gun; but where the shot took effect, the birds scrambled and flew off in such multitudes, and in such confusion, that whilst some eight or ten were falling into the water either dead or wounded, others pushed off their eggs, and these fell into the sea by hundreds in all directions.

The sea now becoming very rough, the boat was obliged to return, with some birds and some eggs; but the crew had not climbed the rock, a great disappointment to me. Godwin tells me the top of the rock is about a quarter of a mile wide, north and south, and a little narrower east and west; its elevation above the sea between three and four hundred feet. The sea beats round it with great violence except after long calms, and it is extremely difficult to land upon it and much more so to climb to the top of it, which is a platform; it is only on the southeast shore that a landing can be made, and the moment a boat touches, it must be hauled up on the rocks. The whole surface is perfectly covered with nests, placed about two feet apart, in such regular order that you may look through the lines as you would look through those of a planted patch of sweet potatoes or cabbages. The fishermen who kill these birds to get their flesh for codfish bait ascend in parties of six or eight, armed with clubs; sometimes, indeed, the party comprises the crews of several vessels. As they reach the top, the birds, alarmed, rise with a noise like thunder and fly off in such hurried, fearful confusion as to throw each other down, often falling on each other till there is a bank of them many feet high. The men strike them down and kill them until fatigued or satisfied. Five

hundred and forty have been thus murdered in one hour by six men. The birds are skinned with little care and the flesh cut off in chunks; it will keep fresh about a fortnight.

The nests are made by scratching down a few inches and the edges surrounded with seaweeds. The eggs are pure white and as large as those of a Goose. By the 20th of May the rock is already covered with birds and eggs; about the 20th of June they begin to hatch. So great is the destruction of these birds annually that their flesh supplies the bait for upwards of forty fishing-boats which lie close to the Byron Island each season. When the young are hatched they are black, and for a fortnight or more the skin looks like that of the dogfish. They become gradually downy and white, and when two months old look much like young lambs. Even while shooting at these birds, hundreds passed us carrying great masses of weeds to their nests. The birds were thick above our heads and I shot at one to judge of the effect of the report of the gun; it had none. A great number of Kittiwake Gulls breed on this rock, with thousands of Foolish Guillemots. The Kittiwake makes its nest of eel weeds, several inches in thickness, and in places too small for a Gannet or a Guillemot to place itself; in some instances these nests projected some inches over the edge of the rock. We could not see any of their eggs.

The breeze was now so stiff that the waves ran high; so much so that the boat was perched on the comb of the wave one minute, the next in the trough. John steered, and he told me afterward he was nearly exhausted. The boat was very cleverly hauled on deck by a single effort. The stench from the rock is insufferable, as it is covered with the remains of putrid fish, rotten eggs and dead birds, old and young. No man who has not seen what we have this day can form the least idea of the impression the sight made on our minds. By dark it blew a gale and we are now most of us rather shaky; rain is falling in torrents, and the sailors are reefing. I forgot to say that when a man walks towards the Gannets, they will now and then stand still, merely opening and shutting their bills; the Gulls remained on their nests with more confidence than the Guillemots, all of which flew as we approached. The feathering of the Gannet is curious, differing from that of most other birds, inasmuch as each feather is concave and divided in its contour

from the next. Under the roof of the mouth and attached to the upper mandible are two fleshy appendages like two small wattles.

June 15. All our party except Coolidge were deadly sick. The thermometer was down to 43° and every sailor complained of the cold. It has rained almost all day. I felt so very sick this morning that I removed from my berth to a hammock, where I soon felt rather more easy. We lay to all this time, and at daylight were in sight of the Island of Anticosti, distant about twenty miles; but the fog soon after became so thick that nothing could be observed. At about two we saw the sun, the wind hauled dead ahead, and we ran under one sail only.

June 16, Sunday. The weather clear, beautiful, and much warmer; but it was calm, so we fished for cod, of which we caught a good many; most of them contained crabs of a curious sort, and some were filled with shrimps. One cod measured three feet six and a half inches and weighed twenty-one pounds. Found two curious insects fastened to the skin of a cod, which we saved. At about six o'clock the wind sprang up fair and we made all sail for Labrador.

June 17. I was on deck at three this morning; the sun, although not above the horizon, indicated to the mariner at the helm one of those doubtful days the result of which seldom can be truly ascertained until sunset. The sea was literally covered with Foolish Guillemots, playing in the very spray of the bow of our vessel, plunging under it as if in fun, and rising like spirits close under our rudder. The breeze was favorable, although we were hauled to the wind within a point or so. The helmsman said he saw land from aloft, but the captain pronounced his assertion must be a mistake, by true calculation. We breakfasted on the best of fresh codfish, and I never relished a breakfast more. I looked on our landing on the coast of Labrador as a matter of great importance. My thoughts were filled not with airy castles but with expectations of the new knowledge of birds and quadrupeds which I hoped to acquire. The *Ripley* ploughed the deep and proceeded swiftly on her way; she always sails well, but I thought that now as the land was expected to appear every moment she fairly skipped over the waters. At five o'clock the cry of land rang in our ears, and my heart bounded with joy; so much for anticipation. We sailed on, and in less than an hour the land was in full sight from the deck.

We approached and saw, as we supposed, many sails, and felt delighted at having hit the point in view so very closely; but, after all, the sails proved to be large snow-banks. We proceeded, how-ever, the wind being so very favorable that we could either luff or bear away. The air was now filled with Velvet Ducks; *millions* of these birds were flying from the northwest towards the southeast. The Foolish Guillemots and the Razor-billed Auk were in immense numbers, flying in long files a few yards above the water with rather undulating motions and passing within good gunshot of the vessel, and now and then rounding to us as if about to alight on the very deck. We now saw a schooner at anchor, and the country looked well at this distance, and as we neared the shore the thermometer, which had been standing at 44°, now rose up to nearly 60°; yet the appearance of the great snowdrifts was forbidding. The shores appeared to be margined with a broad and handsome sand beach; our imaginations now saw bears, wolves, and devils of all sorts scampering away on the rugged shore. When we reached the schooner we saw beyond some thirty fishing-boats fishing for cod, and to our great pleasure found Captain Billings of Eastport standing in the bow of his vessel; he bid us welcome and we saw the codfish thrown on his deck by thousands. We were now opposite to the mouth of the Natasquan River, where the Hudson's Bay Company have a fishing establishment but where no American vessels are allowed to come in. The shore was lined with bark-covered huts and some vessels were within the bight, or long point of land which pushes out from the extreme eastern side of the entrance of the river.

We went on to an American Harbor, four or five miles distant to the westward, and after a while came to anchor in a small bay perfectly secure from any winds. And now we are positively on the Labrador coast, latitude 50° and a little more—farther north than I ever was before. But what a country! When we landed and passed the beach, we sank nearly up to our knees in mosses of various sorts, producing as we moved through them a curious sensation. These mosses, which at a distance look like hard rocks, are, under foot, like a velvet cushion. We scrambled about, and with anxiety stretched our necks and looked over the country far and near, but not a square foot of *earth* could we see. A poor, rugged, miserable

country; the trees like so many mops of wiry composition, and where the soil is not rocky it is boggy up to a man's waist. We searched and searched; but, after all, only shot an adult Pigeon Hawk, a summer-plumage Tell-tale Godwit, and a Razor-billed Auk. We visited all the islands about the harbor; they were all rocky, nothing but rocks. The Great Black-backed Gull was sailing magnificently all about us. The Great Tern was plunging after shrimps in every pool, and we found four eggs of the Spotted Sandpiper; the nest was situated under a rock in the grass, and made of a quantity of dried grass forming a very decided nest, at least much more so than in our Middle States, where the species breed so very abundantly. Wild Geese were seen by our party, and these birds also breed here; we saw Loons and Eider Ducks, Dusky Ducks and the Scoter Duck. We came to our anchorage at twenty minutes past twelve. Tom Lincoln and John heard a Ptarmigan. Toads were abundant. We saw some rare plants, which we preserved, and butterflies and small bees were among the flowers which we gathered.

We also saw Red-breasted Mergansers. The male and female Eider Ducks separate as soon as the latter begin to lay; after this they are seen flying in large flocks, each sex separately. We found a dead basking shark, six and a half feet long; this fish had been wounded by a harpoon and ran ashore or was washed there by the waves. At Eastport fish of this kind have been killed thirty feet long.

June 18. I remained on board all day drawing; our boats went off to some islands eight or ten miles distant after birds and eggs, but the day, although very beautiful, did not prove valuable to us, as some eggers from Halifax had robbed the places ere the boats arrived. We, however, procured about a dozen Razor-billed Auks, Foolish Guillemots, a female Eider Duck, a male Surf Duck, and a Sandpiper—which, I cannot ascertain, although the Least Sandpiper I ever saw, not the Least Auklet of Bonaparte's *Synopsis*. Many nests of the Eider Duck were seen, some at the edge of the woods, placed under the rampant boughs of the fir trees, which in this latitude grow only a few inches above the surface of the ground, and to find the nest these boughs had to be raised. The nests were scooped a few inches deep in the mossy, rotten substance that

forms here what must be called earth; the eggs are deposited on a
bed of down and covered with the same material; and so warm are
these nests that although not a parent bird was seen near them,
the eggs were quite warm to the touch and the chicks in some
actually hatching in the absence of the mother. Some of the nests
had the eggs uncovered; six eggs was the greatest number found in
a nest. The nests found on grassy islands are fashioned in the same
manner and generally placed at the foot of a large tussock of grass.
Two female Ducks had about twelve young on the water, and these
they protected by flapping about the water in such a way as to raise
a spray, whilst the little ones dove off in various directions.

Flocks of thirty to forty males were on the wing without a single
female among them. The young birds procured were about one
week old, of a dark mouse color, thickly covered with a soft and
warm down, and their feet appeared to be more perfect for their
age than any other portion because more necessary to secure their
safety and to enable them to procure food. John found many nests
of the Great Black-backed Gull of which he brought both eggs
and young.

The nest of this fine bird is made of mosses and grasses, raised
on the solid rock, and handsomely formed within; a few feathers
are in this lining. Three eggs, large, hard-shelled, with ground
color of dirty yellowish, splashed and spotted with dark umber and
black. The young, although small, were away from the nest a few
feet, placing themselves to the lee of the nearest sheltering rock.
They did not attempt to escape but when taken uttered a cry not
unlike that of a young chicken under the same circumstances. The
parents were so shy and so wary that none could be shot. At the
approach of the boats to the rocks where they breed, a few standing
as sentinels gave the alarm, and the whole rose immediately in the
air to a great elevation. On another rock, not far distant, a number
of Gulls of the same size, white, and with the same hoarse note,
were to be seen, but they had no nests; these, I am inclined to
think (at present) the bird called the Herring Gull...They fly
altogether, but the white ones do not alight on the rocks where the
Black-backed has its nests. John watched their motion and their
cry very closely, and gave me this information.

Two eggs of a Tern resembling the Cayenne Tern were found

in a nest on the rocks, made of moss also, but the birds, although the eggs were nearly ready to hatch, kept out of gunshot. These eggs measured one and a half inches in length, very oval, whitish, spotted and dotted irregularly with brown and black all over. The cry of those Terns which *I* saw this afternoon resembles that of the Cayenne Tern that I met with in the Floridas, and I could see a large orange bill, but could not discern the black feet. Many nests of the Great Tern were found, two eggs in each, laid on the short grass scratched out, but no nest. One Least Sandpiper, the smallest I ever saw, was procured; these small gentry are puzzles indeed; I do not mean to say in nature, but in Charles [Bonaparte's] *Synopsis*. We went ashore this afternoon and made a bear trap with a gun, baited with heads and entrails of codfish, Bruin having been seen within a few hundred yards of where the lure now lies in wait. It is truly interesting to see the activity of the cod-fishermen about us, but I will write of this when I know more of their filthy business.

June 19. Drawing as much as the disagreeable motion of the vessel would allow me to do; and although at anchor and in a good harbor, I could scarcely steady my pencil, the wind being high from southwest. At three a.m. I had all the young men up and they left by four for some islands where the Great Black-backed Gull breeds. The captain went up the little Natasquan River. When John returned he brought eight Razor-billed Auks and four of their eggs *identified*; these eggs measure three inches in length, one and seven-eighths in breadth, dirty-white ground, broadly splashed with deep brown and black, more so towards the greater end. This Auk feeds on fish of a small size, flies swiftly with a quick beat of the wings, rounding to and fro at the distance of fifty or more yards, exhibiting as it turns the pure white of its lower parts or the jet black of its upper. These birds sit on the nest in an almost upright position; they are shy and wary, diving into the water or taking flight at the least appearance of danger; if wounded slightly they dive and we generally lost them, but if unable to do this, they throw themselves on their back and defend themselves fiercely, biting severely who-ever attempts to seize them.

They run over and about the rocks with ease, and not awkwardly as some have stated. The flesh of this bird when stewed in a particular manner is good eating, much better than would be

expected from birds of its class and species. The Herring Gull breeds on the same islands, and we found many eggs; the nests were all on the rocks, made of moss and grasses and rather neat inwardly. The Arctic Tern was found breeding abundantly; we took some of their eggs; there were two in each nest, one and a quarter inches long, five-eighths broad, rather sharp at the little end. The ground is light olive, splashed with dark umber irregularly and more largely at the greater end; these were deposited two or three on the rocks, wherever a little grass grew, no nest of any kind apparent. In habits this bird resembles the Common Tern and has nearly the same harsh note; it feeds principally on shrimps, which abound in these waters. Five young Black-backed Gulls were brought alive, small and beautifully spotted yet over the head and back somewhat like a leopard; they walked well about the deck, and managed to pick up the food given them; their cry was a *hac, hac, hac, wheet, wheet, wheet.* Frequently, when one was about to swallow a piece of flesh, a brother or sister would jump at it, tug, and finally deprive its relative of the morsel in an instant. John assured me that the old birds were too shy to be approached at all. John shot a fine male of the Scoter Duck, which is scarce here. Saw some Wild Geese, which breed here, though they have not yet formed their nests. The Red-breasted Merganser breeds also here but is extremely shy and wary, flying off as far as they can see us, which to me in this wonderfully wild country is surprising; indeed, thus far all the seafowl are much wilder than those of the Floridas.

Twenty nests of a species of Cormorant not yet ascertained were found on a small, detached, rocky island; these were built of sticks, seaweeds and grasses on the naked rock and about two feet high, as filthy as those of their relations the Floridians. Three eggs were found in one nest, which is the complement, but not a bird could be shot—too shy and vigilant. This afternoon the captain and I walked to the Little Natasquan River and proceeded up it about four miles to the falls or rapids—a small river, dark, irony waters, sandy shores and impenetrable woods along these, except here and there is a small space overgrown with short wiry grass unfit for cattle; a thing of little consequence, as no cattle are to be found here. Returning this evening the tide had so fallen that we waded

a mile and a half to an island close to our anchorage; the sailors were obliged to haul the boat that distance in a few inches of water. We have removed the *Ripley* closer in shore where I hope she will be steady enough for my work tomorrow.

June 20. Thermometer 60° at noon. Calm and beautiful. Drew all day, and finished two Foolish Guillemot. I rose at two this morning, for we have scarcely any darkness now; about four a man came from Captain Billings to accompany some of our party to Partridge Bay on a shooting excursion. John and his party went off by land, or rather by rock and moss, to some ponds three or four miles from the sea; they returned at four this afternoon and brought only one Scoter Duck, male; saw four, but could not discover the nests, although they breed here; saw also about twenty Wild Geese, one pair Red-necked Divers, one White-winged Scoter, one Three-toed Woodpecker, and Tell-tale Godwits. The ponds, although several miles long and of good proportion and depth, had no fish in them that could be discovered and on the beach no shells nor grasses; the margins are reddish sand. A few toads were seen, which John described as "pale-looking and poor." The country a barren rock as far as the eye extended; mosses more than a foot deep on the average, of different varieties but principally the white kind, hard and crisp. Saw not a quadruped. Our bear trap was discharged, but we could not find the animal for want of a dog. An Eider Duck's nest was found fully one hundred yards from the water, unsheltered on the rocks, with five eggs and clean down. In no instance, though I have tried with all my powers, have I approached nearer than eight or ten yards of the sitting birds; they fly at the least appearance of danger. We concluded that the absence of fish in these ponds was on account of their freezing solidly every winter, when fish must die. Captain Billings paid me a visit and very generously offered to change our whale-boat for a large one and his pilot boat for ours; the industry of this man is extraordinary. The specimen of Brindled Guillemot drawn with a white line round the eye was a female; the one without this line was a young bird. I have drawn seventeen and a half hours this day, and my poor head aches badly enough.

One of Captain Billings' mates told me of the Petrels breeding in great numbers in and about Mount Desert Island rocks in the

months of June and July; there they deposit their one white egg in the deepest fissures of the rocks and sit upon it only during the night. When approached whilst on the egg, they open their wings and bill, and offer to defend themselves from the approach of intruders. The Eider Ducks are seen leaving the islands on which they breed at daybreak every fair morning in congregated flocks of males or females separately, and proceed to certain fishing grounds where the water is only a few fathoms deep and remain till towards evening, when the females sit on their eggs for the night and the males group on the rocks by themselves. This valuable bird is extremely abundant here; we find their nests without any effort every time we go out. So sonorous is the song of the Fox-colored Sparrow that I can hear it for hours, most distinctly, from the cabin where I am drawing, and yet it is distant more than a quarter of a mile. This bird is in this country what the Towhee Bunting is in the Middle States.

June 21. I drew all day at an adult Gannet which we brought from the great rock of which I have spoken; it was still in good order. Many eggs of the Arctic Tern were collected today, two or three in a nest; these birds are as shy here as all others and the moment John and Coolidge landed, or indeed approached the islands on which they breed, they all rose in the air, passed high overhead, screaming and scolding all the time the young men were on the land. When one is shot the rest plunge towards it and can then be easily shot. Sometimes when wounded in the body they sail off to extraordinary distances and are lost. The same is the case with the Black-backed Gull. When our captain returned he brought about a dozen female Eider Ducks, a great number of their eggs and a bag of down; also a fine Wild Goose, but nothing new for the pencil. In one nest of the Eider ten eggs were found; this is the most we have seen as yet in any one nest. The female draws the down from her abdomen as far towards her breast as her bill will allow her to do, but the *feathers* are not pulled, and on examination of several specimens I found these well and regularly planted and cleaned from their original down, as a forest of trees is cleared of its undergrowth. In this state the female is still well clothed, and little or no difference can be seen in the plumage unless examined. These birds have now nearly all hatched in this

latitude, but we are told that we shall overreach them in that and meet with nests and eggs as we go northeast until August.

So abundant were the nests of these birds on the islands of Partridge Bay, about forty miles west of this place, that a boatload of their eggs might have been collected if they had been fresh; they are then excellent eating. Our captain called on a half-breed Indian in the employ of the Northeast Fur and Fish Co., living with his squaw and two daughters. A potato patch of about an acre was planted in *sand*, for not a foot of *soil* is there to be found hereabouts. The man told him his potatoes grew well and were good, ripening in a few weeks, which he called the summer. The mosquitoes and black gnats are bad enough on shore. I heard a Wood Pewee.

The Wild Goose is an excellent diver, and when with its young uses many beautiful stratagems to save its brood and elude the hunter. They will dive and lead their young under the surface of the water, and always in a contrary direction to the one expected; thus if you row a boat after one it will dive under it and now and then remain under it several minutes, when the hunter with outstretched neck is looking all in vain in the distance for the *stupid Goose!* Every time I read or hear of a stupid animal in a wild state I cannot help wishing that the stupid animal who speaks thus was half as wise as the brute he despises, so that he might be able to thank his Maker for what knowledge he may possess.

I found many small flowers open this day where none appeared last evening. All vegetable life here is of the pygmy order, and so ephemeral that it shoots out of the tangled mass of ages, blooms, fructifies and dies in a few weeks.

We ascertained today that a party of four men from Halifax took last spring nearly forty thousand eggs, which they sold at Halifax and other towns at twenty-five cents per dozen, making over $800; this was done in about two months. Last year upwards of twenty sail were engaged in "egging"; so some idea may be formed of the birds that are destroyed in this rascally way. The eggers destroy all the eggs that are sat upon, to force the birds to lay again, and by robbing them regularly they lay till nature is exhausted and few young are raised. In less than half a century these wonderful nurseries will be entirely destroyed, unless some kind government will interfere to stop the shameful destruction.

June 22. It was very rainy, and thermometer 54°. After breakfast
dressed in my oilskins and went with the captain in the whale-
boat to the settlement at the entrance of the true Natasquan, five
miles east. On our way we saw numerous seals; these rise to the
surface of the water, erect the head to the full length of the neck,
snuff the air and you also, and sink back to avoid any further
acquaintance with man. We saw a great number of Gulls of various
kinds, but mostly Black-backed and Kittiwakes; these were on
the extreme points of sandbars but could not be approached, and
certainly the more numerous they are, the more wild and wary.

On entering the river we saw several nets set across a portion of
the stream for the purpose of catching salmon; these seines were
fastened in the stream about sixty yards from either shore supported
by buoys; the net is fastened to the shore by stakes that hold
it perpendicular to the water; the fish enter these and entangle
themselves until removed by the fishermen. On going to a house
on the shore, we found it a tolerably good cabin, floored, containing
a good stove, a chimney and an oven at the bottom of this like the
ovens of the French peasants, three beds and a table whereon the
breakfast of the family was served. This consisted of coffee in large
bowls, good bread and fried salmon. Three Labrador dogs came
and sniffed about us and then returned under the table whence
they had issued, with no appearance of anger. Two men, two
women and a babe formed the group, which I addressed in French.
They were French-Canadians and had been here several years,
winter and summer, and are agents for the Fur and Fish Co., who
give them food, clothes and about $80 per annum. They have a
cow and an ox, about an acre of potatoes planted in sand, seven
feet of snow in winter and two-thirds less salmon than was caught
here ten years since. Then three hundred barrels was a fair season;
now one hundred is the maximum; this is because they will catch
the fish both ascending and descending the river. During winter
the men hunt foxes, martens and sables and kill some bear of the
black kind, but neither deer nor other game is to be found without
going a great distance in the interior where reindeer are now and
then procured. One species of Grouse and one of Ptarmigan, the
latter white at all seasons; the former I suppose to be the Willow
Grouse. The men would neither sell nor give us a single salmon,

saying that so strict were their orders that should they sell *one*, the place might be taken from them. If this should prove the case everywhere I shall not purchase many for my friends. The furs which they collect are sent off to Quebec at the first opening of the waters in spring and not a skin of any sort was here for us to look at.

We met here two large boats containing about twenty Montagnais Indians, old and young, men and women. They carried canoes lashed to the sides like whale ships, for the seal fishery. The men were stout and good-looking, spoke tolerable French, the skin redder than any Indians I have ever seen, and more *clear*; the women appeared cleaner than usual, their hair braided and hanging down, jet black but short. All were dressed in European costume except the feet, on which coarse moccasins of sealskin took the place of shoes. I made a bargain with them for some Grouse, and three young men were dispatched at once. On leaving the harbor this morning we saw a black man-of-war-like looking vessel entering it with the French flag; she anchored near us, and on our return we were told it was the Quebec cutter. I wrote a note to the officer commanding, enclosing my card and requesting an interview. The commander replied he would receive me in two hours. His name was Captain Bayfield, the vessel the *Gulnare*. The sailor who had taken my note was asked if I had procured many birds, and how far I intended to proceed.

After dinner, which consisted of hashed Eider Ducks, which were very good, the females always being fat when sitting, I cut off my three weeks' beard, put on clean linen and with my credentials in my pocket went to the *Gulnare*. I was received politely and after talking on deck for a while was invited into the cabin and was introduced to the doctor, who appeared to be a man of talents, a student of botany and conchology. Thus men of the same tastes meet everywhere, yet surely I did not expect to meet a naturalist on the Labrador coast. The vessel is on a surveying cruise and we are likely to be in company the whole summer. The first lieutenant studies ornithology and collects. After a while I gave my letter from the Duke of Sussex to the captain, who read and returned it without comment. As I was leaving the rain poured down and I was invited to remain, but declined; the captain promised to do

anything for me in his power. Saw many Siskins, but cannot get a shot at one.

June 23. It was our intention to have left this morning for another harbor about fifty miles east, but the wind being dead ahead we are here still. I have drawn all day at the background of the Gannets. John and party went off about six miles and returned with half a dozen Guillemots and ten or twelve dozen eggs. Coolidge brought in Arctic Terns and Black-backed Gulls, two young of the latter about three weeks old having the same voice and notes as the old ones. When on board they ran about the deck and fed themselves with pieces of fish thrown to them. These young Gulls as well as young Herons of every kind sit on the tarsus when fatigued with their feet extended before them in a very awkward-looking position, but one which to them is no doubt comfortable.

Shattuck and I took a walk over the dreary hills about noon; the sun shone pleasantly and we found several flowers in full bloom, amongst which the *Kalmia glauca* [swamp laurel], a beautiful small species, was noticeable. The captain and surgeon from the *Gulnare* called and invited me to dine with them tomorrow. This evening we have been visiting the Montagnais Indians' camp, half a mile from us, and found them skinning seals and preparing the flesh for use. Saw a robe the size of a good blanket made of sealskins tanned so soft and beautiful, with the hair on, that it was as pliant as a kid glove; they would not sell it. The chief of the party proves to be well-informed and speaks French so as to be understood. He is a fine-looking fellow of about forty; has a good-looking wife and fine babe. His brother is also married and has several sons from fourteen to twenty years old.

When we landed the men came to us, and after the first salutations, to my astonishment offered us some excellent rum. The women were all seated apart outside of the camp, engaged in closing up sundry packages of provisions and accoutrements. We entered a tent and seated ourselves round a cheerful fire, the smoke of which escaped through the summit of the apartment, and over the fire two kettles boiled. I put many questions to the chief and his brother and gained this information. The country from here to the first settlement of the Hudson's Bay Co. is as barren and rocky

as that about us. Very large lakes of great depth are met with about two hundred miles from this seashore; these lakes abound in very large trout, carp and whitefish, and many mussels, unfit to eat, which they describe as black outside and purple within, and are no doubt unios. Not a bush is to be met with, and the Indians who now and then go across are obliged to carry their tent poles with them as well as their canoes; they burn moss for fuel. So tedious is the traveling said to be that not more than ten miles on an average per day can be made, and when the journey is made in two months it is considered a good one. Wolves and black bear are frequent, no deer and not many caribous; not a bird of any kind except Wild Geese and Brent about the lakes, where they breed in perfect peace. When the journey is undertaken in the winter, which is very seldom the case, it is performed on snowshoes and no canoes are taken. Fur animals are scarce, yet some few Beavers and Otters are caught, a few Martens and Sables and some Foxes and Lynx, but every year diminishes their numbers. The Fur Company may be called the exterminating medium of these wild and almost uninhabitable climes, where cupidity and the love of gold can alone induce man to reside for a while. Where can I go now and visit nature undisturbed?

The American Robin must be the hardiest of the whole genus. I hear it at this moment, eight o'clock at night, singing most joyously its "Good-night!" and "All's well!" to the equally hardy Labradoreans. The common Crow and the Raven are also here, but the Magdalene Islands appear to be the last outpost of the Warblers, for here the Black-poll Warbler, the only one we see, is scarce. The White-throated and the White-crowned Sparrows are the only tolerably abundant land birds. The Indians brought in no Grouse. A fine adult specimen of the Black-backed Gull killed this day has already changed full half of its primary feathers next the body; this bird had two young ones and was shot as it dove through the air towards John, who was near the nest; this is the first instance we have seen of so much attachment being shown to the progeny with danger at hand. Two male Eider Ducks were shot and found very much advanced in the molt. No doubt exists in my mind that male birds are much in advance of female in their molts; this is very slow, and indeed is not completed until late in winter, after

which the brilliancy of the bills and the richness of the coloring of the legs and feet only improve as they depart from the south for the north.

June 24. Drawing most of this day, no birds procured, but some few plants. I dined on board the *Gulnare* at five o'clock and was obliged to shave and dress—quite a bore on the coast of Labrador, believe me. I found the captain, surgeon and three officers formed our party; the conversation ranged from botany to politics, from the Established Church of England to the hatching of eggs by steam. I saw the maps being made of this coast and was struck with the great accuracy of the shape of our present harbor, which I now know full well. I returned to our vessel at ten and am longing to be farther north; but the wind is so contrary it would be a loss of time to attempt it now. The weather is growing warmer and mosquitoes are abundant and hungry. Coolidge shot a White-crowned Sparrow, a male, while in the act of carrying some materials to build a nest with; so they must breed here.

June 25. Made a drawing of the Arctic Tern, of which a great number breed here. I am of Temminck's opinion that the upper plumage of this species is much darker than that of the Common Tern. The young men, who are always ready for sport, caught a hundred codfish in half an hour, and *somewhere* secured three fine salmon, one of which we sent to the *Gulnare* with some cod. Our harbor is called "American Harbor," and also "Little Natasquan"; it is in latitude 50° 12′ north, longitude 23° east of Quebec and 61° 53′ west of Greenwich. The waters of all the streams which we have seen are of a rusty color, probably on account of the decomposed mosses, which appear to be quite of a peaty nature. The rivers appear to be formed by the drainage of swamps fed apparently by rain and the melting snows, and in time of freshets the sand is sifted out and carried to the mouth of every stream, where sandbars are consequently met with. Below the mouth of each stream proves to be the best station for cod-fishing, as there the fish accumulate to feed on the fry which runs into the river to deposit spawn, and which they follow to sea after this as soon as the fry make off from the rivers to deep water. It is to be remarked that so shy of strangers are the agents of the Fur and Fish Company that they will evade all questions respecting the interior of the country, and indeed will

willingly tell you such untruths as at once disgust and shock you. All this through the fear that strangers should attempt to settle here and divide with them the profits which they enjoy.

Bank Swallows in sight this moment, with the weather thick, foggy, and an east wind; where are these delicate pilgrims bound? The Black-poll Warbler is more abundant and forever singing, if the noise it makes can be called a song; it resembles the clicking of small pebbles together five or six times and is renewed every few minutes.

June 26. We have been waiting five days for wind and so has the *Gulnare.* The fishing fleet of six or seven sails has made out to beat four miles to other fishing grounds. It has rained nearly all day but we have all been on shore, to be beaten back by the rain and the mosquitoes. John brought a female White-crowned Sparrow; the black and white of the head was as pure as in the male, which is not common. It rains hard, and is now calm. God send us a fair wind tomorrow morning, and morning here is about half-past two.

June 27. It rained quite hard when I awoke this morning; the fog was so thick the very shores of our harbor, not distant more than a hundred yards, were enveloped in gloom. After breakfast we went ashore; the weather cleared up and the wind blew fresh. We rambled about the brushwoods till dinnertime, shot two Canada Jays, one old and one young, the former much darker than those of Maine; the young one was full fledged, but had no white about its head; the whole of the body and head was of a deep, very deep blue. It must have been about three weeks old, and the egg from which it was hatched must have been laid about the 10th of May, when the thermometer was below the freezing point. We shot also a Ruby-crowned Wren; no person who has not heard it would believe that the song of this bird is louder, stronger and far more melodious than that of the Canary bird. It sang for a long time ere it was shot, and perched on the tops of the tallest fir trees removing from one to another as we approached. So strange, so beautiful was that song that I pronounced the musician, ere it was shot, a new species of Warbler. John shot it; it fell to the ground, and though the six of us looked for it we could not find it, and went elsewhere; in the course of the afternoon we passed by the spot again and John found it and gave it to me. We shot a new

species of Finch, which I have named *Fringilla lincolnii*; it is allied to the Swamp Sparrow in general appearance, but is considerably smaller, and may be known at once from all others thus far described by the light buff streak which runs from the base of the lower mandible until it melts into the duller buff of the breast, and by the bright ash streak over the eye. The note of this bird attracted me at once; it was loud and sonorous; the bird flew low and forward, perching on the firs, very shy, and cunningly eluding our pursuit; we however shot three, but lost one. I shall draw it tomorrow.

June 28. The weather shocking—rainy, foggy, dark and cold. I began drawing at daylight and finished one of my new Finches and outlined another. At noon the wind suddenly changed and blew hard from the northwest with heavy rain and such a swell that I was almost seasick and had to abandon drawing. We dined and immediately afterward the wind came round to southwest; all was bustle with us and with the *Gulnare*, for we both were preparing our sails and raising our anchors ere proceeding to sea. *We* sailed, and managed so well that we cleared the outer cape east of our harbor and went out to sea in good style. The *Gulnare* was not so fortunate; she attempted to beat out in vain, and returned to her anchorage. The sea was so high in consequence of the late gales that we all took to our berths, and I am only now able to write.

June 29. At three this morning we were off the land about fifteen miles, and about fifty from American Harbor. Wind favorable but light; at about ten it freshened. We neared the shore, but as before, our would-be pilot could not recognize the land and our captain had to search for the harbor where we now are, himself. We passed near an island covered with Foolish Guillemots and came to for the purpose of landing; we did so through a heavy surf and found two eggers just landed and running over the rocks for eggs. We did the same and soon collected about a hundred. These men told me they visited every island in the vicinity every day, and that in consequence they had fresh eggs every day. They had collected eight hundred dozen and expect to get two thousand dozen. The number of broken eggs created a fetid smell on this island scarcely to be borne. The Black-backed Gulls were here in hundreds and destroying the eggs of the Guillemots by thousands.

From this island we went to another and there found the Common Puffin breeding in great numbers. We caught many in their burrows, killed some and collected some of the eggs. On this island their burrows were dug in the light black loam formed of decayed moss, three to six feet deep yet not more than about a foot under the surface. The burrows ran in all directions and in some instances connected; the end of the burrow is rounded and there is the pure white egg. Those caught at the holes bit most furiously and scratched shockingly with the inner claw, making a mournful noise all the time. The whole island was perforated with their burrows. No young were yet hatched, and the eggers do not collect these eggs, finding them indifferent. They say the same of the eggs of the Razor-billed Auk, which they call "Tinkers." The Puffin they call "Sea Parrots." Each species seems to have its own island, except the Auks which admits the Guillemots.

As we advanced we passed by a rock literally covered with Cormorants, of what species I know not yet; their effluvia could be perceived more than a mile off. We made the fine anchorage where we now are about four o'clock. We found some difficulty in entering on account of our pilot being an ignorant ass; *twice* did we see the rocks under our vessel. The appearance of the country around is quite different from that near American Harbor; nothing in view here as far as eye can reach but bare, high, rugged rocks, grand indeed, but not a shrub a foot above the ground. The moss is shorter and more compact, the flowers are fewer and every plant more diminutive. No matter which way you glance the prospect is cold and forbidding; deep banks of snow appear here and there and yet I have found the Shore Lark in beautiful summer plumage. I found the nest of the Brown Lark with five eggs in it; the nest was planted at the foot of a rock, buried in dark mould and beautifully made of fine grass, well and neatly worked in circularly without any hair or other lining. We shot a White-crowned Sparrow, two Savannah Finches, and saw more, and a Red-bellied Nuthatch; this last bird must have been blown here accidentally, as not a bush is there for it to alight upon. I found the tail of an unknown Owl, and a dead Snowbird which from its appearance must have died from cold and famine. John brought a young Cormorant alive from the nest but I cannot ascertain its species without the adult, which we hope to

secure tomorrow. At dusk the *Gulnare* passed us. All my young men are engaged in skinning the Puffins.

June 30. I have drawn three birds this day since eight o'clock, one *Fringilla lincolnii*, one Ruby-crowned Wren, and a male White-winged Crossbill. Found a nest of the Savannah Finch with two eggs; it was planted in the moss and covered by a rampant branch; it was made of fine grass, neither hair nor feathers in its composition. Shot the Black-backed Gulls in fine order, all with the wings extending nearly two inches beyond the tail, and all in the same state of molt, merely showing in the middle primaries. These birds suck other birds' eggs like Crows, Jays, and Ravens. Shot six Common Cormorants in full plumage, species well ascertained by their white throat; found abundance of their eggs and young.

July 1. The weather was so cold that it was painful for me to draw almost the whole day, yet I have drawn a White-winged Crossbill and a Puffin. We have had three of these latter on board alive these three days past; it is amusing to see them running about the cabin and the hold with a surprising quickness, watching our motions and particularly our eyes. A Pigeon Hawk's nest was found today; it was on the top of a fir tree about ten feet high, made of sticks and lined with moss and as large as a Crow's nest; it contained two birds just hatched and three eggs, which the young inside had just cracked. The parent birds were anxious about their newly born ones and flew close to us. The little ones were pure white, soft and downy. We found also three young of the American Ring Plover and several old ones; these birds breed on the margin of a small lake among the low grasses. Traces have been seen of hares or rabbits and one island is perforated throughout its shallow substratum of moss by a species of rat, but in such burrows search for them is vain. The *Gulnare* came in this evening; our captain brought her in as pilot. We have had an almost complete eclipse of the moon this evening at half-past seven. The air very chilly.

July 2. A beautiful day for Labrador. Drew another Puffin. Went on shore and was most pleased with what I saw. The country, so wild and grand, is of itself enough to interest anyone in its wonderful dreariness. Its mossy, gray-clothed rocks, heaped and thrown together as if by chance in the most fantastical groups imaginable,

huge masses hanging on minor ones as if about to roll themselves down from their doubtful-looking situations into the depths of the sea beneath. Bays without end, sprinkled with rocky islands of all shapes and sizes, where in every fissure a Guillemot, a Cormorant, or some other wild bird retreats to secure its egg and raise its young or save itself from the hunter's pursuit. The peculiar cast of the sky which never seems to be certain, butterflies flitting over snow banks probing beautiful dwarf flowerets of many hues pushing their tender stems from the thick bed of moss which everywhere covers the granite rocks. Then the morasses, wherein you plunge up to your knees, or the walking over the stubborn, dwarfish shrubbery, making one think that as he goes he treads down the *forests* of Labrador. The unexpected Bunting, or perhaps a Warbler, which perchance, and indeed as if by chance alone, you now and then see flying before you, or hear singing from the creeping plants on the ground. The beautiful freshwater lakes on the rugged crests of greatly elevated islands, wherein the Red and Black-necked Divers swim as proudly as swans do in other latitudes and where the fish appear to have been cast as strayed beings from the surplus food of the ocean. All—all is wonderfully grand, wild—aye, and terrific. And yet how beautiful it is now when one sees the wild bee moving from one flower to another in search of food, which doubtless is as sweet to it as the essence of the magnolia is to those of favored Louisiana. The little Ring Plover rearing its delicate and tender young, the Eider Duck swimming man-of-war-like amid her floating brood, like the guard ship of a most valuable convoy; the White-crowned Bunting's sonorous note reaching the ear ever and anon; the crowds of seabirds in search of places wherein to repose or to feed—how beautiful is all this in this wonderful rocky desert at this season, the beginning of July, compared with the horrid blasts of winter which here predominate by the will of God, when every rock is rendered smooth with snows so deep that every step the traveler takes is as if entering into his grave; for even should he escape an avalanche, his eye dreads to search the horizon, for full well does he know that snow—snow—is all that can be seen. I watched the Ring Plover for some time; the parents were so intent on saving their young that they both lay on the rocks as if shot, quivering their wings and dragging their bodies as if quite

disabled. We left them and their young to the care of the Creator. I would not have shot one of the old ones, or taken one of the young for any consideration, and I was glad my young men were as forbearing. The Black-backed Gull is extremely abundant here; they are forever harassing every other bird, sucking their eggs and devouring their young; they take here the place of Eagles and Hawks; not an Eagle have we seen yet and only two or three small Hawks and one small Owl; yet what a harvest they would have here, were there trees for them to rest upon.

July 3. We had a regular stiff gale from the eastward the whole day accompanied with rain and cold weather, and the water so rough that I could not go ashore to get plants to draw. This afternoon, however, the wind and waves abated and we landed for a short time. The view from the topmost rock overlooking the agitated sea was grand; the small islets were covered with the angry foam. Thank God! we were not at sea. I had the pleasure of coming immediately upon a Cormorant's nest that lay in a declivity not more than four or five yards below me; the mother bird was on her nest with three young; I was unobserved by her for some minutes, and was delighted to see how kindly attentive she was to her dear brood; suddenly her keen eye saw me, and she flew off as if to dive in the sea.

July 4. At four this morning I sent Tom Lincoln on shore after four plants and a Cormorant's nest for me to draw. The nest was literally *pasted* to the rock's edge, so thick was the decomposed, putrid matter below it, and to which the upper part of the nest was attached. It was formed of such sticks as the country affords, sea moss and other garbage, and weighed over fifteen pounds. I have drawn all day and have finished the plate of the *Fringilla lincolnii*, to which I have put three plants of the country, all new to me and probably never before figured; to us they are very fitting for the purpose, as Lincoln gathered them. Our party divided as usual into three bands: John and Lincoln off after Divers; Coolidge, Shattuck and Ingalls to the main land, and our captain and four men to a pond after fish, which they will catch with a seine. Captain Bayfield sent us a quarter of mutton, a rarity, I will venture to say, on this coast even on the Fourth of July. John and Lincoln returned with a Red-necked Diver, or Scapegrace, Coolidge and

party with the nest and two eggs of the Great Northern Diver. This nest was found on the margin of a pond and was made of short grasses, weeds, etc.; well fashioned and fifteen inches in diameter. After dinner John and I went on shore to release a Foolish Guillemot that we had confined in the fissure of a rock; the poor thing was sadly weak, but will soon recover from this trial of ours.

July 5. John and Lincoln returned at sunset with a Red-necked Diver and one egg of that bird; they also found Foolish Guillemots whose pebbled nests were placed beneath large rolling stones on the earth and not in fissures; Lincoln thought them a different species, but John did not. They brought some curious eel, and an Arctic Tern and saw the tracks of deer and caribou, also otter paths from one pond to another. They saw several Loons and *tolled* them by running towards them hallooing and waving a handkerchief, at which sight and cry the Loon immediately swam towards them until within twenty yards. This "tolling" is curious and wonderful. Many other species of waterfowl are deceived by these maneuvers, but none so completely as the Loon. Coolidge's party was fortunate enough to kill a pair of Ptarmigans, and to secure seven of the young birds hatched yesterday at furthest. They met with these on the dreary, mossy tops of the hills over which we tread daily in search of knowledge. This is the species of Grouse of which we heard so much at Dennysville [Maine] last autumn, and glad I am that it is a resident bird with us. The Black-backed Gull was observed trying to catch the young of the Eiders. I drew from four o'clock this morning till three this afternoon; finished a figure of the Red-throated Diver.

Feeling the want of exercise, went off with the captain a few miles to a large, rough island. To tread over the spongy moss of Labrador is a task beyond conception until tried; at every step the foot sinks in a deep, soft cushion which closes over it and it requires a good deal of exertion to pull it up again. Where this moss happens to be over a marsh, then you sink a couple of feet deep every step you take; to reach a bare rock is delightful and quite a relief. This afternoon I thought the country looked more terrifyingly wild than ever; the dark clouds, casting their shadows on the stupendous masses of rugged rock, lead the imagination into regions impossible to describe.

The Scoter Ducks, of which I have seen many this day, were partially molted and could fly only a short distance, and must be either barren or the young bachelors, as I find *parents* in full plumage, convincing me that these former molt earlier than the breeding Ducks. I have observed this strange fact so often now that I shall say no more about it; I have found it in nearly all the species of the birds here. I do not know of any writer on the history of birds having observed this curious fact before. I have now my hands full of work and go to bed delighted that tomorrow I shall draw a Ptarmigan which I can swear to as being a United States species. I am much fatigued and wet to the very skin, but, oh! we found the nest of a Peregrine Falcon on a tremendous cliff, with a young one about a week old, quite white with down; the parents flew fiercely at our eyes.

July 6. By dint of hard work and rising at three I have drawn a Red-throated Diver and a young one and nearly finished a Ptarmigan; this afternoon, however, at half-past five, my fingers could no longer hold my pencil and I was forced to abandon my work and go ashore for exercise. The fact is that I am growing old too fast; alas! I feel it—and yet work I will, and may God grant me life to see the last plate of my mammoth work finished. I have heard the Brown Lark sing many a time this day, both on the wing and whilst sitting on the ground. When on the wing it sings while flying very irregularly in zigzags, up and down, etc.; when on a rock (which it prefers) it stands erect and sings, I think, more clearly. John found the nest of a White-crowned Bunting with five eggs; he was creeping through some low bushes after a Red-necked Diver and accidentally coming upon it, startled the female, which made much noise and complaint. The nest was like the one Lincoln found placed in the moss, under a low bough, and formed of beautiful moss outwardly, dried, fine grass next inside, and exquisitely lined with fibrous roots of a rich yellow color; the eggs are light greenish, slightly sprinkled with reddish-brown, in size about the same as eggs of the Song Sparrow. This Sparrow is the most abundant in this part of Labrador. We have seen two Swamp Sparrows only. We have found two nests of the Peregrine Falcon placed high on rocky declivities. Coolidge and party shot two Oyster Catchers; these are becoming plentiful. Lieutenant Bowen

of the *Gulnare* brought me a Peregrine Falcon and two young of the Razor-billed Auk, the first hatched we have seen and only two or three days old.

July 7. Drawing all day; finished the female Grouse and five young and prepared the male bird. The captain, John and Lincoln went off this afternoon with a view to camp on a bay about ten miles distant. Soon after, we had a change of weather, and for a wonder, bright lightning and something like summer clouds. When fatigued with drawing I went on shore for exercise and saw many pretty flowers, amongst them a flowering Sea pea, quite rich in color. Dr. Kelly from the *Gulnare* went with me. Captain Bayfield and Lieutenant Bowen went off this morning on a three weeks' expedition in open boats, but with tents and more comforts than I have ever enjoyed in hunting excursions. The mosquitoes quite as numerous as in Louisiana.

July 8. Rainy, dirty weather, wind east. Was at work at half-past three, but disagreeable indeed is my situation during bad weather. The rain falls on my drawing-paper despite all I can do and even the fog collects and falls in large drops from the rigging on my table; now and then I am obliged to close my skylight, and then may be said to work almost in darkness. Notwithstanding, I finished my cock Ptarmigan and three more young, and now consider it a handsome large plate. John and party returned, cold, wet and hungry. Shot nothing, camp disagreeable and nothing to relate but that they heard a wolf and found an island with thousands of the Common Puffin breeding on it. Tomorrow I shall draw the beautiful Great Northern Diver or Loon in most perfect plumage.

July 9. The wind east, of course disagreeable; wet and foggy besides. The most wonderful climate in the world. Cold as it is, mosquitoes in profusion, plants blooming by millions, and at every step you tread on such as would be looked upon with pleasure in more temperate climes. I wish I were a better botanist, that I might describe them as I do birds. Dr. Wm. Kelly has given me the list of such plants as he has observed on the coast as far as Macatine Island. I have drawn all day at the Loon, a most difficult bird to imitate. For my part I cannot help smiling at the presumption of some of our authors, who modestly assert that their figures are "up to nature." May God forgive them, and teach me to *copy* His works;

glad and happy shall I then be. Lincoln and Shattuck brought some freshwater shells from a large pond inland; they saw a large bird which they took for an Owl but which they could not approach; they also caught a frog but lost it out of their game bag.

July 10. Could I describe one of these dismal gales which blow ever and anon over this desolate country, it would in all probability be of interest to one unacquainted with the inclemency of the climate. Nowhere else is the power of the northeast gale, which blows every week on the coast of Labrador, so keenly felt as here. I cannot describe it; all I can say is that whilst we are in as fine and safe a harbor as could be wished for, and completely landlocked all round, so strong does the wind blow and so great its influence on our vessel that her motion will not allow me to draw, and indeed once this day forced me to my berth as well as some others of our party. One would imagine all the powers of Boreas had been put to work to give us a true idea of what his energies can produce even in so snug a harbor. What is felt outside I cannot imagine, but greatly fear that few vessels could ride safely before these horrid blasts that now and then seem strong enough to rend the very rocks asunder. The rain is driven in sheets which seem scarcely to fall on sea or land; I can hardly call it rain, it is rather a mass of water so thick that all objects at any distance from us are lost to sight every three or four minutes, and the waters comb up and beat about us in our rockbound harbor as a newly caged bird does against its imprisoning walls. The Great Black-backed Gull alone is seen floating through the storm, screaming loudly and mournfully as it seeks its prey; not another bird is to be seen abroad; the Cormorants are all settled in the rocks close to us, the Guillemots are deep in the fissures, every Eider Duck lays under the lee of some point, her brood snugly beneath her opened wings, the Loon and the Diver have crawled among the rankest weeds and are patiently waiting for a return of fair weather, the Grouse is quite hid under the creeping willow, the Great Gray Owl is perched on the southern declivity of some stupendous rock and the gale continues as if it would never stop.

On rambling about the shores of the numerous bays and inlets of this coast you cannot but observe immense beds of round stone of all sizes, some of very large dimensions, rolled side by side and

piled one upon another many deep, cast there by some great force
of nature. I have seen many such places and never without astonish-
ment and awe. If those great boulders are brought from the bottom
of the sea and cast hundreds of yards on shore, this will give some
idea of what a gale on the coast of Labrador can be and what the
force of the waves. I tried to finish my drawing of the Loon, but
in vain; I covered my paper to protect it from the rain with the
exception only of the few inches where I wished to work, and yet
that small space was not spared by the drops that fell from the
rigging on my table; there is no window and the only light is
admitted through hatches.

July 11. The gale, or hurricane, or whatever else the weather of
yesterday was, subsided about midnight, and at sunrise this morn-
ing it was quite calm and the horizon fiery red. It soon became
cloudy and the wind has been all round the compass. I wished to
go a hundred miles farther north, but the captain says I must be
contented here, so I shall proceed with my drawings. I began a
Cormorant and two young, having sent John and Lincoln for them
before three this morning; and they procured them in less than
half an hour. Many of the young are nearly as large as their parents,
and yet have scarcely a feather, but are covered with woolly down
of a sooty black. The excursions brought in nothing new. The
Shore Lark has become abundant, but the nest remains still
unknown. A tail feather of the Red-tailed Hawk, young, was found;
therefore that species exists here. We are the more surprised that
not a Hawk nor an Owl is seen, as we find hundreds of seabirds
devoured, the wings only remaining.

July 12. At this very moment it is blowing another gale from the
east, and it has been raining hard ever since the middle of the day.
Of course it has been very difficult to draw, but I have finished the
Cormorant. John and Lincoln brought in nothing new except the
nest and ten eggs of a Red-breasted Merganser. The nest was
placed near the edge of a very small freshwater pond under the
creeping branches of one of this country's fir-trees, the top of which
would be about a foot above ground; it is like the Eider's nest but
smaller and better-fashioned, of weeds and mosses, and warmly
lined with down. The eggs are dirty yellow, very smooth-shelled,
and look like hen's eggs, only rather stouter. John lay in wait for

the parent over two hours, but though he saw her glide off the nest, she was too wary to return.

I saw a Black-backed Gull plunge on a Crab as big as my two fists, in about two feet of water, seize it and haul it ashore, where it ate it while I watched it; I could see the Crab torn piece by piece till the shell and legs alone remained. The Gull then flew in a direct line towards her nest, distant about a mile, probably to disgorge her food in favor of her young. Our two young Gulls, which we now have had for nearly a month, act just as Vultures would. We throw them a dead Duck or even a dead Gull, and they tear it to pieces, drinking the blood and swallowing the flesh, each constantly trying to rob the other of the piece of flesh which he has torn from the carcass. They do not drink water, but frequently wash the blood off their bills by plunging them in water, and then violently shaking their heads. They are now half fledged.

July 13. When I rose this morning at half-past three, the wind was northeast, and but little of it. The weather was cloudy and looked bad, as it always does here after a storm. I thought I would spend the day on board the *Gulnare*, and draw at the ground of my Grouse, which I had promised to Dr. Kelly. However, at seven the wind was west and we immediately prepared to leave our fine harbor. By eight we passed the *Gulnare*, bid her officers and crew farewell, beat out of the narrow passage beautifully and proceeded to sea with the hope of reaching the harbor of Little Macatine, distant forty-three miles; but ere the middle of the day it became calm, then rain, then the wind to the east again and all were seasick as much as ever. I saw a Jager near the vessel, but of what kind I could not tell—it flew like a Pigeon Hawk, alighting on the water like a Gull, and fed on some codfish liver which was thrown overboard for it—and some Petrels, but none came within shot and the sea was too rough to go after them. About a dozen common Crossbills, and as many Redpolls, came and perched on our top yards, but I would not have them shot and none were caught. Our young men have been fishing to pass the time and have caught a number of cod.

July 14. The wind blew cold and sharp from the northeast this morning and we found ourselves within twenty miles of Little Macatine, the sea beating heavily on our bows as we beat to the

windward, tack after tack. At noon it was quite calm, and the wished-for island in sight, but our captain despairs of reaching it today. It looks high and horribly rugged, the highest land we have yet seen. At four o'clock, being about a mile and a half distant, we took the green boat and went off. As we approached, I was surprised to see how small some Ducks looked which flew between us and the rocks, so stupendously high were the rough shores under which our little bark moved along. We doubled the cape and came to the entrance of the Little Macatine harbor, but so small did it appear to me that I doubted if it was the harbor; the shores were terribly wild, fearfully high and rugged, and nothing was heard but the croaking of a pair of Ravens and their half-grown brood, mingling with the roar of the surf against the rocky ledges which projected everywhere and sent the angry waters foaming into the air.

The wind now freshened, the *Ripley*'s sails swelled and she was gently propelled through the water and came within sight of the harbor, on the rocks of which we stood waiting for her, when all of a sudden she veered and we saw her topsails hauled in and bent in a moment; we thought she must have seen a sunken rock and had thus wheeled to avoid it, but soon saw her coming up again and learned that it was merely because she had nearly passed the entrance of the harbor ere aware of it. Our harbor is the very representation of the bottom of a large bowl, in the center of which our vessel is now safely at anchor, surrounded by rocks fully a thousand feet high, and the wildest-looking place I ever was in. After supper we all went ashore; some scampered up the steepest hills next to us, but John, Shattuck and myself went up the harbor, and after climbing to the top of a mountain (for I cannot call it a hill) went down a steep incline, up another hill and so on till we reached the crest of the island and surveyed all beneath us.

Nothing but rocks—barren rocks—wild as the wildest of the Apennines everywhere; the moss only a few inches deep and the soil or decomposed matter beneath it so moist that wherever there was an incline the whole slipped from under our feet like an avalanche and down we slid for feet or yards. The labor was excessive; at the bottom of each dividing ravine the scrub bushes intercepted our way for twenty or thirty paces over which we had to scramble with great exertion, and on our return we slid down

fifty feet or more into an unknown pit of moss and mire, more or less deep. We started a female Black-cap Warbler from her nest, and I found it with four eggs, placed in the fork of a bush about three feet from the ground; a beautiful little mansion, and I will describe it tomorrow. I am wet through, and find the mosquitoes as troublesome as in the Floridas.

July 15. Our fine weather of yesterday was lost sometime in the night. As everyone was keen to go off and see the country, we breakfasted at three o'clock this morning. The weather dubious, wind east. Two boats with the young men moved off in different directions. I sat to finishing the ground of my Grouse and by nine had to shift my quarters, as it rained hard. By ten John and Lincoln had returned; these two always go together, being the strongest and most active as well as the most experienced shots, though Coolidge and Ingalls are not far behind them in this. They brought a Red-necked Diver and one egg of that bird; the nest was placed on the edge of a very small pond not more than ten square yards.

Our harbor had many Common Gulls; the captain shot one. I have never seen them so abundant as here. Their flight is graceful and elevated; when they descend for food the legs and feet generally drop below the body. They appear to know gunshot distance with wonderful precision and it is seldom indeed that one comes near enough to be secured. They alight on the water with great delicacy and swim beautifully.

Coolidge's party brought a nest of the White-crowned Bunting and three specimens of the bird, also two Semipalmated Plovers. They found an island with many nests of the Double-crested Cormorant but only one egg, and thought the nests were old and abandoned. One of the young Ravens from the nest flew off at the sight of one of our men and fell into the water; it was caught and brought to me; it was nearly fledged. I trimmed one of its wings, and turned it loose on the deck, but in attempting to rejoin its mother, who called most loudly from on high on the wing, the young one walked to the end of the bowsprit, jumped into the water and was drowned; and soon after I saw the poor mother chased by a Peregrine Falcon with great fury; she made for her nest, and when the Falcon saw her alight on the margin of her ledge it flew off. I never thought that such a Hawk could chase

with effect so large and so powerful a bird as the Raven. Some of our men who have been eggers and fishermen have seen these Ravens here every season for the last eight or nine years.

July 16. Another day of dirty weather, and all obliged to remain on board the greater portion of the time. I managed to draw at my Grouse and put in some handsome wild peas, Labrador tea-plant and also one other plant unknown to me. This afternoon the young men went off, and the result has been three White-crowned Buntings and a female Black-capped Warbler. Our captain did much better for me, for in less than an hour he returned on board with thirty fine codfish, some of which we relished well at our supper. This evening the fog is so thick that we cannot see the summit of the rocks around us. The harbor has been full of Gulls the whole day. The captain brought me what he called an Esquimaux codfish, which perhaps has never been described, and we have *spirited* him. We found a new species of floweret of the genus *Silene* but unknown to us. We have now lost four days in succession.

July 17. The mosquitoes so annoyed me last night that I did not even close my eyes. I tried the deck of the vessel, and though the fog was as thick as fine rain, these insects attacked me by thousands and I returned below, where I continued fighting them till daylight, when I had a roaring fire made and got rid of them. The fog has been as thick as ever and rain has fallen heavily, though the wind is southwest. I have drawn five eggs of land birds: that of the Pigeon Hawk, the White-crowned Sparrow, the Brown Titlark, the Black-poll Warbler and the Savannah Finch. I also outlined in the mountainous hills near our vessel as a background to my Willow Grouse. John and Coolidge with their companions brought in several specimens, but nothing new. Coolidge brought two young of the Red-necked Diver, which he caught *at the bottom* of a small pond by putting his gun rod on them—the little things diving most admirably, and going about the bottom with as much apparent ease as fishes would. The captain and I went to an island where the Double-crested Cormorant were abundant; thousands of young of all sizes, from just hatched to nearly full-grown, all opening their bills and squawking most vociferously; the noise was shocking and the stench intolerable. No doubt exists with us

now that the Shore Lark breeds here; we meet with them very frequently. A beautiful species of violet was found and I have transplanted several for Lucy, but it is doubtful if they will survive the voyage.

July 18. We all, with the exception of the cook, left the *Ripley* in three boats immediately after our early breakfast, and went to the mainland, distant some five miles. The fog was thick enough, but the wind promised fair weather and we have had it. As soon as we landed the captain and I went off over a large extent of marsh ground, the first we have yet met with in this country; the earth was wet, our feet sank far in the soil and walking was extremely irksome. In crossing what is here called a wood, we found a nest of the Hudson's Bay Titmouse containing four young, able to fly; we procured the parents also, and I shall have the pleasure of drawing them tomorrow; this bird has never been figured that I know. Their *manners* resemble those of the Black-headed Titmouse or Chickadee and their notes are fully as strong and clamorous, and constant as those of either of our own species. Few birds do I know that possess more active powers. The nest was dug by the bird out of a dead and rotten stump, about five feet from the ground; the aperture, one and a quarter inches in diameter, was as round as if made by a small Woodpecker or a flying squirrel. The hole inside was four by six inches; at the bottom a bed of chips was found, but the nest itself resembled a purse formed of the most beautiful and softest hair imaginable—of sables, ermines, martens, hares, etc.; a warmer and snugger apartment no bird could desire even in this cold country.

On leaving the wood we shot a Spruce Partridge leading her young. On seeing us she ruffled her feathers like a barnyard hen and rounded within a few feet of us to defend her brood; her very looks claimed our forbearance and clemency, but the enthusiastic desire to study nature prompted me to destroy her and she was shot, and her brood secured in a few moments; the young very pretty and able to fly. This bird was so very gray that she might almost have been pronounced a different species from those at Dennysville last autumn; but this difference is occasioned by its being born so much farther north; the difference is no greater than in the Red Grouse in Maine and the same bird in western

Pennsylvania. We crossed a savannah of many miles in extent; in many places the soil appeared to wave under us, and we expected at each step to go through the superficial moss carpet up to our middles in the mire; so wet and so spongy was it that I think I never labored harder in a walk of the same extent. In traveling through this quagmire we met with a small grove of good-sized, fine white birch trees and a few pines full forty feet high, quite a novelty to us at this juncture.

On returning to our boats the trudging through the great bog was so fatiguing that we frequently lay down to rest; our sinews became cramped, and for my part, more than once I thought I should give up from weariness. One man killed a Pigeon Hawk in the finest plumage I have ever seen. I heard the delightful song of the Ruby-crowned Wren again and again; what would I give to find the nest of this *northern Hummingbird*? We found the Fox-colored Sparrow in full song and had our captain been up to birds' ways, he would have found its nest; for one started from his feet and doubtless from the eggs as she fluttered off with drooping wings and led him away from the spot, which could not again be found. John and Co. found an island with upwards of two hundred nests of the Common Gull, all with eggs but not a young one hatched. The nests were placed on the bare rock; formed of sea-weed, about six inches in diameter within and a foot without; some were much thicker and larger than others; in many instances only a foot apart, in others a greater distance was found. The eggs are much smaller than those of the Great Black-backed. The eggs of the Cayenne Tern [*sic*: probably the Caspian Tern] were also found and a single pair of those remarkable birds, which could not be approached. Two Ptarmigans were killed; these birds have no whirring of the wings even when surprised; they flew at the gunners in defense of the young, and one was killed with a gun rod. The instant they perceive they are observed when at a distance they squat or lie flat on the moss, when it is almost impossible to see them unless right under your feet. From the top of a high rock I had fine view of the most extensive and the dreariest wilderness I have ever beheld. It chilled the heart to gaze on these barren lands of Labrador. Indeed I now dread every change of harbor, so horribly rugged and dangerous is the whole coast and country,

especially to the inexperienced man either of sea or land. The mosquitoes, many species of horsefly, small bees, and black gnats filled the air; the frogs croaked; and yet the thermometer was not high, not above 55°. This is one of the wonders of this extraordinary country. We have returned to our vessel, wet, shivering with cold, tired and very hungry. During our absence the cook caught some fine lobsters; but fourteen men, each with a gun, six of which were double-barreled, searched all day for game and have not averaged two birds apiece, nineteen being all that were shot today. We all conclude that no one man could provide food for himself without extreme difficulty. Some animal was seen at a great distance, so far indeed that we could not tell whether it was a wolf or a caribou.

July 19. So cold, rainy and foggy has this day been that no one went out shooting and only a ramble on shore was taken by way of escaping the motion of the vessel, which pitched very disagreeably, the wind blowing almost directly in our harbor; and I would not recommend this anchorage to a *painter naturalist*, as Charles Bonaparte calls me. I have drawn two Boreal Chickadees, and this evening went on shore with the captain for exercise, and enough have I had. We climbed the rocks and followed from one to another, crossing fissures, holding to the moss hand and foot and with difficulty for about a mile, when suddenly we came upon the deserted mansion of a Labrador sealer. It looked snug outside and we entered it.

It was formed of short slabs, all very well greased with seal oil; an oven without a pipe, a salt box hung on a wooden peg, a three-legged stool, and a wooden box of a bedstead, with a flour-barrel containing some hundreds of seine-floats and an old seal seine, completed the list of goods and chattels. Three small windows, with four panes of glass each, were still in pretty good order, and so was the low door, which moved on wooden hinges for which the maker has received no patent, I'll be bound. This cabin made of hewn logs brought from the main was well put together, about twelve feet square, well roofed with bark of birch and spruce, thatched with moss and every aperture rendered airtight with oakum. But it was deserted and abandoned; the seals are all caught, and the sealers have naught to do here nowadays. We found a pile of good hard wood close to this abode, which we will have removed on board our vessel tomorrow.

I discovered that this cabin had been the abode of two French Canadians; first, because their almanac, written with chalk on one of the logs, was in French; and next, the writing was in two very different styles. As we returned to our vessel I paused several times to contemplate the raging waves breaking on the stubborn, precipitous rocks beneath us and thought how dreadful they would prove to anyone who should be wrecked on so inhospitable a shore. No vessel, the captain assured me, could stand the sea we gazed upon at that moment, and I fully believed him, for the surge dashed forty feet or more high against the precipitous rocks. The Ravens flew above us, and a few Gulls beat to windward by dint of superior sailing; the horizon was hid by fog so thick there and on the crest of the island that it looked like dense smoke. Though I wore thick mittens and very heavy clothing, I felt chilly with the cold. John's violin notes carry my thoughts far, far from Labrador, I assure thee.

July 20. Labrador deserves credit for *one* fine day! Today has been calm, warm, and actually such a day as one might expect in the Middle States about the month of May. I drew from half-past three till ten this morning. The young men went off early and the captain and myself went to the island next to us but saw few birds: a Brown Lark, some Gulls and the two White-crowned Buntings. In some small bays which we passed we found the stones thrown up by the sea in immense numbers and of enormous size. These stones I now think are probably brought on shore in the masses of ice during the winter storms. These icebergs, then melting and breaking up, leave these enormous pebble-shaped stones, from ten to one hundred feet deep. When I returned to my drawing the captain went fishing and caught thirty-seven cod in less than an hour. The wind rose towards evening and the boats did not get in till nine o'clock, and much anxiety did I feel about them. Coolidge is an excellent sailor and John too, for that matter, but very venturesome; and Lincoln equally so. The chase, as usual, poor; two Canadian Grouse in molt—these do molt earlier than the Willow Grouse—some White-throated Sparrows, Yellow-rump Warblers, the Green Black-cap Flycatcher, the small Wood Pewee (?). I think this a new species, but cannot swear to it. The young of the Tawny Thrush were seen with the mother, almost full-grown. All the party are very tired, especially Ingalls, who was swamped up to his

armpits and was pulled out by his two companions; tired as they are, they have yet energy to eat tremendously.

July 21. I write now from a harbor which has no name, for we have mistaken it for the right one, which lies two miles east of this; but it matters little, for the coast of Labrador is all alike comfortless, cold and foggy, yet grand. We left Little Macatine at five this morning with a stiff southwest breeze and by ten our anchor was dropped here. We passed Captain Bayfield and his two boats engaged in the survey of the coast. We have been on shore; no birds but about a hundred Eider Ducks and Red-breasted Mergansers in the inner bay, with their broods all affrighted as our boats approached. Returning on board, found Captain Bayfield and his lieutenants, who remained to dine with us. They were short of provisions, and we gave them a barrel of ship bread and seventy pounds of beef. I presented the captain with a ham, with which he went off to their camp on some rocks not far distant.

This evening we paid him a visit; he and his men are encamped in great comfort. The tea things were yet arranged on the iron-bound bed, the trunks served as seats and the sailcloth clothes bags as pillows. The moss was covered with a large tarred cloth and neither wind nor damp was admitted. I gazed on the camp with much pleasure, and it was a great enjoyment to be with men of education and refined manners such as are these officers of the Royal Navy; it was indeed a treat. We talked of the country where we were, of the beings best fitted to live and prosper here, not only of our species, but of all species, and also of the enormous destruction of everything here except the rocks; the aborigines themselves melting away before the encroachments of the white man, who looks without pity upon the decrease of the devoted Indian from whom he rifles home, food, clothing and life. For as the deer, the caribou and all other game is killed for the dollar which its skin brings in, the Indian must search in vain over the devastated country for that on which he is accustomed to feed, till worn out by sorrow, despair and want, he either goes far from his early haunts to others which in time will be similarly invaded, or he lies on the rocky seashore and dies. We are often told rum kills the Indian; I think not; it is oftener the want of food, the loss of hope as he loses sight of all that was once abundant before the white man

intruded on his land and killed off the wild quadrupeds and birds with which he has fed and clothed himself since his creation. Nature herself seems perishing. Labrador must shortly be depeopled, not only of aboriginal man but of all else having life, owing to man's cupidity. When no more fish, no more game, no more birds exist on her hills, along her coasts and in her rivers, then she will be abandoned and deserted like a worn-out field.

July 22. At six this morning Captain Bayfield and Lieutenant Bowen came alongside in their respective boats to bid us farewell, being bound westward to the *Gulnare.* We embarked in three boats and proceeded to examine a small harbor about a mile east where we found a whaling schooner of fifty-five tons from Cape Gaspé in New Brunswick. When we reached it we found the men employed at boiling blubber in what to me resembled sugar boilers. The blubber lay heaped on the shore in chunks of six to twenty pounds and looked filthy enough. The captain or owner of the vessel appeared to be a good, sensible man of that class, and cut off for me some strips of the skin of the whale from under the throat, with large and curious barnacles attached to it. They had struck four whales of which three had sunk and were lost; this, I was told, was a very rare occurrence.

We found at this place a French Canadian, a seal catcher, who gave me the following information. This portion of Labrador is free to anyone to settle on, and he and another man had erected a small cabin, have seal nets, and traps to catch foxes, and guns to shoot bears and wolves. They carry their quarry to Quebec, receive fifty cents per gallon for seal oil and from three to five guineas for black- and silver-fox skins, and other furs in proportion. From November till spring they kill seals in great numbers. Two thousand five hundred were killed by seventeen men in three days; this great feat was done with short sticks, each seal being killed with a single blow on the snout while resting on the edges of the field ice. The seals are carried to the camp on sledges drawn by Esquimaux dogs that are so well trained that on reaching home they push the seals off the sledge with their noses and return to the hunters with dispatch. (Remember, my Lucy, this is hearsay.) At other times the seals are driven into nets one after another until the poor animals become so hampered and confined that, the gun being used, they

are easily and quickly dispatched. He showed me a spot within a few yards of his cabin where, last winter, he caught six silver-gray foxes; these had gone to Quebec with his partner, who was daily expected. Bears and caribou abound during winter as well as wolves, hares, and porcupines. The hare (I suppose the northern one) is brown at this season and white in winter; the wolves are mostly of a dun color, very ferocious and daring. A pack of about thirty followed a man to his cabin and have more than once killed his dogs at his very door. I was the more surprised at this, as the dogs he had were as large as any wolves I have ever seen.

These dogs are extremely tractable; so much so that when harnessed to a sledge, the leader starts at the word of command and the whole pack gallops off swiftly enough to convey a man sixty miles in the course of seven or eight hours. They howl like wolves and are not at all like our common dogs. They were extremely gentle, came to us, jumped on us and caressed us as if we were old acquaintances. They do not take to the water and are only fitted for drawing sledges and chasing caribou. They are the only dogs which at all equal the caribou in speed. As soon as winter's storms and thick ice close the harbors and the spaces between the mainland and the islands, the caribou are seen moving in great gangs, first to the islands, where, the snow being more likely to be drifted, the animal finds places where the snow has blown away, and he can more easily reach the moss which at this season is its only food. As the season increases in severity, the caribou follow a due northwestern direction and gradually reach a comparatively milder climate; but nevertheless, on their return in March and April, which return is as regular as the migration of birds, they are so poor and emaciated that the white man himself takes pity on them and does not kill them. (Merciful beings who spare life when the flesh is off the bones and no market for the bones is at hand.) The otter is tolerably abundant; these are principally trapped at the foot of the waterfalls to which they resort, these places being the latest to freeze and the first to thaw. The marten and the sable are caught but are by no means abundant, and every winter makes a deep impression on beast as well as on man.

These Frenchmen receive their supplies from Quebec, where

they send their furs and oil. At this time, which the man here calls "the idle time," he lolls about his cabin, lies in the sunshine like a seal, eats, drinks and sleeps his life away, careless of all the world, and the world no doubt careless of him. His dogs are his only companions until his partner's return, who for all I know is not himself better company than a dog.

They have placed their very small cabin in a delightful situation, under the protection of an island on the southwestern side of the main shore, where I was surprised to find the atmosphere quite warm and the vegetation actually rank; for I saw plants with leaves fully a foot in breadth and grasses three feet high. The birds had observed the natural advantages of this little paradise, for here we found the musical Winter Wren in full song, the first time in Labrador, the White-crowned Sparrow or Bunting singing melodiously from every bush, the Foxtail Sparrow, the Black-cap Warbler, the Shore Lark nesting, but too cunning for us; the White-throated Sparrow and a Peregrine Falcon, besides about half a dozen of Lincoln's Finch.

This afternoon the wind has been blowing a tremendous gale; our anchors have dragged with sixty fathoms of chain out. Yet one of the whaler's boats came to us with six men who wished to see my drawings, and I gratified them willingly; they, in return, have promised to let me see a whale before cut up, if they should catch one ere we leave this place for Bras d'Or. Crows are not abundant here; the Ravens equal them in number and Peregrine Falcons are more numerous. The horseflies are so bad that they drove our young men on board.

July 23. We visited today the seal establishment of a Scotchman, Samuel Robertson, situated on what he calls Sparr Point, about six miles east of our anchorage. He received us politely, addressed me by name and told me that he had received intimation of my being on a vessel bound to this country through the English and Canadian newspapers. This man has resided here twenty years, married a Labrador lady, daughter of a Monsieur Chevalier of Bras d'Or, a good-looking woman, and has six children. His house is comfortable and in a little garden he raises a few potatoes, turnips and other vegetables. He appears to be lord of these parts and quite contented with his lot. He told me his profits last year amounted

to £600. He will not trade with the Indians, of whom we saw about twenty, of the Montagnais tribes, and employs only white serving men. His seal-oil tubs were full and he was then engaged in loading two schooners for Quebec with that article. I bought from him the skin of a cross fox for three dollars. He complained of the American fishermen very much, told us they often acted as badly as pirates towards the Indians, the white settlers and the eggers, all of whom have been more than once obliged to retaliate, when bloody encounters have been the result. He assured me he had seen a fisherman's crew kill thousands of Guillemots in the course of a day, pluck the feathers from the breasts and throw the bodies into the sea. He also told me that during mild winters his little harbor is covered with pure white Gulls (the Silvery), but that all leave at the first appearance of spring.

The traveling here is effected altogether on the snow-covered ice by means of sledges and Esquimaux dogs, of which Mr. Robertson keeps a famous pack. With them, at the rate of about six miles an hour, he proceeds to Bras d'Or seventy-five miles with his wife and six children in one sledge drawn by ten dogs. Fifteen miles north of this place, he says, begins a lake represented by the Indians as four hundred miles long by one hundred broad. This sea-like lake is at times as rough as the ocean in a storm; it abounds with Wild Geese, and the water-fowl breed on its margins by millions. We have had a fine day but very windy; Mr. R. says this July has been a remarkable one for rough weather. The caribou flies have driven the hunters on board; Tom Lincoln, who is especially attacked by them, was actually covered with blood and looked as if he had had a gouging fight with some rough Kentuckians. Mr. R.'s newspapers tell of the ravages of cholera in the south and west, of the indisposition of General Jackson at the Tremont House, Boston, etc.; thus even here the news circulates now and then. The mosquitoes trouble me so much that in driving them away I bespatter my paper with ink, as thou seest, God bless thee! Good-night.

July 24. The Semipalmated Plover breeds on the tops or sides of the high hills and amid the moss of this country. I have not found the nest but have been so very near the spot where it undoubtedly was that the female has moved before me, trailing her wings and

spreading her tail to draw me away; uttering a plaintive note, the purpose of which I easily conceive. The Shore Lark has served us the same way; that nest must also be placed amid the deep mosses over which these beautiful birds run as nimbly as can be imagined. They have the power of giving two notes so very different from each other that a person not seeing the bird would be inclined to believe that two birds of different species were at hand. Often after these notes comes a sweet trill; all these I have thought were in intimation of danger and with the wish to induce the sitting mate to lie quiet and silent. Tom Lincoln, John and I went on shore after two bears which I heard distinctly, but they eluded our pursuit by swimming from an island to the main land. Coolidge's party went to the Murre Rocks where the Guillemots breed and brought about fifteen hundred eggs. Shattuck killed two Gannets with a stick; they could have done the same with thousands of Guillemots when they landed; the birds scrambled off in such a hurried, confused and frightened manner as to render them what Charles Bonaparte calls *stupid*, and they were so terrified they could scarcely take to wing. The island was literally covered with eggs, dung and feathers, and smelt so shockingly that Ingalls and Coolidge were quite sick. Coolidge killed a White-winged Crossbill on these Murre rocks; for several weeks we have seen these birds pass over us but have found none anywhere on shore. We have had a beautiful day and would have sailed for Bras d'Or, but our anchor stuck into a rock, and just as we might have sailed a heavy fog came on, so here we are.

July 26. I did not write last night because we were at sea and the motion was too disagreeable, and my mind was as troubled as the ocean. We left Baie de Portage before five in the morning with a good breeze, intending to come to at Chevalier's settlement, forty-seven miles; but after sailing thirty the wind failed us, it rained and blew with a tremendous sea which almost shook the masts out of our good vessel, and about eight we were abreast of Bonne Espérance; but as our pilot knew as much of this harbor as he did of the others, which means *nothing at all*, our captain thought prudent to stand off and proceed to Bras d'Or. The coast we have followed is like that we have hitherto seen, crowded with islands of all sizes and forms against which the raging waves break in a

frightful manner. We saw few birds with the exception of Gannets, which were soaring about us most of the day feeding on capelings, of which there were myriads.

—I had three Foolish Guillemots thrown overboard alive to observe their actions. Two fluttered on top of the water for twenty yards or so, then dove and did not rise again for fully a hundred yards from the vessel. The third went in head foremost, like a man diving, and swam *under the surface* so smoothly and so rapidly that it looked like a fish with wings.

At daylight we found ourselves at the mouth of Bras d'Or harbor, where we are snugly moored. Our pilot not knowing a foot of the ground, we hoisted our ensign and Captain Billings came to us in his Hampton boat and piloted us in. Bras d'Or is the grand rendezvous of almost all the fishermen that resort to this coast for codfish. We found here a flotilla of about one hundred and fifty sail, principally fore-and-aft schooners, a few pickaxes, etc., mostly from Halifax and the eastern portions of the United States. There was a life and stir about this harbor which surprised us after so many weeks of wilderness and loneliness—the boats moving to and fro, going after fish and returning loaded to the gunwales, others with seines, others with capelings for bait. A hundred or more were anchored out about a mile from us, hauling the poor codfish by thousands; hundreds of men engaged at cleaning and salting, their low jokes and songs resembling those of the Billingsgate gentry. On entering the port I observed a large flock of small Gulls, which species I could not ascertain, also Jagers of two species, one small and one large.

As soon as breakfast was over, the young men went ashore to visit Mr. Jones, the owner of the seal-fishing establishment here. He received them well—a rough, brown Nova Scotia man, the lord of this portion of Labrador—and he gave John and the others a good deal of information. Four or five species of Grouse, the Velvet Duck, the Long-tailed Duck and the Harlequin, the Wild Goose and others breed in the swampy deserts at the headwaters of the rivers and around the edges of the lakes and ponds which everywhere abound. He also knew of my coming. John and Coolidge joined parties and brought me eight Redpolls, old and young, which I will draw tomorrow. Query, is it the same which is found

in Europe? Their note resembles that of the Siskin; their flight that of the Siskin and Linnet combined. The young were as large as the old and could fly a mile at a stretch; they resort to low bushes along the edges of ponds and brooks; the hunters saw more than they shot. They brought also Savannah Finches and White-crowned Sparrows. They saw a fine female Spotted Grouse, not quite so gray as the last; the young flew well and alighted on trees and bushes and John would not allow any of them to be shot, they were so trusting. They saw a Willow Grouse, which at sight of them, though at some distance, flew off and flew far; on being started again, flew again to a great distance with a loud, cackling note but no whirr of the wings. They were within three hundred yards of an Eagle, which from its dark color and enormous size and extent of wings, they took to be a female Washington Eagle [i.e., Audubon's Bird of Washington, a young Bald Eagle]. I have made many inquiries, but everyone tells me Eagles are most rare. It sailed away over the hills slowly and like a Vulture.

After drawing two figures of the female White-winged Crossbill I paid a visit to the country seat of Mr. Jones. The snow is still to be seen in patches on every hill around us; the borders of the watercourses are edged with grasses and weeds as rank of growth as may be seen in the Middle States in like situations. I saw a small brook filled with fine trout; but what pleased me best, I found a nest of the Shore Lark; it was embedded in moss so much the color of the birds that when these sit on it, it is next to impossible to observe them; it was buried to its full depth, about seven inches— composed outwardly of mosses of different sorts; within, fine grass circularly arranged and mixed with many large, soft Duck feathers. These birds breed on high tablelands, one pair to a certain district. The place where I found the nest was so arid, poor and rocky that nothing grew there. We see the high mountains of Newfoundland, the summits at present far above the clouds. Two weeks since, the ice filled the very harbor where we now are and not a vessel could approach; since then the ice has sunk and none is to be seen far or near.

July 27. It has blown a tremendous gale the whole day; fortunately I had two Lesser Redpolls to draw. The adult male alone possesses those rich colors on the breast; the female has only the

front head crimson. They resemble the Crossbills, notwithstanding Bonaparte, Nuttall, and others to the contrary. John kept me company and skinned fourteen small birds. Mr. Jones dined with us, after which the captain and the rest of our party went off through the storm to Blanc Sablons, four miles distant. This name is turned into "Nancy Belong" by the fishermen, who certainly tell very strange tales respecting this country.

Mr. Jones entertained us by his account of traveling with dogs during winter. They are harnessed, he says, with a leather collar, a belly and back band, through the upper part of which passes the line of sealskin, which is attached to the sledge and acts for a rein as well as a trace. An odd number of dogs always form the gang, from seven up, according to the distance of the journey or the weight of the load; each dog is estimated to draw two hundred pounds at a rate of five or six miles an hour. The leader is always a well-broken dog and is placed ahead of the pack with a draught line of from six to ten fathoms' length, and the rest with gradually shorter ones, to the last, which is about eight feet from the sledge; they are not, however, coupled, as often represented in engravings, but are each attached separately, so that when in motion they are more like a flock of Partridges, all flying loosely and yet in the same course. They always travel at a gallop, no matter what the state of the country may be, and to go downhill is both difficult and dangerous; and at times it is necessary for the driver to guide the sledge with his feet or with a strong staff planted in the snow as the sledge proceeds; and when heavily laden and the descent great, the dogs are often taken off and the sledge glides down alone, the man steering with his toes and lying flat on his face, thus descending head-foremost like boys on their sleds. The dogs are so well acquainted with the courses and places in the neighborhood that they never fail to take their master and his sledge to their destination, even should a tremendous snowstorm occur whilst underway; and it is always safer to leave one's fate to the instinct which these fine animals possess than to trust to human judgment, for it has been proved more than once that men who have made their dogs change their course have been lost, and sometimes died, in consequence. When travelers meet, both parties come circuitously and as slowly as possible towards each other, which gives the

separate packs the opportunity of observing that their masters are acquainted, when they meet without fighting, a thing which almost always occurs if the dogs meet unexpectedly. Mr. Jones lost a son of fourteen a few years ago in a snowstorm owing to the servant in whose care he was imprudently turning the dogs from their course; the dogs obeyed the command and struck towards Hudson's Bay; when the weather cleared the servant perceived his mistake, but alas! too late; the food was exhausted and the lad gradually sank and died in the arms of the man.

July 28. At daylight this morning the storm had abated and although it was almost calm, the sea was high and the *Ripley* tossed and rolled in a way which was extremely unpleasant to me. Breakfast over, we all proceeded to Mr. Jones' establishment with a view to procuring more information and to try to have some of his men make Esquimaux boots and garments for us. We received little information and were told no work could be done for us; on asking if his son, a youth of about twenty-three, could be hired to guide some of us into the interior some forty miles, Mr. Jones said the boy's mother had become so fearful of accidents since the loss of the other son that he could not say without asking her permission, which she would not grant. We proceeded over the tablelands towards some ponds. I found three young Shore Larks just out of the nest and not yet able to fly; they hopped pretty briskly over the moss, uttering a soft *peep*, to which the parent bird responded at every call. I am glad that it is in my power to make a figure of these birds in summer, winter and young plumage. We also found the breeding place of the Harlequin Duck in the corner of a small pond in some low bushes. By another pond we found the nest of the Velvet Duck, called here the White-winged Coot; it was placed on the moss among the grass, close to the water; it contained feathers but no down as others. The female had six young, five of which we procured. They were about a week old and I could readily recognize the male birds; they all had the white spot under the eye. Four were killed with one shot; one went on shore and squatted in the grass, where Lincoln caught it; but I begged for its life, and we left it to the care of its mother and of its Maker. We also found the breeding place of a Long-tailed Duck by a very large pond; these breed in companies and are shyer than in the States. The

Pied Duck breeds here on the top of the low bushes, but the season is so far advanced we have not found its nest. Mr. Jones tells me the King Duck passes here northwards in the early part of March, returning in October, flying high and in lines like the Canada Goose. The Snow Goose is never seen here; none, indeed, but oceanic species are seen here. (I look on the White-winged Coot as an oceanic species.) Mr. Jones has never been more than a mile in the interior and knows nothing of it. There are two species of Woodpecker here and only two, the Three-toed and the Downy. When I began writing it was calm, now it blows a hurricane, rains hard, and the sea is as high as ever.

July 29. Another horrid, stormy day. The very fishermen complain. Five or six vessels left for further east, but I wish and long to go west. The young men, except Coolidge, went off this morning after an early breakfast to a place called Port Eau, eighteen miles distant, to try to procure some Esquimaux dresses, particularly moccasins. I felt glad when the boat which took them across the bay returned, as it assured me they were at least on terra firma. I do not expect them till tomorrow night and I greatly miss them. When all our party is present, music, anecdotes and jokes, journalizing and comparing notes make the time pass merrily; but this evening the captain is on deck, Coolidge is skinning a bird and I am writing that which is scarcely worth recording, with a horridly bad patent pen.

I have today drawn three young Shore Larks, the first ever portrayed by man. I did wish to draw an adult male in full summer plumage but could not get a handsome one. In one month all these birds must leave this coast or begin to suffer. The young of many birds are full-fledged and scamper over the rocks; the Ducks alone seem backward, but being more hardy can stay till October when deep snows drive them off, ready or not for their laborious journey. I saw this afternoon two, or a pair, of the Brown Phalarope; they were swimming in a small freshwater pond, feeding on insects, and no doubt had their nest close by, as they evinced great anxiety at my approach. I did not shoot at them and hope to find the nest or young; but to find nests in the moss is a difficult job, for the whole country looks alike.

"The Curlews are coming"; this is as much of a saying here as

that about the Wild Pigeons in Kentucky. What species of Curlew I know not yet, for none have been killed, but one of our men who started with John and party broke down and was sent back; he assured me that he had seen some with bills about four inches long and the body the size of a Wild Pigeon. The accounts given of these Curlews border on the miraculous, and I shall say nothing about them till I have tested the fishermen's stories! It is now calm, for a wonder, but as cold as vengeance on deck; we have a good fire in the stove and I am roasting on one side and freezing on the other. The water of our harbor is actually coated with oil and the bottom fairly covered with the refuse of the codfish; the very air I breathe and smell is impregnated with essence of codfish.

July 30. It was a beautiful morning when I arose, and such a thing as a beautiful morning in this mournful country almost amounts to a phenomenon. The captain and myself went off to an island and searched for a Shore Lark and found a good number of old and young associated, both equally wild. The young were led off with great care by the adults and urged to squat quietly till nearly within gunshot, when at a *tweet* from the parent they took to the wing and were off. These birds are very pugnacious and attack a rival at once, when both come to the scratch with courage and tenacity. I saw one beautiful male in full summer dress which I secured and have drawn with a portion of moss. I intend to add two drawn in winter plumage.

This afternoon we visited Mr. Jones and his wife, a good motherly woman who talked well. Our young men returned from Port Eau fatigued and, as usual, hungry; complained, as I expected, of the country, the climate and the scarcity of birds and plants and not a pair of moccasins to be bought; so Lincoln and Shattuck are now barefooted.

They brought a Pomarine Jager, female, a full-grown young Raven and some Finches. Coolidge's party had some Lesser Redpolls, several Swamp Sparrows, three small Black-cap Green Flycatchers, Black-cap Warblers, old and young, the last fully grown, a *Fringilla lincolnii* and a Pine Grosbeak. They saw many Gulls of various species and also an iceberg of immense size. There is at Port Eau a large fishing establishment belonging to fishermen who come annually from the Island of Jersey and have a large store with

general supplies. Ere I go to rest let me tell thee that it is now blowing a young hurricane and the prospect for tomorrow is a bad one. A few moments ago the report of a cannon came to our ears from the sea, and it is supposed that it was from the *Gulnare*. I wish she was at our side and snugly moored as we are.

July 31. Another horrid hurricane, accompanied with heavy rain. I could not go on with my drawing either in the cabin or the hold, though everything was done that could be thought of to assist me in the attempt; not a thing to relate, as not one of us could go on shore.

August 1. Bras d'Or [Village], Coast of Labrador. I have drawn my Pomarine Jager, but under difficulties; the weather has quite changed; instead of a hurricane from the east we have had one all day from the southwest, but no rain. At noon we were visited by an iceberg which has been drifting within three miles of us and is now grounded at the entrance of the bay; it looks like a large man-of-war dressed in light green muslin instead of canvas, and when the sun strikes it, it glitters with intense brilliancy. When these transient monuments of the sea happen to tumble or roll over, the fall is tremendous and the sound produced resembles that of loud, distant thunder; these icebergs are common here all summer, being wafted south with every gale that blows; as the winds are usually easterly, the coast of Newfoundland is more free from them than that of Labrador. I have determined to make a last thorough search of the mountain tops, plains and ponds, and if no success ensues to raise anchor and sail towards the United States once more; and blessed will the day be when I land on those dear shores where all I long for in the world exists and lives, I hope. We have been on shore for an hour for exercise, but the wind blew so fiercely we are glad to return.

August 2. Noon. The thermometer has risen to 58°, but it has rained hard all day; about dinnertime a very handsome schooner from Boston the size of ours, called the *Wizard*, commanded by Captain Wilcomb of Ipswich, arrived, only nine days from Boston; but to our sorrow and disappointment, not a letter or paper did she bring, but we learned with pleasure that our great cities are all healthy [i.e., free of cholera], and for this intelligence I thank God. The *Wizard* brought two young Italian clerks as supercargo, who

are going to purchase fish; they visited us and complained bitterly of the cold and the general appearance of the country. The retrograde migration of many birds has already commenced, more especially that of the lesser species both of land and water birds.

August 3. I was suddenly awakened last night about one o'clock by the shock which our vessel received from the *Wizard*, which had broken her stern chain in the gale, which at that time was raging most furiously. Our captain was up in a moment, the vessels were parted and tranquility was restored, but to John's sorrow and my vexation, our beautiful and most comfortable gig had been struck by the *Wizard* and her bows stove in; at daylight it rained hard and the gale continued. Lincoln went on shore and shot some birds but nothing of importance. This afternoon we all went ashore through a high and frightful sea which drenched us to the skin, and went to the tablelands; there we found the true Esquimaux Curlew so carelessly described in Bonaparte's *Synopsis*. This species here takes the place of the Migratory [Passenger] Pigeon; it has now arrived; I have seen many hundreds this afternoon and shot seven. They fly in compact bodies with beautiful evolutions, over-looking a great extent of country ere they make choice of a spot on which to alight; this is done wherever a certain berry, called here "Curlew berry," proves to be abundant. Here they balance themselves, call, whistle and of common accord come to the ground, as the top of the country here must be called. They devour every berry and if pursued squat in the manner of Partridges. A single shot starts the whole flock; off they fly, ramble overhead for a great distance ere they again alight. This rambling is caused by the scarcity of berries. This is the same bird of which three specimens were sent to me by William Oakes of Ipswich, Mass. The iceberg has been broken into thousands of pieces by the gale.

August 4. Still raining as steadily as ever; the morning was calm and on shore the mosquitoes were shockingly bad, though the thermometer indicates only 49°. I have been drawing at the Esqui-maux Curlew; I find them difficult birds to represent. The young men went on shore and brought me four more; every one of the lads observed today the great tendency these birds have in squatting to elude the eye, to turn the tail towards their pursuer and to lay the head flat. This habit is common to many of the Sandpipers

and some of the Plovers. This species of Curlew, the smallest I ever saw, feeds on the berries it procures with a rapidity equaled only by that of the Passenger Pigeon; in an instant all the ripe berries on the plant are plucked and swallowed, and the whole country is cleared of these berries as our Western woods are of the mast. In their evolutions they resemble Pigeons also, sweeping over the ground, cutting backward and forward in the most interesting manner, and now and then poising in the air like a Hawk in sight of quarry. There is scarcely any difference in the appearance of the adult and the young. The Shore Lark of this season has now made such progress in its growth that the first molting is so forward that the small wing coverts and secondaries are already come and have assumed the beautiful rosy tints of the adults in patches at these parts; a most interesting state of their plumage, probably never seen by any naturalist before.

It is quite surprising to see how quickly the growth is attained of every living thing in this country, either animal or vegetable. In six weeks I have seen the eggs laid, the birds hatched, their first molt half over, their association in flocks and preparations begun for their leaving the country. That the Creator should have commanded millions of delicate, diminutive, tender creatures to cross immense spaces of country to all appearance a thousand times more congenial to them than this, to cause them to people, as it were, this desolate land for a time, to enliven it by the songs of the sweet feathered musicians for two months at most, and by the same command induce them to abandon it almost suddenly, is as wonderful as it is beautiful. The fruits are now ripe, yet six weeks ago the whole country was a sheet of snow, the bays locked in ice, the air a constant storm. Now the grass is rich in growth, at every step flowers are met with, insects fill the air, the snow banks are melting; now and then an appearance as of summer does exist, but in thirty days all is over; the dark northern clouds will enwrap the mountain summits; the rivulets, the ponds, the rivers, the bays themselves will begin to freeze; heavy snowfalls will cover all these shores and nature will resume her sleeping state, nay, more than that, one of desolation and death. Wonderful! Wonderful! But this marvelous country must be left to an abler pen than mine to describe.

The Rock Sandpiper and Least Sandpiper were both shot in numbers this day; the young are now as large as the old and we see little flocks everywhere. We heard the *Gulnare* was at Bonne Espérance, twenty miles west of us; I wish she was here, I should much like to see her officers again.

August 5. This has been a fine day, no hurricane. I have finished two Labrador Curlews, but not the ground. A few Curlews were shot and a Black-breasted Plover. John shot a Shore Lark that had almost completed its molt; it appears to me that northern birds come to maturity sooner than southern ones, yet the reverse is the case in our own species. Sandpipers are constantly passing over our heads in small bodies bound westward, some of the same species which I observed in the Floridas in October. The migration of birds is perhaps much more wonderful than that of fishes, almost all of which go feeling their way along the shores and return to the very same river, creek or even hole to deposit their spawn, as birds do to their former nest; but the latter do not *feel* their way, but launching high in air go at once, and correctly too, across vast tracts of country, yet at once stopping in portions heretofore their own, and of which they know by previous experiences the comforts and advantages. We have had several arrivals of vessels, some so heavily loaded with fish that the water runs over their decks; others, in ballast, have come to purchase fish.

August 10. I now sit down to post my poor book while a heavy gale is raging furiously around our vessel. My reason for not writing at night is that I have been drawing so constantly, often seventeen hours a day, that the weariness of my body at night has been unprecedented, by such work at least. At times I felt as if my physical powers would abandon me; my neck, my shoulders, and, more than all, my fingers, were almost useless through actual fatigue at drawing. Who would believe this? Yet nothing is more true. When at the return of dawn my spirits called me out of my berth, my body seemed to beg my mind to suffer it to rest a while longer; and as dark forced me to lay aside my brushes I immediately went to rest as if I had walked sixty-five miles that day, as I have done *a few times* in my stronger days. Yesternight when I rose from my little seat to contemplate my work and to judge of the effect of it compared with the nature which I had been attempting to

copy, it was the affair of a moment; and instead of waiting as I always like to do until that hazy darkness which is to me the best time to judge of the strength of light and shade, I went at once to rest as if delivered from the heaviest task I ever performed. The young men think my fatigue is added to by the fact that I often work in wet clothes, but I have done that all my life with no ill effects. No! no! it is that I am no longer young. But I thank God that I did accomplish my task; my drawings are finished to the best of my ability, the skins well prepared by John.

We have been to Paroket Island to procure the young of the Common Puffin. As we approached the breeding place the air was filled with these birds and the water around absolutely covered with them, while on the rocks were thousands, like sentinels on the watch. I took a stand, loaded and shot twenty-seven times and killed twenty-seven birds, singly and on the wing, without missing a shot; as friend Bachman would say, "Pretty fair, Old Jostle!" The young men laughed and said the birds were so thick no one could miss if he tried; however, none of them did so well. We had more than we wanted, but the young were all too small to draw with effect. Nearly every bird I killed had a fish in its beak, closely held by the head and the body dangling obliquely in the air. These fish were all of the kind called here *Lints*, a long, slender fish now in shoals of millions. How many must the multitude of Puffins inhabiting this island destroy daily? Whilst flying they all issue a rough croak, but none dropped the fish nor indeed did they let it go when brought to the earth. The Black-backed Gulls have now almost all gone south with their young; indeed, very few Gulls of any sort are now to be seen. Whilst on the island we saw a Hawk pounce on a Puffin and carry it off. Curlews have increased in numbers, but during two fair days we had they could not be approached; indeed, they appear to be so intent on their passage south that whenever the weather permits they are seen to strike high in the air across the harbor.

The gale is so severe that our anchors have dragged forty or fifty yards, but by letting out still more chain we are now safe. It blows and rains so hard that it is impossible to stand in the bow of our vessel. But this is not all—who, *now*, will deny the existence of the Labrador Falcon? Yes, my Lucy, one more new species is on

the list of *The Birds of America*, and may we have the comfort of seeing its beautiful figure multiplied by Havell's engraver. This bird (both male and female) was shot by John whilst on an excursion with all our party, and on the 6th inst., when I sat till after twelve o'clock that night to outline one of them to save daylight the next day to color it as I have done hundreds of times before. John shot them on the wing, whilst they were in company with their two young ones. The birds, one would be tempted to believe, had never seen a man before, for these affectionate parents dashed towards the gunners with fierce velocity, and almost instantly died from the effects of two well-directed shots. All efforts to procure the young birds were ineffectual; they were full grown, and as well as could be seen, exactly resembled the dead ones. The whole group flew much like the Peregrine Falcon, which indeed resembles them much in form, but neither in size nor color. Sometimes they hover almost high in air like a small Sparrow Hawk when watching some object fit for prey on the ground, and now and then cry much like the latter, but louder in proportion with the difference of size in the two species. Several times they alighted on stakes in the sandbar at the entrance of Bras d'Or River and stood not as Hawks generally do, uprightly, but horizontally and much like a Jager or a Tern. Beneath their nest we found the remains of Razor-billed Auks, Foolish Guillemots and Common Puffins, all of which are within their reach on an island here called Paroket Island—also the remains of Curlews and Ptarmigans. The nest was so situated that it could not be reached, only seen into. Both birds were brought to me in excellent order. No more is known of this bird, I believe.

My evening has been enlivened by the two Italians from the *Wizard* who have been singing many songs to the accompaniment of John's violin.

August 11. At sea, Gulf of St. Lawrence. We are now, seven of the evening, fully fifty miles from the coast of Labrador. We left our harbor at eleven o'clock with a fair breeze; the storm of last night had died away and everything looked promising. The boats were sent ashore for a supply of fresh water; John and Coolidge went after Curlews; the rest of the crew, assisted by that of the *Wizard*, raised the anchors, and all was soon in readiness. The bottom of our vessel had been previously scraped and cleaned from the

thousands of barnacles which, with a growth of seaweeds, seemed to feed upon her as they do on the throat of a whale. The two Italians and Captain Wilcomb came on board to bid us adieu; we hoisted sail and came out of the Labrador harbor. Seldom in my life have I left a country with as little regret as I do this; the next nearest to this was East Florida, after my excursions up the St. John's River. As we sailed away and I saw, probably for the last time, the high, rugged hills partly immersed in masses of the thick fog that usually hovers over them, and knew that now the bow of our truly fine vessel was turned towards the place where thou, my Lucy, art waiting for me, I felt rejoiced, although yet far away.

Now we are sailing in full sight of the northwestern coast of Newfoundland, the mountains of which are high, with drifted snow banks dotted over them and cut horizontally with floating strata of fogs reaching along the land as far as the eye can see. The sea is quite smooth; at least I think so, or have become a better seaman through habit. John and Lincoln are playing airs on the violin and flute; the other young men are on deck. It is worth saying that during the two months we have been on the coast of Labrador, moving from one harbor to another or from one rocky isle to another, only three nights have we spent at sea. Twenty-three drawings have been executed, or commenced and nearly completed. Whether this voyage will prove a fruitful one remains to be proved; but I am content, and hope the Creator will permit us to reach our country and find our friends well and happy.

August 13. Harbor of St. George, St. George's Bay, Newfoundland. We have been running, as the sailors say, till five this evening, when we anchored here. Our way here was all in sight of land along the northwest shores of Newfoundland, the highest land we have yet seen; in some places the scenery was highly picturesque and agreeable to the eye, though little more vegetation appeared than in Labrador. Last night was a boisterous one and we were all uncomfortable. This morning we entered the mouth of St. George's Bay, about thirteen leagues broad and fully eighteen deep. A more beautiful and ample basin cannot easily be found; not an obstruction is within it. The northeast shores are high and rocky, but the southern ones are sandy, low and flat. It took us till five o'clock to ascend it and come to our present anchorage in sight of a small

village, the only one we have seen these two months, and on a harbor wherein more than fifty line-of-battle ships could safely ride, the bottom being of clay. The village is built on an elongated point of sand or natural seawall under which we now are, and is perfectly secure from every wind but the northeast. The country as we ascended the bay became more woody and less rough. The temperature changed quite suddenly and this afternoon the weather was so mild that it was agreeable on deck and congenial even to a southerner like myself.

We find here several small vessels engaged in the fisheries and an old hulk from Hull, England, called *Charles Tennison*; she was lost near this on her way from Quebec to Hull some years ago. As we came up the bay a small boat with two men approached and boarded us, assisting as pilots. They had a barrel of fine salmon which I bought for ten dollars. As soon as our anchors touched bottom our young men went on shore to try to purchase some fresh provisions but returned with nothing but two bottles of milk, though the village is said to contain two hundred inhabitants. Mackerel are caught all round us, and sharks of the man-eating kind are said to be abundant just now and are extremely troublesome to the fishers' nets. Some signs of cultivation are to be seen across the harbor and many huts of Mic-Mac Indians adorn the shores. We learn the winter here is not nearly as severe as at Quebec; the latitude of this place and the low, well-guarded situation of the little village at once account for this; yet not far off I see patches of snow remaining from last winter. Some tell us birds are abundant, others that there are none; but we shall soon ascertain which report is true. I have not slept a minute since we left Labrador. The ice here did not break up so that the bay could be navigated till the 17th of May, and I feel confident no one could enter the harbors of Labrador before the 10th of June or possibly even later.

August 14. All ashore in search of birds, plants, shells and all the usual *et ceteras* attached to our vocations; but we all were driven on board soon by a severe storm of wind and rain, showing that Newfoundland has its share of bad weather. Whilst on shore we found the country quite rich compared with Labrador, all the vegetable productions being much larger, more abundant and finer.

We saw a flock of House Swallows that had bred about the little village now on their passage southwest and all gay and singing. I forgot to say that two days since, when about forty miles out at sea, we saw a flock of the Republican Swallow. I saw here the Blue yellow-eyed Warbler, the Fish Hawk, several species of Sparrows, among them the Lincoln's Finch, the Canada Titmouse, Black-headed ditto, White-winged Crossbill, Pine Grosbeak, Maryland Yellow-throat, Pigeon Hawk, Hairy Woodpecker, Bank Swallow, Tell-tale Godwit, Golden-eyed Duck, Red-breasted Merganser, three Loons—of which two were young and almost able to fly; the Spotted Sandpiper, and a flock of Sandpipers, the species of which could not be ascertained. We spoke to some of the native Indians to try to engage them to show us the way to the interior, where we are told the Small or True Ptarmigan abounds, but they were too lazy even to earn money. Among the plants we found two varieties of rose and the narrow-leaved kalmia. Few supplies can be obtained and a couple of small clearings are all the cultivated land we have seen since we left the Magdalene Islands. On returning to our vessel, I was rowed on the roughest sea I have ever before encountered in an open boat, but our captain was at the helm and we reached the deck safely but drenched to the skin. The wind has now abated and I hope to draw plants all day. This evening a flock of Terns, twenty or thirty with their young, traveled due south; they were very clamorous and beat against the gale most beautifully. Several Indians came on board and promised to go tomorrow after hares.

August 15. We have had a beautiful day; this morning some Indians came alongside; they had half a reindeer or caribou and a hare which I had never seen before. We took the forty-four pounds of fresh meat and gave in exchange twenty-one of pork and thirty-three of ship biscuit, and paid a quarter of a dollar for the hare, which plainly shows that these Indians know full well the value of the game which they procure. I spent a portion of the day in adding a plant to my drawing of the Red-necked Diver, after which we all went on shore to the Indians' camp across the bay. We found them as I expected all lying down pell-mell in their wigwams. A strong mixture of blood was apparent in their skins, shape and deportment; some indeed were nearly white, and sorry I am to say

that the nearer to our own noble selves, the filthier and lazier they are; the women and children were particularly disgusting. Some of the former from whom I purchased some rough baskets were frightfully so. Other women had been out collecting the fruit called here "baked apple." When a little roasted it tastes exactly like baked apple. The children were engaged in catching lobsters and eels, of which there are numbers in all the bays here; at Labrador lobsters are rare. The young Indians simply waded out up to their knees, turned the eel grass over and secured their prey. After much parley, we engaged two hunters to go as guides into the interior to procure caribou and hares, for which they were to receive a dollar a day each. Our men caught ninety-nine lobsters, all of good size; the shores truly abound in this valuable shellfish. The Indians roast them in a fire of brushwood and devour them without salt or any other *et ceteras*. The caribous are now "in velvet" and their skins light gray, the flesh tender but the animal poor. The average weight when in good condition, four hundred pounds. In the early part of March the caribou leave the hills and come to the seashore to feed on kelp and sea-grasses cut off by the ice and cast on the shore. Groups of many hundreds may be seen thus feeding. The flesh here is held in low estimation; it tastes like poor venison.

I saw today several pairs of Cayenne Terns on their way south; they flew high and were very noisy. The Great Terns passed also in vast multitudes. When the weather is stormy they skim close over the water; if fair, they rise very high and fly more at leisure. The Tell-tale Godwit is now extremely fat, extremely juicy, extremely tender and extremely good. The Boreal Chickadee is very abundant; so is the Pine Grosbeak, but in a shocking state of molt. The sheep laurel, the natives say, is an antidote for cramp and rheumatism. I was on the point of bidding thee good-night when we all were invited to a ball on shore. I am going with the rest out of curiosity.

August 16. The people seemed to enjoy themselves well at the ball and John played the violin for them till half-past two. I returned on board before eleven and slept soundly till the young men hailed for a boat. This morning has been spent drawing a laurel to a bird. The young men went off with the Indians this morning but returned this evening, driven back by flies and mosquitoes. Lincoln

is really in great pain. They brought a pair of Willow Grouse, old and young; the latter had no hairy feathers yet on the legs. They saw Canada Jays, Crossbills, Pine Grosbeaks, Robins, one Golden-winged Woodpecker, many Canadian Titmice, a Martin Swallow, a Kingfisher (none in Labrador) and heard a squirrel which sounded like the red squirrel. The country was described as being "up and down the whole way." The moss almost as deep as in Labrador, the morasses quite as much so; no tall wood and no hard wood. The lads were all so fatigued that they are now sound asleep.

August 17. We would now be "ploughing the deep" had the wind been fair; but as it was not, here we still are *in statu quo.* I have drawn a curious species of alder to my White-winged Crossbill and finished it. I had a visit from an old Frenchman who has resided on this famous island for fifty years; he assured me that no Red Indians were now to be found: the last he heard of were seen twenty-two years ago. These native Indians give no quarter to anybody; usually, after killing their foes, they cut the heads off the latter and leave the body to the wild beasts of the country. Several flocks of Golden Plovers passed over the bay this forenoon; two Pomarine Jagers came in this evening. Ravens abound here but no Crows have been seen. The Great Tern is passing south by thousands and a small flock of Canada Geese was seen. A young of the Golden-crested Wren was shot, full grown and fledged, but not a sign of yellow on the head. A Flycatcher was killed which probably is new; tomorrow will tell. I bought seven Newfoundland dogs for seventeen dollars; now I shall be able to fulfill my promises to friends. The American Bittern breeds here and leaves in about two weeks hence.

August 18. At daylight the wind was fair, and though cloudy, we broke our anchorage and at five were underway. We coasted Newfoundland till evening, when the wind blew a gale from the southwest and a regular tempest set in. Our vessel was brought to at dusk, and we danced and kicked over the waves all evening and will do so all night.

August 19. The storm still continues without any sign of abating; we are still at anchor, tossed hither and thither and withal seasick.

August 21. Today the storm ceased but the wind is still so adverse that we could make no port of Newfoundland; towards this island

we steered, for none of us wished to return to Labrador. We tried to enter the Strait of Canseau but the wind failed us; while the vessel lay becalmed we decided to try to reach Pictou in Nova Scotia and travel by land. We are now beating about towards that port and hope to reach it early tomorrow morning. The great desire we all have to see Pictou, Halifax, and the country between them and Eastport is our inducement.

August 22. After in vain attempting to reach Pictou, we concluded after dinner that myself and party should be put ashore anywhere, and the *Ripley* should sail back towards the Strait of Canseau, the wind and tide being favorable. We drank a glass of wine to our wives and our friends and our excellent little captain took us to the shore while the vessel stood still with all sails up awaiting his return. We happened to land on an island called Ruy's Island where, fortunately for us, we found some men making hay. Two of these we engaged to carry our trunks and two of the party to this place, Pictou, for two dollars—truly cheap. Our effects, or rather those we needed, were soon put up, we all shook hands most heartily with the captain—to whom we now feel really attached— said farewell to the crew and parted, giving three hearty cheers.

We were now, thanks to God, positively on the mainland of our native country, and after four days' confinement in our berths, and sick of seasickness, the sea and all its appurtenances, we felt so refreshed that the thought of walking nine miles seemed like nothing more than dancing a quadrille. The air felt deliciously warm, the country, compared with those we have so lately left, appeared perfectly beautiful and the smell of the new-mown grass was the sweetest that ever existed. Even the music of the crickets was delightful to mine ears, for no such insect does either Labrador or Newfoundland afford. The voice of a Blue Jay was melody to me, and the sight of a Hummingbird quite filled my heart with delight. We were conveyed a short distance from the island to the main; Ingalls and Coolidge remained in the boat and the rest of us took the road, along which we moved as lightly as if boys just out of school. The roads were good or seemed to be so; the woods were all of tall timber, and the air that circulated freely was filled with perfume. Almost every plant we saw brought to mind some portion of the United States; in a word, all of us felt quite happy. Now and

then as we crossed a hill and looked back over the sea we saw our beautiful vessel sailing freely before the wind, and as she gradually neared the horizon she looked like a white speck or an Eagle high in air. We wished our captain a most safe voyage to Quoddy.

We arrived opposite Pictou in two hours and a half and lay down on the grass to await the arrival of the boat, enjoying the scenery around us. A number of American vessels were in the harbor loading with coal; the village, placed at the upper end of a fine bay, looked well, though small. Three churches rose above the rest of the buildings, all of which are of wood, and several vessels were on the stocks. The whole country appeared in a high state of cultiva- tion and looked well; the population is about two thousand. Our boat came, we crossed the bay and put up at the "Royal Oak," the best house, and have had what seemed to be, after our recent fare, a most excellent supper. The very treading on a carpeted floor was quite wonderful. This evening we called on Professor McCullough, who received us very kindly, gave us a glass of wine, showed his fine collection of well-preserved birds and other things and invited us to breakfast tomorrow at eight, when we are again to inspect his curiosities. The Professor's mansion is a quarter of a mile out of town and looks much like a small English villa.

August 23. We had an excellent Scotch breakfast at Professor McCullough's. His whole family were present, four sons and a daughter besides his wife and her sister. I became more pleased with the Professor the more he talked. I showed a few Labrador drawings after which we went in a body to the University, once more to examine his fine collection. I found there half a dozen specimens of birds which I longed for and said so; the Professor had the cases opened, the specimens taken out, and he offered them to me with so much apparent good will that I took them. He then asked me to look around and not to leave any object which might be of assistance in my publication; but so generous had he already proved himself that I remained mute; I saw several I would have liked to have, but I could not mention them. He offered me all his freshwater shells, and any minerals I might choose. I took a few specimens of iron and copper. I am much surprised that this valuable collection is not purchased by the government of the Province; he offered it for £500. I think it well

worth £1,000. Thou wilt say I am an enthusiast; to this I will reply—True, but there are many more in the world, particularly in Europe.

On our return to the "Royal Oak" we were called on by Mr. Blanchard, the deputy consul for the United States, an agreeable man, who offered to do whatever he could for us; but the coach was almost ready, our birds were packed, our bill paid, and the coach rolled off. I walked on ahead with Mr. Blanchard for about a mile; he spoke much of England, and knew John Adamson of Newcastle and other friends there. The coach came up and we said farewell. The wind had commenced to blow and soon rain fell heavily; we went on smoothly, the road being as good as any in England and broader. We passed through a fine tract of country, well wooded, well cultivated and a wonderful relief to our eyes after the barren and desolate regions of rocks, snow, tempests, and storms. We stopped to dine at four in the afternoon at a wayside house. The rain poured down; two ladies and a gentleman—the husband of one of them—had arrived before us in an open cart or "jersey," and I, with all the gallantry of my nature, at once offered to change vehicles with them. They accepted the exchange at once but did not even thank us in return. Shattuck, Ingalls, and I jumped into the open cart when dinner was ended. I was seated by a very so-so Irish dame named Katy; her husband was our driver. Our exchange proved a most excellent one: the weather cleared up; we saw the country much better than we could have done in the coach. To our surprise we were suddenly passed by Professor McCullough, who said he would see us at Truro. Towards sunset we arrived in view of this pretty, scattered village in sight of the head waters of the Bay of Fundy. What a delightful sensation at that moment ran through my frame as I realized that I was within a few days of home! We reached the tavern, or hotel, or whatever else the house of stoppage might be called, but as only three of us could be accommodated there we went across the street to another. Professor McCullough came in and introduced us to several members of the Assembly of this Province and I was handed several pinches of snuff by the Professor, who *loves it*. We tried in vain to obtain a conveyance for ourselves tomorrow morning instead of going by coach tonight; it could not be done. Professor McCullough then

took me to the house of Samuel George Archibald, Esq., Speaker of the Assembly, who introduced me to his wife and handsome young daughter. I showed them a few drawings and received a letter from Mr. Archibald to the Chief Justice of Halifax, and now we are waiting for the mail coach to proceed to that place.

The village of Truro demands a few words. It is situated in the middle of a most beautiful valley of great extent and well cultivated; several brooks water this valley and empty into the Bay of Fundy, the broad expanse of which we see to the westward. The buildings, though principally of wood, are good-looking, and as cleanly as those in our pretty eastern villages, white, with green shutters. The style of the people, be it loyal or otherwise, is extremely genteel, and I was more than pleased with all those whom I saw. The coach is at the door, the cover of my trunk is gaping to receive this poor book, and therefore once more, good-night.

August 24. Wind due east, hauling to the northeast, good for the *Ripley*. We are now at Halifax in Nova Scotia, but let me tell thee how and in what manner we reached it. It was eleven last night when we seated ourselves in the coach; the night was beautiful and the moon shone brightly. We could only partially observe the country until the morning broke; but the road we can swear was hilly and our horses lazy, or more probably very poor. After riding twenty miles we stopped a good hour to change horses and warm ourselves. John went to sleep, but the rest of us had some supper, served by a very handsome country girl. At the call, "Coach ready!" we jumped in and had advanced perhaps a mile and a half when the linchpin broke, and there we were at a standstill. Ingalls took charge of the horses and responded with great energy to the calls of the owls that came from the depths of the woods, where they were engaged either at praying to Diana or at calling to their parents, friends and distant relations. John, Lincoln and Shattuck, always ready for a nap, made this night no exception; Coolidge and I, not trusting altogether to Ingalls' wakefulness, kept awake and prayed to be shortly delivered from this most disagreeable of traveling experiences, detention—at all times to be avoided if possible, and certainly to be dreaded on a chilly night in this latitude.

Looking up the road, the vacillating glimmer of the flame

intended to assist the coachman in the recovery of the lost linchpin was all that could be distinguished, for by this the time was what is called "wolfy." The man returned, put out the pine-knot—the linchpin could not be found—and another quarter of an hour was spent in repairing with all sorts of odds and ends. How much longer Ingalls could, or would, have held the horses, we never asked him, as from different exclamations we heard him utter we thought it well to be silent on that subject.

The day dawned fair and beautiful. I ran a mile or so ahead of the coach to warm my feet, and afterwards sat by the driver to obtain, if possible, some information about the country, which became poorer and poorer as our journey proceeded. We were all very hungry and were told the "*stand*" stood twenty-five miles from the lost linchpin. I asked our driver to stop wherever he thought we could procure a dozen or so of hardboiled eggs and some coffee, or indeed anything eatable; so he drew up at a house where the owner looked us over, and said it would be quite impossible to provide a breakfast for six persons of our appearance. We passed on and soon came on the track of a tolerably large bear, *in the road*, and at last reached the breakfast ground at a house on the margin of Green Lake, a place where fish and game, in the season, abound. This lake forms part of the channel which was intended to be cut for connecting by canal the Atlantic, the Bay of Fundy and the Gulf of St. Lawrence at Bay Verte. Ninety thousand pounds have been expended, but the canal is not finished and probably never will be; for we are told the government will not assist the company by which it was undertaken, and private spirit is slumbering.

We had an excellent breakfast at this house, seventeen miles from Halifax; this place would be a most delightful summer residence. The road was now level but narrow; the flag of the Halifax garrison was seen when two miles distant. Suddenly we turned short and stopped at a gate fronting a wharf, where was a small ferry boat. Here we were detained nearly an hour; how would this work in the States? Why did Mrs. Trollope not visit Halifax? The number of beggarly-looking Negroes and Negresses would have afforded her ample scope for contemplation and description.

We crossed the harbor, in which rode a sixty-four-gun flagship, and arrived at the house of one Mr. Paul. This was the best hotel

in Halifax, yet with great difficulty we obtained *one* room with four beds but no private parlor—which we thought necessary. With a population of eighteen thousand souls, and just now two thousand soldiers added to these, Halifax has not one good hotel, for here the attendance is miserable, and the table far from good. We have walked about to see the town, and all have aching feet and leg-bones in consequence of walking on hard ground after tramping only on the softest, deepest mosses for two months.

August 25. I rose at four and wrote to thee and Dr. [George] Parkman; Shattuck wrote to his father and he and I took these letters to an English schooner bound to Boston. I was surprised to find every wharf gated, the gates locked and barred and sentinels at every point. I searched everywhere for a barber; they do not here shave on Sunday; finally, by dint of begging, and assuring the man that I was utterly unacquainted with the laws of Halifax, being a stranger, my long beard was cut at last. Four of us went to church where the Bishop read and preached; the soldiers are divided up among the different churches and attend in full uniform. This afternoon we saw a military burial; this was a grand sight. The soldiers walked far apart, with arms reversed; an excellent band executed the most solemn marches and a fine anthem. I gave my letters from Boston to Mr. Tremaine, an amiable gentleman.

August 26. This day has been spent in writing letters to thyself, Nicholas Berthoud, John Bachman and Edward Harris; to the last I have written a long letter describing all our voyage. I took the letters to the *Cordelia* packet [boat], which sails on Wednesday and may reach Boston before we do. I delivered my letters to Bishop Inglis and the Chief Justice, but were assured both were out. John and Ingalls spent their evening very agreeably with Commissary Hewitson.

August 27. Breakfast eaten and bill paid, we entered the coach at nine o'clock, which would only contain five, so though it rained one of us sat with the driver. The road between Halifax and Windsor, where we now are, is macadamized and good, over hills and through valleys, and though the distance is forty-five miles we had only one pair of horses, which nevertheless traveled about six and a half miles an hour. Nine miles of our road lay along the Bay of Halifax and was very pleasant. Here and there a country home

came in sight. Our driver told us that a French squadron was pursued by an English fleet to the head of this bay, and the seven French vessels were compelled to strike their colors; but the French commodore or admiral sunk all his vessels, preferring this to surrendering them to the British. So deep was the water that the very tops of the masts sank far out of sight and once only since that time, twenty years ago, have they been seen; this was on an unusually calm, clear day seven years past. We saw *en passant* the abandoned lodge of Prince Edward, who spent a million pounds on the building, grounds, etc. The whole now is in the greatest state of ruin; thirty years have gone by since it was in its splendor.

On leaving the bay we followed the Salmon River, a small rivulet of swift water which abounds in salmon, trout and other fish. The whole country is miserably poor, yet much cultivation is seen all the way. Much game and good fishing was to be had round the inn where we dined; the landlord said his terms were five dollars a week and it would be a pleasant summer residence. We passed the seat of Mr. Jeffries, President of the Assembly, now Acting Governor. The house is large and the grounds in fine order. It is between two handsome freshwater lakes; indeed, the country is covered with lakes, all of which are well supplied with trout. We saw the college and the common school, built of freestone, both handsome buildings. We crossed the head of the St. Croix River, which rolls its impetuous waters into the Bay of Fundy. From here to Windsor the country improved rapidly and the crops looked well.

Windsor is a neat, pretty village; the vast banks of plaster of Paris all about it give employment to the inhabitants and bring wealth to the place; it is shipped from here in large quantities. Our coach stopped at the best *boarding-house* here, for nowhere in the Provinces have we heard of hotels; the house was full and we were conveyed to another, where after more than two hours' delay we had a very indifferent supper. Meantime we walked to see the Windsor River on the east bank of which the village is situated. The view was indeed novel; the bed of the river [is] nearly a mile wide and quite bare as far as eye could reach, about ten miles. Scarcely any water to be seen, and yet the spot where we stood, sixty-five feet above the river bed, showed that at high tide this

wonderful basin must be filled to the brim. Opposite to us, indeed, the country is diked in, and vessels left dry at the wharves had a strange appearance. We are told that there have been instances when vessels have slid sidewise from the top of the bank to the level of the gravelly bed of the river. The shores are covered for a hundred yards with mud of a reddish color. This conveys more the idea of a flood or great freshet than the result of tide, and I long to see the waters of the ocean advancing at the rate of four knots an hour to fill this extraordinary basin; this sight I hope to enjoy tomorrow.

August 28. I can now say that I have seen the tidewaters of the Bay of Fundy rise sixty-five feet. We were seated on one of the wharves and saw the mass of water accumulating with a rapidity I cannot describe. At half flow the water rose three feet in ten minutes, but it is even more rapid than this. A few minutes after its greatest height is attained it begins to recede, and in a few hours the whole bed of the river is again emptied. We rambled over the beautiful meadows and fields and John shot two Marsh Hawks, one of each sex, and we saw many more. These birds here are much darker above and much deeper rufus below than any I ever procured in the Middle States or farther south. Indeed, it may be said that the farther north I have been, the deeper in tint have I found the birds. The steamboat has just arrived and the young men have been on board to secure our passage. No news from the States.

Eastport, Maine, August 31. We arrived here yesterday afternoon in the steamer *Maid of the Mist.* We left Windsor shortly before twelve noon and reached St. John's, New Brunswick, at two o'clock at night. Passed Cape Blow-me-down, Cape Split and Cape d'Or. We were very comfortable, as there were few passengers, but the price was sufficient for all we had, and more. We perambulated the streets of St. John's by moonlight and when the shops opened I purchased two suits of excellent stuff for shooting garments. At the wharf just as the steamer was about to leave I had the great pleasure of meeting my most excellent friend Edward Harris, who gave me a letter from thee and the first intelligence from the big world we have left for two months. Here we were kindly received by all our acquaintances; our trunks were not opened and the new

clothes paid no duties; this ought to be the case with poor students of nature all over the world. We gave up the *Ripley* to Messrs. Buck and Tinkham, took up our quarters with good Mr. Weston and all began packing immediately.

We reached New York on Saturday morning, the 7th of September, and thank God found all well. Whilst at Boston I wrote several letters, one very long one to Thomas Nuttall, in which I gave him some account of the habits of water birds with which he was unacquainted; he sent me an extremely kind letter in answer.

The Great Black-backed Gull

High in the thin, keen air, far above the rugged crags of the desolate shores of Labrador, proudly sails the tyrant Gull, floating along on almost motionless wing like an eagle in his calm and majestic flight. On widely extended pinions, he moves in large circles, constantly eyeing the objects below. Harsh and loud are his cries, and with no pleasant feeling do they come on the winged multitudes below. Now onward he sweeps, passes over each rocky bay, visits the little islands and shoots off towards the mossy heaths, attracted perhaps by the notes of the Grouse or some other birds. As he flies over each estuary, lake or pool, the breeding birds prepare to defend their unfledged broods or ensure their escape from the powerful beak of their remorseless spoiler. Even the shoals of the finny tribes sink deeper into the waters as he approaches; the young birds become silent in their nests or seek for safety in the clefts of the rocks; the Guillemots and Gannets dread to look up, and the other Gulls, unable to cope with the destroyer, give way as he advances. Far off among the rolling billows he spies the carcass of some monster of the deep and, on steady wing, glides off towards it. Alighting on the huge whale, he throws upwards his head, opens his bill and, louder and fiercer than ever, sends his cries through the air. Leisurely he walks over the putrid mass, and now, assured that all is safe, he tears, tugs, and swallows piece after piece, until he is crammed to the throat, when he lays himself down surfeited and exhausted to rest for a while in the feeble sheen of the northern sun. Great, however, are the powers of his stomach, and before long the half-putrid food which, vulture-like, he has devoured, is digested. Like all gluttons, he loves variety, and away he flies to some well-known isle, where thousands of young birds or eggs are to be found. There, without remorse, he breaks the shells, swallows their contents and begins leisurely to devour the helpless young. Neither the cries of the parents nor all their attempts to drive the plunderer away can induce him to desist until he has again satisfied his ever-craving appetite. But although tyrannical, the Great Gull is a coward, and meanly does he sneak off when he sees the Skua fly up which, smaller as it is, yet evinces a thoughtless intrepidity that strikes the ravenous and merciless bird with terror.

If we compare this species with some other of its tribe, and mark its great size, its powerful flight and its robust constitution, we cannot but wonder to find its range so limited during the breeding season. Few individuals are to be found northward of the entrance into Baffin's Bay, and rarely are they met with beyond this, as no mention is made of them by Dr. Richardson in the *Fauna Boreali-Americana*. Along our coast, none breed farther south than the eastern extremity of Maine. The western shores of Labrador along an extent of about three hundred miles afford the stations to which this species resorts during spring and summer; there it is abundant, and there it was that I studied its habits.

The farthest limits of the winter migrations of the young, so far as I have observed, are the middle portions of the eastern coast of the Floridas. While at St. Augustine in the winter of 1831 I saw several pairs keeping company with the young Brown Pelican, more as a matter of interest than of friendship, as they frequently chased them as if to force them to disgorge a portion of their earnings, acting much in the same manner as the *Lestris* [Jager] does towards the smaller Gulls, but without any effect. They were extremely shy, alighted only on the outer edges of the outer sandbars and could not be approached, as they regularly walked off before my party the moment any of us moved towards them until, reaching the last projecting point, they flew off, and never stopped until out of sight. At what period they left that coast I am unable to say. Some are seen scattered along our seashores, from the Floridas to the Middle States, there being but few old birds among them; but the species does not become abundant until beyond the eastern extremities of Connecticut and Long Island, when their number greatly increases the farther you proceed. On the whole of that extensive range these birds are very shy and wary, and those which are procured are merely "chance shots." They seldom advance far up the bays unless forced to do so by severe weather or heavy gales; and although I have seen this bird on our Great Lakes, I do not remember having ever observed an individual on any of our eastern rivers, at a distance from the sea, whereas the *Larus argentatus* [Herring Gull] is frequently found in such places.

Towards the commencement of summer, these wandering birds are seen abandoning the waters of the ocean to tarry for a while

on the wild shores of Labrador, dreary and desolate to man but to them delightful as affording all that they can desire. One by one they arrive, the older individuals first. As they view from afar the land of their birth, that moment they emit their loud cries with all the joy a traveler feels when approaching his loved home. The males sooner or later fall in with the females of their choice, and together they proceed to some secluded sandbar, where they fill the air with their furious laughs until the rocks echo again. Should the student of nature happen to be a distant spectator of these meetings, he too must have much enjoyment. Each male bows, moves around his mate, and no doubt discloses to her the ardor of his love. Matters are managed to the satisfaction of all parties, yet day after day for awhile, at the retreat of the waters, they meet as if by mutual agreement. Now you see them dressing their plumage, now partially expanding their wings to the sun; some lay themselves comfortably down on the sand, while others, supported by one foot, stand side by side. The waters again advance and the Gulls all move off in search of food. At length the time has arrived; small parties of a few pairs fly towards the desert isles. Some remain in the nearest to prepare their nests, the rest proceed, until each pair has found a suitable retreat, and before a fortnight has elapsed, incubation has commenced.

The nest of this species is usually placed on the bare rock of some low island, sometimes beneath a projecting shelf, sometimes in a wide fissure. In Labrador it is formed of moss and seaweeds carefully arranged, and has a diameter of about two feet, being raised on the edges to the height of five or six inches, but seldom more than two inches thick in the center, where feathers, dry grass and other materials are added. The eggs are three, and in no instance have I found more. They are two inches and seven-eighths in length, by two inches and one-eighth in breadth, broadly ovate, rough but not granulated, of a pale earthy greenish-grey color, irregularly blotched and spotted with brownish-black, dark umber, and dull purple. Like those of most other Gulls, they afford good eating. This species lays from the middle of May to that of June, and raises only one brood in the season. The birds never leave their eggs for any length of time until the young make their appearance. Both sexes incubate, the sitting bird being supplied with food by

the other. During the first week the young are fed by having their supplies disgorged into their bill, but when they have attained some size, the food is dropped beside or before them. When they are approached by man, they walk with considerable speed towards some hiding place or to the nearest projecting ledge, beneath which they squat. When five or six weeks old, they take to the water to ensure their escape, and swim with great buoyancy. If caught, they cry in the manner of their parents. On the 18th of June, several small ones were procured and placed on the deck of the *Ripley*, where they walked with ease and picked up the food thrown to them. As soon as one was about to swallow its portion, another would run up, seize it, tug at it, and if stronger, carry it off and devour it. On the third of that month, two individuals, several weeks old and partly fledged, were also brought on board. Their notes, although feeble, perfectly resembled those of their parents. They ate greedily of everything that was offered to them. When fatigued they sat with their tarsi placed on the ground and extended forward, in the manner of all the Herons, which gave them a very ludicrous appearance. Before a month had elapsed, they appeared to have formed a complete acquaintance with the cook and several of the sailors, had become quite fat and conducted themselves much like Vultures, for if a dead Duck or even a Gull of their own species were thrown to them, they would tear it in pieces, drink the blood and swallow the flesh in large morsels, each trying to rob the others of what they had torn from the carcass. They never drank water, but not unfrequently washed the blood and filth from their bills by immersing them and then shaking the head violently. These birds were fed until they were nearly able to fly. Now and then the sailors would throw them overboard while we were in harbor. This seemed to gratify the birds as well as the sailors, for they would swim about, wash themselves, and dress their plumage, after which they would make for the sides, and would be taken on board. During a violent gale, one night while we were at anchor in the harbor of Bras d'Or, our bark rolled heavily, and one of our pets went over the side and swam to the shore where, after considerable search next day, it was found shivering by the lee of a rock. On being brought to its brothers, it was pleasant to see their mutual congratulations, which were extremely animated. Before we

left the coast, they would sometimes fly of their own accord into the water to bathe, but could not return to the deck without assistance, although they endeavored to do so. I had become much attached to them, and now and then thought they looked highly interesting, as they lay panting on their sides on the deck, although the thermometer did not rise above 55°. Their enmity to my son's pointer was quite remarkable, and as that animal was of a gentle and kindly disposition, they would tease him, bite him and drive him fairly from the deck into the cabin. A few days after leaving St. George's Bay in Newfoundland, we were assailed by a violent gale and obliged to lie-to. Next day one of the Gulls was washed overboard. It tried to reach the vessel again, but in vain: the gale continued; the sailors told me the bird was swimming towards the shore, which was not so far off as we could have wished and which it probably reached in safety. The other was given to my friend Lieutenant Green of the United States Army at Eastport in Maine. In one of his letters to me the following winter, he said that the young *Larus marinus* was quite a pet in the garrison and doing very well, but that no perceptible change had taken place in its plumage.

On referring to my journal again, I find that while we were at anchor at the head of St. George's Bay, the sailors caught many codlings, of which each of our young Gulls swallowed daily two, measuring from eight to ten inches in length. It was curious to see them after such a meal: the form of the fish could be traced along the neck, which for a while they were obliged to keep stretched out; they gaped and were evidently suffering; yet they would not throw up the fish. About the time the young of this species are nearly able to fly, they are killed in considerable numbers on their breeding grounds, skinned and salted for the settlers and resident fishermen of Labrador and Newfoundland, at which latter place I saw piles of them. When they are able to shift for themselves, their parents completely abandon them, and old and young go separately in search of food.

The flight of the Great Black-backed Gull is firm, steady, at times elegant, rather swift, and long protracted. While traveling, it usually flies at the height of fifty or sixty yards and proceeds in a direct course with easy, regulated flappings. Should the weather prove tempestuous, this Gull, like most others, skims over the

surface of the waters or the land within a few yards or even feet, meeting the gale but not yielding to it and forcing its way against the strongest wind. In calm weather and sunshine, at all seasons of the year, it is fond of soaring to a great height, where it flies about leisurely and with considerable elegance for half an hour or so in the manner of eagles, vultures and ravens. Now and then while pursuing a bird of its own species or trying to escape from an enemy, it passes through the air with rapid boundings which, however, do not continue long, and as soon as they are over it rises and slowly sails in circles. When man encroaches on its domains, it keeps over him at a safe distance, not sailing so much as moving to either side with continued flappings. To secure the fishes on which it more usually preys, it sweeps downwards with velocity, and as it glides over the spot, picks up its prey with its bill. If the fish is small, the Gull swallows it on wing, but if large, it either alights on the water or flies to the nearest shore to devour it.

Although a comparatively silent bird for three-fourths of the year, the Great Black-backed Gull becomes very noisy at the approach of the breeding season and continues so until the young are well fledged, after which it resumes its silence. Its common notes when it is interrupted or surprised sound like *cack, cack, cack.* While courting, they are softer and more lengthened, and resemble the syllables *cawah,* which are often repeated as it sails in circles or otherwise within view of its mate or its place of abode.

This species walks well, moving firmly and with an air of importance. On the water it swims lightly but slowly, and may soon be overtaken by a boat. It has no power of diving, although at times, when searching for food along the shores, it will enter the water on seeing a crab or a lobster to seize it, in which it at times succeeds. I saw one at Labrador plunge after a large crab in about two feet of water when, after a tug, it hauled it ashore, where it devoured it in my sight. I watched its movements with a [spy]glass, and could easily observe how it tore the crab to pieces, swallowed its body, leaving the shell and the claws, after which it flew off to its young and disgorged before them.

It is extremely voracious and devours all sorts of food excepting vegetables, even the most putrid carrion, but prefers fresh fish, young birds or small quadrupeds, whenever they can be procured.

It sucks the eggs of every bird it can find, thus destroying great numbers of them as well as the parents if weak or helpless. I have frequently seen these Gulls attack a flock of young Ducks while swimming beside their mother, when the latter, if small, would have to take to wing, and the former would all dive, but were often caught on rising to the surface, unless they happened to be among rushes. The Eider Duck is the only one of the tribe that risks her life, on such occasions, to save that of her young. She will frequently rise from the water, as her brood disappear beneath, and keep the Gull at bay, or harass it until her little ones are safe under some shelving rocks, when she flies off in another direction, leaving the enemy to digest his disappointment. But while the poor Duck is sitting on her eggs in any open situation, the marauder assails her and forces her off, when he sucks the eggs in her very sight. Young Grouse are also the prey of this Gull, which chases them over the moss-covered rocks and devours them before their parents. It follows the shoals of fishes for hours at a time and usually with great success. On the coast of Labrador I frequently saw these birds seize flounders on the edges of the shallows; they often attempted to swallow them whole but, finding this impracticable, removed to some rock, beat them and tore them to pieces. They appear to digest feathers, bones, and other hard substances with ease, seldom disgorging their food unless for the purpose of feeding their young or mates, or when wounded and approached by man, or when pursued by some bird of greater power. While at Boston in Massachusetts one cold winter morning I saw one of these Gulls take up an eel about fifteen or eighteen inches in length from a mud bank. The Gull rose with difficulty, and after some trouble managed to gulp the head of the fish, and flew towards the shore with it, when a White-headed Eagle made its appearance, and soon overtook the Gull, which reluctantly gave up the eel, on which the Eagle glided towards it and, seizing it with its talons before it reached the water, carried it off.

This Gull is excessively shy and vigilant, so that even at Labrador we found it difficult to procure it, nor did we succeed in obtaining more than about a dozen old birds and that only by stratagem. They watched our movements with so much care as never to fly past a rock behind which one of the party might be likely to lie

concealed. None were shot near the nests when they were sitting on their eggs, and only one female attempted to rescue her young and was shot as she accidentally flew within distance. The time to surprise them was during violent gales, for then they flew close to the tops of the highest rocks, where we took care to conceal ourselves for the purpose. When we approached the rocky islets on which they bred, they left the place as soon as they became aware of our intentions, cackled and barked loudly, and when we returned, followed us at a distance more than a mile.

They begin to molt early in July. In the beginning of August the young were seen searching for food by themselves, and even far apart. By the 12th of that month they had all left Labrador. We saw them afterwards along the coast of Newfoundland and while crossing the Gulf of St. Lawrence, and found them over the bays of Nova Scotia as we proceeded southward. When old, their flesh is tough and unfit for food. Their feathers are elastic and good for pillows and such purposes, but can rarely be procured in sufficient quantity.

The most remarkable circumstance relative to these birds is that they either associate with another species, giving rise to a hybrid brood, or that when very old they lose the dark color of the back, which is then of the same tint as that of the *Larus argentatus* or even lighter. This curious fact was also remarked by the young gentlemen who accompanied me to Labrador; and although it is impossible for me to clear up the doubts that may be naturally entertained on this subject, whichever of the two suppositions is adopted, the fact may yet be established and accounted for by persons who may have better opportunities of watching them and studying their habits. No individuals of *Larus argentatus* were, to my knowledge, seen on that coast during the three months which I passed there, and the fishermen told us that the "saddlebacks were the only large Gulls that ever breed there."

This bird must be of extraordinary longevity, as I have seen one that was kept in a state of captivity more than thirty years. The following very interesting account of the habits of a partially domesticated individual I owe to my esteemed and learned friend Dr. Neill of Edinburgh.

"In the course of the summer of 1818, a 'big scorie' [i.e., scaurie,

Orkney and Shetland dialect: the young of any kind of gull] was brought to me by a Newhaven fisher boy, who mentioned that it had been picked up at sea, about the mouth of the Firth of Forth. The bird was not then fully fledged: it was quite uninjured: it quickly learned to feed on potatoes and kitchen refuse, along with some ducks; and it soon became more familiar than they, often peeping in at the kitchen window in hopes of getting a bit of fat meat, which it relished highly. It used to follow my servant Peggy Oliver about the doors, expanding its wings and vociferating for food. After two molts I was agreeably surprised to find it assuming the dark plumage of the back and the shape and color of the bill of the *Larus marinus*, or Great Black-backed Gull; for I had hitherto regarded it as merely a large specimen of the Lesser Black-backed (*L. fuscus*), a pair of which I then possessed, but which had never allowed the newcomer to associate with them. The bird being perfectly tame, we did not take the precaution of keeping the quills of one wing cut short so as to prevent flight; indeed, as it was often praised as a remarkably large and noble looking Sea-maw [i.e., Sea-mew, a common gull], we did not like to disfigure it. In the winter 1821–2 it got a companion in a Cock-Heron, which had been wounded in Coldinghame Muir, brought to Edinburgh alive and kept for some weeks in a cellar in the old College, and then presented to me by the late Mr. John Wilson, the janitor, a person remarkably distinguished for his attachment to natural history pursuits. This Heron we succeeded in taming completely, and it still (1835) remains with me, having the whole garden to range in, the trees to roost upon, and access to the loch at pleasure, the loch being the boundary of my garden.

"Some time in the spring of 1822 the large Gull was missing, and we ascertained (in some way that has now escaped my memory) that it had not been stolen nor killed, as we at first supposed, but had taken flight, passing northwards over the village, and had probably therefore gone to sea. Of course I gave up all expectation of ever hearing more of it. It was not without surprise, therefore, that on going home one day in the end of October of that year, I heard my servant calling out with great exultation, 'Sir, Big Gull is come back!' I accordingly found him walking about in his old haunts in the garden, in company with and recognizing (as I am

firmly persuaded) his old friend the Heron. He disappeared in the evening, and returned in the morning for several days, when Peggy Oliver thought it best to secure him. He evidently did not like confinement, and it was concerted that he should be allowed his liberty, although he ran much risk of being shot on the millpond by youthful sportsmen from Edinburgh. After this temporary captivity he was more cautious and shy than formerly; but still he made almost daily visits to the garden and picked up herrings or other food laid down for him. In the beginning of March 1823 his visits ceased and we saw no more of him till late in the autumn of that year. These winter visits to Canonmills and summer excursions to the unknown breeding place were continued for years with great uniformity: only I remarked that after the Gull lost his protectress, who died in 1826, he became more distant in his manners. In my notebook under date of 6th October 1829, I find this entry: 'Old Peggy's Great Black-backed Gull arrived at the pond this morning, the seventh (or eighth) winter he has regularly returned. He had a scorie with him, which was soon shot on the loch by some cockney sportsman.' The young bird, doubtless one of his offspring, had its wing shattered, and continued alive in the middle of the pond, occasionally screaming piteously for two or three days, till relieved by death. The old Gull immediately abandoned the place for that winter as if reproaching us for cruelty. By next autumn, however, he seemed to have forgotten the injury, for according to my record, '30th October 1830, The Great Black-backed Gull once more arrived at Canonmills garden.' The periods of arrival, residence and departure were nearly similar in the following year. But in 1832 not only October but the months of November and December passed away without Gull's making his appearance, and I of course despaired of again seeing him.

"He did, however, at length arrive. The following is the entry in my commonplace book: 'Sunday, 6th January 1833. This day the Great Black-back returned to the millpond, for (I think) the eleventh season. He used to reappear in October in former years, and I concluded him dead or shot. He recognized my voice and hovered over my head.' He disappeared early in March as usual, and reappeared at Canonmills on 23rd December 1833, being a fortnight earlier than the date of his arrival in the preceding season,

but six weeks later than the original period of reappearance. He left in the beginning of March as usual, and I find from my notes that he 'reappeared on 30th December 1834 for the season, first hovering around and then alighting on the pond as in former years.' The latest entry is, '11th March 1835: The Black-backed Gull was here yesterday, but has not been seen today; nor do I expect to see him till November.'

"This Gull has often attracted the attention of persons passing the village of Canonmills, by reason of its sweeping along so low or near the ground, and on account of the wide expanse of wing which it thus displays. It is well known to the boys of the village as 'Neill's Gull' and has, I am aware, owed its safety more than once to their interference in informing passing sportsmen of its history. When it first arrives in the autumn it is in the regular habit of making many circular sweeps around the pond and garden, at a considerable elevation, as if reconnoitering; it then gradually lowers its flight and gently alights about the center of the pond. Upon the gardener's mounting the garden-wall with a fish in his hand, the Gull moves towards the overhanging spray of some large willow trees, so as to catch what may be thrown to him, before it sinks in the water. There can be no doubt whatever of the identity of the bird. Indeed, he unequivocally shows that he recognizes my voice when I call aloud 'Gull, Gull,' for whether he be on wing or afloat, he immediately approaches me.

"A few pairs of the Great Black-backed Gull breed at the Bass Rock yearly, and it seems highly probable that my specimen had originally been hatched there. If I may be allowed a conjecture, I would suppose that after attaining maturity he for some years resorted to the same spot for the purpose of breeding; but that of late years, having lost his mate or encountered some other disaster, he has extended his migration for that purpose to some very distant locality, which has rendered his return to winter quarters six weeks later than formerly."

[The Great Black-backed Gull, *Larus marinus*, appears in Plate 241 of *The Birds of America*.]

John Woodhouse Audubon to Thomas Lincoln
"I give you a lesson in the art of skinning birds..."

Charleston, South Carolina
9 January 1834

My dear Thomas,

I now commence without knowing what I am to say, but you must not grumble out, "Why does he write without a reason?" for I have one and you shall have it. It is because I could not ship just opposite to you in a cabin ten feet across for three months without forming an attachment, to say nothing of all our days of fun and of [sea]sickness being spent together during that period; and that is my first reason for keeping up a correspondence. I flatter myself you would give, from your conduct while we were together, much the same answer to a similar question.

Now I am going to give you my selfish reason: I want you to catch and skin for Mr. [John] Bachman, of this place, all the shrews & mice and small quadrupeds you can; he will send you in return the same number of animals from this place. Write and let him know your determination on this subject. In the meantime, I don't mind if I give you a lesson in the art of skinning birds. I have made a great improvement in the art, or trade, whichever you choose to call it, and I hope you will profit by my knowledge on the subject. Turn the page over and be instructed.

You open the birds from a little above the lower end of the breast bone to within half an inch of the parson's nose or point from which the tail feathers start. You then push up the legs (the knee joint comes out first) and cut the bone just below the knee, which loosens all the nerves, and you may pull it out easily and clean the bones. Then turn them back, because it gives more room. You then pull the skin backwards over the legs, which you cut through and turn it (the skin) over the pope's nose and then inside out over the head and ears (the wings ought to be broken with a pair of pinchers), close to the body of the bird. You will find that the best mode of performing the operation.

My parents send respects—and remembrances to all your friends—and I am your affectionate friend and well-wisher

J. W. Audubon

P.S. To skin an animal, you open him between the forelegs and cut off his head. You will find the skin tears off the rest of the body, *comme il faut.*

John James Audubon to Victor Gifford Audubon
"Our work will be the standard of American ornithology..."

Charleston, South Carolina
22 January 1834

My dear beloved Victor,

God willing, we will be with you about the 4th of July next—
I have been much tormented for some weeks past on account of
the requisitions which you have made, that I should return to
England as early in the spring as possible. *No reasons* have you
given, and sorry indeed shall I be if, on our arrival in England,
I find, as on a former occasion, that I should have been recalled to
Europe for the mere gratification of a few friends and acquaint-
ances, the whole of whom may I daresay long to see me, but none
of whom can know the intentions, the cares and the anxieties
which your father feels towards your welfare, that of your brother
and equally that of your most kind mother. The die is cast, how-
ever; I have given up my urgent wish to revisit the Floridas and a
certain portion of the western and northwestern parts of our own
beloved country, and unless you write in answer to my last letters
to you on this subject, with open thoughts of your own, that I may
remain in America, depend upon what I say at the beginning of
this: God willing, we will be with you about the 4th of July!

Fearing that you are troubled for the want of money, I will exert
myself to the very utmost to send you forthwith 2, 3 or 4 hundred
pounds to alleviate the difficulties (if any there are) in your calls for
cash...I wish you had made it a point to have sent me the 20
volumes [i.e., sets of Vol. I] for which I have so often written to
you—through them I could have sent you perhaps one thousand
pounds. But this is all over now, and I must do the best I can without
any of them but the 2 copies. I can do no more in England than
you have done; depend upon it, the southern part of England
will be of no effect when I go there. America, I am sure, is the
country that will support us after all. This day the Numbers 34 and
35 have come into port for this city and the Columbia College, but
I have not seen them yet. All the numbers by the *President* were

wet and good for nothing. They have been sold at auction in New York, and vexed enough I have been about them. I ask you most earnestly not to ship anything more in this *slack manner*. If Havell will not see that our work is properly packed, *see it yourself*. I shall reach England, I hope, with as many drawings of water birds as will complete the 3rd volume of our work—but to tell you the truth, it will prove a most wonderful thing if the fourth volume does contain 100 plates. *You* are afraid of new species coming in, *I* am greatly afraid of wanting them. But enough of this; when we meet all will be understood in a few weeks, and in a few months I must return to our country to complete my researches and procure here (America) subscribers to enable us all to become one day independent of the world and particularly of England.

Long ere this reaches you, I hope you will have received the duplicate paper sent you for *Loudon's Magazine*, and also that Mr. Loudon will have it inserted in his *Journal*. That that paper may produce some effect on the minds of many, I have no doubt, but that it will be an equivalent to the representations of my character being false is quite another affair. Here, rattlesnakes are known to climb trees—to feed on squirrels, &c. Here, Vultures are known to have no sense of smell, &c., but all that we know of these matters will require a century of time to establish these facts in the eyes of the British public.

Our work will become important even long ere it is completed; for this reason it is imperiously necessary that every execution in our power should be kept up, with truth, firmness, dignity and consistency, from beginning to end. That the world and naturalists especially will become satisfied that when finished, our work will be the standard of American ornithology, I have no doubt; but as this will in all probability only appear after my death, you and your brother are the ones that will reap the benefit of the worthiness of my practical studies, therefore I strongly advise you to believe in your father's thoughts, that through this publication yourself and John may expect to become rich, respected and highly thought of.

Twenty years ago, my writing in the present style would have been ridiculous in me—but now I am sure of what I say, and proud that when thus I express my feelings freely to my sons, I am equally

sure that I tell them the truth and nothing but the truth connected
with my most ardent wish that they should become most happy
through my exertions, joined with their own . . .

Lucy Audubon to Victor Gifford Audubon
"Nearly 100 water birds are arranged..."

Charleston, South Carolina
26 January 1834

... We have been as fully occupied as possible this winter, and in the amiable family [of John Bachman] we have spent our evenings and days in the society of, we have not felt the want of any of the society we enjoyed last winter in Boston. Nearly 100 water birds are arranged for the [third] volume [of *The Birds of America*] and many more, but your father becomes more and more particular about them, and draws some of them three or four times over, but they really are all beautiful, and I am sure there must be a time when it will be much sought-after...

John James Audubon to Edward Harris
"Who will believe my story?"

New York, New York
15 April 1834

My Dear Friend

To tell you that I am surprised at your generous conduct in remitting to me four hundred & ninety dollars in advance for all the Numbers of my work would be a poor gratification to me; I *feel* your generosity and cannot say any more. God bless you. Numbers 36 & 37 have reached this place. My drawings shipped from Charleston are safely in the hands of Victor at London. I have been able to forward him 650£ and I have 30 sovereigns to defray our expenses from Liverpool to the great metropolis.

In 1824, poor, I had dreams, but how far was I then from believing that I should ever have succeeded as I have? Who will believe my story? Only one or 2 besides yourself have an idea of what I have undergone, but if God grants me life, I shall publish that story and send you the sheets thereof as they are struck by the printer. Whenever you see [the portrait painter Henry] Inman tell him to give you the sketch, as it is of my good wife, and you keep it for Victor should we be lost [at sea]. I have recommended to Victor to continue *The Birds of America* with all possible dispatch and to consult you and our other friend, John Bachman of Charleston, S.C., and should we be lost let me beg of you to assist my son by your friendly, prudent & worthy advice.

The election was a most remarkable one and I regret you did not witness it. I did, now I think that matters will soon operate powerfully and that the Tyrant will have to shrink from the view of the people—I mean *the American People*! I wish you to write to us soon, and not to wait with etiquette for regular answers. I will, or we all will, inform you of all that may happen to us after we are landed...

PART VII:
HOPE FOR GREAT THINGS

John James Audubon to Richard Harlan, M.D.
"My life from my earliest youth has been uncommon..."

*Audubon refers in this letter to writing his autobiography. None was
ever published, nor is the text known to have survived.*

London, England
20 August 1834

My dear Harlan,

What has become of you? We have been here four months and
although I wrote to you from Liverpool the day we landed there,
not a line have we received from you—do let us know how yourself
& good lady are as well as the rest of your family.

Here we go on much on the usual plan; that is, we all work hard
and daily. I have finished my 2nd volume of [bird] biographies
about ten days ago, but will not bring it out until December next
on account of the emptiness of London until that time...

[page damaged] I spend at writing my own biography...This
will be a curious book, for I shall give the good, the bad and the
indifferent in a style which perhaps will not make *every* reader
laugh. My friends will all be mentioned and my foes not neglected,
and as my life from my earliest youth has been a singular and
uncommon one, the whole may prove interesting to my kind and
to naturalists more especially. It will prove 4 quarto volumes with
the portrait of the author, from the miniature painted by Cruick-
shank, who has improved that picture much since my return to
England. The famous William Turner is the person who will
engrave it on steel. You see that I have a good winter's task before
me, besides other avocations connected with my present works.

We came over in the company of Mr. Charles Maywood of the
Philadelphia theater, whom we have found a most interesting man,
and of whom we have seen a good deal *here*...

John Woodhouse Audubon to Thomas Lincoln
"This wonderful city is a poor man's hell..."

London, England
24 August 1834

Dear Thomas,

I believe if my recollection of you depended on the letters I received from you I should no longer believe in the existence of such a person, but fortunately it does not, and I cannot forget the many happy days we have spent together, and hope that you will not think of cutting me entirely, so let me beg you will write what you are at, what you have done and are likely to do in the next few months, for now we are so far apart, unless we let each other into prospects we shall know nothing of each other.

Have you ever sent any small animals to Mr. Bachman in Charleston, or have you any birds for us that you think new? I really believe that were you not urged on, you would let us all drop off, one by one, and all our enjoyment of studying the same subjects in different parts of the world be done away with. Papa has nearly done his 2nd volume of letterpress, and I believe your moose hunt will flourish in one part of it.

I have been truly astonished with the wealth and poverty of this wonderful city. It is a poor man's hell. To the rich it is a paradise at last in point of luxuries and amusements. The rich have the best of everything and are as much above the poor (yes, more above the poor) than the rich whites of the south are above their slaves; if you walk the fashionable streets, you see liveries of the richest materials and colors, the most beautiful carriages and horse and dresses such as our richest men could only afford [at] one-half off, while perhaps in the next street all is poverty and the most filthy vagabonds fill the streets, begging to every corner. This is truly the state of London. This is all owing to the overpopulation, and an act of Parliament that prevents the estates of noblemen from passing away from their heirs; the duties on every foreign article are most outrageous, even on the very bread they eat... All things pay duties and of course only the rich can afford [them]... [Here

is] none of that happy poverty which we see in America, where a man owns a little house and a little land around and from that gains all he makes and is contented. All the poor are literally the slaves of the rich. But I must not run down a country that I find it convenient to live in.

Write soon and let me know where you are at...

John James and Lucy Audubon to John Bachman
"I hate this infernal smoky London...!"

London, England
25 August 1834

My dear Bachman,

You really are a lazy fellow! I have been in England four months, have written to you God knows how often, and yet the only letter I have received from you reached us 15 minutes ago. Now when I receive letters, I write in answer at once, you see; and if I receive none, I keep hammering at my friends' doors like a Woodpecker on the back of some tough tree, the inside of which it longs to see.

Your letter is of July 22nd and was most welcome I assure you. To see your dear handwriting has quite raised our spirits, the more especially as you give us intelligence of all being well & happy under your roof. I wish I was there also, for between you & I and the post I hate this infernal smoky London as I do the Devil!!

I hear nothing more of [Audubon's relentless critic Charles] Waterton. Your paper certainly "used him up" and I have no one to trouble me on the like scores. I am heartily glad that what the *honest* gentleman said of me has so well insured his purpose. Tell my sweetheart [Maria Martin, Audubon's background illustrator and Bachman's sister-in-law] and our dear daughters [i.e., Bachman's daughters] that I am most happy to hear of their perseverance, industry and augmentation of their acquirements. Tomorrow we forward them some dresses, prints and a book of instruction in the art of painting miniatures given us by Cruickshank. Also a box containing a 2nd volume for Mr. Rees and the Numbers for Charleston & Columbia. All those deliver and receive the money for—*as soon as you can!* We are going on now bravely, the 4th and 5th Numbers of water birds are engraved, and the 3 of which you will see with this will give you an idea of how they look. We will publish 7 Numbers of water birds by December next, and 10 next year and so on to the completion of the Work.

As it seems that you have received only 4 lines from me, I must repeat a great deal, and here goes.

I have written so constantly for two months, that I was obliged to leave off after having finished 100 articles of [bird] biography and 13 episodes. I became swelled [with piles] as I was at your house, &c., and have been idle there 10 days to assist my recovery. [William] MacGillivray is assisting me as before; he says this volume will be much superior to the first, & larger. The fact is that my late tramps, and our visitation to you was of the greatest benefit imaginable to my studies. Since here I have read [Prideaux John] Selby's & [Conrad Jacob] Temminck's works, but they are, I am sorry to say, *not from Nature*. Not a word could I find in them but what was compilation. I could not even be told at what time the Golden Eagle laid her eggs in Europe! Sir William Jardine has published an enormous quantity of trash, all compilation, and takes the undue liberty of giving figures from my work and those of all others who may best suit his views. Mr. [John] Gould is publishing the Birds of England, of Europe, &c., &c., &c., in all sorts of ways. [William] Swainson has 17 volumes in his head and on papers, half-finished. I have seen him twice only. [William] Yarrell, who is a first-rate naturalist and a most excellent man, is now publishing a beautiful work (wood cuts) on the fishes of this country. Two brothers Meyers are also publishing the Birds of England. In fact, you could not pass a bookseller's shop from the extreme "West End" to Wapping without seeing new books on Zoology in every window —and "at most reduced prices"! Swainson says he has upwards of 50,000 insects, and more bird skins that his house will hold.

Henry Ward [a bibulous taxidermist whom Audubon had employed during his Florida expeditions] is on the pavé, a poor miserable object who can scarcely make out a living for his wife & himself. He exchanged, sold, &c., all his bird skins, pulled off the whole of his stolen White Herons' feathers, sold those to the shops for ladies' headdresses and the mutilated skins to a Jew, who offered them to Havell at $^1/_2$ a dollar apiece. I sold 52 pounds sterling of skins to the British Museum about a month ago, and again 20£ worth two days ago, & Havell has sold a good number more, so I shall not be a loser in that way. My own *double* collection I have in drawers at home.

Charles Bonaparte has written very kindly to me, and it appears that what William Cooper of New York told me was fudge. On

the 8th of next month, about 500 philosophers on zoology will meet at Edinburgh from all parts of these mighty British Isles. I have other fish to fry—I go to Manchester, &c., &c., &c., to see the whole of my patrons; I start next Saturday and will be absent about one month or so, after which to France I go for another month and on my return begin the printing of the 2nd volume of biographies. This coming winter I will spend at writing my own biography, to be published as soon as possible and to be continued as God may be pleased to grant me life!

Our dear sons are studying every day. My old friend [i.e., Lucy] mends our socks, makes our shirts, reads to us at times, but drinks no brandy nowadays. She has cast off her purchased sham curls, wears her own dear grey locks and looks all the better. John can make a pretty good portrait in black chalk and Victor a pretty landscape in oil. They are studying music & other matters. On the whole, we are happy and contented as much as can be whilst absent from our dear & beloved friends of Charleston. Tell my sweetheart that Cruickshank has improved my miniature very considerably— he has worked over the hair, &c. This picture goes to Turner to be engraved in mezzotints and you all shall hear report hereafter.

Your having shot a Chaffinch is indeed curious enough; but not more so than my having seen a Yellow-billed Cuckoo shot within 40 miles of London.

The town is now what is called "empty"; that is, the grandees are off shooting Partridges, Grouse, hares & Pheasants. Parliament is prorogued and there is, in fact, not more than a million and a half of people in town, one good or bad half of whom are beggars, thieves and blackguards of all sorts. We have an unaccountably hot summer—indeed, just such as I might have expected in New York. Fruit has been abundant and peaches has lowered in price to 25 cents! The theaters and shows of all sorts [have been] prodigiously crammed, as are now the different watering places of Britain. Victor told us on his return from Paris, the population there appeared as if constituted of English alone. A few cases of cholera have appeared, but London is now healthy. The queen of these realms has returned in perfect safety, she was hissed at her departure and groaned at on her return. The Irish are fighting like devils and I hope their rows will open the eyes of their merciless landlords.

Now, my dear Bachman, nothing in this world will give more pleasure than to go with you to the Floridas, and if you will prepare yourself for November 1835, God willing I will be your companion there, and as much further as you choose. This year it is impossible, for I have much to do ere I return to our dear shores, and I look upon my labors as a duty I owe to my family and to my Almighty Maker.

Whenever you have a good opportunity of preserving *excellent* Wild Turkey Cock skins pray do so—the only one I had I have sold for 20£ or 100 dollars! A female I sold for 25$, and if I had 50 males I could get the same price for each of them. Fine Anhingas, small Blue Herons and clean White Egrets sell well. Insects are now very high. I paid 20 dollars the other day for 5 which on account of their beauty have been thought cheap by Swainson. Common birds from any portion of the world are mere drug. I have some promises of fine dogs after the shooting season is over, and I hope to send you some shortly, as I will be at Lord Stanley's manor in about 2 weeks.

The old Zoological Gardens are much poorer than when I left England. The new ones carry the day. In fact, novelty is the motto of every Englishman, and scarcely any thing can live here longer than a month at most. One week generally suffices to kill the integrity of general subjects in exhibitions of all sorts...

I send you my own copy of [Thomas] Bewick's works, and also a pamphlet on Swans from Yarrell. And why did you not send me the eggs of the Chuck-Will's-Widow & "other matters"? I might, no doubt, have had some further opportunities of speaking of them in my 2nd volume. I left at your house several drawings which I want. Send them to the Messrs. Rathbone Brothers & Co., Merchants, Cornhill, Liverpool, or to Robert Havell if you have an opportunity for [a ship sailing to] London.

Now here is my 4th or 5th Episode to you and I beg an answer...

My dear sir,

My good husband having left some blank paper in his letter, I take up my pen to tell you how glad we were to hear from you at last, and to beg you not to be uneasy about your *sober friend* and the *brandy*, for none did I see until a few days ago, an old lady called

upon me and being ill, asked for some brandy, and to my *cost* I sent and had a *decanter* filled, for you must be told that brandy, and that very indifferent, is eight dollars a gallon, so that even if we wished for it, we should not have it, but I am so completely *set against* it by being obliged to drink it when sick at sea, that I shall not attempt to touch it again till I set out to return towards you; when at sea I take anything to give me one moment's relief. I send you our copy of Bewick because we are not sure of another copy, so scarce are they become, and I must do all I can soon or late to keep my word. Thank the Ladies for their zeal in our behalf on every point, when the "Birds of America" begin to return some of the sums they fly off with, I hope to send many a little remembrance amongst friends I love so well and think so much of. I should now *delight you* with the sight of a cap for Mrs. Bachman and Mrs. Davis, but they cannot go in such a squeezing package, however, "better late than never." Tell the young ladies to remember my mockingbirds, male & female, and not to let a ship come to London without letting us know, for I hate to pay *pounds* of carriage from this, to Liverpool. Hitherto we have all been hard at work since we arrived. What is become of Miss [Maria] Martin's beau, whom I expected to see this summer in town? Give, and accept, my best wishes *for you all*, excuse this hasty scrawl and believe me, truly your friend,

Lucy Audubon

Dialogue in a House in London
(John Bachman to John James Audubon)

John Bachman wrote this affectionate dialogue in response to Audubon's complaints that he was neglecting their correspondence. Bachman had christened Audubon "Jostle" early in their friendship after hearing Audubon complain repeatedly of being jostled in the hard-riding stage coaches of the day. When John Woodhouse joined his father in Charleston, Audubon became "Old Jostle," his son "Young Jostle." "Our sweetheart" is a reference to Maria Martin, Bachman's sister-in-law, who painted background flowers and plants for a number of Audubon's drawings and with whom both men competitively flirted.

Charleston, South Carolina
4 October 1834

Old Jostle: Bless my soul. What can be the reason that John Bachman never writes me a single line? I am sure he is vexed with me for something.

Lucy: Why, my dear, you were always contradicting each other. He did not like your drinking grog, though he took as much snuff as you, and then you would never bear to be told that you could make a mistake in a bird.

Young Jostle: Father, I think he may be angry because when he criticized your drawings, you called him a goose. When he beat you at shooting you said he shut the wrong eye, and when he gammoned you, you went to bed in a pet.

Old Jostle: Why, John, that is true. But you know, he was no more of a painter than a piano player. As for shooting, he was not so bad, but I am equal to him any day, and when I get back to America I will lead him such a dance as he will long remember. I don't blame him for shutting the wrong eye because he never could shut the other. In backgammon, I confess, he could beat me, but it is a trifling game and after all he must have grown jealous because our sweetheart thought more of me than of him.

Victor: As for my part, I think you are all mistaken. From what I have heard, you were both very free with each other. Like two

479

lovers, quarreling today and making up tomorrow. You know, father, you cannot bear to hear of your faults; he may be the same way; and I am sure both of you esteem each other as much as ever. The letters may have miscarried as he may have been very busy; be patient, father, and all will yet be explained. (*The bell rings—a letter*)

Old Jostle: God bless me, it is from John Bachman himself.
Young Jostle: Why father, you have kicked over the coffee pot.
[*Note:* The letter begins as follows:]

My old friend,
A line from you would be a pleasant sight just now. It is a long time since I heard the sound of your voice or saw your fine face or looked at your fair hand. Now though you are negligent enough, I do not accuse you of anything. I always say he is busy. He is frolicking, etc., but I never say he has forgotten his friends.

Were you ever in bedlam? If not, you would have a probable idea if you surrounded the same table with me at this moment. Here are Harriet and Julia kicking up a row, frightened at a cat. Jane is sitting as prim as you please. The two other girls' tongues are running thirteen to the dozen. My wife is poking at a stocking and ever and anon dropping a stitch. Our sweetheart with a book on agriculture before her, a stocking in her hand, giving directions about setting a mousetrap. Those that can rattle away with their tongues and roar and laugh must be well. So you can form an idea how all your friends in this family are. That was rather an unfortunate promise I made you in the middle of last month to write you twice a month. Here I am making you pay postage for nothing in compelling myself to write nonsense to fill up this foolscap.

The weather is very warm for the season. We have a great deal of sickness among the lower classes of emigrants and my hands are busy and I am employed in half a dozen capacities. In a few weeks it will again be healthy and with it I will again have a little leisure. We have found no new bird this summer. For this we must go to Florida. An intelligent botanist sent out by the King of Prussia has been with the expedition sent along the borders of Mexico and the Rocky Mountains. He promises to show me all his bird skins. He is no ornithologist. His name is Brickenheim. He is a Count, but

a very intelligent man, his title notwithstanding, which he always concealed from me.

I rejoice to hear that your last bird is written. Now for the proof sheets and the printer's devils, a horrible business, but you will soon get through with it and then hie on to Edinburgh. Let your book be of the size, etc., to correspond with the last. Richardson and Swainson's *Fauna Borealis* you took with you and I can get no copy in this country. I only want our notes so as I will try to review your book (and may scratch you in the bargain). You must in your next just look over your volume and give me a list of the mistakes they made and wherein they were right. Be careful and don't forget...

John James Audubon to Edward Harris
"I have great hopes to see the whole completed in three years..."

Edinburgh, Scotland
5 November 1834

My dear friend,

Your kind & interesting letter gave me much pleasure; it was the first and only one which had come to us and, anxious as I always am respecting your health & welfare, we all felt happy to know that all with you was as it should be. My old friend and I have been here some time, attending to the publication of my second volume of Ornithological Biographies, and we have now nine sheets cast. In about four weeks more, say the middle of December, that volume will be cast off to the world. What that world may think of it remains unknown and doubtless properly so. As soon as this present business is ended we will return to London where we left our sons at their several avocations.

I have little to tell you in the way of news of any kind, for although the world of politics goes on apace, that pace is that of the blind worm, at least in this country, when although every one individual is ever complaining, no one attempts to correct the evil. I sincerely hope that the case is different at home, and that ere long the Tormentor of our peace will be hurled into regions from whence his recollection may not even reach our ear, and that all the cormorants around him will share the same fate. The post office business must be of great importance before our next Congress and I shall not be sorry to know that material changes are made in that department.

I wish that, like yourself, I was being at home on a good planta-tion looking at my well-filled barn, fat stock of cattle and warm fireside waiting to enjoy each returning spring, but all such wishes, nay the very thoughts of them, must be laid aside for some future period. I shall do all in my power to return to America in the month of August next, when I sincerely hope you may consider it agreeable to take a long tramp with me somewhere beyond the Middle States! I am glad you have a warbler in your possession not described in

books, and I hope you will take care of it until you and I together give it a name if positively new. Your second volume of my work must have reached you long ere this. I examined it well and believe it to be the best out of Havell's shop. I am sadly in want of *birds in the flesh* of any sort and in pairs, for in Europe every one is agog to prove this, that or some other thing in natural science, which *without the proof before their eyes*, no one will believe. I have written to several of my friends in different parts of the Union to throw into a barrel of common whiskey a pair of each species they can collect until I reach that dear land once more, and if *you* would assist me in the same manner I shall really be most glad; the birds ought to be in as good order of feather as possible. Young birds too will not be amiss, no matter how common the species. They all would be acceptable, indeed necessary, to me to render my *Synopsis* efficient. When you go to New York try to procure rare skins for me. The Cape May Warbler, the Blue Mountain *do* [i.e., ditto] and Morning Warbler Male & F & young. I should much like to have, when I reach you next Autumn, of eggs all you can procure even by paying something for them.

Have you heard anything from the Nuttall expedition? Do you know if young Doctor Townsend of Philadelphia is still with him? When you next favor me with a letter, give me all you can on all these different subjects. Harlan, one would fear, has given me up, not a word from him as of yet. I have sent him 3 letters. My third volume goes on bravely; 5 Numbers are out and I think are an improvement on the previous ones. I have great hopes now to see the whole completed in three years from this date, plates & letterpress...

John James Audubon to Richard Harlan, M.D.
"Why should America be fearful to read the life of Audubon?"

Responding to Audubon's inquiry of 20 August 1834 (p. 471), his Philadelphia physician friend Richard Harlan evidently cautioned him not to publish the autobiography he was writing; here Audubon offers his proud rebuttal. What a pity the work has not survived.

Edinburgh, Scotland
16 November 1834

... The 5th Number of water birds is out. I now publish 10 Numbers per annum, and in 3 years (how soon that will pass by) the whole work will be finished, when I certainly hope to retire from the world, and live & die in peace in some of our furthest back settlements!

Nelson was cast as a great man—so certainly was Napoleon—what do you think of our Washington!!!! Have you forgotten Ben Franklin or Rittenhouse or even Bill Penn? Were they not all wonderful in their way? Has not your city produced a Ruth, a [illegible], a Westen? And nourished a Duponceau and a Vaughn? Have not our backwoods granted us a Clay, a Clark, and a Croghan? Aye, all these are "true bill!" Thus, my dear Harlan, if these are strictly true, and if you will allow me to add your name to that city; why should America be fearful to read of the life of her poor Audubon? Cannot, or will not, people of our days read with as much pleasure of the delightful studies of nature in our woods as they can of frightful revolutions, bloody battles and the carnage of wars which overrun lands as the fearful lava runs down the burning mountain?

Certainly yes. And for that reason alone, I have determined to picture my life on paper as I have already done that of our birds! Simple, full of pleasure, few [illegible] and altogether original! Only think how shocking it would prove to my [illegible] to be tortured by compilers who would produce ten chapters of untruths for my one of realities. Look at the life of Wilson by *anybody* and think for a moment how [illegible]. No one, in my humble opinion, ever [reckons] the stories of another heart. No one [illegible]

pointing his faults with half the truth the original can and will do! As to future reviewers, those beings will forever be as they have ever been: just, unjust, fools or learned men, and from their chaff the sound grain can by all be sifted. Truth, plain and unveiled truth fears no one and I shall abide all consequences when my *Autobiography* appears before them.

As to [Charles] Waterton, let him lie in his own filth. As to [George] Ord, forgive the fool. Selfishness has been the object of both, the charms of science in ornithology my only object; and should I not live long enough to enjoy the little benefit which I hope I deserved—what does it signify? Alive this day, dead tomorrow. Forgotten, perhaps, by this world, but, it is my hope, received without constraint within a far better one. As to number of volumes, I cannot say, but I know this well: that had you read the journals now around me, you would be not a little puzzled to condense them, even by the assistance of steam...

John James Audubon to John Bachman
"The truth is the truth, after all..."

Edinburgh, Scotland
10 December 1834

My dear Bachman,

We were much amused and gratified at receiving and reading your funny letter of October 4. It has had a famous long passage too. If this increases its value is certes more than doubtful.

I am sorry to hear of the disastrous effects and probable consequences originating in the cholera in your neighborhood as well as the fever in your own dear city; may God save you all!

My dear fellow, "the Book" [i.e., volume 2 of the *Ornithological Biography*] is out! Yes, quite done, and I am relieved for a moment at least. It consists of 38 sheets, better stuff than the first Vol. and I am sure much better looking. The reviewers are at work here— God only knows how they may trounce me but no matter, the truth is the truth after all, and beyond that I care not a single jot. I have replied to no one for previous abuses of me, and I think and trust that [George] Ord and that fool [Charles] Waterton will be greatly punished by my contemptuous silence. When *you* read my book, *scratch* all you can and welcome! I shall ship you a few English copies direct to Charleston from Liverpool next week. I cannot send you your own remarks about the *Fauna boreali Americana* of Swainson as my copy is gone back to London, but as soon as I reach there will do so. I think however that what I have said will amply suffice you on this head.

My third volume of plates is going on at so rapid a step that I am extremely desirous to have from you all the assistance your friendship towards me can collect and suggest. I now send you a list of queries to which I particularly beg of you to attend to, and in which I trust and hope you will not be slow, respecting habits:

Grus Canadensis—Canada Goose. Freshwater Marsh Hen— Saltwater Marsh Hen. Virginian Rail. Wood Ducks. Least Bittern. Great Blue Heron. Wood Ibis. Louisiana Heron and every Heron that breed or visit you. Mallard Ducks. White Ibis. Killdeer Plover.

All the Ducks that visit your shores and your market. *Long-billed Curlew.* Sora Rail. Marbled Godwit. Coot. Snipe (common). American Dab Chick (breed about you). Woodcocks. Telltale Godwit. American Bittern. Dusky Duck. Blue-winged Teal. Save all the windpipes and tongues of every species of water birds you can, in spirits, well marked with a ticket on which put sexes, dates, &c., &c., &c. Of all the above I am anxious you should study the habits, I mean describe in black and white their flight, motions on land or in the water. The construction of nests either if deep or flattish or shallow. Situations & localities, materials, eggs, time of incubation, appearance of young from old, food, intestines, time of arrival & departure, if singly or in flocks. Notes in love season, when affrighted or otherwise. Make all inquiries from good and true men and note down their sayings for future corroborations. And "do not put off until tomorrow what can be done today!" Ask the Lee family to note down whatever they meet with in Alabama.

Land birds:

Our Bank Swallows. Mark well, I think we have two species, at least one large variety—so says my Louisiana journals. Hairy Woodpecker, Red-cockaded Woodpecker and all other small species. Find the nest of the Southern Black-capped Titmouse. Watch the habits of the Barn Owl & save one or two bodies in spirits. Marsh Hawk—we have *two* species, I am quite sure! Brown Creeper. Scarlet Tanager. Black-throated Bunting, and indeed every other land bird not included in my 2nd Vol. of biography.

I am very sorry to hear of the expedition along Mexico and the Rocky Mountains. This will prove bad for me and *us*. As to the Prussian naturalist, I have no hopes of information from him and you need not expect any skins from that quarter. Some numskull will describe the whole they find in as dry a manner as possible, and old Jostle will have lost a great good chance. However, God granting me life & health, I shall follow their track some days not far off. Procure if you can the experiments made on the Buzzard by Dr. Leitner on paper of the poisonous drugs. Where is Benjamin Strobel, can he not assist us? Write to Dr. Gibbs and ask him to bear us a hand also. Here I am carefully comparing every species supposed to be identical in both continents.

The 7th Number of my water birds is out, and we proceed

soundly, although we have met with a great loss in the death of our first colorer. The *Little Work* [probably an early reference to the Octavo edition] will be begun as soon as we return to London, *but of this not a word.*

Edward Harris of Moorestown, New Jersey, is an excellent friend of mine. I have written to him also to procure for me all sorts of skins and to preserve birds' heads & feet or entire when small. I wish you would write to him also at least 2 letters on this subject. The same to [Dr. Richard] Harlan, who thinks I have given him up.

I am quite sure I never have been half so anxious as I am at this moment to do all in my power to complete my vast enterprise, and sorrowful indeed would be my dying moments if this work of mine was not finished ere my eyes are forever closed. Nay, my dear friend, there is something within me that tells me that should I be so fortunate as to see the close of my present publication, my name will be honorably handed to posterity and the comforts of my sons and their families much augmented through this means. *You are a member of my family,* and someone besides under your roof [i.e., John Woodhouse's fiancée Maria Bachman], not mentioning our own dearly-beloved sweetheart [i.e., Maria Martin] and the children, and I know you all so well that I feel confident that your shoulder (and it is a good strong one) will willingly be applied to the wheel.

It seems that I have missed several of your letters, for 2 are all that have reached us and 2 from Maria Martin, of the other dear Maria, I know a youth at London who has received quite a budget. But we are getting old, both of us and perhaps that accounts for the laxity of correspondence, or quite as probable one full half of your letters are thrown overboard during bad weather to lighten the gallant ship!

... Try to study the habits of the alligators, the time of their propagation, number of eggs, forms of the nests &c., &c., &c. I long to possess all respecting this reptile (amphibian) for my article of the Wood Ibis and Sandhill Crane, for it will make a fine picture on paper, and I can shew *Waterton the bold* astride of one's bare back in great style.

By now Dr. Parkman of Boston has at least a portion of the

letterpress [i.e., the *Ornithological Biography*], and I hope has begun printing the second volume of biography—750 copies for America and the same number are printed here. I wish you would cut out from all the newspapers the pros & cons about me.

I shall try my utmost to sail for America on the 1st of August next and in 8 days after reaching New York hope to be with you all, when I am sure you will muster your gun and go with me the Lord knows whereto! The boys keep "grinding" at London, and I, as soon as we reach there, will begin to macerate the third volume of the letterpress. Nay, it must be written all ere I sail for our dear shores.

On Saturday next, I send copies of the 2nd volume of biography to all our agents. Only think, it is just 6 weeks since we began printing and we have finished upwards of 650 pages! The same size, better paper, &c., to correspond, notwithstanding the ludicrous outcry about large books just now in this great and enlightened country. The fashionable size of books just now is in inches 4 by 2^1/$_2$, so modest, so empty of novelty and devoid of facts that it is enough to sicken one to look at their pompous coverings—but "never you mind," my dear fellow, I shall go on just as I began to the last and my work shall not be a beacon but a tremendous lighthouse!

John James Audubon to Charles-Lucien Bonaparte
"After this is completed I bid adieu to the public forever..."

London, England
14 January 1835

My Dear Friend—

I have had a copy of my 2nd volume of biographies packed and directed for you these 2 weeks, and cannot find the means of sending to you without putting you to the expense of carriage, &c. What should I do with it? The confounded elections have so completely taken hold of everyone here that I have not been able to have even a glance at your brother-in-law. It was not a little amazing to me to find that he had charged you 2 guineas for each of the plates you wanted. He called at Havell's thinking that the latter had made this extraordinary charge, when Havell opened his books and showed him his entry, in which the charge was as usual to *friend*? I underline the word because I do not replace any lost plates to anybody—numbers, once sent off and certified as having been sent, are conclusive. I have daily applications for plates of early numbers of the work that have been lost through the carelessness of the owners, and I cannot now replace those to them—my colorers will not work them up...

The 49th Number of my work goes to America this week and I am now closely engaged at preparing the letterpress of my 3rd volume, which will be printed this coming summer. The 3rd volume of illustrations will be finished January next.

My second volume of biographies has been well received here; it is reprinted at Boston in America, and is probably now before the American public. I find that my 3rd volume will consist of nearly 700 pages, the second has 600. The first 500. The 4th and last will be about the size of the first. After this is completed I bid adieu to the public forever and return to my own dear woods of the West, to plant cabbages; now & then shoot a Wild Turkey, or catch a trout, and die in peaceable comfort forgotten by the world. But next year I am bound to the Pacific Ocean accompanied by

my youngest son and a large party; the journey will positively be my last in search of information connected with ornithology.

Do, I pray you, write to me as soon as convenient and let me know how soon I can have the satisfaction of shaking you by the hand, to present my small family to you, and offer you a Kentucky dinner in London...

John James Audubon to John Bachman
"I am neither growed rich, fat or lazy..."

Edinburgh, Scotland
20 July 1835

... You are wrong in saying that I write to you but seldom. I never wait the length of a month without doing so, as my good wife can prove by her books, in which every letter forwarded is entered. I am neither growed rich, fat or lazy. I would have no great objection to the first of these misfortunes to a younger man than I am, but the two others I would despise. We were all glad to know that your ear had got better or well and hope that it will never return. Pray is it a fact that you have had a distressing fire at Charleston? I read a short paragraph in an English paper saying that on the 5th of June a great number of houses & barns had been destroyed, but not a word has appeared since, although I received a letter from William Gaston dated the 10th without allusions to this. But we are all concerned until we receive Maria's next letter to John, which must be in a few days, as these young folks are indeed *punctual* in their correspondence.

The kind opinion which you evince towards the worth of my second volume [of the *Ornithological Biography*] is a treasure to me, because I believe every word you say. I have some hopes that the one now being printed will please you still more so... As to the rage of Mr. Waterton or the lucubrations of Mr. Neal, who by the bye is a subscriber to the *Birds of America* (bona fide) I really care not a fig. All such stuffs will soon evaporate being mere smoke from a dunghill...

John is making rapid progress in portrait painting. He works now for money and has abundance to do here—on an average, five setters a day, which keeps him at the easel for eight hours. He is in fact more industrious than I used to think he ever would be; had I been as much so at his age, I might have become a great man, but I had no one to point out the way to me. I left my father too early or too late and unfortunately had too much money at my command in those days. I am now trying hard to make *amend honorable* by laboring from morn to night everyday, for this being

Sunday I devote altogether to writing to my correspondents &
friends, and as you see, pretty long epistles too! Victor paints fine
landscapes and works hard also! My old friend knits socks for us
all; indeed, my dear friend, we are a working family.

If I can live to complete my work, I shall leave my sons in a
good way, having the hope that when all is settled, each will have
a very fair amount to go on with. Our expenses are considerably
less here than they were in London, we see very little company
here at mealtimes, which in London is quite a misfortune to those
without thousands of guineas. Our sons spend many of their even-
ings at Professor Wilson's, who has a delightful family, learned &
amiable as well as accomplished . . .

You say nothing respecting money matters. Have you not
received my letters on this subject? Is the business [of old claims
against Audubon from Henderson days] settled? Do let me know.
We have no new subscribers in Europe; nay, I do not expect to
have many more, but expect to procure some when I go to America,
which I expect will be in the course of the next summer, in time
to see you all before I push for the Sabine River along the Mexican
Gulf. John will go with me. Lucy & Victor will remain to attend
to the work. I should have liked to have sailed next April, but I
am desirous to prepare the letterpress of the 4th volume as much
as possible in case of accident happening to me. I also wish to
write something personal of myself, which I think necessary to do
before I depart . . .

The Bluebird

This lovely bird is found in all parts of the United States, where it is generally a permanent resident. It adds to the delight imparted by spring and enlivens the dull days of winter. Full of innocent vivacity, warbling its ever-pleasing notes and familiar as any bird can be in its natural freedom, it is one of the most agreeable of our feathered favorites. The pure azure of its mantle and the beautiful glow of its breast render it conspicuous as it flits through the orchards and gardens, crosses the fields or meadows or hops along by the roadside. Recollecting the little box made for it as it sits on the roof of the house, the barn or the fence stake, it returns to it even during the winter, and its visits are always welcomed by those who know it best.

When March returns the male commences his courtship, manifesting as much tenderness and affection towards his chosen one as the dove itself. Martins and House Wrens! be prepared to encounter his anger or keep at a respectful distance. Even the wily cat he will torment with querulous chirpings whenever he sees her in the path from which he wishes to pick up an insect for his mate.

The Bluebird breeds in the Floridas as early as January and pairs at Charleston in that month, in Pennsylvania about the middle of April and in the State of Maine in June. It forms its nest in the box made expressly for the purpose or in any convenient hole or cavity it can find, often taking possession of those abandoned by the Woodpecker. The eggs are from four to six, of a pale blue color. Two and often three broods are raised in the year. While the female sits on the second set of eggs the male takes charge of the first brood and so on to the end.

The food of this species consists of coleoptera, caterpillars, spiders and insects of various kinds, in procuring which it frequently alights against the bark of trees. They are also fond of ripe fruits such as figs, persimmons and grapes, and during the autumnal months they pounce on grasshoppers from the tops of the great mullein, so frequent in the old fields. They are extremely fond of newly ploughed land on which, especially during winter and early spring, they are often seen in search of the insects turned out of their burrows by the plough.

The song of the Bluebird is a soft agreeable warble, often repeated during the love-season when it seldom sings without a gentle quivering of the wings. When the period of migration arrives its voice consists merely of a tender and plaintive note, perhaps denoting the reluctance with which it contemplates the approach of winter. In November most of the individuals that have resided during the summer in the Northern and Middle Districts are seen high in the air moving southward along with their families or alighting to seek for food and enjoy repose. But many are seen in winter whenever a few days of fine weather occur, so fond are they of their old haunts and so easily can birds possessing powers of flight like theirs move from one place to another. Their return takes place early in February or March when they appear in parties of eight or ten of both sexes. When they alight at this season the joyous carols of the males are heard from the tops of the early-blooming sassafras and maple.

During winter they are extremely abundant in all the Southern states and more especially in the Floridas, where I found hundreds of them on all the plantations that I visited. The species becomes rare in Maine, still more so in Nova Scotia and in Newfoundland and Labrador none were seen by our exploring party.

My excellent and learned friend Dr. Richard Harlan of Philadelphia told me that one day while in the neighborhood of that city, sitting in the piazza of a friend's house, he observed that a pair of Bluebirds had taken possession of a hole cut out expressly for them in the end of the cornice above him. They had young and were very solicitous for their safety, insomuch that it was no uncommon thing to see the male especially fly at a person who happened to pass by. A hen with her brood in the yard came within a few yards of the piazza. The wrath of the Bluebird rose to such a pitch that notwithstanding its great disparity of strength it flew at the hen with violence and continued to assail her until she was at length actually forced to retreat and seek refuge under a distant shrub, when the little fellow returned exultingly to his nest and there caroled his victory with great animation. At times, however, matters take a very different course, and you may recollect the combats of a Purple Martin and a Bluebird of which I gave you an account in my first volume.

This species has often reminded me of the Robin Redbreast of Europe, to which it bears a considerable resemblance in form and habits. Like the Bluebird the Redbreast has large eyes, in which the power of its passions are at times seen to be expressed. Like it also he alights on the lower branches of a tree where, standing in the same position, he peeps sidewise at the objects beneath and around until, spying a grub or an insect, he launches lightly towards it, picks it up and gazes around intent on discovering more, then takes a few hops with a downward inclination of the body, stops, erects himself and should not another insect be near, returns to the branch and tunes his throat anew. Perhaps it may have been on account of having observed something of this similarity of habits that the first settlers in Massachusetts named our bird the Blue Robin, a name which it still retains in that state.

Were I now engaged in forming an arrangement of the birds of our country, I might conceive it proper to assign the Bluebird a place among the Thrushes.

[The Bluebird, *Sialia sialis*, appears in Plate 113 of *The Birds of America*.]

John Bachman to John James Audubon
"East Florida is in great measure ruined."

Charleston, South Carolina
22 January 1836

My dear old friend:

As the ship *Thomas Bennett* sails for London tomorrow, I embrace this favorable opportunity of adding my mite to what the ladies are saying in their letters. I presume they have given you all the chitchat of the town and have left nothing but what is stale for me to say. I will therefore leave family matters to them and address you on other subjects.

You have heard no doubt of the war which your particular favorites, the redskins, are waging in Florida. If you were here just now I would challenge you to another dispute about William Penn, etc., but it is indeed a serious and melancholy affair. All the plantations from St. Augustine up the St. John's River are ruined, houses burnt, Negroes carried off and cattle killed and many of the inhabitants murdered. There are no white inhabitants, I think, left to the south of that on the east Florida coast but those on Indian Key and Key West. Our army too has in several encounters, from our great inferiority of force, been beaten and the soldiers scalped. General Hernandez still holds out manfully at his plantation. I fear, however, that he and his little band may have fallen by this time. Troops are now flocking in from all quarters and in a month the tables will be turned, but alas, it will be too late. East Florida is in great measure ruined.

I yesterday received a letter from [Nicholas] Berthoud together with your last plates, which have arrived but they are yet at Kimhardt's. Before I forget it, let me ask you why your second volume was never republished in America. None of your subscribers have received it and the Columbia College make bitter complaints about it and have not paid your bill. Still there would be money enough in my hands to pay your [law]suit if I were not too lazy to collect it. You will, however, be soon here yourself and tell us all about it.

I have tried to collect the opinions of the most intelligent about

you and your work in America and I am prepared to state that both stand as fair as it is possible. We have, I think, said enough here about [Charles] Waterton in *The Northern Intelligencer* and all our reviews, it is time to spare the toad else he might fancy himself a bullfrog. Please do not speak of, or trouble yourself about, him... In truth these attacks have only pushed you on higher, pushed up your metal and made you work harder. I hope you may live to complete your work and review it too and where any error may have crept in, correct them. This, by the bye, is the noblest part of the man's character. Your work then completed will be standard for all future time to come and your book will be triumphantly referred to as authority when all the fooleries that your enemies have written against it will be forgotten. There is at this day nothing like it in the world. When I look across at your best English works on natural history, I look in vain for an account of habits. No wonder that the community will not study natural history when the books on the subject contain nothing but hard names and dissertations by the hour on the peculiar structure of a bill or toe and no more. I long for a sight of your third volume...

Nell, the pointer, sends her respects to you. She is just saying so whilst she is looking in my face, I understand her, she is a lady. Alas, I have scarcely had time to take a gun in my hand—but she is first-rate.

Maria [Martin], good girl, has sent you a few drawings of shells as evidence of what she will send you in a few weeks. She is my right hand still—paints for me, keeps butterflies and even toads and snakes if I should wish them, makes caps for the girls and breeches for the boys and works for everybody but herself. May she be rewarded with a good husband and may you and I crack a joke at her wedding. All our loves to our friend, Mrs. A. and the boys...

John James Audubon to John Bachman
"The fire at New York has destroyed our library..."

London, England
22 January 1836

My worthy friend,

The first Number of the last volume of *The Birds of America* is now under the graver, and my friend Robert Havell tells me that unless *I* keep him back, the enormous work will be finished and complete in *22 months* from this date!! How delicious is the idea and how comfortable should I feel at this moment were I able fully to say to Havell *you shall not be detained a moment!* But there are drawbacks in all undertakings, and in mine especially, numerous ones. Nay, I have still to cross the broad Atlantic twice at least, and go and ransack the wildest portions of our Southern country...

I have shipped per packet *The England*, three hundred copies of the third volume of my text, in six boxes each containing fifty copies, and have directed Mr. Berthoud of New York to send one case of these volumes to your care, and I now beg of you to have them sold, not given away! Here that volume has been soundly reviewed and is spoken of as far better than the formers, and I am proud of this inasmuch as the habits of our water birds was not understood by the great Wilson!

The fire at New York has destroyed the whole of our library, our bedding, sheets, implements of drawing, &c., &c., &c., and our guns, so that I am obliged to have guns at least made anew. The riots at Baltimore were also much against us, and there we have lost many a number unpaid and undelivered of *The Birds of America*. Here, we thank God go on well, and are prospering, although just now we pay 200£ rent for the house we are in. Number 58 is finished and will be forwarded to America next week. Number 59 up to plate 295 is already engraved, so that, in two months from this date, I shall have at least exceeded Wilson in numeric species. You will read of the reviews here, and therefore I must remain mum on that subject...

I am happy to hear that no war is to take place between us and

the French, at all events to the full impression here and in Paris. John and myself proposed to be with you all sometime next summer when I expect you will be ready to go along with us to the Sabine River, &c....

John James Audubon to John Bachman
"The news from the Floridas are painful indeed..."

London, England
9 March 1836

My dear Bachman,

I now write to you merely because it is my rather painful duty to announce to you that in consequence of the destruction of our guns by the fire at New York, and the required time necessary to have others made in lieu of them, it will be entirely out of my power to sail for America as I had dearly anticipated on the first of April forthcoming, the guns &c. required for my next and probably last journey to our own dear woods unlikely to be finished before the middle of May, when it would be too late for John & I to venture towards the mouth of the Sabine *where we must go...*

I therefore beg of you to lay these, our present plans (which are fixed) in your best manner to our dear daughter, your own beloved [daughter] Maria, and to assure her that on the first of August next (God willing) we both will be underway to America and to you all.

In John's letter to Maria of this day he gives her further explanations than are necessary for me to enter in just now; but as we are fathers and not precisely lovers in factor, I repeat that I beg of you to represent to our own dear daughter to consider her disappointment at not meeting with her "John" as one that is and must be common to all in this our transient world. As to my own self I feel most awfully disappointed, but what can I do? Why, nothing more than exert my poor faculties whilst remaining here four months longer than I did wish to do, all of which I shall spend in scribbling on my *Life* and *The Birds of America.*

The news from the Floridas are painful indeed, and much do I regret the total forthcoming extirpation of a race of beings all of whom must forever be acknowledged to have once been the only lords of the land allotted to them by our God! Thanks to that God, however, the general country will be at peace with France, which with me is synonymous to be at war with the whole of Europe, therefore with all we must consider ourselves tolerably well off...

John James Audubon to John Bachman
"I have purchased ninety-three bird skins!"

Philadelphia, Pennsylvania
23 October 1836

My dear Bachman,

I have added two subscribers' names to my list since I wrote to you. Therefore I have now 15 new ones. I hope the dogs, rum, &c., have reached you ere this. I hope too, and that most sincerely, that you are quite recovered and that your dear family are all well, and the cholera gone to Jericho!

John went to the seashore of New Jersey with our young friend Mr. Trudeau of Louisiana on Thursday morning last, and I expect them to return here tomorrow night. And *perhaps* I will dispatch John to Charleston at once to see his beloved one!

Now, good friend, open your eyes! Aye, open them tight!! Nay, place specs on your proboscis if you choose! Read aloud!! quite aloud!!! I have purchased ninety-three bird skins! Yes 93 bird skins!—Well, what are they? Why, naught less than 93 bird skins sent from the Rocky Mountains and the Columbia River by Nuttall & Townsend! Cheap as dirt, too—only one hundred and eighty four dollars for the whole of these, and hang me if you do not echo my saying so when you see them!! Such beauties! Such rarities! Such novelties! Ah, my worthy friend, how we will laugh and talk over them!

Have counted the points of exclamation? No, very well. Good then. Titian Peale has given me a new *Rallus* and six young ones to draw, caught about 30 miles below this, last summer, and plenty more there! William Cooper of New York has positively given me some very rare bird skins. Friend Harris, a great number of ditto ditto. So you see—or do not you see—how lucky the "Old Man" is yet! And why all this Luck? Simply because I have labored like a cart horse for the last thirty years on a Single Work, have been successful almost to a miracle in its publication thus far, and now am thought a-a-a-(I dislike to write it, but no matter, here goes) a Great Naturalist!!! That's all. Oh what a strange world we do

live in, and how grateful to our God must we be, when after years of trouble, anxiety & sorrow, we find ourselves happy because true to him! Him without whose assistance, and even parental care, we poor things never could be called worthy the notice of even our own race.

I am obliged to remain here about 10 days longer to finish a few drawings wanted in London. When this is done, I will proceed southward, a few days at Baltimore and the same at Washington, and then trot or gallop on, nags or horses; until [I] reach the door of my worthy friends the Bachmans. Then for my having a Daughter! Oh, how dearly I love her now; but how much more will I love her when I can call her my own beloved child & daughter! Your dear sister & wife & children and yourself, oh how I long to see and be with you. But let hope, and the time will soon come...

John James Audubon to the John Bachman Family
"100 Creek warriors were confined in irons..."

*On his way to his last expedition collecting birds for his great folio,
Audubon crossed the trail of Creek Indians being forcibly removed
from their lands; he describes the encounter with feeling.*

Mobile, Alabama
24 February 1837

My dearest friends,

We left Charleston on the 17th instant (Ed Harris, John & I) and
arrived here last night. Our journey was performed first by the
railroad to Augusta, a pretty village in Georgia. The weather was
extremely cold; nay, the ice on the morning of the 18th was one-
half-inch deep. At Augusta we took the mail [coach], and luckily
for us had no others than ourselves in the coach. The roads, in
consequence of several previous days & nights of rain, were as bad
as can be; but we proceeded apace and had no accidents. Having
crossed Georgia, we entered the State of Alabama after crossing a
bridge at Columbus; here the swamps were shockingly bad, and
we feared that our goods & chattels would have been wetted, but
thanks to our Yankee drivers (*the very best in the world*) all was
kept dry as cocks. The next morning we breakfasted at the village
of——, where 100 Creek warriors were confined in irons, prepara-
tory to leaving forever the land of their births! Some miles onward
we overtook about two thousands of these once free owners of the
forest, marching towards this place under an escort of rangers and
militia mounted men, destined for distant lands, unknown to them,
and where, alas, their future and latter days must be spent in the
deepest of sorrows, affliction and perhaps even physical want. This
view produced on my mind an afflicting series of reflections more
powerfully felt than easy of description. The numerous groups of
warriors, of half-clad females and of naked babes, trudging through
the mire under the residue of their ever scanty stock of camp
furniture and household utensils. The evident regret expressed in
the masked countenances of some and the tears of others, the

howlings of their numerous dogs and the cool demeanor of the chiefs, all formed such a picture as I hope I never will again witness in reality. Had Victor been with us, ample indeed would have been his means to paint Indians in sorrow.

We reached Montgomery at night, remained there until 10 of the next day, and on board of a steamer, made down the River Alabama, a stream which though much smaller than the Missis-sippi, resembles it very much: like it, it is muddy, winding, and lined on its shores by heavy canebrakes and bluffs of various elevations & formations.

Our intentions to visit the families of our friends the Lees were abandoned, and I wrote to them instead. We heard from different persons that they were all well-doing and in good health. We saw many Southern birds, but felt no difference in the climate. Indeed, even here the weather is cool, and the country exhibits no appear-ance of spring.

Our first enquiry at this place was for Judge Hitchcock, but he is absent. A Mr. Martineau answered in his stead, and introduced us to the Collector of Mobile, who in turn presented us to Capt. Foster, who commands a cutter; a jolly old gentleman, who gave us to understand that he should like a tour with us, provided I would obtain Commodore Dallas' permission to do so. He gave us some pleasing information of desired birds, &c., and we have concluded to go to Pensacola tomorrow by steamer to pay our regards to the Commodore. Our intention is to spend but one day there; to return here, and await the receipt of answers to letters sent to Mr. Grimshaw and Capt. Coste, who we are told is on the New Orleans station, and now at that place. Thus far, you perceive, we are unable to form our plans; but expect to be able to do so very soon, when I shall not fail to give you all desirable information.

Mobile is a small, compact, thriving place, of goodly appearance. There are about 10 steamers that ply up the Mobile & Alabama Rivers, some to New Orleans daily, and also some to Pensacola daily. The country around is flat and swampy, and the accounts of the healthiness of this place [are] so varied that no one can depend on what is said on the subject; at the exception, that the population is about 13,000 people during winter, and that in July & August, it is reduced to about 5,000! To me this, and what I have seen, is

sufficient. My mind therefore is made up never to seek refuge (much less health) in either the lower parts of Alabama or any of our Southern states.

Need I say to you all, how dearly glad we would be to be enabled suddenly to accompany you to church on Sunday next? I believe not!

My spirits are not above par, I assure you, and this day I have suffered much from the [discomfort?] of drinking Alabama water. Tomorrow I [hope] to be cured by a dance over the waters of the Mexican Gulf—and then all will be right again.

John Bachman, my friend, the salamanders are still asleep. Hares we have seen none of. Parakeets, by the hundreds, and also Wild Pigeons and Hutchins' Geese...

Sweetheart [i.e., Maria Martin] will be so good as to write to my Lucy and give her the interest if any of this letter. I send my love to you all, and thousands of kisses on the wing...

John James Audubon to John Bachman
"We hope to go as far as Cape Sable..."

New Orleans, Louisiana
3 March 1837

My dear Bachman,

Having given you an account of our journey as far as Mobile in my last, I now will proceed with one of what has happened since then.

The next day we left Mobile for Pensacola by steamer and reached the latter the same evening late. Went to a most rascally house called "Collin's Hotel." May your star never shoot you there! However, morning came, it was Sunday and poured of rain, notwithstanding which, we delivered a few letters of introduction and were taken on board the U.S. frigate the *Constellation*, in Commodore Dallas' barge! The Commodore received Friend Harris and I *quite well* (John remained at Mobile), we found him a very amiable person, and after he had read [Secretary of the Treasury Levi] Woodbury's letter he assured us that he would do all in his power to serve us & Science, and that in all probability he would put us on board of the cutter now commanded by Captain Robert Day and that he would write to us at Mobile in 5 or 6 days. He presented us to all his principal officers, shewed us every part of his superb ship, gave us some first-rate wine and a bottle of Copenhagen snuff that would make your nostrils expand with pleasure and draw tears from your eyes, the stuff is so very potent. We took our leave and returned to the *Collins* where we sat contemplating the weather to our hearts' content. Pensacola is a small place at present; principally inhabited by Creole Spaniards of the lowest class and some few amiable & talented families of Scotch, and Americans. The place is said to be perfectly healthy. The country is deeply sandy, and nothing but pine barrens exist for about 80 miles back. The bay is grand and of good depth. The bar at the entrance, about 22 feet, admits of vessels of great burthen; this is guarded by two powerful fortifications. The naval depot or navy yard is 9 miles before the village; we had not time to visit it.

Fish is abundant, and there I saw I think the finest oysters ever observed by me in any portion of the southern country. Deer, Wild Turkeys and smaller game is said to be very plentiful. We saw thousands of salamander burrows; and here let me assure you that these animals have an entrance to their burrows resembling that of European rabbits, but smaller of course. It is yet too early to procure them. Railroads are in progress, and some projected to communicate with Blakeley (opposite Mobile distant 65 miles) and Montgomery in Alabama distant 175 or thereabouts. Major Ingram of the Topographical Department politely shewed us all the plans on paper. Much of the iron cars, engines &c. are already on the spot. A new town is laid out for sale, and an immense hotel is now being erected there. But after all the back country is so poor, and the want of some navigable stream so great in my opinion, that I have great doubts of the ultimate boasted-of advancement of either the new or the old town. The former belongs to a company of New York speculators, and the rage for new cities in this section is so great, that the lots already sold have brought great sums. I have forgotten to tell you that Commodore Dallas shewed us the last received dispatches from Gen. Jessup in which he gives great hopes of the Florida War being at an end! May this prove true. Harris and I walked the whole of Monday, and heard of a bird breeding in that section called the Gris which, from the imperfect descriptions we have had, I conclude is my Brown Ibis, but of this we will tell you more another time. We returned to Mobile on Tuesday. Called on Mr. Logan, but only saw his wife. Frank Lee and John had passed their time pleasantly &c. I found 2 letters from my dear wife dates 8th and 19th of December and one from Mr. Grimshaw informing me that [Capt. Napoleon] Coste was on the New Orleans station but absent and assisting a wrecked vessel on one of the Keys—that he would be here in less than one month. He is not under the control of Commodore Dallas, and we expect to sail with him for the Sabine and intermediate places. We hope to go with Capt. Day or Capt. Coste as far as Cape Sable and visit all the Keys [and explore?] the western coast of Florida before we sail for the westward. Harris has gone back to Pensacola in the revenue cutter the *Jackson*, Capt. Foster, to remain and see the Commodore until something profitable is offered or said, and John

& myself will await for news from Harris at this place, where I
hope to procure a few subscribers. Were snug and comfortable at
Mr. Grimshaw's (James Grimshaw, Esq.) to whose care please to
write to us. It pours of rain, and cannot go to market this morning.
The first fair day we will do so and seek for squirrels and rabbits
for you. Yesterday I received another letter from London dated 31
of December. This latter had rather perplexed me on account of
the rapidity with which Victor and Havell have proceeded with
the work, but Victor will do his best, and I hope that the drawings
made at Charleston will arrive in time to be disposed of accordingly
with my late arrangements. We have found our clothes here, from
England, but the things from Charleston have not yet arrived.
Why our English letters have been sent here, instead of to you, I
cannot guess. I beg of our dear sweetheart to write to my wife and
to copy whatever parts of my letters to you or to her, and send
these promptly...I find New Orleans so large, and so much
improved in every point of view that I can scarcely recognize one
street from another. We have lost however by death the greater
portion of our numerous former acquaintances here. Ten thousands
of kisses for all the dear girls and mamma too—and "Rabbit" and
"Sweetmeats"—and old friend Mrs. Davies, and the master in
phrenology!

John James Audubon to John Bachman
"We hope for great things..."

New Orleans, Louisiana
22 March 1837

My dear Bachman,

We will leave this city tomorrow morning, before day, on board of the cutter the *Campbell*, Commandant Napoleon L. Coste, and proceed directly though slowly on our researches. The vessel is small, yet very roomy, i.e. she is less encumbered than any of her size I have yet seen. Coste is full of the expedition and so is the first lieutenant. The other lieutenant is, I conceive, a "man-o'-war man"—full of his duty on the weather side of the quarterdeck during his daily or nightly watch! 16 men, 3 boats, and provisions for about 2 months, one great gun and many pikes, cutlasses (*cutlasses*), pistols and muskets as can be crammed in so small a craft. We intend visiting the whole of Galveston Bay and islets thereabouts, spite of the Mexicans' flotilla—which after all I think is all "my eye." We hope for great things but God knows how many new species will be added to our fauna. We are well provided with ammunition, &c., but our apples have turned into sour cider and I have some doubts whether our butter will not run through our biscuits ere we gobble the latter. John is packing up 4 squirrels and a wildcat for you; I hope you never have seen the like? I have and think that you will be pleased with them. John, or my nephew young Berthoud, [will] send you a bill of lading. I am glad, and proud too, that I have at last been acknowledged by the public prints as a native citizen of Louisiana [*sic*: Audubon was born in Saint Dominique, West Indies, a fact he knew], and had it been supposed when first we arrived here that our stay would have been half as long as it has been, I really think that my countrymen would have honored us with a public dinner! Try to find out the paragraphs in the *New Orleans Courier* (French & English) of the beginning of this month. And above all, my Dear Bachman, pray attend to the following:

There is coming here another cutter to take the place of the

Campbell, and she may be here before our return, when the *Campbell* will scarcely be called for on this coast. [Captain Napoleon] Coste is very anxious to have, *in her* (the *Campbell*) the Key West station (not the Savannah) and tells me that he would be delighted to take us round to Charleston, after having shewed us the different breeding places which he has discovered on the western Florida coast. Now I should like this myself of all things, and the thought has crossed my mind, that the *Florida war being at an end!!!* the Secretary of the Treasury, Mr. Levi Woodbury, might grant us the privilege of that vessel for the purpose mentioned above, if someone was at his elbow, with strength and power enough to urge him to such an act of generosity towards a poor student of Nature, who in all probability is not likely ever afterwards to trouble his government again—and now that [Joel R.] Poinsett is the Secretary of War, and you very intimate with him, that were you to write to that gentleman at once, and ask of him to speak to Mr. [Levi] Woodbury, and ask the request I long for, Woodbury *I think* would hardly refuse *him* (Mr. Poinsett). All this must, however, be done at once, and not be put off even for a day if possible, as you know our time is growing very short, and we are anxious to make the best we can of it. Ask of Mr. Poinsett that in case this last petition is granted by Woodbury to urge the latter to forward me a letter to the effect, care of James Grimshaw, Esq., New Orleans...

John James Audubon to Lucy Audubon
"The Florida war is actually ended!"

New Orleans, Louisiana
23 March 1837

My dearest beloved!

I have only a little time to say to thee, that we will leave this [place] tomorrow morning on board the revenue cutter, the *Campbell*, Capt. Napoleon Coste, for a coasting voyage of about two months. That we three are quite well! that I have received our dear Victor's letters of the 6th and 9th of January and that I am now happy and comfortable in the thought that he will carry the publication [of *The Birds of America*] according with the lists I have sent him. I have heard of the arrival at Liverpool of the *Mohawk* on the 22nd January and hope that the 9 drawings sent by her were in good time for the Numbers intended for these. I hope the *Superb* has also reached safely, and if so Victor will have enough [drawings] until I return to you. I have felt great uneasiness about your precious healths since I have read the accounts of the influenza in London. May God preserve you both, and may he grant us the happiness of meeting again all well and happy. It is not probable that I shall hear from you now for two months but I will be patient and take good care of John, [Edward] Harris and self. *The Florida war is actually ended!* Depend upon this intelligence. We therefore hope to return by that coast to Charleston after we have been to Galveston Bay &c. on the western coast of the Gulf. Not a new subscriber at New Orleans as yet. Mr. Forrestal has not even asked me to his house once. I dined at Governor Roman's in a large company. He is a fine man, and has written a few kind things in the papers here. My "Natal City"! Remember us to everybody, even to Bessie. Oh how glad I shall feel when I land at No. 4 Wimpole Street and kiss again my best beloved and dearest friend & wife and our dear Victor...

John James Audubon to John Bachman
"Sandhill Cranes are yet here..."

Below New Orleans
29 March 1837

My dear Bachman,

I have the great satisfaction of receiving your letter of the 15th instant yesterday, and send you my thanks for it, and a thousand kisses for all the sweethearts you and I and Johnny have about you!

We are on board of the cutter, the *Campbell*, about 2 miles below New Orleans, anchored on the western side of the great river, and today is the 29th of March of the Year of our Lord 1837. We are only waiting for 5 sailors, and as our Capt. Coste and the first lieutenant are gone to New Orleans in search of the hands we want, we hope to see the remainder of our crew completed this day, cut stick tonight, &c., &c. Johnny is in the swamps outlining cypress trees with the camera [lucida] for Victor. [Edward] Harris is gone to town for letters if any there are and here I am scribbling this to you. I thought you would want me pretty soon, but I can echo you at that, and I would willingly give up one year of my life (*hereafter*) to have you at my side just *now*.

I would first ask, what do you say to those *squirrels*? and again to this wildcat? for I hope you have those, which we have shipped to you, before your eyes just at this very moment. About one other hundred questions I would ask of you to answer, but we are a pretty good distance asunder now, and must wait for the pleasure of meeting again in *this world*! A world which though wicked enough in all conscience, is *perhaps* as good as woods unknown.

We took Harris on an alligator hunt on a fine bayou. We killed about 20 of these beautiful creatures, and brought only 7 on board. Harris killed several. He never had seen any before. He likes their flesh too, but not so Johnny, excepting the latter [part]; our mess made a grand dinner of the "tail end" of one, and after all, alligators' flesh is far from being bad. God preserve us from ever "riding" a live one [an allusion to Audubon's English critic Charles Waterton, who claimed to have ridden an alligator on an expedition to South

America]. We had a fine frolic of this, but after all they are not to be fooled with.

Sandhill Cranes are yet here—blue wings & green wings. Few, very few Herons have come to this latitude and longitude, but we have procured here the Common American Gull, *L. Torhinas*. We have heard through Mr. Grimshaw's English letters that all was well at London at a late date, but have had no letters ourselves. Bats are plentiful and you shall I hope see some of them. The deer here is different from yours, and this also I trust you shall see. In a word you will be thought of as of a "worthy friend" during the whole of our expedition. My former letters will have given you many details which I cannot now repeat. One of your letters (I mean one of our beloved Maria Martin's) has not reached us—God bless her; and d— the post!

I have a most kind friend here collecting birds in rum for me during our absence. I trust that those at Charleston will not forget their promises on that score, and we already thank the latter for certain "Brown Creepers" that are now snoozing in rum. Harris stands the packets admirably. He is in facto one of the finest men of God's creation—I wish he was my brother!

The steamer *Fancy* was totally destroyed a few evenings ago on her way to Louisville, Ky. She belonged to my youngest brother-in-law, cargo and all. I fear his loss is considerable. The whole of the living on board saved themselves *only* with what they had on their backs. William Bakewell saved a babe from the waters, but the nurse was drowned. The child belonged to one of the passengers. Had this accident taken place at night, it is more than probable that one half of the people must have been drowned or burnt to death.

Have you written to my Lucy [in London]? Do not forget this I pray you. My beloved daughter must write also, and so must our dear amiable friend & sweetheart. Do not forget to write to Mr. Poinsett for me to ask of Mr. Levi Woodbury to let me have the *Campbell*, Capt. N. L. Coste, to go to Charleston on our return, which I am anxious to make around the Floridas. Write soon, and send Woodbury's answer or orders (I hope) to this place care of James Grimshaw, Esq. The failures at New Orleans have dampened the spirits of everyone who speculates on cotton, land or dollars . . .

[P.S.] There is no grog on board of the *Campbell* !! What do [you] say to that? Snuff is yet partially afloat, but will be dropped astern very soon!

John James Audubon to John Bachman
"The weather was fair and the sea smooth…"

Aboard the U.S. Revenue Cutter *Campbell*
Island of Barataria, Grande Terre
6 April 1837

My dear Bachman,

I wrote a few lines to you from this place by a schooner bound to New Orleans, but as winds & mail carriers are not always to be depended on, I will try to have this ready for a gentleman going from here to New Orleans by the bayous 105 miles, and who promises to have it put in the post office.

We were detained a few miles below New Orleans for the want of sailors, until, raising the wages to 40 dollars, we procured a few crew and some stout fellows, after which we sailed down the great stream to its southwest pass or entrance. The next morning we sailed (very foolishly) to the northeast pass, and sent an officer in a boat in search of a Capt. Taylor, also of the revenue service, to whom the collector at New Orleans had sent orders to join us, and to assist us as a pilot. That day was lost. The next morning we went shooting and killed 4 Marsh Terns and some other birds. We had put Mrs. Coste on shore at a fisher's house to await the return of her husband, and the next morning early we sailed on our expedition. The weather was fair and the sea smooth until we approached the bar at this place; we however crossed it guided by Mr. Taylor, whom we towed on board of his *Crusader*, a small schooner of about 8 tons acting as a tender on the *Campbell*. We anchored safely under the lee of Barataria Island and have been here ever since, shooting & fishing at a proper rate. Johnny & I shot 4 White Pelicans, Harris and the two latters a great number of different *Tringas* [i.e., Yellowlegs and Sandpipers], Terns, Gulls, &c., and so we have passed our time at potting species, their habits, and skinning and placing specimens in rum. Cask is already filled. We are all well. We intend proceeding to Cayo Island, 52 miles west, by the first fair wind, and then expect to do well, as it is said to be a great breeding ground. Not a bat on our island, and only

raccoons, otters, wild cats and a few rabbits. We have not seen anything more than tracks. Not a new bird as yet. Have killed 5 *Tringa himantopus* [Long-legged Sandpipers]. Marsh Terns abundant. Cayenne and Common Terns as well. *Larus atricilla* [Laughing Gull] also. White & Brown Pelicans and a good variety of Ducks and the Florida Cormorant. Few land birds. Saltwater Marsh Hens and Boat-tailed Grackles breeding. But enough, as I have noted every incident worth notice, which you will read from the journal. We have now in contemplation to leave the schooner as soon as we have reached Texas and seen Galveston (Galveston Bay) and return over land to New Orleans, and there make ready either to go back to you at once, or proceed around the west coast of Florida. We will, however, be guided by circumstances and do all for the best. Have this copied and forwarded to my dear wife, and if you please, have us "reported" in the papers. We have been very kindly treated by a planter here who is a partner of Mr. Forrestal of New Orleans, who gave me a few lines of Introduction. We have had fine vegetables, milk & cornbread and *fresh butter*!

This island is about 10 miles long but scarcely a mile broad. It is low and mostly marsh (hard however), with many ponds, lagoons, &c. It possesses one sugar plantation and a few dilapidated government buildings, began by [Andrew] Jackson but now abandoned and rotting. This was Lafitte's (the pirate) stronghold. The remains of his fortification, and the ground on which his houses stood, are yet discernible. Some say that much money is deposited thereabouts—I wish it was all in the Charleston bank placed to our credit!

The island is flat, and in 1830 was overflowed by the waves of the Gulf impelled by a hurricane to the depth of 4 feet above the highest ground, and castle, &c., was sent adrift towards the main distant some 12 or 15 miles. The soil is good enough to produce cotton or sugar and the place healthy and pleasant; and yet I should not like to be imprisoned at large upon it the remainder of my life. It abounds with snakes, not, however, injurious excepting a very small ground rattler species. We have placed several in rum for Dr. Holbrook and crabs for yourself! No insects of note except mosquitoes and sand flies, of which we could spare enough, God knows.

I forgot on former occasions to say to you that the Bird of Washington [Audubon's erroneous but stubborn identification of a new species of eagle, in fact the immature Bald Eagle] is found pretty abundant on the lakes near New Orleans. Governor Roman's cousin assured Harris & I of this fact. We are promised some in rum. Mr. Zaringue (the cousin) has seen it dive after fish frequently and was the man who spoke of it thus: "*Connaissez vous le Grand Aigle Brun Pecheur?*" He says that it breeds on trees. He knows the White-headed [Bald Eagle] well . . .

John James Audubon to John Bachman
"We are ransacking the shores..."

Bayou Salle Bay, Gulf of Mexico
18 April 1837

My dear Bachman,

Here we are all safe & well in Bayou Salle Bay, about 18 [miles] west of the mouth of the Teche, and in Attakapas. We are now on board of our tender cutter the *Crusader*, ransacking the shores of this coast, most of which is flat & marshy, and not so abundantly supplied with birds as either of the [illegible] might wish it to be. However, we have filled 3 casks with valuables, but not with any new bird! We still intend moving westward as far as Galveston Bay, and may return across the land. I hope this will reach you all well, and that you may have received good accounts from my dear wife & Victor from England, the result of which I shall expect to find awaiting our return at New Orleans—but when, I cannot precisely say.

We are all in good spirits and work very hard, I promise you...

American White Pelican

I feel great pleasure, good reader, in assuring you that our White Pelican, which has hitherto been considered the same as that found in Europe, is quite different. In consequence of this discovery I have honored it with the name of my beloved country, over the mighty streams of which, may this splendid bird wander free and unmolested to the most distant times, as it has already done from the misty ages of unknown antiquity.

In Dr. Richardson's introduction to the second volume of the *Fauna Boreali-Americana*, we are informed that the *Pelecanus Onocrotalus* (which is the bird now named *P. Americanus*) [*P. erythrorhynchos* today] flies in dense flocks all the summer in the fur countries. At page 472, the same intrepid traveler says that "Pelicans are numerous in the interior of the fur countries up to the sixty-first parallel; but they seldom come within two hundred miles of Hudson's Bay. They deposit their eggs usually on rocky islands, on the brink of cascades, where they can scarcely be approached; but they are otherwise by no means shy birds." My learned friend also speaks of the "long thin bony process seen on the upper mandible of the bill of this species," and although neither he nor Mr. [William] Swainson pointed out the actual differences otherwise existing between this and the European species, he states that no such appearance has been described as occurring on the bills of the White Pelicans of the old Continent.

When, somewhat more than thirty years ago, I first removed to Kentucky, Pelicans of this species were frequently seen by me on the sand bars of the Ohio and on the rockbound waters of the rapids of that majestic river, situated, as you well know, between Louisville and Shippingport. Nay, when a few years afterwards I established myself at Henderson, the White Pelicans were so abundant that I often killed several at a shot on a well-known sandbar which protects Canoe Creek Island. During those delightful days of my early manhood, how often have I watched them with delight! Methinks indeed, reader, those days have returned to me as if to enable me the better once more to read the scattered notes contained in my often-searched journals.

Ranged along the margins of the sandbar in broken array stand

a hundred heavy-bodied Pelicans. Gorgeous tints, all autumnal, enrich the foliage of every tree around, the reflection of which, like fragments of the rainbow, seems to fill the very depths of the placid and almost sleeping waters of the Ohio. The subdued and ruddy beams of the orb of day assure me that the Indian summer has commenced: that happy season of unrivaled loveliness and serenity, symbolic of autumnal life, which to every enthusiastic lover of nature must be the purest and calmest period of his career. Pluming themselves, the gorged Pelicans patiently wait the return of hunger. Should one chance to gape, all, as if by sympathy, in succession, open their long and broad mandibles, yawning lazily and ludicrously. Now the whole length of their largest quills is passed through the bill until at length their apparel is as beautifully trimmed as if the party were to figure at a route. But mark, the red beams of the setting sun tinge the tall tops of the forest trees; the birds experience the cravings of hunger, and to satisfy them they must now labor. Clumsily do they rise on their columnar legs and heavily waddle to the water. But now how changed do they seem! Lightly do they float as they marshal themselves and extend their line, and now their broad, paddle-like feet propel them onwards. In yonder nook the small fry are dancing in the quiet water, perhaps in their own manner bidding farewell to the orb of day, perhaps seeking something for their supper. Thousands there are, all gay, and the very manner of their mirth causing the waters to sparkle invites their foes to advance towards the shoal. And now the Pelicans, aware of the faculties of their scaly prey, at once spread out their broad wings, press closely forward with powerful strokes of their feet, drive the little fishes towards the shallow shore and then, with their enormous pouches spread like so many bag nets, scoop them out and devour them in thousands.

How strange it is, reader, that birds of this species should be found breeding in the fur countries at about the same period when they are to be found on the waters of the inland bays of the Mexican Gulf! On the 2nd of April 1837 I met with these birds in abundance at the southwest entrance or mouth of the Mississippi, and afterwards saw them in the course of the same season in almost every inlet, bay or river as I advanced towards Texas, where I found some of them in the Bay of Galveston on the 1st of May. Nay, while on

the Island of Grande Terre I was assured by Mr. Andry, a sugar planter who has resided there for some years, that he had observed White Pelicans along the shores every month of the year. Can it be that in this species of bird, as in many others, barren individuals should remain in sections of countries altogether forsaken by those which are reproductive? The latter, we know, travel to the Rocky Mountains and the fur countries of the north and there breed. Or do some of these birds, as well as of certain species of our ducks, remain and reproduce in those southern localities, induced to do so by some organic or instinctive peculiarity? Ah, reader, how little do we yet know of the wonderful combinations of nature's arrangements, to render every individual of her creation comfortable and happy under all the circumstances in which they may be placed!

My friend John Bachman, in a note to me, says that "This bird is now more rare on our coast than it was thirty years ago; for I have heard it stated that it formerly bred on the sand banks of our Bird Islands. I saw a flock on the bird banks off Bull's Island on the 1st day of July 1814, when I procured two full-plumaged old birds, and was under the impression that they had laid eggs on one of those banks, but the latter had the day previous to my visit been overflowed by a spring tide, accompanied with heavy wind."

A single pair of our White Pelicans were procured not far from Philadelphia on the Delaware or Schuylkill ten or twelve years ago. These were the only birds of this kind that, I believe, were ever observed in our Middle Districts, where even the Brown Pelican, *Pelecanus fuscus* [*occidentalis* today], is never seen. Nor have I heard that an individual of either species has ever been met with on any part of the shores of our Eastern states. From these facts it may be concluded that the White Pelicans reach the fur countries of Hudson's Bay by inland journeys, and mostly by passing along our great western rivers in the spring months, as they are also wont to do, though with less rapid movements, in autumn.

Reader, I have thought a thousand times perhaps that the present state of migration of many of our birds is in a manner artificial, and that a portion of the myriads of Ducks, Geese and other kinds which leave our Southern Districts every spring for higher latitudes

were formerly in the habit of remaining and breeding in every section of the country that was found to be favorable for that purpose. It seems to me that it is now on account of the difficulties they meet with from the constantly increasing numbers of our hostile species that these creatures are urged to proceed towards wild and uninhabited parts of the world where they find that security from molestation necessary to enable them to rear their innocent progeny, but which is now denied them in countries once their own.

The White American Pelican never descends from on wing upon its prey, as is the habit of the Brown Pelican; and although on many occasions it fishes in the manner above described, it varies its mode according to circumstances, such as a feeling of security or the accidental meeting with shoals of fishes in such shallows as the birds can well compass. They never dive for their food, but only thrust their head into the waters as far as their neck can reach and withdraw it as soon as they have caught something or have missed it, for their head is seldom out of sight more than half a minute at a time. When they are upon rivers they usually feed along the margin of the water, though I believe mostly in swimming depth, when they proceed with greater celerity than when on the sand. While thus swimming, you see their necks extended with their upper mandible only above the water, the lower being laterally extended and ready to receive whatever fish or other food may chance to come into the net-like apparatus attached to it.

As this species is often seen along the seashores searching for food as well as on fresh water, I will give you a description of its manners there. While on the island of Barataria in April 1837, I one afternoon observed a number of White Pelicans in company with a flock of the Brown species, all at work searching for food, the Brown in the manner already described, the White in the following: They all swam against the wind and current with their wings partially extended and the neck stretched out, the upper mandible alone appearing above the surface, while the lower must have been used as a scoop net, as I saw it raised from time to time and brought to meet the upper; when the whole bill immediately fell to a perpendicular position, the water was allowed to run out and

the bill being again raised upwards, the fish was swallowed. After thus swimming for about a hundred yards in an extended line and parallel to each other, they would rise on wing, wheel about and re-alight at the place where their fishing had commenced, when they would repeat the same actions. They kept farther from the shore than the Brown Pelicans and in deeper water, though at times one of the latter would dive after fish close to some of them without their showing the least degree of enmity towards each other. I continued watching them more than an hour concealed among a large quantity of drifted logs until their fishing was finished, when they all, White and Brown together, flew off to the lee of another island, no doubt to spend the night there, for these birds are altogether diurnal. When gorged they retire to the shores, to small islands in bays or rivers, or sit on logs floating in shallow water at a good distance from the beach; in all which situations they are prone to lie down or stand closely together.

Being anxious when on my last expedition to procure several specimens of these birds for the purpose of presenting you with an account of their anatomical structure, I requested all on board our vessel to shoot them on all occasions; but no birds having been procured, I was obliged to set out with a "select party" for the purpose. Having heard some of the sailors say that large flocks of White Pelicans had been seen on the inner islets of Barataria Bay within the island called Grande Terre, we had a boat manned, and my friend Edward Harris, my son and myself went off in search of them. After awhile we saw large flocks of these birds on some grounded logs, but found that it was no easy matter to get near them on account of the shallowness of the bay, the water being scarcely two feet in depth for upwards of half a mile about us. Quietly and with all possible care we neared a flock; and strange it was for me to be once more within shooting distance of White Pelicans. It would no doubt be a very interesting sight to you were you to mark the gravity and sedateness of some hundreds of these Pelicans closely huddled together on a heap of stranded logs or a small bank of raccoon oysters. They were lying on their breasts, but as we neared them they all arose deliberately to their full height. Some, gently sliding from the logs, swam off towards the nearest flock, as unapprehensive of danger as if they had been a mile

distant. But now their bright eyes were distinctly visible to us; our guns, charged with buckshot, were in readiness, and my son was lying in the bow of the boat waiting for the signal. "Fire!" The report is instantly heard, the affrighted birds spread their wings and hurry away, leaving behind three of their companions floating on the water. Another shot from a different gun brought down a fourth from on wing; and as a few were scampering off wounded, we gave chase and soon placed all our prizes in the after sheets. About a quarter of a mile farther on we killed two and pursued several that were severely wounded in the wing; but they escaped, for they swam off so rapidly that we could not propel our boat with sufficient force amidst the tortuous shallows. The Pelicans appeared tame if not almost stupid; and at one place where there were about sixty on an immense log, could we have gone twenty yards nearer, we might have killed eight or ten at a single discharge. But we had already a full cargo and therefore returned to the vessel, on the decks of which the wounded birds were allowed to roam at large. We found these Pelicans hard to kill, and some which were perforated with buckshot did not expire until eight or ten minutes after they were fired at. A wonderful instance of this tenacity of life was to be seen on board a schooner then at anchor in the harbor. A Pelican had been grazed on the hind part of the head with an ounce ball from a musket, and yet five days afterwards it was apparently convalescent and had become quite gentle. When wounded they swim rather sluggishly and do not attempt to dive or even to bite, like the Brown Pelicans, although they are twice as large and proportionally stronger. After being shot at they are perfectly silent, but when alighted they utter a hollow guttural sound somewhat resembling that produced by blowing through the bunghole of a cask.

The White Pelicans appear almost inactive during the greater part of the day, fishing only soon after sunrise and again about an hour before sunset; though at times the whole flock will mount high in the air and perform extended gyrations in the manner of the Whooping Crane, Wood Ibis and Vultures. These movements are probably performed for the purpose of assisting their digestion and of airing themselves in the higher and cooler regions of the atmosphere. Whilst on the ground they at times spread their wings

to the breeze or to the rays of the sun; but this act is much more rarely performed by them than by the Brown Pelicans. When walking they seem exceedingly awkward, and like many cowardly individuals of our own species are apt to snap at objects which they appear to know perfectly to be so far superior to them as to disdain taking notice of them. Their usual manner of flight is precisely similar to that of our Brown species. It is said by authors that the White Pelican can alight on trees; but I have never seen a single instance of its doing so. I am of opinion that the ridge projecting from the upper mandible increases in size as the bird grows older, and that it uses that apparatus as a means of defense or of attack when engaged with its rivals in the love season.

The number of small fishes destroyed by a single bird of this species may appear to you, as it did to me, quite extraordinary. While I was at General [Joseph M.] Hernandez's plantation in East Florida, one of them chanced to pass close over the house of my generous host and was brought dead to the ground. It was not a mature bird but apparently about eighteen months old. On opening it we found in its stomach several hundreds of fishes of the size of what are usually called minnows. Among the many which I have at different times examined I never found one containing fishes as large as those commonly swallowed by the Brown species, which in my opinion is more likely to secure a large fish by plunging upon it from wing than a bird which must swim after its prey.

This beautiful species—for reader, it is truly beautiful, and you would say so were you to pick it up in all the natural cleanness of its plumage from the surface of the water—carries its crest broadly expanded, as if divided into two parts from the center of the head. The brightness of its eyes seemed to me to rival that of the purest diamond; and in the love season or the spring of the year, the orange-red color of its legs and feet as well as of the pouch and bill is wonderfully enriched, being as represented in my plate, while during the autumnal months these parts are pale. Its flesh is rank, fishy and nauseous and therefore quite unfit for food unless in cases of extreme necessity. The idea that these birds are easily caught when gorged with fish is quite incorrect, for when approached on such an occasion they throw up their food as Vultures are wont to do.

I regret exceedingly that I cannot say anything respecting their nests, eggs or young, as I have not been in the countries in which they are said to breed.

[The American White Pelican, *Pelecanus erythrorhynchos*, appears in Plate 311 of *The Birds of America*.]

A Meeting with Sam Houston

These journal entries, edited by Lucy Audubon, appear in a Life of
Audubon *(1868) ghostwritten from a manuscript biography she
drafted after her husband's death; the original journal was destroyed.*

April 24 [1837]. Arrived in Galveston Bay this afternoon, having
had a fine run from Atchafalaya Bay. We were soon boarded by
officers from the Texan vessels in the harbor, who informed us that
two days before, the U.S. sloop of war *Natchez* fell in with the
Mexican squadron of the harbor of Velasco, captured the brig *Urea*
and ran two other vessels ashore; another report says they sunk
another ship, and went in pursuit of the squadron. These vessels
were taken as pirates—the fleet having sailed from Vera Cruz with-
out being provisioned, had been plundering American vessels on
the coast. There is also a rumor that the Texan schooner
Independence has been captured by a Mexican cruiser. The American
schooner *Flash* was driven ashore a few days since by a Mexican
cruiser and now lies on the beach at the lower end of the island.

April 25. A heavy gale blew all night, and this morning the
thermometer in the cabin is 63°, and thousands of birds, arrested
by the storm in their migration northward, are seen hovering
around our vessels and hiding in the grass, and some struggling in
the water, completely exhausted.

We had a visit this morning from the secretary of the Texan
navy, Mr. C. Rhodes Fisher, who breakfasted with us. He appeared
to be a well-informed man, and talked a great deal about the infant
republic, and then left us for the seat of government at Houston,
seventy miles distant, on the steamer *Yellowstone,* accompanied by
Captains Casto and Taylor, taking the *Crusader* in tow.

April 26. Went ashore at Galveston. The only objects we saw of
interest were the Mexican prisoners; they are used as slaves; made
to carry wood and water and cut grass for the horses and such
work; it is said that some are made to draw the plough. They all
appear to be of delicate frame and constitution, but are not dejected
in appearance.

April 27. We were off at an early hour for the island, two miles
distant; we waded nearly all the distance, so very shallow and filled

with sandbanks is this famous bay. The men made a large fire to keep off the mosquitoes, which were annoying enough for even me. Besides many interesting birds, we found a new species of rattlesnake with a double row of fangs on each side of its jaws.

April 28. We went on a deer hunt on Galveston Island, where these animals are abundant; we saw about twenty-five, and killed four.

April 29. John took a view of the rough village of Galveston with the [camera] lucida. We found much company on board on our return to the vessel, among whom was a contractor for beef for the army; he was from Connecticut, and has a family residing near the famous battleground of San Jacinto. He promised me some skulls of Mexicans [Audubon was collecting skulls for a Scottish colleague] and some plants, for he is bumped with botanical bumps somewhere.

Galveston Bay, May 1, 1837. I was much fatigued this morning and the muscles of my legs were swelled until they were purple, so that I could not go on shore. The muskrat is the only small quadruped found here, and the common house rat has not yet reached this part of the world.

May 2. Went ashore on Galveston Island and landed on a point where the Texan garrison is quartered. We passed through the troops and observed the miserable condition of the whole concern; huts made of grass, and a few sticks or sods cut into square pieces composed the buildings of the poor Mexican prisoners, which, half clad and half naked, strolled about in a state of apparent inactivity. We passed two sentinels under arms, very unlike soldiers in appearance. The whole population seemed both indolent and reckless. We saw a few fowls, one pig and a dog, which appeared to be all the domestic animals in the encampment. We saw only three women, who were Mexican prisoners. The soldiers' huts are placed in irregular rows and at unequal distances; a dirty blanket or coarse rag hangs over the entrance in place of a door. No windows were seen except in one or two cabins occupied by Texan officers and soldiers. A dozen or more long guns lay about on the sand, and one of about the same caliber was mounted. There was a lookout house fronting and commanding the entrance to the harbor, and at the point where the three channels meet there were four guns mounted of smaller caliber.

We readily observed that not much nicety prevailed among the Mexican prisoners, and we learned that their habits were as filthy as their persons. We also found a few beautiful flowers and among them one which Harris and I at once nicknamed the Texan daisy; and we gathered a number of their seeds, hoping to make them flourish elsewhere. On the top of one of the huts we saw a badly stuffed skin of a gray or black wolf, of the same species as I have seen on the Missouri. When we were returning to the vessel we discovered a large swordfish grounded on one of the sandbanks, and after a sharp contest killed her with our guns. In what we took to be a continuation of the stomach of this fish we found four young ones, and in another part resembling the stomach six more were packed, all of them alive and wriggling about as soon as they were thrown on the sand. It would be a fact worth solving to know if these fish carry their young like viviparous reptiles. The young were about thirty inches in length, and minute sharp teeth were already formed.

May 8. Today we hoisted anchor, bound to Houston: after grounding a few times, we reached Red Fish Bar, distant twelve miles, where we found several American schooners and one brig. It blew hard all night and we were uncomfortable.

May 9. We left Red Fish Bar with the *Crusader* and the gig, and with a fair wind proceeded rapidly and soon came up to the new-born town of New Washington, owned mostly by Mr. Swartwout, the collector of customs of New York. We passed several plantations; and the general appearance of the country was more pleasing than otherwise. About noon we entered Buffalo Bayou, at the mouth of the San Jacinto River and opposite the famous battle-ground of the same name. Proceeding smoothly up the bayou, we saw abundance of game, and at the distance of some twenty miles stopped at the house of a Mr. Batterson. This bayou is usually sluggish, deep, and bordered on both sides with a strip of woods not exceeding a mile in depth. The banks have a gentle slope, and the soil on its shores is good; but the prairies in the rear are cold and generally wet, bored by innumerable crayfish, destitute of clover but covered with coarse grass and weeds, with a sight here and there of a grove of timber rising from a bed of cold, wet clay.

It rained and lightened, and we passed the night at Mr.

Batterson's. The tenth it rained again, but we pushed on to Houston and arrived there wet and hungry. The rain had swollen the water in the bayou and increased the current, so that we were eight hours rowing twelve miles.

May 15. We landed at Houston, the capital of Texas, drenched to the skin, and were kindly received on board the steamer *Yellowstone*, Captain West, who gave us his stateroom to change our clothes and furnished us refreshments and dinner.

The Buffalo Bayou had risen about six feet, and the neighboring prairies were partly covered with water; there was a wild and desolate look cast on the surrounding scenery. We had already passed two little girls encamped on the bank of the bayou, under the cover of a few clapboards, cooking a scanty meal; shanties, cargoes of hogsheads, barrels, &c., were spread about the landing; and Indians drunk and hallooing were stumbling about in the mud in every direction. These poor beings had come here to enter into a treaty proposed by the whites; many of them were young and well-looking, and with far less decorations than I have seen before on such occasions. The chief of the tribe is an old and corpulent man.

We walked towards the President's house, accompanied by the secretary of the navy, and as soon as we rose above the bank we saw before us a level of far-extending prairie, destitute of timber, and rather poor soil. Houses half finished, and most of them without roofs, tents and a liberty pole, with the capitol, were all exhibited to our view at once. We approached the President's mansion, however, wading through water above our ankles. This abode of President Houston is a small log house consisting of two rooms and a passage through, after the Southern fashion. The moment we stepped over the threshold on the right hand of the passage we found ourselves ushered into what in other countries would be called the ante-chamber; the ground floor however was muddy and filthy, a large fire was burning, a small table covered with paper and writing materials was in the center, camp beds, trunks and different materials were strewed around the room. We were at once presented to several members of the cabinet, some of whom bore the stamp of men of intellectual ability, simple though bold, in their general appearance. Here we were presented to Mr. Crawford, an agent of the British minister to Mexico, who has come here on some secret mission.

The President was engaged in the opposite room on national business and we could not see him for some time. Meanwhile we amused ourselves by walking to the capitol, which was yet without a roof, and the floors, benches and tables of both houses of Congress were as well-saturated with water as our clothes had been in the morning. Being invited by one of the great men of the place to enter a booth to take a drink of grog with him, we did so; but I was rather surprised that he offered his name instead of cash to the barkeeper.

We first caught sight of President Houston as he walked from one of the grog shops, where he had been to prevent the sale of ardent spirits. He was on his way to his house and wore a large gray coarse hat; and the bulk of his figure reminded me of the appearance of General Hopkins of Virginia, for like him he is upwards of six feet high, and strong in proportion. But I observed a scowl in the expression of his eyes that was forbidding and disagreeable. We reached his abode before him, but he soon came, and we were presented to his excellency. He was dressed in a fancy velvet coat and trousers trimmed with broad gold lace; around his neck was tied a cravat somewhat in the style of '76. He received us kindly, was desirous of retaining us for awhile and offered us every facility within his power. He at once removed us from the anteroom to his private chamber, which by the way was not much cleaner than the former. We were severally introduced by him to the different members of his cabinet and staff, and at once asked to drink grog with him, which we did, wishing success to his new republic. Our talk was short; but the impression which was made on my mind at the time by himself, his officers and his place of abode can never be forgotten.

We returned to our boat through a melee of Indians and black-guards of all sorts. In giving a last glance back we once more noticed a number of horses rambling about the grounds, or tied beneath the few trees that have been spared by the axe. We also saw a liberty pole, erected on the anniversary of the battle of San Jacinto, on the twenty-first of last April, and were informed that a brave tar who rigged the Texan flag on that occasion had been personally rewarded by President Houston with a town lot, a doubloon and the privilege of keeping a ferry across the Buffalo Bayou at the town, where the bayou forks diverge in opposite directions.

May 16. Departed for New Washington, where we received kind attentions from Col. James Morgan; crossed San Jacinto Bay to the *Campbell*, and the next day dropped down to Galveston.

May 18. Left the bar of Galveston, having on board Mr. Crawford, British consul at Tampico, and a Mr. Allen of New Orleans.

May 24. Arrived at the S.W. Pass [of the Mississippi River] and proceeded to the Balize and thence to New Orleans, where we arrived in three days.

New Orleans, May 28. Breakfast with ex-governor Roman and his delightful family, with Mr. Edward Harris.

May 31. We bid adieu to our New Orleans friends, leaving in their care for shipment our collections, clothing, and a dog, Dash, for Mr. W. Bakewell. Harris went up the river, and we [i.e., Audubon and his son John Woodhouse] crossed to Mobile in the steamer *Swan*, paying fare twelve dollars each, and making the trip of one hundred and fifty miles in twenty-one hours. If New Orleans appeared prostrated, Mobile seemed quite dead. We left in the afternoon for Stockton, Alabama, forty-five miles distant, where we were placed in a cart and tumbled and tossed for one hundred and sixty-five miles to Montgomery; fare twenty-three dollars each, miserable road and rascally fare. At Montgomery we took the mail coach, and were much relieved; fare to Columbus twenty-six dollars each. Our traveling companions were without interest, the weather was suffocating and the roads dirty and very rough; we made but three miles an hour for the whole journey, walking up the hills and galloping down them to Augusta and paying a fare of thirteen dollars and fifty cents each, and thence by rail to Charleston for six dollars and seventy-five cents each, distance one hundred and thirty-six miles, and making eight and a half days from New Orleans.

John James Audubon to Mrs. John Bachman
"Everything has been new to Maria's senses..."

On June 24, 1837, soon after the Audubons, father and son, reached Charleston from their expedition to Texas, the Reverend John Bachman joined his oldest daughter Maria and Audubon's younger son John Woodhouse in marriage. Audubon and the newlyweds left Charleston by steamboat the same day, stopped in Washington to meet the new President, Martin van Buren, and then divided at Edward Harris's farm in New Jersey, Audubon staying on with Harris while John and Maria enjoyed a ten-day honeymoon at Niagara Falls before sailing for England. Audubon was delighted with his new daughter-in-law.

Moorestown, New Jersey
2 July 1837

My dear friends,

Do not believe me forgetful, for although this is the first time I have attempted to write you, I and our beloved children have not ceased to think of you all. I have been busy, aye very much so for the time being, and here I am at Friend Harris's as [if] by magic. Our beloved Maria wrote to you this day week from Norfolk, and there I might have done the same had I not felt perfectly exhausted. Now indeed I am not yet what I wish to be—quite well—although I think I am *gradually* recovering both my health and my former good spirits. From Norfolk we went to Washington City by steamer, stayed there nearly 2 days. I saw the President and the different heads of the departments and I now have almost concluded in assuring you that the land expedition has not yet sailed [probably a reference to the U.S. Exploring Expedition then being organized in Washington]. I think I have obtained the Savannah Station for Capt. Day, but the captaincy for [Napoleon] Coste must wait awhile. Tell them so should you see them. Should Mr. Poinsett be with you, ask him to have our work taken for West Point; if not with you, pray write to him on the subject. I saw him

and had some converse with him but could not introduce this subject. There is some talk of a National Museum...

Our children left me yesterday morning for New York and the Falls of Niagara, to return by the 12th or 13th Instant to New York, and we will sail on the 16th for England, and I wish you to write to us at New York by the express mail in answer to this.

When you receive this, see at once whether the *Superb* has sailed, and if not, lose not a moment in dividing my collection of Rocky Mountain bird skins as equally as you can and ship the better half by her to Liverpool care of Messrs. Rathbone Brothers and Co. and the other half by the vessel that takes the rummed birds, the Blue Grosbeak, the large case of books, &c., and the flying squirrels which we altogether forgot to mention. The latter vessel goes to London, and Friend Kunhardt will attend to this part of the job— I ask of you to do so that I may have at least one chance to receive a series of these valuable bird skins.

I have a new and superb Hawk from Louisiana as large as the Caracara Eagle and somewhat like it in colors. A new *Downy Woodpecker* from the same state, overlooked by John Bachman, Audubon and all others except young Trudeau. You will shoot it, I have no doubt, and will know it at once by the longer bill and shape of the mandible, both of which are considerably curved. It has a few *yellow* feathers over each eye and is in size between the Downy and Hairy Woodpecker.

Never in my whole life have I enjoyed traveling so much as I have with my beloved daughter. Everything has been new to her senses—hills and dales, trees & fruits, bridges, rail cars and highly fashionable circles have danced before her alternately like so many novelties of Nature and of the world, and her own descriptions of the feelings which have accompanied these transitions are so simple and meantime so truly poetical and *just*, that I have envied her situation a thousand times! She is I believe as happy as she can be after the severe separation she has had to bear from friends & parents ever dear to her. But she will write to you herself & express all this far better than I can do, therefore on to other matters.

News from Mamma have reached me to the 15th of May, all well. Nicholas Berthoud has not failed [the Panic of 1837 was then in process] but suspended payment and all my concerns then are

safe enough. He wrote me as usual, and John & Maria are at this moment under his roof. I will be there tomorrow evening. I wish you would send me a copy of your paper on the molting of birds by the London ship. Harris is well and sends his very best regards to you all. He is not going to Europe at present...

I hope you got a Buzzard for me in rum besides the one John shot. I think you will conclude me lucky in my collections, for beyond what I have said above, I will receive 360$ from the Congress Library at New York in a few days and some also from the State of Maryland, and I now hope to carry over with us 600£ in sovereigns!

The *England* is a fine ship and I have already crossed the Atlantic with her Capt. (Waite) and we are not likely to be crowded as there are but few voyageurs nowadays.

I may perhaps not go to Boston, but will write to you once or twice more without however charging you with 75 cents postage. Pickering is yet here, Nuttall is at Boston. Harlan feels very sore at J.B. not having called upon him [Bachman had recently visited Philadelphia], he was, as well as his wife, very kind to Maria and gave her a grand ride to the [Philadelphia] waterworks, hospitals, &c. We have dreadful hot weather and great rains, the vegetation is very backwards, scarcely any fruit of the larger kind this season...

I formed the acquaintance of a gentleman from Matanzas, Cuba, who will send you some flamingos for me. He presented Victor with a thousand splendid cigars, and that reminds me of taking a pinch of snuff! Kisses from you all dearest fair ones would suit me better just now, but alas two years must probably elapse ere I touch your sweet lips!

There is scarcely a dollar of silver in circulation, and the present trashy paper medium is beyond endurance, at every change of state or towns you are obliged to see to what you have and spend or give it away, for in fact it soon becomes useless. Business of all description is at a stand, and it is not everyone who cries in sorrow of Van Buren, I assure you...

John James Audubon to Lucy and
Victor Gifford Audubon
"The times are hard..."

New York, New York
8 July 1837

My dearest friends,

I have been here since the 3rd Instant and constantly engaged at arranging our affairs so as to enable me to take over to you as much gold and silver as I possibly can; but indeed the times [are] hard—so hard that I am unable to say how much the sum will be. Whatever it is, I shall insure it.

John & Maria left me at Philadelphia on the 1st and went from this to the Falls of Niagara on the morning of the 3rd (I arrived here in the afternoon of the same day) and I look for them on Wednesday or Thursday next, when they will have to prepare for our voyage, as I have taken our passages on board the *England*, Capt. Waite, and will sail on the 17th for Liverpool. (The 16th being Sunday, when no packets nowadays leave New York.) The *England* is a fine ship, not an old one, and I hope our time on board will not exceed twenty-five days. We are to have some agreeable companions, such as the eldest daughter of old Dr. [Benjamin] Rush, now Mrs. Manners, her daughter, &c., and the famous Mademoiselle Celeste & crew. The captain has given John and Maria a nice room in the very center of the ship, and as Maria was not seasick when we came from Charleston to Norfolk in a steamer, I hope that she will fare well. He has given me a stateroom to myself very close midship, and seems greatly pleased to have us. We are now 19 passengers. We pay three hundred and fifty dollars; and I go to Liverpool instead of to London, because none of the vessels sailing in this month for England (London) are agreeable to me.

I found dearest Mamma's letter of the 21st of May in which she tells me not to hurry, but you cannot form any idea of the state of affairs on this side the Atlantic, and to remain here would only be extremely expensive without any benefit whatever. There is no

money, no credit, and I assure you no likelihood of new subscribers. When John Bachman wrote to you that one hundred [new subscribers] might be obtained, the times were different, and I thought the same when I reached New Orleans, where however I soon discovered that we were both mistaken. But we will talk of all this anon, when I will be able to rest my poor old bones near you both, and with Johnny & his Dear Maria; who is indeed a most excellent and amiable girl, agreeable to everybody to whom she has been presented. We have come to Nicholas Berthoud's, where we are very comfortable. Eliza and all of us indeed are quite well, but suffer much in mind on account of the painful state of affairs [i.e., the Panic].

I saw Mr. DeRham yesterday morning, and prevailed on him to take the work; he perhaps will pay a portion of the sum of 660$?

The whole of our effects save our trunk each will be shipped to London on the 20th Instant or on the first of July. I am doing my best to fill up my list of commissions for Mamma and others, but again I am forced to tell you that money is scarcer with me than I anticipated it would be. The exchange for Sovereigns is at 5 Dollars & 45 @ 50 cents—13 percent for silver—I will not trust to bills of exchange, which by the way are terribly high just now.

Tomorrow, Sunday, I will write to you again and give you more details as regards the amount I may take with me, &c., and I will leave a long letter to be forwarded by the packet of the 20th July as perchance she may get to England before us. We have had constant rains since 3 weeks, and the weather is cold and unpleasant. The seeds, plants, &c., did not leave Charleston until the middle of last April, but I hope that they reached safe at last. All friends are well at Charleston...

John James Audubon to John Bachman
"This sum will suffice us to finish our work..."

New York, New York
16 July 1837, Sunday early morning

My dear Bachman & all about you!

Tomorrow morning we will sail for Liverpool in the packet ship the *England* of 733 tons, commanded by Benj. Waite, to whom I have paid 350 dollars for our 3 passages. Our dear children have a fine room to themselves almost in the center of this superb ship, where I hope they will not suffer from seasickness—they have the 2 stewardesses just opposite to them. I have a whole stateroom to myself also, in the large cabin and near the stewards, &c.—all as comfortable as can be wished whilst thus caged on the waves. We are in all 23 passengers, and at the exception of Miss Celeste and band of 4, pretty select—no single young men. We hope for a fine "run" and our captain says that he will land us at Liverpool on the 6th August. May God will it so!

We received your 2 letters by the express mail and are glad to see that you are all well, although our beloved sweet [i.e., Maria Martin] complains of headaches—she *must* go a journey this summer, do persuade her to do so for our own sakes. In the way of business I have, considering the times, been I think very fortunate. I carry with me nine hundred and eighty-one Half-Eagles and one hundred and twenty-five Sovereigns, equal to 1,106 pounds sterling. This of course *I have insured*. Now, barring accidents, this sum will suffice us to finish our work with the usual annual collections we make in England, and I leave behind us about 8,000 dollars. I procured a new subscriber yesterday. I have settled my accounts with my brother-in-law, [Nicholas] Berthoud, in full to the present day; and we will go on as usual as he is willing to be yet my agent here. All this is very gratifying to me, and will I daresay be equally so by yourselves. I leave a few volumes of my work with N. Berthoud and some [*Ornithological*] *Biographies*, and one volume in the hands of John B. Morris of Baltimore. I have delivered all the rest, and will collect the money when we return to purchase a place

somewhere in our country! N. Berthoud calls me one of the happiest of men—free of debts and having available funds and talents!

Our dear children returned from Niagara a few days ago quite well and as happy as if angels in heaven. My sweet Maria becomes dearer to me every moment, and my heart swells with joy as I see her approaching me to kiss me as she would kiss her dearest of friends. God bless her! She will give you the details of her journey, &c. Indeed, I think that she feels well satisfied that her new father is not a bad one and her husband the very first in the world, this is all right, and we all see this 25 years hence! I have filled all my old friend's [i.e., Lucy's] commissions and more. The shawl, 70$, is superb. The rifle is first rate. So is the ginger, mackerel, &c., &c. I say all this because my beloved friend Maria Martin will be glad to know of it. We have not yet received the birds in rum and skulls from New Orleans; they are at sea, however, and I hope will soon reach this to go with all the like material, heavy trunks, &c., direct to London. John has some skins of beasts for you, he brought me some valuable ones of birds from Niagara, where he saw 2 of the Birds of Washington that the gentleman possessing them would not sell, being anxious to do so in Europe where he is going. Harris is here and well. Should he not go to England this autumn, you will see him probably at Charleston on his way southwest, &c., as he contemplates a long journey after natural knowledge. Do search for the new Downy Woodpecker; its bill will be sufficient for you to recognize it at once, so: [here Audubon draws the bill] the common is so [here Audubon draws the bill of the common Downy Woodpecker]. [Thomas] Brewer has given me the nest of the Northern Common Titmouse, also the triple one of the *Sylvia sativa*, rendered so to hide 2 eggs of the Cow Bunting in 2 different chambers as it were, and having deposited 4 of its own in the upper apartment! What will [George] Ord say to this? Pray attend as much as you can to the procuring of birds in rum for me agreeably with the list here enclosed. William Cooper married his last wife's sister on Monday last, and I have not seen him at all. [Henry] Ward [Audubon's larcenous young English taxidermist] is a complete scamp, and I have not seen him, but have paid him 118$ for the trash he has given N. Berthoud in my absence, and who was told

to pay him when asked. Be careful of him or he may play you some ugly trick yet.

Harris has lost another brother-in-law and is now as deep in mourning as ever. Dr. Spencer will remain undecided about going to England until we return from it! I have no letters from my Lucy or Victor by the last packet, and therefore conclude that they expect us about the time we, ourselves, hope to arrive at London. Mr. Gordon has not yet failed. N. Berthoud will pay every cent, and will be comfortable besides, and so will thousands of other *honest American merchants*! Our country is physically and intrinsically too powerful to remain long in its present state of inactivity, and I dare hope that ere a twelvemonth is over, things will have taken a new and a healthy turn. God grant it! I have received several letters from Dr. [George] Shattuck; he announces the expectation of Dr. Parkman of Boston about the beginning of September. The latter was in London when last heard of.

I hope that you, your dear Harriet, my dear Maria, Eliza and even the younger folks will let us hear of you all "middling often." If you do not, why, we will suffer—and you all will be the cause.

Mr. Grimshaw goes to England next month; his wife, child & servant will remain with my sister[-in-law] Eliza Berthoud; and all this will be pleasing as Nicholas contemplates taking a journey to the West this next autumn. You cannot conceive how much we all regret that Maria M. & Eliza could not have gone over with us. It would have so much improved them both, one in health, the other in mind or knowledge of things which descriptions do not bear out. When, as I now do, [I] expect to be with my beloved wife in less than 30 days, it feels like a dream, aye, like a dearly pleasing one too, and yet it seems quite as if a dream! As it is useless to be sorry about the bird skins from the Rocky Mountains having gone by the rice ship, I will say no more about them or the sweet finch and pretty squirrels, but will fidget until I see all these things again. Oh, if I have good luck, how I will revise my own work in my fourth volume. How I will cut & slash at my own poor past ignorance; and yet how more careful than ever must I proceed not to blunder worse than I have already done. I wish I had you at my elbow all the while, my good friend, that we might argue every point coolly, aye, as coolly as we always have done, and hope

to do again. What a strange realization of a dream this finishing of a work that has cost me so many years of enjoyment, of labor and of vexations, and yet a *few* more months will, I trust, see it ended, aye, ended, and myself a naturalist no longer! No more advertisements of this poor me. No more stares at my face whilst traveling. No, I have some idea of revising even myself and altering my very name, not to be pestered anymore. I feel in better spirits since the return of our children to me, but you would be surprised to see how much thinner I am. Why, when my beard is longish, I look as I thought formerly I never could look; but our captain tells me that with turtle soups, good wines and agreeable company he expects to render me quite fit to meet my wife and to be presented to my friends in England. We carry ice for the whole voyage, and sweet daughter is tickled at the idea of ice creams and other good things which he has on board—on board! This will be a new sight to her, for she has not yet seen the superb ship, and I know how surprised and pleased she will be to find so much splendor and comfort combined. We have a fine bath house, &c., &c., and a very decent library.

Now, dear friends, I must conclude this my last from this side of the Atlantic, and part even this letter which I really envy, for it will be with you whilst I shall be tossing over the billows, seasick and far from being as comfortable. But so it is, and must be, I hope for the sake of us all...

Now for the rub:

Wanted! Wanted!! Wanted!!!

Bachman's Warbler!	Orange-crowned Warbler
Bewick's Wren	Painted Finch
Bemaculated Duck	Pipiry Flycatcher
Boat-tailed Grackle	Purple Martin
Bird of Washington	Ring-necked Duck
Black-throated Diver	Roseate Tern
Black Warrior Hawk	Sandwich Tern
Blue-green Warbler	Sooty Tern
Blue Grosbeak!	Stanley Hawk
Blue-headed Pigeon	Swainson's Warbler
Bonaparte's Flycatcher	Tennessee Warbler

Booby Gannet

Carbonated Warbler

Carolina Paroquet

Common Gallinule

Dusky Petrel

Florida Jay

Fork-tailed Flycatcher

Freshwater Marsh Hen

White Heron

Henslow's Bunting

Least Bittern

Mango hummingbird

Mangrove Cuckoo

Tropic Bird

White-headed Pigeon

Whooping Crane

Wood Ibis

Worm-eating Warbler

Yellow-breasted Chat

Yellow-crowned Heron

Zenaida Dove

Turkey Buzzard

Key West Pigeon

Long-eared Owl

Wood Ducks

New York Rail

Do all you can, and that as quickly as possible, so as to have what you may collect in London by May 1838, and now once more God bless you all. N. Berthoud says at this moment that the sum due me now in the U.S. amounts to $9,354.74 …

John James Audubon to John Bachman
"The Birds of America *will have closed their pinions . . . !*"

London, England
14 August 1837

My dear Bachman,

We have been snugly at home already for a week, and thank God are well and well doing. We had a pleasant and short passage; and such a set of companions as would have been quite congenial to your gay spirits. We saw Ireland 15 days after we had lost sight of America. Our children were both well, and I only sick (sea) the morning on which we landed at Liverpool. At this latter place I wrote you a few lines and sent you a beautiful church. We left that emporium of commerce two days afterwards and reached Birmingham by the railroad, traveled 96 miles in 4¹/₂ hours. We slept at Birmingham and the next morning, after an early breakfast, started for London by the coach called the "Tally O" and were rolled over the smooth and firm roads of England exactly 10 miles per hour. Having dined at [a] lovely village about halfway, on we again moved and at 8 of the evening I was in the arms of my Lucy! Dear old friend, she was not very well, our arrival produced a great revolution of her nervous system, but after a while all was gaiety and happiness at our house in Wimpole Street. Our family physician was present. Our children were happy, and as we after a while retired to our separate apartments we blessed the Being from whom we had received this long-wished-for moment.

Our dearest Maria, with a mind and eyes filled with wonders, was not at all fatigued, and even since then she has been enjoying the sights of this as it were New World to her. We have dined out twice, shewn her many a wonderful object, and even this morning took [her] to the St. James Park to view the Queen's palace and list to some exquisite martial music. At 5 this afternoon we are going to Mr. Gordon's to dine, and afterwards to view *ad secundum* the Zoological Gardens.

We brought our budget for this year quite safely, and I am to

say, that by having purchased *American gold* at New York, I have saved something like a couple and a half of hundred dollars.

Our Work too is going on quite well, the 76th Number is out, and the next packet [ship] will take all the American sets from No. 72 to 76 both inclusive. Havell tells me that on the first day of January next the *Birds of America* will be finished! Think of that!! What a glorious Christmas I will then enjoy. Would that you all were with us at that precious moment, and for awhile after that we might talk and laugh and kiss all the dear ones about us, and thank God for the privileges he has granted to your poor old friend.

Whilst at Liverpool, I went on board the ship *Superb* and found that only 13 birds had reached Earl Derby alive; and that the alligator had died on its reaching the docks. The other vessel has not yet arrived, and as you may suppose I am already pretty fidgety about my valuable bird skins and valuable birds in rum. Lord Ravensworth has received all the seeds and plants and I brought 18 Wild Pigeons alive, and the all of my terrapins in good order.

London is just as I left it, a vast artificial area as well covered with humbug as are our pine lands and old fields with broom grass. [William] Swainson is publishing his incomprehensible works. [John] Gould has just finished his *Birds of Europe* and now will go on with those of Australia. [William] Yarrell is publishing the British birds quarto size—and about one thousand other very trying works are in progress to assist in the mass of confusion already scattered over the world.

The Arrival of J.J.A., his son & his daughter has been proclaimed throughout these realms, &c., &c., &c.

After ten years or more of constant exertions to obtain and to study both a good representation and the habits of our Marsh Tern, and when, as I thought, both were actually in my possession, I find on the opening of all our trunks, boxes, &c., that my drawing of this curiously interesting species is actually *wanting* or *missing!* This is the 15th of August, and on the last day of the present year my work will be finished, but unless you find that drawing at your house and send it to me immediately (via New York) through Mr. Berthoud, it will come too late. The Charleston ship with our dear little pet the Blue Grosbeak (I unfortunately do not know the name of the ship) is not yet arrived, and just now the winds are sadly

adverse. The above paragraph is addressed to my beloved friend Maria Martin, and to her I must beg to attend to it, as quick as this may reach you all.

Oh how much I now regret that I did not bring my bird skins along with me—but it is all over and I must wait and probably after all be disappointed, for the *Superb* has been in at Liverpool for more than a fortnight and the other vessel has never been as yet heard of.

Maria & John are going to the opera this evening, and today at 5 we have two gents to dine with us—one a clergyman the other the editor of the *London Courier*.

Victor will leave us in a few days on a tour of recreation and rest for the seashore, for about two weeks. He has not been very well of late, and I trust that such a jaunt will greatly benefit his health.

The 14 turtles caught by us in Texas are now crawling about our little back yard in good health, the poor things have not eat a mouthful since caught! My good friend [William] MacGillivray has lately published a work (the 1st volume of a work) on the ornithology of British subjects, but the reviewers have spoken of it so curiously that I will now copy a small extract of their strictures, which I hope you will not consider as egotism in me to transmit to you all, joined as we are by a good, solid and friendly band!— "The writing appears to us an affected attempt to imitate the styles of Isaac Walton and of Audubon, which being extremely peculiar, can only be relished in the originals, and here, as in the case of similar imitations, we desiderate their freshness, and dislike the misplaced quaintness of expression," &c., &c., &c.

William Swainson is rattling away as wild as ever... with his lunatic systematical rhapsodies of circles, &c., &c., and has been leathered well on a work of elemental conchology. May those cut him to the very marrow. Yarrell is, as I believe I have already said, publishing a *The Birds of England* on a small scale.

The wedding cake is quite nice and as yet uncut. Mamma keeps it for some *grand occasion!* All our friends are fond of our beloved daughter, and I have kissed her dear [illegible] almost off...

God bless you all! Whatever you have to do for me, do quickly, for recollect that January will soon come, and then, why, the *Birds of America* will have closed their pinions, never to be opened more...

John James Audubon to John Bachman
"Four hundred plates are now actually published..."

London, England
20 December 1837

My dear Bachman,

I first wish you, and the whole of your dear family, a most Happy Christmas, a Happy New Year, and [many?] odd more besides! Next I thank you for the intelligence contained in your last favor (the third letter received from you since my arrival in England) in which you say that, immediately after the receipt of my letter to Doctor Wilson, that worthy friend had shewn it to you, and that yourself had communed with a certain seafaring captain, who had promised to exert himself in the procuring some Flamingoes in the flesh for me! In the same letter you also say that you have shipped two barrels of birds in rum, one from your own gathering, the other, the result of Capt. Coste's cruise around the Floridas, another having been washed overboard the *Campbell* during a gale. The *Nimrod*, the ship by which these barrels are to come, has not yet made its appearance, and I have received no bills of lading for the same, which it appears to me strange after the particular injunctions to that effect for some very considerable time past.

My work progresses on as usual, four hundred plates are now actually published and I intend to send very soon the Numbers which follow those last sent to you and others. I have now some hopes that I will finish my great task with twenty-five additional plates, and that about four hundred and sixty *genuine species* will form the present amount of our ornithological fauna. I have lately procured five very odd species from towards the Mackenzie River, and yet go destroying many nominal species, the dreams of several naturalists such as Swainson, Bonaparte and our humble self. Whilst on this head, I feel disposed to give you my now real view of the character of Charley [i.e., Charles-Lucien Bonaparte]! When he first came to London, he began by going the rounds and trying to pump each and every one of those from whom he thought he might acquire knowledge, and of course as far as the birds of

North America are concerned, I was the very first on his list. Days after days he has visited us, pumped me as far as I was willing to be, made list of all our new species, examined each bird in the skin, corresponded his systematical arrangements after asking me thousands of questions, and after all is still desirous that I should give him my ideas or in fact knowledge of their habitats, migrations, &c.! Quite trifles, you see; but in this, I will stop his career, and will tell him bluntly and honestly; when we come to the scratch, that as to acquiring the all of this from me (before being printed and before the world) he is as mistaken as if he "had torn his shirt"! The beauty of his maneuvers is that whilst doing all this for his own fame and benefit, he pretends that he is acting for my sake! Capital, is it not? When I am confident that he, *positively speaking*, knows very little indeed of our birds! Otherwise he is a mild, pleasant-speaking personage, not at all of the Prince about him whilst with us at least, but so very fond of praise that I doubt of his sincerity (I am sorry to say this) as it has become rather too clear to me, that he never possessed one half the credit which I have been wont heretofore to grant to him, blinded as I have been by the apparent friendly manners which he never ceases for a moment to assume. Yesterday he even carried off the whole of the list which he has made at our house, including among them one in Victor's handwriting. He has kept me at home waiting for him for hours and whole days without attending to his appointments, and has made his appearance sometimes early, at others late, and in fact only when he has found this to be most convenient to himself. I now greatly regret my not having paid more attention to the strong language of Harlan respecting Charley, for if I had been more prudently guarded, he would at this moment know still less than he does. But I will now change the subject.

When your last letter had been read, I sent one of my own to the Earl of Derby, in which I gave him full cognizance of your desires to receive some live Pheasants from his Lordship, I told him that I had sent you a famous jar of birdlime (which I have done by young John Bethune of Cambridge, Boston, Massachusetts) and told the Earl that it was your intention and wish to procure and to send him more live birds. He is particularly anxious to receive live *Anhingas*, not one of which was ever seen in Europe. In his

prompt answer, he says that he will send you some Pheasants, and I am sure that he will do so, for he is a first-rate man, and one who has never deceived me. Nay he is now sending me some birds which I greatly want and which no one else possesses, and wrote to me a letter of six pages giving me much salutary advice respecting certain nominal species with which others might (in my ignorance) have induced me to publish as North American birds.

Should this letter reach you before you have shipped the Flamingoes, I beg of you to send them by a first-rate ship direct to London from Charleston, and if no such opportunities be likely to occur at once, to send them to Mr. Berthoud by a ship (one of your packets) with a request to forward them at once, by the first packet ship bound to London, urging him indeed not to neglect this, or it will prove too late.

I think that I will be able to prove that we have a Swan in the United States which has been confounded with the Bewick Swan of Yarrell…In my opinion there is more real merit in destroying one single nominal species, than in the publishing six new good species, as the latter are always well able to speak for themselves when found!

We are all, at the exception of my old friend, pretty well, she however still remains confined to her room, and frequently for several days to her bed. The days now at their shortest light are thickly fogged, rainy and most disagreeable, and at this very moment it blows a horrible gale from the southwest. I have not heard from America for several weeks, although our packets have been numerous from thither, and with very quick passages. Your last letter, for instance, came to hand in 30 days after the date put on the face of it at Charleston by you. We hear no more from the Floridas, and I conclude that the noble Osceola has been murdered in cold blood! Some strange accounts respecting the Canadas have reached us through the public press, upon which little if any reliance can be placed. Van Buren and his party, we are also told, have fallen a "considerable deal" in the estimation of the millions— but this also is all newspaper talk, and our friends keep us in the dark on all such points as are truly interesting to Americans. Can you not send me a single new species of bird in time for my publication? I should think that amongst the smaller species of

Woodpeckers this might yet be done, and I have to regret my inattention to this tribe during my late visit to the South of the Union.

Not a word of Townsend. Not a line from Nuttall, or Dr. Morton. I suppose that Peale and Pickering have sailed for the Antipodes, but cannot tell. The only true correspondent has been young [Thomas] Brewer, who indeed has done much for me since I left you all. Earl Derby has sent a beautiful egg of the Whooping Crane....

Were you in London for one single month you would be surprised to see the mad desire at present existing in everyone [who] would be [a] naturalist, to bring forth his own unintelligible systematical arrangements of Nature's works. One says that the Flamingo is merely a Duck with long legs, and that hummingbirds are only Swifts, or Chimney Swallows, &c., &c., &c. Some ask my opinions; others do not; and I must say I should be much more pleased if none of their gentry were not to trouble me more.

Has the great [U.S. Exploring] Expedition sailed? When? And how arranged as regards the scientific corps? Come stir up, take a pen, place half a quire of paper before you and let us know anon. The wished-for letter from our sweetheart has not yet made its appearance, but I shall expect the perusal of its contents two days after the arrival of the next packet for she never broke her promises! God bless her, and God bless you all; write more often and longer letters, assure all our friends that we rarely pass a day without speaking of you and them, and as far as I am concerned that I rarely eat my dinner without pledging them and the whole of you, though distant, with a health in a good bumper of the best wine I can afford to drink. Again and again God bless you all.

Your sincerest of friends,

John J. Audubon, his wife & three children

28 December 1837—My dear Bachman: Since writing the few lines therein, I have received a letter from Friend Ed Harris, announcing the return to Philadelphia of Dr. Townsend with an increase of new ornithological species amounting, if all correctly told, to upwards of twenty species, some of which I expect are very curious, and others beautiful. Harris has bought a specimen of each for me, and I suppose that at this moment they are underway from New York to

London, as they were to have been shipped on the 20th Instant. Townsend also is sending me a parcel of them for sale on his account. I also expect from him some information respecting habits, &c. I am glad that he has sent you his new hare and other quadrupeds. Should the birds come in time, I will of course publish the whole of the new species, and my work will be *the* work indeed! Bonaparte is gone at last and I am much relieved, for the days are very short and I have a great deal to do. We are all well, Mamma has I think been better than usual for the last fortnight, and I hope that she will soon recover her strength. Her spirits are as good as ever! Not a word from our sweetheart for a long time. I hope no parson has carried her into the Sand Hills. We received Eliza's last letter this morning. I am told that there is a book from you for me in the London docks. I will have it in a few days. It came through N. Berthoud. The *Nimrod* has not yet arrived. When will the Flamingoes come??? Wishing you all a Happy Year ...

John James Audubon to John Bachman
"My dear Bachman, both of us will soon be grandfathers!"

At the end of the main body of this letter, Audubon refers to writing "crossways." To limit postage charges, a correspondent in his day often wrote letters on a single sheet of paper. A space had to be left as well for the address, since the sheet would be folded to serve as its own envelope, addressed and sealed with a wax seal. If the correspondent thought of something more he wished to add before he folded up the sheet, he could turn it sideways and write at a 90-degree angle across the previous lines. The resulting "crossed" palimpsest could be difficult to read, but laying a ruler under a crosswise line made scanning it easier.

London, England
14 April 1838

My dear Bachman,

The last intelligence of your being still in the land of the living reached us this morning, and Eliza's letter is dated the 13th of last month. We have heard of the loss of your venerable mother with sorrow commensurate, but were almost happy at the thought that at her extraordinary American old age she was removed in peaceful quietude to that world towards which we are all doomed or blessed sooner or later to remove!

That yourself and the remainder of your dear family are quite well is quite a comfort to us all at this distance from Charleston and blessed indeed would I feel as at this moment were I able to say as much of each member of my own beloved family. My dearest friend is still aching, John has had a violent attack of an ulcerated throat, but is now again up, and I trust will soon be able to resume his daily avocations. Our child [i.e., Maria Bachman Audubon, John Woodhouse's wife] is quite well and as sound as anyone in love of her could possibly wish; indeed, my dear Bachman, it may be possible that ere this reaches you, both of us will be grandfathers! Nay, Mr. Phillips thinks that the chance may be a *double*, and if so, how blessed I will feel to have a pair of them born Audubons.

Doctor Wilson's valuable letter reached me two days ago, old date, but full of fun and just what was wanted to raise the spirits of a hypochondriacal of 53 years of age, and thank God yet able to put his forefinger and thumb up to his nose holding withal a pinch of the "American Gentleman." (Snuff! Snuff!) Flamingoes are now very far below par; indeed it will prove a curiosity to the world of science, when that world will know that John Bachman, D.D., himself, assisted by Samuel Wilson, M.D., and about one half of a hundred persons besides have not been able to send me even a stuffed specimen in time for my publication. So it is, however, and I drop the subject. *What have you done with the birdlime?* How preciously lazy you have become, and yet we here are told that you are gone with your beloved Monty to Liberty Hall! Would that I was there at this moment with my dearest friend, our children, our sweetheart and all that have a jot to do with either or all of our party.

Alexander Gordon has been with you and now tell me what do you think of that gentleman—he is somewhat learned and keen, and may be a friend besides.

Charles Bonaparte has treated me most shockingly—he has published the whole of our secrets, which I foolishly communicated to him after his giving me his word of honor that he would not do so, and now I have *cut him*, and he never will have from me the remaining unpublished Numbers of my work (which, by the bye, he calls a poor thing) and the latter simply because I at last refused to give him my knowledge of the migratory or geographical distribution of our birds. So much for *a Prince*!

Will you not be surprised when I tell you that my last volume of illustrations will contain one hundred and ninety-five species of birds? cutting off all young birds and spurious species; and yet Bonaparte exceeds my lists by upwards of 20 false species—so much for the cabinet man.

Our packets appear to have had very long passages to America, and I am sorry that you all should have abandoned writing by way of New York, which after all is the best way.

You will be surprised when you see the last Numbers of the work at the numbers of Woodpeckers and Owls which we now *must* know to be found in North America, and my opinions are (between

you and I) that the contents of our fauna will not be filled by me by about one good & solid hundred species.

God bless you all—

Your friend J. J. Audubon, 4 Wimpole Street, Cavendish Square

Maria will not be confined until the middle or latter end of July next, if then?

I have thought it proper to write to you crossways, on finding that I have some more to say to you. First, did you receive the birdlime, have you caught any birds with it; and have [you] written to Earl Derby? ... Have you not met with any new Woodpeckers among our small tribes? Depend upon it, both you & I have not been as diligent on this head as we ought to have been ... I have made bold enough to name a new Woodpecker after you; it is another species of Hairy Woodpecker from the Columbia River sent to me by Townsend, and I think you will be quite astonished to see that at this moment no less than 19 species of this interesting tribe are in my published plates. Townsend has sent two new Oyster Catchers, two new Cormorants, a new something which I intend to name in the way of a subgenus allied to *Tringa* [i.e., long-legged waders], a new Burrowing Owl or one described by Temminck and a new species of *Bombycilla* [i.e., a Waxwing], the given name of which is also pointed out by the latter author, &c., &c. Will you believe that since Bonaparte has left London I have drawn one hundred birds; indeed, I feel quite fagged, and now think that I never labored harder than I have done within the last two months.

A long article on general ornithology has been published of late in the *Encyclopedia Britannica*, in which my work is spoken of in most luxuriant words, and some good hints are given to students of zoology generally, though on the whole I look upon the article as far beneath what it ought to have been in such publication. Mr. [John] Gould, the author of the *Birds of Europe*, is about leaving this country for New Holland, or as it is now called, Australia. He takes his wife and bairns with him, a wagon the size of a squatter's cabin and all such apparatus as will encumber him not a little. He has never traveled in the woods, never salted his rump steaks with gunpowder and how he will take to it will be a "sin to Crockett."

Before this reaches you I daresay that you will have received my plates up to 405, wherein you will see some rara avis, but believe me when I tell you that in the 6th concluding Numbers you will be quite surprised at what you will see when you look over these . . .

John Bachman to John James Audubon
"I believe I have now attended to all your commissions..."

Charleston, South Carolina
16 April 1838

My dear Audubon,

A week ago I shipped by the steamboat to New York to go by the packet of today, a barrel containing flamingos. May they go safely, come in time to meet all your wishes and prove satisfactory. I did not open the barrel. It came from Mr. Chartrand, to whom I had written on the subject and who also met your youth somewhere and seems well acquainted with you. The barrel was accompanied with a very friendly letter. He begged me to say that he would write to you, but that no opportunity afforded from Matanzas. The situation of his family was such that he could not go to the breeding places of the birds, but had obtained from one in whom all confidence could be placed the habits of the bird. As the notes appear of some value, confirming what we previously knew with regard to the habits of this singular species, I think you will not grumble at the postage if I enclose them. I expect plenty more of this bird from other persons—these may not come as cheap—for I have offered higher rewards, and expect soon to have more about them than I could wish in prudence. I think you had best write Chartrand a little letter to my care in Charleston as he really was very friendly and sent his own boat and hands to procure the birds—they seem also in excellent spirits. May you find them singing "Yankee Doodle."

I believe I have now attended to all your commissions. What you will do next, I know not. I doubt whether the giving of our quadrupeds would be profitable although it would certainly be serviceable to science...

John James Audubon to Lucy Audubon and Family
"The newborn is just the weight of a Loon..."

Edinburgh, Scotland
5 July 1838

My dearest friend,

Your joint letter of the 3rd Instant has just reached me, and as it announces the arrival in England of our friend John Bachman, I write to you at once with the hope that this may reach you before the leaving of Victor for this place.

Mamma's short letter announcing the safe delivery of our dear daughter Maria reached me in the unaccountable short period of 30 hours! How it came I know not, though it was postmarked at London. I am happy to know that she and little "Lulu" (as John calls the young stranger) are both doing well, and that dearest Mamma is also better from the effects of warm weather which, for a wonder, has wafted its influence as far northward as the quiet city of Edinburgh.

I am now exceedingly anxious to see John Bachman here; he could not be near me for a few weeks to greater advantage than at present, and I hope you all will join in urging his accompanying Victor. Tell him besides that I really and most truly feel extremely desirous to hail his coming to Europe by a most sincerely well-felt shake of the hand!

Mamma's shoemaker is a shabby fellow. I have no faith in him and I would advise her to write to New York, the West Indies or to China for shoes. I have found the Golden Eagle, etc. but not one single "half-eagle" as Victor wittingly says.

The newborn thing must be a considerable size, just the weight of a Loon, and according to John's account almost as greedily inclined, though more anxious for mother's milk than for fish, as I will myself be in a few hours. Has the *Chicora* brought me the guts of some flamingoes? Two sheets of the biography are now finished, and on Saturday I will have another. Mac and I are working like horses. Remembrances to all and ever your most truly attached friend, father, husband and granddad...

Lucy Audubon to Euphemia Gifford
"It is strange how few complete copies there will be..."

Edinburgh, Scotland
29 September 1838

My dear Mrs. Gifford,

I do not like to wait any longer for some account of your health, nor without telling you where we are and what has occurred to us. I wrote you a few lines in July telling you of the birth of our granddaughter, and of she and the mother doing well. I was at that time in very poor health, but the warm weather, with such good medical aid as I have had about that time, was of great service to me, and it was so very disagreeable as well as expensive to us to be part living in London & part in Edinburgh that the moment it was thought safe for me we all removed to this beautiful city. I still find myself mending, though obliged to live very quiet and strictly attend to my physician's orders. Whether I shall be well enough to undertake the voyage to America this year or not is still doubtful, even if the work be done in time and the business closed. But we are all fully sensible of the advantage of our living in the United States as soon as we can, with our limited means. We do not yet know exactly when the letterpress will be out, but the printers are working as fast as they can, and all Mr. A.'s time is fully occupied in correcting the proof sheets. Our sons are occupying themselves in the most advantageous manner they can under the present circumstances of not being permanently settled, & our daughter is quite engaged with her little babe who grows finely and takes up nearly all her time; she is indeed a nice little thing and we all make quite a pet of her. Maria was very much gratified with a visit from her father before we left London (the Rev. Dr. Bachman), who came over in part to renovate his health, and partly to see Europe. He is now about Paris, having been into Germany and Switzerland.

Before we sail for America, I hope we shall be able to show the young people the curiosities and beauty of Derbyshire. I should like very much to peep at the spots of my childhood once more. On Saturday the 15 we all took the steamboat to Sterling and made

a little tour by way of Callendar and Loch Lomond, &c. We returned home the following Friday, having enjoyed ourselves extremely, and having had but one rainy day. You have, I daresay, visited that beautiful journey, and now that the inns and accommodations are so numerous there are no difficulties in the way.

The house we occupy in Edinburgh belongs to a Lady Mary Hay, and is more comfortable than the houses let furnished usually are, we have our own servants, and I hope she will find it in quite as good order when we give it up as when we took it. I understood from the agent Lady Mary was gone for a while to Aylesbury; so that she must be in your neighborhood. I cannot say anything of my Scotch acquaintance not having yet made a visit among them, indeed as I am at present obliged to retire to bed by half past eight or nine at the latest, my few personal habits and hours would agree with me. I hope before long you will write to me. My husband & children all join in best respects to yourself and Mr. Harrison's family. Mr. Audubon says it will not be many months before you have your volume. It is strange rather how few complete copies of the *Birds of America* there will be, everyone believing that afterwards it would be cheaper and already the mistake is beginning to be felt since the copies are all put by—in the application of some for a few extra plates which cannot be had even now.

When we last heard from America the families were all well, and no changes whatever. My Aunt Atterbury looking as well as for these ten years past, and my Uncle Benjamin and family all well. My brothers have had some pecuniary difficulties to contend with, but they have happily none of them had the trials we endured for about 15 years; for the sorrows I have had I am more than recompensed by the continued and unremitting kindness of my own immediate family, who during these (nearly three years) of illness have watched and ministered to my comfort night & day. When these pains and attacks will cease we know not, but as I am better, [I] hope at last to be well . . .

Lucy and John James Audubon to
Victor Gifford Audubon
"Last night the Synopsis *was done!!"*

Postscript
Edinburgh, Scotland
30 June–2 July 1839

My dear Child,

Papa brought from the post office this morning yours by the *Great Western* which, as before, Mr. Phillips franked from London. We see a little depression of spirits as soon as you leave Charleston, but as you say I hope many years yet of happiness is in store for us. All about your Eliza and self as well as much other matters you will find in the folio letter, so I shall at once refer to this one. We could not get berths in the *Liverpool* on application, and again Providence favors us, for if we had succeeded and since got your letter we should have been very uncomfortable, the berths we wrote for in the *Western* are taken and we have made a last effort just now at Glasgow for [cabin] 43 or 44 on deck, every other being taken, and if there are none to be had we have concluded to take the packet of the first or eighth of August from Liverpool or London, whichever we may find most to our liking. You do not say where you write from, only June 7, and we got a letter on the 28th from Miss Martin, same date, in answer to one from 31 Rutland Square. You seem surprised we sent on the young ones, but it was as Mr. Phillips said, high time! She should be stationary and I hope they will get safe over.

My plan, as Papa agrees—of all going to Charleston for the winter to be confined, to be married, to draw and write about quadrupeds and consider where the permanent abode should be—is a good one provided you find a roof to shelter us; however, we leave it in the hands of you all on that side the sea and we shall be content.

On looking over the items you will see what sums the *Birds of America* required and I am sure without that (though we paid by it) you would find our expenditure quite moderate for the number

of us and the comfort we have had. This day we calculate upon the arrival of the *Liverpool* at New York & almost of that of the *Toronto*, for the wind has been East all the month. Last night the *Synopsis* was done!! and in another week we think it will be bound and ready for sale, tomorrow Papa is beginning to pack up and we shall go to Liverpool as soon as we can. If we sail in a packet we shall have all our goods and chattels along with us, if not do take care of my big trunk, &c., which will be shipped per packet. However, as all these plans may not occur, look at the *British Queen* and make report. I wish the prints for Mr. Naysmith were here, but Papa will call on him before I go to have my tooth out.

July 2. Dear Children, we have just heard from the agents that there are no staterooms in the *Great Western* except in the fore cabin, which we decline, and will come to you in a packet either of the first or eighth of August, and a disagreeable anticipation it is to me but perhaps for the best; at any rate it must be, and I give myself up to Providence. The Miss Mitchell you may have seen at Neill's is going to set up a school somewhere in America. She asked for a letter to you to aid them in landing, &c., and I have given them one. I must stop for Papa to write, therefore God bless you all and manage the best you can till we meet. Papa thinks I am very well but I am as weak as a cat and good for nothing.

Ever your devoted Mother, Lucy Audubon.

Where are the shirts for Naysmith?

My dear Children. Mamma, who is simply low-spirited just now, has told you everything except business . . . The *Synopsis* is finished in 300 pages and at the binders . . . We will leave this on the 10th or 11th Instant . . .

John Bachman to John James Audubon
"I congratulate you on your safe arrival…"

Charleston, South Carolina
13 September 1839

Dear Audubon,

Yours of the 8th Instant was this moment received, and as I have an hour of leisure before I go out to dine with Friend Bickley, I do not know that I can spend my time better than by holding a little communion with you.

Imprimus I congratulate you on your & Mrs. Audubon's safe arrival in spite of storms, calms & hurricanes. But after this, don't speak of the tardy progress of Charleston packets. I beat you both ways & had pleasant passages withal. The voyage from England to America along the northern coast is seldom so pleasant & never much shorter than the Southern course, especially in winter. We sailed down to Latitude 20 & then took the trade winds & it reminded me of sailing in a mill pond, so smooth was the water. I am sorry to hear that you have not been quite well, but you must remember that you are now getting to be an old boy & the time for aches and pains has come. Let us both agree not to complain and to keep well.

With regard to the exhibition of your paintings, I am quite sure it will prove a good speculation, provided also that you are quite sure of your man. It is both a great risk & responsibility you are to depend entirely on the character of the gentleman & there seem to be no checks—suspicions may arise & perhaps bad feelings. Still, I do not know that you can do anything better. Victor's department will no doubt be well-managed.

I am glad you are about to do something in regard to your small edition of the *Birds* …

But are you not a little fast in issuing your prospectus in regard to the birds & quadrupeds without having a Number of the works by which the public could judge of their merits? My idea was in regard to the latter, that you would carefully get up in their best style a volume about the size of Holbrook's *Reptiles*; this would

enable you to decide on the terms of the book & be an attraction to subscribers. The great object should be to obtain a large subscription at once. With proper management I think two thousand subscribers at $100 each might be obtained. But it must be no halfway affair. The animals are not numerous but they have never been carefully described, & you will find difficulty at every step. The books cannot aid you much. Long journeys will have to be undertaken—several species remain to be added—their habits ascertained. The drawings can be easily made if you can get the specimens. What have you done in England with the rare American species? I wish I had you here for only two days. I think I have studied the subject more than you have. You will be bothered with the wolves & foxes. To begin with, I have two species of rats & shrews & [illegible] to add. The western deer are no joke and the ever-varying squirrels were sent I fear by the old boy himself to puzzle the naturalists. I have arranged them in my own mind, but in some particulars I may yet be wrong. You must look more carefully at the teeth & you will find that F. Cuvier, the best writer on this subject, is not always right. Say in what manner I can assist you.

My own health has greatly improved. The family are all well. It will be a terrible disappointment if Maria & John do not come to Charleston this winter. But my paper is full. Kind regards to John, Maria, Victor & Mrs. Audubon. I am told little Lucy has a will of her own. She must have inherited it from the John Bull & Johnny Crapeau mixture—not from the Germans. It is a pity that the grumbling Englishman & the excitable Frenchman should spoil the blood of so many good children . . .

The fever has nearly disappeared . . .

Eliza Bachman Audubon to Mrs. I. M. Davis
"The poor girl has suffered severely..."

Maria and Eliza Bachman were consumptives, victims of the chronic illness now known as tuberculosis, which they probably contracted from their father. In November 1839, Eliza's dormant disease reactivated and she hemorrhaged, coughing up bright red blood. Victor Audubon, who had been courting her, rushed to her side in Charleston, and as soon as she recovered they were married and sailed for New York. In the meantime, Maria, John Woodhouse's wife, also became ill in the wake of the birth of her second child, Harriet. The illness took the form initially of sores in her mouth that refused to heal and made it difficult for her to eat. Lucy Audubon cared for her two grandchildren that winter while Eliza nursed her older sister.

New York, New York
21 January 1840

My dear Grandmother,

At last I have a few leisure moments to spare and I feel that they cannot be employed more agreeably than in writing you your long promised letter. I daresay you thought me negligent and have often fancied that my old friends have been thrown aside by the acquisition of new ones, but could you see me, dearest Grandmother, and enter into my thoughts, you would soon discover that new scenes and new faces have only served to endear to me my absent friends.

By this time you will be aware of the indisposition of dear Ria [i.e., Maria], and this, I'm sure, will be a sufficient excuse for me. Mamma's time has been so fully occupied in taking care of the little ones and in preparing delicacies to tempt the appetite of the invalid that my time has been fully taken up in keeping dear Ria company and trying to raise her spirits. The poor girl has suffered severely from a sore mouth and a general weakness, which rendered us all for a few days quite anxious about her, but she has had such kind attendance and so skillful a physician that she is now in a fair way of recovering, this morning we took a ride through the city together, which seemed to refresh her very much

and this evening she is downstairs, eating her bread and milk on the sofa. The weather, I hope, will soon moderate and we will then be able to take some delightful walks together. I find by the letters from home that the weather there has been extremely cold, here it has been very severe and I think had dear Mother and Aunt and poor Amelia been transported here, they would certainly have been frozen. Nothing but warm clothing and great care in venturing out of the house has prevented me from suffering severely.

We were all invited a few evenings ago to a great ball at Mr. DeRham's, and Mr. A. and myself had determined upon going, but towards evening the weather became so uncomfortably cold that we thought it more prudent to stay at home and enjoy the comfortable fire instead of eating cold ice creams and seeing strange faces. We went today to pay our respects to them and to our great delight had the pleasure of leaving our cards.

Papa and my dear husband are compelled on account of business to leave us tomorrow for Philadelphia, and I suppose you may imagine how reluctant I am to part with the latter for the first time, although he will only be absent for a few days. I expect the time will pass heavily enough, for each day only serves to endear him more to me—but I suppose you will all laugh at my simplicity in supposing that you are not aware of this fact.

Mamma begs me to return her thanks to you for the beautiful cup and the nice shrimps which you sent her and for the sweet potatoes; I must really say they were a treat, we all enjoyed them very much and thought of you while eating them. On Sunday, dear Grandmother, I often think of the happy group at your own hospitable table and could I fly, would be with you pretty frequently. Tell dear Mother we are looking anxiously for the arrival of the cake which I wrote for; tell her that it may be prejudice, but that the New York cake makers are not to be compared to those of poor humble Charleston...

John James Audubon to Maria Martin
"I regret that I have not yet danced in America..."

Baltimore, Maryland
29 February 1840

My dear good friend,

Although you will, ere now, have heard much of all that concerns me and my doings through the medium of dearest Maria and Johnny, whose safe arrivals at your house reached me by letter from home; I feel irresistibly inclined to address a letter to yourself, which I know will be the better welcome because of the good fortune of your admiring servant and sincerely attached friend since his arrival in the "blessed monumental city."

Only think that in the course of a short fortnight, the citizens of Baltimore have so contributed to the publication of the Small Edition of the *Birds of America* as to have presented the American Woodsman with no less than one hundred and fifty-three names!! Unexpected as this success has been, I can even now scarcely believe the truth of this fact; and every one of these good people say to me, proceed onward and do likewise in every city of the Union. But sanguine as I have always been since the beginning of my career as a student of Nature's work, I can scarcely expect to meet another Baltimore in this respect!

Victor forwarded me last evening the list of names procured at Charleston, and as in terms of old, "it is pretty fair" and I trust that it will [be] still more so as soon as my old phiz [i.e., face] appears through the streets of hospitable Charleston, where I hope to be bye & bye! Do you not think my little Lucy a sweet, interesting child and somewhat superior to most children of her age? To me she is everything at present, but when little Harriet [John and Maria's second child] can be handled without fears and caressed with equal fondness, it will be difficult for me to say whom I will love best. You, my dear friend, cannot imagine how desirous I feel to see some *grandsons*; perhaps you will call it vanity in me to say that I have a great desire that the name of Audubon should be

handed to posterity, but as that is absolutely my present feeling, I say so to you in confidence!

Since I have been here, I have seen a good deal of company and that of the best kind. I have dined out and spent some evenings likewise among the elite of Baltimore, and proud do I feel myself able to say, that in every instance the gentleness of those of your sex and the nobility of the feelings of those who all adore the ladies has filled my heart with delight. One thing only I regret, and that is, that I have not yet *danced* in America, since I first visited Europe. Perchance when at Charleston, you will have the goodness to assist me in that pleasure.

Our dear friends at New York were all well two days ago, and I hope to hear from them again this afternoon; and now that the mail is about to close, I must close my short talk to you, and ask you as a finale to give my love to all under your roof and to those who are our mutual friends...

John Bachman and John James Audubon to Victor Gifford Audubon
"My last week here has been one of deep sorrow..."

By May, Maria was mortally ill; stomach pains had given way to diarrhea and she was starving to death. Bachman and Audubon both wrote Victor in despair.

Charleston, South Carolina
10 May 1840

Dear Victor,

I am very sorry to say that I have nothing favorable to give you in poor Maria's case—no abatement of her disorder. Indeed, as you may well suppose, her constant operations [i.e., bowel movements] render her weaker every day. I saw her a few moments ago & think her more feeble than yesterday. The physicians fear that there are ulcerations along the whole line of the intestinal canal & leave us nothing to hope for but the interposition of Providence on her behalf. We have had many trials of late, but none equal to this. I have had philosophy & I hoped religion to stay me under other calamities, but now I am bewildered & unhappy. I hope dear Eliza will be fortified to bear up under this visitation—we must look to a higher power for support under the directions of His wisdom...

Our family is even better than could be expected under present circumstances...[J.B.]

My dearest friends,

John Bachman has told you all that can be said respecting our beloved Maria's situation, and I assure you as he does himself that my last week here has been one of deep sorrow. I go to town and return without scarcely seeing or caring about anyone, and when I return home it is only to augment the pains of my poor heart.

Johnny is, thank God, quite well, though much fatigued by his constant attention on Maria. I am quite well also, but wish now that I had not come south this year. But who, alas, can foresee or

568

foretell the future? I was much grieved at not hearing from you all this morning. I hope that you are all quite well but should like to see you say so. Do write oftener, I beseech you. A few days more I fear I will have to send you disagreeable news, and yet I hope in God that he may spare our Maria. I would give much to be with you all, if only for an hour.

God bless you all; take care of dearest Mamma and Eliza and the babe and believe forever your affectionate friend... [J.J.A.]

Audubon had begun drinking in the morning to numb his despair; early in June he and Bachman fought and the two friends separated, Audubon working his way north into New England selling subscriptions to the "little book," the Octavo edition of The Birds of America. *Maria died on September 15, 1840, leaving two little girls whom the families would love and Lucy Audubon would raise. Eventually, Audubon and Bachman repaired their professional relationship, but the artist never set foot in Bachman's house again.*

John James Audubon to Daniel Webster
"If our government would establish a natural history institution..."

New York, New York
8 September 1841

My dear friend,

Your honored letter of the 31st reached me last week, and I feel truly grateful to you for your kindness to me.

I am sorry the present condition of the finances of the National Institute at Washington are such as to preclude my having a salary in my old age from that quarter.

In your kind letter I see that you allude to a situation perhaps immediately under your own eye & care. This I should certainly prefer to any other situation in public life, but I fear anything but natural history, in which I am an authority, would be hard for me to attend to. But if any thing in that way is to be done—for instance if the natural history connected with the Exploring Expedition is to be published—I should be delighted to superintend it, and would draw from the specimens, and prepare them, and see to the getting up of the whole work, or such part of it as would be more immediately essential natural history.

I should expect to be paid a good salary for this annual task, but would be better pleased if our government would establish a natural history institution to advance our knowledge of natural science, and place me at the head of it, when I flatter myself I could serve the interests of such an institution as well as anyone, and certainly with equal zeal would devote my energies to that purpose.

It would give me great pleasure to hear from you on this subject when your leisure will permit, and I need hardly say how much obliged to you I shall be if you can give me your advice as well as influence in case anything can be done for me. As to salary, I should like either a fair compensation annually (or if I am to supervise the production of a work, for only a few years) a reasonable price for my labor, and I believe few men can be found more industrious and, may I say it, able, than myself...

Audubon's Progress: Three Letters from
Will Bakewell

To collect specimens for the illustrated work on American mammals that he, his sons and John Bachman were preparing, and to see something of the trans-Mississippi West, Audubon arranged to steam up the Missouri River on the American Fur Company steamboat, the Omega, *during the spring and summer of 1843. He planned to summer at Fort Union, at the Missouri's junction with the Yellowstone in what is now far northwestern North Dakota. In these three letter extracts, the artist's brother-in-law Will Bakewell records his passage towards St. Louis, from which the* Omega *would depart when the ice broke up on the Missouri.*

William G. Bakewell to Victor Gifford Audubon
Louisville, Kentucky
30 January 1843

I have just returned from Henderson. It made me melancholy to think of the happy days I spent there & to see the old house ready to fall down & all the fences gone. The source of all your father's troubles there (the mill) still stands & is used as a tobacco [store house]... Game is almost as scarce there as here and now the Long Pond (where your father & I have had so much enjoyment), instead of being full of geese, ducks, &c., &c., & surrounded by a grand & solitary forest of largest hickory, pecan & cypress trees & evergreen canebrakes, is in the midst of log cabins...

William G. Bakewell to John James Audubon
Louisville, Kentucky
25 February 1843

Dear Audubon

I have your kind letter of the 17th & nothing would afford me more pleasure than to accompany you to the Yellowstone, it would be an advantage to my health & as I can *come close to the center* at 100 yards with my big rifle, I could make myself useful & I fear

I'll never have such a chance again, but unfortunately the state of my affairs is such that it would be like *running off* to leave them, to say nothing of the absolute necessity of making the best of *matters as they are* & trying to get some way of making a living. If John does not go with you he ought to be *shot with hot mush*, as he used to say. I hope at all events you will find some clever thoroughgoing fellows to go with you who know something about what they are undertaking & who are good hunters, able to bring in fresh meat & do not expect featherbeds to sleep on. Some might be found in the West. Those you find East are all *shotgunned* and mad woodsmen, so that if they are not too timid to venture, there will be *more bother finding them* than finding the game or specimens you are in pursuit of. I will be most happy to see you on your way out & as the Ohio is & will continue in fine order you may calculate on coming from Wheeling to this place in $2^{1}/_{2}$ or 3 days & hence to St. Louis in 3 or $3^{1}/_{2}$. Boats are going nearly every day & I may go as far as St. Louis with you...

William G. Bakewell to Victor Gifford Audubon
Louisville, Kentucky
24 March 1843

Dear Victor

Your father, after spending a day or two with us, attending parties at Mr. Hale's and Mr. Fellow's, *out dancing the whole of us & keeping all the ladies* in the range of his acquaintance, left yesterday on the steamboat *Gallant* for St. Louis with Mr. [Edward] Harris, [taxidermist John G.] Bell, [background artist Isaac] Sprague & [secretary Lewis] Squires & I hope will have a pleasant trip, although no doubt he will be detained by ice in the Mississippi, the weather having turned very cold. In fact no one ever saw the like at this time of the year. The ink is frozen & my hands are in nearly the same fix & the river at this place full of floating ice. I presume it cannot last much longer, we are sick & tired of winter & it is very likely we will be launched into summer very suddenly. I think it will be impossible for your father to leave St. Louis for two or three weeks... I was surprised to find your father going without rifles, as shotguns are comparatively good for nothing in

such a country, particularly for killing *large wild animals*. I sold him my large rifle for $30 & will venture to say if placed in the hands of anyone that knows how to handle it, it will kill *more animals* from the size of a wolf up than all their shotguns put together, besides the chance of killing something out of a flock 400 yards off...

The American Bison

Between 1846 and 1854 the Audubons and John Bachman published
The Viviparous Quadrupeds of North America, *attempting to
offer as complete a catalog of land mammals as Audubon had
previously offered of birds. Bachman did most of the writing of the*
Quadrupeds, *but several of the descriptions are clearly the work of
Audubon himself—including these observations on the buffalo that
still roamed the Upper Midwest and Far West in numbers estimated
to range as high as 50 million, the most numerous of all American
grazing animals. By 1874 they had been nearly exterminated, as
Bachman and Audubon here predict.*

Whether we consider this noble animal as an object of the chase
or as an article of food for man, it is decidedly the most important
of all our contemporary American quadrupeds; and as we can no
longer see the gigantic mastodon passing over the broad savannas
or laving his enormous sides in the deep rivers of our widespread
land, we will consider the buffalo as a link (perhaps sooner to be
forever lost than is generally supposed) which to a slight degree
yet connects us with larger American animals belonging to extinct
creations.

But ere we endeavor to place before you the living and breathing
herds of buffaloes, you must journey with us in imagination to the
vast western prairies, the secluded and almost inaccessible valleys
of the Rocky Mountain chain and the arid and nearly impassable
deserts of the western table lands of our country; and here we may
be allowed to express our deep, though unavailing, regret that the
world now contains only few and imperfect remains of the lost
races of which we have our sole knowledge through the researches
and profound deductions of geologists; and even though our know-
ledge of the osteology of the more recently exterminated species
be sufficient to place them before our "mind's eye," we have no
description and no figures of the once living and moving but now
departed possessors of these woods, plains, mountains and waters
in which, ages ago, they are supposed to have dwelt. Let us however
hope that our humble efforts may at least enable us to perpetuate
a knowledge of such species as the Giver of all good has allowed

to remain with us to the present day. And now we will endeavor to give a good account of the majestic bison.

In the days of our boyhood and youth, buffaloes roamed over the small and beautiful prairies of Indiana and Illinois and herds of them stalked through the open woods of Kentucky and Tennessee; but they had dwindled down to a few stragglers which resorted chiefly to the Barrens towards the years 1808 and 1809, and soon after entirely disappeared. Their range has since that period gradually tended westward, and now you must direct your steps "to the Indian country" and travel many hundred miles beyond the fair valleys of the Ohio towards the great rocky chain of mountains which forms the backbone of North America, before you can reach the buffalo and see him roving in his sturdy independence upon the vast elevated plains which extend to the base of the Rocky Mountains.

Hie with us then to the West! Let us quit the busy streets of St. Louis, once considered the outpost of civilization but now a flourishing city in the midst of a fertile and rapidly growing country with towns and villages scattered for hundreds of miles beyond it; let us leave the busy haunts of men, and on good horses take the course that will lead us into the buffalo region, and when we have arrived at the sterile and extended plains which we desire to reach we shall be recompensed for our toilsome and tedious journey: for there we may find thousands of these noble animals and be enabled to study their habits as they graze and ramble over the prairies or migrate from one range of country to another, crossing on their route watercourses or swimming rivers at places where they often plunge from the muddy bank into the stream to gain a sandbar or shoal midway in the river that affords them a resting place from which, after a little time, they can direct their course to the opposite shore when, having reached it, they must scramble up the bank ere they can gain the open prairie beyond.

There we may also witness severe combats between the valiant bulls in the rutting season, hear their angry bellowing and observe their sagacity as well as courage when disturbed by the approach of man.

The American bison is much addicted to wandering, and the various herds annually remove from the North at the approach of

winter, although many may be found during that season remaining in high latitudes, their thick, woolly coats enabling them to resist a low temperature without suffering greatly. During a severe winter, however, numbers of them perish, especially the old and the very young ones. The breeding season is generally the months of June and July, and the calves are brought forth in April and May, although occasionally they are produced as early as March or as late as July. The buffalo most frequently has but one calf at a time, but instances occur of their having two. The females usually retire from the herd either singly or several in company, select as solitary a spot as can be found, remote from the haunt of wolves, bears or other enemies that would be most likely to molest them and there produce their young.

Occasionally, however, they bring forth their offspring when the herd is migrating, and at such times they are left by the main body, which they rejoin as soon as possible. The young usually follow the mother until she is nearly ready to have a calf again. The buffalo seldom produces young until the third year but will continue breeding until very old. When a cow and her very young calf are attacked by wolves, the cow bellows and sometimes runs at the enemy and not unfrequently frightens him away; this, however, is more generally the case when several cows are together, as the wolf, ever on the watch, is sometimes able to secure a calf when it is only protected by its mother.

The buffalo begins to shed its hair as early as February. This falling of the winter coat shows first between the forelegs and around the udder in the female on the inner surface of the thighs, &c. Next the entire pelage of long hairs drop gradually but irregularly, leaving almost naked patches in some places, whilst other portions are covered with loosely hanging wool and hair.

At this period these animals have an extremely ragged and miserable appearance. The last part of the shedding process takes place on the hump. During the time of shedding the bison searches for trees, bushes, &c. against which to rub himself and thereby facilitate the speedy falling off of his old hair. It is not until the end of September or later that he gains his new coat of hair. The skin of a buffalo killed in October, the hunters generally consider, makes a good buffalo robe; and who is there that has driven in an open

sleigh or wagon that will not be ready to admit this covering to be the cheapest and the best as a protection from the cold, rain, sleet and the drifting snows of winter? for it is not only a warm covering, but impervious to water.

The bison bulls generally select a mate from among a herd of cows and do not leave their chosen one until she is about to calve.

When two or more males fancy the same female, furious battles ensue and the conqueror leads off the fair cause of the contest in triumph. Should the cow be alone the defeated lovers follow the happy pair at such a respectful distance as will ensure to them a chance to make their escape if they should again become obnoxious to the victor, and at the same time enable them to take advantage of any accident that might happen in their favor. But should the fight have been caused by a female who is in a large herd of cows, the discomfited bull soon finds a substitute for his first passion. It frequently happens that a bull leads off a cow and remains with her separated during the season from all others, either male or female.

When the buffalo bull is working himself up to a belligerent state he paws the ground, bellows loudly and goes through nearly all the actions we may see performed by the domesticated bull under similar circumstances, and finally rushes at his foe head foremost with all his speed and strength. Notwithstanding the violent shock with which two bulls thus meet in mad career, these encounters have never been known to result fatally, probably owing to the strength of the spinous process commonly called the hump, the shortness of their horns and the quantity of hair about all their foreparts.

When congregated together in fair weather, calm or nearly so, the bellowing of a large herd (which sometimes contains a thousand) may be heard at the extraordinary distance of ten miles at least.

During the rutting season or while fighting (we are not sure which), the bulls scrape or paw up the grass in a circle sometimes ten feet in diameter, and these places being resorted to from time to time by other fighting bulls become larger and deeper and are easily recognized even after rains have filled them with water.

In winter, when the ice has become strong enough to bear the

weight of many tons, buffaloes are often drowned in great numbers, for they are in the habit of crossing rivers on the ice, and should any alarm occur, rush in a dense crowd to one place; the ice gives way beneath the pressure of hundreds of these huge animals, they are precipitated into the water, and if it is deep enough to reach over their backs, soon perish. Should the water, however, be shallow, they scuffle through the broken and breaking ice in the greatest disorder to the shore.

From time to time small herds crossing rivers on the ice in the spring are set adrift in consequence of the sudden breaking of the ice after a rise in the river. They have been seen floating on such occasions in groups of three, four and sometimes eight or ten together, although on separate cakes of ice. A few stragglers have been known to reach the shore in an almost exhausted state, but the majority perish from cold and want of food rather than trust themselves boldly to the turbulent waters.

Buffalo calves are often drowned from being unable to ascend the steep banks of the rivers across which they have just swam, as the cows cannot help them, although they stand near the bank and will not leave them to their fate unless something alarms them.

On one occasion Mr. Kipp of the American Fur Company caught eleven calves, their dams all the time standing near the top of the bank. Frequently, however, the cows leave the young to their fate, when most of them perish. In connection with this part of the subject we may add that we were informed when on the Upper Missouri River that when the banks of that river were practicable for cows, and their calves could not follow them, they went down again after having gained the top and would remain by them until forced away by the cravings of hunger. When thus forced by the necessity of saving themselves to quit their young they seldom, if ever, returned to them.

When a large herd of these wild animals are crossing a river, the calves or yearlings manage to get on the backs of the cows and are thus conveyed safely over; but when the heavy animals, old and young, reach the shore, they sometimes find it muddy or even deeply miry; the strength of the old ones struggling in such cases to gain a solid footing enables them to work their way out of danger in a wonderfully short time. Old bulls, indeed, have been

known to extricate themselves when they had got into the mire so deep that but little more than their heads and backs could be seen. On one occasion we saw an unfortunate cow that had fallen into, or rather sank into a quicksand only seven or eight feet wide; she was quite dead and we walked on her still-fresh carcass safely across the ravine which had buried her in its treacherous and shifting sands.

The gaits of the bison are walking, cantering and galloping, and when at full speed he can get over the ground nearly as fast as the best horses found in the Indian country. In lying down, this species bends the forelegs first, and its movements are almost exactly the same as those of the common cow. It also rises with the same kind of action as cattle.

When surprised in a recumbent posture by the sudden approach of a hunter who has succeeded in nearing it under the cover of a hill, clump of trees or other interposing object, the bison springs from the ground and is in full race almost as quick as thought, and is so very alert that one can scarcely perceive his manner of rising on such occasions.

The bulls never grow as fat as the cows, the latter having been occasionally killed with as much as two inches of fat on the boss or hump and along the back to the tail. The fat rarely exceeds half an inch on the sides or ribs but is thicker on the belly. The males have only one inch of fat and their flesh is never considered equal to that of the females in delicacy or flavor. In a herd of buffaloes many are poor, and even at the best season it is not likely that all will be found in good condition; and we have occasionally known a hunting party when buffalo was scarce compelled to feed on a straggling old bull as tough as leather. For ourselves this was rather uncomfortable, as we had unfortunately lost our molars long ago.

The bison is sometimes more abundant in particular districts one year than another and is probably influenced in its wanderings by the mildness or severity of the weather as well as by the choice it makes of the best pasturage and most quiet portions of the prairies. While we were at Fort Union the hunters were during the month of June obliged to go out twenty-five or thirty miles to procure buffalo meat, although at other times the animal was quite abundant in sight of the fort. The tramping of a large herd in wet

weather cuts up the soft clayey soil of the river bottoms (we do not mean the bottom of rivers) into a complete mush. One day when on our journey up the Missouri River we landed on one of the narrow strips of land called bottoms which formed the margin of the river and was backed by hills of considerable height at a short distance. At this spot the tracks of these animals were literally innumerable; as far as the eye could reach in every direction the plain was covered with them; and in some places the soil had been so trampled as to resemble mud or clay when prepared for making bricks. The trees in the vicinity were rubbed by these buffaloes, and their hair and wool were hanging on the rough bark or lying at their roots. We collected some of this wool; we think it might be usefully worked up into coarse cloth and consider it worth attention. The roads that are made by these animals so much resemble the tracks left by a large wagon train that the inexperienced traveler may occasionally imagine himself following the course of an ordinary wagon road. These great tracks run for hundreds of miles across the prairies and are usually found to lead to some salt spring or some river or creek where the animals can allay their thirst.

The captain of the steamboat on which we ascended the Missouri informed us that on his last annual voyage up that river he had caught several buffaloes that were swimming the river. The boat was run close upon them, they were lassoed by a Spaniard who happened to be on board and then hoisted on the deck, where they [were] butchered... One day we saw several that had taken to the water and were coming towards our boat. We passed so near them that we fired at them but did not procure a single one. On another occasion one was killed from the shore and brought on board, when it was immediately divided among the men. We were greatly surprised to see some of the Indians that were going up with us ask for certain portions of the entrails, which they devoured with the greatest voracity. This gluttony excited our curiosity, and being always willing to ascertain the quality of any sort of meat, we tasted some of this sort of tripe and found it very good, although at first its appearance was rather revolting.

The Indians sometimes eat the carcasses of buffaloes that have been drowned, and some of those on board the *Omega* one day

asked the captain most earnestly to allow them to land and get at the bodies of three buffaloes which we passed that had lodged among the drift logs and were probably half putrid. In this extraordinary request some of the squaws joined. That when stimulated by the gnawings of hunger, Indians or even Whites should feed upon carrion is not to be wondered at, since we have many instances of cannibalism and other horrors when men are in a state of starvation, but these Indians were in the midst of plenty of wholesome food and we are inclined to think their hankering after this disgusting flesh must be attributed to a natural taste for it, probably acquired when young, as they are no doubt sometimes obliged in their wanderings over the prairies in winter to devour carrion and even bones and hides to preserve their lives. In the height of the rutting season, the flesh of the buffalo bull is quite rank and unfit to be eaten except from necessity, and at this time the animal can be scented at a considerable distance.

When a herd of bisons is chased, although the bulls run with great swiftness their speed cannot be compared with that of the cows and yearling calves. These in a few moments leave the bulls behind them, but as they are greatly preferred by the hunter, he always (if well mounted) pursues them and allows the bulls to escape. During the winter of 1842 and '43 as we were told, buffaloes were abundant around Fort Union and during the night picked up straggling handfuls of hay that happened to be scattered about the place. An attempt was made to secure some of them alive by strewing hay as a bait from the interior of the old fort, which is about two hundred yards off, to some distance from the gateway, hoping the animals would feed along into the enclosure. They ate the hay to the very gate: but as the hogs and common cattle were regularly placed there for security during the night, the buffaloes would not enter, probably on account of the various odors issuing from the interior. As the buffaloes generally found some hay scattered around, they soon became accustomed to sleep in the vicinity of the fort, but went off every morning and disappeared behind the hills about a mile off.

One night they were fired at from a four-pounder loaded with musket balls. Three were killed and several were wounded, but this disaster did not prevent them from returning frequently to the fort

at night, and they were occasionally shot during the whole winter quite near the fort.

As various accounts of buffalo hunts have been already written, we will pass over our earliest adventures in that way, which occurred many years ago, and give you merely a sketch of the mode in which we killed them during our journey to the West in 1843.

One morning in July our party and several persons attached to Fort Union (for we were then located there) crossed the river, landed opposite the fort and passing through the rich alluvial belt of woodland which margins the river were early on our way to the adjacent prairie beyond the hills. Our equipment consisted of an old Jersey wagon to which we had two horses attached, tandem, driven by Mr. Culbertson, principal at the fort. This wagon carried Mr. Harris, Bell and ourselves and we were followed by two carts which contained the rest of the party, while behind came the running horses or hunters led carefully along. After crossing the lower prairie we ascended between the steep banks of the rugged ravines until we reached the high undulating plains above. On turning to take a retrospective view we beheld the fort and a considerable expanse of broken and prairie land behind us, and the course of the river was seen as it wound along for some distance. Resuming our advance we soon saw a number of antelopes, some of which had young ones with them. After traveling about ten miles farther we approached the Fox River, and at this point one of the party espied a small herd of bisons at a considerable distance off. Mr. Culbertson, after searching for them with the telescope, handed it to us and showed us where they were. They were all lying down and appeared perfectly unconscious of the existence of our party. Our vehicles and horses were now turned towards them and we traveled cautiously to within about a quarter of a mile of the herd, covered by a high ridge of land which concealed us from their view. The wind was favorable (blowing towards us) and now the hunters threw aside their coats, tied handkerchiefs around their heads, looked to their guns, mounted their steeds and moved slowly and cautiously towards the game. The rest of the party crawled carefully to the top of the ridge to see the chase. At the word of command given by Mr. Culbertson the hunters dashed forward after the bulls, which already began to run off in a line nearly parallel with

the ridge we were upon. The swift horses, urged on by their eager riders and their own impetuosity, soon began to overtake the affrighted animals; two of them separated from the others and were pursued by Mr. Culbertson and Mr. Bell; presently the former fired and we could see that he had wounded one of the bulls. It stopped after going a little way and stood with its head hanging down and its nose near the ground. The blood appeared to be pouring from its mouth and nostrils and its drooping tail showed the agony of the poor beast. Yet it stood firm and its sturdy legs upheld its ponderous body as if naught had happened. We hastened towards it but ere we approached the spot the wounded animal fell, rolled on its side and expired. It was quite dead when we reached it. In the meantime Mr. Bell had continued in hot haste after the other, and Mr. Harris and Mr. Squires had each selected and were following one of the main party. Mr. Bell shot and his ball took effect in the buttocks of the animal. At this moment Mr. Squires' horse threw him over his head fully ten feet: he fell on his powder horn and was severely bruised; he called to some one to stop his horse and was soon on his legs, but felt sick for a few moments. Friend Harris, who was perfectly cool, neared his bull, shot it through the lungs and it fell dead on the spot. Mr. Bell was still in pursuit of his wounded animal and Mr. Harris and Mr. Squires joined and followed the fourth which, however, was soon out of sight. We saw Mr. Bell shoot two or three times and heard guns fired either by Mr. Harris or Mr. Squires, but the weather was so hot that, fearful of injuring their horses, they were obliged to allow the bull they pursued to escape. The one shot by Mr. Bell tumbled upon his knees, got up again and rushed on one of the hunters, who shot it once more, when it paused and almost immediately fell dead.

The flesh of the buffaloes thus killed was sent to the fort in the cart and we continued our route and passed the night on the prairie at a spot about halfway between the Yellowstone and the Missouri Rivers. Here just before sundown seven more bulls were discovered by the hunters, and Mr. Harris, Mr. Bell and Mr. Culbertson each killed one. In this part of the prairie we observed several burrows made by the swift fox but could not see any of those animals although we watched for some time in hopes of doing so. They

probably scented our party and would not approach. The hunters on the prairies, either from hunger or because they have not a very delicate appetite, sometimes break in the skull of a buffalo and eat the brains raw. At sunrise we were all up and soon had our coffee, after which a mulatto man called LaFleur, an excellent hunter attached to the American Fur Company, accompanied Mr. Harris and Mr. Bell on a hunt for antelopes, as we wanted no more buffaloes. After waiting the return of the party, who came back unsuccessful, we broke up our camp and turned our steps homeward.

The buffalo bulls which have been with their fair ones are at this season wretchedly poor, but some of them, which appear not to have much fondness for the latter, or may have been driven off by their rivals, are in pretty good condition. The prairies are in some places whitened with the skulls of the buffalo, dried and bleached by the summer's sun and the frosts and snows of those severe latitudes in winter. Thousands are killed merely for their tongues, and their large carcasses remain to feed the wolves and other rapacious prowlers on the grassy wastes.

A large bison bull will generally weigh nearly two thousand pounds and a fat cow about twelve hundred. We weighed one of the bulls killed by our party and found it to reach 1,727 pounds, although it had already lost a good deal of blood. This was an old bull and was not fat; it had probably weighed more at some previous period. We were told that at this season a great many half-breed Indians were engaged in killing buffaloes and curing their flesh for winter use, on Moose River about 200 miles north of us.

When these animals are shot at a distance of fifty or sixty yards they rarely if ever charge on the hunters. Mr. Culbertson told us he had killed as many as nine bulls from the same spot unseen by these terrible animals. There are times, however, when they have been known to gore both horse and rider after being severely wounded and have dropped down dead but a few minutes afterwards. There are indeed instances of bulls receiving many balls without being immediately killed, and we saw one which during one of our hunts was shot no less than twenty-four times before it dropped.

A bull that our party had wounded in the shoulder and which was thought too badly hurt to do much harm to anyone was found

rather dangerous when we approached him, as he would dart forward at the nearest of his foes, and but that his wound prevented him from wheeling and turning rapidly he would certainly have done some mischief. We fired at him from our six-barreled revolving pistol which, however, seemed to have little other effect than to render him more savage and furious. His appearance was well calculated to appall the bravest had we not felt assured that his strength was fast diminishing. We ourselves were a little too confident and narrowly escaped being overtaken by him through our imprudence. We placed ourselves directly in his front and as he advanced fired at his head and ran back, not supposing that he could overtake us; but he soon got within a few feet of our rear with head lowered and every preparation made for giving us a hoist; the next instant, however, we had jumped aside, and the animal was unable to alter his headlong course quick enough to avenge himself on us. Mr. Bell now put a ball directly through his lungs, and with a gush of blood from the mouth and nostrils, he fell upon his knees and gave up the ghost, falling (as usual) on the side, quite dead.

On another occasion when the same party were hunting near the end of the month of July, Mr. Squires wounded a bull twice, but no blood flowing from the mouth, it was concluded the wounds were only in the flesh and the animal was shot by Mr. Culbertson, Owen McKenzie and Mr. Squires again. This renewed fire only seemed to enrage him the more and he made a dash at the hunters so sudden and unexpected that Mr. Squires, attempting to escape, rode between the beast and a ravine which was near, when the bull turned upon him, his horse became frightened and leaped down the bank, the buffalo following him so closely that he was nearly unhorsed; he lost his presence of mind and dropped his gun; he, however, fortunately hung on by the mane and recovered his seat. The horse was the fleetest and saved his life. He told us subsequently that he had never been so terrified before. This bull was fired at several times after Squires' adventure, and was found to have twelve balls lodged in him when he was killed. He was in very bad condition, and being in the rutting season we found the flesh too rank for our dainty palates and only took the tongue with us.

Soon afterwards we killed a cow in company with many bulls

and were at first afraid that they would charge upon us, which in similar cases they frequently do, but our party was too large and they did not venture near, although their angry bellowings and their unwillingness to leave the spot showed their rage at parting with her. As the sun was now sinking fast towards the horizon on the extended prairie we soon began to make our way towards the camping ground and passed within a moderate distance of a large herd of buffaloes which we did not stop to molest but increasing our speed reached our quarters for the night just as the shadows of the western plain indicated that we should not behold the orb of day until the morrow.

Our camp was near three conical hills called the Mamelles only about thirty miles from Fort Union, although we had traveled nearly fifty by the time we reached the spot. After unloading and unsaddling our tired beasts all hands assisted in getting wood and bringing water and we were soon quietly enjoying a cup of coffee. The time of refreshment to the weary hunter is always one of interest: the group of stalwart frames stretched in various attitudes around or near the blazing watch fires recalls to our minds the masterpieces of the great delineators of night scenes; and we have often at such times beheld living pictures far surpassing any of those contained in the galleries of Europe.

There were signs of grizzly bears around us and during the night we heard a number of wolves howling among the bushes in the vicinity. The serviceberry was abundant and we ate a good many of them; and after a hasty preparation in the morning started again after the buffaloes we had seen the previous evening. Having rode for some time, one of our party who was in advance as a scout made the customary signal from the top of a high hill that buffaloes were in sight; this is done by walking the hunter's horse backward and forward several times. We hurried on and found our scout lying close to his horse's neck as if asleep on the back of the animal. He pointed out where he had discovered the game, but they had gone out of sight and (as he said) were traveling fast, the herd being composed of both bulls and cows. The hunters mounted at once and galloped on in rapid pursuit, while we followed more leisurely over hills and plains and across ravines and broken ground at the risk of our necks. Now and then we could see the hunters

and occasionally the buffaloes, which had taken a direction towards the Fort. At last we reached an eminence from which we saw the hunters approaching the buffaloes in order to begin the chase in earnest. It seems that there is no etiquette among buffalo hunters, and this not being understood beforehand by our friend Harris, he was disappointed in his wish to kill a cow. The country was not as favorable to the hunters as it was to the flying herd. The females separated from the males and the latter turned in our direction and passed within a few hundred yards of us without our being able to fire at them. Indeed we willingly suffered them to pass unmolested, as they are always very dangerous when they have been parted from the cows. Only one female was killed on this occasion. On our way homeward we made towards the coupee, an opening in the hills where we expected to find water for our horses and mules, as our supply of Missouri water was only enough for ourselves.

The water found on these prairies is generally unfit to drink (unless as a matter of necessity), and we most frequently carried eight or ten gallons from the river on our journey through the plains. We did not find water where we expected and were obliged to proceed about two miles to the eastward, where we luckily found a puddle sufficient for the wants of our horses and mules. There was not a bush in sight at this place and we collected buffalo dung to make a fire to cook with. In the winter this prairie fuel is often too wet to burn and the hunters and Indians have to eat their meat raw. It can however hardly be new to our readers to hear that they are often glad to get anything, either raw or cooked, when in this desolate region.

Young buffalo bulls are sometimes castrated by the Indians, as we were told, for the purpose of rendering them larger and fatter; and we were informed that when full grown they have been shot and found to be far superior to others in the herd in size as well as flavor. During severe winters the buffaloes become very poor, and when the snow has covered the ground for several months to the depth of two or three feet they are wretched objects to behold. They frequently in this emaciated state lose their hair and become covered with scabs; and the magpies alight on their backs and pick the sores. The poor animals in these dreadful seasons die in great numbers.

A singular trait in the buffalo when caught young was related to us as follows: When a calf is taken, if the person who captures it places one of his fingers in its mouth it will follow him afterwards, whether on foot or on horseback, for several miles.

We now give a few notes from our journal kept at Fort Union, which may interest our readers.

August 7th, 1843. A buffalo cow was killed and brought into the fort and to the astonishment of all was found to be near her time of calving. This was an extraordinary circumstance at that season of the year.

August 8th. The young buffaloes have commenced shedding their first (or red) coat of hair, which drops off in patches about the size of the palm of a man's hand. The new hair is dark brownish-black. We caught one of these calves with a lasso and had several men to hold him, but on approaching to pull off some of the old hair he kicked and bounced about in such a furious manner that we could not get near him. Mr. Culbertson had it however taken to the press post, and there it was drawn up and held so closely that we could handle it, and we tore off some pieces of its old pelage, which hung to the side with surprising tenacity.

The process of butchering or cutting up the carcass of the buffalo is generally performed in a slovenly and disgusting manner by the hunters and the choicest parts only are saved unless food is scarce. The liver and brains are eagerly sought for and the hump is excellent when broiled. The pieces of flesh from the sides are called by the French, *fillets*, or the *dépouille*; the marrow bones are sometimes cut out and the paunch is stripped of its covering of fat.

Some idea of the immense number of bisons to be still seen on the wild prairies may be formed from the following account, given to us by Mr. Kipp, one of the principals of the American Fur Company. While he was traveling from Travers' Bay to the Mandan nation in the month of August in a cart heavily laden, he passed through herds of buffalo for six days in succession. At another time he saw the great prairie near Fort Clark on the Missouri River almost blackened by these animals, which covered the plain to the hills that bounded the view in all directions and probably extended farther.

When the bisons first see a person, whether white or red, they

trot or canter off forty or fifty yards and then stop suddenly, turn their heads and gaze on their foe for a few moments, then take a course and go off at full speed until out of sight and beyond the scent of man.

Although large, heavy and comparatively clumsy, the bison is at times brisk and frolicsome, and these huge animals often play and gambol about, kicking their heels in the air with surprising agility and throwing their hinder parts to the right and left alternately or from one side to the other, their heels the while flying about and their tails whisking in the air. They are very impatient in the fly and mosquito season and are often seen kicking and running against the wind to rid themselves of these tormentors.

The different Indian tribes hunt the buffalo in various ways: some pursue them on horseback and shoot them with arrows, which they point with old bits of iron or old knife blades. They are rarely expert in loading or reloading guns (even if they have them), but in the closely contested race between their horse and the animal they prefer the rifle to the bow and arrow. Other tribes follow them with patient perseverance on foot until they come within shooting distance or kill them by stratagem.

The Mandan Indians chase the buffalo in parties of from twenty to fifty, and each man is provided with two horses, one of which he rides and the other, being trained expressly for the chase, is led to the place where the buffaloes are started. The hunters are armed with bows and arrows, their quivers containing from thirty to fifty arrows according to the wealth of the owner. When they come in sight of their game they quit the horses on which they have ridden, mount those led for them, ply the whip, soon gain the flank or even the center of the herd and shoot their arrows into the fattest, according to their fancy. When a buffalo has been shot, if the blood flows from the nose or mouth he is considered mortally wounded; if not, they shoot a second or a third arrow into the wounded animal.

The buffalo, when first started by the hunters, carries his tail close down between the legs; but when wounded he switches his tail about, especially if intending to fight his pursuer, and it behooves the hunter to watch these movements closely, as the horse will often shy, and without due care the rider may be thrown,

which when in a herd of buffalo is almost certain death. An arrow will kill a buffalo instantly if it takes effect in the heart, but if it does not reach the right spot a dozen arrows will not even arrest one in his course, and of the wounded, many run out of sight and are lost to the hunter.

At times the wounded bison turns so quickly and makes such a sudden rush upon the hunter that if the steed is not a good one and the rider perfectly cool, they are overtaken, the horse gored and knocked down and the hunter thrown off and either gored or trampled to death. But if the horse is a fleet one and the hunter expert, the bison is easily outrun and they escape. At best it may be said that this mode of buffalo hunting is dangerous sport, and one that requires both skill and nerve to come off successfully.

The Gros Ventres, Blackfeet and Assiniboine often take the buffalo in large pens, usually called parks, constructed in the following manner.

Two converging fences built of sticks, logs and brushwood are made leading to the mouth of a pen somewhat in the shape of a funnel. The pen itself is either square or round according to the nature of the ground where it is to be placed, at the narrow end of the funnel, which is always on the verge of a sudden break or precipice in the prairie ten or fifteen feet deep and is made as strong as possible. When this trap is completed, a young man very swift of foot starts at daylight provided with a bison's hide and head to cover his body and head when he approaches the herd that is to be taken, on nearing which he bleats like a young buffalo calf and makes his way slowly towards the mouth of the converging fences leading to the pen. He repeats this cry at intervals, the buffaloes follow the decoy and a dozen or more of mounted Indians at some distance behind the herd gallop from one side to the other on both their flanks, urging them by this means to enter the funnel, which having done, a crowd of men, women and children come and assist in frightening them, and as soon as they have fairly entered the road to the pen beneath the precipice, the disguised Indian, still bleating occasionally, runs to the edge of the precipice, quickly descends and makes his escape, climbing over the barricade or fence of the pen beneath, while the herd follow on till the leader (probably an old bull) is forced to leap down into the pen and is

followed by the whole herd, which is thus ensnared and easily destroyed even by the women and children, as there is no means of escape for them.

This method of capturing the bison is especially resorted to in October and November, as the hide is at that season in good condition and saleable and the meat can be preserved for the winter supply. When the Indians have thus driven a herd of buffalo into a pen, the warriors all assemble by the side of the enclosure, the pipe is lighted and the chiefs smoke to the honor of the Great Spirit to the four points of the compass and to the herd of bisons. As soon as this ceremony has ended the destruction commences, guns are fired and arrows shot from every direction at the devoted animals and the whole herd is slaughtered before the Indians enter the space where the buffaloes have become their victims. Even the children shoot tiny arrows at them when thus captured and try the strength of their young arms upon them.

It sometimes happens, however, that the leader of the herd becomes alarmed and restless while driving to the precipice, and should the fence be weak, breaks through, and the whole drove follow and escape. It also sometimes occurs that after the bisons are in the pen, which is often so filled that they touch each other, the terrified crowd swaying to and fro, their weight against the fence breaks it down, and if the smallest gap is made it is immediately widened, when they dash through and scamper off leaving the Indians in dismay and disappointment. The side fences for the purpose of leading the buffaloes to the pens extend at times nearly half a mile, and some of the pens cover two or three hundred yards of ground. It takes much time and labor to construct one of these great traps or snares, as the Indians sometimes have to bring timber from a considerable distance to make the fences and render them strong and efficient.

The bison has several enemies: the worst is, of course, man; then comes the grizzly bear; and next the wolf. The bear follows them and succeeds in destroying a good many; the wolf hunts them in packs and commits great havoc among them, especially among the calves and the cows when calving. Many buffaloes are killed when they are struggling in the mire on the shores of rivers where they sometimes stick fast, so that the wolves or bears can attack them

to advantage, eating out their eyes and devouring the unresisting animals by piecemeal.

When we were ascending the Missouri River the first buffaloes were heard of near Fort Leavenworth, some having a short time before been killed within forty miles of that place. We did not, however, see any of these animals until we had passed Fort Croghan, but above this point we met with them almost daily either floating dead on the river or gazing at our steamboat from the shore.

Every part of the bison is useful to the Indians, and their method of making boats by stretching the raw hide over a sort of bowl-shaped frame work is well known. These boats are generally made by the women, and we saw some of them at the Mandan village. The horns are made into drinking vessels, ladles and spoons. The skins form a good bed or admirable covering from the cold and the flesh is excellent food, whether fresh or dried or made into pemmican; the fat is reduced and put up in bladders and in some cases used for frying fish, &c.

The hide of the buffalo is tanned or dressed altogether by the women or squaws and the children; the process is as follows: The skin is first hung on a post and all the adhering flesh taken off with a bone, toothed somewhat like a saw; this is performed by scraping the skin downwards and requires considerable labor. The hide is then stretched on the ground and fastened down with pegs; it is then allowed to remain till dry, which is usually the case in a day or two. After it is dry the flesh side is pared down with the blade of a knife fastened in a bone, called a grate, which renders the skin even and takes off about a quarter of its thickness. The hair is taken off with the same instrument and these operations being performed and the skin reduced to a proper thickness, it is covered over either with brains, liver or grease and left for a night. The next day the skin is rubbed and scraped either in the sun or by a fire until the greasy matter has been worked into it and it is nearly dry; then a cord is fastened to two poles and over this the skin is thrown and pulled, rubbed and worked until quite dry; after which it is sewed together around the edges excepting at one end; a smoke is made with rotten wood in a hole dug in the earth and the skin is suspended over it on sticks set up like a tripod and

thoroughly smoked, which completes the tanning and renders the skin able to bear wet without losing its softness or pliability afterwards.

Buffalo robes are dressed in the same manner, only that the hair is not removed and they are not smoked. They are generally divided into two parts: a strip is taken from each half on the back of the skin where the hump was and the two halves, or sides, are sewed together after they are dressed, with thread made of the sinews of the animal; which process being finished, the robe is complete and ready for market.

The scrapings of the skins, we were informed, are sometimes boiled with berries and make a kind of jelly which is considered good food in some cases by the Indians. The strips cut off from the skins are sewed together and make robes for the children or caps, mittens, shoes, &c. The bones are pounded fine with a large stone and boiled; the grease which rises to the top is skimmed off and put into bladders. This is the favorite and famous marrow grease, which is equal to butter. The sinews are used for stringing their bows and are a substitute for thread; the intestines are eaten, the shoulder blades made into hoes and in fact (as we have already stated) nothing is lost or wasted, but every portion of the animal by the skill and industry of the Indians is rendered useful.

Balls are found in the stomach of the buffalo, as in our common domestic cattle.

Having heard frequent discussions respecting the breeding of the bison in a domesticated state, and knowing that Robert Wickliffe, Esq., of Kentucky had raised some of these animals, we requested his son, then on his way to Europe, to ask that gentleman to give us some account of their habits under his care, and shortly afterwards received a letter from him dated Lexington, November 6th, 1843, in which he gives an interesting account of the bison breeding with the common cow and other particulars connected with this animal. After expressing his desire to comply with our request intimated to him by his son he proceeds to give us the following information: "as far," he writes, "as his limited knowledge of natural history and his attention to these animals will permit him to do." He proceeds: "The herd of buffalo I now possess have descended from one or two cows that I purchased from a man who

brought them from the country called the Upper Missouri; I have had them for about thirty years, but from giving them away and the occasional killing of them by mischievous persons, as well as other causes, my whole stock at this time does not exceed ten or twelve. I have sometimes confined them in separate parks from other cattle, but generally they herd and feed with my stock of farm cattle. They graze in company with them as gently as the others. The buffalo cows, I think, go with young about the same time the common cow does, and produce once a year; none of mine have ever had more than one at a birth. The approach of the sexes is similar to that of the common bull and cow under similar circumstances at all times when the cow is in heat, a period which seems as with the common cow confined neither to day nor night nor any particular season, and the cows bring forth their young of course at different times and seasons of the year, the same as our domesticated cattle. I do not find my buffaloes more furious or wild than the common cattle of the same age that graze with them.

"Although the buffalo, like the domestic cow, brings forth its young at different seasons of the year, this I attribute to the effect of domestication, as it is different with all animals in a state of nature. I have always heard their time for calving in our latitude was from March until July, and it is very obviously the season which nature assigns for the increase of both races, as most of my calves were from the buffaloes and common cows at this season. On getting possession of the tame buffalo I endeavored to cross them as much as I could with my common cows, to which experiment I found the tame or common bull unwilling to accede, and he was always shy of a buffalo cow, but the buffalo bull was willing to breed with the common cow.

"From the domestic cow I have several half-breeds, one of which was a heifer; this I put with a domestic bull, and it produced a bull calf. This I castrated, and it made a very fine steer, and when killed produced very fine beef. I bred from the same heifer several calves and then, that the experiment might be perfect, I put one of them to the buffalo bull, and she brought me a bull calf which I raised to be a very fine large animal, perhaps the only one to be met with in the world of his blood, viz., a three-quarter, half-quarter and half-quarter of the common blood. After making these experiments

I have left them to propagate their breed themselves, so that I have only had a few half-breeds and they always prove the same, even by a buffalo bull. The full-blood is not as large as the improved stock, but as large as the ordinary cattle of the country. The crossed or half-blood are larger than either the buffalo or common cow. The hump, brisket, ribs and tongue of the full- and half-blooded are preferable to those of the common beef, but the round and other parts are much inferior. The udder or bag of the buffalo is smaller than that of the common cow, but I have allowed the calves of both to run with their dams upon the same pasture and those of the buffalo were always the fattest; and old hunters have told me that when a young buffalo calf is taken it requires the milk of two common cows to raise it. Of this I have no doubt, having received the same information from hunters of the greatest veracity. The bag or udder of the half-breed is larger than that of full-blooded animals and they would, I have no doubt, make good milkers.

"The wool of the wild buffalo grows on their descendants when domesticated, but I think they have less of wool than their progenitors. The domesticated buffalo still retains the grunt of the wild animal and is incapable of making any other noise, and they still observe the habit of having select places within their feeding grounds to wallow in.

"The buffalo has a much deeper shoulder than the tame ox but is lighter behind. He walks more actively than the latter, and I think has more strength than a common ox of the same weight. I have broke them to the yoke and found them capable of making excellent oxen; and for drawing wagons, carts or other heavily laden vehicles on long journeys they would, I think, be greatly preferable to the common ox. I have as yet had no opportunity of testing the longevity of the buffalo, as all mine that have died did so from accident or were killed because they became aged. I have some cows that are nearly twenty years old that are healthy and vigorous, and one of them has now a sucking calf.

"The young buffalo calf is of a sandy-red or rufus color and commences changing to a dark brown at about six months old, which last color it always retains. The mixed breeds are of various colors; I have had them striped with black on a gray ground like

the zebra, some of them brindled red, some pure red with white faces and others red without any markings of white. The mixed-bloods have not only produced in my stock from the tame and the buffalo bull, but I have seen the half-bloods reproducing; viz.: those that were the product of the common cow and wild buffalo bull. I was informed that at the first settlement of the country, cows that were considered the best for milking were from the half-blood down to the quarter and even eighth of the buffalo blood. But my experiments have not satisfied me that the half-buffalo bull will produce again. That the half-breed heifer will be productive from either race, as I have before stated, I have tested beyond the possibility of a doubt.

"The domesticated buffalo retains the same haughty bearing that distinguishes him in his natural state. He will, however, feed or fatten on whatever suits the tame cow and requires about the same amount of food. I have never milked either the full-blood or mixed-breed but have no doubt they might be made good milkers, although their bags or udders are less than those of the common cow; yet from the strength of the calf the dam must yield as much or even more milk than the common cow."

Since reading the above letter we recollect that the buffalo calves that were kept at Fort Union, though well fed every day, were in the habit of sucking each other's ears for hours together.

There exists a singular variety of the bison, which is however very scarce, and the skin of which is called by both the hunters and fur traders a "beaver robe." These are valued so highly that some have sold for more than three hundred dollars. Of this variety Mr. Culbertson had the goodness to present us with a superb specimen which we had lined with cloth and find a most excellent defense against the cold whilst driving in our wagon during the severity of our northern winters.

Geographical Distribution

The range of the bison is still very extensive; but although it was once met with on the Atlantic coast it has, like many others, receded and gone west and south, driven onward by the march of civilization and the advance of the axe and plow. His habits as we

have seen are migratory, and the extreme northern and southern limits of the wandering herds not exactly defined. Authors state that at the time of the first settlement of Canada it was not known in that country, and [the seventeenth-century French missionary Gabriel] Sagard-Theodat mentions having heard that bulls existed in the Far West but saw none himself. According to [Arctic explorer] Dr. [John] Richardson, Great Slave Lake, latitude 60°, was at one time the northern boundary of their range; but of late years according to the testimony of the native, they have taken possession of the flat limestone district of Slave Point on the north side of that lake and have wandered to the vicinity of Great Marten Lake, in latitude 63° or 64°. The bison was not known formerly to the north of the Columbia river on the Pacific coast, and Lewis and Clark found buffalo robes were an important article of traffic between the inhabitants of the east side and those west of the Rocky Mountains.

The bison is spoken of by [sixteenth-century Spanish naturalist Dr. Francisco] Hernandez as being found in New Spain or Mexico, and it probably extended farther south. [Eighteenth-century American explorer] John Lawson speaks of two buffaloes that were killed in one season on Cape Fear River in North Carolina. The bison formerly existed in South Carolina on the seaboard, and we were informed that from the last herd seen in that state, two were killed in the vicinity of Columbia. It thus appears that at one period this animal ranged over nearly the whole of North America.

At the present time, the buffalo is found in vast herds in some of the great prairies and scattered more sparsely nearly over the whole length and breadth of the valleys east and west that adjoin the Rocky Mountain chain.

John James Audubon to John Bachman
"I came home with a beard and mustachios…"

Minnie's Land, New York
12 November 1843

My dear Bachman,

I reached my happy home this day week last at 3 o'clock and found all well. The next day Victor handed me your letter of the 1st Instant, to which I will now answer as much as I can do in the absence of my cargo of skins, &c., which I trust will be at home early next week. Now, friend, we were never out of sight of the coffee pot, feather beds or white faces, and never failed in our being hungry and thirsty! Nay not even while on the prairies feeding on the juicy ribs or humps of the bison. Harris stood the journey quite well but lost flesh and weight. I gained 22 pounds and am as fat as a grizzly bear in good season. Harris would have been better had he given up taking physic almost every day. The rest of my party got on well enough, and when we meet I will then say more on this subject.

I have no less than 14 new species of birds, perhaps a few more, and I hope that will in a great measure defray my terribly heavy expenses. The variety of quadrupeds is small in the country we visited, and I fear that I have not more than 3 or 4 new ones. I have brought home alive a deer which we all think will prove new. I have also a live badger and a swift fox. I have first-rate skins in pickle of the buffalo bull, cow and calves. Elks, bighorn antelopes, black-tailed deer, the deer I have alive and sundry wolves. I have Townsend's hare, *Tamias quadrivitatus*, prairie marmots (prairie dog so-called), a fine grizzly bear, &c., but I have no list. I have written much and taken ample and minute measurements of everything.

I have a large collection of dried plants, principally flowers, and an abundance of precious seeds, one or 2 fishes, but there are no shells in the streams of the country we have visited.

You wish me to go to you but this is impossible. As soon as my collections reach me I will draw first all the birds, that they may

be added to my present publication, and then 30 or 40 species of quadrupeds. I have brought home good sketches of scenery, drawings of flowers and also of the heads of antelopes, bighorns, wolves and buffalos.

I am most heartily glad to hear that you are all well, and that is the case with us also.

I came home with a beard and mustachios of 7 months' growth, and Johnny has painted my head as it was, for I am now shaved and much as usual except in fatness which is almost disagreeable to me.

Now that I am in the lap of comfort and without the hard and continued exercise so lately my lot, I feel somewhat lazy and disinclined even to write a long letter. I tried to copy my last journal yesterday but could not write more than one hour, and yet I must do that as soon as possible as no man on earth can do it for me. In a few days my things will be here and I will send you a catalog of what I have. By the way, I think that I have a new porcupine—*nous verrons* [i.e., we will see]. I have the best account of the habits of the buffalo, beaver, antelopes, bighorns, &c., that were ever written and a great deal of information of divers nature. Now remember me most kindly to every member of your dear family. I wrote to Maria from St. Louis. She must have received my letter. Remember me to Dr. Wilson and all other friends...

John Woodhouse Audubon to Thomas Lincoln
"My father is an old man...."

Minnie's Land, New York
11 March 1845

My dear Lincoln,

I suppose you have not thought of me for some years, at least I might judge so from your not having answered my last letter from Charleston in 1840. But I will not let you drop on my part, as I want your assistance for the procuring of specimens of the quadrupeds of our country and for information in regard to the habits of such as you have about you or a knowledge of, or any anecdotes relative to, the subject. The animals we want are caribou—male and female & young. Black and white foxes—silver gray. Black and white bears—some of your fishermen might come across the latter on the coast of Labrador, very far north. He would keep it opened, without skinning, and covered with salt about 1 foot thick and renewing it once or twice. We would gladly pay the expenses of such an experiment and a fair price for the animal. Perhaps a caribou could be sent to us in a large box filled with salt.

Since our happy trip to Labrador a great many changes have taken place in our family. My father is an old man and my mother quite gray, in fact a white hair is now and then to be seen among my own dark crop. My children, thrice little girls, two of my first wife's and one of my present wife, are from one and a half to six and a half years old. Brother has a little one by his second wife and we are all in the same house with Mamma as the head of the family affairs and our two wives living with us as her children.

I hope you will soon answer this and give me some account of your life, for the last 5 or 6 years I have had only an occasional bit of news from Shattuck—now Dr. Shattuck. You will greatly oblige us by giving us as full histories of the animals you have about you as you can get or know already, also the mode of hunting or procuring them. The number taken, etc. In short, everything you think of interest to those desirous of information of any natural history subject. After so long an absence I cannot send regards,

remembrances to anybody in your family or to those I knew at Eastport. Have you ever found a lady who could split rails and play a concerto? Goodbye. "For auld langsyne," let me hear from you . . .

John Bachman to His Family
"His noble mind is all in ruins..."

Audubon began to show symptoms of dementia in 1847, and by the time John Bachman, on his way to attend a church meeting in New York City, visited him at his Hudson River estate in the spring of 1848, he no longer recognized his old friend and collaborator.

Minnie's Land, New York
11 May 1848

... The girls say that they have heard "the music of the minstrel's nose." As I sit on an armchair with my feet on the hot fender this chilly evening, I am half inclined to think that they were, in part, right, for I feel a little drowsy just now. I had better try to shake off lethargy by writing a few lines home. But how shall I collect my thoughts amid the din and confusion that prevail around me; yet I like to see these happy faces and hear their merry laugh.

I found all well here as far as health is concerned. Mrs. Audubon is straight as an arrow and in fine health, but sadly worried. John has just come in from feeding his dogs. Audubon has heard his little song sung in French and has gone to bed. Alas, my poor friend Audubon! The outlines of his countenance and his form are there, but his noble mind is all in ruins. I have often, in sadness, contemplated in ruin a home that, in other years, I have seen in order and beauty, but the ruins of a mind once bright and full of imagination, how much more inexpressibly melancholy and gloomy. But why dwell upon these? I turn away from the subject with a feeling of indescribable sadness...

The weather has been rainy for the past four days, but this afternoon it was clear, but quite cold. The spring here is further advanced than I expected to find it, the fruit trees are in full bloom and the grass of a dark green. The woods and the grounds are full of the melody of singing birds. There are not less than twenty woodrobins whose notes can be heard in this vicinity. A red-breast has built a nest in the cherry tree near the piazza; the peewee is building close by, and the robins have found a home here. I, too, would willingly linger, but I must be on the wing. Day after tomorrow

I expect to take the girls with me to New York, during the meeting of Synod. I want them to see a little this great city.

I am working away among the Quadrupeds; and if I had nothing else to do could spend a month here with great satisfaction; but as it is, time is passing and I must soon turn my face homewards. I do not yet know if the girls will decide to return with me.

Mrs. Audubon is going into the city maid-hunting tomorrow morning, and I shall send this letter by her to be posted.

Tell Master John Bachman (Haskell) that these little folk, of all sizes, sit and play all day in my room and do not touch the specimens; if my little restless, roaring, tearing dog was here, he would make the fur fly as well as the heads and the tails. All send love to Aunt Maria and to the girls and boys...

Victor Gifford Audubon to Maria Martin
"My poor old father enjoys his little notions..."

Minnie's Land, New York
29 January 1849

My dear Aunt Maria,

Your letter of no date was received day before yesterday, and I assure you it was with no ordinary satisfaction that I read it, and I am now more assured of the completion of our hopes and wishes in regard to the letterpress of the *Quadrupeds* than I have been for months past. You will, I know, readily imagine the unpleasant position in which the long delay that has already occurred has placed us, but I must pass over many things connected with this subject which it would only worry you to no purpose to relate to you. I hope the task of completing the work will not prove too irksome to you and to our friend, your husband [Martin had married John Bachman in 1848, after her sister's death], and can truly say that it will be gratefully remembered by me, and that we all shall try to make him some return one way or another.

My brother will leave us in a few days for California, and I shall have the cares and responsibilities of providing for our large family fully upon me. The duties before me do not alarm, but excite regrets that I shall necessarily be detained from other work a good deal by the supervision of the letterpress, which has so long (when I could easily have last summer spared the time to attend to it) been delayed. Pray excuse this single allusion to the situation in which I am now placed.

The absence of John will be perhaps 18 months or two years, and his journey is undertaken with the hope, based on the intelligence we have been able to obtain, that he will be able to get at least $20,000 worth of the gold! What may be the result only God knows, but we are all willing and as heretofore our family is united in their views of what is best to be done; which is a great comfort to us all. John is accompanied by Col. H. L. Webb, as military leader, and has Henry Mallory as bookkeeper, & the party consists of about 70 to 80 picked men. They are to go down the Ohio and

Mississippi & across Texas & part of Mexico—via Chihuahua & thence west & northwest to the gold region. Perhaps William Gordon *may* go with them from New Orleans, Jacob Henry Bachman goes along from here ...

My poor old father is apparently comfortable, and enjoys his little notions, but has no longer any feeling of interest for any of us and requires the care and attendance of a man. This is the hardest of all to bear among the trials in store for us. My mother is better, and but for a cold she has lately been much troubled with, she would be tolerably comfortable.

Lucy & Harriet are growing finely and are well-educated except a sort of country manner they have. We shall probably call in a *maitre de danse* for them in a short time who will polish them up and improve their *understanding* (a pun meant) at the same time.

I am about to go to Washington to get a letter from the President for John, and I will try to see the collection brought back by the Exploring Expedition including the famous black-tailed deer ...

I am in quite a bustle—the office *full* of *Californians* ...

"The Task Is Accomplished..."

In the introduction to the fifth and last volume of the Ornithological Biography, *published in 1839, Audubon celebrated the end of his long labors on that text and on* The Birds of America. *If he embroidered his encounters with "Red Indians" and "white-skinned murderers" for his middle-class English audience, he also wrote authentically of his struggle and pleasure exploring wild America and encouraged his readers—then and now—to pursue and to further the work.*

How often, Good Reader, have I longed to see the day on which my labors should be brought to an end! Many times, when I had laid myself down in the deepest recesses of the western forests, have I been suddenly awakened by the apparition of dismal prospects that have presented themselves to my mind. Now sickness, methought, had seized me with burning hand and hurried me away, in spite of all my fond wishes, from those wild woods in which I had so long lingered to increase my knowledge of the objects which they offered to my view. Poverty, too, at times walked hand in hand with me, and on more than one occasion urged me to cast away my pencils, destroy my drawings, abandon my journals, change my ideas and return to the world. At other times the Red Indian, erect and bold, tortured my ears with horrible yells and threatened to put an end to my existence; or white-skinned murderers aimed their rifles at me. Snakes, loathsome and venomous, entwined my limbs, while vultures, lean and ravenous, looked on with impatience. Once, too, I dreamed when asleep on a sandbar on one of the Florida Keys that a huge shark had me in his jaws and was dragging me into the deep.

But my thoughts were not always of this nature, for at other times my dreams presented pleasing images. The sky was serene, the air perfumed and thousands of melodious notes from birds all unknown to me urged me to arise and go in pursuit of those beautiful and happy creatures. Then I would find myself furnished with large and powerful wings and, cleaving the air like an eagle, I would fly off and by a few joyous bounds overtake the objects of my desire. At other times I was gladdened by the sight of my

beloved family, seated by their cheerful fire and anticipating the delight which they should experience on my return. The glorious sun would arise, and as its first rays illumined the earth I would find myself on my feet, and while preparing for the business of the day, I would cheer myself with the pleasing prospect of the happy termination of my labors and hear in fancy the praises which kind friends would freely accord. Many times, indeed, have such thoughts enlivened my spirits; and now, Good Reader, the task is accomplished. In health and in sickness, in adversity and prosperity, in summer and winter, amidst the cheers of friends and the scowls of foes I have depicted the Birds of America, and studied their habits as they roamed at large in their peculiar haunts.

Few persons can better than myself appreciate the pleasures felt by the weary traveler when he sees before him the place of repose for which he has long been seeking. Methinks I see him advance with a momentary renovation of vigor and, although heavily laden, with expanded chest and brightened eye. He has now reached his home, embraced his family, laid aside his gun and thrown off his knapsack; while his faithful dog, glad too no doubt, lays himself down, wags his tail, and casting glances of friendship around, kindly licks the hands of the children who are caressing him. Anxiety of another nature now prevails among the members of the happy group; the contents of the traveler's wallet [i.e., knapsack] are sought for and arranged in view of the whole family. One looks at this and likes it, another has caught hold of a different object, the oldest perhaps reads the "journal," while some prefer gazing on the sketches "from nature." Meanwhile the traveler and his dearest friend feel perfectly happy in being once more together— never again to part.

Now, Reader, you may well imagine how happy I am at this moment when, like the traveler alluded to, I find my journeys all finished, my anxieties vanished, my mission accomplished; and when I expect soon to see myself and my dearest friends seated beneath lofty and fragrant trees, listening to the gay carolings of the Mockingbird, or the sweet though perhaps melancholy song of my favorite, the Wood Thrush. Fishing tackle, bird nets and a good gun will then be often exchanged for the pencil and the pen; and although I can never entirely relinquish the pleasure of noting

new facts in zoology, or of portraying natural objects, whether on canvass or on paper, I shall undertake few journeys save short rambles for amusement. If I have a regret at this moment, it is that I cannot transfer to you the whole of the practical knowledge which I have acquired during so many years of enthusiastic devotion to the study of nature.

You will perceive that the number of species of birds which have been discovered, figured and described since the publication of the *American Ornithology* by Alexander Wilson is very great. Indeed, the list is now extended to double the length that it shewed at the period of his death, or even when his work was completed by the addition of the ninth volume. Yet I am confident that very many species remain to be added by future observers who shall traverse the vast wastes extending northward and westward from the Canadas and along the western slopes of the Rocky Mountains from Nootka to California. Nay, I look upon the whole range of those magnificent mountains as being yet unexplored, for the few scientific travelers who have traversed it have merely, as it were, picked up the scattered objects that crossed their path. Of this I am persuaded in consequence of the many conversations I have had with my friend Thomas Nuttall and the notices which I have received from Dr. Townsend, as well as the valuable observations transmitted in a letter to me by my friend Dr. Richardson. Both Captain James Ross and Captain Back of the British Navy have assured me that they saw curious birds which they were unable to procure. Indeed, this has been the case with myself, even in some of the inhabited portions of the United States, as well as in Labrador and Newfoundland. Therefore, Reader, I would strongly advise you to make up your mind, shoulder your gun, muster all your spirits and start in search of the interesting unknown, of which I greatly regret I cannot more go in pursuit—not for want of will, but of the vigor and elasticity necessary for so arduous an enterprise. Should you agree to undertake the task, and prove fortunate enough to return full of knowledge, laden with objects new and rare, be pleased, when you publish *your* work, to place my name in the list of subscribers, and be assured that *I* will not "leave you in the lurch."

Now, supposing that you are full of ardor and ready to proceed, allow me to offer you a little advice. Leave nothing to memory but

note down all your observations with *ink*, not with a black-lead pencil; and keep in mind that the more particulars you write at the time, the more you will afterwards recollect. Work not at night, but anticipate the morning dawn, and never think for an instant about the difficulties of ransacking the woods, the shores or the barren grounds, nor be vexed when you have traversed a few hundred miles of country without finding a single new species. It may, indeed it not unfrequently does happen, that after days or even weeks of fruitless search, one enters a grove, or comes upon a pond, or forces his way through the tall grass of a prairie and suddenly meets with several objects, all new, all beautiful and perhaps all suited to the palate. Then how delightful will be your feelings and how marvelously all fatigue will vanish! Think, for instance, that you are on one of the declivities of the Rocky Mountains with shaggy and abrupt banks on each side of you, while the naked cliffs tower high over head as if with the wish to reach the sky. Your trusty gun has brought to the ground a most splendid "American pheasant" weighing fully two pounds! What a treat! You have been surprised at the length of its tail, you have taken the precise measurement of all its parts and given a brief description of it. Have you read this twice, corrected errors and supplied deficiencies? "Yes," you say. Very well; now you have begun your drawing of this precious bird! Ah! you have finished it. Now then, you skin the beautiful creature, and are pleased to find it plump and fat. You have, I find, studied comparative anatomy under my friend Macgillivray, and at last have finished your examination of the esophagus, gizzard, coeca, trachea and bronchi. On the ignited dry castings of a buffalo, you have laid the body, and it is now almost ready to satisfy the longings of your stomach as it hisses in its odorous sap. The brook at your feet affords the very best drink that nature can supply, and I need not wish you better fare than that before you. Next morning you find yourself refreshed and reinvigorated, more ardent than ever, for success fails not to excite the desire of those who have entered upon the study of nature. You have packed your bird skin flat in your box, rolled up your drawing round those previously made and now, day after day, you push through thick and thin, sometimes with success, sometimes without; but you at last return with such a load on your

shoulders as I have often carried on mine. Having once more reached the settlements, you relieve your tired limbs by mounting a horse, and at length gaining a seaport, you sail for England, if that be your country, or you repair to Boston, New York or Baltimore, where you will find means of publishing the results of your journey...

I have pleasure in saying that my enemies have been few and my friends numerous. May the God who granted me life, industry and perseverance to accomplish my task, forgive the former and forever bless the latter!

Index

611

Acknowledgments

The Library of the American Philosophical Society, Philadelphia, Pennsylvania; the John James Audubon Museum, John James Audubon State Park, Henderson, Kentucky; the Bibliothèque Centrale of the Musée Nationale d'Histoire Naturelle, Paris; the Filson Historical Society, Louisville, Kentucky; the Houghton Library at Harvard University, Cambridge, Massachusetts; the Manuscripts Division, Department of Rare Books and Special Collections, Princeton University Library, Princeton, New Jersey; the Stark Museum, Orange, Texas; and the Beineke Rare Book and Manuscript Library, Manuscripts Division, Department of Rare Books and Special Collections, Yale University, New Haven, Connecticut, all generously allowed the editor access to their collections.

The editor was unable to determine a copyright holder for Howard Corning's *Letters of John James Audubon*, 1930 (Boston: Club of Odd Volumes).

About the Editor

Richard Rhodes is the author or editor of more than twenty works of history, biography and fiction. His biography *John James Audubon: The Making of an American* was published in 2004. His 1986 history of the development of the first atomic bombs, *The Making of the Atomic Bomb*, won a Pulitzer Prize in Nonfiction and a National Book Award. A Kansas native, he lives in Northern California.